DOING
PHILOSOP

DOING PHILOSOPHY

An Introduction through Thought Experiments

Sixth Edition

THEODORE SCHICK, JR.
Muhlenberg College

DOING PHILOSOPHY: AN INTRODUCTION THROUGH THOUGHT EXPERIMENTS, SIXTH EDITION

Published by McGraw-Hill Education, 2 Penn Plaza, New York, NY 10121. Copyright © 2020 by McGraw-Hill Education. All rights reserved. Printed in the United States of America. Previous editions © 2013, 2010, and 2006. No part of this publication may be reproduced or distributed in any form or by any means, or stored in a database or retrieval system, without the prior written consent of McGraw-Hill Education, including, but not limited to, in any network or other electronic storage or transmission, or broadcast for distance learning.

Some ancillaries, including electronic and print components, may not be available to customers outside the United States.

This book is printed on acid-free paper.

1 2 3 4 5 6 7 8 9 LCR 21 20 19

ISBN 978-0-07-811917-0 (bound edition)
MHID 0-07-811917-0 (bound edition)
ISBN 978-1-260-68704-0 (loose-leaf edition)
MHID 1-260-68704-X (loose-leaf edition)

Product Developers: *Erika Lo, Elisa Odoardi*
Marketing Manager: *Nancy Baudean*
Content Project Managers: *Maria McGreal, Danielle Clement*
Buyer: *Susan K. Culbertson*
Design: *Beth Blech*
Content Licensing Specialist: *Jacob Sullivan*
Cover Image: *Jacob W. Frank/National Park Service*
Compositor: *Cenveo® Publisher Services*

All credits appearing on page or at the end of the book are considered to be an extension of the copyright page.

Library of Congress Cataloging-in-Publication Data

Names: Schick, Theodore, author.
Title: Doing philosophy : an introduction through thought experiments / Theodore Schick, Jr., Muhlenberg College.
Description: Sixth Edition. | Dubuque : McGraw-Hill Education, 2020. | Includes bibliographical references and index.
Identifiers: LCCN 2018040554 (print) | LCCN 2018043333 (ebook) | ISBN 9781260686425 (ebook) | ISBN 9780078119170 (alk. paper)
Subjects: LCSH: Philosophy—Introductions.
Classification: LCC BD21 (ebook) | LCC BD21 .S34 2019 (print) | DDC 100—dc23 LC record available at https://lccn.loc.gov/2018040554

The Internet addresses listed in the text were accurate at the time of publication. The inclusion of a website does not indicate an endorsement by the authors or McGraw-Hill Education, and McGraw-Hill Education does not guarantee the accuracy of the information presented at these sites.

mheducation.com/highered

To my students, for all they've taught me.

Preface

Teaching an introductory philosophy course is one of the most difficult tasks a philosophy instructor faces. Because philosophy isn't usually taught in secondary schools, most entering college students have no idea what philosophy is or why they should be studying it. Any notions they do have about philosophy generally have little to do with the practice of professional philosophers. To help students understand the nature and purpose of philosophical inquiry, *Doing Philosophy: An Introduction through Thought Experiments* explains how philosophical problems arise and why searching for solutions is important.

It is essential for beginning students to read primary sources, but if that is all they are exposed to, the instructor must bear the burden of interpreting, explaining, and providing context for the selections. This burden can be a heavy one, for most articles in introductory anthologies were written for professional philosophers. After reading a number of these articles, students are often left with the impression that philosophy is a collection of incompatible views on a number of unrelated subjects. To pass the course, they end up memorizing who said what and do not develop the critical thinking skills often considered the most important benefit of studying philosophy. By exploring the interrelationships among philosophical problems and by providing a framework for evaluating their solutions, *Doing Philosophy* overcomes the problem of fragmentation encountered in smorgasbord approaches to philosophy.

One can know a great deal about what philosophers have said without knowing what philosophy is because philosophy is as much an activity as it is a body of knowledge. So knowing how philosophers arrive at their conclusions is at least as important as knowing what conclusions they've arrived at. This text acquaints students with both the process and the product of philosophical inquiry by focusing on one of the most widely used philosophical techniques: the method of thought experiment or counterexample. Thought experiments test philosophical theories by determining whether they hold in all possible situations. They make the abstract concrete and highlight important issues in a way that no amount of exegesis can. By encouraging students to evaluate and perform thought experiments, *Doing Philosophy* fosters active learning and creative thinking.

Good critical thinkers are adept at testing claims by asking the question "What if . . . ?" and following the answer through to its logical conclusion. Thought experiments are particularly useful in testing philosophical theories because they often reveal hidden assumptions and unexpected conceptual complications. Given the central role that thought experiments have played in philosophical inquiry, there is reason to believe that knowing classic thought experiments is as important to understanding philosophy as knowing classic

physical experiments is to understanding science. By tracing the historical and logical development of thinking on a number of classic philosophical problems, we hope to provide students with a solid grounding in the discipline and prepare them for more advanced study.

Students sometimes express surprise that philosophy is still being done. They have the idea that it's merely a historical curiosity, of no contemporary relevance. Purely historical survey courses often perpetuate that idea. *Doing Philosophy* attempts to show that philosophy is a vibrant, thriving discipline actively engaged in some of the most important intellectual inquiries being conducted today.

To give instructors maximum flexibility in designing their course, the text is divided into self-contained chapters, each of which explores a philosophical problem. The introduction to each chapter explains the problem, defines some key concepts, and identifies the intellectual objectives students should try to achieve as they read the chapter. Classic arguments and thought experiments are highlighted in the text, and numerous "thought probes" or leading questions are placed throughout to encourage students to think more deeply about the material covered. Various boxes and quotations are also included that relate the material to recent discoveries or broader cultural issues. Each section concludes with study and discussion questions. Classic and contemporary readings are included at the end of each chapter so that students can see some of the more important theories and thought experiments in context. Some sets of readings contain a piece of fiction—an extended thought experiment—that raises many of the questions dealt with in the chapter. The goal throughout is not only to present students with the best philosophical thinking on each topic but also to challenge them to examine their own philosophical beliefs. Only through active engagement with the issues can real philosophical understanding arise.

The sixth edition of *Doing Philosophy* features new readings by Ernest Sosa, Mark Balaguer, Eddy Nahmias, John Stuart Mill, and Hans Moravec and new material on Stoicism, alternatives to theism, the argument from nonbelief, the actual infinite, the Libet experiment, the integrated information theory of mind, the simulation hypothesis, nonhuman persons, and transhumanism. There are also a number of new boxes, thought probes, and discussion questions to stimulate more in-depth thinking on the issues. Important continuing features include a coherent theoretical framework that helps students understand both the historical and the logical development of philosophical thinking; more than seventy-five thought experiments that test the adequacy of various philosophical theories; classic and contemporary readings that acquaint students with the original writings from which the theories and thought experiments are drawn; probing questions throughout each chapter that foster active learning and creative thinking; boxed features and quotes that relate philosophical issues to current events and classic writers; Internet Inquiries at the end of each chapter that suggest Internet searches students can perform to learn more about the issues raised in the chapter; biographical boxes that provide background information on important philosophers covered in the text; chapter introductions that explain the philosophical problem being explored, define key concepts, and identify chapter objectives; and

chapter summaries, study questions, and discussion questions that encourage students to think more deeply about the subject matter.

Acknowledgments

Special thanks to Lewis Vaughn for all his help on previous editions. Many people have offered their wisdom and insight on this project. Although I have not always heeded it, I would especially like to thank Wayne Alt, Community College of Baltimore County; Gordon Barnes, SUNY Brockport; Jack DeBellis, Lehigh University; Nori Geary, New York Hospital—Cornell Medical Center; Stuart Goldberg; James Hall, Kutztown University; Dale Jacquette, Pennsylvania State University; Robert Charles Jones, Stanford University; Jonathan Levinson; Jeffrey Nicholas, Bridgewater State College; Nick Oweyssi, North Harris College; Abram Samuels; Ludwig Schlecht, Muhlenberg College; Thomas Theis, Thomas J. Watson Research Center; Vivian Walsh, Muhlenberg College; Robert Wind, Muhlenberg College; and James Yerkes, Moravian College. We would also like to thank the following reviewers for their suggestions: Julius Bailey, Wittenburg University; David Chalmers, University of Arizona, Tucson; Alfred A. Decker, Bowling Green State University; Rev. Ronald DesRosiers, SM, Madonna University; Stephen Russell Dickerson, South Puget Sound Community College; Kevin E. Dodson, Lamar University; Jeremiah Hackett, University of South Carolina; David L. Haugen, Western Illinois University; Douglas E. Henslee, San Jose State University; Charles Hinkley, Texas State University, San Marcos; Karen L. Hornsby, North Carolina A&T State University; Margaret C. Huff, Northeastern University; David Kyle Johnson, King's College; John Knight, University of Wisconsin Centers—Waukesha; Richard Lee, University of Arkansas; Chris Lubbers, Muskegon Community College; Thomas F. MacMillan, Mendocino College; Mark A. Michael, Austin Peay State University; Dr. Luisa Moon, Mira Costa College; Augustine Minh Thong Nguyen, Eastern Kentucky University; David M. Parry, Penn State Altoona; Jerrod Scott, Brookhaven College; Leonard Shulte, North West Arkansas Community College; Robert T. Sweet, Clark State Community College; Joseph Vitti, Central Maine Community College; Ron Wilburn, University of Nevada, Las Vegas; and David Wisdo, Columbus State University. I also wish to thank Muhlenberg College and the staff of the Trexler Library for their unflagging support.

| Students—study more efficiently, retain more and achieve better outcomes. Instructors—focus on what you love—teaching.

SUCCESSFUL SEMESTERS INCLUDE CONNECT

For Instructors

You're in the driver's seat.

Want to build your own course? No problem. Prefer to use our turnkey, prebuilt course? Easy. Want to make changes throughout the semester? Sure. And you'll save time with Connect's auto-grading too.

65%
Less Time Grading

They'll thank you for it.

Adaptive study resources like SmartBook® help your students be better prepared in less time. You can transform your class time from dull definitions to dynamic debates. Hear from your peers about the benefits of Connect at **www.mheducation.com/highered/connect**

Make it simple, make it affordable.

Connect makes it easy with seamless integration using any of the major Learning Management Systems—Blackboard®, Canvas, and D2L, among others—to let you organize your course in one convenient location. Give your students access to digital materials at a discount with our inclusive access program. Ask your McGraw-Hill representative for more information.

©Hill Street Studios/Tobin Rogers/Blend Images LLC

Solutions for your challenges.

A product isn't a solution. Real solutions are affordable, reliable, and come with training and ongoing support when you need it and how you want it. Our Customer Experience Group can also help you troubleshoot tech problems—although Connect's 99% uptime means you might not need to call them. See for yourself at **status.mheducation.com**

FOR STUDENTS

©Shutterstock/wavebreakmedia

Effective, efficient studying.

Connect helps you be more productive with your study time and get better grades using tools like SmartBook, which highlights key concepts and creates a personalized study plan. Connect sets you up for success, so you walk into class with confidence and walk out with better grades.

> " I really liked this app—it made it easy to study when you don't have your textbook in front of you. "
>
> - Jordan Cunningham,
> Eastern Washington University

Study anytime, anywhere.

Download the free ReadAnywhere app and access your online eBook when it's convenient, even if you're offline. And since the app automatically syncs with your eBook in Connect, all of your notes are available every time you open it. Find out more at **www.mheducation.com/readanywhere**

No surprises.

The Connect Calendar and Reports tools keep you on track with the work you need to get done and your assignment scores. Life gets busy; Connect tools help you keep learning through it all.

Learning for everyone.

McGraw-Hill works directly with Accessibility Services Departments and faculty to meet the learning needs of all students. Please contact your Accessibility Services office and ask them to email accessibility@mheducation.com, or visit **www.mheducation.com/about/accessibility.html** for more information.

Contents

Preface vii

Chapter 1 The Philosophical Enterprise 1

Objectives 3

Section 1.1 Explaining the Possibility of the Impossible: Philosophical Problems and Theories 4

Philosophical Problems 5
 Metaphysics 5
 Epistemology 5
 Axiology 5
 Logic 6

The Stakes in Philosophical Inquiry 7
 The Mind-Body Problem 8
 The Problem of Free Will 8
 The Problem of Personal Identity 9
 The Problem of Moral Relativism 10
 The Problem of Evil 11
 The Problem of Skepticism 11

 Box: What Is Your Philosophy? 12

Necessary and Sufficient Conditions 12

Socrates and the Socratic Method 15
 Box: In the News: The Oracle at Delphi 17
 Box: Pre-Socratic Philosophers 18

Science and the Scientific Method 22
 Box: The Laws of Thought 24

Logical versus Causal Possibility 25
 Thought Probe: Possibilities 26

Summary 26
Study Questions 26
Discussion Questions 27
Internet Inquiries 27

Section 1.2 Evidence and Inference: Proving Your Point 28

Identifying Arguments 29
Deductive Arguments 31
 Some Valid Argument Forms 31
 Some Invalid Argument Forms 33
Inductive Arguments 34
 Enumerative Induction 34

Analogical Induction 35
 Hypothetical Induction (Abduction, Inference to the Best Explanation) 36
 Informal Fallacies 38
 Unacceptable Premises 39
 Irrelevant Premises 39
 Insufficient Premises 41
 Summary 42
 Study Questions 42
 Discussion Questions 42
 Internet Inquiries 43

 Section 1.3 The Laboratory of the Mind: Thought Experiments 44
 Thought Probe: Platonic Humans 46
 Case Study: Explaining How Moral Abortions Are Possible 46
 Thought Experiment: Warren's Moral Space Traveler 46
 Thought Probe: Nonhuman Persons 49
 How Are Thought Experiments Possible? 50
 Criticizing Thought Experiments 51
 Conceivability and Possibility 52
 Scientific Thought Experiments 54
 Thought Experiment: Impossibility of Aristotle's Theory of Motion 54
 Summary 55
 Study Questions 55
 Discussion Questions 55
 Thought Experiment: Tooley's Cat 55
 Thought Experiment: Thomson's Diseased Musician 56
 Internet Inquiries 57

Readings

 BERTRAND RUSSELL: *The Value of Philosophy* 59
 Reading Questions 62

 BRAND BLANSHARD: *The Philosophic Enterprise* 63
 Reading Questions 66

Notes 67

Chapter 2 *The Mind-Body Problem* 69

 Thought Experiment: Descartes' Mechanical Moron 70
 Thought Experiment: Leibniz's Mental Mill 72
 Box: In the News: The Approaching Singularity 74
 Thought Probe: Artificial Intelligence 74
 Objectives 76

 Section 2.1 The Ghost in the Machine: Mind as Soul 77
 Descartes' Doubt 78
 Thought Probe: Are We Living in a Computer Simulation? 79
 Box: René Descartes: Father of Modern Philosophy 80

I Think, Therefore I Am 80
The Conceivability Argument 81
- *Box: The Biblical Conception of the Person 82*
- *Box: In the News: Descartes and Vivisection 84*
- *Thought Probe: Heaven without Bodies 85*

The Divisibility Argument 86
- *Thought Probe: A Split-Brain Patient of Two Minds 87*

The Problem of Interaction 88
- *Box: Parallelism: Occasionalism and the Preestablished Harmony 89*

The Causal Closure of the Physical 90
- *Thought Probe: Mental Relay Stations 92*

The Problem of Other Minds 92
Summary 93
Study Questions 93
Discussion Questions 94
Internet Inquiries 94

Section 2.2 You Are What You Eat: Mind as Body 96

Empiricism 97
- *Box: David Hume: The Model Philosopher 98*

Logical Positivism 99
Logical Behaviorism 100
- *Box: Ryle's Category Mistake 102*
 - *Thought Experiment: Ryle's University Seeker 102*
- *Thought Experiment: The Perfect Pretender 103*
- *Thought Experiment: Putnam's Super-Spartans 104*
- *Box: Behavioral Therapy 105*
- *Thought Experiment: Chisholm's Expectant Nephew 106*

The Identity Theory 107
Identity and Indiscernibility 109
- *Box: Do You Use Only 10 Percent of Your Brain? 110*

Conscious Experience 110

- *Thought Experiment: Nagel's Bat 111*
- *Thought Experiment: Lewis's Pained Martian 112*
- *Thought Experiment: Putnam's Conscious Computer 113*
- *Thought Probe: Speciesism 114*
- *Thought Experiment: Searle's Brain Replacement 115*
- *Thought Probe: Neural Prostheses 116*
- *Box: In the News: Neural Chips 117*

Summary 117
Study Questions 118
Discussion Questions 118
- *Thought Experiment: Your Mother, the Zombie 119*

Internet Inquiries 119

Section 2.3 I, Robot: Mind as Software 120
Artificial Intelligence 121
- *Box: Transhumanism and the Promise of Immortality* 122
 - *Thought Probe: Transhumanism* 122

Functionalism and Feeling 123
- *Thought Experiment: Lewis's Pained Madman* 123
- *Thought Experiment: Block's Chinese Nation* 124
- *Thought Experiment: Putnam's Inverted Spectrum* 125
- *Box: Inverted Spectra and Pseudonormal Vision* 127
 - *Thought Probe: Pseudonormal Vision* 127

The Turing Test 128
- *Thought Experiment: The Imitation Game* 128
- *Box: Alan Turing: Father of Code and Computers* 130
- *Thought Experiment: Searle's Chinese Room* 131
- *Thought Probe: Total Turing Test* 134

Intentionality 134
- *Thought Experiment: Block's Conversational Jukebox* 135
- *Thought Probe: Devout Robots* 136

Summary 136
Study Questions 137
Discussion Questions 137
Internet Inquiries 138

Section 2.4 There Ain't No Such Things as Ghosts: Mind as Myth 139
- *Thought Experiment: Rorty's Demons* 139

Folk Psychology 141

Subjective Knowledge 142
- *Thought Experiment: Mary, the Color-Challenged Scientist* 142
- *Box: In the News: Seeing Color for the First Time* 144
 - *Thought Probe: Seeing Color* 144
- *Thought Experiment: Zombies* 144
- *Thought Probe: Zombies* 146

Summary 146
Study Questions 147
Discussion Questions 147
Internet Inquiries 147

Section 2.5 The Whole Is Greater Than the Sum of Its Parts: Mind as Quality 148
Primitive Intentionality 148
- *Box: The Double Aspect Theory* 149
- *Thought Experiment: Jacquette's Intentionality Test* 149

Emergentism 150
- *Box: Integrated Information Theory and the Consciousness Meter* 152

Panpsychism 155
Summary 156

Study Questions 157
Discussion Questions 157
Internet Inquiries 157

Readings
RENÉ DESCARTES: *Meditations on First Philosophy: Meditation II* 159
Reading Questions 161
DAVID M. ARMSTRONG: *The Mind-Brain Identity Theory* 162
Reading Questions 167
DAVID CHALMERS: *The Puzzle of Conscious Experience* 168
Reading Questions 173

Notes 174

Chapter 3 Free Will and Determinism 177

Box: In the Courts: The Devil Made Me Do It 181
Objectives 182

Section 3.1 The Luck of the Draw: Freedom as Chance 184
Hard Determinism 184
Thought Experiment: Laplace's Superbeing 185
Thought Probe: The Book of Life 186
Box: Freedom and Foreknowledge 187
Thought Probe: Freedom and Foreknowledge 187
The Consequence Argument 188
Box: Fatalism versus Causal Determinism 189
Thought Probe: A World without Responsibility 191
Science and the Nature/Nurture Debate 191
Box: Free Will: A Noble Lie? 193
Thought Probe: A Noble Lie 193
Thought Probe: Behavior Modification 194
Box: Is Determinism Self-Refuting? 195
Thought Probe: Defending Determinism 195
Thought Probe: Genetic Engineering 196
Thought Experiment: Gardner's Random Bombardier 197
Common Sense and Causal Determinism 198
Thought Probe: Living with Hard Determinism 199
Indeterminism 199
Box: William James: Physiologist, Psychologist, Philosopher 200
Thought Experiment: Taylor's Unpredictable Arm 201
Summary 201
Study Questions 202
Discussion Questions 202
Thought Experiment: Newcomb's Paradox 203
Internet Inquiries 203

Section 3.2 The Mother of Invention: Freedom as Necessity 204

Thought Experiment: Locke's Trapped Conversationalist 205
Box: Thomas Hobbes: The Great Materialist 206

Traditional Compatibilism 206
Punishment 208
Prepunishment 209
Thought Probe: Minority Report 209
Thought Experiment: Taylor's Ingenious Physiologist 209
Box: In the News: Guilty Minds and Pre-Crime 211
 Thought Probe: Guilty Minds and Pre-Crime 211
Thought Experiment: Taylor's Drug Addiction 211
Box: In the Courts: Government-Sponsored Brainwashing 212
 Thought Probe: The Manchurian Candidate 212
Thought Probe: Religious Cults 213

Hierarchical Compatibilism 213
Thought Experiment: Frankfurt's Unwilling and Wanton Addicts 214
Thought Experiment: Frankfurt's Happy Addict 215
Thought Experiment: Frankfurt's Decision Inducer 216
Thought Experiment: Slote's Hypnotized Patient 217
Thought Probe: The Willing Bank Teller 218

Summary 218
Study Questions 219
Discussion Questions 219
Internet Inquiries 219

Section 3.3 Control Yourself: Freedom as Self-Determination 220

The Case for Freedom 221
The Argument from Experience 221
The Argument from Deliberation 222

The Neurophysiological Challenge 222
Thought Probe: Is Free Won't Enough for Free Will? 224
Box: Neurophysiological Evidence for Free Will 226

Agent Causation 227
Box: Sartre and Smullyan on Free Will 228
 Thought Probe: Self-Consciousness and Free Will 228
Thought Probe: Free Androids 232

Summary 232
Study Questions 233
Discussion Questions 233
Internet Inquiries 233

Readings

BARON D'HOLBACH: *A Defense of Hard Determinism 234*
 Reading Questions 235

EDDY NAHMIAS: *Is Neuroscience the Death of Free Will? 236*
 Reading Questions 239

 MARK BALAGUER: *Torn Decisions* 240
 Reading Questions 242
 GEOFFREY KLEMPNER: *The Black Box* 243
 Reading Questions 245

Notes 246

Chapter 4 The Problem of Personal Identity 249

 Box: In the Courts: Kathleen Soliah, a.k.a. Sara Jane Olson 253
 Thought Probe: A Different Person 253
Objectives 254

Section 4.1 We Are Such Stuff as Dreams Are Made On: Self as Substance 255

 Thought Probe: Hobbes's Ship of Theseus 256
Persons 257

 Thought Probe: Dolphins 257
Animalism 258

 Thought Experiment: The Vegetable Case 258
 Box: In the News: Eternal Life through Cloning 260
 Thought Probe: Safe Cloning 260
 Thought Experiment: Benjamin's Questionable Cure 261
 Box: The Definition of Death 262
 Thought Probe: Permanently Unconscious 262
 Thought Experiment: Locke's Tale of the Prince and the Cobbler 263
 Thought Experiment: The Transplant Case 264
 Thought Experiment: Unger's Great Pain 264
 Box: In the Courts: Multiple-Personality Disorder 266
 Thought Probe: Multiple Personalities 266

The Soul Theory 267

 Box: St. Augustine: Soul Man 267
 Thought Experiment: The King of China 268
 Box: Transubstantiation 269
 Thought Experiment: Nestor and Thersites 270
 Thought Experiment: Kant's Soul Switch 271
 Thought Probe: Souls in Heaven 272

Summary 272
Study Questions 273
Discussion Questions 273
Internet Inquiries 274

Section 4.2 Golden Memories: Self as Psyche 275

The Memory Theory 275

 Box: John Locke: The Great Empiricist 276
 Box: In the Courts: Sleepwalking and Murder 277
 Thought Probe: Sleepwalking and Murder 277
 Thought Probe: Memory Damping 278

 The Inconsistency Objection 278
 Thought Experiment: Reid's Tale of the Brave Officer and
 Senile General 279
 Thought Probe: Were You Ever a Fetus? 280
 The Circularity Objection 280
 Box: In the News: Soul Catcher 282
 Thought Probe: Soul Catcher 282
 Thought Probe: Merging of the Minds 283
 The Insufficiency Objection 283
 Thought Probe: Should Joshua Blahyi Be Punished? 284
 The Psychological Continuity Theory 285
 Thought Probe: Is Darth Vader Anakin Skywalker? 285
 The Reduplication Problem I: Reincarnation 285
 Thought Experiment: Williams's Reincarnation of Guy Fawkes 286
 Thought Experiment: Williams's Reduplication Argument 286
 The Reduplication Problem II: Teletransportation 287
 Thought Experiment: Parfit's Transporter Tale 287
 Box: Quantum Teleportation 289
 Thought Probe: Transporter Travel 289
 Thought Probe: Can You Go to Heaven? 290
Summary 290
Study Questions 291
Discussion Questions 291
 Thought Experiment: Bodily Torture 292
Internet Inquiries 292

Section 4.3 You Can't Step into the Same River Twice: Self as Process 293
 The Brain Theory 293
 Thought Experiment: Shoemaker's Brain Transplant 293
 Box: A Brain Is a Terrible Thing to Waste 295
 Thought Probe: Body Transplants 295
 Split Brains 295
 Box: Alien Hand Syndrome 297
 Thought Probe: Who Is Behind the Hand? 297
 Thought Experiment: Parfit's Division 297
 Closest Continuer Theories 298
 Box: Buddhists on the Self and Nirvana 299
 Thought Probe: Branch Lines 300
 Identity and What Matters in Survival 300
 Identity and What Matters in Responsibility 301
 Thought Experiment: Parfit's Reformed Nobelist 302
 Explaining the Self 303
 Thought Probe: Robert and Frank 304
 Moral Agents, Narratives, and Persons 304
 Thought Probe: Being Clive Wearing 306
 Summary 306
 Study Questions 307

Discussion Questions 307
Internet Inquiries 308

Readings

JOHN LOCKE: *Of Identity and Diversity* 309
 Reading Questions 312

DEREK PARFIT: *Divided Minds and the Nature of Persons* 313
 Reading Questions 317

HANS MORAVEC: *Dualism from Reductionism* 318
 Reading Questions 323

Notes 324

Chapter 5 The Problem of Relativism and Morality 325

Objectives 330

Section 5.1 Don't Question Authority: Might Makes Right 331

Subjective Absolutism 332
Subjective Relativism 332
Emotivism 333
 Thought Experiment: Blanshard's Rabbit 334
Cultural Relativism 335
 Box: In the News: Universal Human Rights 337
 The Anthropological Argument 337
 The Logical Structure of Moral Judgments 338
 Thought Probe: When in Rome 340
The Divine Command Theory 340
 Box: In the Courts: God Is My Attorney 343
 Thought Probe: Commanded to Kill 343
 Box: The Fortunes of Hell 345
Are There Universal Moral Principles? 345
 Box: Moral Children 346
 Thought Probe: Moral Children 346
 Thought Probe: Moral Knowledge 347
Summary 347
Study Questions 348
Discussion Questions 349
Internet Inquiries 349

Section 5.2 The End Justifies the Means: Good Makes Right 350
 Box: Is Life Intrinsically Valuable? 351
 Thought Probe: Moral Justification 351
Ethical Egoism 351
 Box: Ayn Rand on the Virtue of Selfishness 353
 Thought Experiment: Feinberg's Single-Minded Hedonist 354
Act-Utilitarianism 355
 Box: Jeremy Bentham: Making Philosophy Do Work 357
 Thought Probe: Our Obligations to Future Generations 358

 Problems with Rights 359
 Thought Experiment: McCloskey's Utilitarian Informant 359
 Thought Experiment: Brandt's Utilitarian Heir 360
 Problems with Duties 360
 Thought Experiment: Ross's Unhappy Promise 360
 Thought Experiment: Godwin's Fire Rescue 361
 Problems with Justice 361
 Thought Experiment: Ewing's Utilitarian Torture 362
 Thought Experiment: Ewing's Innocent Criminal 362
 Thought Probe: The Utility Machine 363
Rule-Utilitarianism 363
 Thought Experiment: Nozick's Experience Machine 365
 Thought Probe: Paradise Engineering and the Abolitionist Project 366
Summary 367
Study Questions 367
Discussion Questions 368
 Thought Experiment: Williams's South American Showdown 368
 Thought Experiment: Thomson's Trolley Problem 369
 Thought Experiment: Thomson's Transplant Problem 369
Internet Inquiries 370

Section 5.3 Much Obliged: Duty Makes Right 371
 Kant's Categorical Imperative 372
 The First Formulation 372
 Box: Immanuel Kant: Small-Town Genius 373
 Thought Probe: Enhanced Punishment 375
 Thought Experiment: Hare's Nazi Fanatic 375
 Thought Experiment: Ross's Good Samaritan 376
 The Second Formulation 377
 Thought Probe: Animal Rights 379
 Thought Experiment: Broad's Typhoid Man 379
 Thought Experiment: Ewing's Prudent Diplomat 380
 Thought Probe: Easy Rescue 380
 Ross's *Prima Facie* Duties 380
 Thought Probe: Desert Island Bequest 382
 Rawls' Contractarianism 382
 Thought Probe: Just Policies 386
 Nozick's Libertarianism 386
 Thought Experiment: Nozick's Basketball Player 386
 Thought Probe: Consensual Cannibalism 388
 Justice, the State, and the Social Contract 389
 Hobbes 390
 Locke 390
 Nozick 391
 Thought Experiment: Widerquist's Libertarian Monarchy 392
 Thought Probe: Libertarian Government 393
 Box: In the News: Jillian's Choice 394
 Thought Probe: Jillian's Choice 394
 The Ethics of Care 394
 Thought Probe: Lying with Care 396

Making Ethical Decisions 396
 Thought Probe: The Zygmanik Brothers 399
Summary 399
Study Questions 400
Discussion Questions 400
Internet Inquiries 401

Section 5.4 Character Is Destiny: Virtue Makes Right 402
The Virtuous Utilitarian 402
 Thought Probe: Giving to Charity 403
The Virtuous Kantian 403
 Thought Experiment: Stocker's Hospitalized Patient 404
 Box: Children without a Conscience 405
 Thought Probe: Empathy and Agency 405
The Purpose of Morality 406
Aristotle on Virtue 406
 Box: Aristotle: Pillar of Western Thought 407
 Box: The Buddha on Virtue 409
The Stoics on Virtue 410
 Thought Probe: Aristotle versus the Stoics on the Good Life 413
MacIntyre on Virtue 413
Nussbaum on Virtue 414
 Thought Probe: Medical Treatment 417
Virtue Ethics 417
 Thought Probe: The Ring of Gyges 418
Summary 418
Study Questions 419
Discussion Questions 419
Internet Inquiries 419

Readings
 JEREMY BENTHAM: *Of the Principle of Utility* 420
 Reading Questions 422
 IMMANUEL KANT: *Good Will, Duty, and the Categorical Imperative* 423
 Reading Questions 426
 MARTHA NUSSBAUM: *Non-Relative Virtues* 427
 Reading Questions 431

Notes 432

Chapter 6 The Problem of Evil and the Existence of God 435

 Box: Biblical Archaeology 439
 Thought Probe: Biblical Truths 439
 Box: Religious Adherents 441
 Thought Probe: Deluded Believers 441
 Thought Probe: Holy Scripture 442
Objectives 442

Section 6.1 The Mysterious Universe: God as Creator 443

 The Traditional Cosmological Argument 443
 Box: Thomas Aquinas 444
 Box: An Actual Infinite: The Quantum Hilbert Hotel 447

 The Kalam Cosmological Argument 447
 Thought Probe: Why a Universe? 451

 The Teleological Argument 451
 The Analogical Design Argument 452
 Thought Experiment: Paley's Watch 453
 The Best-Explanation Design Argument 455
 Box: In the Courts: Is Evolution Just a Theory? 457
 Box: Extraterrestrial Design 460
 Thought Probe: Intelligent Design 460
 Box: Creationism and Morality 462
 Thought Probe: Human Design Flaws 465

 The Argument from Miracles 466
 Box: Was Jesus a Magician? 469
 Thought Probe: Jesus's Miracles 469
 Box: Parting the Red Sea 470
 Thought Probe: Parting the Red Sea 470
 Thought Probe: The Fivefold Challenge 470

 The Argument from Religious Experience 471
 Box: This Is Your Brain on God 473
 Thought Probe: Religious Experience 473
 Thought Probe: St. Paul on the Road to Damascus 474

 The Ontological Argument 475
 Anselm's Ontological Argument 475
 Thought Experiment: Gaunilo's Lost Island 476
 Descartes' Ontological Argument 477
 Thought Experiment: Edwards's Gangle 477
 Thought Probe: One More God 479

 Pascal's Wager 479
 Thought Experiment: Pascal's Wager 480
 Box: Silverman's Wager 481
 Thought Probe: The Best Bet 481
 Thought Probe: Alien Religion 481

 God and Science 482
 Thought Probe: Goulder versus Augustine 483

 Summary 484
 Study Questions 485
 Discussion Questions 485
 Internet Inquiries 486

Section 6.2 When Bad Things Happen to Good People: God as Troublemaker 487
 Thought Experiment: Rowe's Fawn 489
 St. Augustine and the Free-Will Defense 490
 Thought Probe: Is There Free Will in Heaven? 493

 The Knowledge Defense 493
 The Ideal-Humanity Defense 494
 Box: In the News: Natural Evil 495
 Thought Probe: Wrath of God 495
 The Soul-Building Defense 496
 The Finite-God Defense 497
 Box: Karma and the Problem of Inequality 498
 Thought Probe: Karma 498
 Box: The Argument from Nonbelief 499
 Thought Probe: The Argument from Nonbelief 499
 Thought Probe: What If God Died? 500
 Alternatives to Theism 500
 Gnosticism 500
 Deism 501
 Pantheism 502
 Summary 503
 Study Questions 504
 Discussion Questions 504
 Thought Experiment: The Invisible Gardener 504
 Internet Inquiries 505

 Section 6.3 **Faith and Meaning: Believing the Unbelievable** 506
 The Leap of Faith 506
 Thought Probe: Kierkegaard and Russell 508
 Evidentialism 509
 Thought Probe: Blanshard's Beliefs 512
 The Will to Believe 512
 Thought Probe: James and Pandeism 514
 The Meaning of Life 514
 Thought Experiment: God's Plan 514
 Thought Probe: Meaning and Morality 516
 Existentialism 516
 Thought Probe: Meaning and Purpose 517
 Religion without God 518
 Summary 519
 Study Questions 519
 Discussion Questions 520
 Internet Inquiries 520

 Readings
 ST. THOMAS AQUINAS: *The Five Ways* 521
 Reading Questions 522
 DAVID HUME: *Dialogues Concerning Natural Religion* 523
 Reading Questions 527
 JOHN STUART MILL: *A Finite God* 528
 Reading Questions 532

Notes 533

Chapter 7 The Problem of Skepticism and Knowledge 537

Objectives 544

Section 7.1 Things Aren't Always What They Seem: Skepticism about Skepticism 545

Greek Rationalism 545
 Parmenides 546
 Thought Probe: Thinking about Nothing 547
 Zeno 547
 Thought Experiment: Zeno's Paradox of Bisection 547
 Plato 548
 Box: Solving Parmenides' and Zeno's Paradoxes 549
 Thought Probe: Innate Knowledge 552

Cartesian Skepticism 552
 Cartesian Doubt 553
 Thought Experiment: Descartes' Dream Argument 553
 Thought Probe: Dreams and Reality 554
 Thought Experiment: Descartes' Evil Genius Argument 555
 Thought Experiment: Unger's Mad Scientist 555
 Cartesian Certainty 556

Reasonable Doubt 559

The Empiricist Alternative 559

The Problem of Induction 561
 Thought Probe: Science and Faith 562

The Kantian Synthesis 563
 Thought Probe: Constructing Reality 566

Mystical Experience 566

Summary 568

Study Questions 569

Discussion Questions 569

Internet Inquiries 570

Section 7.2 Facing Reality: Perception and the External World 571

Direct Realism 571

Representative Realism 573
 Thought Probe: Hypothesizing the External World 574

Phenomenalism 575
 Thought Experiment: The Inconceivability of the Unconceived 576
 Box: George Berkeley: The Ultimate Empiricist 578

Summary 581

Study Questions 582

Discussion Questions 582

Internet Inquiries 583

Section 7.3 What Do You Know?: Knowing What Knowledge Is 584
 Thought Experiment: Gettier's Guy in Barcelona 584
 The Defeasibility Theory 585
 Thought Experiment: Lehrer and Paxson's Demented Mrs. Grabit 586
 The Causal Theory 587
 Thought Experiment: Goldman's Fake Barns 587
 The Reliability Theory 588
 Thought Experiment: Lehrer's Human Thermometer 588
 Virtue Perspectivism 589
 Summary 591
 Study Questions 592
 Discussion Questions 592
 Internet Inquiries 592

Readings

RENÉ DESCARTES: *Meditations on First Philosophy: Meditation 1* 594
 Reading Questions 596

BERTRAND RUSSELL: *On Induction* 597
 Reading Questions 600

ERNEST SOSA: *Getting It Right* 601
 Reading Questions 602

THOMAS D. DAVIS: *Why Don't You Just Wake Up?* 603
 Reading Questions 605

Notes 606

Index 607

Chapter 1
The Philosophical Enterprise

> *Philosophy consists not in airy schemes or idle speculations: the rule and conduct of all social life is her great province.*
> —JAMES THOMSON

Philosophy, Plato tells us, "begins in wonder"—wonder about the universe, its contents, and our place in it. What is the universe? Is it composed solely of matter, or does it contain immaterial things like spirits? How can we tell? Is sense experience the only source of knowledge, or are there other ways of knowing? Why are we here? Were we created by God as part of a divine plan, or did we come into being as the result of purely natural processes? Is there a God? If so, what sort of being is he (she) (it)? What kind of creatures are we? Do we have a soul that will survive the death of our bodies, or will we cease to exist when our bodies die? Are we masters of our destiny, or are our actions determined by forces beyond our control? What are our obligations to other people? Do we have a duty to help others, or is our only obligation to not harm them? Such questions are at once both familiar and strange: familiar because most of us have had to face them at some point in our lives; strange because it's unclear how we should go about answering them. Unlike most questions, they can't be answered by scientific investigation. Some would say that that makes the answers unknowable. But to say that something is unknowable is to have already answered the question about the nature of knowledge. You can't claim that something is unknowable without assuming a particular theory of knowledge. Philosophical questions are unavoidable because any attempt to avoid them requires taking a stand on them. As Pascal put it, "To ridicule philosophy is to philosophize."

Whether you know it or not, you assume that certain answers to the foregoing questions are true. These assumptions constitute your philosophy. The discipline of philosophy critically examines such assumptions in an attempt to determine whether they are true. The word "philosophy" means "love of wisdom." It's derived from the Greek *philo* meaning "love" and *sophia* meaning "wisdom." The desire to know the truth—the love of wisdom—is only one motivation for doing philosophy, however. The desire to lead a good life is another. Actions are based on beliefs, and actions based on true beliefs are more likely to succeed than those based on false ones. So it's in your best interest to have true philosophical beliefs. This text is designed to help you achieve that goal. By describing, explaining, and encouraging you to do philosophy, it attempts to provide you with the intellectual tools necessary to develop your own philosophy.

"An expert," says physicist Werner Heisenberg, "is someone who knows some of the worst mistakes that can be made in his subject and how to avoid them."[1] In philosophy, knowing the major theories and the problems they face is particularly important. As you construct your own philosophy, you don't want to commit the same mistakes made by others, and as you study the problems faced by various philosophical theories, you may discover that some of your philosophical beliefs are mistaken. To help you avoid making philosophical errors, this text traces the historical development of philosophical thinking on a number of central philosophical problems. After reading each chapter, you should have a good sense of the strengths and weaknesses of past theories, as well as the most promising avenues for future research.

Philosophy is a search for the truth about the world and our place in it. By doing philosophy, you'll learn to distinguish good reasons from bad ones, strong arguments from weak ones, and plausible theories from implausible ones. You'll find that every view is not as good as every other. While everyone may have a right to an opinion, not every opinion is right. Acquiring such critical thinking skills will improve your ability to make sound judgments and lessen the chance that you'll be taken in by frauds, swindlers, and charlatans.

Doing philosophy involves reflecting on the beliefs and values you use to organize your experience and guide your decisions. It entails questioning assumptions, analyzing concepts, and drawing inferences. In the process, you'll come to see connections, relationships, and meanings that you were previously unaware of. As a result, doing philosophy should deepen your understanding of yourself and your world.

We will begin our philosophical explorations by examining the nature and import of a number of central philosophical problems. We will then take a look at the methods philosophers use to solve these problems. Philosophical thinking is nothing if not logical. To distinguish between plausible and implausible philosophical claims, you must know the difference between logical and illogical arguments. Section 1.2 provides an overview of the different types of arguments people use to make their points. The final section examines one of the most widely used techniques for testing philosophical theories: thought experiments. Philosophical problems are conceptual problems, and conceptual problems can be most effectively solved in the laboratory of the mind.

The discovery of what is true, and the practice of that which is good, are the two most important objects of philosophy.

—VOLTAIRE

Objectives

After reading this chapter, you should be able to

- identify the various branches of philosophy.
- describe a number of basic philosophical problems.
- distinguish necessary from sufficient conditions, and logical from causal possibility.
- identify and evaluate different types of arguments.
- recognize informal logical fallacies.
- use the criteria of adequacy to evaluate hypotheses.
- test theories by performing thought experiments.

Section 1.1

Explaining the Possibility of the Impossible
Philosophical Problems and Theories

Man is made by his belief. As he believes, so he is.

—Bhagavad Gita

The extent to which our thoughts and actions are influenced by our philosophy becomes most evident when we examine the lives of those who don't share our philosophy. For example, many in the West believe that the world contains physical objects, that our senses give us knowledge of those objects, and that our selves are legitimate objects of concern. Many in the East, however, deny all three of these claims. For them, consciousness is the only reality, mystical experience is the only source of knowledge, and belief in the existence of the self is the root of all evil. As a result, they lead very different lives than we do. (Compare the life of a Buddhist monk with that of a Wall Street tycoon.) Because the kinds of lives we lead are determined by the philosophical beliefs we hold, we ignore philosophy at our peril. If our philosophy is flawed, we may well spend our lives pursuing false ideals, worshipping false gods, and nurturing false hopes. That is why the ancient Greek philosopher Socrates maintained that the unexamined life is not worth living.

If we have not examined our philosophy, not only may the quality of our lives suffer, but so may our freedom. Every society, every religion, and every ideology provides answers to philosophical questions. We internalize those answers in the process of growing up. But if we never question those answers— if we never critically evaluate them in light of the alternatives—then our beliefs aren't truly our own. If we haven't freely chosen the principles on which our thoughts and actions are based, our thoughts and actions aren't truly free. By replacing the blind acceptance of authority with a reasoned consideration of the evidence, philosophical inquiry liberates us from preconceived ideas and prejudices.

Because our lives are shaped by our philosophy, many have been willing to die for their philosophy. Revolutions, for example, are often inspired by a philosophy. The American, Russian, and Iranian revolutions, for example, were fueled, respectively, by the philosophies of democratic capitalism, Marxist communism, and Islamic fundamentalism. Whether a revolution ultimately

succeeds is determined not by force of arms but by the strength of its philosophy. As Napoleon realized, "There are two powers in the world, the sword and the mind. In the long run, the sword is always beaten by the mind." But the mind can overcome the sword only if it is armed with viable ideas. The goal of philosophical inquiry is to determine whether our philosophical beliefs are, in fact, viable.

Philosophical Problems

Philosophical beliefs fall into four broad categories, which correspond to the major fields of philosophy: (1) *metaphysics,* the study of ultimate reality, (2) *epistemology,* the study of knowledge, (3) *axiology,* the study of value, and (4) *logic,* the study of correct reasoning. The following are some of the questions explored by the various branches of philosophy.

Science without epistemology is—insofar as it is thinkable at all—primitive and muddled.
—ALBERT EINSTEIN

Metaphysics

- What is the world made of?
- Does the world contain only one basic type of substance (e.g., matter), or are there other types (e.g., mind)?
- What is the mind?
- How is the mind related to the body?
- Can the mind survive the death of the body?
- Do we have free will, or is every action determined by prior causes?
- What is a person?
- Under what conditions is a person at one time identical with a person at another time?
- Is there a God?

Epistemology

- What is knowledge?
- What are the sources of knowledge?
- What is truth?
- Can we acquire knowledge of the external world?
- Under what conditions are we justified in believing something?

Axiology

- What is value?
- What are the sources of value?
- What makes an action right or wrong?
- What makes a person good or bad?

- What makes a work of art beautiful?
- Are value judgments objective or subjective?
- Does morality require God?
- Are there universal human rights?
- What is the best form of government?
- Is civil disobedience ever justified?

Logic

- What is an argument?
- What kinds of arguments are there?
- What distinguishes a good argument from a bad one?
- When are we justified in believing the conclusion of an argument?

Whether or not we have consciously considered any of these questions, we all unconsciously assume certain answers to them. We all have beliefs about what is real, what is valuable, and how we come to know what is real and valuable. Philosophy examines these beliefs in an attempt to determine which of them are worthy of our assent.

> *Philosophy is the art and law of life, and it teaches us what to do in all cases, and, like good marksmen, to hit the white at any distance.*
> —SENECA

Philosophical beliefs affect not only how we live our lives, but also how we conduct our inquiries. What we look for is determined by our theory of reality, how we look for something is determined by our theory of knowledge, and what we do with what we find is determined by our theory of value. In science, as in everyday life, having a good philosophy is important, for, as English philosopher Alfred North Whitehead observed, "No science can be more secure than the unconscious metaphysics which it tacitly presupposes." The philosophical assumptions underlying various endeavors are studied by such additional subfields of philosophy as the philosophy of science, philosophy of religion, philosophy of art, philosophy of history, philosophy of education, and philosophy of law. Even though every intellectual pursuit takes certain answers to philosophical questions for granted, the correct answer to those questions is by no means obvious. What makes definitive answers to philosophical questions so hard to come by is that conflicting views of reality, knowledge, and value often appear equally plausible.

Consider, for example, the beliefs that the universe contains only material objects and that we have minds. The success of science lends credence to the former, whereas our personal experience supports the latter. It also seems that both of these beliefs can't be true, for minds do not appear to be material objects. Material objects have properties like mass, spin, and electric charge; minds, apparently, do not. Take, for example, your thought that you're reading a book right now. How much does that thought weigh? How long is that thought? What is its electric charge? Such questions seem absurd because thoughts do not seem to be the type of thing that can have physical properties. Does that mean that the mind is immaterial? If so, how

can the mind affect the body (and vice versa)? Such are the issues raised by the **mind-body problem.**

The **problem of personal identity** arises from the beliefs that we change in many ways throughout our lives and that these changes happen to the same person. But if we change, we're different. So how is it possible for a person to change and yet remain the same?

The **problem of free will** arises from the beliefs that every event has a cause and that humans have free will. Yet if every event is caused by some prior event, how can anything we do be up to us?

The **problem of evil** arises from the beliefs that the world was created by an all-powerful, all-knowing, and all-good being (namely, God) and that there is evil in the world. If God is all-knowing, God knows that evil exists; if God is all-good, God doesn't want evil to exist; and if God is all-powerful, God can prevent evil from existing. So how can there be evil in a world created by such a being?

The **problem of moral relativism** arises from the beliefs that certain actions are objectively right or wrong and that all moral judgments are relative. If all moral judgments are relative (to individuals, societies, religions, etc.), then no actions are objectively right or wrong. But if no actions are objectively right or wrong, how is moral disagreement possible? If believing something to be right makes it right, how can anyone legitimately claim that what another did was wrong?

The **problem of skepticism** arises from the beliefs that knowledge requires certainty and that we have knowledge of the external world. Our knowledge of the external world is based on sense experience. But our senses sometimes deceive us. Given that we can't be certain of what we've learned through our senses, how can we have knowledge of the external world?

Some of our most fundamental beliefs about reality, knowledge, and value seem to be inconsistent with one another. To anyone who wants to understand the world and our place in it, this situation should be disturbing. If the beliefs in question really are inconsistent with one another, at least one of them must be false, and if we act on a false belief, our action is unlikely to succeed. To come up with a way of looking at the world that not only makes sense but also helps us achieve our goals, philosophy tries to eliminate these inconsistencies from our belief system.

The Stakes in Philosophical Inquiry

Making our belief system consistent is no idle task, for not only do our individual thoughts and actions depend on the truth of certain philosophical beliefs, but so do many of our social institutions. If those beliefs turned out to be false, the institutions that rely on them would have to be radically altered or even abolished. To get an idea of what's at stake in philosophical inquiry, let's examine the implications of accepting or rejecting some of the beliefs just mentioned.

mind-body problem The philosophical problem of explaining how it is possible for a material object to have a mind.

problem of personal identity The philosophical problem of explaining how it is possible for a person to change and yet remain the same person.

problem of free will The philosophical problem of explaining how it is possible for a causally determined action to be free.

problem of evil The philosophical problem of explaining how it is possible for there to be evil in a world created by an all-powerful, all-knowing, and all-good being.

problem of moral relativism The philosophical problem of explaining how it is possible for there to be absolute moral standards.

problem of skepticism The philosophical problem of explaining how it is possible for there to be knowledge.

The Mind-Body Problem

> *Metaphysics is the anatomy of the soul.*
> —STANISLAS BOUFFLERS

Many philosophers and scientists have held that the mind is nothing but the brain. Francis Crick, the Nobel Prize–winning codiscoverer of the structure of DNA, has defended this view. In his book *The Astonishing Hypothesis,* Crick claims, "The astonishing hypothesis is that you, your joys and your sorrows, your memories and ambitions, your sense of personal identity and free will, are in fact no more than the behavior of a vast assembly of nerve cells and their associated molecules. As Lewis Carroll's Alice might have phrased it, 'You're nothing but a pack of neurons.'"[2] Although Crick's hypothesis may be astonishing, it is by no means new. The idea that we are purely material beings was proposed more than twenty-five hundred years ago by the ancient Greek philosophers Leucippus and Democritus. In their view, we are nothing but a pack of atoms—indivisible material particles that are in constant random motion. If Crick and Leucippus are right, then most religious believers are wrong—we can't survive the death of our bodies. When our bodies die, we cease to exist.

What's more, if the mind is a physical thing, it should be possible to construct one. Many working in the field of artificial intelligence believe that it's only a matter of time before we produce a robot that is as intelligent as we are. Because computers evolve much more rapidly than we do, intelligent robots could quickly become much smarter than we. Of such robots, Marvin Minsky, cofounder of MIT's artificial-intelligence laboratory, has reportedly said, "If we're lucky, maybe they'll want to keep us around as pets."

The Problem of Free Will

> *To deny the freedom of the will is to make morality impossible.*
> —JAMES FROUDE

It is commonly believed that we can be held responsible only for those actions that we freely perform. If we are forced to do something against our will, we aren't to blame. But if every event has a cause, then it would seem that nothing we do is up to us, for all of our actions are determined by forces beyond our control. The principle of causal determinism, then, seems to be inconsistent with the notion of free will.

The view that we have no free will has long been thought to follow from materialism. The ancient Greeks realized that if everything happens as the result of a collision between atoms, then we are powerless to change the future. Whatever will be, will be. We may seem to be masters of our destiny, but that is just an illusion.

In recent years, this view has been most forcefully argued by the late Harvard psychologist B. F. Skinner. Skinner claims that the belief in free will is a prescientific belief left over from animist days when we believed that every object contained a spirit. Physics, chemistry, and biology advanced only after they had given up that notion. Similarly, he says, psychology can become a science only if it gives up the belief that human behavior is caused by an indwelling agent. According to Skinner, we are robots that are programmed by our environment. What we do as adults is the result of what happened to us as children. Consequently, we should not be held responsible for our

actions and should not be given credit for our achievements. A truly enlightened society would have no use for the notions of freedom and dignity.[3]

Although Skinner believes that our behavior is determined primarily by how we are brought up, or nurtured, other scientists believe that it is determined primarily by our genetic endowment, or nature. According to these scientists, the information encoded in our genes determines not only what proteins our bodies manufacture but also how we respond to our environment. As biologist Richard Dawkins puts it, "We are survival machines—robot vehicles blindly programmed to preserve the selfish molecules known as genes."[4] So Dawkins shares Skinner's belief that we are robots. He simply has a different view about where our dominant program comes from.

If either of these scientists is right, then a good number of our social institutions need to be overhauled. Skinner recognized this and wrote a novel, *Walden II*, depicting what life would be like in a world where the idea of free will had been abolished. In such a world, there would be no lawyers, for lawyers determine responsibility, and, according to Skinner, individuals are not responsible for their actions. There would also be no jails, for if individuals are not responsible for their actions, no one should be punished for what he or she does. Those who engage in antisocial behavior have simply been programmed improperly and thus need to be reprogrammed at a behavioral reconditioning center.

> *An idea that is not dangerous is unworthy of being called an idea at all.*
> —Elbert Hubbard

Some psychologists have argued that the use of behavioral reconditioning techniques should be much more widespread than it currently is. Psychologist James McConnell, for example, writes,

> . . . the day has come when . . . it should be possible . . . to achieve a very rapid and highly effective type of positive brainwashing that would allow us to make dramatic changes in a person's behavior and personality. . . .
>
> We should reshape our society so that we all would be trained from birth to want to do what society wants us to do. We have the techniques now to do it. . . . No one owns his own personality. . . . You had no say about what kind of personality you acquired, and there is no reason to believe you should have the right to refuse to acquire a new personality if your old one is antisocial. . . . Today's behavioral psychologists are the architects and engineers of the Brave New World.[5]

A world in which these techniques were the norm would indeed be a brave new world.

The Problem of Personal Identity

The belief that people retain their identity over time is a cornerstone of our legal system. If you sign a thirty-year mortgage contract, for example, you will normally be expected to honor the terms of that contract even though your body and your memories will change considerably during that time. The law recognizes, however, that under certain circumstances people change enough to alter their legal responsibilities. At parole hearings, for example, it isn't uncommon to hear the following sort of argument: "He isn't the same person he was ten years ago. He has realized the error of his ways and has completely

> *The sense of identity provides the ability to experience one's self as something that has continuity and sameness, and to act accordingly.*
> —Erik Erikson

reformed. Therefore, he should be granted parole." But how much and in what ways must someone change in order to be considered a different person?

Some maintain that any change, no matter how slight, makes us a different person. Buddhists, for example, maintain that because everything in the world is constantly changing, so are we. For them, the self is created anew each instant. Others maintain that only certain types of changes can alter our personal identity. Who we are seems to be closely tied to our memories. If we suffered from total amnesia and were unable to remember anything about ourselves, there would be grounds for saying that we had ceased to exist. Does that mean that we are our memories? If we have no memory of doing something, can we legitimately claim that we didn't do it? Would it be wrong to punish us for something that we had no recollection of doing? What if there were a way to transfer our memories from our present body to another, say through a brain transplant? (Partial brain transplants have already been performed.) Would we survive such a transfer? What if our memories were transferred into a body of a different sex? A number of computer scientists believe that it will soon be possible to transfer our memories from our brains into a computer. Could we exist inside a computer? What if we uploaded our memories into two different computers? Would there then be two of us? Although these questions may seem far-fetched, some believe that we will have to face them in the not-too-distant future. How we answer them will be determined by our notion of personal identity.

The Problem of Moral Relativism

When in Rome, do as the Romans do.
—St. Ambrose

All of us make moral judgments. We all have beliefs about what is morally right or wrong. Sometimes we even get into heated arguments about the morality of an action or a policy. But the widespread disagreement about what is moral—as for example in discussions over abortion, capital punishment, and drug use—has led many to believe that there are no objective moral standards. If morality is just a matter of personal opinion, however, then there is no more reason to argue about what is right or wrong than there is to argue about what tastes better—chocolate or vanilla—because there is no accounting for taste.

Furthermore, if there were nothing more to something's being right than our believing it to be right, we would be morally infallible. As long as we did what we thought was right, we could do no wrong. But that, too, seems implausible. Our believing something to be right doesn't make it right. If it did, we would have to say that what Hitler did was right (provided, of course, that he believed in what he was doing). Doing the right thing seems to involve more than simply doing what you believe in.

The notion that morality is subjective faces serious difficulties. But so does the notion that morality is objective. Resolving these difficulties is of the highest importance, for many of the problems we face as individuals and as a society are moral ones. When we ask, "What should we do about . . . ?" we are asking a moral question. How we answer such questions will be determined by what we consider our moral obligations to be. So it's important to be clear about just what those obligations are.

The Problem of Evil

We have seen that the existence of an all-powerful, all-knowing, and all-good being seems to be incompatible with the existence of evil. If God possessed only two of these three attributes, however, there would be no problem. For example, if God were all-knowing and all-good but not all-powerful, we could account for the existence of evil by claiming that God is powerless to prevent it. If God were all-powerful and all-good but not all-knowing, we could account for the existence of evil by claiming that God is ignorant of its existence. If God were all-powerful and all-knowing but not all-good, we could account for the existence of evil by claiming that God isn't opposed to it. To many, however, a being that is limited in any of these ways would not be God. So unless a solution to this problem can be found, it looks like the traditional conception of God must be revised.

> *If it turns out that there is a God, I don't think that he's evil. But the worst that you can say about him is that basically he's an underachiever.*
> —Woody Allen

The Problem of Skepticism

We claim to know many things about the world around us. We claim to know, for example, that snow is white, that the Earth orbits the sun, and that $E = mc^2$. If we really know something, however, it seems that we must be certain of it, for any possibility of error appears to undercut our claim to know. The problem is that most of our information about the external world comes to us through our senses, and we can't be certain of anything we've learned through our senses. There is always the possibility that we've misidentified or misinterpreted our sense experience. Because we can't rule out these possibilities, some claim that we can't have knowledge of the external world.

> *What we know here is very little, but what we are ignorant of is immense.*
> —Pierre-Simon Laplace

Skeptics in the Western intellectual tradition usually don't claim that our sense experience is illusory, only that it could be. As long as knowledge requires certainty, all the skeptics need to make their claim is the possibility that our sense experience misleads us. Many Eastern thinkers, however, go further than the Western skeptics and claim that our sense experience is illusory. This doesn't mean that we cannot have knowledge of reality, however, because, for them, knowledge can be acquired through mystical experience. Mystical experience, they claim, puts us in direct contact with reality and reveals that our ordinary waking consciousness is just a dream. Because what the mystics tell us about reality seems similar to the claims of some modern physicists, some Western thinkers have endorsed the claim that mystical experience is a source of knowledge. If knowledge of the external world is impossible or if there are other sources of knowledge than those traditionally recognized in the West, our conception of education and intellectual inquiry would have to be radically altered.

It should now be clear that a lot hangs on our philosophy. The structure of our belief system can be compared to that of a tree. Just as certain branches support other branches, so certain beliefs support other beliefs. And just as bigger branches support more branches than little ones, so fundamental beliefs support more beliefs than secondary ones. Our philosophical beliefs are among our most fundamental because their truth is assumed by so many

What Is Your Philosophy?

Where do you stand on these issues? What are your philosophical beliefs? You can indicate your views by writing the appropriate number in the space provided at the end of each question. Use the following scale: 5 = true; 4 = probably true; 3 = neither probable nor improbable; 2 = probably false; and 1 = false.

1. The mind (soul) can exist independently of the body. ____
2. The mind is the brain or a by-product of the brain. ____
3. Humans have free will. ____
4. All of our actions are determined by forces beyond our control. ____
5. Persons retain their identity over time, so a seventy-year-old and a five-year-old can be one and the same person. ____
6. Persons do not retain their identity over time because they are constantly changing. ____
7. There are universal moral principles that apply to everyone everywhere. ____
8. Morality is relative to the individual or to society. ____
9. An all-powerful, all-knowing, all-good God exists. ____
10. There is no God. ____
11. We can have definite knowledge about the external world. ____
12. Real knowledge is impossible; all we can have are opinions. ____

Are your views consistent? After you've finished the book, you might want to take the survey again to see whether your views have changed.

of our other beliefs. Consequently, rejecting a philosophical belief is like cutting off a large branch or even part of the tree's trunk: All the beliefs that depend on that fundamental belief must be rejected as well.

Philosophical inquiry attempts to arrive at a belief system or worldview that is both comprehensive and coherent: comprehensive in the sense that it can account for every aspect of our experience, coherent in the sense that none of the beliefs contradict one another. Such a worldview would not only give us a better understanding of the world but also help us deal more effectively with it.

Necessary and Sufficient Conditions

It may well be doubted whether human ingenuity can construct an enigma of the kind which human ingenuity may not, by proper application, resolve.
—EDGAR ALLAN POE

As we have seen, philosophical problems arise because some of our most fundamental beliefs seem to conflict with one another. To solve these problems, we have to eliminate the conflict. The first step in this process is arriving at a correct view of the things those beliefs are about.

Many philosophical problems have the form: What is the nature of ____? where the blank is filled in with the thing in question. For example: What is the nature of the mind? free will? personal identity? morality? God? knowledge? To inquire into the nature or essence of something is to try to identify the features of it that make it what it is. These features are its distinguishing or defining characteristics because they are had by all and only things of that kind.

To solve the mind-body problem, for example, we have to know what it is to have a mind. To know that, we have to know what all and only things with minds have in common in virtue of which they have minds. And to know that is to know the necessary and sufficient conditions for having a mind.

A **necessary condition** is a requirement, it's a condition that must be met in order for something to occur or exist. For example, a necessary condition of your graduating is your taking the required number of courses. It's a necessary condition because you will graduate *only if* you fulfill that requirement. Similarly, a necessary condition for being a bachelor is being unmarried because someone is a bachelor *only if* he's unmarried; a necessary condition for being a cow is being an animal because something is a cow *only if* it is an animal; and a necessary condition for being a triangle is to have three sides because something is a triangle *only if* it has three sides. In general, then, if something X is a necessary condition for something Y, then the presence of Y implies the presence of X because Y can't occur or exist without X.

If something X is a necessary condition for something Y, then it's impossible to have Y without X. For example, being a citizen of the United States is a necessary condition for being the president of the United States because it's impossible to be the president without being a citizen. To show that something X is *not* necessary for something Y, then, all you have to show is that it's possible to have Y without X. For example, if someone claimed that being a male is a necessary condition for being the president of the United States, all you would have to do to refute that claim is show that it's possible for a woman to be president. Even if no woman ever holds that office, it is still false that being a male is a necessary condition for being the president because a woman could be president.

While a necessary condition is a requirement, a **sufficient condition** meets all the requirements. In other words, it suffices; it gives you everything you need. For example, graduating from college is a sufficient condition for meeting all your course requirements. It's sufficient because *if* you've graduated, then you've met your course requirements. Similarly, being a bachelor is a sufficient condition for being a male because *if* someone is a bachelor, then he's a male; being a cow is a sufficient condition for being an animal because *if* something is a cow, then it's an animal; and being a three-sided plane figure is a sufficient condition for being a triangle because *if* something is a three-sided plane figure, then it is a triangle. In general, if something X is a sufficient condition for something Y, the presence of X implies the presence of Y because the presence of X guarantees the presence of Y.

If X is a sufficient condition for Y, then it's impossible to have X without Y. For example, being a Catholic priest is a sufficient condition for being unmarried because it's impossible to be a Catholic priest and not be unmarried. To show that something X is *not* a sufficient condition for something Y, then, all you have to show is that it's possible to have X without Y. For example, if someone claimed that being a four-sided plane figure is a sufficient condition for being a square, all you would have to do to refute that claim is show that it's possible for a four-sided figure not to be a square, perhaps by drawing a rectangle with unequal sides.

necessary condition
Something X is a necessary condition for something Y if and only if it's impossible for Y to exist without X.

sufficient condition
Something X is a sufficient condition for something Y if and only if it's impossible for X to exist without Y.

Logicians use the phrase "if and only if" to indicate that a condition or set of conditions is both necessary and sufficient. For example, something is a noun if and only *if it is* a word used as a name or designation. It's important to realize that a condition can be necessary without being sufficient. Oxygen is a necessary condition for fire, but it's not sufficient because you can have oxygen without having a fire. Similarly, a condition can be sufficient without being necessary. Getting your head cut off is a sufficient condition for dying, but it's not necessary because you can die in many other ways.

Philosophers are not the only ones who search for necessary and sufficient conditions. Scientists, too, often want to know what makes something what it is. For example, in constructing the periodic table of the elements, chemists were trying to discover the nature or essence of each element. What they found was that the necessary and sufficient condition for being a particular element is having a certain atomic number. (The atomic number of an element is the number of protons in the nuclei of its atoms.) The necessary and sufficient condition for being gold, for example, is having the atomic number 79.

Determining whether a condition is necessary or sufficient for something involves deciding whether it's possible for the thing to exist without the condition being met, or vice versa. If something can exist in the absence of the condition, then the condition is not necessary for that thing. For example, being less than ten feet tall is not a necessary condition for being a bachelor because it's possible for someone to be a bachelor and be over ten feet tall. It may well be that all bachelors who have ever lived—and all bachelors who ever will live—are less than ten feet tall. Nevertheless, being less than ten feet tall is not a necessary condition for being a bachelor because height is not a requirement for bachelorhood. Conversely, if it's possible for a condition to be met without the thing existing, then the condition is not sufficient for that thing. For example, loving someone is not a sufficient condition for being loved by that person because the feeling might not be mutual.

To fully understand the nature or essence of a thing—to know what makes a thing what it is—is to know both its necessary and its sufficient conditions. If we knew only one or the other, we wouldn't always be able to tell whether the thing in question was present. For example, if all we knew about being a bachelor was that being unmarried was a necessary condition, we wouldn't be able to tell whether an unmarried woman was a bachelor. Similarly, if all we knew about being a bachelor was that being a Catholic priest was a sufficient condition, we wouldn't be able to tell whether someone who wasn't a priest was a bachelor. Ideally, then, our search for understanding should result in both necessary and sufficient conditions.

The ideal may not be realizable in practice, however, because the concepts we're interested in may not have precise boundaries. Consider, for example, the concept of a game. The British philosopher Ludwig Wittgenstein famously claimed that there is no set of necessary and sufficient conditions that all games have in common in virtue of which they are games. He asks us to think of all the different types of activities we call games: board games, card games, ball games, Olympic games, and so on. He asserts that there is no feature or set of features that is shared by all of them. Rather, there is a network

of overlapping similarities that criss-cross one another, like those that exist among members of a family. So he prefers to say that games share a "family resemblance" with one another instead of a common nature or essence.[6]

- Some think that Wittgenstein is wrong about the concept of a game and claim that necessary and sufficient conditions can be given for being a game. For example, Bernard Suits in his book *The Grasshopper: Games, Life and Utopia* provides an in-depth analysis of games, which he summarizes this way: "the voluntary attempt to overcome unnecessary obstacles."[7] Others have offered similar analyses.[8] Even if our concept of a game is vague, however, we may still search for a more precise characterization of it. As we have seen, our conceptual scheme is shot through with inconsistencies, and if we can eliminate some of those inconsistencies by taking a vague concept and making it more precise, that's all to the good. The German philosopher Rudolf Carnap called this process "explication" and defined it this way: "the transformation of an inexact, prescientific concept into a new exact concept."[9] By making our conceptual scheme more coherent, conceptual explication can both deepen and broaden our understanding of the world.

> *The philosophy of one century is the common sense of the next.*
> —HENRY WARD BEECHER

What's more, in many cases, solving a philosophical problem doesn't require coming up with both necessary and sufficient conditions. Identifying one or the other or showing that a condition is *not* necessary or sufficient may be all that is needed. For example, the problem of free will arises because it seems that we can't act freely if all of our actions are determined by forces beyond our control. If only one course of action is open to us—if we can't do otherwise—we have no free will. Some, however, have argued that this condition is not necessary for free will—that we can act freely even if we couldn't do otherwise. If they are correct, then they may have solved (or dissolved) the problem of free will.

- Identifying necessary and sufficient conditions is difficult because we can have a concept without being able to state the conditions for applying it. For example, we can have the concept of a joke without being able to say what it is that makes something a joke. When the conditions for applying concepts are unclear, clarifying them usually requires taking a hypothetical approach. This involves formulating a hypothesis about the conditions for applying a concept and testing that hypothesis to determine whether the conditions specified are necessary or sufficient. This method of conceptual inquiry was pioneered by the celebrated Greek philosopher Socrates (469–399 BCE.).

Socrates and the Socratic Method

Socrates is the pivotal figure in the history of Western philosophy. Not only was he the first to ask many of the questions that are central to the discipline, but he also pioneered a method of answering them that is still in use today. There were philosophers before Socrates, but they are known collectively as "pre-Socratics," again indicating his importance to the discipline. The pre-Socratics were concerned primarily with questions about the nature of reality. Socrates, too, was originally interested in such questions. He studied under Anaxagoras, who was charged with the crime of impiety for teaching that

> *The men of action are, after all, only the unconscious instruments of the men of thought.*
> —HEINRICH HEINE

the sun was a molten mass of rock. Socrates eventually gave up the study of nature, perhaps because there seemed to be no way to decide among competing theories. (The experimental method that we associate with scientific investigation had not yet been devised.) Instead, he focused his considerable intellectual talents on the study of problems more directly relevant to human life. He sought answers to such questions as, "What is justice?" "What is virtue?" "What is knowledge?" Because our lives are guided by what we take to be the correct answers to such questions, Socrates claimed that only those who had considered such questions could lead a good life.

Socrates was a native of Athens, Greece, and a stonecutter by trade. Like most able-bodied Athenian men at that time, he served in the army. But unlike most of them, he distinguished himself on the battlefield. In the battle of Delium, he reportedly saved the life of Xenophon and retreated with dignity when the other Athenians were running for their lives. In the battle of Potideaea, he won a citation for valor for holding his ground throughout the night. He is most famous, however, for the public conversations he had with the leading figures of Athens.

Socrates' strength of character and force of mind were widely known. So much so, that when his friend Chaerophon asked the Oracle at Delphi whether anyone was wiser than Socrates, the priestess replied, "Of all men living, Socrates is the wisest." When word of this got back to Socrates, he thought the Oracle must have made a mistake. So he set out to prove the Oracle wrong. He reasoned that if he could find at least one person who was wiser than himself, he would have shown the Oracle to be in error. He sought out the greatest politicians, poets, and craftsmen of his day in an attempt to determine whether any of them possessed true wisdom. Socrates describes his search this way:

> I went to one who had the reputation of wisdom, and observed him. When I began to talk with him, I could not help thinking that he was not really wise, although he was thought wise by many, and wiser still by himself; and I went and tried to explain to him that he thought himself wise, but was not really wise; and the consequence was that he hated me, and his enmity was shared by several who were present and heard me. So I left him, saying to myself, as I went away: Well, although I do not suppose that either of us knows anything really beautiful and good, I am better off than he is—for he knows nothing, and thinks that he knows. I neither know nor think that I know. In this latter particular, then, I seem to have slightly the advantage of him.[10]

Although Socrates was unable to find anyone wiser than himself, he did not conclude that he had any substantive knowledge that they lacked. What made him wiser than they, he claimed, was that, unlike them, he knew that he didn't have any wisdom.

Socrates liked to conduct his inquiries in the marketplace, and he often drew a large crowd. No one likes to be made a fool of in public, however, and eventually some of those who felt the sting of his sharp tongue brought charges against him. His accusers were Miletus the poet, Anytus the tanner, and Lycon the orator. They claimed that he was guilty of worshipping false gods and corrupting the youth. The penalty they sought was death. Socrates

In the News: The Oracle at Delphi

The Oracle at Delphi was one of the most revered and powerful people in ancient Greece. She advised farmers when to plant their crops and generals when to wage war. No great project was undertaken without the blessings of the Oracle. The oracle in the movie *The Matrix* was modeled after the Oracle at Delphi. Both foretold the future, and both had the saying "Know Thyself" hanging over the entrance to their chambers (although one was in Greek and the other in Latin). Who was this enigmatic figure? It turns out that the Oracle at Delphi was not any one person, but a succession of older women of impeccable virtue who served as the mouthpiece of the god Apollo.

Delphi, which is situated at the foot of Mt. Parnassus, was considered sacred to Apollo because it was there, according to Homer, that he slew the dragon Python. The dragon's body allegedly fell into a fissure in the floor of a cave on the side of Mt. Parnassus. As it decomposed, it gave off fumes. The Oracle, also known as the Pythia, would sit on a tripod over the fissure in the cave, breathe in the fumes, and become possessed by the spirit of Apollo. In this intoxicated state, she gave her prophecies. They were often incoherent, but the Greek priests would make them more intelligible by translating them into hexameter verse.

Before Alexander the Great set out on his first military campaign, he traveled to Delphi to seek the Oracle's counsel. When he arrived, legend has it that the Oracle was unavailable. Anxious to know his prospects for success, he tracked down the Oracle and forced her to make a prediction. She is reported to have cried out in exasperation, "Oh, child, you are invincible." Alexander took this as a favorable omen and went on to conquer the world.

Recent geological research has identified a possible source of the fumes.

Several years ago, Greek researchers found a fault running east to west beneath the oracle's temple. De Boer [a geologist at Wesleyan University] and his colleagues discovered a second fault, which runs north to south. "Those two faults do cross each other, and therefore interact with each other, below the site," said De Boer....

About every 100 years a major earthquake rattles the faults, the faults are heated by adjacent rocks and the hydrocarbon deposits stored in them are vaporized. These gases mix with ground water and emerge around springs.

De Boer conducted an analysis of these hydrocarbon gases in spring water near the site of the Delphi temple. He found that one is ethylene, which has a sweet smell and produces a narcotic effect described as a floating or disembodied euphoria.

"Ethylene inhalation is a serious contender for explaining the trance and behavior of the Pythia," said Diane Harris-Cline, a classics professor at The George Washington University in Washington, D.C.

"Combined with social expectations, a woman in a confined space could be induced to spout off oracles," she said.[11]

When the fissure at Delphi stopped producing gas, the Greek priests purportedly started burning belladonna and jimson weed in the cave and found that they could get some pretty good oracular declamations from the smoke that produced as well.

was tried before the Athenian Council of 500, and the proceedings were recorded by his pupil Plato. (Socrates never committed his thoughts to paper, so most of what we know about Socrates' philosophy comes from the dialogues of Plato in which Socrates always appears as the main character.) Socrates argued that the charges were false—that he was guilty of nothing more than seeking the truth. The council wasn't convinced, however, and by a vote of 280 to 220 found him guilty as charged. When asked, as was the custom, what an appropriate penalty would be, Socrates defiantly replied that he should be kept in the Pyrtaneum (the dining hall of Olympic and military heroes) at the

Pre-Socratic Philosophers

Philosophy and science have a common origin in ancient Greece. There, on the banks of the Aegean Sea around 600 B.C., Thales (ca. 624–547 B.C.) asked—and answered—a question that philosophers and scientists are struggling with to this day: "What is the world made of?" Two important assumptions underlie Thales' question: (1) that the nature of a thing is determined by the stuff out of which it is made, and (2) that everything is made out of the same kind of stuff. These assumptions lie behind our most advanced physical theory: string theory. According to that theory, everything in the world is made out of infinitesimally small, multidimensional strings that vibrate at different frequencies. Thales' basic stuff is not so arcane. According to him, the world is made of water. Although that theory may not seem very plausible, it should be noted that water can exist in a number of different states: solid, liquid, and gas. Thales apparently believed that everything in the world was a different state of water.

The Greeks traditionally recognized four different substances: earth, air, fire, and water. Thales claimed that there was only one—water—and that everything else was a modification of it. Thales' pupil Anaximander (ca. 610–546 B.C.) didn't find Thales' explanation convincing, however, because it couldn't account for fire. Earth and air may be types of water, but fire cannot be made out of water because water puts out fire. Furthermore, he argued that Thales' theory couldn't account for change. Water may exist in many different forms, but Thales doesn't explain what causes it to assume all those forms.

Anaximander sought to improve on Thales' theory by postulating a mechanism for change. He argued that change was the result of a war between opposites that he called "the hot," "the cold," "the wet," and "the dry." Because each of these forces is struggling for dominance, none of them can be basic. So the original stuff, Anaximander reasoned, must be utterly different from anything that currently exists. He referred to this stuff as the Apeiron, meaning "the indefinite" or "the unbounded." The four forces precipitated out of this basic stuff and gave rise to the world as we know it.

Echoes of Anaximander can also be found in current scientific theories. Modern physics recognizes four basic forces—electromagnetism, gravity, the strong nuclear force, and the weak nuclear force—as the causes of change. It also teaches that the original stuff out of which everything came is no longer present. That stuff existed at the moment of the big bang (the explosion that brought our universe into existence), but as it cooled, it turned into the particles we are familiar with.

Anaximines (d. 528 B.C.), another student of Thales, thought that Anaximander's theory was no better than Thales' because it couldn't explain how the four forces emerged out of the Apeiron. He thought that Thales had the right idea but the wrong substance. According to Anaximines, the basic stuff is air. Unlike Thales, however, he was able to explain how air could take on so many different forms: through the processes of condensation and rarefaction. Condense air, he claimed, and you get water. Condense water, and you get earth.

public expense in recognition of the service he had performed for the people of Athens. Outraged by his impudence, the council took another vote and by a vote of 360 to 140 sentenced him to death.

Normally, convicted criminals were executed the day after the trial. Socrates' execution was delayed for thirty days, however, because the sacred ship sent to Delos every year to celebrate Theseus's victory over the minotaur had just set sail. In honor of the god Apollo, no one could be executed while the ship was at sea. During that time, Socrates had a number of remarkable philosophical discussions with his disciples.

Socrates' friends knew that the charges brought against him were false and the conviction unjust, so they tried to help him escape. They prepared a

Rarefy air, and you get fire. Thus, Anaximines could account for all four elements in terms of one basic substance.

Pythagoras (fl. 530 B.C.) is the only pre-Socratic philosopher whose name is still widely known. We recognize him as the discoverer of the Pythagorean theorem. But he also pioneered a novel approach to understanding the world. According to Pythagoras, what makes something what it is, is not the stuff out of which it is made but the form that it possesses. What's more, Pythagoras claimed that form can be represented mathematically. Pythagoras made a number of important mathematical discoveries, including square numbers, cube numbers, and irrational numbers. Modern science shares Pythagoras's insight that the underlying form of nature can be represented mathematically. (That's why all science students have to take math courses.)

Other pre-Socratics focused on the problem of change and developed radically different theories to deal with it. The problem is, How can something change and yet remain the same thing? If it has changed, it's different, and if it's different, it's no longer the same. Heraclitus (ca. 540–480 B.C.) took change to be an undeniable fact and concluded that we must give up the notion that things remain the same through change. "The only constant is change," he paradoxically proclaimed. "You can never step into the same river twice." Parmenides (b. 515 B.C.), on the other hand, believed that only that which is unchanging is real, so he denied that change occurred. For him, change was an illusion.

Parmenides' view is important because it was backed by a logical argument. He recognized that anything that involves a logical contradiction cannot exist. So he concluded that nonexistence cannot exist. What's more, he reasoned that if there is no place where there is nothing—if every place is occupied—there is no place to move to. So motion, and thus change, is impossible. It may seem that we can move from one place to another, but that is just an illusion. For Parmenides, the world is a solid ball of matter that never changes.

This view did not sit well with most Greek thinkers, although Parmenides' pupil Zeno of Elea (ca. 490–435 B.C.) provided a number of additional arguments to support his claim. To resolve the impasse, Democritus (ca. 460–370 B.C.) combined the insights of both Heraclitus and Parmenides. He affirmed the existence of empty space and claimed that the world is made up of particles that are constantly moving through space. These particles are like Parmenidean worlds: They have no internal structure and cannot be broken down into any smaller constituents. Democritus called them "atoms," which comes from the Greek *atomon*, meaning "uncuttable." What we call atoms are not indivisible, but we do recognize the existence of indivisible particles, such as electrons and quarks, out of which everything is made. What's important about the pre-Socratics is not the details of their theories but the types of questions they asked and the types of answers they gave to them, for they have shaped Western intellectual history for more than two thousand years.

ship for him and convinced the guard to unlock the door to his cell. Socrates refused to leave, however, arguing that because he had enjoyed the benefits of Athenian citizenship throughout his life, he owed it to the people of Athens to abide by their decision. When the sacred ship returned from Delos, Socrates drank a cup of hemlock and died.

According to the biographer Diogenes Laertius, the citizens of Athens soon recognized the error of their judgment. He writes,

> Not long afterward, the Athenians felt such remorse that they closed the training grounds and gymnasiums. They put Meletus to death and banished his other accusers. They erected a bronze statue of Socrates to honor him; it was the work of Lysippus and was placed in the hall of processions.[12]

SOCRATES
469–399 BCE.

Apparently the Athenians came to agree with Socrates that he had indeed performed a valuable public service in teaching them to seek virtue and wisdom.

When Socrates asked questions like "What is justice?" "What is virtue?" "What is knowledge?" those he interrogated often responded by citing instances of the concept in question. Socrates wouldn't accept such responses, however, for they didn't answer his question. He wanted to know what made the thing in question what it is, and listing examples didn't give him that knowledge. Once he got his interlocutors to specify necessary and sufficient conditions for applying the concept, he would examine those conditions to determine whether they were indeed necessary or sufficient.

For example, in Plato's dialogue *Euthyphro,* Socrates tries to determine what makes something holy. Believing that a theologian should know something about this, he questions the young theologian Euthyphro, who at the time was prosecuting his own father on a charge of murder. It seems that one of the father's hired laborers had killed one of his house slaves in a fit of drunken rage. Euthyphro's father captured the laborer, tied his hands and feet, and threw him into a ditch. He then sent a messenger to Athens to consult a religious authority to determine what should be done with the culprit. In the meantime, he neglected the laborer, figuring that it would not matter if he died, because he was a murderer. The laborer did die before the messenger returned, and Euthyphro alleged that his father was guilty of murdering the laborer. Socrates meets Euthyphro on the steps of the courthouse:

SOCRATES: Then tell me. How do you define the holy and the unholy?

EUTHYPHRO: Well then, I say that the holy is what I am now doing, prosecuting the wrongdoer who commits a murder or a sacrilegious robbery, or sins in any point like that, whether it be your father, or your mother, or whoever it may be. And not to prosecute would be unholy. . . .

SOCRATES: . . . my friend, you were not explicit enough before when I put the question. What is holiness? You merely said that what you are now doing is a holy deed—namely, prosecuting your father on a charge of murder.

EUTHYPHRO: And, Socrates, I told the truth.

SOCRATES: Possibly. But, Euthyphro, there are many other things that you will say are holy.

EUTHYPHRO: Because they are.

SOCRATES: Well, bear in mind that what I asked of you was not to tell me one or two out of all the numerous actions that are holy; I wanted you to tell me what is the essential form of holiness which makes all holy actions holy. I believe you held that there is one ideal form by which unholy things are all unholy, and by which all holy things are holy. Do you remember that?

EUTHYPHRO: I do.

SOCRATES: Well then, tell me what, precisely, this ideal is, so that, with my eye on it, and using it as a standard, I can say that any action done by you or anybody else is holy if it resembles this ideal, or, if it does not, can deny that it is holy.

EUTHYPHRO: Well, Socrates, if that is what you want, I certainly can tell you.

SOCRATES: It is precisely what I want.

EUTHYPHRO: Well then, what is pleasing to the gods is holy, and what is not pleasing to them is unholy.

SOCRATES: Perfect Euthyphro! Now you give me just the answer that I asked for. Meanwhile, whether it is right I do not know, but obviously you will go on to prove your statement true.

EUTHYPHRO: Indeed I will.[13]

Socrates has now received an answer to his question. Euthyphro has finally proposed necessary and sufficient conditions for something's being holy. Socrates proceeds to test this proposal by trying to determine whether the conditions identified really are necessary and sufficient.

SOCRATES: Come now, let us scrutinize what we are saying. What is pleasing to the gods, and the man that pleases them, are holy; what is hateful to the gods, and the man they hate, unholy. But the holy and unholy are not the same; the holy is directly opposite to the unholy. Isn't it so?

EUTHYPHRO: It is. . . .

SOCRATES: Accordingly, my noble Euthyphro, by your account some gods take one thing to be right, and others take another and similarly with the honorable and the base, and good and bad. They would hardly be at variance with each other, if they did not differ on these questions. Would they?

EUTHYPHRO: You are right.

SOCRATES: And what each one of them thinks noble, good and just, is what he loves and the opposite is what he hates?

EUTHYPHRO: Yes, certainly.

SOCRATES: But it is the same things, so you say, that some of them think right, and others wrong, and through disputing about these they are at variance, and make war on one another. Isn't it so?

EUTHYPHRO: Yes it is.

SOCRATES: Accordingly, so it would seem the same things will be hated by the gods and loved by them; the same things would alike displease and please them.

EUTHYPHRO: It would seem so.

SOCRATES: And so, according to this argument, the same things, Euthyphro, will be holy and unholy.

EUTHYPHRO: That may be.

SOCRATES: In that case, admirable friend, you have not answered what I asked you. I did not ask you to tell me what at once is holy and unholy, but it seems that what is pleasing to the gods is also hateful to them. Thus, Euthyphro, it would not be strange at all if what you now are doing in

punishing your father were pleasing to Zeus, but hateful to Cronus and Uranus, and welcome to Hephaestus, but odious to Hera, and if any other of the gods disagree about the matter, satisfactory to some of them and odious to others.[14]

Euthyphro suggests that holiness is what is pleasing to the gods. Socrates puts this suggestion to the test by exploring its implications. He points out that what is pleasing to one of the gods may not be pleasing to the others—for example, what is pleasing to Zeus may not be pleasing to Hera. So if being pleasing to the gods is what makes something holy, something could be holy and unholy at the same time. But that's impossible. Nothing can have a property and lack it at the same time. Consequently, the conditions proposed can't be correct. Being pleasing to the gods can be neither a necessary nor a sufficient condition for being holy.

The Socratic Method for analyzing a concept, then, involves the following steps:

1. *Identify a problem or pose a question.* Ask, "What makes something an X?" "In virtue of what is something an X?" "How is it logically possible for something to be an X?" "What is the logical relationship between X and Y?"

2. *Propose a hypothesis.* Specify the necessary or sufficient conditions for applying the concept in question. Try to identify the features shared by all and only those things to which the concept applies.

3. *Derive a test implication.* Ask, "What if the hypothesis were true?" "What does it imply?" "What does it commit us to?" Test implications have the following form: If hypothesis H is true, then concept X should apply in this situation.

4. *Perform the test.* Determine whether the concept applies in the situation envisioned.

5. *Accept or reject the hypothesis.* If the concept applies in the situation envisioned, there is reason to believe that it's true. If it doesn't apply, there is reason to believe that it's false. In that case, you should either reject the hypothesis or go back to step 2 and revise it.

Science and the Scientific Method

The ground aim of all science is to cover the greatest number of empirical facts by logical deductions from the smallest possible number of hypotheses.
—Albert Einstein

While philosophers are in the business of trying to identify the necessary or sufficient conditions for the application of concepts, scientists are in the business of trying to identify the necessary or sufficient conditions for the occurrence of events. Consider, for example, the problem of Uranus's orbit. By 1844, it was known that there was a wobble in Uranus's orbit that couldn't be explained by Newton's theories of gravity and motion. The observed orbit differed from the predicted orbit by two minutes of arc, a discrepancy much greater than that of any other known planet. If astronomers couldn't explain how this was possible, Newton's theory would be in trouble because it would be inconsistent with the data. In 1845, astronomer Urbain Le Verrier

explained how the wobble was possible by postulating the existence of an unknown planet. Using Newton's theories of gravity and motion, he calculated the mass and trajectory a planet would need to have in order to affect Uranus's orbit in the way observed. On the basis of those calculations, he requested astronomer Johann Galle to search a particular region of the sky for such a planet. Less than an hour after Galle began his search, he noticed something that was not on his charts. When he checked again the next night, the object had moved a considerable distance. Galle had discovered Neptune.

Uranus's orbit seemed impossible because it conflicted with Newton's laws of gravity and motion. Le Verrier explained how it was possible by identifying sufficient conditions for Uranus having the orbit it did that were consistent with Newton's laws of gravity and motion. Because Le Verrier's claim turned out to be true, Newton's laws did not have to be revised or abandoned.

The scientific method, then, involves the following steps:

1. *Identify a problem or pose a question.* Ask, "What causes something to be X?" "In virtue of what does X occur?" "How is it causally possible for X to occur?" "What is the causal relationship between X and Y?"
2. *Propose a hypothesis.* Specify the necessary or sufficient conditions for the event's occurring. Try to identify the features shared by all and only those things that cause X.
3. *Derive a test implication.* Ask, "What if the hypothesis were true?" "What does it imply?" "To what does it commit us?" Test implications have the following form: If hypothesis H is true, then event X should occur in this situation.
4. *Perform the test.* Produce the situation in the laboratory or look for it in the field.
5. *Accept or reject the hypothesis.* If the event occurs in the situation specified, there is reason to believe that the hypothesis is true. If it doesn't apply, there is reason to believe that it is false. In that case, you should either reject the hypothesis or go back to step 2 and revise it.

Philosophy, like science, aims at solving problems and getting at the truth. Unlike science, however, philosophy is more concerned with explaining how it's possible for concepts to apply than how it's possible for events to occur. Jerry Fodor illuminates the difference between these two types of inquiry with the following example:

> Consider the question: 'What makes Wheaties the breakfast of champions?' (Wheaties, in case anyone hasn't heard, is, or are, a sort of packaged cereal. The details are very inessential.) There are, it will be noticed, at least two kinds of answers that one might give. A sketch of one answer, which belongs to what I shall call the 'causal story' might be: 'What make Wheaties the breakfast of champions are the health-giving vitamins and minerals that it contains'; or 'It's the carbohydrates in Wheaties, which give the energy one needs for hard days on the high hurdle'; or 'It's the special springiness of all the molecules in Wheaties, which gives Wheaties eaters their unusually high coefficient or restitution', etc.

The Laws of Thought

The laws of logic are often called the laws of thought because, just as social laws make society possible, so logical laws make thought possible. Aristotle (384–322 B.C.) was the first to codify these laws. They include:

The law of noncontradiction: Nothing can both have a property and lack it at the same time. (No statement can be both true and false at the same time.)

The law of identity: Everything is identical to itself. (Everything is what it is and not another thing.)

The law of excluded middle: For any property, everything either has it or lacks it. (Every statement is either true or false.)

In order to think about the world, your thoughts must have a specific content; they must represent the world as being one way rather than another. If the law of noncontradiction didn't hold, however, that wouldn't be possible because every one of your thoughts would be both true and false. In such a situation, thinking would be impossible. Aristotle explains:

> . . . if all are alike both wrong and right, one who is in this condition will not be able either to speak or to say anything intelligible; for he says at the same time both "yes" and "no." And if he makes no judgment but "thinks" and "does not think" indifferently, what difference will there be between him and a vegetable?[15]

What difference, indeed? Without the law of noncontradiction, you couldn't affirm or deny anything because every affirmation would also be a denial. But if you can't affirm or deny anything, you can't think at all.

Because the laws of thought are the basis for all logical proofs, they can't be directly proven by means of a logical demonstration. But they can be indirectly proven by showing that you cannot deny them without assuming them! Aristotle puts the point this way:

> The starting point for all such proofs is that our opponent shall say something which is significant both for himself and for another; for this is necessary if he really is to say anything. For if he means nothing, such a man will not be capable of reasoning, either with himself or with another. But if any one says something that is significant, demonstration will be possible; for we shall already have something definite. The person responsible for the proof, however, is not he who demonstrates but he who listens; for while disowning reason he listens to reason. And again he who admits this has admitted that something is true apart from demonstration.[16]

The law of noncontradiction can't be demonstrated to someone who won't say something definite, for demonstration requires that our words mean one thing rather than another. On the other hand, the law of noncontradiction need not be demonstrated to someone who will say something definite, for in saying something definite, the speaker has already assumed its truth.

> . . . I suggested that there is another kind of answer that 'What makes Wheaties the breakfast of champions?' may appropriately receive. I will say that answers of this second kind belong to the 'conceptual story'. In the present case, we can tell the conceptual story with some precision: What makes Wheaties the breakfast of champions is the fact that it is eaten (for breakfast) by nonnegligible numbers of champions. This is, I take it, a conceptually necessary and sufficient condition for anything to be the breakfast of champions; as such, it pretty much exhausts the conceptual story about Wheaties.
>
> The point to notice is that answers that belong to the conceptual story typically do not belong to the causal story and vice versa.[17]

Questions of the form "What makes something X?" can be answered in one of two ways: (1) by specifying the causally necessary and sufficient conditions for being X or (2) by specifying the logically necessary and sufficient conditions for being X. The first sort of answer—the causal story—is usually provided by science. The second sort of answer—the conceptual story—is usually provided by philosophy. To understand the difference between philosophy and science, then, it's important to understand the difference between logical and causal possibility.

Logical versus Causal Possibility

Something is **logically impossible** if and only if it violates a law of logic. The fundamental law of logic is the **law of noncontradiction,** which says that nothing can have a property and lack it at the same time. For example, a round square is logically impossible because nothing can be both round and square at the same time. Anything that is logically impossible cannot exist. We know, for example, that there are no round squares, no married bachelors, and no largest number because these notions involve a contradiction. The laws of logic, then, not only determine the bounds of the rational, they also determine the bounds of the real. That is why the great German logician Gottlob Frege called logic "the study of the laws of the laws of science."

The laws of science must obey the laws of logic. But the laws of logic need not obey the laws of science. In other words, something can be logically possible even though it's causally impossible. Something is **causally impossible** if and only if it violates a law of nature. A cow's jumping over the moon, for example, is causally impossible because it violates natural laws concerning mass, force, acceleration, and gravity, among others. But such a feat isn't logically impossible, for the notion of a moon-jumping cow doesn't involve a logical contradiction. The notion of logical possibility, then, is more inclusive than that of causal possibility. Many more things are logically possible than are causally possible.

Because scientific theories try to explain how it's causally possible for an event to occur, they can often be tested by means of physical experiments in the laboratory. If a scientific theory is true, then certain events should occur under certain conditions. Scientists test their theories by constructing artificial situations in which those conditions are met. If the events occur as predicted, the test is successful. If not, it's unsuccessful. Suppose, for example, that you wanted to test the effectiveness of a new antibacterial drug. You could grow some bacteria in a culture and then apply the drug to them. If most of the bacteria died, you would have reason to believe that the drug was effective.

Because philosophical theories explain how it's logically possible for a concept to apply, they cannot be tested by physical experiments in a scientist's laboratory. But they can be tested by thought experiments in the laboratory of the mind. If a philosophical theory is true, then certain concepts should apply under certain conditions. Philosophers test their theories by constructing

The only way to discover the limits of the possible is to go beyond them into the impossible.

—Arthur C. Clarke

logically impossible Something is logically impossible if and only if it violates a law of logic.

law of noncontradiction The principle that nothing can both have and lack a property at the same time and in the same respect.

causally impossible Something is causally impossible if and only if it violates a law of nature.

imaginary situations in which those conditions are met. If the concepts apply as predicted, the test is successful. If not, it's unsuccessful. So even though philosophy deals with abstract concepts rather than concrete events, its theories can be tested, and the results of these tests can be used to judge the plausibility of these theories.

Thought Probe

Possibilities

Are the following situations causally possible? Are they logically possible? A human with feathers. Traveling faster than the speed of light. A cat speaking English. A bowling ball speaking English. A rabbit laying multicolored eggs. A soft-shelled prime number. A thinking machine. A computer with a soul.

Summary

We all have a philosophy, for we all have beliefs about what is real, what is valuable, and how we come to know what is real and valuable. The quality of our lives is determined by the nature of our philosophy, for every decision we make is influenced by our views of reality, value, and knowledge. The goal of philosophical inquiry is to determine whether these views are viable.

Philosophical problems arise from the realization that some of our most fundamental beliefs seem to be inconsistent with one another. Apparent inconsistencies among some of our central beliefs give rise to the mind-body problem, the problem of personal identity, the problem of free will, the problem of evil, the problem of moral relativism, and the problem of skepticism. Philosophical theories try to resolve such conflicts by explaining how it is possible (or why it is impossible) for a concept to apply to something.

Philosophy differs from science in that it tries to explain how it's possible for a concept to apply rather than how it's possible for an event to occur. Philosophical theories provide the logically necessary and sufficient conditions for a concept's applying, whereas scientific theories provide the physically necessary and sufficient conditions for an event's occurring. Because scientific theories explain the causal relations between events, they can be tested by means of physical experiments in the laboratory. Because philosophical theories explain the logical relations between concepts, they can be tested by means of thought experiments in the laboratory of the mind.

Study Questions

1. What are the four main branches of philosophy?
2. How do philosophical problems arise?
3. How can philosophical problems be solved?
4. What is a necessary condition?

5. What is a sufficient condition?
6. What do philosophical theories try to explain?
7. What do scientific theories try to explain?
8. What makes something logically impossible?
9. What makes something causally impossible?
10. How can scientific theories be tested?
11. How can philosophical theories be tested?

Discussion Questions

1. How has your philosophy affected your decisions? Give specific examples.
2. Are philosophical beliefs the only beliefs worth dying for? Illustrate your answer by means of examples.
3. What if Crick were able to demonstrate convincingly that we are "nothing but a pack of neurons"? What effect, if any, should this have on our legal system? On our religious beliefs?
4. What if it were convincingly demonstrated that we do not have free will? What effect, if any, should this have on our legal system? On our religious beliefs?
5. What if it were convincingly demonstrated that knowledge is impossible? What effect, if any, should this have on our educational system? On government support for research?
6. Is being a resident of Iowa a necessary or a sufficient condition for being a resident of the United States?
7. Is being a citizen of the United States a necessary or a sufficient condition for being president of the United States?

Internet Inquiries

1. How consistent is your belief system? To find out, take the "Philosophical Health Check" at *The Philosophers' Magazine* Web site: **http://www.philosophyexperiments.com/**
2. In 2006, the *Edge* "World Question Center" asked a number of leading thinkers: "What Is Your Dangerous Idea?" Their answers can be found at: **http://www.edge.org/q2006/q06_index.html**. Which of these ideas are dangerous because they call into question philosophical beliefs? Which idea do you think is the most dangerous? Why?
3. Diogenes Laertius's biography of Socrates (and many other ancient Greek philosophers) can be found at: **https://en.wikisource.org/wiki/Lives_of_the_Eminent_Philosophers/Book_II#Socrates**. Read Socrates' biography. Do you agree that he was the wisest of men? Why or why not?

Section 1.2

Evidence and Inference
Proving Your Point

> *It was a saying of the ancients, that "truth lies in a well"; and to carry on the metaphor, we may justly say that logic supplies us with steps whereby we may go down to reach the water.*
>
> —Isaac Watts

To arrive at the truth, we have to reason correctly. Philosophers have always appreciated this fact and have made the study of correct reasoning—logic—one of their central concerns. Logic doesn't attempt to determine how people in fact reason. Rather, it attempts to determine how people should reason if they want to avoid error and falsehood. Logical thinking is rational thinking, and rational thinking is that which is most likely to lead us to the truth.

When you're doing philosophy, you're trying either to determine whether a claim is true or to demonstrate that a claim is true. The first activity involves *identifying* and *evaluating* other people's arguments. The second involves *constructing* and *defending* your own arguments. Performing either of these tasks requires following certain rules and procedures. Mastering these rules and procedures will make you not only a better thinker but also a more persuasive speaker and writer.

What distinguishes a rational claim from an irrational one is that it's backed by good reasons. When you present reasons for believing that a claim is true, you're making an argument. The reasons you give for the claim you're making (which are themselves claims) are known as the **premises** of the argument. The claim you're trying to make is known as the **conclusion** of the argument. An **argument,** then, is a group of claims consisting of one or more premises and a conclusion that supposedly follows from the premises.

In ordinary parlance, any sort of disagreement is called an argument, but as we all know, these disagreements can be anything but logical. In philosophy, the term "argument" is reserved for those claims in which there is supposedly a logical relation between the premises and the conclusion.

A good argument is one that provides a good reason for accepting its conclusion. To help us distinguish good arguments from bad ones, logic identifies the ways in which premises and conclusion must be related in order for the conclusion to follow from them. Only when the conclusion logically follows

premise A reason given for accepting the conclusion of an argument.

conclusion The claim that an argument is trying to establish.

argument A group of claims consisting of one or more premises and a conclusion that supposedly follows from the premises.

from the premises does an argument provide a good reason for accepting its conclusion.

Consider, for example, the following argument:

1. Roses are red.
2. Violets are blue.
3. Therefore daffodils are yellow.

All of the premises in this argument are true, but it's not a good argument because the conclusion doesn't follow from the premises. There is no logical relation between the premises and the conclusion. Consequently, it doesn't provide a good reason for believing the conclusion.

Identifying Arguments

The first step in identifying an argument is identifying its conclusion. The conclusion of an argument is the main point it's trying to make. It's the claim the argument is trying to justify. Identifying the conclusion is not always an easy task, however, because there may be several intermediate conclusions. In some cases, the author may even think that the conclusion is so obvious that it doesn't need to be stated. In many cases, however, the conclusion follows certain conclusion indicator words such as "thus," "therefore," "hence," "so," "then," "consequently," "as a result," "shows that," "means that," "implies that," "establishes that," and "can be concluded that." For example, consider the following arguments:

Logic is the art of convincing us of some truth.
—Jean de La Bruyere

1. Only things made of flesh and blood can think. Therefore computers can't think.
2. You have no control over the neurons in your brain. It follows that you have no control over anything you do.
3. Everybody does it, so I should be allowed to do it, too.

In each of these cases, the conclusion is preceded by a conclusion indicator word.

Sometimes, however, the conclusion isn't preceded by anything. For example:

4. God exists since the world needs a designer.
5. She's a vegetarian because she thinks that eating meat is immoral.
6. The president's action is a mistake, for it will escalate terrorism, strengthen the resolve of our enemies, and alienate friendly states.

In these arguments, the conclusion comes before the premises.

Once you've identified the conclusion, the next step in identifying an argument is to identify its premises. Premises are often preceded by certain premise indicator words such as "since," "because," "for," "if," "follows from," "given that," "provided that," and "assuming that." Like conclusions,

Evidence and Inference

Believe nothing, no matter where you read it, or who said it, no matter if I said it, unless it agrees with your own reason and your own common sense.
—Buddha

however, premises can also be the first claim in an argument, as in the first three arguments.

The third step in identifying an argument is spelling out any unstated premises. An argument with an unstated premise or conclusion is known as an **enthymeme.** Most of the arguments you will encounter will fall into that category.

Consider again the first three arguments. Each of them has an unstated premise. Spelling out the unstated premise, they become:

7. Only things made of flesh and blood can think. Computers are not made of flesh and blood. Therefore computers can't think.

8. You have no control over the neurons in your brain. If you have no control over the neurons in your brain, you have no control over anything you do. It follows that you have no control over anything you do.

9. Everybody does it. If everyone does it, I should be allowed to do it. So I should be allowed to do it, too.

Making explicit the implicit claims of an argument shows exactly what the argument is committed to. When filling in missing premises, it's important to be as fair as possible. You don't want to misrepresent the author's position. Since the purpose of identifying arguments is getting at the truth, the choice among different interpretations of an argument should be guided by the **principle of charity:** Choose that interpretation which makes the most sense from a logical point of view. By following that principle, you'll put the argument in the best possible light.

In the spider-web of facts, many a truth is strangled.
—Paul Eldridge

Arguments come in two basic varieties: deductive and inductive. Good deductive arguments differ from good inductive ones in that they are valid. In a **valid argument,** the conclusion logically follows from its premises. In other words, in a valid argument, it's logically impossible for the premises to be true and the conclusion false, because the conclusion expresses what is implied by the combination of premises. Consider, for example, this argument:

1. If all that exists is matter in motion, then there are no disembodied spirits.

2. All that exists is matter in motion.

3. Therefore, there are no immaterial spirits.

enthymeme An argument with an unstated premise or conclusion.

principle of charity Choose that interpretation of an argument which makes the most sense from a logical point of view.

valid argument A deductive argument in which it's logically impossible for the premises to be true and the conclusion false.

This argument is valid because if the premises are true, the conclusion must be true. There's no way that the premises can be true and the conclusion false. So deductive arguments are said to be "truth preserving" because the truth of their premises guarantees the truth of their conclusions.

Inductive arguments, on the other hand, are not truth preserving because the truth of their premises doesn't guarantee the truth of their conclusions. Consider, for example, this argument:

1. Every raven that has ever been observed has been black.

2. Therefore, every raven that ever will be observed will be black.

It's possible for the premise of this argument to be true and the conclusion false. Because we haven't observed every raven, we can't be sure that there isn't a nonblack raven somewhere. And because we can't observe the future,

we can't be sure that the future will resemble the past. So, unlike deductive arguments, which can establish their conclusions with certainty, inductive arguments can establish their conclusion with only a high degree of probability. A strong inductive argument is one that would establish its conclusion with a high degree of probability if its premises were true.

Deductive Arguments

Whether a deductive argument is valid depends on the form or structure of the argument. The form of an argument can be represented in many different ways, but one of the most effective is to substitute letters for the statements contained in the argument. Some statements are compound in that they contain other statements as constituents. To accurately represent the form of these statements, each constituent statement should be assigned a letter. For example, a conditional or if-then statement is compound because it contains at least two statements. To accurately represent the form of these statements, assign one letter to the statement following the "if" (known as the "antecedent"), and another to the statement following the "then" (known as the "consequent"). Using this method, four of the most common valid argument forms can be represented as follows.

Logic is the armory of reason, furnished with all offensive and defensive weapons.
—Thomas Fuller

Some Valid Argument Forms

Affirming the Antecedent (Modus Ponens)

> If p, then q.
> p.
> Therefore, q.

For example:

1. If the soul is immortal (p), then thinking doesn't depend on brain activity (q).
2. The soul is immortal (p).
3. Therefore, thinking doesn't depend on brain activity (q).

Denying the Consequent (Modus Tollens)

> If p, then q.
> Not q.
> Therefore, not p.

For example:

1. If the soul is immortal (p), then thinking doesn't depend on brain activity (q).
2. Thinking does depend on brain activity (not q).
3. Therefore, the soul is not immortal (not p).

Evidence and Inference **31**

> *Reason is man's instrument for arriving at the truth, intelligence is man's instrument for manipulating the world more successfully: the former is essentially human, the latter belongs to the animal part of man.*
>
> —Erich Fromm

Hypothetical Syllogism

If p, then q.

If q, then r.

Therefore, if p, then r.

For example:

1. If the Federal Reserve Board raises interest rates, it will be more difficult to borrow money.
2. If it's more difficult to borrow money, home sales will fall.
3. Therefore, if the Federal Reserve Board raises interest rates, home sales will fall.

Disjunctive Syllogism

Either p or q.

Not p.

Therefore, q.

For example:

1. Sally either walked or rode the bus.
2. She didn't walk.
3. Therefore, she rode the bus.

Because validity is a matter of form, any argument that exhibits any of these forms is valid, regardless of whether the statements it contains are true. So, to determine an argument's validity, it's not necessary to ascertain the truth of its premises.

To see this, consider this argument:

1. If one human is made of tin, then every human is made of tin.
2. One human is made of tin.
3. Therefore, every human is made of tin.

The premises and conclusion of this argument are false. Nevertheless, this argument is valid because *if* the premises were true, *then* the conclusion would be true. A valid argument can have false premises and a false conclusion, false premises and a true conclusion, or true premises and a true conclusion. The one thing it cannot have is true premises and a false conclusion.

Since the purpose of logic is to help us discover the truth, there must be more to being a good deductive argument than being valid. In addition, the premises must be true. When both conditions are met—when an argument is valid and its premises are true—the argument is said to be **sound.**

Only a sound argument provides a good reason for believing its conclusion. To determine whether you are justified in believing the conclusion of a deductive argument, then, you have to determine whether it's sound.

sound argument A valid deductive argument that contains only true premises.

This involves three steps: (1) identifying the premises and conclusion, (2) determining whether the argument is valid, and (3) determining whether the premises are true. If the argument is not valid, there is no reason to proceed to step 3, for in that case, the conclusion doesn't follow from the premises.

There are many valid argument forms, and it is not feasible to memorize them all. But once you have ascertained the form of an argument, you can test it for validity by determining whether there is another argument with the same form that would allow the premises to be true and the conclusion false. If so, the argument is invalid. Such an interpretation serves as a counter-example to the claim that the argument is valid.

Some Invalid Argument Forms

Affirming the Consequent

If p, then q.

q.

Therefore, p.

Let's test this argument form for validity by substituting the sentence "Chicago is the capital of Illinois" for p and "Chicago is in Illinois" for q. Then we have:

1. If Chicago is the capital of Illinois (p), then Chicago is in Illinois (q).
2. Chicago is in Illinois (q).
3. Therefore, Chicago is the capital of Illinois (p).

Clearly, this argument is invalid. In a valid argument, you will recall, it's impossible for the premises to be true and the conclusion false. But in this case, both of the premises are true and the conclusion is false. So any argument with this form does not provide a good reason for accepting its conclusion.

Here's another type of argument you may come across:

Denying the Antecedent

If p, then q.

Not p.

Therefore, not q.

Can you imagine any situation in which the premises are true and the conclusion false? Suppose we substitute "Joe is a bachelor" for p, and "Joe is a male" for q. Then we get:

1. If Joe is a bachelor (p), then Joe is a male (q).
2. Joe is not a bachelor (not p).
3. Therefore, Joe is not a male (not q).

This argument is also invalid because it's possible for the premises to be true and the conclusion false. So anyone who uses this form of reasoning—no matter what statements they use in the place of p or q—has not proved their point.

Affirming a Disjunct

> Either p or q.
>
> p.
>
> Therefore, not q.

In logic, the word "or" is usually understood inclusively. In the inclusive sense, a statement of the form p or q is true whenever p or q *or both* are true. The word "or" can also be understood exclusively, however. In the exclusive sense, a statement of the form p or q is true whenever p or q *but not both* are true. The fallacy of affirming a disjunct occurs when an inclusive or is interpreted exclusively. For example:

1. Either the car battery is dead or the car is out of gas.
2. The car battery is dead.
3. Therefore, the car is not out of gas.

This argument is invalid because it's possible for both disjuncts to be true: The car could have a dead battery and be out of gas at the same time. Consequently, from the fact that one is true, we cannot validly conclude that the other is not true.

Inductive Arguments

All truths are easy to understand once they are discovered; the point is to discover them.
—Galileo Galilei

Even though inductive arguments are not valid, they can still give us good reasons for believing their conclusions, provided that certain conditions are met. An inductive argument that would establish its conclusion with a high degree of probability if its premises were true is known as a **strong argument.** A strong inductive argument with true premises is known as a **cogent argument.** To get a better idea of what constitutes a strong inductive argument, let's examine some common forms of induction.

strong argument An inductive argument that would establish its conclusion with a high degree of probability if its premises were true.

cogent argument A strong inductive argument that contains only true premises.

Enumerative Induction

Enumerative induction is the sort of reasoning we use when we arrive at a generalization about a group of things after observing only some members of that group. The premise of a typical enumerative induction is a statement reporting what percentage of the observed members of a group have a particular property. The conclusion is a statement claiming that a certain percentage of the members of the whole group have that property. Enumerative induction, then, has the following form:

1. X percent of the observed members of A are B.
2. Therefore, X percent of the entire group of A are B.

For example, suppose you use enumerative induction to argue from the observation that 54 percent of the students in your college are female to the conclusion that 54 percent of all college students are female. This would be a strong argument only if your sample were sufficiently large and sufficiently representative of the entire group of college students. A sample is considered representative of a group when every member of the group has an equal chance to be part of the sample. If your sample consisted of those students attending a small, select engineering school, then your argument would not be very strong because your sample would be too limited and unrepresentative. But if your sample consisted of those students attending a large state university with a national reputation, your argument would be stronger because your sample would be larger and more representative.

Analogical Induction

When we show how one thing is similar to another, we draw an analogy between them. When we claim that two things that are similar in some respects are similar in some further respect, we make an analogical induction. For example, prior to the various missions to Mars, NASA scientists may have argued as follows: Earth has air, water, and life. Mars is like Earth in that it has air and water. Therefore, it's probable that Mars has life. The form of such analogical inductions can be represented as follows:

1. Object A has properties F, G, H, and so on, as well as the property Z.
2. Object B has properties F, G, H, and so on.
3. Therefore, object B probably has property Z.

Like all inductive arguments, analogical inductions can only establish their conclusions with a certain degree of probability. The more similarities between the two objects, the more probable the conclusion. The fewer similarities, the less probable the conclusion.

The dissimilarities between Earth and Mars are significant. The Martian atmosphere is very thin and contains very little oxygen, and the water on Mars is trapped in ice caps at the poles. So the probability of finding life on Mars is not very high. Mars was more like Earth in the past, however. So the probability of finding evidence of past life on Mars is greater.

NASA scientists are not the only ones who make analogical inductions. This kind of reasoning is used in many other fields, including medical research and law. Whenever medical researchers test a new drug on laboratory animals, they are making an analogical induction. Essentially, they are arguing that if this drug has a certain effect on the animals, then it's probable that it will have the same sort of effect on human beings. The strength of such arguments depends on the biological similarities between the animals and humans. Rats, rabbits, and guinea pigs are often used in these kinds of experiments. Although they are all mammals, their biology is by no means identical

to ours. So we cannot be certain that any particular drug will affect us in the same way that it affects them.

The American legal system is based on precedents. A precedent is a case that has already been decided. Lawyers often try to convince judges of the merits of their case by citing precedents. They argue that the case before the court is similar to one that has been decided in the past, and since the court decided one way in that case, it should decide the same way in this case. The opposing attorney will try to undermine that reasoning by highlighting the differences between the case cited and the current case. Which side wins such court cases is often determined by the strength of the analogical arguments presented.

Hypothetical Induction (Abduction, Inference to the Best Explanation)

We attempt to understand the world by constructing explanations of it. Not all explanations are equally good, however. So even though we may have arrived at an explanation of something, it doesn't mean that we're justified in believing it. If other explanations are better, then we're not justified in believing it.

Inference to the best explanation has the following form:

1. Phenomenon p.
2. If hypothesis h were true, it would provide the best explanation of p.
3. Therefore, it's probable that h is true.

The American philosopher Charles Sanders Peirce was the first to codify this kind of inference, and he dubbed it "abduction" to distinguish it from other forms of induction.

Inference to the best explanation may be the most widely used form of inference. Doctors, auto mechanics, and detectives (as well as you and I) use it almost daily. Anyone who tries to figure out why something happened uses inference to the best explanation. Sherlock Holmes was a master of inference to the best explanation. Here's Holmes at work in *A Study in Scarlet*:

> I knew you came from Afghanistan. From long habit the train of thoughts ran so swiftly through my mind that I arrived at the conclusion without being conscious of intermediate steps. There were such steps, however. The train of reasoning ran, 'Here is a gentleman of a medical type, but with the air of a military man. Clearly an army doctor, then. He has just come from the tropics, for his face is dark, and that is not the natural tint of his skin, for his wrists are fair. He has undergone hardship and sickness, as his haggard face says clearly. His left arm has been injured. He holds it in a stiff and unnatural manner. Where in the tropics would an English army doctor have seen much hardship and got his arm wounded? Clearly in Afghanistan.' The whole train of thought did not occupy a second. I then remarked that you came from Afghanistan, and you were astonished.[18]

Although this passage appears in a chapter entitled "The Science of Deduction," Holmes is not using deduction here, because the truth of the premises does not guarantee the truth of the conclusion. From the fact that Watson has a deep tan and a wounded arm, it doesn't necessarily follow that he has been in Afghanistan. He could have been in California and cut himself surfing. Properly speaking, Holmes is using abduction, or inference to the best explanation, because he arrives at his conclusion by citing a number of facts and coming up with the hypothesis that best explains them.

Often what makes inference to the best explanation difficult is not that no explanation can be found, but that too many can be found. The trick is to identify which among all the possible explanations is the best. The goodness of an explanation is determined by the amount of understanding it produces, and that is determined by how well it systematizes and unifies our knowledge. We begin to understand something when we see it as part of a pattern, and the more that pattern encompasses, the more understanding it produces. The extent to which a hypothesis systematizes and unifies our knowledge can be measured by various **criteria of adequacy,** such as *consistency*, both internal and external; *simplicity*, the number of assumptions made by a hypothesis; *scope*, the amount of diverse phenomena explained by the hypothesis; *conservatism*, how well the hypothesis fits with what we already know; and *fruitfulness*, the ability of a hypothesis to successfully predict novel phenomena. Let's take a closer look at how these criteria are used to evaluate hypotheses.

The first requirement of any adequate hypothesis is *consistency*. Not only must an adequate hypothesis be internally consistent—consistent with itself—but it must also be externally consistent—consistent with the data it is supposed to explain. If a hypothesis is internally inconsistent—if it's self-contradictory—it can't possibly be true. Thus one of the most effective ways to refute a theory is to show that it harbors a contradiction. (This technique, you will recall, is the one that Socrates used against Euthyphro.) If a hypothesis is externally inconsistent—if it's inconsistent with the data it's supposed to explain—there's reason to believe that it's false. The data, of course, could be mistaken, but until we know that, we shouldn't accept the theory.

Other things being equal, the *simpler* a hypothesis is—the fewer assumptions it makes—the better it is. If phenomena can be explained without making certain assumptions, there's no reason to make them. So a theory that makes unnecessary assumptions is unreasonable. Medieval philosopher William of Occam put the point this way: "Entities should not be multiplied beyond necessity." In other words, you shouldn't assume the existence of anything that's not needed to explain the phenomena. This principle has come to be known as "Occam's razor" because it's used to shave off unneeded entities from theories. (This principle, which is also known as "the principle of parsimony," looms large in Carl Sagan's book and movie entitled *Contact*.)

Scope—the amount of diverse phenomena explained by a theory—is also an important consideration in theory evaluation. If two theories do equally well with respect to the other criteria of adequacy but one has more scope, it's clearly the better theory, for it has greater explanatory power.

Conservatism—the quality of fitting well with existing theories—is a mark of a good theory because if accepting a theory requires rejecting a good deal

criteria of adequacy
The features that distinguish a good theory from a bad one: consistency (lack of contradictions), simplicity (quality of relying on only a small number of assumptions), scope (the amount of diverse phenomena explained), conservatism (quality of fitting well with existing theories), and fruitfulness (the number of new facts predicted or problems solved).

of what we've already established, then it may diminish our understanding. Instead of systematizing and unifying our knowledge, it may fragment it. A theory can make up in scope and simplicity what it lacks in conservatism, however. In that case, it may be worthy of acceptance.

In science, *fruitfulness* is determined by the number of successful, novel predictions a theory makes. In philosophy, it's determined by the number of problems it solves. In both cases, it's evidence for the truth of the hypothesis because the best explanation of the fact that a theory makes a successful, novel prediction or solves problems is that it's true.

Unfortunately, there is no formula for applying the criteria of adequacy. We can't quantify how well a hypothesis does with respect to any particular criterion, nor can we rank the criteria in order of importance. At times, we may rate conservatism more highly than scope, especially if the hypothesis in question is lacking in fruitfulness. At other times, we may rate simplicity higher than conservatism, especially if the hypothesis has at least as much scope as any other hypothesis. Choosing among theories isn't the purely logical process it is often made out to be. Like judicial decision making, it relies on factors of human judgment that resist formalization.

This doesn't mean that the process of theory selection is subjective, however. There are many distinctions we can't quantify that are nevertheless perfectly objective. The point at which day turns into night or a hirsute person becomes bald can't be precisely specified. But the distinctions between night and day or baldness and hirsuteness are as objective as they come. There are certainly borderline cases about which reasonable people can disagree, but there are also clear-cut cases where disagreement would be irrational. It would simply be wrong to believe that a person with a full head of (living) hair is bald. It would be equally wrong to believe that a theory that does not meet the criteria of adequacy as well as its competitors is the better theory.

Informal Fallacies

> When dealing with people, let us remember we are not dealing with creatures of logic. We are dealing with creatures of emotion, creatures bustling with prejudices and motivated by pride and vanity.
>
> —DALE CARNEGIE

When we give reasons for accepting a claim, we are making an argument. If the premises are acceptable, and if they adequately support the conclusion, then our argument is a good one. If not—if the premises are dubious, or if they do not justify the conclusion—then our argument is fallacious. A fallacious argument is a bogus one, for it fails to do what it purports to do: provide a good reason for accepting a claim. Unfortunately, logically fallacious arguments can be psychologically compelling. Because most people have never learned the difference between a good argument and a fallacious one, they are often persuaded to believe things for no good reason. To avoid holding irrational beliefs, then, it is important to understand the ways in which an argument can fail.

An argument is fallacious if it contains (1) unacceptable premises, (2) irrelevant premises, or (3) insufficient premises.[19] Premises are unacceptable if they are at least as dubious as the claim they are supposed to support. In a good argument, the premises provide a firm basis for accepting the conclusion. If the premises are shaky, the argument is inconclusive. Premises are

irrelevant if they have no bearing on the truth of the conclusion. In a good argument, the conclusion follows from the premises. If the premises are logically unrelated to the conclusion, they provide no reason to accept it. Premises are insufficient if they do not establish the conclusion beyond a reasonable doubt. In a good argument, the premises eliminate reasonable grounds for doubt. If they fail to do this, they don't justify the conclusion. So when someone gives you an argument, you should ask yourself, Are the premises acceptable? Are they relevant? Are they sufficient? If the answer to any of these questions is no, then the argument is not logically compelling.

Unacceptable Premises

Begging the Question An argument begs the question—or argues in a circle—when its conclusion is used as one of its premises. For example, "Jane has telepathy," says Susan. "How do you know?" asks Jill. "Because she can read my mind," replies Susan. Since telepathy is, by definition, the ability to read someone's mind, all Susan has told us is that she believes that Jane can read her mind because she believes that Jane can read her mind. Her reason merely reiterates her claim. Consequently, her reason provides no additional justification for her claim.

False Dilemma An argument proposes a false dilemma when it presumes that only two alternatives exist when in actuality there are more than two. For example: "Either science can explain how she was cured or it was a miracle. Science can't explain how she was cured. So it must be a miracle." These two alternatives do not exhaust all the possibilities. It's possible, for example, that she was cured by some natural cause that scientists don't yet understand. Because the argument doesn't take this possibility into account, it's fallacious.

Irrelevant Premises

Equivocation Equivocation occurs when a word is used in two different senses in an argument. For example, consider this argument: "(i) Only man is rational. (ii) No woman is a man. (iii) Therefore no woman is rational." The word "man" is used in two different senses here: In the first premise, it means human being; in the second, it means male. As a result, the conclusion doesn't follow from the premises.

Composition An argument may claim that what is true of the parts is also true of the whole; this is the fallacy of composition. For example, consider this argument: "Subatomic particles are lifeless. Therefore anything made out of them is lifeless." This argument is fallacious because a whole may be greater than the sum of its parts; that is, it may have properties not possessed by its parts.

Division The fallacy of division is the converse of the fallacy of composition. It occurs when one assumes that what is true of a whole is also true of its parts. For example: "We are alive and we are made out of subatomic

particles. So they must be alive too." To argue in this way is to ignore the very real difference between parts and wholes.

Argument against the Person When someone tries to rebut an argument by criticizing or denigrating its presenter rather than by dealing with the issues it raises, that person is guilty of the fallacy of argument against the person. This fallacy is referred to as *ad hominem,* or "to the man." For example: "This theory has been proposed by a believer in the occult. Why should we take it seriously?" Or: "You can't believe Dr. Jones's claim that there is no evidence for life after death. After all, he's an atheist." The flaw in these arguments is obvious: An argument stands or falls on its own merits; who proposes it is irrelevant to its soundness. Crazy people can come up with perfectly sound arguments, and sane people can talk nonsense.

Genetic Fallacy To argue that a claim is true or false on the basis of its origin is to commit the genetic fallacy. For example: "Jones's idea is the result of a mystical experience, so it must be false (or true)." Or: "Jane got that message from a Ouija board, so it must be false (or true)." These arguments are fallacious because the origin of a claim is irrelevant to its truth or falsity.

Appeal to Unqualified Authority We often try to support our views by citing experts. This sort of appeal to authority is perfectly valid, provided that the person cited really is an expert in the field in question. If not, it is fallacious. Celebrity endorsements often involve fallacious appeals to authority because being famous doesn't necessarily give you any special expertise. The fact that Dionne Warwick is a great singer, for example, doesn't make her an expert on the efficacy of psychic hotlines.

Appeal to the Masses A remarkably common but fallacious form of reasoning is, "It must be true (or good) because everybody believes it (or does it)." Mothers understand that this is a fallacy; they often counter this argument by asking, "If everyone jumped off a cliff, would you do it too?" Of course you wouldn't. What this shows is that just because a lot of people believe something or like something doesn't mean that it's true or good. A lot of people used to believe that the Earth was flat, but that certainly didn't make it so. Similarly, a lot of people used to believe that women should not have the right to vote. Popularity is not a reliable indication of either reality or value.

Appeal to Tradition We appeal to tradition when we argue that something must be true (or good) because it is part of an established tradition. For example: "Astrology has been around for ages, so there must be something to it." Or: "Mothers have always used chicken soup to fight colds, so it must be good for you." These arguments are fallacious because traditions can be wrong. This becomes obvious when you consider that slavery was once an established tradition. The fact that people have always done or believed something is no reason for believing that we should continue to do or believe something.

Appeal to Ignorance The appeal to ignorance comes in two varieties: using an opponent's inability to disprove a conclusion as proof of the conclusion's correctness, and using an opponent's inability to prove a conclusion as

proof of its incorrectness. In the first case, the claim is that since there is no proof that something is true, it must be false. For example: "There is no proof that the parapsychology experiments were fraudulent, so I'm sure they weren't." In the second case, the claim is that since there is no proof that something is false, it must be true. For example: "Bigfoot must exist because no one has been able to prove that he doesn't." The problem with these arguments is that they take a lack of evidence for one thing to be good evidence for another. A lack of evidence, however, proves nothing. In logic, as in life, you can't get something for nothing.

Appeal to Fear To use the threat of harm to advance one's position is to commit the fallacy of the appeal to fear. It is also known as "swinging the big stick." For example: "If you do not convict this criminal, one of you may be her next victim." This is fallacious because what a defendant might do in the future is irrelevant to determining whether she is responsible for a crime committed in the past. Threats extort; they do not help us arrive at the truth.

Insufficient Premises

Hasty Generalization You are guilty of hasty generalization or jumping to conclusions when you draw a general conclusion about all things of a certain type on the basis of evidence concerning only a few things of that type. For example: "Every medium that's been investigated has turned out to be a fraud. You can't trust any of them." Or: "I know one of those psychics. They're all a bunch of phonies." You can't make a valid generalization about an entire class of things from observing only one or even a number of them. An inference from a sample of a group to the whole group is legitimate only if the sample is representative—that is, only if the sample is sufficiently large and every member of the group has an equal chance to be part of the sample.

Fallacies do not cease to be fallacies because they become fashions.
—G. K. CHESTERTON

Faulty Analogy An argument from analogy claims that things that resemble one another in certain respects resemble one another in further respects. For example: "Earth has air, water, and living organisms. Mars has air and water. Therefore Mars has living organisms." The success of such arguments depends on the nature and extent of the similarities between the two objects. The greater their dissimilarities, the less convincing the argument will be. For example, consider this argument: "Astronauts wear helmets and fly in spaceships. The figure in this Mayan carving seems to be wearing a helmet and flying in a spaceship. Therefore it is a carving of an ancient astronaut." Although features of the carving may bear a resemblance to a helmet and spaceship, they may bear a greater resemblance to a ceremonial mask and fire. The problem is that any two things may have some features in common. Consequently, an argument from analogy can be successful only if the dissimilarities between the things being compared are insignificant.

False Cause The fallacy of false cause consists of supposing that two events are causally connected when they are not. People often claim, for example,

that because something occurred after something else, it is caused by it. Latin scholars dubbed this the fallacy of *post hoc, ergo propter hoc,* which means "After this, therefore because of this." Such reasoning is fallacious because from the fact that two events are constantly conjoined, it doesn't follow that they are causally related. Night follows day, but that doesn't mean that day causes night.

Summary

Arguments come in two basic varieties: deductive and inductive. In a valid deductive argument, it's impossible for the premises to be true and the conclusion false. A deductive argument is sound if it's valid and its premises are true. In a strong inductive argument, it's improbable for the premises to be true and the conclusion false. An inductive argument is cogent if it's strong and its premises are true.

Hypothetical induction, or inference to the best explanation, is one of the most common inductive arguments. The goodness of an explanation is determined by how much understanding it produces, and the amount of understanding produced by an explanation is determined by how well it systematizes and unifies our knowledge. The extent to which a hypothesis accomplishes this goal can be measured by various criteria of adequacy, such as consistency, simplicity, scope, conservatism, and fruitfulness.

Study Questions

1. What is the difference between deductive and inductive arguments?
2. What is a valid deductive argument?
3. What is a sound deductive argument?
4. What is a strong inductive argument?
5. What is a cogent inductive argument?
6. What is the logical form of affirming the antecedent, denying the consequent, hypothetical syllogism, disjunctive syllogism, affirming the consequent, denying the antecedent?
7. What is the logical form of enumerative induction, analogical induction, hypothetical induction?
8. What are the criteria of adequacy for good explanations?
9. What are informal fallacies?

Discussion Questions

Determine whether the following deductive arguments are valid or invalid, and, if valid, whether they are sound or unsound.

1. If it rained, the streets are wet. The streets are wet. So it must have rained.

2. If Richard Roe is willing to testify, then he's innocent. But he's not willing to testify. Therefore he's not innocent.

3. If Bogotá is north of New Orleans, and New Orleans is north of Mexico City, then Bogotá is north of Mexico City. Bogotá is not north of New Orleans. Therefore Bogotá is not north of Mexico City.

Determine whether the following inductive arguments are strong or weak, and, if strong, whether they are cogent or uncogent.

4. Every day you've lived has been followed by another day in which you have been alive. Therefore every day you ever will live will be followed by another day in which you are alive. (You will live forever.)

5. Every day you've lived has been a day before tomorrow. Therefore every day you ever will live will be a day before tomorrow. (You will die tonight.)

6. Almost every Mummers Parade has been held in freezing weather. Therefore, probably, this year's Mummers Parade will be held in freezing weather.

7. A recent Roper poll found that a significant number of Americans have woken up paralyzed, lost time, seen inexplicable lights, found puzzling scars on their bodies, and felt as if they were flying. So a significant number of Americans must have been abducted by aliens.

Identify the informal fallacy committed in the following arguments.

8. Nobel Prize winner Linus Pauling says we should take massive doses of vitamin C every day. Therefore massive doses of vitamin C must be good for you.

9. Quartz crystals cure colds because after I wore a quartz crystal around my neck, my cold went away.

10. Society's interest in the occult is growing. Therefore Joe's interest in the occult is growing.

11. Either we're going to lose the war on terrorism or we'll have to give up some of our civil liberties.

Internet Inquiries

1. How logical are you? To find out, play the "Elementary, My Dear Wason" game at *The Philosophers' Magazine* Web site: **http://www.philosophyexperiments.com/wason/Default.aspx**.

2. How good at probability are you? To find out, play the "Urn a Red Ball" game at *The Philosophers' Magazine* Web site: **http://www.philosophyexperiments.com/balls/Default.aspx**.

3. Find at least five examples of fallacious arguments by searching blogs, editorials, articles, and so on. Identify the fallacy that each commits.

Section 1.3

The Laboratory of the Mind
Thought Experiments

> *Philosophy is the microscope of thought.*
> —Victor Hugo

Philosophical theories usually identify necessary or sufficient conditions for the application of a concept. Thought experiments test such theories by determining whether the conditions identified are necessary or sufficient. Remember, if it's possible for a concept to apply without a condition being met, then that condition is not necessary for the application of the concept. Conversely, if it's possible for a condition to be met without the concepts applying, then that condition is not sufficient for the application of the concept. **Thought experiments** describe possible situations in which a concept should apply or a condition should be met. If it turns out that the concept doesn't apply or the condition isn't met, then there's reason to believe that the theory is mistaken. To see how this works, let's put Aristotle's theory of human beings to the test.

The first step of the Socratic Method, you will recall, is to identify a problem or pose a question. The question that Aristotle is trying to answer is: What makes something a human being? The second step is to propose a hypothesis that solves the problem or answers the question. Aristotle's hypothesis is that human beings are rational animals. The third step is to derive a **test implication**. A test implication is a conditional, or if-then, statement indicating what should be the case if the theory is true. To derive a test implication, you have to ask yourself questions like: What if this theory were true? What does it imply? What is it committed to? After considering such questions, you might come up with the following test implication: If human beings are rational animals, then human infants are rational animals.

The fourth step is to perform the test—examine the situation in your mind, and see whether the implication holds. If it doesn't, then the situation serves as a **counterexample** to the hypothesis. A counterexample is an example that runs counter to or conflicts with the theory. It suggests that the theory is mistaken and should be rejected or revised. Does the implication hold in this case? It wouldn't seem so. Human infants are not rational animals because

thought experiment The description of a possible situation in which a concept should apply or a condition should be met if the theory in question is true.

test implication A conditional or if-then statement indicating what should be the case if the theory is true.

counterexample An example that runs counter to or conflicts with a theory.

they do not know how to reason. Thus human infants are a counterexample to Aristotle's theory. So we need to either reject Aristotle's theory or go back to step 2 and revise it. In this case, it looks like Aristotle's theory can be saved with only a minor correction. We could revise it to read that human beings are animals with the capacity to reason. This would take care of the infant counterexample because although infants can't reason, they have the capacity to reason (given time). To assess this new theory, we need to go through the process of deriving a test implication and performing a test.

Every thought experiment is part of an argument that usually has the form of denying the consequent or affirming the antecedent. In this case, the form of the argument is denying the consequent. It goes like this:

1. If human beings are rational animals, then human infants must be rational animals.
2. But human infants aren't rational animals.
3. Therefore it's not necessarily true that human beings are rational animals.

This is a deductively valid argument—if the premises are true, the conclusion must be true.

Human infants are a counterexample to Aristotle's theory because they're human beings that are not rational animals. What they show is that being a rational animal is not a necessary condition for being a human being. To refute a universal generalization like all human beings are rational animals, all you need to show is that there is at least one human being that is not a rational animal. Similarly, all you need to show to refute the claim that all ravens are black is that there is at least one nonblack raven.

The most difficult part of performing a thought experiment is deriving the test implication, because there is no formula for deriving one. Inventing a thought experiment involves a creative leap of the imagination that cannot be dictated by a set of formal rules. German philosopher Edmund Husserl called thought experiments "free fancies" because the situations involved are often produced by the free play of the imagination. But even though thought experiments can be fanciful, they are not frivolous, for as Husserl recognized, "fiction is the source from which the knowledge of 'eternal truths' draws its sustenance."[20] To determine whether a conceptual claim is true, we have to determine whether it holds in all conceivable situations. And to determine that, we have to go beyond the actual to the possible.

Thought experiments, like physical experiments, can perform many functions. In addition to refuting a theory (by showing that a condition is not necessary or sufficient), they can also confirm a theory by showing that a condition is necessary or sufficient. By demonstrating the possibility or impossibility of something, they help explain the logical relations among concepts. The improved conceptual understanding they give us often aids in the construction of new theories. As philosophers Lewis White Beck and Robert L. Holmes note, "Thinking is a process of learning by trial and error in which the trials and error are not made in overt bodily behavior, but in imagination."[21] Performing thought experiments is the essence of human thinking and the wellspring of human creativity. The better you get at evaluating and constructing thought experiments, the better thinker you will become.

> The true method of discovery is like the flight of an aeroplane. It starts from the ground of particular observation; it makes a flight in the thin air of imaginative generalization; and it again lands for renewed observation rendered acute by rational interpretation.
> —ALFRED NORTH WHITEHEAD

The Laboratory of the Mind 45

Thought Probe

Platonic Humans

Plato once defined human beings as "two-legged featherless animals." Is this a good hypothesis concerning the nature of human beings? Put Plato's theory to the test by using the Socratic Method.

Philosophical inquiry is not just idle, abstract speculation. Sometimes it has concrete, practical applications. It can even be a matter of life and death. To see this, let's consider a variant of the problem Aristotle was addressing: "What makes something a person?" Understanding the concept of a person will be important to solving a number of philosophical problems we will encounter later in the text.

Case Study: Explaining How Moral Abortions Are Possible

> *In religion and politics people's beliefs and convictions are in almost every case gotten at second-hand, and without examination, from authorities who have not themselves examined the questions at issue but have taken them at second-hand from other nonexaminers, whose opinions about them were not worth a brass farthing.*
>
> —MARK TWAIN

Many people believe that, in certain circumstances, abortion is morally permissible. But abortion seems to involve the intentional killing of an innocent human being, and such an act is usually considered murder. So those who believe that abortion is morally permissible need to explain how it is possible for abortion not to be murder.

Murder is wrong because it violates our rights, specifically our right to life. But what is it about us that gives us a right to life? Why is it murder to intentionally kill an innocent human being but not a cow, a pig, or a chicken? What do we have that gives us our special moral status? Is it something about our physiology? Are we morally superior to these animals because we have an opposable thumb? Because we lack fur or feathers or hoofs? Because we have 46 chromosomes? This was the issue that Mary Anne Warren set out to investigate in her article "On the Moral and Legal Status of Abortion."[22]

In ethics, a being with full moral status—and thus full moral rights—is called a person. The question is, Are all and only human beings persons? In other words, is being a biological human being a necessary and sufficient condition for being a person? To determine whether it is, Warren proposed the following thought experiment.

Thought Experiment

Warren's Moral Space Traveler

What characteristics entitle an entity to be considered a person? . . . In searching for such criteria, it is useful to look beyond the set of people with whom we are acquainted, and ask how we would decide whether a totally alien being was a person or not. . . . Imagine a space traveler who lands on an unknown planet

and encounters a race of beings utterly unlike any he has ever seen or heard of. If he wants to be sure of behaving morally toward these beings, he has to somehow decide whether they are people, and hence have full moral rights, or whether they are the sort of thing which he need not feel guilty about treating as, for example, a source of food. How should he go about making this decision? . . .

I suggest that the traits which are most central to the concept of personhood, or humanity in the moral sense, are, very roughly, the following:

1. consciousness (of objects and events external and/or internal to the being, and in particular the capacity to feel pain);
2. reasoning (the developed capacity to solve new and relatively complex problems);
3. self-motivated activity (activity which is relatively independent of either genetic or direct external control);
4. the capacity to communicate, by whatever means, messages of an indefinite variety of types, that is, not just with an indefinite number of possible contents, but on indefinitely many possible topics;
5. the presence of self-concepts, and self-awareness, either individual or racial, or both. . . .

We needn't suppose that an entity must have all of these attributes to be properly considered a person. (1) and (2) alone may well be sufficient for personhood, and quite probably (1)–(3) are sufficient. Neither do we need to insist that any one of these criteria is necessary for personhood, although once again (1) and (2) look like fairly good candidates for necessary conditions, as does (3), if "activity" is construed so as to include the activity of reasoning.[23]

If being a human were a necessary condition for being a person, it would be impossible for a nonhuman to be a person. But as Warren's thought experiment shows, it's not impossible for a nonhuman to be a person, for the notion of a nonhuman person doesn't involve a logical contradiction. According to

Everything that is possible to be believed is an image of the truth.
—WILLIAM BLAKE

ENCOUNTERING ALIENS
If you encountered alien creatures, what tests would you use to determine whether they are persons?

Warren, what gives us our special moral status isn't the stuff out of which we are made, but rather what we can do with that stuff. So being a human being is neither a necessary nor a sufficient condition for being a person.

Remember, a logically necessary condition is one that something cannot possibly do without. So even if every person who ever has existed or ever will exist is human, it doesn't follow that being a human is a logically necessary condition for being a person. A possibility may be real even if it is never realized. To show that a condition isn't logically necessary for something, you have only to show that it's logically possible for the thing to exist without it.

Mary Anne Warren wasn't the first person to recognize that the concept of a person and the concept of a human being aren't the same. English philosopher John Locke realized this more than three hundred years ago. He writes, ". . . we must consider what Person stands for; which I think, is a thinking intelligent Being, that has reason and reflection, and can consider it self as it self. . . ."[24] Locke also uses a thought experiment to demonstrate that persons need not be humans. Instead of appealing to the possibility of intelligent aliens, however, Locke appeals to the possibility of an intelligent parrot. It seems that a certain Sir William Temple wrote in his memoirs of a parrot in Brazil that "spoke, and asked, and answered common Questions like a reasonable Creature. . . ."[25] If there really were such a parrot, Locke argued, and if it really did possess reason and reflection, then it would be a person even though it wasn't a human being.

> *Once you have eliminated the impossible, whatever remains, however improbable, must be the truth.*
>
> —SIR ARTHUR CONAN DOYLE

The notion that not all persons are human beings is one that is widely held but little recognized. Most Christians, for example, take God to be a person. But few would claim that God is a biological human being. As English philosopher Richard Swinburne puts it, "That God is a person, yet one without a body, seems the most elementary claim of theism."[26] So the distinction between persons and human beings is by no means a novel one.

From her analysis of the concept of a person, Warren draws the following conclusion about the moral status of the fetus:

> All we need to claim, to demonstrate that a fetus isn't a person, is that any being which satisfies none of (1)–(5) is certainly not a person. I consider this claim to be so obvious that I think anyone who denied it and claimed that a being which satisfied none of (1)–(5) was a person all the same, would thereby demonstrate that he had no notion at all of what a person is—perhaps because he had confused the concept of a person with that of genetic humanity. . . .
>
> Furthermore, I think that on reflection even the antiabortionists ought to agree not only that (1)–(5) are central to the concept of personhood, but also that it is part of this concept that all and only people have full moral rights. . . .[27]

The question we began with was, How is it possible for abortion not to be murder? Warren provides the following answer: It is possible for abortion not to be murder because only persons can be murdered and fetuses are not persons. In Warren's view, abortion doesn't violate a fetus's right to life because a fetus isn't the sort of thing that can have a right to life.

The realization that persons need not be humans and that humans need not be persons has important implications for our beliefs in other areas, as Warren notes:

Now if (1)–(5) are indeed the primary criteria of personhood, then it is clear that genetic humanity is neither necessary nor sufficient for establishing that an entity is a person. Some human beings are not people, and there may well be people who are not human beings. A man or woman whose consciousness has been permanently obliterated but who remains alive is a human being which is no longer a person; defective human beings, with no appreciable mental capacity, are not and presumably never will be people; and a fetus is a human being which isn't yet a person, and which therefore can't coherently be said to have full moral rights. Citizens of the next century should be prepared to recognize highly advanced, self-aware robots or computers, should such be developed, and intelligent inhabitants of other worlds, should such be found, as people in the fullest sense, and to respect their moral rights. But to ascribe full moral rights to an entity which is not a person is as absurd as to ascribe moral obligations and responsibilities to such an entity.[28]

What makes something a person is what it can do, not what it's made of. So if a biological human being can no longer feel, think, move, communicate, or be aware of itself and its surroundings—if it's brain dead, for example—it's no longer a person. Conversely, if something can do all of those things, then it's a person even if it's made out of something besides flesh and blood. Since something's moral status is determined by these capabilities, Warren claims we should be prepared to recognize the rights of nonhuman persons, whether they come from outer space or from the labs of computer scientists.

Thought Probe

Nonhuman Persons

Being a biological human being is neither a necessary nor a sufficient condition for being a person. It's not necessary because something can be a person without being a biological human being, for example, God. It's not sufficient because something can be a biological human being without being a person, for example, someone in a permanent vegetative state. Since personhood is determined by what something can do rather than how it's made, some believe that we are not the only persons on the planet. Dolphins, for example, are conscious and self-aware and can reason and communicate at a level that rivals our own. Consequently, some scientists think that dolphins should be considered nonhuman persons. As Dr. Thomas White, author of *In Defense of Dolphins: The New Moral Frontier*, reveals:

> . . . the discoveries of marine mammal scientists over the last 50 years have made it clear that whales and dolphins share traits once believed to be unique to humans: self-awareness, abstract thought, the ability to solve problems by planning ahead, understanding such linguistically sophisticated concepts as syntax and the formation of cultural communities. The scientific evidence is so strong for the intellectual and emotional sophistication of dolphins that there simply is no question that they are "nonhuman persons" who deserve respect as individuals.[29]

India's Ministry of Environment and Forests agrees. In a 2013 policy statement, they declared:

> Whereas cetaceans in general are highly intelligent and sensitive, and various scientists who have researched dolphin behavior have suggested that the unusually high intelligence as compared to other animals means that dolphins should be seen as "non-human persons" and as such should have their own specific rights and it is morally unacceptable to keep them captive for entertainment purposes.[30]

It is not only biological creatures that have been declared nonhuman persons, however. Recently, Saudi Arabia granted Sophia, a robot created by Hanson Robotics, citizenship.[31] Whether Sophia meets enough of Warren's criteria to be considered a person is debatable. But robot persons are something we may have to deal with in the not too distant future. In anticipation of the discrimination such robots will undoubtedly face, some Americans have already formed "The American Society for the Prevention of Cruelty to Robots." Their position is this:

> Should robots reach the level of self-awareness and show genuine intelligence, we must be prepared to treat them as sentient beings, and respect their desires, wants and needs as we respect those things in our human society.
>
> Failure to recognize and grant these rights to nonhuman artificial intelligences would be similar to early western cultures' failure to recognize the humanity and attendant rights of non-European peoples. Outward differences in appearances should in no way affect our ethical treatment of self-aware, intelligent beings.[32] (http://www.aspcr.com/newcss_rights.html)

Some believe that the battle for animal rights and robot rights will be to the twenty-first century what the battle for women's rights and human rights were to the twentieth. Do you agree? Do you think that by the end of the century, there will be a general consensus that certain animals and robots should be given the same sorts of rights that we enjoy? Why or why not?

How Are Thought Experiments Possible?

Every great advance in science has issued from a new audacity of imagination.
—JOHN DEWEY

Thought experiments test claims about the conditions under which concepts apply or events occur. But how can such flights of fancy prove anything? Why should we trust our imaginations to reveal anything about the way things are? The answer to these questions lies in our conceptual competence. Having a concept gives us the ability to make accurate judgments about its applicability, even in imaginary situations.

We acquire a concept by being given a definition of it or by being shown examples of it. In either case, once we have a concept, we have the ability to apply it to things we have never encountered before. If we have the concept of the letter A, for example, we can apply it to typefaces we have never seen before. A thought experiment is like a newly encountered typeface. Just as we can trust our judgment to determine whether the concept of the letter A applies to a letter in a typeface, so we can trust our judgment to determine whether a particular concept applies to the situation described in a thought experiment.

Of course, the more flourishes the letters in a typeface have, the more difficult it will be to determine whether a letter is an A. Similarly, the more outlandish the thought experiment, the more difficult it will be to determine whether the concept in question applies. So not all thought experiments are equally persuasive. Some are more convincing than others.

To have a concept is to be able to apply it correctly. But we may be able to apply a concept without being able to state the criteria we use in applying it. For example, we may be able to identify a grammatical sentence without being able to state the rules of grammar. In such a case, we have an intuitive understanding of grammar even though we do not have a theoretical understanding of it. In attempting to identify the conditions for applying a concept, we are trying to transform our intuitive understanding into a theoretical one. That is, we are trying to make explicit what is implicit in our understanding of a concept. Because having the ability to apply a concept correctly doesn't necessarily give us the ability to state the conditions for applying it, different people may have different theories about what those conditions are. But because we have an intuitive understanding of the concept, there is a body of data—our "intuitions"—that can be used to adjudicate various theories of it.

> *Logical consequences are the scarecrows of fools and the beacons of wise men.*
> —THOMAS H. HUXLEY

Conceptual intuitions are not the only data that philosophical theories must take into account, however. As we've seen, philosophical problems arise when our intuitions seem to conflict with other beliefs we have. Often these beliefs come from science. Trying to square our philosophical beliefs with our scientific ones has been a major concern of philosophy since its inception. The goal is to arrive at a view of the world that makes sense of it. As American philosopher Wilfred Sellars puts it, "The aim of philosophy, abstractly formulated, is to understand how things in the broadest possible sense of the term hang together in the broadest possible sense of the term."[33] To accomplish this goal, philosophy can't afford to leave anything out of account.

Criticizing Thought Experiments

The value of any experiment is determined by the amount of control with which it is executed. The more controlled the experiment, the less chance that its results will be misleading. It is not possible to control all the variables in an experiment, however. No one, for example, can control the position of Earth relative to the sun and the other planets. Nevertheless, it is sometimes possible to control all the *relevant* variables—that is, all the variables that could reasonably be expected to affect the outcome of the experiment. Criticizing an experiment usually involves explaining how it's possible that something other than the variable under investigation could have produced the result.

> *Truth, like gold, is to be obtained not by its growth, but by washing away from it all that is not gold.*
> —LEO TOLSTOY

Some thought experiments describe situations that are physically impossible. That is not necessarily a strike against them, however, for their more fantastic aspects may not be relevant to their outcome. Thought experiments examine the logical relations between concepts, and abstracting from physical reality is sometimes necessary to throw those relations into proper relief. Of course, the more outlandish a thought experiment, the more likely it is to alter

> *Good reasons must, of force, give place to better.*
> —WILLIAM SHAKESPEARE

a variable that is relevant to its outcome. If you doubt the results of an experiment, however, the burden of proof is on you to show where it went wrong by providing an alternative explanation of the results.

There is usually widespread agreement about the outcome of a thought experiment.[34] Thus thought experiments serve as an objective check on philosophical theorizing. When there is disagreement, it usually focuses on the interpretation of the results rather than on the results themselves. In the case of Warren's moral space traveler, for example, there is widespread agreement that persons need not be human beings, and vice versa. There is much less agreement, however, about what implications this has for the abortion controversy.

Even if fetuses aren't persons, many claim that fetuses are nonetheless valuable forms of life and thus should be destroyed only if there are good reasons for doing so. For example, Daniel Callahan, cofounder of the Hastings Center, an institute devoted to studying biomedical ethical issues, claims, "[Abortion] is not the destruction of a human person—for at no stage of its development does the conceptus fulfill the definition of a person, which implies a developed capacity for reasoning, willing, desiring and relating to others—but it is the destruction of an important and valuable form of human life."[35] As a result, Callahan maintains, taking such a life "demands of oneself serious reasons for doing so."[36] Just what those reasons are, he doesn't say. Nevertheless, it's clear that Callahan doesn't believe that the nonpersonhood of the fetus justifies abortion on demand. So Warren's moral space traveler thought experiment has not settled the abortion controversy. By clarifying the concept of a person, however, it has raised the level of discussion.

Even if the situation envisioned in a thought experiment is well defined, we may still reject the results of the thought experiment on the grounds that its assumptions are unreasonable. No theory—whether about concepts or physical objects—can be tested in isolation. Theories of any sort have testable consequences only in the context of certain background assumptions. Assumptions about the nature of human cognition and the nature of the external world, for example, lie behind every experiment. Thus if an experiment yields an incredible result, the problem may lie with the background assumptions rather than with the theory being tested.

Conceivability and Possibility

> *Imagination rules the world*
> —NAPOLEON

coherently imaginable A situation is coherently imaginable when its details can be filled in and its implications drawn out without running into a contradiction.

To show that a condition is not necessary for the application of a concept, one needs to show only that it's possible for the concept to apply without the condition being met. The best evidence that a situation is possible is that it's conceivable—that is, coherently imaginable. A situation is **coherently imaginable** when its details can be filled in and its implications drawn out without running into a contradiction. If, on examination, a situation is found to harbor an inconsistency, then it is not conceivable.

Consider, for example, time travel. At first glance, traveling backward in time seems perfectly conceivable. It may be technically impossible to build a time machine, but many science-fiction stories that make use of this notion seem to suggest that it's at least logically possible. This suggestion is mistaken,

however, because an event that has already happened cannot also not have happened. Suppose you travel back in time to a town at the turn of the century whose population was exactly 10,000 on January 1, 2000. After you arrive, the town will then have a population of 10,001. But it is logically impossible for a town to have a population of both 10,000 and 10,001 on January 1, 2000. So, appearances to the contrary, traveling backward in time to the same universe is not coherently imaginable because when we fill in the details and examine the consequences, we arrive at a contradiction.

If our time machine takes us back to a different universe, however, the contradiction can be avoided. Science writer Martin Gardner explains.

> The basic idea is as simple as it is fantastic. Persons can travel to any point in the future of their universe, with no complications, but the moment they enter the past, the universe splits into two parallel worlds, each with its own time track. Along one track rolls the world as if no looping had occurred. Along the other track spins the newly created universe, its history permanently altered.[37]

If the universe splits when you travel backward in time, there will be no contradiction because in neither universe will something both be and not be the case.

What the time travel example shows is that apparent conceivability doesn't guarantee possibility. From the fact that a situation seems coherently imaginable, it doesn't follow that it is, for it may contain a hidden contradiction. Apparent conceivability does provide good evidence for possibility, however, because if, after careful reflection, we haven't found a contradiction in a situation, we're justified in believing that it's possible.

Our conceptual ability can be compared to our perceptual ability. We can seem to perceive something that isn't real, but we can't actually perceive something that isn't real. For example, we might seem to perceive a cat in the yard while in actuality it's an old shoe. In that case, we never perceived a cat; we just thought we did. Similarly, we can seem to conceive something that's impossible, but we can't actually conceive something that's impossible. To distinguish apparent from real perception, we often gather more perceptual data; we look more closely at the situation or perform additional physical experiments. Similarly, to distinguish apparent from actual conception, we often gather more conceptual data; we look more closely at the logical implications of the situation or perform additional thought experiments. If we doubt the results of a physical experiment, we can check them by means of another physical experiment. Similarly, if we doubt the results of a thought experiment, we can check them by means of another thought experiment.

Because our conceptual scheme is an interconnected web of beliefs, every philosophical problem has a bearing on every other. Whatever solution is proposed to one problem must be judged in terms of the sorts of solutions it suggests to others. Deciding among various solutions to philosophical problems, then, requires appealing to considerations of scope, simplicity, conservatism, and fruitfulness. The theory that does best with regard to the criteria of adequacy will produce the most understanding.

Thought experiments are just one tool among many that philosophers use to evaluate their theories. But they are an important tool, for not only can they

> *Nothing is as far away as one minute ago.*
> —JIM BISHOP

> *Our reason must be considered as a kind of cause, of which truth is the natural effect.*
> —DAVID HUME

strengthen or weaken existing theories, they can also generate data that any future theory must take into account. Theories at the forefront of philosophical research are generally superior to their predecessors because the thought experiments of the past have broadened the evidence base on which future theories must rest.

Scientific Thought Experiments

Truth is what stands the test of experience.
—ALBERT EINSTEIN

Thought experiments aren't unique to philosophy. They can also be found in the sciences, where they have helped produce a number of scientific advances. Their use in the sciences is instructive.

One of the hallmarks of a good theory is that it is free from contradiction. Any theory that implies that something both is and is not the case is unacceptable, for not only is it uninformative, it cannot possibly be true. Thought experiments are particularly useful in testing for contradictions. Galileo used a thought experiment to demonstrate that Aristotle's theory of motion was self-contradictory, and thereby paved the way for the modern science of mechanics.

Aristotle held that heavier bodies fall faster than lighter ones. Galileo, on the other hand, maintained that all bodies, regardless of their weight, fall at the same rate. To show that his view was superior to Aristotle's, Galileo proposed the following thought experiment.

Thought Experiment

Impossibility of Aristotle's Theory of Motion

Imagine that a heavy cannonball is attached to a light musket ball by means of a rope. Now imagine that both this combined system and an ordinary cannonball are dropped from a height at the same time. What should happen? According to Aristotle, because lighter objects fall more slowly than heavier ones, the musket ball attached to the cannonball should act as a drag on it. So the combined system should fall more slowly than the cannonball alone. But because the combined system is heavier than the cannonball alone and because heavier objects fall faster than lighter ones, the combined system should also fall faster than the cannonball alone. But it is logically impossible for one object to fall both faster and more slowly than another. So Aristotle's theory cannot be correct. Galileo's theory, however, avoids the contradiction by maintaining that all bodies fall at the same rate. It follows, then, that Galileo's view is more credible than Aristotle's.

By showing that Aristotle's theory harbored an inconsistency, Galileo made the modern science of mechanics possible. The value of thought experiments, then, lies not only in their immediate results but also in their long-term consequences.

Summary

Philosophical theories explain how it is possible or why it is impossible for a concept to apply by identifying the conditions for applying it. Thought experiments test these theories by determining whether they hold in all possible situations. If they do not—that is, if there are counterexamples to the theory—there is reason to believe that the theory is mistaken.

Like scientific experiments, thought experiments can go wrong and can be criticized for it. If they are not sufficiently spelled out or if they rest on unreasonable assumptions, their value is questionable. If you believe that a thought experiment is problematic, however, the burden of proof is on you to provide an alternative explanation of the results.

The adequacy of a theory is determined by how much understanding it produces, and the amount of understanding produced by a theory is determined by how well it systematizes and unifies our knowledge. Criteria such as conservatism, scope, fruitfulness, and simplicity can be used to gauge the adequacy of a theory.

Thought experiments not only help us evaluate theories but also generate data that any future theory must take into account. Theories at the cutting edge of philosophical research are usually superior to their predecessors because previous thought experiments have added important considerations that any future theory must incorporate.

Study Questions

1. What is a thought experiment?
2. How are thought experiments possible?
3. On what grounds can thought experiments be criticized?
4. What is Warren's moral space traveler thought experiment? How does it attempt to undermine the claim that all human beings are persons?
5. On what grounds can philosophical theories be criticized?
6. What are the criteria of adequacy that good theories should meet?

Discussion Questions

1. According to Mary Anne Warren, fetuses aren't persons. But they are potential persons. Does being a potential person give something a right to life? Michael Tooley believes not. To make his point, he offers the following thought experiment.

Thought Experiment

Tooley's Cat

My argument against the potentiality principle can now be stated. Suppose at some future time a chemical were to be discovered which when injected into the brain of a kitten would cause the kitten to develop into a cat possessing a

brain of the sort possessed by humans, and consequently into a cat having all the psychological capabilities characteristic of adult humans. Such cats would be able to think, to use language, and so on. Now it would surely be morally indefensible in such a situation to ascribe a serious right to life to members of the species *Homo sapiens* without also ascribing it to cats that have undergone such a process of development: there would be no morally significant differences. . . .

Suppose a kitten is accidentally injected with the chemical. As long as it has not yet developed those properties that in themselves endow something with a right to life, there cannot be anything wrong with interfering with the causal process and preventing the development of the properties in question. . . .

But if it is not seriously wrong to destroy an injected kitten which will naturally develop the properties that bestow a right to life, neither can it be seriously wrong to destroy a member of *Homo sapiens* which lacks such properties. . . .[38]

According to Tooley, being a potential person is not a sufficient condition for having a right to life. Is Tooley right about this? If not, where is the flaw in his experiment?

2. Judith Jarvis Thomson believes that the question of whether a fetus is a person or even a potential person is irrelevant to the abortion controversy, for even if the fetus is a person, the woman may be under no obligation to care for it. In defense of her view, she offers the following thought experiment.

Thought Experiment

Thomson's Diseased Musician

I propose, then, that the fetus is a person from the moment of conception. . . . But now let me ask you to imagine this. You wake up in the morning and find yourself back to back in bed with an unconscious violinist. A famous unconscious violinist. He has been found to have a fatal kidney ailment, and the Society of Music Lovers has canvassed all the available medical records and found that you alone have the right blood type to help. They have therefore kidnapped you, and last night the violinist's circulatory system was plugged into yours, so that your kidneys can be used to extract poisons from his blood as well as your own. The director of the hospital now tells you, "Look, we're sorry the Society of Music Lovers did this to you—we would never have permitted it if we had known. But still, they did it, and the violinist now is plugged into you. To unplug you would be to kill him. But never mind, it's only for nine months. By then he will have recovered from his ailment, and can safely be unplugged from you." Is it morally incumbent on you to accede to this situation? No doubt it would be very nice of you if you did, a great kindness. But do you have to accede to it?[39]

Are you morally obligated to share your bloodstream with the diseased musician? If not, are you morally obligated to share your bloodstream with a developing fetus? Is this thought experiment flawed in a significant way?

3. Consider this theory of the function of lightbulbs:

> For years it was believed that electric bulbs emitted light. However, recent information has proven otherwise. Electric bulbs don't emit light, they suck dark. Thus we will now call these bulbs "dark suckers." The dark sucker theory, according to a spokesperson, proves the existence of dark, that dark has mass heavier than that of light, and that dark is faster than light.
>
> The basis of the dark sucker theory is that electric bulbs suck dark. Take, for example, the dark suckers in the room where you are. There is less dark right next to them than there is elsewhere. The larger the dark sucker, the greater its capacity to suck dark. Dark suckers in a parking lot have a much greater capacity than ones in this room. . . .
>
> Dark has mass. When dark goes into a dark sucker, friction from this mass generates heat. Thus it is not wise to touch an operating dark sucker. . . .
>
> Finally, we must prove that dark is faster than light. If you were to stand in an illuminated room in front of a closed, dark closet, then slowly open the closet door, you would see the light slowly enter the closet, but since dark is so fast, you would not be able to see the dark leave the closet.
>
> In conclusion, it has been stated that dark suckers make all our lives much easier, so the next time you look at an electric bulb remember that it is indeed a dark sucker.[40]

Rate this theory and the traditional photon theory in terms of the criteria of adequacy.

Internet Inquiries

1. Diogenes the Cynic offered a dramatic refutation of Plato's definition of a human being. Plato's definition of a human being, you will recall, was "a two-footed featherless animal." Diogenes brought a plucked rooster to Plato's academy and announced: "There's Plato's man. And he has broad flat nails, too." You can read about it here (Book VI): **https://en.wikisource.org/wiki/Lives_of_the_Eminent_Philosophers/Book_VI#Diogenes.** What did Diogenes' refutation prove? Do you think it was effective? Why or why not?

2. Many well-respected biblical scholars and theologians claim that the Bible does not forbid abortion. The Bible's view, they say, is similar to the one articulated by Mary Anne Warren: The fetus is not a person. See, for example, **http://www.huppi.com/kangaroo/L-bibleforbids.htm.** Others disagree. You can find arguments on both sides of the issue by doing an Internet search on "Bible" and "abortion." Identify the strongest argument on each side. Which argument do you think is the best? Why? Given the strength of the arguments on both sides, can anyone legitimately claim to know that the Bible endorses one view over the other? Why or why not?

3. In January 2005, the United States Supreme Court let stand a Florida Supreme Court decision to strike down "Terri's law," a statute passed by the Florida state legislature giving Governor Jeb Bush (President George W. Bush's brother) the authority to prevent a feeding tube from being removed, against the wishes of the patient, Terri Schiavo, and her

husband, Michael Schiavo. Terri Schiavo had been in a persistent vegetative state (PVS) since 1990 when a heart attack allegedly deprived her brain of oxygen for over five minutes. The National Institute of Neurological Disorders and Stroke describes PVS this way:

> A persistent vegetative state (commonly, but incorrectly, referred to as "brain-death") sometimes follows a coma. Individuals in such a state have lost their thinking abilities and awareness of their surroundings, but retain non-cognitive function and normal sleep patterns. Even though those in a persistent vegetative state lose their higher brain functions, other key functions such as breathing and circulation remain relatively intact. Spontaneous movements may occur, and the eyes may open in response to external stimuli. They may even occasionally grimace, cry, or laugh. Although individuals in a persistent vegetative state may appear somewhat normal, they do not speak and they are unable to respond to commands.[41]

Is someone in a persistent vegetative state a person? Why or why not? If a person ceases to exist before the entire brain dies, should we revise our definition of death? Why or why not? For a more detailed exploration of these issues, take a look at David Perry's article "Ethics and Personhood": **https://www.scu.edu/ethics/focus-areas/bioethics/resources/ethics-and-personhood/.** An Internet search on "higher brain death" will yield a host of viewpoints.

BERTRAND RUSSELL

The Value of Philosophy

Bertrand Russell (1872–1970) is one of the greatest philosophers of the twentieth century, making significant contributions in all of the major branches of philosophy. Perhaps his greatest contribution was in the field of logic, where his *Principia Mathematica* (co-authored with Alfred North Whitehead) tried to demonstrate that all of mathematics could be derived from logic. Although Russell did not write much fiction, the Nobel Committee decided to recognize his importance as a man of letters by awarding him the Nobel Prize for Literature in 1950. The following selection is the concluding chapter of his text *The Problems of Philosophy*. In it, he describes the importance of philosophy for the life of the mind.

Having now come to the end of our brief and very incomplete review of the problems of philosophy, it will be well to consider, in conclusion, what is the value of philosophy and why it ought to be studied. It is the more necessary to consider this question, in view of the fact that many men, under the influence of science or of practical affairs, are inclined to doubt whether philosophy is anything better than innocent but useless trifling, hair-splitting distinctions, and controversies on matters concerning which knowledge is impossible.

This view of philosophy appears to result, partly from a wrong conception of the ends of life, partly from a wrong conception of the kind of goods which philosophy strives to achieve. Physical science, through the medium of inventions, is useful to innumerable people who are wholly ignorant of it; thus the study of physical science is to be recommended, not only, or primarily, because of the effect on the student, but rather because of the effect on mankind in general. This utility does not belong to philosophy. If the study of philosophy has any value at all for others than students of philosophy, it must be only indirectly, through its effects upon the lives of those who study it. It is in these effects, therefore, if anywhere, that the value of philosophy must be primarily sought.

But further, if we are not to fail in our endeavour to determine the value of philosophy, we must first free our minds from the prejudices of what are wrongly called "practical" men. The "practical" man, as this word is often used, is one who recognizes only material needs, who realizes that men must have food for the body, but is oblivious of the necessity of providing food for the mind. If all men were well off, if poverty and disease had been reduced to their lowest possible point, there would still remain much to be done to produce a valuable society; and even in the existing world the goods of the mind are at least as important as the goods of the body. It is exclusively among the goods of the mind that the value of philosophy is to be found; and only those who are not indifferent to these goods can be persuaded that the study of philosophy is not a waste of time.

Philosophy, like all other studies, aims primarily at knowledge. The knowledge it aims at is the kind of knowledge which gives unity and system to the body of the sciences, and the kind which results from a critical examination of the grounds of our convictions, prejudices, and beliefs. But it cannot be maintained that philosophy has had any very great measure of success in its attempts to provide definite answers to its questions. If you ask a mathematician, a mineralogist, a historian, or any other man of learning, what definite body of truths has been ascertained by his science, his answer will last as long as you are willing to listen. But if you put the same question to a philosopher, he will, if he is candid, have to confess that his study has not achieved positive results such as have been achieved by other sciences. It is true that this is partly accounted for by the fact that, as soon as definite knowledge concerning any subject becomes possible, this subject ceases to be called philosophy, and becomes a separate science. The whole study of the heavens, which now belongs to astronomy, was once included in philosophy; Newton's great work was called "the mathematical principles of natural philosophy." Similarly, the study of the human mind,

Source: Bertrand Russell, *The Problems of Philosophy* (New York: Henry Holt and Company, 1912) 237–250.

which was, until very lately, a part of philosophy, has now been separated from philosophy and has become the science of psychology. Thus, to a great extent, the uncertainty of philosophy is more apparent than real: those questions which are already capable of definite answers are placed in the sciences, while those only to which, at present, no definite answer can be given, remain to form the residue which is called philosophy.

This is, however, only a part of the truth concerning the uncertainty of philosophy. There are many questions—and among them those that are of the profoundest interest to our spiritual life—which, so far as we can see, must remain insoluble to the human intellect unless its powers become of quite a different order from what they are now. Has the universe any unity of plan or purpose, or is it a fortuitous concourse of atoms? Is consciousness a permanent part of the universe, giving hope of indefinite growth in wisdom, or is it a transitory accident on a small planet on which life must ultimately become impossible? Are good and evil of importance to the universe or only to man? Such questions are asked by philosophy, and variously answered by various philosophers. But it would seem that, whether answers be otherwise discoverable or not, the answers suggested by philosophy are none of them demonstrably true. Yet, however slight may be the hope of discovering an answer, it is part of the business of philosophy to continue the consideration of such questions, to make us aware of their importance, to examine all the approaches to them, and to keep alive that speculative interest in the universe which is apt to be killed by confining ourselves to definitely ascertainable knowledge.

Many philosophers, it is true, have held that philosophy could establish the truth of certain answers to such fundamental questions. They have supposed that what is of most importance in religious beliefs could be proved by strict demonstration to be true. In order to judge of such attempts, it is necessary to take a survey of human knowledge, and to form an opinion as to its methods and its limitations. On such a subject it would be unwise to pronounce dogmatically; but if the investigations of our previous chapters have not led us astray, we shall be compelled to renounce the hope of finding philosophical proofs of religious beliefs. We cannot, therefore, include as part of the value of philosophy any definite set of answers to such questions. Hence, once more, the value of philosophy must not depend upon any supposed body of definitely ascertainable knowledge to be acquired by those who study it.

The value of philosophy is, in fact, to be sought largely in its very uncertainty. The man who has no tincture of philosophy goes through life imprisoned in the prejudices derived from common sense, from the habitual beliefs of his age or his nation, and from convictions which have grown up in his mind without the co-operation or consent of his deliberate reason. To such a man the world tends to become definite, finite, obvious; common objects rouse no questions, and unfamiliar possibilities are contemptuously rejected. As soon as we begin to philosophize, on the contrary, we find, as we saw in our opening chapters, that even the most everyday things lead to problems to which only very incomplete answers can be given. Philosophy, though unable to tell us with certainty what is the true answer to the doubts which it raises, is able to suggest many possibilities which enlarge our thoughts and free them from the tyranny of custom. Thus, while diminishing our feeling of certainty as to what things are, it greatly increases our knowledge as to what they may be; it removes the somewhat arrogant dogmatism of those who have never travelled into the region of liberating doubt, and it keeps alive our sense of wonder by showing familiar things in an unfamiliar aspect.

Apart from its utility in showing unsuspected possibilities, philosophy has a value—perhaps its chief value—through the greatness of the objects which it contemplates, and the freedom from narrow and personal aims resulting from this contemplation. The life of the instinctive man is shut up within the circle of his private interests: family and friends may be included, but the outer world is not regarded except as it may help or hinder what comes within the circle of instinctive wishes. In such a life there is something feverish and confined, in comparison with which the philosophic life is calm and free. The private world of instinctive interests is a small one, set in the midst of a great and powerful world which must, sooner or later, lay our private world in ruins. Unless we can so enlarge our interests as to include the whole outer world, we remain like a garrison in a beleaguered fortress, knowing that the enemy prevents escape and that ultimate surrender is inevitable. In such a life there is no peace, but a constant strife between the insistence of desire and the powerlessness of will. In one way or another, if our life is to be great and free, we must escape this prison and this strife.

One way of escape is by philosophic contemplation. Philosophic contemplation does not, in its widest survey, divide the universe into two hostile camps—friends and foes, helpful and hostile, good and bad—it views the whole impartially. Philosophic contemplation, when it is unalloyed, does not aim at proving that the rest of the universe is akin to man. All acquisition of knowledge is an enlargement of the Self, but this enlargement is best

attained when it is not directly sought. It is obtained when the desire for knowledge is alone operative, by a study which does not wish in advance that its objects should have this or that character, but adapts the Self to the characters which it finds in its objects. This enlargement of Self is not obtained when, taking the Self as it is, we try to show that the world is so similar to this Self that knowledge of it is possible without any admission of what seems alien. The desire to prove this is a form of self-assertion and, like all self-assertion, it is an obstacle to the growth of Self which it desires, and of which the Self knows that it is capable. Self-assertion, in philosophic speculation as elsewhere, views the world as a means to its own ends; thus it makes the world of less account than Self, and the Self sets bounds to the greatness of its goods. In contemplation, on the contrary, we start from the not-Self, and through its greatness the boundaries of Self are enlarged; through the infinity of the universe the mind which contemplates it achieves some share in infinity.

For this reason greatness of soul is not fostered by those philosophies which assimilate the universe to Man. Knowledge is a form of union of Self and not-Self; like all union, it is impaired by dominion, and therefore by any attempt to force the universe into conformity with what we find in ourselves. There is a widespread philosophical tendency towards the view which tells us that Man is the measure of all things, that truth is man-made, that space and time and the world of universals are properties of the mind, and that, if there be anything not created by the mind, it is unknowable and of no account for us. This view, if our previous discussions were correct, is untrue; but in addition to being untrue, it has the effect of robbing philosophic contemplation of all that gives it value, since it fetters contemplation to Self. What it calls knowledge is not a union with the not-Self, but a set of prejudices, habits, and desires, making an impenetrable veil between us and the world beyond. The man who finds pleasure in such a theory of knowledge is like the man who never leaves the domestic circle for fear his word might not be law.

The true philosophic contemplation, on the contrary, finds its satisfaction in every enlargement of the not-Self, in everything that magnifies the objects contemplated, and thereby the subject contemplating. Everything, in contemplation, that is personal or private, everything that depends upon habit, self-interest, or desire, distorts the object, and hence impairs the union which the intellect seeks. By thus making a barrier between subject and object, such personal and private things become a prison to the intellect. The free intellect will see as God might see, without a *here* and *now,* without hopes and fears, without the trammels of customary beliefs and traditional prejudices, calmly, dispassionately, in the sole and exclusive desire of knowledge—knowledge as impersonal, as purely contemplative, as it is possible for man to attain. Hence also the free intellect will value more the abstract and universal knowledge into which the accidents of private history do not enter, than the knowledge brought by the senses, and dependent, as such knowledge must be, upon an exclusive and personal point of view and a body whose sense-organs distort as much as they reveal.

The mind which has become accustomed to the freedom and impartiality of philosophic contemplation will preserve something of the same freedom and impartiality in the world of action and emotion. It will view its purposes and desires as parts of the whole, with the absence of insistence that results from seeing them as infinitesimal fragments in a world of which all the rest is unaffected by any one man's deeds. The impartiality which, in contemplation, is the unalloyed desire for truth, is the very same quality of mind which, in action, is justice, and in emotion is that universal love which can be given to all, and not only to those who are judged useful or admirable. Thus contemplation enlarges not only the objects of our thoughts, but also the objects of our actions and our affections: it makes us citizens of the universe, not only of one walled city at war with all the rest. In this citizenship of the universe consists man's true freedom, and his liberation from the thraldom of narrow hopes and fears.

Thus, to sum up our discussion of the value of philosophy: Philosophy is to be studied, not for the sake of any definite answers to its questions, since no definite answers can, as a rule, be known to be true, but rather for the sake of the questions themselves; because these questions enlarge our conception of what is possible, enrich our intellectual imagination, and diminish the dogmatic assurance which closes the mind against speculation; but above all because, through the greatness of the universe which philosophy contemplates, the mind also is rendered great, and becomes capable of that union with the universe which constitutes its highest good.

Reading Questions

1. What does Russell mean by the value of philosophy being found in its uncertainty? What do you think he would say about people who restrict their whole lives to the habitual, comforting beliefs of their culture?

2. What does Russell say about the worldviews of "practical" people? He declares that the goods of the mind are at least as important as the goods of the body. Do you think he is right? Why or why not?

3. He maintains that if our life is to be great and free, we must escape the prison of instinctive, private interests. Do you agree? Explain.

4. According to Russell, through philosophical contemplation, the boundaries of the Self are enlarged and the mind achieves some share of infinity. What does he mean by this? Do you believe that philosophy is a spiritual quest, as he contends? Explain.

Brand Blanshard

The Philosophic Enterprise

Brand Blanshard (1892–1989), eminent American philosopher and Rhodes scholar, received his A.B. from Michigan University and his Ph.D. from Harvard University. He taught at Swarthmore College for two decades and chaired the Yale philosophy department from 1945 until his retirement in 1961. His major works include *The Nature of Thought, Reason and Goodness,* and *Reason and Analysis.* In this selection, he presents his view of the relationship between philosophy and science.

Philosophy is best understood, I think, as part of an older and wider enterprise, the enterprise of understanding the world. We may well look first at this understanding in the large. I shall ask, to begin with, what is its goal, then what are its chief stages, then what are the ways in which philosophy enters into it.

The enterprise, we have just said, is that of understanding the world. What do we mean by understanding—understanding anything at all? We mean, I suppose, explaining it to ourselves. Very well; what does explaining anything mean? We stumble upon some fact or event that is unintelligible to us; what would make it intelligible? The first step in the answer is, seeing it as an instance of some rule. You suffer some evening from an excruciating headache and despondently wonder why. You remember that you just ate two large pieces of chocolate cake and that you are allergic to chocolate; the headache seems then to be explained. It is no longer a mere demonic visitor intruding on you from nowhere; you have domesticated it, assimilated it to your knowledge, by bringing it under a known rule.

What sort of rules are these that serve to render facts intelligible? They are always rules of connection, rules relating the fact to be explained to something else. You explain the headache by bringing it under a law relating it *causally* to something else. In like manner, you explain the fact that a figure on the board has angles equal to two right angles by relating it *logically* to something else; by pointing out that it is a triangle, and that it belongs to the triangles as such to have this property....

[Philosophers] have tried to supplement the work of science in at least two respects. In both of these respects science has to be extended if our thirst for understanding is to be satisfied, but in neither of them do scientists take much interest. The fact is that, logically speaking, philosophy begins before science does, and goes on after science has completed its work. In the broad spectrum of knowledge, science occupies the central band. But we know that there is more to the spectrum than this conspicuous part. On one side, beyond the red end of the spectrum, there is a broad band of infrared rays; and on the other side, beyond the violet end, are the ultraviolet rays. Philosophy deals with the infrareds and the ultraviolets of science, continuous with the central band but more delicate and difficult of discernment.

Take the red end first. Consider the sense in which philosophy comes before science. Many of the concepts the scientist uses and many of his working assumptions he prefers to take for granted. He can examine them if he wishes, and some scientists do. Most do not, because if they waited till they were clear on these difficult basic ideas, they might never get to what most interests them at all. But it would be absurd to leave these basic ideas unexamined altogether. This somewhat thankless preliminary work is the task of the philosopher.

We referred to these unexamined ideas as concepts and assumptions. Let us illustrate the concepts first.

Common sense and science are constantly using certain little words of one syllable that seem too familiar and perhaps unimportant to call for definition. We say, "What time is it?" "There is less space in a compact car," "There was no cause for his taking offense," "He must be

Source: Brand Blanshard, "The Philosophic Enterprise" from *The Owl of Minerva: Philosophers on Philosophy*, edited by Charles J. Bontempo and S. Jack Odell (New York: McGraw-Hill, 1975). Reprinted with the permission of the Yale University Office of Trusts & Estates.

out of his mind," "I think these strikes are unjust to the public." Consider the words we have used: 'time', 'space', 'cause', 'good', 'truth', 'mind', 'just', 'I'. If someone said to us, "What do you mean, *I*?" or, when we asked what time it was, "What do you mean by 'time'?" we should probably say, "Oh, don't be an idiot," or perhaps with St. Augustine, "I know perfectly well what time means until you ask me, and then I don't know." I suspect this last is the sound answer regarding all these words. We know what they mean well enough for everyday purposes, but to think about them is to reveal depth after depth of unsuspected meaning. This fact suggests both the strength and the weakness of present-day linguistic philosophy. It is surely true, as this school contends, that a main business of philosophy is to define words. The first great outburst of philosophy in the talk of Socrates was largely an attempt at defining certain key words of the practical life—'justice', 'piety', 'temperance', 'courage'. But their meanings proved bafflingly elusive; he chased the ghost of justice through ten books of the *Republic* and barely got his hands on it in the end. Socrates saw that to grasp the meaning even of these simple and common terms would solve many of the deepest problems in ethics and metaphysics. But we must add that Socrates was no ordinary language philosopher. He was not an Athenian Noah Webster, collecting the shopworn coins that were current in the marketplace; on the contrary, he took special pleasure in showing that at the level of ordinary usage our meanings were muddled and incoherent. Only by refining and revising them could we arrive at meanings that would stand.

Now the scientist who is trying to find the truth about the cause of flu cannot discontinue his experiments till he has reached clearness on the nature of truth or the concept of causality. The political scientist who holds that democracy is in certain respects better than communism cannot remain dumb till all his colleagues have agreed as to the definition of 'good'. These people must get on with their work, and they are right not to stop and moon about ultimates. But these ideas are ultimates after all; we must use them hourly in our thinking; and it would be absurd if, while researchers were trying to be clear about relatively unimportant matters, no one tried to get clear about the most important things of all. And the right persons to make that effort are surely the philosophers. A philosopher friend of mine sat down in a railway car beside a salesman who, recognizing a kindred spirit, poured out a stream of talk about his line. "And what's your line?" he concluded. "Notions," replied the philosopher. That seemed all right to the salesman, and it should be so to us. Notions are the line of the philosopher, such key notions as truth, validity, value, knowledge, without which scientific thought could not get under way, but which the scientist himself has neither the time nor the inclination to examine.

We suggested that it is not only his ultimate concepts but also his ultimate assumptions that the scientist prefers to turn over to others for inspection. Let me list a few and ask whether there is any natural scientist who does not take them for granted. That we can learn the facts of the physical order through perception. That the laws of our logic are valid of this physical order. That there is a public space and a public time in which things happen and to which we all have access. That every event has a cause. That under like conditions the same sort of thing has always happened, and always will. That we ought to adjust the degree of our assent to any proposition to the strength of the evidence for it. These are all propositions of vast importance, which the scientist makes use of every day of his life. If any one of them were false, his entire program would be jeopardized. But they are not scientific propositions. They are assumed by all sciences equally; they are continuous with the thought of all; yet they are the property of none. It would be absurd to leave these unexamined, for some or all of them may be untrue. But the scientist would be aghast if, before he used a microscope or a telescope, he had to settle the question whether knowledge was possible through perception, or whether there could be a logic without ontology. Scientists have at times discussed these matters, and their views are always welcome, but they generally and sensibly prefer to turn them over to specialists. And the specialists in these problems are philosophers.

I have now, I hope, made clear what was meant by saying that philosophy comes before science. It comes before it in the sense of taking for examination the main concepts and assumptions with which scientists begin their work. Science is logically dependent on philosophy. If philosophy succeeded in showing, as Hume and Carnap thought it had, that any reference to a nonsensible existent was meaningless, the physics that talks of electrons and photons would either have to go out of business or revise its meanings radically. If philosophy succeeded, as James, Schiller, and Freud thought it had, in showing that our thinking is inescapably chained to our impulses and emotions, then the scientific enterprise, as an attempt at impartial and objective truth, would be defeated before it started. Philosophy does not merely put a bit of filigree on the mansion of science; it provides its foundation stones.

If philosophy begins before science does, it also continues after the scientist has finished his work. Each science may be conceived as a prolonged effort to

answer one large question. Physics asks, "What are the laws of matter in motion?" Biology asks, "What kinds of structure and behavior are exhibited by living things?" Each science takes a field of nature for its own and tries to keep within its own fences. But nature has no fences; the movement of electrons is somehow continuous with the writing of *Hamlet* and the rise of Lenin. Who is to study this continuity? Who is to reflect on whether the physicist, burrowing industriously in his hole, can break a tunnel through to the theologian, mining anxiously in his? Surely here again is a task that only the philosopher can perform. One way of performing it, which I do not say is the right way, is suggested by the definition of philosophy as the search by a blind man in a dark room for a black hat that isn't there, with the addendum that if he finds it, that is theology. It may be thought that since no two true propositions can contradict each other, the results of independent scientific search could not conflict, and that there is no problem in harmonizing them. On the contrary, when we examine even the most general results of the several sciences, we see that they clash scandalously and that the task of harmonizing them is gigantic. Indeed the most acute and fascinating of metaphysical problems arise in the attempt to reconcile the results of major disciplines with each other.

How are you to reconcile physics with psychology, for example? The physicist holds that every physical event has a physical cause, which seems innocent enough. To say that a material thing could start moving, or, once started, could have its motion accelerated or changed in direction without any physical cause, would seem absurd. If you say that a motion occurs with no cause at all, that is to the physicist irresponsible; if you say that it represents interference from outside the spatial order, it is superstitious. Now is not the psychologist committed to saying that this interference in fact occurs daily? If my lips and vocal cords now move as they do, it is because I am thinking certain thoughts and want to communicate them to you. And the only way in which a thought or desire can produce such results is through affecting the physical motions of waves or particles in my head. It will not do to say that only the nervous correlates of my thought are involved in producing these results, for those physical changes are not my thoughts, and if my thoughts themselves can make no difference to what I do, then rational living becomes a mummery. My action is never in fact guided by conscious choice, nor anything I say determined by what I think or feel. Common sense would not accept that, nor can a sane psychology afford to; the evidence against it is too massive. And what this evidence shows is that conscious choice, which is not a physical event at all, does make a difference to the behavior of tongue and lips, of arms and legs. Behavior may be consciously guided. But how are you to put that together with the physicist's conviction that all such behavior is caused physically? That is the lively philosophical problem of body and mind.

Conflicts of this kind may occur not only between natural sciences but between a natural and a normative science. Take physics and ethics. For the physicist all events—at least all macroscopic events—are caused; that is, they follow in accordance with some law from events immediately preceding them. This too seems innocent enough. But now apply the principle in ethics. A choice of yours is an event, even if not a physical event, and thus falls under the rule that all events are caused. That means that every choice you make follows in accordance with law from some event or events just preceding it. But if so, given the events that just preceded any of my choices, I had to do what I did do; I could not have done otherwise. But if that is true, does it not make nonsense to say in any case that I ought to have done otherwise, since I did the only thing that I could have done? But then what becomes of ethics as ordinarily conceived? If the scientific principle is true, one will have to rethink the ethical ground for remorse and reward and punishment and praise and blame. This is the ancient problem of free will, which was discussed with fascination by Milton's angels while off duty from their trumpets, and is discussed with equal fascination by undergraduates today....

There are many other conflicts like the two we have mentioned. They fall in no one of the disciplines, but between them, and they must be arbitrated by an agency committed to nonpartisanship. The only plausible nominee for this post is philosophy. Philosophy is the interdepartmental conciliation agency, the National Labor Relations Board, or if you prefer, the World Court, of the intellectual community. Like these other agencies, it has no means of enforcing its verdicts. Its reliance is on the reasonableness of its decisions.

We are now in a position to see the place of philosophy in the intellectual enterprise as a whole. Intelligence has shown from the beginning a drive to understand. To understand anything means to grasp it in the light of other things or events that make it intelligible. The first great breakthrough of this drive was the system of common sense, which was molded into form by millennia of trial and error. This system is being superseded by science, whose network of explanation is far more precise and comprehensive. Philosophy is the continuation of this enterprise into regions that science leaves unexplored. It is an attempt to carry understanding to its furthest possible limits. It brings into the picture the

foundations on which science builds and the arches and vaultings that hold its structures together. Philosophy is at once the criticism and the completion of science. That, as I understand it, is what all the great philosophers have been engaged upon, from Plato to Whitehead.

They may never wholly succeed. It is quite possible that men will use such understanding as they have achieved to blow themselves and their enterprise off the planet. But while they do allow themselves further life, the enterprise is bound to go on. For the effort to understand is not a passing whim or foible; it is no game for a leisure hour or "lyric cry in the midst of business." It is central to the very nature and existence of man; it is what has carried him from somewhere in the slime to the lofty but precarious perch where he now rests. The drive of his intelligence has constructed his world for him and slowly modified it into conformity with the mysterious world without. To anyone who sees this, philosophy needs no defense. It may help in practical ways, and of course it does. But that is not the prime reason why men philosophize. They philosophize because they cannot help it, because the enterprise of understanding, ancient as man himself, has made him what he is, and alone can make him what he might be.

Reading Questions

1. What does Blanshard mean by philosophy coming before science? He says that philosophy provides science with its foundation stones. Is he right? Or do you think science can supply its own foundation stones? Explain.

2. According to Blanshard, how do physics and psychology conflict and thus give rise to the mind-body problem? Why couldn't further research in either science resolve the conflict?

3. Why does Blanshard refer to philosophy as the World Court of the intellectual community? Why is philosophy in a better position to reconcile fundamental conflicts between various sciences than the sciences themselves?

4. What is the "enterprise of understanding"? How does Blanshard think philosophy fits into it? Do you agree that the drive to understand is central to the nature and existence of humankind? Explain.

Notes

1. Werner Heisenberg, *Physics and Beyond* (New York: Harper & Row, 1972) 210.
2. Francis Crick, *The Astonishing Hypothesis* (New York: Simon & Schuster, 1994) 3.
3. B. F. Skinner, *Beyond Freedom and Dignity* (New York: Bantam, 1971) 3ff.
4. Richard Dawkins, *The Selfish Gene* (Oxford: Oxford University Press, 1976) IX.
5. James McConnell, "Criminals Can Be Brainwashed—Now," *Psychology Today* 3 (1970) 14.
6. Ludwig Wittgenstein, *Philosophical Investigations*, 3rd ed., trans. G. E. M. Anscombe (Oxford: Blackwell, 1972) sec. 66.
7. Bernard Suits, *The Grasshopper: Games, Life and Utopia* (Toronto: University of Toronto Press, 1978).
8. M. W. Rowe, "The Definition of 'Game,'" *Philosophy* (67) (Oct., 1992) 467–479.
9. Rudolf Carnap, *Logical Foundations of Probability* (London: Routledge and Kegan Paul, 1950) 3.
10. Plato, "The Apology," *The Dialogues of Plato*, trans. Benjamin Jowett (Oxford: Oxford University Press, 1892) 110.
11. John Roach, "Delphic Oracle's Lips May Have Been Loosened by Gas Vapors," *National Geographic News*, August 14, 2001, www.nationalgeographic.com/news/2001/08/0814_delphicoracle.html. Retrieved August 1, 2005.
12. Diogenes Laertius, *The Lives of the Philosophers*, ed. and trans. A. Robert Camonigri (Chicago: Henry Regnery Company, 1969) 78.
13. Plato, "Euthyphro," 5d–8b, trans. Lane Cooper, *Plato: The Collected Dialogues* (Princeton, NJ: Princeton University Press, 1973) 173–176.
14. Plato 176.
15. Aristotle, "Metaphysics," book 4, 1008b, *Aristotle*, trans. Richard McKeon (New York: Random House, 1941) 742.
16. Aristotle 1006a, 737.
17. Jerry Fodor, *The Language of Thought* (Cambridge, MA: Harvard University Press, 1979) 6–7.
18. Arthur Conan Doyle, *A Study in Scarlet* (New York: P. F. Collier and Son, 1906) 29–30.
19. Ludwig F. Schlecht, "Classifying Fallacies Logically," *Teaching Philosophy* 14, no. 1 (1991) 53–64.
20. Edmund Husserl, *Ideas*, trans. Boyce Gibson (London: Allen and Unwin, 1952) 201.
21. Lewis White Beck and Robert L. Holmes, *Philosophic Inquiry* (Englewood Cliffs: Prentice Hall, 1968) 180.
22. Mary Anne Warren, "On the Moral and Legal Status of Abortion," *The Monist* 57 (1973) 43–61.
23. Warren 54–56.
24. John Locke, *An Essay Concerning Human Understanding* (Oxford: Oxford University Press, 1991) 335.
25. Locke 333.
26. Richard Swinburne, *The Coherence of Theism* (Oxford: Clarendon Press, 1977) 99.
27. Warren 57.
28. Warren 56–57.
29. Thomas White, quoted in Andrew C. Revkin, "When is a Person Not a Human? When It's a Dolphin, or Chimp, or . . . " https://dotearth.blogs.nytimes.com/2013/04/10/when-is-a-person-not-a-human-when-its-a-dolphin-or-chimp-or/ accessed 7/12/2018.
30. Government of India, Ministry of Environment and Forests (2013) Authority Letter No. 20-1/2010-CZA, http://www.cza.nic.in/g15.pdf, accessed 7/12/2018.
31. https://en.wikipedia.org/wiki/Sophia_(robot), accessed 7/12/2018.
32. (http://www.aspcr.com/newcss_rights.html), accessed 7/12/2018.
33. Wilfred Sellars, "Philosophy and the Scientific Image of Man," *Frontiers of Science and Philosophy* (Pittsburgh, PA: University of Pittsburgh Press, 1962) 37.
34. Antoni Gomila, "What Is a Thought Experiment?" *Metaphilosophy* 22 (1991) 88.
35. Daniel Callahan, "Abortion Decisions: Personal Morality," *Biomedical Ethics*, ed. Thomas A. Mappes and Jane S. Zembaty (New York: McGraw-Hill, 1991) 446.
36. Callahan 446.
37. Martin Gardner, *Time Travel and Other Mathematical Bewilderments* (New York: Freeman, 1988) 7.
38. Michael Tooley, "Abortion and Infanticide," *Intervention and Reflection*, ed. R. Munson (Belmont, CA: Wadsworth, 1983) 72.
39. Judith Jarvis Thomson, "A Defense of Abortion," *Rights, Restitution, and Risk: Essays in Moral Theory*, ed. William Parent (Cambridge: Harvard University Press, 1986) 2–3.
40. Jesper Hogstrom, "Dark Suckers," *Project Galactic Guide* (10 May 1992) online, Internet.
41. National Institute of Neurological Disorders and Stroke, "Coma and Persistent Vegetative State," https://www.brainline.org/article/coma-and-persistent-vegetative-state, accessed 10/15/2018.

Chapter 2
The Mind-Body Problem

Is there a mind/body problem? If so, which is it better to have?

—WOODY ALLEN

Like all creatures, we have bodies. But unlike some of them, we also have minds. With our bodies we eat, drink, walk, talk, breathe, and the like. With our minds we think, feel, desire, perceive, and understand, among other things. Modern science has shown that what goes on in our bodies can be explained in physical terms, as the result of various electrochemical or biomechanical interactions. But what about what goes on in our minds? Can our thoughts also be explained physically? Many think not. Foremost among them is sixteenth-century philosopher (and inventor of analytic geometry) René Descartes. Although Descartes considers bodies to be machines, he maintains that human beings are more than just bodies—because no machine will ever be able to do what we do. In his *Discourse on Method*, Descartes describes how he arrived at this view.

Thought Experiment

Descartes' Mechanical Moron

Such persons will look upon this body as a machine made by the hands of God, which is incomparably better arranged, and adequate to movements more admirable than is any machine of human invention. And here I specially stayed to show that, were there such machines exactly resembling organs and outward form an ape or any other irrational animal, we could have no means of knowing that they were in any respect of a different nature from these animals; but if there were machines bearing the image of our bodies, and capable of imitating our actions as far as it is morally possible, there would still remain two most certain tests whereby to know that they were not therefore really men. Of these the first is that they could never use words or other signs arranged in such a manner as is competent to us in order to declare our thoughts to others: for we may easily conceive a machine to be so constructed that it emits vocables, and even that it emits some correspondent to the action upon it of external objects which cause a change in its organs; for example, if touched in a particular place it may demand what we wish to say to it; if in another it may cry out that it is hurt, and such like; but not that it should arrange them variously so as appositely to reply to what is said in its presence, as men of the lowest grade of intellect can do. The second test is, that although such machines might execute many things with equal or perhaps greater perfection than any of us, they would, without doubt, fail in certain others from which it could be discovered that they did not act from knowledge, but solely from the disposition of their organs: for while reason is an universal instrument that is alike available on every occasion, these organs, on the contrary, need a particular arrangement for each particular action; whence it must be morally impossible that there should exist in any machine a diversity of organs sufficient to enable it to act in all the occurrences of life, in the way in which our reason enables us to act.[1]

Descartes believes that we are not machines because we possess two abilities that no machine ever will: (1) the ability to talk intelligently on an indefinite variety of topics and (2) the ability to act intelligently in an indefinite variety of situations. Machines may be able to talk or act intelligently in certain limited contexts, but their abilities will never match our own. Machines can act intelligently only when they are dealing with situations they have been designed or programmed to handle. We, on the other hand, can act intelligently even in situations we have never before encountered. Consequently, we must be more than mere machines.

Although many people working in the field of cognitive science disagree with Descartes' assessment of the prospects for artificial intelligence, they do agree that the ability to use language and solve problems are two of the best indicators of intelligence. In fact, as we shall see, one of the most widely accepted (and widely criticized) tests for artificial intelligence—the Turing test—is a test of just the sort Descartes proposed. Alan Turing, one of the founders of computer science, claimed that if a computer's ability to use language was indistinguishable from that of an ordinary human being, then the machine must be able to think.

Could we build a machine that has our linguistic and problem-solving abilities? Suppose we could. Would such a machine have a mind? How we answer that question will determine how we treat the robots that will eventually walk among us. David Levy, author of the book, *Love and Sex with Robots*, predicts that by the year 2050, humans will be marrying robots.[2] This raises a number of interesting questions. What rights should a robot spouse have? What if there were a divorce? Should the robot get half of the community property? Our notion of rights is intimately connected to our notion of reasoning. If a machine can reason as well as we can, it's going to be difficult not to grant it the same rights that we enjoy.

An intelligent robot would be the ultimate labor-saving device. In fact, some have claimed that once intelligent robots become available, we will all live like kings, for the robots will provide us with an inexhaustible supply of slave labor. James S. Albus, former chief of the Industrial Systems Division of the National Bureau of Standards, for example, has described what he sees as the coming utopia in his book *People's Capitalism: The Economics of the Robot Revolution*. He remarks,

> Before the Industrial Revolution, the aristocracy could only exist based on slavery because it was simply not possible for a single human being to produce enough wealth to live the life of an aristocrat. Now, in the age of robotics, you will have machines that can think for themselves, that can act for themselves, that can even reproduce themselves. Raw materials will go in, finished products will come out and be distributed through a market system that brings money into an unoccupied structure, which can then be passed out as dividends to the society.

The fundamental history of humankind is the history of the mind.
—WILLIAM BARRETT

The Mind-Body Problem

This source of wealth can, in fact, create a new level of civilization that hitherto has only been achieved by a small number of people—namely, the aristocrats. The age of robotics and automation and automatic factories brings us to the point where every citizen could live the life of an aristocrat in the sense that we could be economically self-sufficient and secure, not beholden to any employer.[3]

Albus believes that within fifty years (from the time of his writing) a robotic workforce would be able to give each of us an annual income of around $750,000.[4]

Human slavery is unethical. Wouldn't robotic slavery be similarly unethical? Albus's robots can think for themselves. In other words, they have minds of their own. Can we in good conscience force such creatures to do something against their will? Wouldn't it be just as wrong to treat them as slaves as it would be to treat human beings that way? If not, what's the relevant difference? That they're made out of inorganic rather than organic materials? But isn't that just as morally irrelevant as someone's sex or race? Perhaps Albus's scenario is not as much of a utopia as he thinks it is.

Suppose we eventually create machines that can speak and solve problems as well as we do. Would that show that we are machines? Not necessarily, for we may not process information in the same way the machines do. But even if we are machines, our thoughts may not be explainable in mechanical terms. According to the seventeenth-century philosopher (and inventor of calculus) Gottfried Wilhelm von Leibniz, thinking isn't a mechanical concept. So even if a machine could think, thinking couldn't be explained mechanically. Leibniz elucidates this view by means of the following thought experiment.

Thought Experiment

Leibniz's Mental Mill

... it must be avowed that perception and what depends upon it cannot possibly be explained by mechanical reasons, that is by figure and movement. Suppose that there be a machine, the structure of which produces thinking, feeling, and perceiving; imagine this machine enlarged but preserving the same proportions, so that you could enter it as if it were a mill. This being supposed, you might visit its inside; but what would you observe there? Nothing but parts which push and move each other, and never anything that could explain perception. This explanation must therefore be sought in the simple substance, not in the composite, that is, in the machine.[5]

Although it's not made out of steel and silicon, the brain is a thinking, feeling, and perceiving machine. Yet if you were to shrink to the size of a blood cell and walk around inside of it, you would observe only the exchange of

WALKING AROUND INSIDE THE BRAIN. Suppose you were able to walk around inside a brain, like the crew from the movie *Fantastic Voyage*. Would you observe thinking?

chemicals between nerve cells. You wouldn't observe the thinking, feeling, and perceiving that the brain is doing. So, like Descartes, Leibniz believes that it's impossible to provide a mechanical account of the mind. But unlike Descartes, he doesn't believe that it's impossible to construct thinking machines. In his view, there can be machines that think; there just can't be mechanical explanations of thinking.

This may seem a strange view, but it has a number of adherents, even to this day. Wholes are often greater than the sum of their parts. A team, for example, may be the best in its league even though none of its members are. In such a case, an understanding of the parts may not yield an understanding of the whole. Similarly, the mind may be greater than the sum of its parts. Persons, for example, are intelligent even though none of their nerve cells are. So an understanding of their nerve cells may not yield an understanding of their minds.

Leibniz, however, doesn't believe that consciousness emerges from complex arrangements of matter. He believes that matter emerges from complex arrangements of consciousness. For him, the basic building blocks of the universe—the stuff out of which everything is made—are particles of consciousness ("monads") rather than particles of matter. So, according to Leibniz, consciousness is not something possessed by only a select few creatures. It is possessed, in some degree, by everything, even the most fundamental particles. That is why he says the explanation of consciousness must be sought in the simple rather than the complex.

In the News: The Approaching Singularity

To date, there have not been any human–robot marriages. Nevertheless, a number of thinkers believe that within the next couple of decades, computers will become as intelligent as we are. Such computers would be able to reproduce by designing and building other computers with even greater capabilities. At that point—known as the singularity—technological advance-ment would become so rapid that we could not foresee its outcome. Mathematician Verner Vinge explores the ramifications of this event:

> Within thirty years, we will have the technological means to create superhuman intelligence. Shortly after, the human era will be ended.
>
> ... we are on the edge of change comparable to the rise of human life on Earth. The precise cause of this change is the imminent creation by technology of entities with greater than human intelligence. There are several means by which science may achieve this breakthrough (and this is another reason for having confidence that the event will occur):
>
> - There may be developed computers that are "awake" and superhumanly intelligent. ...
> - Large computer networks (and their associated users) may "wake up" as a superhumanly intelligent entity.
> - Computer/human interfaces may become so intimate that users may reasonably be considered superhumanly intelligent.
> - Biological science may provide means to improve natural human intellect. ...
>
> From the human point of view this change will be a throwing away of all the previous rules, perhaps in the blink of an eye, an exponential runaway beyond any hope of control. Developments that before were thought might only happen in "a million years" (if ever) will likely happen in the next century.
>
> I think it's fair to call this event a singularity. It is a point where our old models must be discarded and a new reality rules. As we move closer to this point, it will loom vaster and vaster over human affairs till the notion becomes a commonplace. Yet when it finally happens it may still be a great surprise and a greater unknown. . . .
>
> Let an ultra intelligent machine be defined as a machine that can far surpass all the intellectual activities of any man however clever. Since the design of machines is one of these intellectual activities, an ultra intelligent machine could design even better machines; there would then unquestionably be an "intelligence explosion," and the intelligence of man would be left far behind. Thus the first ultra intelligent machine is the *last* invention that man need ever make, provided that the machine is docile enough to tell us how to keep it under control. . . . [6]

Thought Probe

Artificial Intelligence

If further research into artificial intelligence may result in the extinction of the human race, should it be allowed to continue? Should we try to ban it? How? Is there any way to ensure that artificially intelligent machines will not be created? What if one nation banned their creation and others didn't?

Such a view may seem odd to those of us raised in the West. But to those raised in the East, it may seem obvious. Many Hindu thinkers claim that all there is, is consciousness. The great Hindu theologian Shankara, for example, claims that reality is pure being, pure consciousness, and pure bliss.[7] According to Shankara, there is no matter in the world. There seems

to be matter, but that is an illusion created by our ignorance of the true nature of reality.

The view that mind is the sole reality is known as **idealism**. The view that matter is the sole reality is known as **materialism**. And the view that reality contains both mental and material things is known as **dualism**. One of the tasks of the philosophy of mind is to determine which of these views, if any, is the most reasonable. In the major research universities of the West, materialism is the dominant view. To date, however, no completely satisfactory materialist theory of the mind has been given. In other words, no one has fully explained how it is possible for a material object to think. But then again, no one has fully explained how it is possible for a nonmaterial object to think either. In an attempt to understand what it is to have a mind, we will explore various theories of mind, examine the thought experiments that have been used to test them, and show how they have developed in response to criticism.

Understanding the nature of mind and consciousness is one of the most pressing intellectual problems we face because, as we have seen, many believe we're on the verge of creating artificial beings with real general intelligence (AGI). Will these beings have minds of their own? Will they be self-aware? Will they be conscious? If so, how should we treat them? Should we give them the same rights that we have? Should they be allowed to vote, to marry, to own property? How we answer these questions will depend on the theory of mind we accept, and developing such a theory will require philosophical insight. As David Deutsch, physicist and father of quantum computing, reveals, "I am convinced that the whole problem of developing AGIs is a matter of philosophy, not computer science or neurophysiology, and that the philosophical progress that will be essential to their future integration is also a prerequisite for developing them in the first place."[8] Maybe you will be the one who develops the philosophical theory needed to deal with these issues. But in constructing such a theory, it's important to know the strengths and weaknesses of the theories that have come before. This chapter attempts to acquaint you with those theories.

We will begin by examining the dualistic theory of Descartes (Section 2.1). Then we will examine the materialistic theories of behaviorism and the identity theory (Section 2.2). Next we'll explore the nonmaterialist theory of functionalism (Section 2.3). Finally, we'll explore the materialist theories of eliminative materialism (Section 2.4) and property dualism (Section 2.5).

Each of these theories is the basis of an active research program in psychology, parapsychology, cognitive science, artificial intelligence, or linguistics. These theories determine not only how researchers in these fields interpret their results but also how they frame their experiments. What we look for is determined by what we expect to find. So if the philosophy behind these research programs is flawed, they are unlikely to succeed. As Alfred North Whitehead pointed out, science can only be as good as the philosophy behind it. An adequate theory of the nature of mind, then, must be informed by a sound philosophy.

idealism The doctrine that minds and their contents are all that exists.

materialism The doctrine that material objects are all that exist.

dualism The doctrine that reality contains both mental and material things.

Objectives

After reading this chapter, you should be able to

- state the various theories of mind.
- describe the thought experiments that have been used to test them.
- evaluate the strengths and weaknesses of the various theories of mind.
- define qualitative content, intentionality, and emergent property.
- formulate your own view of the nature of the mind and the possibility of artificial intelligence.

Section 2.1

The Ghost in the Machine
Mind as Soul

Descartes thought that no machine could think as well as we do. The only machines known to Descartes, however, were purely mechanical ones like clocks and waterwheels. If there had been electronic computers in his day, perhaps he would not have been so skeptical of artificial intelligence. Nevertheless, Descartes' belief that thinking could not be a physical process led him to conclude that it must be a nonphysical one. In his view, the mind is an immaterial entity that interacts with the body and yet is capable of existing independently of it. In other words, according to Descartes, the mind is the soul. The doctrine that mental states are states of an immaterial substance that interacts with the body is called **Cartesian dualism.**

Descartes' theory is dualistic because it claims that human beings are composed of two fundamentally different kinds of stuff: material and mental. Material stuff has physical properties like mass, charge, momentum, location in space, and so on. As a result, material objects can be detected by means of the senses. Mental stuff, on the other hand, has no physical properties whatsoever—it's colorless, odorless, and tasteless. It can't be detected by any physical instrument because it doesn't even have a location in space. Nevertheless, according to Descartes, not only does this stuff exist, but it's the stuff we think with—it's what our minds are made of—and it's capable of existing independently of our bodies. So when our bodies die, our minds will continue to exist.

Descartes' most persuasive arguments for the immateriality of the mind (and the immortality of the soul) appear in his *Meditations on First Philosophy,* which was originally subtitled "In which the existence of God and the Immortality of the Soul are demonstrated." Proving that the mind is separate from the body was not Descartes' only goal in writing the *Meditations,* however. He also wanted to prove that God exists and to explain how knowledge was possible. To understand how Descartes arrived at his theory of mind, it's helpful to know something about his larger project.

The soul of man is immortal and imperishable.
—Plato

One of the proofs of the immortality of the soul is that myriads have believed it—they also believed the world was flat.
—Mark Twain

Cartesian dualism
The doctrine that mental states are states of an immaterial substance that interacts with the body.

Descartes' Doubt

> To have doubted one's first principles is the mark of a civilized man.
> —Oliver Wendell Holmes

While still a student, Descartes came to a realization familiar to many undergraduates: Much of what he took to be certain and indubitable was uncertain and dubious. He concluded that most of what passes for knowledge is mere opinion, for knowledge requires certainty, and almost nothing is certain. The only place where Descartes found certainty (and thus knowledge) was in mathematics, especially geometry. Geometrical theorems are proved by deducing them from self-evident truths. If science is to yield knowledge, Descartes believed that it, too, must rest on a foundation of indubitable truths.

In the *Meditations,* Descartes sets out to find those truths. Finding just one indubitable truth, he thought, would go a long way toward putting science on a firm footing. He tells us, "Archimedes, that he might transport the entire globe from the place it occupied to another, demanded only a point that was firm and immovable; so, also, I shall be entitled to entertain the highest expectations, if I am fortunate enough to discover only one thing that is certain and indubitable."[9] To determine whether there is such an Archimedean point from which our knowledge of the external world could be derived, Descartes tried to determine whether there are any nonmathematical propositions that could not be doubted.

> I was thrown out of college for cheating on the metaphysics exam: I looked into the soul of the boy sitting next to me.
> —Woody Allen

Descartes realized that to carry out his project, he did not have to examine each of his beliefs individually. Rather, he could examine entire families of beliefs by investigating the principles from which they were derived. If those principles could be doubted, then everything based on them could also be doubted. As Descartes puts it, "Nor for this purpose will it be necessary even to deal with each belief individually, which would be truly an endless labor; but, as the removal from below of the foundation necessarily involves the downfall of the whole edifice, I will at once approach the criticism of the principles on which all my former beliefs rested."[10]

One of the principles on which the edifice of science rests is that sense experience is a source of knowledge. But, Descartes argues, this principle is dubious because we can't be certain that sense experience accurately represents the world. Sometimes, we experience things that aren't really there, as in the case of hallucinations. Other times, we experience things differently from the way they really are, as in the case of illusions. So, just as we can't trust a witness who has lied in the past, we can't trust sense experience to give us an accurate picture of reality.

To demonstrate the unreliability of sense experience, Descartes appeals to the phenomenon of dreams. "How often have I dreamt that I was in these familiar circumstances, that I was dressed, and occupied this place by the fire, when I was lying undressed in bed?"[11] he asks. The problem is that dreams often seem very real, and there is no way to tell for certain while we are dreaming that we are dreaming. It is possible, for example, that you will wake up in a few minutes and realize that your reading this book was nothing but a (bad?) dream. Because we can never be absolutely certain that we are *not* dreaming, sense experience cannot be a source of knowledge.

If sense experience is not a source of knowledge, then a lot of what passes for knowledge isn't really knowledge. But sense experience isn't our *only* source of knowledge. We also have knowledge of mathematics, and that isn't based on sense experience. Mathematical theories, unlike scientific ones, need not be verified by observation. Their truth can be discovered by the light of pure reason.

But even the deliverances of reason, claims Descartes, can be doubted. To demonstrate this, Descartes proposes a thought experiment. It is possible, he argues, that there is a being (like God) who brings it about that everything he believes, even in the realm of mathematics and geometry, is false. As Descartes says,

> How do I know that He has not brought it to pass that there is no earth, no heaven, no extended body, no magnitude, no place, and that nevertheless they seem to me to exist just exactly as I now see them? And, besides, as I sometimes imagine that others deceive themselves in the things which they think they know best, how do I know that I am not deceived every time that I add two and three, or count the sides of a square, or judge of things yet simpler if anything simpler can be imagined?[12]

Because he cannot rule out the possibility that there is such a demon, it seems that Descartes can't know whether any of his beliefs are true.

Descartes envisions a supernatural being who, through some sort of mental telepathy, puts thoughts in his mind. But Descartes' point can be made without appeal to the supernatural. We know that thoughts and sensations can be produced by electrically or chemically stimulating the brain. Once we understand the brain well enough, we should be able to give anyone any kind of experience by stimulating his or her brain in the right ways. Descartes' question is this: How do we know that our experiences aren't being produced artificially? How do we know, for example, that we're not brains in a vat, like the people in the movie *The Matrix*, whose experiences are being controlled by computers? Or how do we know that we're not playing an advanced virtual reality game, as depicted in the movies *The Thirteenth Floor* and *Existenz*? Descartes claims that because there is no way to tell whether such possibilities are actual, we can't acquire knowledge of the external world by means of sense experience.

Doubt is the key to knowledge.
—Persian Proverb

Men become civilized, not in proportion to their willingness to believe, but in proportion to their readiness to doubt.
—H. L. Mencken

Thought Probe

Are We Living in a Computer Simulation?

Are we living in a computer simulation? Elon Musk, CEO of Tesla, SpaceX, and Solar City, thinks so. It's a topic that he and his brother had discussed so often that they agreed not to bring it up if they ever found themselves in a hot tub (because it would ruin the vibe). At a conference in China, Musk spelled out his reasoning this way:

> The strongest argument for us probably being is a simulation is the following: 40 years ago we had pong—two rectangles and a dot—now

René Descartes: Father of Modern Philosophy

In the seventeenth century, systems of thought that had been framed by ancient philosophers and church fathers were breaking down under pressure from an intellectual revolution inspired in large part by science. And René Descartes (1596–1650) was probably the revolution's greatest hero and the true founder of modern philosophy.

He was born near Tours, France, a contemporary of Galileo and Kepler, arriving just after Copernicus did his work and just before Newton did his. At age ten, he was sent off to the Jesuit College of La Fleche in Anjou, where his studies included philosophy and mathematics. After La Fleche, he received a degree in law and in 1618 enlisted in the Dutch army to round out his education. During his tour of duty, his interest in creating a new scientific and philosophical system was inspired by dreams he had while sleeping in a "stove-heated room."

He was an extremely bright student, very advanced for his age, and as a young man he accomplished some impressive intellectual feats. He saw through his teachers and realized that their reasoning was faulty and their arguments flawed. Everything was doubtful—a state of affairs that he sought most of his life to remedy. In his twenties, he devoted most of his energies to mathematics, a field in which he made a remarkable contribution: He invented coordinate geometry. (The term "Cartesian coordinates" is a reference to Descartes.) In mathematics Descartes saw a rational system that led from simple premises to certain knowledge, and he hoped that somehow all knowledge might have the same simple structure and yield the same degree of certainty.

In 1628, he emigrated to Holland, where he produced his two most important philosophical works: *Discourse on Method* and *Meditations on First Philosophy*, his masterpiece. Later followed *Principles of Philosophy*, a compendium of his ideas on metaphysics and science, and *The Passions of the Soul*, a work on ethics and psychology.

In 1649, he left Holland to teach philosophy to Queen Kristina of Sweden. There he contracted pneumonia and died—allegedly because he was forced to tutor at 5:00 A.M., an arduous break from his usual routine of sleeping in. His last words were reputed to be yet another reference to his dualist view of mind and body: "So, my soul, it is time to part."

we have photorealistic 3d simulations with millions of people playing simultaneously, and it's getting better every year. . . . If you assume any rate of improvement at all, then the games will become indistinguishable from reality, even if that rate of advancements drops by a thousand from what it is right now. Then you say, "Okay, let's imagine it's 10,000 years in the future (which is nothing in the evolutionary scale), so it's a given that we're clearly on a trajectory to have games that are indistinguishable from reality and those games could be played on any set-top box or on a PC or whatever. . . . It would seem to follow that the odds we're in base reality is one in billions."[13]

Is this a good argument? Why or why not? Do you agree with Musk that the chances are billions to one that we're *not* living in a computer simulation?

I Think, Therefore I Am

It's beginning to look like Descartes can't know anything, for it appears to be possible to doubt everything. But even here, Descartes claims, appearances

can be deceiving, for there is at least one thing that he cannot doubt, namely, the fact that he is doubting. But if it's certain that he is doubting, it's also certain that he exists, for he can't doubt unless he exists. Thus Descartes concludes that he knows at least one thing: "I think, therefore I am." Here is Descartes' account of how he arrived at this realization.

RENÉ DESCARTES
1596–1650

> I observed that, whilst I thus wished to think that all was false, it was absolutely necessary that I, who thus thought, should be somewhat; and as I observed that this truth, I think, therefore I am (COGITO ERGO SUM), was so certain and of such evidence that no ground of doubt, however extravagant, could be alleged by the Sceptics capable of shaking it, I concluded that I might, without scruple, accept it as the first principle of the Philosophy of which I was in search.[14]

Descartes thought that this truth—"I think, therefore I am"—could serve as the foundation for our knowledge of the external world. We will examine this claim in more detail in Chapter 7, but our present concern is Descartes' theory of mind. What sort of beings are we?

The Conceivability Argument

Materialists claim that we are material objects—complex arrangements of particles of matter. If that were the case, we could not exist without a body. But, Descartes claims, we *can* exist without a body. As a result, we must be something more than matter in motion. What more? An immaterial mind. Here is how Descartes arrived at this view:

One cannot conceive anything so strange and so implausible that it has not already been said by one philosopher or another.

—RENÉ DESCARTES

> I attentively examined what I was and as I observed that I could suppose that I had no body, and that there was no world nor any place in which I might be; but that I could not therefore suppose that I was not; and that, on the contrary, from the very circumstance that I thought to doubt of the truth of other things, it most clearly and certainly followed that I was; while, on the other hand, if I had only ceased to think, although all the other objects which I had ever imagined had been in reality existent, I would have had no reason to believe that I existed; I thence concluded that I was a substance whose whole essence or nature consists only in thinking, and which, that it may exist, has need of no place, nor is dependent on any material thing; so that "I," that is to say, the mind by which I am what I am, is wholly distinct from the body, and is even more easily known than the latter, and is such, that although the latter were not, it would still continue to be all that it is.[15]

It's conceivable that we can exist without our bodies. After all, many believe that their souls will continue to exist after their bodies die, and on the face of it, that belief doesn't seem to be self-contradictory. It's not conceivable that we can exist without our minds, however. If we can no longer think, Descartes claims, we no longer exist. Minds, though, are not material things, for they do not occupy space. So, Descartes concludes, we are thinking things, immaterial substances with no physical properties. In the words of the rock musician Sting, "We are spirits in a material world."

The Biblical Conception of the Person

Although many people believe that Descartes' dualistic view of the person is the traditional Christian view, they are mistaken. Rather, the Bible presents a monistic view of the person in which the mind and the body are inseparable from each other. British theologian Adrian Thatcher explains,

> There appears to be a rare unanimity among biblical scholars that the biblical picture of the person is non-dualist, and that the Bible gives little or no support to the idea that a person is essentially a soul, or that the soul is separable from the body. Dualists, of course, may reply that, regardless of what the Bible said about the issue then, dualism offers a convincing framework for Christian teaching now. Even so, they cannot get around the fact that, from a biblical point of view, dualism is very odd. Lynn de Silva summarizes the position thus:
>
>> Biblical scholarship has established quite conclusively that there is no dichotomous concept of man in the Bible, such as is found in Greek and Hindu thought. The biblical view of man is holistic, not dualistic. The notion of the soul as an immortal entity which enters the body at birth and leaves it at death is quite foreign to the biblical view of man. The biblical view is that man is a unity; he is a unity of soul, body, flesh, mind, etc. all together constituting the whole man. None of the constituent elements is capable of separating itself from the total structure and continuing to live after death. . . .
>
> In biblical thought, the entire human being, not merely the human body, is subject to death and decay. Dust you are, and to dust you shall return, says God to the man in the garden (Gen. 3:19). All mankind is grass, cries the prophet; 'they last no longer than a flower of the field. The grass withers, the flower fades, when the breath of the Lord blows upon them; the grass withers, the flowers fade, but the word of our God endures for evermore' (Isa. 40:6–8). Your life, what is it?, asks St. James. You are no more than a mist, seen for a little while and then dispersing (Jas. 4:14).
>
> More important, the doctrines of creation, incarnation, resurrection, and ascension all favor the non-dualist view. To say that our souls are immortal is to blur the distinction between the Creator and the creature. What is created, as the biblical passages just quoted clearly show, has an end as well as a beginning; indeed, the whole point of these images in these verses is to draw attention to the brevity of human life, especially when compared with the eternal life of God. But this makes no sense if persons are immortal, appearances notwithstanding. The incarnation of God in Christ is a profoundly materialistic affair which allows the human nature of Christ in its totality—not merely Christ's human soul—to be taken up into perfect unity of his single divine Person. Moreover, the resurrection and ascension of Christ seem clearly to exclude dualistic accounts of the human person. The death of Christ was a real and total death, not merely the death of his mortal body. The miracle of the resurrection is precisely that God raises Jesus from the dead, not that he raises Jesus' mortal body and reunites it with his immortal soul. What purpose does the resurrection of Jesus serve, we may ask, if Jesus was not really dead? Was it just to convince the disciples that the bonds of death were forever loosened? Hardly, for if the disciples had believed in immortal souls they would not have required assurance on that point; and if they had needed such assurance, a resurrection miracle would not have provided it; it would merely have created confusion. The ascension of Christ is also rendered superfluous by a dualist account of the person; for the soul of Christ, being alive after his physical death, would presumably have been capable of returning to the Father without its body. What then is the ascension? A highly visual way of saying cheerio? It is, rather, the return of the transformed, transfigured, glorified, yet still embodied, Christ to the Father. No particular historical version of the event is favored by arguing thus. The point is that the theological convictions expressed by the resurrection and ascension narratives make much better sense on the assumption that all men and women are essentially bodily unities, after, as well as before, their bodily deaths.[16]

Descartes provides a familiar—and comforting—view of the self. Most of us would like to believe that we will survive the death of our bodies. But even though the prospect of immortality is enticing, very few philosophers or psychologists find Descartes' view convincing. To see why there are so few Cartesian dualists, let's take a closer look at his reasoning.

Descartes is trying to find his nature or essence. The nature or essence of a thing is what makes it what it is. It consists of those properties the thing could not possibly do without. For example, having four equal sides is an essential property of a square because if a square lost that property, it would cease to exist. An essential property, then, is a logically necessary condition. It's a requirement that must be met in order for a thing to exist.

Descartes first considers the hypothesis that having a body is essential to him. He reasons that if his body is essential to him, then it should be inconceivable for him to exist without a body. But, he claims, that's not inconceivable. The notion of a disembodied mind is coherently imaginable. So, he concludes, having a body is not essential to him.

He then considers the hypothesis that having a mind is essential to him. He reasons that if his mind is essential to him, then it should be inconceivable for him to exist and not have a mind. That he finds to be inconceivable. If he lost the ability to think, he would cease to exist. So having a mind is essential to him.

Descartes' argument can be spelled out as follows:

1. It's conceivable for me to exist without having a body.
2. Whatever is conceivable is possible.
3. Therefore, it's possible for me to exist without having a body.
4. If it's possible for me to exist without having a body, then having a body is not essential to me.
5. Therefore, having a body is not essential to me.
6. It's inconceivable for me to exist without having a mind.
7. Whatever is inconceivable is impossible.
8. Therefore, it's impossible for me to exist and not have a mind.
9. If it's impossible for me to exist without having a mind, then having a mind is essential to me.
10. Therefore, having a mind is essential to me.

Although these arguments are valid—their conclusions follow from their premises—they may not be sound, for some of their premises may be false. The crucial premise here is that disembodied existence is conceivable. Is it? Try the thought experiment yourself. Imagine you have no body—no arms, no legs, no hands, no eyes, no ears, and so on. Can you do it? If so, are you really imagining existing without a body, or are you imagining existing in a ghostlike quasi-physical body? Remember, Cartesian minds have no physical attributes, not even a location in space. You wouldn't be able to do anything (besides think) or feel anything because you wouldn't have a body. You wouldn't be able to communicate with others unless you were given some sort

> *Thinking is being.*
> —PARMENIDES

> *Man is to himself the most wonderful object in nature; for he cannot conceive what the body is, still less what the mind is, and least of all how a body should be united to a mind. This is the consummation of his difficulties, and yet it is his very being.*
> —BLAISE PASCAL

The Ghost in the Machine

In the News: Descartes and Vivisection

On January 18, 1982, a member of the Animal Liberation Front (ALF) entered the headquarters of the Royal Society—the United Kingdom's national academy of science—and slashed Descartes' portrait several times with a knife. What would motivate a member of the ALF to do such a thing? Descartes, it turns out, is believed by many to be the father of modern vivisection—the practice of experimenting on live animals.

That dubious distinction is often bestowed on Descartes because he believed that animals had no souls and thus could feel no pain. He writes in his *Discourse on Method*:

> It is also very worthy of remark, that, though there are many animals which manifest more industry than we in certain of their actions, the same animals are yet observed to show none at all in many others: so that the circumstance that they do better than we does not prove that they are endowed with mind, for it would thence follow that they possessed greater reason than any of us, and could surpass us in all things; on the contrary, it rather proves that they are destitute of reason, and that it is nature which acts in them according to the disposition of their organs: thus it is seen, that a clock composed only of wheels and weights can number the hours and measure time more exactly than we with all our skin.[17]

Descartes thought that in order to think or feel, you had to be conscious; and that in order to be conscious, you had to have a mind. Since animals do not have minds, they couldn't think or feel. Nicholas Malebranch sums up Descartes' view this way: "They eat without pleasure, cry without pain, grow without knowing; they desire nothing, fear nothing, and know nothing."[18]

Scientists convinced of this view supposedly carried out all sorts of experiments on live animals without a twinge of guilt. La Fontaine, for example, reports:

> They [the Cartsian scientists] administered beatings to dogs with perfect indifference and made fun of those who pitied the creatures as if they had felt pain. They said that the animals were clocks; that the cries they emitted when struck were only the noise of a little spring which had been touched, but that the whole body was without feeling. They nailed poor animals up on boards by their four paws to vivisect them and see the circulation of the blood which was a great subject of controversy.[19]

As far as we know, however, Descartes himself did not perform any vivisections. He even had a pet dog named "Monsieur Grat" that he cared for dearly—not the sort of behavior one would expect from someone who thought that animals were robots.

Descartes' kindness toward his dog may stem from the fact that he was uncertain of his view of animals. In a letter to Henry Moore, he writes, "Though I regard it as established that we cannot prove there is any thought in animals, I do not think it is thereby proved that there is not, since the human mind does not reach into their hearts."[20] Descartes realizes that from the fact that we cannot prove something to be true, it doesn't follow that it's false. To think otherwise would be to commit the fallacy of the appeal to ignorance. We cannot prove that animals have minds, but that doesn't mean that they don't because we can't get inside an animal's head (or heart). Since we can't know whether animals have minds, Descartes appears to be willing to give them the benefit of the doubt.

of telepathic ability. But, even then, it's unclear how you would identify them, for they, too, would have neither a body nor a location in space.

On reflection, many find the notion of disembodied existence inconceivable. British philosopher C. D. Broad sums up his reservations about it this way:

> Speaking for myself, I find it more and more difficult, the more I try to go into concrete detail, to conceive of a person so unlike the only ones that I know

anything about, and from whom my whole notion of personality is necessarily derived, as an unembodied person would inevitably be. He would have to perceive foreign things and events (if he did so at all) in some kind of clairvoyant way, without using special sense-organs, such as eyes and ears, and experiencing special sensations through their being stimulated from without. He would have to act upon foreign things and persons (if he did so at all) in some kind of telekinetic way, without using limbs and without the characteristic feelings of stress, strain, etc., that come from the skin, the joints, and the muscles, when we use our limbs. He would have to communicate with other persons (if he did so at all) in some kind of telepathic way, without using vocal organs and emitting articulate sounds; and his conversations with himself (if he had any) would have to be conducted purely in imagery, without any help from incipient movements in the vocal organs and the sensations to which they give rise in persons like ourselves.

All this is 'conceivable', so long as one keeps it in the abstract; but, when I try to think 'what it would be like' in concrete detail, I find that I have no clear and definite ideas. That incapacity of mine, even if it should be shared by most others, does not of course set any limit to what may in fact exist and happen in nature. But it does set a very definite limit to profitable speculation on these matters. And, if I cannot clearly conceive what it would be like to be an unembodied person, I find it almost incredible that the experiences of such a person (if such there could be) could be sufficiently continuous with those had in his lifetime by any deceased human being as to constitute together the experiences of *one and the same* person.[21]

> My mind is incapable of conceiving such a thing as a soul. I may be in error, and man may have a soul; but I simply do not believe it.
> —Thomas A. Edison

Broad claims that existing without a body is not conceivable because it's not coherently imaginable. Once he started filling in the details and drawing out the implications of such an existence, he ended up with something so foreign to his experience that it was unintelligible. What's more, he claims that even if you have an immaterial soul, and even if it survives the death of your body, *you* won't survive the death of your body because your identity is tied to your body. (We will examine this issue more thoroughly in Chapter 4.)

We are justified in believing something only if it's beyond a reasonable doubt. Broad's reflections, however, indicate that there's good reason to doubt that a disembodied existence is conceivable. Because we're not justified in believing the first premise of Descartes' conceivability argument, it doesn't prove that we can exist without our bodies.

Thought Probe

Heaven without Bodies

Suppose that you have an immaterial soul, and suppose that it goes to heaven when you die, so that heaven is populated exclusively with immaterial souls. Would heaven be something to look forward to? You would no longer be able to perform any of the physical activities that gave you pleasure or gaze on the face

of your loved ones. All of the sights, sounds, and smells of your former existence would be gone. Because the only possible means of communication would be telepathy, everybody might be able to read your mind. In that case, you would have no privacy whatsoever. You wouldn't even be able to keep your thoughts to yourself. Is that any way to spend eternity?

The Divisibility Argument

Mind is a lyric cry in the midst of business.

—GEORGE SANTAYANA

The argument from conceivability isn't the only one Descartes presents for his brand of dualism. He also gives us the following argument from divisibility:

> . . . there is a vast difference between mind and body, in respect that body, from its nature, is always divisible, and that mind is entirely indivisible. For in truth, when I consider the mind, that is, when I consider myself in so far only as I am a thinking thing, I can distinguish in myself no parts, but I very clearly discern that I am somewhat absolutely one and entire; . . .But quite the opposite holds in corporeal or extended things; for I cannot imagine any one of them [how small soever it may be], which I cannot easily sunder in thought, and which, therefore, I do not know to be divisible. This would be sufficient to teach me that the mind or soul of man is entirely different from the body, if I had not already been apprised of it on other grounds.[22]

Here Descartes is appealing to the principle known as the **indiscernibility of identicals:** If two things are numerically identical (that is, if two names or descriptions refer to one and the same thing), then whatever is true of one is true of the other, and vice versa. For example, if Mark Twain is numerically identical to Samuel Clemens, then whatever is true of Mark Twain is true of Samuel Clemens, and vice versa. Descartes' divisibility argument, then, is this:

1. If minds are identical to bodies, then whatever is true of minds is true of bodies, and vice versa.

2. But minds are indivisible and bodies are divisible.

3. Therefore, minds are not identical to bodies.

This, too, is a valid argument. So again, the question is, how believable are the premises?

Premise 2 might be questioned on the grounds that neurophysiologists have shown that minds can be divided. There is a neurophysiological operation—cerebral commissurotomy—that severs the bundle of nerves that connects the two hemispheres of the brain (the *corpus callosum*). Patients who undergo this split-brain operation (usually to alleviate epilepsy) seem to be left with split minds. As Roger Sperry, the Nobel Prize–winning psychologist who pioneered this technique, reveals, "Everything we have seen so far indicates that the surgery has left these people with two separate minds, that is, two separate spheres of consciousness. What is experienced

indiscernibility of identicals The principle that if two things are identical, then they must both possess the same properties.

86 Chapter 2 • The Mind-Body Problem

in the right hemisphere seems to be entirely outside the realm of awareness of the left."[23] This raises an intriguing question: After the operation, do we now have two people where before there was only one? This is a question we will consider more fully in the chapter on personal identity (Chapter 4).

Even if Descartes is correct in claiming that bodies are divisible and minds aren't, it doesn't follow that minds can exist independently of them. For minds could be capacities of the body. To see this, consider voices. Voices are not vocal chords. When you lose your voice, you don't lose your vocal chords; you lose the capacity to produce sound. This capacity, however, isn't divisible. You can no more divide a capacity than you can divide a feeling. This doesn't mean, however, that voices can exist independently of vocal chords. Just as voices are capacities to produce sounds, minds may be capacities to produce behaviors. If so, then even though minds are not divisible, they could not exist independently of bodies.

Thought Probe

A Split-Brain Patient of Two Minds

Split-brain patients (those who have had the bundle of nerve fibers connecting the two hemispheres of the brain severed) appear not only to have two separate centers of consciousness (one hemisphere may be aware of something that the other is not) but also to have separate wills (one hemisphere may want to do something that the other does not). But can they have two separate sets of beliefs? Apparently so.

Talking to the left hemisphere is easy because language processing usually occurs in that part of the brain. But the right hemisphere can understand simple questions and can be taught to respond to them by pointing to answers such as "Yes," "No," and "I don't know." To probe the psychology of the right hemisphere, the neurophysiologist Vilayanur Ramachandran taught the right hemisphere of a number of split-brain patients to respond to questions in this manner. In one case, however, he asked the patient, "Do you believe in God?" The left hemisphere answered "Yes," and the right hemisphere pointed to "No." Ramachandran describes the situation this way:

> Here's a human being whose right hemisphere is an atheist and left hemisphere believes in God. This finding should have sent a tsunami through the theological community but barely produced a ripple. Because it raises all kinds of profound theological questions: if this person dies, what happens? Does one hemisphere go to heaven and the other go to hell?[24]

What do you think will happen when the body containing the two opposed hemispheres dies? Maybe there is no afterlife. But if there is, how can the person(s) involved get their just reward?

The Problem of Interaction

Oh! ridiculous writer, if I once admit these two distinct substances, you have nothing more to teach me. For you do not know what it is that you call soul, less still how they are united, nor how they act reciprocally on one another.

—Diderot

Descartes' theory is a form of dualistic interactionism because although it holds that the mind and the body are two distinct substances, they nonetheless interact with one another. What goes on in our minds affects what happens to our bodies, and vice versa. For example, embarrassment can cause you to blush, anger can cause your blood pressure to rise, fear can cause you to break out in a cold sweat, and so on. Conversely, getting pinched can cause you to feel pain, taking drugs can make you hallucinate, eating chocolate can give you pleasure, and so on. But Cartesian minds have no physical properties. So how can they interact with physical objects? They can't interact with bodies by bumping into them because they have no location in space. Nor can they interact with bodies by means of forces like electromagnetism or gravity because those forces affect only physical bodies. Insofar as Cartesian dualism doesn't explain how mind-body interaction is possible, it can't account for some of the most important facts about the mind.

The problem that mind-body interaction poses for Descartes' theory was recognized early on. Princess Elizabeth of Bohemia (1618–1680), a woman of remarkable intellectual talent who refused to marry because she preferred the life of the mind, began reading Descartes' *Meditations* in 1642. When Descartes learned of Elizabeth's interest in his work, he wrote her a letter offering to explain anything she might not understand. In a response penned on May 6, 1643, Elizabeth put the following question to Descartes:

> I beg of you to tell me how the human soul can determine the movement of the animal spirits (the chemicals released by neurons) in the body so as to perform voluntary acts—being as it is merely a conscious substance. For the determination of movement seems always to come about from the moving body's being propelled—to depend on the kind of impulse it gets from what sets it in motion, or again, on the nature and shape of this latter thing's surface. Now the first two conditions involve contact, and the third involves that the impelling thing has extension; but you utterly exclude extension from your notion of soul, and contact seems to me incompatible with a thing's being immaterial.[25]

Elizabeth saw clearly that Descartes' characterization of the soul as nonphysical made it difficult to explain how it could have any physical effects.

Descartes did not have a good answer to Elizabeth's question. He originally responded by saying that minds may affect bodies in the same way that gravity does, but this won't do because gravity is a physical force, and minds have no physical properties. Later, in *The Passions of the Soul,* Descartes tries to explain mind-body interaction by attributing it to the pineal gland:

> It is also necessary to know that although the soul be joined to all the body, yet there is some part in that body wherein she exercises her functions more peculiarly than all the rest. And, it is commonly believed that this part is the brain, or it may be the heart. The brain, because thither tend the organs of the senses, and the heart because therein the passions are felt. But having searched this business carefully, me thinks I have plainly found out that that part of the body wherein

> ### Parallelism: Occasionalism and the Preestablished Harmony
>
> One way to deal with the problem of mind-body interaction is to claim that it is only apparent, not real. The mind and body seem to interact with each other, but that's because mental processes and physical processes run parallel to each other. According to **parallelism**, the correlation between mental and physical events is not the result of a causal interaction between the two.
>
> Some parallelists believe that God produces the correlation by constantly intervening in our affairs. A decision to raise one's arm, for example, is an occasion for God to cause certain nerve cells to fire. Similarly, getting kicked in the shins is an occasion for God to create a feeling of pain in our minds. This view, known as **occasionalism**, solves the problem of mind-body interaction, but at the price of introducing yet another entity into the picture, namely, God. Unfortunately, the price seems to be rather high, for divine intervention is just as mysterious as mind-body interaction.
>
> Other parallelists believe that God produced the correlation by designing the mental and physical realms in such a way that events in one naturally correspond to events in the other. Leibniz, for example, likens the mind and the body to two clocks that have been synchronized with each other. Just as events in one clock correspond to events in the other without the need for any sort of intervention, so events in the mind correspond to events in the body without the need for any sort of divine intervention. Leibniz called this view the **preestablished harmony** because the correlation between the mind and the body was set up by God from the beginning of the universe.
>
> Neither of these versions of parallelism is very appealing, for both make mind-body interaction miraculous. Occasionalism requires a lot of little miracles, and the preestablished harmony requires one big miracle—and miracles defy human understanding.

the soul immediately exercises her function is not a jot of the heart, nor yet all the brain, but only the most interior part of it, which is a certain very small kernel situated in the middle of the substance of it and so hung on the top of the conduit by which the spirits of its anterior cavities have communication with those of the posterior, whose least motions in it cause the course of the spirits very much to change, and reciprocally, the least alteration befalling the course of the spirits cause the motions of the kernel very much to alter.[26]

Descartes considered the pineal gland to be the locus of mind-body interaction because he thought it was the organ that unified our sense experience. We have two eyes, two hands, two ears, and so on, but ordinarily we do not see, feel, or hear double. Because we have only one pineal gland, Descartes thought it was responsible for weaving the various inputs from our different senses into a coherent whole.

We now know that the pineal gland doesn't unify our sense experiences. But even if it did, Descartes hasn't offered us a solution to the problem of mind-body interaction because he hasn't told us how the mind alters the flow of "animal spirits" in the nerve cells. It's just as difficult to understand how a nonphysical thing can move a miniscule physical object as it is to understand how such a thing can move a massive one. Without a credible account of how the mind and the body interact, Descartes' theory doesn't provide a satisfactory account of the mind.

parallelism The doctrine that the mind and the body are two separate things that do not interact with one another.

occasionalism The parallelist theory of the mind that claims the correlation between mental and physical events is produced on each occasion by God.

preestablished harmony The parallelist theory of mind that claims that the correlation between mental and physical events was established by God at the beginning of the universe.

The Causal Closure of the Physical

The physical cause threatens to exclude, and preempt, the mental cause.

—Jaegwon Kim

Descartes' dualistic interactionism also runs afoul of a basic principle of materialism known as the **causal closure of the physical.** According to this principle, no physical effect has a nonphysical cause. Any bodily movement, for example, can be explained by the fact that certain muscles contracted. And the fact that certain muscles contracted can be explained by the fact that certain neurons fired. And the fact that certain neurons fired can be explained by the fact that certain chemicals were present in the brain. And so on. Nowhere in this chain of explanations must we postulate a nonphysical cause.

What's more, the very notion of a nonphysical cause seems to contradict one of the most fundamental laws of physics: the law of the conservation of mass-energy. According to this law, the total amount of mass-energy in a closed system—a system in which no mass-energy can enter or exit—remains constant. The idea is that mass-energy can't magically appear or disappear. Since modern science takes the physical world to be a closed system, no nonphysical thing like a Cartesian mind can affect it. Remember Cartesian minds exist "outside" the physical world because they have no physical properties. If they affected the physical world, they'd have to change its energy level. But that's impossible because the physical world is closed—no mass-energy can enter or leave it. So Cartesian minds can't interact with the physical world.

Nevertheless, people do have thoughts, feelings, and desires, and these things seem to be nonphysical. How can we reconcile these facts? Some have suggested that we can reconcile them by admitting the existence of Cartesian minds and denying them any causal power.

This view, known as **epiphenomenalism,** holds that causation between the mind and the body is a one-way street: The body affects the mind, but the mind does not affect the body. The mind is merely an ineffective by-product of physical processes going on in the body. (An "epiphenomenon" is a secondary process that results from and depends on a primary process.) So epiphenomenalists believe that just as the smoke produced by a fire has no effect on the fire itself, the thoughts, feelings, and desires produced by the brain have no effect on the brain. Or to use another analogy, just as steam is a by-product of boiling water and has no effect on the water that produced it, so the mind is a by-product of the brain and has no effect on the brain that produced it.

This view of the mind-body relation is an attractive one to those who believe that science can explain everything that happens in the world in purely physical terms. It leaves unexplained the mechanism by which the body affects the mind, but it doesn't postulate any unobservable causes. Epiphenomenalism was championed by a number of thinkers in the nineteenth and twentieth centuries, most notably, Thomas Huxley:

> All states of consciousness in us, as in [brutes], are immediately caused by molecular changes of the brain-substance. It seems to me that in men, as in brutes, there is no proof that any state of consciousness is the cause of change in the motion of the matter of the organism. If these positions are well based, it follows that our mental conditions are simply the symbols in consciousness of the changes which take place automatically in the organism; and that, to take an

causal closure of the physical The principle that no physical effect has a nonphysical cause.

epiphenomenalism The doctrine that the mind is an ineffective by-product of physical processes.

THE MIND-BODY INTERFACE. According to Descartes, the pineal gland is the interface between the mind and the body. In this illustration from the 1664 French edition of the *Treatise of Man,* the pineal gland sends information to the mind from the eyes and receives instructions from the mind to move the muscles.

extreme illustration, the feeling we call volition is not the cause of a voluntary act, but the symbol of that state of the brain which is the immediate cause of that act. We are conscious automata. . . .[27]

Huxley would have us believe that our thoughts, feelings, and desires have no effect on what we do. Our lives would have been no different if we had never formed any beliefs, felt any pain, or longed for any objects. In fact, the entire history of the human race would have been no different if no one had ever had a single thought.

Such a view flies in the face of common sense. What we do with our lives seems very much to depend on what goes on in our minds. For example, wanting to greet a friend can cause you to raise your arm. Believing that a road is closed can cause you to take another route. Feeling pain can cause you to remove your hand from a hot stove. If epiphenomenalism were true, all of these claims would be false because mental states would be only effects, never causes.

What's more, if mental states don't cause anything, it's unclear why they exist. If minds have no physical effects, they confer no reproductive advantage on those who have them. So epiphenomenalists can't explain the existence of minds by appeal to their survival value because, in their view, minds have no survival value. Creatures with minds are no better off than creatures

How . . . can the consciousness be dismissed as an epiphenomenon when only by virtue of this epiphenomenon could it be perceived to be an epiphenomenon—or anything else?

—JOSEPH WOOD KRUTCH

The Ghost in the Machine 91

without them. As a theory of mind, then, epiphenomenalism seems to have little to recommend it over Cartesian dualism.

Thought Probe

Mental Relay Stations

According to Cartesian dualism, we don't think with our brains; we think with our minds. So for the Cartesian dualist, the brain must be nothing more than a sophisticated relay station, receiving messages from the mind and sending messages to it. In this view, those suffering from severe brain damage or from diseases such as Alzheimer's have not suffered any cognitive impairment at all. Their minds are just as good as they ever were; they have simply lost the ability to communicate with their bodies. Is this plausible? Are minds unaffected by brain damage or disease? Or does the loss of brain function also result in a loss of mental function? Which explanation is more plausible? Why?

The Problem of Other Minds

> One of the things that makes Wittgenstein a real artist to me is that he realized that no conclusion could be more horrible than solipsism.
>
> —DAVID FOSTER WALLACE

Both epiphenomenalism and Cartesian dualism face another embarrassing problem: There seems to be no sure way to tell whether other people have minds. This is the **problem of other minds.** You know that you have a mind because you experience it directly. You have various thoughts, feelings, and desires, and this proves that you have a mind. But you can't directly experience anybody else's mind. You can't have other people's thoughts, feelings, or desires. So, to arrive at the conclusion that other people have minds, you must appeal to certain physical facts. But it seems that those facts can't establish the existence of immaterial minds beyond a reasonable doubt.

Because immaterial minds have no physical properties, you can't use physical instruments to detect them. CAT (computerized axial tomography) scans and MRIs (magnetic resonance imaging) may be able to tell you whether other humans have brains, but they can't tell you whether they have minds. And because any behavior can be produced mechanically, the fact that something behaves in a certain way can't prove that it has a mind. Descartes himself was aware of this problem. He writes, "And yet what do I see from the window beyond hats and cloaks that might cover artificial machines, whose motions might be determined by springs?"[28] For all a substance dualist knows, then, all the other humans he encounters are mindless automatons—like Stepford Wives—only perhaps not so benign.

The view that one's mind is the only mind that can be known to exist is called **solipsism.** Although some people are attracted to this position, it is decidedly odd, if not insane, because accepting it means rejecting a great many other beliefs we have about the nature of reality, knowledge, and value. For example, we ordinarily claim to know that other people have minds, that what's on their minds affects their behavior, and that those with minds

problem of other minds The philosophical problem of explaining how it is possible to know that there are other minds in the world.

solipsism The view that there is only one mind in the universe, namely, one's own.

deserve special treatment, and so on. If some sort of substance dualism is true, however, it's unclear that we can legitimately claim to know any of these things. Thus the price of accepting substance dualism appears to be quite high.

Summary

According to Cartesian dualism, mental states are states of an immaterial substance that affects and is affected by one's body. Descartes offers two arguments in support of this view: the conceivability argument and the divisibility argument. In the conceivability argument, Descartes claims that because he can conceive of himself existing without a body, his body is not essential to him. In the divisibility argument, he claims that because his body is divisible but his mind isn't, his mind isn't identical to his body. These arguments are inconclusive, however, for it is doubtful that disembodied existence is conceivable, and even if the mind were indivisible, it doesn't necessarily follow that the mind could exist independently of the body.

The major problem facing Cartesian dualism is that of explaining how two substances (mind and body) that are so dissimilar could possibly interact. Descartes offers no credible account of mind-body interaction.

Epiphenomenalism is a dualist view that holds that although the body can affect the mind, the mind cannot affect the body. In this view, mental states are a by-product of physical processes. But if immaterial minds have no effect on anything—if they serve no purpose—their existence seems inexplicable.

Cartesian dualism also faces the problem of other minds, for if it were true, there would seem to be no way of telling whether other humans have minds. Thus, for all a Cartesian dualist knows, solipsism is true—he has the only mind in the universe. Any view that implies that we are not justified in believing in the existence of other minds, however, is suspect.

Study Questions

1. According to Cartesian dualism, what is it to be in a mental state?
2. What reasons does Descartes give for believing that he doesn't have knowledge of the external world?
3. What reasons does Descartes give for believing that he does know that he thinks and that he exists?
4. What is Descartes' argument from conceivability?
5. What is Descartes' argument from divisibility?
6. What is the principle of the causal closure of the physical?
7. What is the law of the conservation of energy?
8. What is epiphenomenalism?
9. What is the problem of other minds?

Discussion Questions

1. Is disembodied existence conceivable, or does it involve a logical contradiction? Can you construct a thought experiment to back up your view?
2. Descartes identifies the mind with the soul. Should the mind be so identified? Is the mind the same thing as the soul? If not, how does the soul differ from the mind? What is the relationship between the mind and the soul?
3. In addition to minds and souls, many claim that humans also have a spirit. What is a spirit? Is it just another name for a mind or soul, or is it something else altogether? Can you give necessary and sufficient conditions for having a spirit?
4. Suppose someone claimed to have a device that destroyed people's souls. When it was used, it prevented a person's soul from going to heaven but otherwise had no discernible effect on that person. How would you evaluate such a claim? Is the claim that people have souls any more plausible? Why or why not?
5. Some people claim to have found physical evidence for the existence of the soul. Duncan McDougall, for example, placed dying people on a very precise scale and found that they lost between ¾ oz. and 1½ oz. at the moment of death. Does this evidence prove the existence of a Cartesian soul? Why or why not?
6. Is it possible to build a machine that has our linguistic and problem-solving abilities? Would a machine that had our linguistic and problem-solving abilities have a mind?
7. Descartes did not believe that animals have souls because they do not exhibit any behavior that cannot be accounted for in purely mechanical terms. That is, they do not reason or speak in such a way as to suggest that they have minds. Is Descartes right? Do animals not have minds? If you think that they do have minds or souls, what do you consider the mind to be?
8. Do parapsychological phenomena (telepathy, clairvoyance, precognition, psychokinesis, and the like) provide sufficient reason for believing in the existence of Cartesian minds? Why or why not?
9. In a letter to John Adams dated August 15, 1820, Thomas Jefferson wrote, "To talk of immaterial existences is to talk of nothings. To say the human soul, angels, god are immaterial is to say they are nothings or that there is no god, no angels, no soul." Jefferson says to talk of immaterial objects is to talk of nothings. Do you agree? Why or why not?

Internet Inquiries

1. Biblical scholars claim that the Bible provides no reason for believing in an immortal soul. Adrian Thatcher rehearses some of their arguments in the box "The Biblical Conception of the Person." To find more arguments concerning the Bible and immortal souls, type the words "Bible"

and "immortal soul" (with the quotation marks) into an Internet search engine. Which arguments(s) do you find most compelling? Why?

2. Vivisection is widely practiced. Millions of animals are the subject of scientific experiments every year. This practice can no longer be given a Cartesian justification by claiming that animals have no feelings. Can it be justified at all? If so, how? If not, why not? Do an Internet search on vivisection to find evidence for your position.

3. As the singularity approaches and computers become smarter, some believe that humans are going to have to incorporate various technical advances in order to survive and thrive. Others believe that altering ourselves in this way is wrong because it will change our human nature. What do you think? Nick Bostrom addresses this problem in his article "In Defense of Posthuman Dignity," which can be found here: **http://www.nickbostrom.com/ethics/dignity.html.**

Section 2.2

You Are What You Eat
Mind as Body

> *I respect faith, but doubt is what gets you an education.*
> —WILSON MIZNER

Although Cartesian dualism did not solve the mind-body problem, it did help resolve the conflict between science and religion. Beginning in the eleventh century—when Western scholars "discovered" the writings of ancient Greek philosophers in the libraries of Toledo, Spain—there was a growing tension between clergymen and scientists (or "natural philosophers," as they were then called). These writings showed that it was possible to explain the universe in natural rather than supernatural terms. Reason as well as revelation could be a source of knowledge.

In the twelfth century, Pierre Abelard (1079–1142), a French philosopher and theologian, articulated four rules that should govern any investigation:

1. Use systematic doubt and question everything.
2. Learn the difference between statements of rational proof and those merely of persuasion.
3. Be precise in the use of words, and expect precision from others.
4. Watch for error, even in Holy Scripture.

Realizing that such an approach to knowledge would undermine its intellectual authority, the Catholic Church condemned Abelard in 1140. In 1210, it banned the teaching of logic in Paris. But the genie was already out of the bottle. Too many people had already experienced the power of the new way of thinking. So in 1255, the Church reluctantly agreed to allow logic to be taught in the universities.

Nature was now no longer a closed book. Its mysteries could be understood by anybody willing to logically examine the evidence of the senses. The most startling claim produced by this new approach to knowledge was that of Copernicus (1473–1543): The earth is not the center of the universe. Copernicus showed that the motion of the planets could be explained on the hypothesis that the earth revolved around the sun. Moreover, he showed

that this hypothesis was simpler than the hypothesis that the sun revolved around the earth. Copernicus completed his work in 1530, but because it contradicted Church teaching, he was reluctant to publish it. The first edition of his *On the Revolutions of the Heavenly Spheres* didn't appear until 1543, on the day he died.

A number of scholars recognized the importance of Copernicus's discovery and began writing their own books on the subject. One such individual was Giordano Bruno. In 1593, the Church found him guilty of heresy, and in 1600 he was burned at the stake. Another was Galileo Galilei. Looking through one of the first telescopes, he saw the moons of Jupiter and the phases of Venus. Because the Copernican hypothesis provided the best explanation of these findings, Galileo accepted it. In 1632, he published his *Dialogues Concerning the Two Chief World Systems,* in which a proponent of a sun-centered universe (a Copernican) debates a proponent of an earth-centered universe. At the end of the book, the Copernican concedes the argument to his opponent. Although this was meant to placate the Church, it did not succeed, for it was clear from the text that Galileo sided with the Copernicans. Consequently, the Church banned the book and destroyed all the copies it could find. Galileo was brought before the Inquisition, forced under threat of torture to recant his views, and placed under house arrest for the rest of his life.

This was the intellectual climate in which Descartes wrote. Scientific theories called into question the teachings of the Church, and the Church tried to put a stop to scientific inquiry by persecuting those who practiced it. Descartes helped diffuse this volatile situation by claiming that the world contained two distinct substances, only one of which was a suitable object of scientific inquiry. Because the Church had a realm forever beyond the reach of science—the realm of the spirit—it could allow scientists to pursue their investigations unhindered. Science was no longer the threat it had seemed to be, for if Descartes was right, science could never usurp the Church's authority in matters of mind and morals.

This accommodation worked well for more than two hundred years. But by the end of the nineteenth century, many scientists no longer believed that a science of the mind was impossible. Not only did they recognize the flaws in Descartes' arguments, they realized that the same principles that were used to explain animal behavior could be used to explain human behavior. It was widely believed, however, that science could investigate the mind only if it were directly observable. So scientists and philosophers sought ways of understanding the mind that would make it a legitimate object of scientific inquiry. To understand the new scientific theories of the mind, it's helpful to understand the theory of knowledge that motivated them—namely, empiricism.

Empiricism

Empiricism claims that the only source of knowledge about the external world is sense experience. Although there were empiricists in ancient Greece, the most influential modern versions of empiricism were produced by the British philosophers John Locke and David Hume in the seventeenth and eighteenth

empiricism The epistemological theory that the only source of knowledge about the external world is sense experience.

David Hume: The Model Philosopher

In philosophy, some think that only Socrates is the nearly perfect model of a great philosopher: one who combines wisdom with noble personal qualities. But there is another who approaches this ideal—David Hume (1711–1776). By all accounts, Hume was beloved, respected, and admired by all who knew him. He was obviously learned, but also charming, congenial, and gregarious. "Upon the whole," says the philosopher-economist Adam Smith, one of Hume's many friends, "I have always considered him, both in his life-time and since his death, as approaching as nearly to the idea of a perfectly wise and virtuous man, as perhaps the nature of human frailty will admit."

He could grapple with philosophical issues both complex and deep, but he never lost touch with the everyday world, for he often found himself working outside the sphere of serious philosophy. At different times, he was an economist; a companion to a mentally unstable nobleman; a military attaché; a librarian; an essayist; an accomplished historian (he wrote the six-volume *History of England*); the private secretary to the British ambassador in Paris; and an undersecretary of state for Britain.

In addition, Hume was impressively eclectic in his studies. He knew the classical authors well and had an excellent education in mathematics, logic, moral philosophy, and history. He read the main French and English poets of the day as well as the great literature in English, Latin, and French.

Somehow, in between these forays into ordinary life and great literature, Hume found time to do grand philosophy. By taking a reasoned and skeptical look at knowledge, self, causation, and religion, he forced a philosophical reassessment in all these areas. Much of the work done in philosophy since Hume has been attempts to answer the arguments that he put forth.

DAVID HUME
1711–1766

centuries. They held that there is nothing in the mind that isn't first in the senses. As Locke put it, the mind is a blank slate (a *tabula rasa*) that contains nothing more than what the senses have put there.

Traditional empiricism claims that our minds contain two types of ideas: simple and complex. Simple ideas (those that do not contain other ideas as constituents) correspond to or represent sensations such as hot, cold, light, dark, loud, soft, sweet, sour, rough, and smooth. Complex ideas are built out of simple ideas. The idea of an apple, for example, is composed of the simple ideas of a certain shape, size, color, taste, texture, and so on. Thus all complex ideas can be reduced to or analyzed into simple ideas that represent sensations.

The Empiricists drew two important corollaries from this view of the nature of thought: (1) an idea corresponds to a real object only if it is derived from or reducible to sense impressions, and (2) a term is meaningful only if it stands for a real object. Hume used these principles to demonstrate that terms such as "liberty," "causality," and "self" are not meaningful, for they are not derived from sense impressions. As he says in his *Enquiries Concerning the Human Understanding*, "When we entertain, therefore, any suspicion that a philosophical term is employed without any meaning or idea (as is but too frequent), we need but enquire, *from what impression is that supposed idea derived?* And if it be impossible to assign any, this will serve to confirm our suspicion."[29] Such terms, according to Hume, should be purged from our language.

> When we run over libraries, persuaded of these principles, what havoc must we make? If we take in our hand any volume; of divinity or school metaphysics,

for instance; let us ask, *Does it contain any abstract reasoning concerning quantity or number?* No. *Does it contain any experimental reasoning concerning matter of fact and existence?* No. Commit it then to the flames: for it can contain nothing but sophistry and illusion.[30]

According to Hume, those who use terms that are not derived from sensations don't know what they are talking about because they're talking nonsense.

Hume used his empiricism to show not only that Cartesian minds don't exist but also that the very notion of a Cartesian mind is unintelligible. In his *A Treatise of Human Nature*, he writes,

> As every idea is derived from a precedent impression, had we any idea of the substance of our minds, we must also have an impression of it; which is very difficult, if not impossible to be conceived. For how can an impression represent a substance, otherwise than by resembling it? And how can an impression resemble a substance, since, according to this philosophy, it is not a substance, and has none of the peculiar qualities or characteristics of a substance? . . .
>
> Thus neither by considering the first origin of ideas, nor by means of a definition are we able to arrive at any satisfactory notion of substance; which seems to me a sufficient reason for abandoning utterly that dispute concerning the materiality and immateriality of the soul, and makes me absolutely condemn even the question itself.[31]

According to Hume, we cannot sense the soul. Because there is no sense impression from which the idea of the soul could have been derived, we have no idea what the word "soul" stands for. The question of the existence of the soul, then, cannot be answered because no one knows what they're talking about when they use the word "soul."

To talk of immaterial existences is to talk of nothings. To say that the human soul, angels, God, are immaterial, is to say they are nothings, or that there is no God, no angels, no soul.

—THOMAS JEFFERSON

Logical Positivism

The rise of modern physics raised a number of problems for traditional empiricism. At the beginning of the nineteenth century, John Dalton experimentally confirmed what the Greek atomists had suggested over two thousand years before, namely, that physical objects were made out of tiny particles of matter called atoms. Dalton correctly believed that atoms were the smallest particle of an element that retained the chemical properties of that element. He incorrectly believed, however, that atoms were indestructible and unchangeable. By the beginning of the twentieth century, studies of radiation and radioactivity had shown that Dalton's atoms could be not only broken into smaller pieces but also changed into other atoms. Dalton's atoms were not the basic building blocks of the universe. That distinction fell to even smaller subatomic particles. Subatomic particles like electrons are so small, however, that they cannot be directly observed, even in principle. But if they can't be directly observed, the idea of a subatomic particle can't be derived from sense experience. And if the idea of a subatomic particle isn't derived from sense experience, traditional empiricism would have us believe that talk of subatomic particles is meaningless.

I consider that a man's brain is like a little empty attic, and you have to stock it with such furniture as you choose.

—SIR ARTHUR CONAN DOYLE

This conclusion did not sit well with a group of philosophically minded scientists who lived in Vienna at the turn of the century. Known as the Vienna circle, they sought to put the new physics on a firm philosophical footing by developing a theory of meaning that would not only make sense of modern science but also eliminate meaningless metaphysical speculation. This theory became the central doctrine in a philosophical movement known as **logical positivism** or logical empiricism.

Traditional empiricism maintains that a term is meaningful only if it can be derived from sense experience. Logical positivism maintains that a sentence is meaningful only if it can be verified by sense experience. The idea is that if there is no way to tell whether a sentence is true, it doesn't tell us anything about the world. Consider, for example, this sentence from Martin Heidegger's *What Is Metaphysics?* "The Nothing nothings." What does this tell us about the world? What must the world be like in order for this sentence to be true? How could we determine whether the world really is that way? In his essay "The Elimination of Metaphysics through the Logical Analysis of Language," the logical positivist Rudolf Carnap argues that we can't answer these questions because that sentence is meaningless.[32] Those who believe that this statement contains a deep insight into the nature of reality have confused obscurity with profundity.

Sentences that occur in the writings of physicists, even though they contain terms that are not derived from sensation, are nonetheless meaningful because they can be verified. We know what the world must be like if they are true and how to go about determining whether the world is that way. As a result, they give us a real understanding of the nature of reality.

The logical positivists believed that to know the meaning of a sentence is to know how to verify it. To know the meaning of the sentence "The cat is on the mat," for example, is to know what observations would establish its truth. From this, the logical positivists concluded that the meaning of a sentence is its method of verification. This is their famous **verifiability theory of meaning,** which they used to develop the theory of mind known as "logical behaviorism."

Logical Behaviorism

We verify whether individuals are in a mental state by observing their behavior. We can tell whether people are thirsty, for example, by observing what they do when they are given a drink. If they take it, there is reason to believe that they're thirsty. Given that the meaning of a statement is its method of verification, and given that the way we verify statements about people's minds is by observing their behavior, it follows that what we mean when we say that someone is in a mental state is that he or she will behave in certain ways in certain situations. According to **logical behaviorism,** then, mental states are behavioral dispositions.

To have a **behavioral disposition** is to have a tendency to respond in certain ways to certain stimuli. For example, if you have a tendency to scream

logical positivism The philosophical movement based on the assumption that to know what a sentence means is to know what observations would make it true.

verifiability theory of meaning The doctrine that the meaning of a statement is its method of verification.

logical behaviorism The doctrine that mental states are behavioral dispositions.

behavioral disposition A tendency to respond to certain stimuli in certain ways.

whenever you see a mouse, you have a certain behavioral disposition. Logical behaviorism maintains that there is nothing more to being in a mental state than having certain behavioral dispositions. For example, to believe that it's raining is to be disposed to take rainwear with you when you go outside; to desire wealth is to be disposed to engage in activities that make money; and to fear heights is to be disposed to avoid high places. According to logical behaviorism, the mental state doesn't cause the behavioral disposition; it *is* the behavioral disposition. Anyone who has the behavioral disposition has the mental state and vice versa.

Logical behaviorism is a materialist theory because it doesn't postulate the existence of any immaterial (nonphysical) objects. It is also a reductive theory because it holds that mental states are nothing but behavioral dispositions. Reductive theories are highly prized in science because they simplify our ontology (our theory of what there is in the world) by reducing the number of entities that we must suppose to exist. If one type of entity is reducible to another, there is no need to admit the existence of the former in addition to that of the latter.

For example, consider the statement "The average parent has 1.5 children." The subject of this sentence—the average parent—seems to be a rather unusual individual. Which half of the half-child does this "average" parent have: the top half or the bottom half? None of us who understand what "average" means would want to admit that in addition to real parents, there are also such things as average parents in the world. We know that talk about average parents is just shorthand for talk about real parents. To say that the average parent has 1.5 children is just to say that the number of children divided by the number of parents is 1.5. Once it is realized that we can replace all talk about average parents with talk about real parents, any tendency to admit the existence of average parents in addition to real parents disappears. Similarly, claim the logical behaviorists, once it is realized that we can replace all talk about mental states with talk about behavioral dispositions, any tendency to admit the existence of minds in addition to bodies also disappears.

Logical behaviorism is a simpler theory than Cartesian dualism because it makes fewer assumptions. Specifically, it doesn't assume the existence of any immaterial or nonphysical objects. Occam's razor tells us that we should not multiply entities beyond necessity. So if there's no reason to assume that there are immaterial objects, it's irrational to do so.

Logical behaviorism is also a more conservative theory than Cartesian dualism because accepting it doesn't require giving up any well-established laws or theories. Accepting Cartesian dualism, on the other hand, seems to require giving up the principle of the causal closure of the physical and the law of conservation of energy, which is one of the cornerstones of modern physics. Logical behaviorism leaves the theoretical framework of modern science intact; Cartesian dualism seems to rip it apart.

In addition, logical behaviorism is a more fruitful theory than Cartesian dualism because it solves the problem of other minds. There is no way to tell whether Cartesian minds exist because they are immaterial and thus unobservable.

> [Psychologists should use their self-knowledge to recall] some devastating conflict of desires, some moral struggle hardly won, some intense pain, some base temptation, some impulse of profound pity or of tender devotion, of fierce anger or horrible fear. Is there not something radically wrong with a system of thought (i.e. behaviourism) which tells us that these experiences are of no account in the world?
>
> —W. McDougall

Ryle's Category Mistake

Logical positivism is not the only route to logical behaviorism. The English philosopher Gilbert Ryle (1900–1976) came to the conclusion that mental states are behavioral dispositions through a careful analysis of how mental terms are used in ordinary language. We tend to assume that nouns refer to substances. But this is not always the case. Consider, for example, the word "waltz" in the sentence "She danced a waltz." Although "waltz" is a noun, it doesn't refer to a thing. Rather, it refers to a way of dancing. So instead of saying "She danced a waltz," we could just as well have said (albeit somewhat awkwardly) "She danced waltzily." In any event, we would be quite mistaken if we thought that waltzes could exist independently of people dancing. Similarly, Ryle claims, we would be quite mistaken if we thought that minds could exist independently of people behaving. To dance a waltz is simply to dance in a certain way. Similarly, to have a mind is simply to behave in a certain way. Ryle provides the following illustration of the linguistic confusion behind the mind-body problem.

Thought Experiment

Ryle's University Seeker

A foreigner visiting Oxford or Cambridge for the first time is shown a number of colleges, libraries, playing fields, museums, scientific departments, and administrative offices. He then adds "But where is the University? I have seen where the members of the Colleges live, where the Registrar works, where the scientists experiment and the rest. But I have not yet seen the University in which reside and work the members of your university." It has then to be explained to him that the University is not another collateral institution, some ulterior counterpart to the colleges, laboratories, and offices which he has seen. The University is just the way in which all that he has already seen is organized. When they are seen and when their coordination is understood, the University has been seen. His mistake lay in his innocent assumption that it was correct to speak of the Christ Church, the Bodleian Library, the Ashmolean Museum, and the University, to speak, that is, as if "the University" stood for an extra member of the class of which these other units are members. He was mistakenly allocating the University to the same category as that to which the other institutions belong.[33]

Ryle's university seeker makes what Ryle calls a "category mistake" in assuming that the university exists in the same way that libraries, museums, and laboratories do. Similarly, dualists make a category mistake in assuming that minds exist in the same way that bodies do. Minds, like universities, are simply complex patterns of behavior. To believe otherwise is to accept what Ryle calls "the dogma of the ghost in the machine." For Ryle, there's nothing more to having a mind than having a tendency to behave in certain ways.

According to logical behaviorism, however, minds are patterns of actual and possible behavior. Since behavior is observable, minds are observable. In fact, it's sometimes easier to observe other people's behavior than your own. That's the point of the old behaviorist joke: What does one behaviorist say to another after sex? "I can see it was good for you. But was it good for me?"

Since logical behaviorism maintains that there's nothing more to having a mind than having certain behavioral dispositions, it has no trouble admitting

the possibility of intelligent robots. If a robot's behavior were indistinguishable from that of a normal human being, it would have a mind, even if it were made of silicon and steel. Whether it had any feelings would be irrelevant. All that matters from a logical behaviorist's point of view is the sort of behavior it exhibits. As long as that behavior is sufficiently similar to our own, it would have the same mental states that we do.

According to the criteria of adequacy, then, logical behaviorism is a better theory than Cartesian dualism. To see whether it's an acceptable theory, though, we'll have to see whether it can explain all the relevant aspects of mental phenomena.

Since logical behaviorism maintains that having a certain set of behavioral dispositions is both necessary and sufficient for being in a mental state, it is committed to the following two claims: (1) if something is in a mental state, then it must have a certain set of behavioral dispositions (this is the necessary part) and (2) if something has a certain set of behavioral dispositions, then it must be in a mental state (this is the sufficient part). To refute logical behaviorism, then, all we have to show is (1) that it's possible to be in a mental state and not have a certain set of behavioral dispositions or (2) that it's possible to have a certain set of behavioral conditionals and not be in a mental state. Let's put logical behaviorism to the test and see whether either of these situations is possible.

Many mental states, such as pain, love, and fear, have certain feelings associated with them. What it feels like to be in one of those states is known as its subjective character or its **qualitative content.** The qualitative content of a mental state seems to be essential to it; if you don't have the appropriate feeling, you aren't in the mental state. For example, if you don't feel anything when someone punches you in the nose, you aren't in pain. Logical behaviorism maintains, on the contrary, that feelings are irrelevant to mental states. As long as you have the right behavioral dispositions, you're in a mental state, regardless of what you're feeling. But that seems implausible.

Consider someone who, as a result of a neurological disorder, can't feel pain:

Experience is a good teacher but she sends in terrific bills.
—MINNA ANTRIM

Thought Experiment

The Perfect Pretender

Some people are born without the ability to feel pain. This is a very dangerous condition, for such people often can't tell before it's too late that they have suffered serious bodily damage. Imagine that such a person is a particularly good student of human behavior and has learned to exhibit the appropriate pain behavior in the appropriate situations. If someone kicks him in the shins, for example, he grabs his shin, hops on one leg, and yells "Ouch!" in the same way that a normal pain sufferer would. He has become such a good actor that his behavior is indistinguishable from that of someone who can feel pain.

qualitative content
The felt quality of certain mental states.

The perfect pretender behaves just like someone who can feel pain. Through years of study, he has acquired the same behavioral dispositions as a normal person. But he can't feel pain, and if he can't feel pain, he can't be in pain. So having the right behavioral dispositions isn't sufficient for being in a mental state.

Having the right behavioral dispositions also isn't necessary for being in a mental state. There are people who, through a supreme act of will, can act as if they aren't in pain even though they are suffering terribly. If these people were to become so good at hiding their pain that no one could ever tell when they were in pain, then logical behaviorism would have us believe that they never are in pain. But that can't be right. Anyone who feels pain is in pain whether or not he or she shows it. To demonstrate that being in pain doesn't require behaving in a certain way, Hilary Putnam offers the following thought experiment.

Thought Experiment

Putnam's Super-Spartans

Imagine a community of "super-Spartans" or "super-stoics"—a community in which the adults have the ability to successfully suppress all involuntary pain behavior. They may, on occasion, admit that they feel pain, but always in pleasant well-modulated voices—even if they are undergoing the agonies of the damned. They do not wince, scream, flinch, sob, grit their teeth, clench their fists, exhibit beads of sweat or otherwise act like people in pain or people suppressing the unconditional responses associated with pain. However, they do feel pain, and they dislike it (just as we do). They even admit that it takes a great effort of will to behave as they do. It is only that they have what they regard as important ideological reasons for behaving as they do, and they have, through years of training, learned to live up to their own exacting standards.[34]

Body am I entirely, and nothing more; and soul is only the name of something in the body.
—FRIEDRICH NIETZSCHE

Putnam's super-Spartans may sound familiar to those acquainted with the original *Star Trek* TV series. They bear a remarkable resemblance to Vulcans, like Mr. Spock, who also suppress pain behavior for ideological reasons. After a particularly bloody war, the Vulcans decided that they would survive as a race only if they learned to control their emotions. So, from that time on, all Vulcans were trained from birth to hide their feelings. They still have feelings: They just don't show them. Logical behaviorism would have us believe that because Vulcans never act as if they are in pain, they never are in pain. But that's ludicrous. You don't have to behave in a certain way to be in pain. So having a certain behavioral disposition is not necessary for being in a mental state.

Putnam's argument can be spelled out as follows:

1. If having certain behavioral dispositions were a necessary condition for being in a certain mental state, then it would be impossible to be in that state and not have those dispositions.

> ## Behavioral Therapy
>
> The notion that mental states are behavioral dispositions has implications for how we treat mental illness. If we want to alter a person's mind, all we have to do is alter his or her behavior. Psychologist Morton Hunt describes some of the techniques used by behavioral therapists:
>
>> As Joseph Wolpe, a leading exponent of behavior therapy, put it several years ago, the Freudian explanations of neuroses were simply unnecessary; a neurosis was "just a habit—a persistent habit of unadaptive behavior" that could be cured by counterconditioning techniques such as "systematic desensitization." Typically, a female patient with a morbid fear of the penis was induced to relax and think pleasant thoughts, and then to envision a nude male statue far off (where the penis was relatively unthreatening). When the association of relaxation and pleasant thoughts with the remote nonliving penis made it tolerable, the patient was then told to envision it closer and closer, and eventually to practice this association with images of a live male. This was reported to have led her to be able to tolerate the real thing.
>>
>> Other behavior therapists have used "aversive" conditioning techniques to link unwanted behavior to unpleasant experiences and so eliminate that behavior. Some have given electric shocks to male homosexuals as they looked at erotic photos of nude males. Others have sought to combat overeating by training their patients to imagine themselves vomiting in public when they feel like gorging themselves, or given them pills that produce nausea shortly after eating. Early reports claimed considerable success with these efforts.[35]
>
> The movie *A Clockwork Orange* graphically depicts the use of aversive conditioning techniques. Unfortunately (or fortunately, as the case may be), these techniques did not turn out to be as successful as originally hoped. Hunt explains,
>
>> The view of the human being as rat is simply too narrow: people do think and, thinking, find reason to reshape their own behavior; they follow their own minds despite all the external pressures of reward and punishment.
>>
>> For much the same reason, many of the behavior therapies have failed to live up to their first promise. The short-term sex therapies, for instance, originally seemed to cure most of the disabilities they were used to treat but follow-up studies have shown that there is a high relapse rate. . . .
>>
>> The most disappointing results of all have been those of the aversive therapies: The association of homosexuality, overeating, alcoholism, and other behaviors with sharply unpleasant stimuli has shown a high rate of cessation of those behaviors—but the results have been largely ephemeral. For in contrast to laboratory animals, human patients in aversive therapy know that the painful stimulus is being given them for a purpose.[36]

2. But, as the example of the super-Spartans shows, it is possible to be in pain and not have the behavioral dispositions associated with pain.
3. Therefore, having certain behavioral dispositions is not a necessary condition for being in a certain mental state.

Putnam's super-Spartans don't exhibit pain behavior because they don't *want* to. Wanting, however, is a mental state. So the most natural explanation of the Spartans' behavior is that it was caused by their mental states. According to logical behaviorism, however, that's impossible because mental states aren't causes—they're just dispositions to respond. This is logical behaviorism's fatal flaw. It assumes that mental states are *causally* inert; that no

one does anything because they're in a mental state. As a result, it is not an adequate theory of the mind.

Logical positivists maintain that all talk about mental states can be translated into talk about behavioral dispositions. Because there's more to being in a mental state than behaving in a certain way, there's reason to doubt that such a translation can be carried out. Roderick Chisholm demonstrates this by means of the following thought experiment.

Thought Experiment

Chisholm's Expectant Nephew

Jones, let us suppose, expects to meet his aunt at the railroad station in twenty-five minutes. Our formulation as applied to this situation would yield: "Jones is in a bodily state which would be fulfilled if he were to meet his aunt at the station within twenty-five minutes or which would be disrupted if he were not to meet her there within that time." . . . But what if he were to meet his aunt and yet take her to be someone else? Or if he were to meet someone else and yet take her to be his aunt? In such cases, the fulfillments and disruptions would not occur in the manner required by our definition.[37]

According to logical behaviorism, the sentence "Jones expects his aunt to arrive at the train station in twenty-five minutes" means something like: If Jones were to see his aunt, he would greet her; if he were asked, "When is your aunt arriving?" he would say "In about 25 minutes"; and so on. But these two statements don't mean the same thing because the former can be true while the latter is false. If Jones were to see his aunt, he would not necessarily greet her because he might not take the person he sees to be his aunt. If he were asked, "When is your aunt arriving?" he would not necessarily say, "In about 25 minutes," because he might not understand the question or might not want to tell the truth. The point is that how we react to a stimulus is determined by other mental states we are in at the time. Since mental states interact with one another to produce behavior, we can't identify a mental state with any one set of behavioral dispositions.

The failure of logical behaviorism suggests that the verifiability theory of meaning is flawed. And indeed it is. If the meaning of a statement were its method of verification, then whenever a new method of verification was discovered, the meaning of those statements that could be verified by that method would change. But if we found a new way of measuring height, the meaning of the statement "Jones is five feet tall" wouldn't change.

The most significant problem facing the verifiability theory of meaning, however, is that it undermines itself: If it's true, it's meaningless. Because the verifiability theory of meaning applies to all statements, it applies to itself. So the verifiability theory of meaning is meaningful only if it can be verified. But there is no way to verify the statement "The meaning of a statement is its

LIFE MASK AND SKULL OF PHINEAS GAGE. Gage's accident showed that the mind depends on the brain.

method of verification" because it is not an empirical statement. There are no observations that would confirm it. By its own lights, then, it's meaningless. It's ironic that a theory designed to rid the world of meaningless statements should end up eliminating itself.

The Identity Theory

It has long been known that the mind is affected by the brain. But it has only recently been recognized that different parts of the brain perform different functions. This was dramatically demonstrated by an incident that occurred near the small town of Cavendish, Vermont, in 1848. Phineas Gage, the foreman of a team of railroad workers, was setting a charge of dynamite. This involved drilling a hole into the rock, filling it with dynamite, and tamping down the dynamite with a steel bar. As Gage was doing the tamping, the dynamite went off, sending the steel bar right through his head. Although the injury knocked him out, it didn't kill him. After a few minutes he regained consciousness and was able to speak. Eventually, he recovered. But he was a changed man. One of the attending physicians, John Harlow, described him this way:

So what is this mind, what are these atoms with consciousness? Last week's potatoes!
—RICHARD P. FEYNMAN

> His physical health is good, and I am inclined to say that he has recovered. . . . The equilibrium or balance, so to speak, between his intellectual faculties and animal propensities, seems to have been destroyed. He is fitful, irreverent, indulging at times in the grossest profanity (which was not previously his custom), manifesting but little deference for his fellows, impatient of restraint or advice when it conflicts with his desires, at times pertinaciously obstinate, yet capricious and vacillating, devising many plans of future operation, which are no sooner arranged than they are abandoned. . . . In this regard his mind was radically changed, so decidedly that his friends and acquaintances said that he was "no longer Gage."[38]

You Are What You Eat **107**

What happened to Gage's brain obviously affected his mind in a profound way.

Since Gage's accident, psychologists have amassed a huge amount of data that many believe is best explained on the hypothesis that the mind is the brain. Psychologist Barry Beyerstein catalogs some of this evidence:

Phylogenetic: There is an evolutionary relationship between brain complexity and species' cognitive attributes.

Developmental: Abilities emerge with brain maturation; failure of the brain to mature arrests mental development.

Clinical: Brain damage from accidental, toxic, or infectious sources, or from deprivation of nutrition or stimulation during brain development, results in predictable and largely irreversible losses of mental function.

Experimental: Mental operations correlate with electrical, biochemical, biomagnetic, and anatomical changes in the brain. When the human brain is stimulated electrically or chemically during neurosurgery, movements, percepts, memories, and appetites are produced that are like those arising from ordinary activation of the same cells.

Experiential: Numerous natural and synthetic substances interact chemically with brain cells. Were these neural modifiers unable to affect consciousness pleasurably and predictably, the recreational value of nicotine, alcohol, caffeine, LSD, cocaine, and marijuana would roughly be equal to that of blowing soap bubbles.

Despite their abundance, diversity, and mutual reinforcement, the foregoing data cannot, by themselves, entail the truth of PNI [the psychoneural identity theory, or the identity theory for short]. Nevertheless, the theory's parsimony [simplicity] and research productivity [fruitfulness], the range of phenomena it accounts for [scope], and the lack of credible counter-evidence are persuasive to virtually all neuroscientists.[39]

This excerpt from Beyerstein is instructive not only for the information it conveys but also for the demonstration it provides of how the criteria of adequacy help decide among competing theories. He admits that the **identity theory**—the theory that mental states are brain states—is not the only theory that can explain the data. But it's the best theory because the explanation it provides is simpler, is more fruitful, and has greater scope than any competing explanation.

The brain—which in its normal state is about the consistency of half done Jell-O—contains about 100 billion cells, weighs approximately 3 pounds, and consumes about 20 watts of electricity. Brain cells come in two basic varieties: glial cells and neurons. Glial cells provide support for the neurons while the neurons process and store information received from various parts of the body. The neurons in the brain are organized into various assemblies capable of acting as a closed system. When they function that way, they fire at the same time in the same frequency. So a brain state can be viewed as a particular pattern of firing in a particular group of neurons.

The identity theory is simpler than Cartesian dualism because it doesn't assume the existence of an immaterial substance. The brain is a physical

identity theory The theory that mental states are brain states.

object, and all of its properties can be accounted for in purely physical terms. So there is no need to go beyond the physical to explain the mental.

The identity theory is also more fruitful than Cartesian dualism because it has successfully predicted a number of novel phenomena, such as the production of mental states through electronic stimulation of the brain. By electrically stimulating the brains of patients undergoing brain surgery, researchers have found that they can trigger various sights, sounds, smells, memories, and so on—which is exactly what one would expect if the identity theory were true. Cartesian dualism yields no such verifiable predictions.

> *Thought is a secretion of the brain.*
>
> —PIERRE-JEAN GEORGES CABANIS

The identity theory is also superior to logical behaviorism because it provides a straightforward account of mental causation. Logical behaviorism foundered because it could not account for the fact that mental states affect behavior. The identity theory has no trouble accounting for this fact. Since what we do is caused by what's going on in our brains, and since mental states are brain states, mental states affect behavior. According to the identity theory, mental causation is simply a type of physical causation.

Like logical behaviorism, the identity theory is a reductive theory. It claims that mental states are nothing but brain states. Unlike logical behaviorism, however, the identity theory does not provide an analysis of the meaning of mental terms. It does not claim that what we mean when we say that someone is in a mental state is that they're in a brain state. It claims only that mental states and brain states are one and the same thing. In this regard, it's like the claim that lightning is an electrical discharge; that claim is not true by definition but was discovered through scientific investigation. To determine whether the identity theory is an adequate theory of mind, however, we'll have to see whether it fits the facts.

Identity and Indiscernibility

If two things are identical—that is, if two terms refer to one and the same thing—then whatever is true of one must be true of the other. So if mental states are identical to brain states, whatever is true of mental states must be true of brain states. But there seem to be many things that are true of mental states that are not true of brain states. Suppose, for example, that you have a headache. In that case, you know that you're in pain, but you don't know that you're in a particular brain state. So the mental state and the brain state seem to have different properties; one is known by you and the other isn't. Consequently, it seems that mental states can't be identical to brain states.

This argument has the same structure as Descartes' divisibility argument. It tries to show that mental states aren't identical to brain states because they have different properties. Although this seems to be a straightforward application of the principle of the indiscernibility of identicals (the principle that says that if two things are identical, then whatever is

Do You Use Only 10 Percent of Your Brain?

There is a myth abroad in the land that we use only 10 percent of our brains. Some believe that this myth grew out of research conducted by British neurophysiologist John Lorber. Working with individuals suffering from hydrocephalus (water on the brain), Lorber found that some people whose skulls were 95 percent filled with cerebrospinal fluid nevertheless had IQs above 100. Writing in *Science*, Lorber provides the following account of one young man who had an IQ of 126 and yet had virtually no brain: "When we did a brain scan on him, we saw that instead of the normal 4.5 centimeter thickness of brain tissue between the ventricles and the cortical surface, there was just a thin layer of mantle measuring a millimeter or so. His cranium is filled mainly with cerebrospinal fluid."[40] Lorber admits, "I can't say whether the mathematics student has a brain weighing 50 grams or 150 grams, but it's clear that it is nowhere near the normal 1.5 kilograms, and much of the brain he does have is in the more primitive deep structures that are relatively spared in hydrocephalus."[41] Lorber's explanation? "There must be a tremendous amount of redundancy or spare capacity in the brain, just as there is with kidney and liver."[42] Even if we can get by with much less gray matter than normal, it doesn't follow that we're not using the gray matter that we do have. So Lorber's work provides no support for the 10 percent myth. But it does provide reason for believing that the identity theory is mistaken. If the same mental state can be realized in radically different brain states, we're not going to be able to identify one type of mental state with one type of brain state, even in the same species. In that case, the identity theory won't be able to give us an informative answer to the question: What does it mean for something to be in a particular mental state?

true of the one is true of the other, and vice versa), it is fallacious—because that principle doesn't apply to such subjective properties as being known by someone. In Sophocles' *Oedipus Rex*, Oedipus knows that Jocasta is his wife, but he doesn't know that his mother is his wife. But that doesn't mean that Jocasta is not his mother. So this argument fails to disprove the identity theory.

Conscious Experience

Life is a series of sensations connected to different states of consciousness.
—REMY DE GOURMONT

There is a related argument, however, that does not suffer from the same flaw. It states that whereas brain states are knowable by empirical investigation, mental states are not. So mental states can't be identical with brain states. This argument succeeds where the foregoing one failed because being knowable by empirical investigation is an objective property that should be shared by identical things.

Thomas Nagel presents one of the most influential statements of this argument in his article "What Is It Like to Be a Bat?" Nagel claims that there is something that every conscious being knows—namely, what it's like to be a being of that sort. Furthermore, he claims, this knowledge isn't something that can be acquired through empirical investigation. All of the physical properties of a thing, however, are knowable by empirical investigation. So, he concludes, being conscious is not a physical property. Here's how Nagel puts it.

Thought Experiment

Nagel's Bat

I assume we all believe that bats have experience. After all, they are mammals, and there is no more doubt that they have experience than that mice or pigeons or whales have experience. . . .

I have said that the essence of the belief that bats have experience is that there is something that it is like to be a bat. Now we know that most bats (the microchiroptera, to be precise) perceive the external world primarily by sonar, or by echolocation, detecting the reflections, from objects within range, of their own rapid, subtly modulated, high-frequency shrieks . . . but bat sonar, though clearly a form of perception, is not similar in its operation to any sense that we possess, and there is no reason to suppose that it is subjectively like anything we can experience or imagine. . . .

This bears directly on the mind-body problem. For if the facts of experience—facts about what it is like for the experiencing organism—are accessible only from one point of view, then it is a mystery how the true character of experiences could be revealed in the physical operation of that organism.[43]

According to Nagel, there is something no non-bat will ever know, namely, what it is like to be a bat. But all of the physical properties of bats can be known by non-bats. So mental states can't be identical to physical states.

Nagel's argument is this:

1. If mental states are identical to brain states, then it is possible to know everything about the mind by knowing everything there is to know about the brain.
2. But, as the example of the bat shows, it's not possible to know everything about the mind by knowing everything about the brain.
3. Therefore, mental states are not brain states.

What the identity theory leaves out of account, according to Nagel, is what any adequate theory of mind must account for—namely, the subjective character of conscious experience. What something feels like can be known only from the "inside," so to speak—from a first-person point of view. The physical properties of something, however, can all be known from the "outside"—from a third-person point of view. Because a complete knowledge of physical properties does not yield a knowledge of mental properties, the mind cannot be identified with the brain.

Nagel's reflections on the mental life of bats suggest that we aren't the only creatures that are conscious. On the contrary, there's reason to believe that most vertebrates have some form of conscious experience. Moreover, there's reason to believe that consciousness could have evolved on other planets.

Scientists and science-fiction writers alike have found silicon-based (as opposed to carbon-based) life-forms conceivable. But if there can be silicon-based life, why not silicon-based consciousness?

If mental states were identical to brain states, then only creatures with brains could have minds. But it seems that thoughts can be caused by and realized in other structures than the brain. David Lewis explores this possibility in the following thought experiment.

Thought Experiment

Lewis's Pained Martian

... there might be a Martian who sometimes feels pain, just as we do, but whose pain differs greatly from ours in its physical realization. His hydraulic mind contains nothing like our neurons. Rather, there are varying amounts of fluid in many inflatable cavities, and the inflation of any one of the cavities opens some valves and closes others. His mental plumbing pervades most of his body—in fact, all but the heat exchanger inside his head. When you pinch his skin you cause no firing of C-fibers—he has none—but, rather, you cause the inflation of many smallish cavities in his feet. When these cavities are inflated, he is in pain. And the effects of his pain are fitting: his thought and activity are disrupted, he groans and writhes, he is strongly motivated to stop you from pinching him and to see to it that you never do it again. In short, he feels pain but lacks the bodily states that either are pain or else accompany it in us.

There might be such a Martian; this opinion too seems pretty firm. A credible theory of mind had better not deny the possibility of Martian pain. I needn't mind conceding that perhaps the Martian is not in pain in quite the same sense that we Earthlings are, but there had better be some straightforward sense in which he and we are both in pain.[44]

Lewis's Martian has a very different physiology than we do. Specifically, he has no neurons and thus no brain. Nevertheless, he can feel pain. If the identity theory were true, this would be impossible. Nothing without a brain could feel pain. But the notion of a conscious alien doesn't seem to be self-contradictory. Consider the alien in the movie *E.T.—The Extra-terrestrial*. Like Lewis's Martian, E.T. can feel pain (as well as love, sorrow, and homesickness). Even if an autopsy revealed that he was constructed like Lewis's Martian, we wouldn't deny that he was conscious. So having a brain is not necessary for having a mind.

Hilary Putnam makes the same point by using a more down-to-earth example: computers.

Thought Experiment

Putnam's Conscious Computer

Assume that . . . we are, as wholes, just material systems obeying physical laws. Then . . . our mental states, e.g., thinking about next summer's vacation, cannot be identical with any physical or chemical states. For it is clear from what we already know about computers, etc. that whatever the program of the brain may be, it must be physically possible, though not necessarily feasible, to produce something with that same program but quite a different physical and chemical constitution. Then to identify the state in question with its physical or chemical realization would be quite absurd, from the point of view of psychology anyway (which is the relevant science). It is as if we met Martians and discovered that they were in all functional respects isomorphic to us, but we refused to admit that they could feel pain because their C-fibers were different.[45]

"Stop staring at me!!!"

Source: Cartoon by Alexei Talimonov. Copyright © www.CartoonStock.com. All rights reserved. Used with permission.

It's conceivable that computers could feel pain even though they don't have brains. Computers use silicon chips instead of neurons to process information. If those silicon chips could be made to perform the same functions as neurons, computers might be able to think and feel as we do.

The possibility of conscious computers has been explored in many works of science fiction. Perhaps the most famous thinking machine is Hal from the movie *2001: A Space Odyssey*. Hal can not only perform calculations, he can carry on an intelligent conversation and implement plans of his own design. But Hal is composed solely of silicon chips and wires. There is not a single neuron anywhere in his circuitry. Nevertheless, he can think. If Hal is a

logical possibility—if thinking doesn't require a brain—the identity theory cannot be correct.

Lewis's and Putnam's arguments can be put this way:

1. If the identity theory were true, then it would be impossible for anything without a brain to have a mind.

2. But, as Lewis's pained Martian and Putnam's conscious computer show, things without brains can have minds.

3. So the identity theory is not true; having a brain is not a necessary condition for having a mind.

What Lewis's and Putnam's thought experiments show is that minds can be realized in things other than brains. In other words, minds are "multiply realizable." Many take this **multiple realizability** to be a decisive objection to the identity theory because it shows that you don't need a brain to have a mind.

Those who believe otherwise—those who believe that only things with brains like ours can have minds—are often referred to as "speciesists," for they believe that only certain species of animals can have minds. Creatures with minds are due a certain amount of respect. It would be wrong to make such creatures suffer unnecessarily, for example. Speciesists, however, respect only those creatures with brains like ours.

Consider the scene from Steven Spielberg's movie *AI* where the humans destroy the robots. Or consider the scene in *The Animatrix* where the humans refuse to admit the robots into the United Nations. In both cases, the humans are guilty of speciesism because they discriminate against the robots on the grounds they're not made of flesh and blood. We may someday create computers that are as intelligent as we are. How we deal with them will say a lot about our moral intelligence.

A racist makes negative judgments about others because of their race. A sexist makes negative judgments about others because of their sex. A speciesist makes negative judgments about others because of their species. Speciesists who believe that only carbon-based life-forms can have minds are known as "carbon chauvinists." Identity theorists are carbon chauvinists because they believe that no matter how intelligently a creature behaves, it can't have a mind unless it has a brain.

multiple realizability
The view that minds can be realized in things other than brains.

Thought Probe

Speciesism

Suppose you fall in love with someone who seems to be the most intelligent, witty, and caring person you've ever met. Now suppose that "person" turns out to be an android. Would you conclude that the android doesn't really have a mind? Why or why not?

Lewis's pained Martian and Putnam's conscious computer suggest that mental states are not brain states, and the failure of logical behaviorism suggests that they are not behavioral dispositions either. To demonstrate the inadequacy of both of these reductive theories of the mind, John Searle offers the following thought experiment.

Thought Experiment

Searle's Brain Replacement

Imagine that your brain starts to deteriorate in such a way that you are slowly going blind. Imagine that the desperate doctors, anxious to alleviate your condition, try any method to restore your vision. As a last resort, they try plugging silicon chips into your visual cortex. Imagine that to your amazement and theirs, it turns out that the silicon chips restore your vision to its normal state. Now, imagine further that your brain, depressingly, continues to deteriorate and the doctors continue to implant more silicon chips. You can see where the thought experiment is going already: in the end, we imagine that your brain is entirely replaced by silicon chips; that as you shake your head, you can hear the chips rattling around inside your skull. In such a situation there would be various possibilities. One logical possibility, not to be excluded on any a priori grounds alone, is surely this: You continue to have all of the sorts of thoughts, experiences, memories, etc., that you had previously; the sequence of your mental life remains unaffected....

A second possibility, also not to be excluded on any a priori grounds, is this: as the silicon is progressively implanted into your dwindling brain, you find that the area of your conscious experience is shrinking, but that this shows no effect on your external behavior. You find, to your total amazement, that you are indeed losing control of your external behavior. You find, for example, that when the doctors test your vision, you hear them say, "We are holding up a red object in front of you; please tell us what you see." You want to cry out, "I can't see anything. I'm going totally blind." But you hear your voice saying in a way that is completely out of your control, "I see a red object in front of me." If we carry this thought experiment out to the limit, we get a much more depressing result than last time. We imagine that your conscious experience slowly shrinks to nothing, while your externally observable behavior remains the same....

Now consider a third variation. In this case, we imagine that the progressive implantation of the silicon chips produces no change in your mental life, but you are progressively more and more unable to put your thoughts, feelings, and intentions into action. In this case, we imagine that your thoughts, feelings, experiences, memories, and so forth, remain intact, but your observable external behavior slowly reduces to total paralysis. Eventually you suffer from total paralysis, even though your mental life is unchanged. So in this case, you might hear the doctors saying, "The silicon chips are able to maintain heartbeat,

respiration, and other vital processes, but the patient is obviously brain dead. We might as well unplug the system, because the patient has no mental life at all." Now in this case, you would know that they are totally mistaken. That is, you want to shout out, "No, I'm still conscious! I perceive everything going on around me. It's just that I can't make any physical movement. I've become totally paralyzed."[46]

It's entirely possible that in the not-too-distant future there will be artificial devices that function like neurons. (See the box "In the News: Neural Chips.") After all, we already have artificial devices that function like arms, legs, hearts, lungs, kidneys, and so on. Such devices could be implanted in the brains of those with failing neurons, gradually replacing all of them. Searle describes three possible outcomes of such a procedure, each of which counts against either behaviorism or the identity theory.

In the first case, the procedure is entirely successful. Your new silicon chips perform all of the functions of your old brain cells. This possibility is a counterexample to the identity theory because it shows that you don't need a brain to have a mind.

In the second case, the procedure does not affect your behavior, but it obliterates your consciousness. You behave as you always did, but you have no control over—and ultimately no awareness of—what your body is doing. The operation has turned you into a zombie. A zombie is a creature that behaves like a normal human being but has no conscious awareness of its activities, much like a sleepwalker. The second case is a counterexample to behaviorism because it shows that there's more to having a mind than having the right behavioral dispositions.

In the third case, the procedure does not affect your mind, but it does affect your behavior. The operation leads to total paralysis. You are aware of everything that's going on around you, but you are unable to move. Stephen Hawking, the physicist who had Lou Gehrig's disease, was in a similar predicament. He could move only a few fingers of his left hand. This last case is a counterexample to both logical behaviorism and the identity theory because it shows that you don't need to have any behavioral dispositions *or* a brain to have a mind.

Thought Probe

Neural Prostheses

Suppose you have a failing brain and your only hope for survival is to have your brain replaced by silicon chips. Would you do it? Suppose the procedure has been successfully performed many times before and those who've had it report that they feel no different after the procedure than before. Would that affect your decision?

> ### In the News: Neural Chips
>
> Silicon chips that can replace neurons are not science-fiction fantasies. Such chips have been developed at the University of Southern California.
>
> > While most neuroscientists have labored to understand why the brain works the way it does, the USC researchers are taking a different approach: They're hoping that by tracking how individual neurons communicate, they can restore lost brain functions by implanting computer chips that mimic neuron chatter.
> > Never mind the whys: "If we can learn the input/output, that's all we need to know," said lead researcher Ted Berger, 46. "We can put them on a chip, and we're ready to go."
> > If Berger's team can get the brain to talk back to the chips, people who lose memory to old age, are paralyzed after a car accident or lose the ability to speak after a stroke might be able to get lost functions back.
> > "Everyone grows old with age. Everyone loses their memory," said Dalal, a biomedical-engineering doctoral candidate.
> > "If we can come up with something that helps people (regain) their memory, that would be great. Obviously we would help out a lot of people." . . .
> > The team members have recorded much of how neurons in the hippocampus—a part of the brain responsible for memory—respond to signals. They have already managed to etch chips with these neuron codes, and tests show they mimic the language perfectly. Now they face a few substantial hurdles: Can they make the chip talk to the brain? Can they make the chips small enough to fit in the skull?
> > Berger and fellow researcher Armand R. Tanguay Jr. are confident the answer to both questions is yes.
> >
> > Tanguay, 47, is so certain the team will build workable brain prostheses—and perhaps "extras" that improve memory and ability to calculate—that just thinking about the implications of the work takes his breath away.
> > "I gotta tell you, this freaks us out on a daily basis," said Tanguay, an associate professor of electrical engineering. "The reality of it is so mind-blowing, you almost can't function to do the stuff." . . .
> > Researchers are trying to graft neurons to the chips' surfaces to see if they will serve as conduits. And they hope that by building prostheses that look and talk like the real thing—with the same shape and with electrical conduits clumped as neurons would be on the part being replaced—the neurons surrounding it will naturally talk to it.
> > Once the problems get worked out—and both researchers have no doubt they will be—scientists will be able to replace any region of the brain, they predict.
> > "There's no reason why you couldn't," Berger said.
> > "Is it possible to do this in a way to replace parts of the brain that have been damaged? I think the answer is yes, and not a pipe dream. Yes, a real yes," Berger said. . . .
> > Researchers are confident that one day, not too long from now, their research will mean the blind will see, the paralyzed will walk, the deaf will hear, the mute will talk.
> > "There's a real potential to relieve human suffering," Tanguay said.
> > Amazing as it all seems, "it's real," Berger said. "It's very real."[47]

Summary

Out of the empiricist tradition rose the theory of mind known as logical behaviorism, which says that mental states are behavioral dispositions. A behavioral disposition is a tendency to respond in certain ways to certain stimuli. Logical behaviorism is a materialist theory because it does not postulate the existence of any immaterial entities. It is also a reductive theory because it holds that all

statements about minds can be translated into statements about bodies. It is not an adequate theory, however, because it cannot account for the felt quality of our mental states, and the translation it envisions cannot be performed.

The identity theory, which says that mental states are brain states, is superior to behaviorism because it can explain mental causation. But there is reason to doubt that mental states are identical to brain states because brain states are knowable by empirical investigation and mental states are not. Moreover, having a brain does not seem to be a necessary condition for having a mind, for it is conceivable that an alien without a brain, or a computer made of silicon, or a person whose neurons have been replaced with biochips could have a mind.

Study Questions

1. What is Ryle's university seeker thought experiment? How does it attempt to undermine Cartesian dualism?
2. According to logical behaviorism, what is it to be in a mental state?
3. What is the verifiability theory of meaning?
4. According to empiricism, what is the source of knowledge?
5. What is the perfect pretender thought experiment? How does it attempt to undermine logical behaviorism?
6. What is Putnam's super-Spartans thought experiment? How does it attempt to undermine logical behaviorism?
7. According to the identity theory, what is it to be in a mental state?
8. What is Nagel's bat thought experiment? How does it attempt to undermine the identity theory?
9. What is Lewis's pained Martian thought experiment? How does it attempt to undermine the identity theory?
10. What is Putnam's conscious computer thought experiment? How does it attempt to undermine the identity theory?
11. What is Searle's brain replacement thought experiment? How does it attempt to undermine the identity theory and logical behaviorism?

Discussion Questions

1. Suppose that a robot was created whose behavior was indistinguishable from that of a normal human being. Should such a robot be given the same rights as a human being? Why or why not?
2. Suppose that an autopsy was performed on an alien found in a crashed flying saucer, and suppose that none of its internal organs resembled a brain. Would that show that it isn't intelligent? Why or why not?
3. What if behaviorism or the identity theory is right and mental states are nothing but physical states? What changes, if any, would we have to make to our legal systems? To our society?

4. Larry Hauser proposes the following thought experiment, which, he claims, calls into question dualism, the identity theory, and functionalism, while supporting behaviorism.

Thought Experiment

Your Mother, the Zombie

Imagine . . . that *your mother's a zombie.* How you might discover this is, strictly, beside the point; but as an aid to imagination, add some cheesy special effects. It's discovered during would-have-been-routine brain surgery that Mother, in place of a brain (like you) has a head full of sawdust (like some antique dolls): a head full of something that's (1) not like our neurophysiological stuff, (2) not apt to be giving off qualia [feelings], and (3) insufficiently differentiated to support much functional organization. Of course, nothing turns essentially on sawdust. Substitute whatever you like. . . . Stipulate (or imagine), then, that Mother hasn't a quale [feeling] to call her own; nor has she suitable neurophysiological stuff, nor appropriate functional organization. Her behavior, as ever, is unchanged. I submit, you should *not* deny her mental abilities and attainments.[48]

Do you agree? In this situation, would you still believe that your mom has a mind? Or would you conclude that she is just a cleverly constructed automaton? What theory underlies your judgment?

5. According to behaviorism, is it possible for our minds to survive the death of our bodies? How?

6. According to the identity theory, is it possible for our minds to survive the death of our bodies? How?

Internet Inquiries

1. Read the short story at the end of the chapter, "They're Made of Meat," and watch the YouTube video of the same name: **http://www.youtube.com/watch?v=gaFZTAOb7IE.** What's the moral of this story? Do you agree with it? Why or why not?

2. If the mind is the brain, the only way to improve the mind is to improve the brain. Some have argued that we should use all of the techniques at our disposal to do just that, including electronic stimulation of the brain. Those who want to improve the mind by directly manipulating the brain are known as "wireheads" and believe that wireheading can lead to paradise on earth: **http://www.wireheading.com.** Do you agree? Why or why not?

3. Behaviorists have argued that we should use behavior modification techniques in prisons to change the behavior patterns of convicted criminals. Would this be a wise use of public funds? Do an Internet search on "behavior modification" and "prisons" to assess the arguments on both sides.

Section 2.3

I, Robot
Mind as Software

> *Minds are simply what brains do.*
> —Marvin Minsky

If mental states are not brain states or states of an immaterial substance, what are they? Many believe that they are functional states. A functional state is one that is defined in terms of what it does rather than what it is made of. Consider, for example, clocks. Clocks can be made out of many different materials. Think of sundials, water clocks, cuckoo clocks, grandfather clocks, digital clocks, to name but a few. What makes these things clocks is not what they're made of but what they do, namely, keep time. According to functionalism, minds are more like clocks than rocks, for they, too, can be defined by what they do.

To perform a function is to take a certain input and produce a certain output. Each worker on an assembly line, for example, performs a function by taking certain parts and putting them together in certain ways. When two things perform the same function, they are said to have the same "causal role." So if a robot was able to replace a worker on an assembly line, the robot would have the same causal role as the worker.

According to the theory of mind known as **functionalism,** mental states are functional states. Unlike the identity theory, which claims that the mind is the brain, functionalism claims that the mind is what the brain does. In this view, mental states are defined by their causal role—that is, their characteristic inputs and outputs. Behaviorism, too, defined mental states in terms of their causal role, but the only inputs it recognized were physical stimuli, and the only outputs it recognized were bodily movements. Functionalism differs from behaviorism in that it allows mental states to serve as both the input and the output of other mental states. For example, functionalism recognizes that coming to believe that your lover is cheating on you can cause you to become jealous. According to functionalism, then, mental states not only can cause behavior, but they can also cause other mental states.

functionalism The doctrine that mental states are functional states.

Logical behaviorism proved to be an inadequate theory of the mind because it failed to recognize the causal role of mental states. Because functionalism takes mental causation seriously, it doesn't suffer from that failing. The identity theory proved to be an inadequate theory of the mind because it failed to recognize that things without brains could have minds. Because functionalism allows minds to be caused by and realized in things other than brains, it doesn't suffer from that failing either. The question, then, is whether there's more to having a mind than being able to perform certain functions.

Artificial Intelligence

Functionalism is the theory of mind that underlies the field of artificial intelligence. The goal of artificial-intelligence research is to create a computer that can think for itself. Such a computer would have a mind of its own.

An intelligent computer would be a great labor-saving device, especially if it were equipped with a robot body. Not only would robots of this sort be useful around the house or on the job, they would also be useful on the battlefield. With enough intelligent robots, humans would no longer have to spend their lives toiling away at menial jobs or fighting in wars.

According to functionalism, to have a mind is to have the ability to perform certain functions. The functions a computer performs are determined by the programs it runs. So, according to the strong view of artificial intelligence, known as "strong AI," there's nothing more to having a mind than running the right kind of program. In this view, the mind is to the brain as the software of a computer is to its hardware. In other words, your mind is the program that's running on your brain.

This view has a number of interesting consequences. If you are your program, then anything that ran your program would be you. A number of computer scientists believe that it will soon be possible to scan your brain, identify the program that's running on it, and transfer that program to a computer, thus giving you eternal life. Marvin Minsky, former head of the artificial-intelligence laboratory at MIT, is one of these scientists. He writes, "In the next 100 years or so, there will be no reason to die anymore. You can just take your personality and download it into another being."[49] Computer scientist Gerald Jay Sussman agrees. In an interview with journalist Grant Fjermedal, he said,

> "If you can make a machine that contains the contents of your mind, then that machine is you. The hell with the rest of your physical body, it's not very interesting. Now, the machine can last forever. Even if it doesn't last forever, you can always dump it out onto tape and make backups, then load it up on some other machine if the first one breaks."
>
> "Everyone would like to be immortal," Sussman said. "I don't think the time is quite right. But it's close. It isn't very long from now. I'm afraid, unfortunately, that I'm the last generation to die. Some of my students may manage to survive a little longer."

Man is still the most extraordinary computer of all.

—JOHN F. KENNEDY

Transhumanism and the Promise of Immortality

Transhumanism is a philosophical, ideological, and political movement that seeks to transcend the limits of human biology by utilizing technology to enhance our physical and mental capabilities. By employing technology appropriately, transhumanists believe that it can improve both the quality and the length of our lives, ultimately to the point of becoming immortal. Thus the transhumanist movement differs from all other political movements that have come before because transhumanists don't believe in death or taxes. No death, because genetic engineering, robotics, and nanotechnology will make it possible for us to become immortal. No taxes, because these technologies will make it possible to provide for everyone's basic needs.

Advances in prosthetics and stem cell research should give us an almost unlimited supply of spare parts. When a joint, a limb, or an organ wears out, we can just produce a new one through manufacturing, cloning, or three-dimensional (3D) printing. Advances in biology and medicine should allow us to cure many diseases, both infectious and genetic, through improved drugs and gene editing. But many transhumanists look forward to eternal life unfettered by the demands of human biology. They hope to attain immortality by uploading their minds into computers and living forever.

And that day may not be far off. Ray Kurzweil, Chief Engineer for Google, believes that we will be able to upload our minds into computers by 2045.[51] By that time, relatively cheap computers will have many times the processing power of the human brain, and we will know enough about the workings of the brain to transfer the program running on it into a computer. (Moravec describes how such a transfer could take place in his article "Transmigration," which can be found at the end of Chapter 4.)

The theory of mind upon which this scenario is based is functionalism. So the plausibility of mind uploading is only as plausible as the theory of functionalism. And even if functionalism is sound, there is the further question of whether we should do it. Some, like computer scientist Bill Joy and historian Francis Fukuyama, argue against the pursuit of technological immortality on the grounds that it would mean the end of the human race as we know it.[52] The recent movie *Transcendence*, starring Johnny Depp, gives us a glimpse into what mind-uploading could mean for society.

Thought Probe

Transhumanism

Suppose that it were possible to transfer the program running on your brain into a computer. Would you do it? Do you think we should allow it to be done, or should we pass laws against it? Why?

When I told Sussman that Danny Hillis had recently told me very nearly the same thing, he replied, "We are sort of on the edge."

"Do you think we are that close?" I asked.

"Yes."[50]

Sussman believes that minds are programs. Just as it is possible to transfer a program from a hard disk to a CD, Sussman looks forward to the day when we will be able to transfer our minds from our brains to computers. (We will explore the philosophical implications of this possibility in more detail in Chapter 4.)

Is this sort of immortality really possible? That depends on whether functionalism is an adequate theory of the mind. To assess its adequacy, we'll

have to examine its implications. Functionalism implies that there's nothing more to being in a mental state than being in a certain functional state. Let's see if that's true.

Functionalism and Feeling

Putnam's super-Spartans thought experiment shows that it's possible to be in a mental state without having any particular behavioral disposition. (Putnam's super-Spartans, you will recall, experienced pain but never behaved as if they were in pain.) Similarly, David Lewis argues that it's possible to be in a mental state without being in any particular functional state.

The relation between thought and the brain is roughly of the same order as that between bile and the liver or urine and the bladder.

—CARL VOGT

Thought Experiment

Lewis's Pained Madman

There might be a strange man who sometimes feels pain, just as we do, but whose pain differs greatly from ours in its causes and effects. Our pain is typically caused by cuts, burns, pressure, and the like; his is caused by moderate exercise on an empty stomach. Our pain is generally distracting; his turns his mind to mathematics, facilitating concentration on that but distracting him from anything else. Intense pain has no tendency whatever to cause him to groan or writhe, but does cause him to cross his legs and snap his fingers. He is not in the least motivated to prevent pain or to get rid of it. In short, he feels pain, but his pain doesn't at all occupy the typical causal role of pain. He would doubtless seem to us to be some form of madman, and that is what I shall call him, though of course the sort of madness I have imagined may bear little resemblance to the real thing.[53]

Lewis's madman is in pain, but his pain has a very different function than ours. Instead of distracting him and making him groan and writhe, it turns his mind to mathematics and makes him cross his legs and snap his fingers. Such a person is decidedly odd, but not inconceivable. The poor fellow may simply be wired wrong. If there can be such a person, however, functionalism is mistaken because being in a mental state doesn't depend on being in a particular functional state. The causes and effects of the madman's pain are totally different from ours. Yet he may nevertheless experience pain in the same way we do.

Lewis's argument goes something like this:

1. If functionalism were true, it would be impossible for someone to be in pain and function differently than we do when we are in pain.

2. But, as Lewis's pained madman shows, it's not impossible for someone to be in pain and function differently than we do.
3. So functionalism is false; being in a certain functional state is not a necessary condition for being in a mental state.

To be in pain, you do not have to be in any particular functional state. What makes something a pain is what it feels like, not what it makes you do. Because functionalism suggests otherwise, it's mistaken.

Just as Lewis shows that being in a specific functional state is not necessary for being in a mental state, Ned Block tries to show that it's not sufficient. According to functionalism, there's nothing more to having a mind than running the right kind of program. What the program is running on—whether it be neurons, silicon chips, or people—is irrelevant. Computer scientist Joseph Wiezenbaum once demonstrated that a computer could be made out of sticks, stones, and toilet paper. Functionalism would have us believe that if those sticks, stones, and toilet paper were running the right kind of program, it would have a mind. Block disagrees. To prove his point, he imagines a computer made of people.

Thought Experiment

Block's Chinese Nation

Suppose we convert the government of China to functionalism, and we convince its officials that it would enormously enhance their international prestige to realize a human mind for an hour. We provide each of the billion people in China (I chose China because it has a billion inhabitants) with a specially designed two-way radio that connects them in the appropriate way to other persons and to [an] artificial body. . . . we arrange to have letters displayed on a series of satellites so they can be seen from anywhere in China. The system of a billion people communicating with one another plus satellites plays the role of an external "brain" connected to the artificial body by radio. . . .

It is not at all obvious that the China–body system is physically impossible. It could be functionally equivalent to you for a short time, say an hour. . . .

What makes the homunculi-headed [miniature man–headed] system . . . just described a *prima facie* counterexample to (machine) functionalism is that there is *prima facie* doubt as to whether it has any mental states at all—empirically whether it has what philosophers have variously called "qualitative states," "raw feels," or "immediate phenomenological qualities. . . ." In Nagel's terms, there is a *prima facie* doubt whether there is anything which it is like to be the homunculi-headed system.[54]

In Block's thought experiment, the people in China are functioning like neurons in a brain: They are sending and receiving signals to and from one

another. If functionalism were true, then once the billion people in China started running the program, there would be a billion and one people in China; the billion people with walkie-talkies and the "person" whose program they're running. If the project were carried out properly, it should even be possible to talk to that "person." Block's point, however, is that such a "person" could not possibly have any conscious experience and thus could not be considered to have a mind. So there must be more to having a mind than having the right sort of functional organization.

Block's argument can be put as follows:

1. If functionalism were true, then anything that had the right sort of functional organization would have a mind.

2. But as Block's Chinese nation shows, it is not the case that anything that had the right sort of functional organization would have a mind.

3. So functionalism is false; having the right sort of functional organization is not a sufficient condition for having a mind.

A computer can be made out of anything: mechanical gears, vacuum tubes, silicon chips, and the like. All that's required is that its components be related to one another in the right sort of way. Similarly, functionalism claims that a mind can be made out of anything. As long as something has the right sort of functional organization—as long as it produces the right sort of output given the input it receives—it can be considered to have a mind. Block's Chinese nation thought experiment calls this claim into question. It suggests that no purely relational theory of mental states can account for their qualitative content.

Block's Chinese nation presents a version of what is known as the **absent qualia objection** to functionalism because it purports to show that it's possible for something to be functionally equivalent to a human being and yet have no conscious experience. This objection lies behind many people's rejection of the possibility of artificial intelligence. Robots made out of silicon and steel, they say, might be able to function like we do, but they would never be able to feel like we do. They would never be able to have sensations or experience emotions, for example. So they could not have minds like ours.

Not only does it seem to be possible for something to be functionally equivalent to us and not have any conscious experience, it also seems possible for something to be functionally equivalent to us and have the wrong kind of conscious experience. This second possibility is known as the **inverted spectrum problem**. Here's Putnam's version of it:

Thought Experiment

Putnam's Inverted Spectrum

The inverted spectrum example (which appears in the writings of Locke) involves a chap who walks about seeing things so that blue looks red to him and red looks blue to him (or so that his subjective colors resemble the colors on a color negative rather than the colors on a color positive). One's first reaction on

absent qualia objection The objection to functionalism based on the belief that a functional state could have all the functional properties of a mental state without having any of its qualitative content.

inverted spectrum problem The problem of accounting for the fact that people's color experiences could be very different even though they are functionally equivalent.

hearing of such a case might be to say, "Poor chap, people must pity him." But how would anyone ever know? When he sees anything blue, it looks red to him, but he's been taught to call that color blue ever since he was an infant, so that if one asked him what color the object is he would say "blue." So no one would ever know.

My variation was the following: imagine your spectrum becomes inverted at a particular time in your life and you remember what it was like before that. There is no epistemological problem about "verification." You wake up one morning and the sky looks red, and your red sweater appears to have turned blue, and all the faces are an awful color, as on a color negative. Oh my God! Now perhaps you could learn to change your way of talking, and to call things that look red to you "blue," and perhaps you could get good enough so that if someone asked you what color someone's sweater was you would give the "normal" answer. But at night, let us imagine you would moan, "Oh, I wish the colors looked the way they did when I was a child. The colors just don't look the way they used to."[55]

The problem that the inverted spectrum poses for functionalism is this: The two people with inverted spectra or the one person before and after the inversion are in the same functional state. They would both produce the same output from the same input. For example, if you asked them, "What color are stop signs?" they would both say, "Red." Similarly, if you asked them, "Are ripe tomatoes the same color as stop signs?" they would both say, "Yes." But even though they are in the same functional state, they are not in the same mental state, for the qualitative content of their visual experiences is vastly different—one experiences redness when looking at red objects, whereas the other experiences blueness. So there must be more to being in a mental state than being in a functional state.

Putnam's argument can be spelled out like this:

1. If functionalism were true, it would be impossible for people with the same functional organization to be in different mental states.

2. But, as Putnam's inverted spectrum shows, it's not impossible for people with the same functional organization to be in different mental states.

3. So functionalism is false; having a certain functional organization is not a sufficient condition for being in a certain mental state.

The character Mouse in the movie *The Matrix* raises a similar problem with regard to the faculty of taste. After Mouse eats some of the gruel served aboard the *Nebuchadnezzar,* the following discussion ensues:

Mouse: Do you know what it really reminds me of? Tasty Wheat. Did you ever eat Tasty Wheat?

Switch: No, but technically neither did you.

> ### Inverted Spectra and Pseudonormal Vision
>
> People with inverted spectrums may be more than a physical possibility, as the phenomenon of pseudonormal vision suggests. Are you one of them?
>
> Is it possible that a person who behaves just like you and me in normal life situations and applies color words to objects just as we do and makes the same color discriminations, see green where we see red and red where we see green? Or, to put the same question from another perspective: Is it possible that you are yourself red-green inverted with respect to all or most other people and that you thus are and have always been radically wrong about what other people see when looking at a sunset or the moving leaves of a tree?
>
> Philosophers normally discuss the possibility of Qualia Inversion by considering thought experiments. But there is, in fact, scientific evidence for the existence of such cases. Theories about the physiological basis of color vision deficiencies together with theories about the genetics of color vision deficiencies lead to the prediction that some people are "pseudonormal." Pseudonormal people "would be expected to have normal color vision except that the sensations of red and green would be reversed—something that would be difficult, if not impossible, to prove." This inversion would affect the perception of any color that contains a red or green component. A greenish blue river would appear violet to a pseudonormal person. Remember, however, that this description will give you a correct idea of what pseudonormal people experience only if you are not yourself one of them. But there is a chance that you are. According to a model of the genetics of color vision deficiencies that was first presented by Piantanida in 1974 pseudonormality occurs in 14 of 10 000 males.[56]
>
> ### Thought Probe
>
> Pseudonormal Vision
>
> People with pseudonormal vision are functionally indistinguishable from normal people. Does their existence support the claim that functionalism can't account for conscious experiences? Why or why not?

MOUSE: That's exactly my point. Exactly. Because you have to wonder: now how do machines really know what Tasty Wheat tasted like? Maybe they got it wrong. Maybe what I think Tasty Wheat tasted like actually tasted like oatmeal or tuna fish. That makes you wonder about a lot of things. . . .[57]

Mouse realizes that the way Tasty Wheat tastes to people outside the Matrix may be different from the way it tastes to people in the Matrix. (The Matrix is a computer simulation of reality.) The program running in the Matrix may be functionally equivalent to one running in someone's brain, but that doesn't mean that it produces the same experiences. So again it seems that a functional equivalence does not guarantee a mental equivalence.

The absent qualia and inverted spectrum objections to functionalism are compelling. To meet them, functionalists must show either that the situations envisioned in these thought experiments aren't possible or that the qualitative content associated with a mental state isn't essential to it.

Paul Churchland adopts the second alternative and argues that the qualitative content associated with a mental state is irrelevant to it. "What this means," he tells us, "is that the qualitative character of your sensation-of-red might be different from the qualitative character of my sensation-of-red, and a third person's sensation-of-red might be different again. But so long as all three states are

standardly caused by red objects and standardly cause all three of us to believe that something is red, then all three states are sensations-of-red, whatever their intrinsic qualitative character."[58] Such a reply to the absent qualia and inverted spectrum objections, however, simply begs the question. It assumes the truth of functionalism in an attempt to defend it. To see the inadequacy of this reply, just put yourself in the shoes of the person who underwent Putnam's spectrum inversion. Would you say that your mental states before and after the inversion are the same? Could you consider the sensation of redness to be the same as the sensation of blueness as long as both had the same causal role? If not, Churchland's bite-the-bullet defense isn't very persuasive.

The problem with functionalism's analysis of sensations is that it assumes that what's essential to a sensation is its typical causes and effects. But that doesn't seem to be the case. What makes a sensation the sensation that it is, is not its relations to other things, but what it feels like to have it. What makes something a pain, for example, is not what causes it or what it makes you do, but what it feels like when you have one. The painfulness of pain is an intrinsic property of the sensation of pain, and it can't be reduced to a set of cause-effect relationships.

Even if functionalism doesn't capture the essence of mental states that have qualitative content (like sensing), it might be argued that it does capture the essence of mental states that do not have qualitative content (like believing). After all, *Star Trek*'s Mr. Spock and Data suggest that one can be intelligent without having any feelings. To explore this possibility, let's take a closer look at the notion of intelligence.

The Turing Test

> A computer would deserve to be called intelligent if it could deceive a human into believing that it was human.
>
> —ALAN TURING

One of the first people to investigate the possibility of artificial intelligence was Alan Turing, one of the founders of modern computer science. In his 1950 article "Computing Machinery and Intelligence," he considered the question, Can machines think? Instead of trying to answer the question by defining the words "machine" and "think," he proposed a test that, if passed by a machine, would indicate that the machine was intelligent. Here is Turing's description of the test.

Thought Experiment

The Imitation Game

The new form of the problem [Can machines think?] can be described in terms of a game which we call the "imitation game." It is played with three people, a man (A), a woman (B), and an interrogator (C) who may be of either sex. The interrogator stays in a room apart from the other two. The object of the game for the interrogator is to determine which of the other two is the man and which is the woman. He knows them by labels X and Y, and at the end of the game he says either "X is A and Y is B" or "X is B and Y is A." The interrogator is allowed to put questions to A and B thus:

"We'll know whether to treat it with any special moral consideration when we see if it passes the Turing test."

C: "Will X please tell me the length of his or her hair?"

Now suppose X is actually A, then A must answer. It is A's object in the game to try to cause C to make the wrong identification. His answer might therefore be: "My hair is shingled, and the longest strands are about nine inches long."

In order that tones of voice may not help the interrogator, the answer should be written, or better still, typewritten. The ideal arrangement is to have a teleprinter communicating between the two rooms. Alternatively the question and answers can be repeated by an intermediary. The object of the game for the third player (B) is to help the interrogator. The best strategy for her is probably to give truthful answers. She can add such things as "I am the woman, don't listen to him!" to her answers, but it will avail nothing as the man can make similar remarks.

We now ask the question, "What will happen when a machine takes the part of A in this game?" Will the interrogator decide wrongly as often when the game is played like this as he does when the game is played between a man and a woman? These questions replace our original, "Can machines think?"[59]

Turing contends that if a machine could play this game as well as a normal man—that is, if it could convince an interrogator that it was a man as often as a normal man could—then the machine would be intelligent. For Turing, there is nothing more to being intelligent than being able to use language as we do.

Turing predicted in 1950 that in fifty years we would have computers powerful enough to "play the imitation game so well that an average interrogator will not have more than a 70% chance of making the right identification after five minutes of questioning."[60] Arthur C. Clarke was aware of this prediction and titled his novel about the English-speaking computer, Hal, *2001: A Space Odyssey* because if Turing were correct, there would be computers like Hal in the year 2001.

ALAN TURING
1912–1954

Alan Turing: Father of Code and Computers

The genius of Alan Turing (1912–1954) seems inexplicable. In his childhood, creativity and exploration were never encouraged, and in adulthood there were almost no precedents for his creations and no intellectual stepping-stones toward his grand achievements. Turing was a loner, sometimes an outcast, and mostly misunderstood, but he became the father of computer science and the first to see the now-obvious links between mathematics, logic, mind, and machines.

Alan Turing was born in London and educated at King's College, Cambridge. But long before his formal education, he was asking fundamental philosophical and scientific questions. One of his earliest queries was how the human mind could be embodied in matter and whether it could exist independently of matter. He also wondered whether quantum theory (the area of physics dealing with subatomic particles) played a significant part in the mystery of mind-matter. Ostensibly he was a promising young mathematician, but his real interests were broader, encompassing mathematics, logic, and physics.

Turing's first great achievement was the Turing machine, a theoretical device that could compute anything that was computable. The computers we use today are all universal Turing machines.

During World War II, Turing worked for the British government department that was charged with making and breaking codes. At the time, Germany was using a code device—called the Enigma cipher machine—that could produce seemingly unbreakable codes for vital wartime communications. But Turing cracked the Enigma code by envisioning another powerful device that could decode Enigma messages if a small portion of the code text were worked out. Turing's labors were a major contribution to the Allied war effort.

After the war, Turing was a top track runner and a serious candidate for a spot in the 1948 Olympic Games, but an injury prevented him from competing. In 1950, Turing published a landmark paper in the philosophy journal *Mind*. He described the Turing test, a method for determining whether machines can think. His work in this area had a major impact on research in artificial intelligence (AI).

Turing was a homosexual. In Britain in the 1950s, however, homosexuality was a crime. When his homosexuality was discovered, he was arrested, thrown in jail, and given massive injections of estrogen—the preferred "treatment" for homosexuality in Britain at that time. Sometime after he was released from jail, he committed suicide by eating an apple laced with cyanide.

The Turing test is not just a thought experiment. Every year since 1991, Hugh Loebner, in conjunction with the Cambridge Center for Behavioral Studies, has conducted a "formal instantiation" of a Turing test. The Loebner Prize for the first computer that can fool the human judges into thinking it's human is $100,000 plus a gold medal. No computer has yet won the prize, but each year the best performing computer is awarded $2,000.

Although no computer can yet converse as well as a human, they can perform better than humans at a number of intellectual tasks. In 1997, Gary Kasparov, the world's reigning chess champion, was beaten by IBM's supercomputer, Deep Blue. In 2011, Brad Rutter and Ken Jennings, the highest winning and longest playing Jeopardy contestants, respectively, were beaten by another IBM supercomputer, Watson (named after Thomas J. Watson, IBM's first president). Watson was not allowed to go to the Internet for answers; all of its knowledge was self-contained. IBM has not yet entered a computer in the Loebner competition.

The difficulty of passing the Turing test should not be underestimated. To pass it, a computer would apparently have to lie. For example, no computer that answered "Yes" to the question "Are you a computer?" would pass the test. When asked, "What color are your eyes?" "What is your favorite food?" "When did you graduate from high school?" the computer would have to give false but believable answers. It seems that only a machine that knew it was taking the Turing test would be able to pass it. But any machine with that sort of knowledge, it seems, would have to be intelligent.

John Searle denies that intelligence is required to pass the Turing test. To see this, Searle suggests, all you have to do is put yourself in the place of the computer.

Thought Experiment

Searle's Chinese Room

Consider a language you don't understand. In my case, I do not understand Chinese. To me Chinese writing looks like so many meaningless squiggles. Now suppose I am placed in a room containing baskets full of Chinese symbols. Suppose also that I am given a rule book in English for matching Chinese symbols with other Chinese symbols. The rules identify the symbols entirely by their shapes and do not require that I understand any of them. The rules might say such things as, "Take a squiggle-squiggle sign from basket number one and put it next to a squoggle-squoggle sign from basket number two."

Imagine that people outside the room who understand Chinese hand in small bunches of symbols and that in response I manipulate the symbols according to the rule book and hand back more small bunches of symbols. Now, the rule book is the "computer program." The people who wrote it are "programmers," and I am the "computer." The baskets full of symbols are the "data base," the small bunches that are handed in to me are "questions" and the bunches I then hand out are "answers."

Now suppose that the rule book is written in such a way that my "answers" to the "questions" are indistinguishable from those of a native Chinese speaker. For example, the people outside might hand me some symbols that unknown to me mean, "What's your favorite color?" and I might after going through the rules give back symbols that, also unknown to me, mean, "My favorite is blue, but I also like green a lot." I satisfy the Turing test for understanding Chinese. All the same, I am totally ignorant of Chinese. And there is no way I could come to understand Chinese in the system as described, since there is no way that I can learn the meanings of any of the symbols. Like a computer, I manipulate symbols, but I attach no meaning to the symbols.[61]

> *The question of whether a computer can think is no more interesting than the question of whether a submarine can swim.*
>
> —EDSGER W. DIJKSTRA

Inside the room, Searle is doing what a computer does when it processes information; that is, he is manipulating formal symbols in accordance with a set of rules. To those outside the room, it appears that he understands what the symbols mean, for the string of symbols he produces in response to the string of symbols he receives is like the one a native Chinese speaker would produce. But he doesn't understand what the symbols mean. So, Searle concludes, passing the Turing test is not a sure sign of intelligence. His argument can be put like this:

1. If a computer could understand a language solely in virtue of running a program, then the man in the room would understand Chinese (because he's doing the same thing that a computer does—namely, manipulating symbols in accordance with a set of rules).

2. But the man in the room doesn't understand Chinese.

3. So computers can't understand a language solely in virtue of running a program.

The difference between the ways computers and humans manipulate symbols is this: Computers manipulate symbols on the basis of their physical features or form, whereas humans manipulate symbols on the basis of their meaning or content. But the meaning of a symbol is not a physical feature of it. You can't tell what a symbol means by examining its form, for anything can symbolize anything else. Xs and Os, for example, can symbolize football players, hugs and kisses, or players in a game of tic-tac-toe. Because computers, as computers, respond only to the form of symbols and not to their meaning, their responses can't be considered intelligent.

syntax How a symbol can be combined with other symbols to form a sentence.

semantics What a symbol means.

How a symbol can be combined with other symbols is determined by its **syntax.** What a symbol means is determined by its **semantics.** Searle's point is that no matter how good a computer gets at producing syntactically correct strings of symbols, it will not understand what those symbols mean, for, as he puts it,

"syntax alone is not sufficient for semantics."[62] To understand what a symbol means, you must know what it is intended to represent. And what it is intended to represent is not determined by any of its physical or functional properties.

Those in the artificial-intelligence community realized early on that Searle's Chinese room thought experiment posed a serious challenge to their whole project. Consequently, they produced a number of replies to it in an attempt to blunt its force. Here's a synopsis of some of the replies and Searle's responses to them:

- *Systems reply:* The man in the room may not understand Chinese, but the whole system including the room, the man, the symbols, and the rule book does understand Chinese. *Rejoinder:* The man could become such a system by internalizing all the rules and yet he would still not understand Chinese.

- *Robot reply:* The man in the room may not understand Chinese, but if the room were put inside a robot that interacted with the world, then the robot would understand Chinese. *Rejoinder:* To make this reply is to give up the position of strong AI that says there's nothing more to having a mind than running the right kind of program. The view implicit in this reply, known as "weak AI," says that in addition to running the right program, the program must be running on the right kind of machine. What's more, Searle believes the same experiment could be made to apply to this situation with only a slight modification. Suppose that the symbols the man receives come in through television cameras and that the symbols he produces run the robot's arms and legs. Even in that case, running the program would not give him an understanding of Chinese.

- *Brain simulator reply:* The man in the room does not understand Chinese because he is running the wrong kind of program. If, instead of manipulating symbols, the program simulated the sequence of nerve firings that occur when a Chinese speaker speaks the language, the system would understand Chinese. *Rejoinder:* Again, a slight modification of the experiment shows that this wouldn't work. Suppose that in place of the symbols, the man operates an elaborate set of water pipes connected by valves. The program indicates which valves must be open and shut depending on what symbols are received. Here, the system of water pipes simulates the actions of neurons. Nevertheless, says Searle, neither the man nor the man plus the water pipes understands Chinese.

- *Combination reply:* Even if each of these above replies is unsuccessful, taken together they would create a system that understands Chinese, for the behavior of the resulting system would be indistinguishable from that of one who does understand Chinese. *Rejoinder:* This reply assumes the truth of logical behaviorism, for it says that if something acts as if it understands, then it does understand. But logical behaviorism is not a viable theory of the mind. If we knew nothing about the system, we might justifiably conclude that it did understand Chinese. Given what we know, however, such a conclusion would not be justified, for we can account for its behavior without assuming that it understands Chinese.[63]

To understand a language, one must know what the symbols in that language represent. Searle's point is that simply running a program will not give one that knowledge. Something more is needed. Exactly what more, Searle doesn't say. But whatever it is, it must give to the thing running the program a knowledge of semantics, of what the symbols mean.

Thought Probe

Total Turing Test

Psychologist Stevan Harnad has proposed the Total Turing Test for artificial intelligence. To pass this test, the computer being tested would have to be able to do *everything* that a normal human being does, including walking, riding a bicycle, swimming, dancing, playing a musical instrument, and so on. Only a computer with a robot body could do that. Is passing the Total Turing Test either necessary or sufficient for being intelligent and thus having a mind? Why or why not?

Intentionality

> An utterance can have Intentionality, just as a belief has Intentionality, but whereas the Intentionality of the belief is intrinsic the Intentionality of the utterance is derived.
>
> —John Searle

When we think, we think about something. For example, the hope that the Yankees will win the pennant is about the Yankees, the pennant, and the proposition that the Yankees will win the pennant. The "aboutness" of thought is known as **intentionality.** The word "intentionality" comes from the Latin verb *intendo,* which means "to point or aim at something." So something that possesses intentionality points or aims at something. The things it points or aims at are known as its intended objects.

The intentionality of mental states must not be confused with the intentionality of persons. We often speak of persons doing things intentionally, or on purpose. To say that a mental state has intentionality, however, is not to say that it does anything on purpose. Rather, it is to say that it represents or refers to something.

One of the most remarkable things about mental states is that they can be about things that don't exist. We can think about mermaids, unicorns, and centaurs, for example, even though there are no such things. German philosopher Franz Brentano claimed that this is what distinguishes mental states from physical states. Mental states can be directed on nonexistent objects; physical states cannot. You can think about an imaginary rock, but you can't kick one. In any event, the ability to conceive of nonexistent objects and states of affairs is essential for thinking.

Any adequate theory of the mind must account for the intentionality of mental states. That is, it must explain how it is possible for us to think about things. Searle's Chinese room thought experiment is designed to show that functionalism can't account for this aspect of our minds. According to the thought experiment, we can be functionally equivalent to a Chinese speaker

intentionality The property of mental states that makes them of or about something.

and still not understand a word of Chinese. Consequently, the intentionality of a mental state can't be determined by its function.

Does Searle's Chinese room thought experiment show that machines can't think? No, for as Searle himself admits, "we are all machines and we can think."[64] What it shows is that there's more to thinking than just running a program. What more? Running it on the right kind of hardware. According to Searle, something can have a mind only if the stuff it thinks with has the same "causal powers" as our brains. Specifically, it must have the power to produce states that possess intentionality, for without intentionality, it can't think about anything.

Does Searle's Chinese room thought experiment show that the Turing test isn't a good test of intelligence? No, for even if passing the test isn't proof of intelligence, it may nevertheless be good evidence for it. Evidence need not be conclusive to be convincing. Test results must always be taken with a grain of salt because it's possible that the results are due to something other than what the test is designed to measure. Most tests provide only *prima facie* evidence for the hypothesis in question. That is, they provide evidence that is good on its face but may be overridden by other considerations. So although it's not necessarily true that whatever passes the Turing test is intelligent, it's probable that whatever passes the Turing test is intelligent. Further investigation, however, may reveal that the probability isn't actual.

Ned Block describes one way of passing the Turing test that doesn't require any intelligence.

Thought Experiment

Block's Conversational Jukebox

Call a string of sentences whose members, spoken one after another, can be uttered in an hour or less, a speakable string of sentences. A speakable string can contain one very long sentence, or a number of shorter ones. Consider the set of all speakable strings of sentences. Since English has a finite number of words (indeed, a finite number of sound sequences forming possible words short enough to appear in a speakable string), this set has a very large but finite number of members. Consider the subset of the set of all speakable strings of sentences, each of whose member strings can be understood as a conversation in which at least one party is "making sense." Call it the set of smart speakable strings. . . . We need not be too restrictive about what is to count as making sense. For example, if sentence 1 is "let's see you talk nonsense," then sentence 2 could be nonsensical. The set of smart speakable strings is a finite set which could in principle be listed by a very large team working for a long time with a very large grant. Imagine that the smart speakable strings are recorded on a tape and deployed by a very simple machine, as follows. An interrogator utters sentence A. The machine searches the set of smart speakable strings, picks out those strings that begin with A, and picks one string at random (or it might pick the first string it finds beginning with A, using a random search). It then

produces the second sentence in that string, call it "B." The interrogator utters another sentence, call it "C." The machine picks a string at random that starts with A, followed by B, followed by C, and utters its fourth sentence, and so on.

Now, if the team has been thorough and imaginative in listing the smart speakable strings, this machine would simulate human conversational abilities. Indeed, if the team did a brilliantly creative job, the machine's conversational abilities might be superhuman (though if it is to "keep up" with current events, the job would have to be redone often). But this machine clearly has no mental states at all. It is just a huge list-searcher plus a tape recorder.[65]

The storage capacity required to house all these conversations would be immense. And the longer the conversations were carried on, the more storage space would be required. So such a machine may be impossible to build. Nevertheless, Block's conversational jukebox, like Searle's Chinese room, shows that there's more to being intelligent than just producing a certain output relative to a given input. How that output is produced is also important. If it's produced in a way that doesn't require any intelligence, then even if it can pass the Turing test, it isn't intelligent.

Thought Probe

Devout Robots

Suppose that a robot that passed the Turing test asks to be baptized. Should it be? Why or why not? Should it be given the same rights that we have? Why or why not?

Summary

According to functionalism, mental states are not material states or states of a nonphysical substance. They're functional states. That is, they are states with a certain function or causal role. The function of a state can be defined in terms of its inputs and outputs. Because computer programs can also be defined in terms of their inputs and outputs, functionalism considers minds to be programs. In this view, the mind is to the brain as the software of a computer is to its hardware. You are your program, so anything that runs your program would be you. Theoretically, then, you could become immortal by downloading your mind into a computer.

Being in a certain functional state, however, seems to be neither a necessary nor a sufficient condition for being in a certain mental state. For, like behaviorism, functionalism does not account for the felt quality of our mental states. People whose experiences are very different could nonetheless be functionally identical. Consequently, functionalism doesn't capture the essence of the mental.

Some have thought that functionalism does provide an adequate explanation of mental states that lack qualitative content, like belief. The essential

feature of those mental states is their intentionality—they are directed on or about something. But functionalism can't account for intentionality because one can know how to manipulate symbols without knowing what they mean, as Searle's Chinese room thought experiment demonstrates. This doesn't mean that machines can't think, but it does mean that there's more to having a mind than running a program.

Study Questions

1. According to functionalism, what is it to be in a mental state?
2. What is Lewis's pained madman thought experiment? How does it attempt to undermine functionalism?
3. What is Block's Chinese nation thought experiment? How does it attempt to undermine functionalism?
4. What is Putnam's inverted spectrum thought experiment? How does it attempt to undermine functionalism?
5. What is the Turing test for intelligence?
6. What is Searle's Chinese room thought experiment? How does it attempt to undermine the Turing test?
7. What is intentionality?
8. What is Block's conversational jukebox argument? How does it attempt to undermine the Turing test?

Discussion Questions

1. Is it possible to build a computer that can pass the Turing test? Why or why not?
2. It is possible to make a fully functional computer out of sticks, stones, and toilet paper. If such a computer ran your program, would it be you? Why or why not?
3. Consider the various replies to Searle's Chinese room thought experiment. Which do you think is the most plausible? Why?
4. Suppose that the "person" whose program is being run by Block's Chinese nation claims that she is cold. Would you believe her? Why or why not?
5. Psychologist Stevan Harnad has proposed the Total Turing Test for artificial intelligence. To pass this test, the computer being tested would have to be able to do *everything* that a normal human being does, including walking, riding a bicycle, swimming, dancing, playing a musical instrument, and so on. Only a computer with a robot body could do that. Is passing the Total Turing Test either necessary or sufficient for being intelligent and thus having a mind? Why or why not?

Internet Inquiries

1. Inventor Ray Kurzweil has bet computer scientist Mitchell Kapor $20,000 that a computer will pass the Turing test by 2029. You can find the details of their wager here: **http://www.longbets.org/1.** Who do you think is going to win? Why?

2. Programs that can carry on conversations with humans are known as "chatterbots." A number of different chatbots, arranged by species, can be found here: **http://simonlaven.com/.** Try having a conversation with some of the chatbots. Which species do you find the most sophisticated? Would you call any of them intelligent? Why or why not?

3. The Loebner Prize home page can be found here: **https://www.aisb.org.uk/events/loebner-prize.** Look at some of the transcripts of the winning programs. Would they have fooled you?

4. Data is an android in the television series *Star Trek: The Next Generation*. He has no emotions, but he has a great desire to have them because he would like to become more human. In the episode "The Measure of a Man," it was argued that his lack of feelings meant that he wasn't a person. A trial was held to determine whether he was a person or merely the property of Star Fleet. The script for this episode can be found here: **http://www.st-minutiae.com/resources/scripts/135.txt.** Videos of the trial can be found here: **https://www.youtube.com/watch?v=vjuQRCG_sUw.** Do you think the judge made the right decision? Why or why not?

5. The creation of artificially intelligent computers may threaten the continued survival of the human race. One of the best computer scientists on the planet—Bill Joy—is so worried about this possibility that he has called for a ban on all artificial-intelligence research (as well as research into genetics and nanotechnology). The article in which he spelled out his concerns can be found here: **http://www.wired.com/wired/archive/8.04/joy.html.** Do you agree that we should restrict research into these areas to preserve the human race? Why or why not?

Section 2.4

There Ain't No Such Things as Ghosts
Mind as Myth

None of the reductive theories of the mind—logical behaviorism, the identity theory, or functionalism—has succeeded (or appears likely to succeed) in providing an adequate account of the nature of the mind. The apparent failure of these theories is an important result of philosophical research and a piece of data that any adequate theory of mind must explain. **Eliminative materialism** provides one such explanation. It claims that reductive theories of the mind have failed because mental terms do not refer to anything. In other words, the reason why there has been no reduction of the mental to the physical is that there is nothing to reduce—mental states do not exist!

Such a claim may seem startling. But eliminative materialists contend that the claim that there are no devil-loving witches would have seemed equally startling to members of the Spanish Inquisition. Just as demonic witches were part of a folk theory that nearly everyone in the thirteenth century took for granted, so mental states are part of a folk theory that nearly everyone in the twenty-first century takes for granted. And just as the advance of scientific knowledge has shown that there are no demonic witches, so, someday, the advance of scientific knowledge may show that there are no mental states.

Richard Rorty, an early advocate of eliminative materialism, provides the following thought experiment to clarify this point.

What is mind?
No matter.
What is matter?
Never mind.
—Thomas Key

Thought Experiment

Rorty's Demons

A certain primitive tribe holds the view that illnesses are caused by demons—a different demon for each sort of illness. When asked what more is known about these demons than that they cause illness, they reply that certain members of the tribe—the witch doctors—can see, after a meal of sacred mushrooms, various

eliminative materialism The doctrine that there are no mental states.

> (intangible) humanoid forms on or near the bodies of the patients. The witch-doctors have noted, for example, that a blue demon with a long nose accompanies epileptics, a fat red one accompanies sufferers from pneumonia, etc. They know such further facts as that the fat red demon dislikes a certain sort of mold which the witch-doctors give people who have pneumonia. If we encountered such a tribe, we would be inclined to tell them that there are no demons. We would tell them that diseases were caused by germs, viruses, and the like. We would add that the witch-doctors were not seeing demons, but merely having hallucinations.[66]

Diseases used to be explained in terms of demons. Now we explain them in terms of germs, viruses, and the like. All references to demons have been eliminated from our medical textbooks. Similarly, claims Rorty, all references to mental states will someday be eliminated from our psychology textbooks. He explains,

> The absurdity of saying "Nobody has ever felt a pain" is no greater than that of saying "Nobody has ever seen a demon," if we have a suitable answer to the question "What was I reporting when I said I felt a pain?" To this question, the science of the future may reply "You were reporting the occurrence of a certain brain-process, and it would make life simpler for us if you would, in the future, say 'My C-fibers are firing' instead of saying 'I'm in pain.'" In so saying, he has as good a *prima facie* case as the scientist who answers the witch-doctor's question "What was I reporting when I reported a demon?" by saying "You were reporting the content of your hallucination, and it would make life simpler if, in the future, you would describe your experiences in those terms."[67]

Modern science can explain everything that the demon theory explained without referring to demons. Similarly, says Rorty, modern science may be able to explain everything that the pain theory explains without referring to pains. If so, science will have shown that there is no good reason to believe in the existence of pains. In such a case, those who continue to believe in pains would be just as deluded as those who continue to believe in demons.

Eliminative materialism differs from reductive materialism in that the former doesn't identify the mind with anything physical. Both logical behaviorism and the identity theory contend that to talk about mental states is to talk about physical states of some sort. Eliminative materialism, on the other hand, contends that to talk about mental states is to talk about nothing. The mind is a myth. Mental states have no more reality than the Greek gods. As a result, all talk about minds can be eliminated from our explanations of behavior.

If no one has ever been in pain, however, it follows that no one has ever done anything because he or she was in pain. If there are no mental states, there are no mental causes. So, like epiphenomenalism, eliminative materialism denies that mental states affect behavior. But, unlike epiphenomenalism, it also denies that mental states exist.

Folk Psychology

Folk psychology is our commonsense theory of the mind that explains people's behavior in terms of mental states like belief and desire. Not only does folk psychology assume that we have beliefs and desires, it also assumes that they affect what we do. Eliminative materialists reject both of these assumptions. In their view, there are no beliefs and desires, so they cannot affect our behavior.

How can the eliminative materialists deny something that seems so obvious? They do so by claiming that mental states are theoretical entities. Theoretical entities are things that are assumed to exist to account for something. Atoms, for example, were theoretical entities when they were first postulated. Until very recently, no one had seen an atom. Nevertheless, they were assumed to exist because they provided the best explanation of certain phenomena. Eliminative materialists claim that mental states are like atoms: The only reason we have for believing in them is that they seem to provide the best explanation of certain phenomena. But contrary to popular belief, mental states do not explain anything. Consequently, we are not justified in believing in them.

Philosopher Paul Churchland, for example, claims that folk psychology fails to explain a number of psychological phenomena.

> So much of what is central and familiar to us remains a complete mystery from within folk psychology. We do not know what sleep is, or why we have to have it, despite spending a full third of our lives in that condition. . . . We do not understand how learning transforms each of us from a gaping infant to a cunning adult or how differences in intelligence are grounded. We have not the slightest idea how memory works, or how we manage to retrieve relevant bits of information instantly from the awesome mass we have stored. We do not know what mental illness is, nor how to cure it.[68]

Because sleep, intelligence, memory, mental illness, and the like can't be explained by folk psychology, Churchland claims that folk psychology will eventually be replaced by another theory that doesn't rely on beliefs and desires.

The fact that folk psychology can't explain certain phenomena would be a strike against it only if it was intended to explain them. But it wasn't. Folk psychology was intended to explain the waking actions of normal adults. There is no more reason to reject folk psychology because it can't explain sleep than there is to reject the theory of continental drift because it can't explain how planets are formed. Different theories explain different things. Just because a theory doesn't explain everything is no reason to reject it.

Although Rorty suggests that mental states are analogous to demons, there is a significant disanalogy: We can explain away demonic visions as hallucinations, but we can't explain away sensations as hallucinations because hallucinations are sensations. To have a hallucination is to have a sensation. To make his case, then, Rorty must find some other way of explaining how it's possible for us to be mistaken about the fact that we have sensations. But how could we be mistaken about the fact that we have sensations? Descartes seems to have been onto something when he suggested that he couldn't be deceived about the fact that he was thinking. This suggests that sensations are not theoretical entities. Instead, they are the data that any adequate theory of the mind must explain.

> *My psychology belongs to everyone.*
> —ALFRED ADLER

folk psychology Our commonsense theory of mind that explains people's behavior in terms of beliefs and desires.

Contemporary philosopher Galen Strawson agrees. He considers the denial of conscious experience to be "the silliest view ever held in the history of human thought," for if there is no conscious experience, "no one has ever really suffered, in spite of agonizing diseases, mental illness, murder, rape, famine, slavery, bereavement, torture, and genocide. And no one has ever caused anyone else pain."[69] Silliness indeed.

Subjective Knowledge

The sensation of colour cannot be accounted for by the physicist's objective picture of light-waves.
—ERWIN SCHRODINGER

If either reductive or eliminative materialism were true, it would be possible to provide a complete description of the world in purely physical terms, for there would be no nonphysical things or properties. Frank Jackson, however, claims that a complete knowledge of all the physical facts about the world would not give us a complete knowledge of the world. Consider, for example, the following well-informed scientist who has never seen colors.

Thought Experiment

Mary, the Color-Challenged Scientist

Mary is a brilliant scientist who is, for whatever reason, forced to investigate the world from a black and white room via a black and white television monitor. She . . . acquires, let us suppose, all the physical information there is to obtain about what goes on when we see ripe tomatoes, or the sky, and use terms like "red," "blue," and so on.

What will happen when Mary is released from her black and white room . . . ? Will she learn anything or not? It seems just obvious that she will learn something about the world and our visual experience of it. But then it is inescapable that her previous knowledge was incomplete. But she had all the physical information. Ergo there is more to have than that, and physicalism is false.[70]

Although Mary has never seen anything that is colored, she knows all the physical facts about vision. If physicalism were true, she would know everything there is to know about vision. But she doesn't know everything that there is to know about vision because she doesn't know what it's like to see colored objects. So, Jackson concludes, physicalism is false; there's more to the world than just physical objects and physical properties.

According to Jackson, any account of the world that doesn't include the qualitative content of our conscious experience can't be considered complete. But any purely physicalistic account of the world can't include it, for what it feels like to have a certain experience isn't a physical fact. (All physical facts, remember, are knowable from a third-person point of view.) So, contrary to what the eliminative materialists would have us believe, it isn't possible to provide a complete account of the world in purely physical terms.

This is a telling argument against eliminative materialism in particular and physicalism in general. As David Lewis admits, "We dare not grant there is a sort of information we overlook. . . . that would be defeat." So how does Lewis propose to deal with Jackson's thought experiment? "Our proper answer," he tells us, "is that knowing what it's like isn't the possession of information at all. It isn't the elimination of any hitherto open possibilities. Rather, knowing what it's like is the possession of abilities: abilities to recognize, abilities to imagine, abilities to predict one's behavior by means of imaginative experiments."[71] According to Lewis, then, Mary (in her room) didn't lack any information about the world. She simply lacked certain abilities.

What Mary didn't know is what it's like to see colors. According to Lewis, to know what something is like is to know how to do something. So Mary didn't lack any factual knowledge, she just lacked performative knowledge. The problem with this argument is that knowing how to do something is neither a necessary nor a sufficient condition for knowing what something is like. Consequently, Lewis's attempt to save physicalism fails.

Knowing how is not a sufficient condition for knowing what, for Mary could have all of the abilities mentioned by Lewis without knowing what red is like. She could know, for example, that red objects appear as a particular shade of gray on her TV screen. This knowledge would give her the ability to recognize or imagine red objects by recognizing or imagining that particular shade of gray. (In this case, she would be imagining red objects, but she would not be imagining them as red objects.) Because Mary could know how to recognize or imagine red objects without knowing what red is like, knowing how doesn't entail knowing what.

Nor does knowing what entail knowing how, for someone could know what something is like without being able to do anything. People paralyzed from birth, for example, can know what pain is even though they can't move a muscle. So knowing what can't be construed as a species of knowing how.

If physicalism were true, then a knowledge of all the physical facts would give us a complete understanding of the world. But there seems to be much about the world that we wouldn't understand if we had no knowledge of qualitative content. Suppose there were a well-informed materialist who couldn't feel pain. She would know that people tend to avoid painful things. But would she understand why this is so? She would know that painful things tend to cause bodily damage and that people usually want to avoid bodily damage, but would that give her a complete understanding of why people tend to avoid painful things? It wouldn't seem so. It leaves out of account the most important reason for avoiding pain—namely, that it hurts! Insofar as sensations (and the fear of sensations) cause actions, anyone who has not experienced them cannot completely understand human behavior.

That pain feels like *this* (where *this* refers to the qualitative content of the experience) is a fact about the world. It is not a physical fact, however, for as we have seen, it is neither identical to nor reducible to a physical fact. Any attempt to describe or explain the world in purely physicalistic terms, then, must leave something out of account—namely, the nature of conscious experience.

To highlight the difficulty that any physicalistic theory has in explaining the mind, David Chalmers offers the following thought experiment about zombies.

In the News: Seeing Color for the First Time

Mary the color-challenged scientist is not just a creature of the imagination. There are people who are born seeing only black and white and later gain the ability to see in color. Reporter Jojo Moyes filed the following story in the British newspaper *The Independent*.

> A teenager told yesterday how he cried when he saw in colour for the first time, thanks to revolutionary contact lenses developed by British scientists.
>
> Kevin Staight, 18, was born with a rare eye defect, affecting one in a million people, which meant he saw everything in black and white. Now he is learning about colour, after his grandparents Don and Dorothy Staight saved up for the special lenses.
>
> "After I put them on I went for a walk and slowly saw the world in colour for the first time," said Kevin, from Cheltenham, Gloucestershire. "Up until then I didn't have any idea what colour was because I couldn't see it."
>
> "I couldn't stop crying because the world looked so different to what I was used to. The reds just kept on jumping out at me and I had to ask my grandparents which colours were which because I didn't have a clue."
>
> "It has opened up a whole new world for me. I never realized just how beautiful things like trees and flowers are."
>
> Mrs. Staight, Kevin's grandmother, who raised him, said: "He is a completely changed person. I don't think anybody realized just how gloomy his world has been up until now."
>
> "The opticians had told us there was nothing that could be done because he was so severely colour blind. When we heard about these lenses we decided to give them a go to see if they would work for Kevin and the results were amazing.
>
> "He dragged us outside and was rushing around pointing at things and asking what colour they were. It was all very emotional because he was crying."
>
> Mrs. Staight said that Kevin's girlfriend, Sarah Gill, had been nervous about his reaction, as she is half Vietnamese and wasn't sure how he would react to her skin.
>
> "It has made absolutely no difference to Kevin because we explained to him beforehand that people have different colour and textures to their skin," Mrs. Staight said.
>
> Kevin's career prospects have also been aided by the new lenses. As a result of being able to see on-screen colour, he has secured a job working with computers.
>
> The lenses, called ChromaGen, have only been available at six opticians in Britain since they were released last July and are £540 a pair. They were supplied by Bristol optician Roger Spooner, who said: "Kevin's case was very dramatic because he lived in a totally grey world. He was the first person I have come across who was totally colour blind."
>
> "The whole practice was in tears when he came here to try on his lenses but it was a very rewarding experience to help him."[72]

Thought Probe

Seeing Color

Kevin claims that he had no idea what color was before he received his lenses. Does this real-world case bolster Jackson's claim that qualia are not physical properties?

Thought Experiment

Zombies

> ... consider the logical possibility of a zombie: someone or something physically identical to me (or to any other conscious being), but lacking conscious experience altogether. At the global level, we can consider the logical possibility

of a *zombie world:* a world physically identical to ours, but in which there are no conscious experiences at all. In such a world, everybody is a zombie.

So let us consider my zombie twin. This creature is molecule for molecule identical to me, and identical in all the low-level properties postulated by a completed physics, but he lacks conscious experience entirely. (Some might prefer to call a zombie "it," but I use the personal pronoun; I have grown quite fond of my zombie twin.) To fix ideas, we can imagine that right now I am gazing out the window, experiencing some nice green sensations from seeing the trees outside, having pleasant taste experiences through munching a chocolate bar, and feeling a dull aching sensation in my right shoulder.

What is going on in my zombie twin? He is physically identical to me, and we may as well suppose that he is embedded in an identical environment. He will certainly be identical to me *functionally:* he will be processing internal configurations being modified appropriately and with indistinguishable behavior resulting. He will be *psychologically* identical to me. . . . He will be perceiving the trees outside, in the functional sense, and tasting the chocolate, in the psychological sense. All of this follows from the fact that he is physically identical to me, by virtue of the functional analyses of psychological notions. . . . It is just that none of this functioning will be accompanied by any real conscious experience. There will be no phenomenal feelings, there is nothing [that] it is like to be a zombie.[73]

Chalmers's zombies—unlike Hollywood zombies or voodoo zombies—are physiologically and behaviorily identical to us. They are made out of the same stuff that we are, and they act the same way that we do. The only difference between us and them is that they have no conscious experience. There is nothing that it is like to be a zombie because they have no sensations or emotions. But you couldn't tell that by looking at them, or even by dissecting them, for both internally and externally, they are indistinguishable from us.

Like Descartes' conceivability argument, Chalmers's zombie argument is designed to show that consciousness is nonphysical. Although it advocates a sort of dualism, it is not the sort of dualism advocated by Descartes. Chalmers is not trying to resurrect the notion that the mind is a nonphysical thing that can exist independently of the body. Instead, he is trying to show that mental properties are not reducible to or explainable in terms of physical properties.

Science has traditionally tried to explain things by identifying their structure or function. Many aspects of consciousness may be explainable in this way, such as the ability to discriminate stimuli, integrate information, and control behavior. These Chalmers calls the "easy problems" of consciousness, not because their solution is obvious, but because they should be solvable in the traditional manner. The problems of how and why physical processes give rise to consciousness, however, do not seem to be similarly solvable. No amount of structural or functional knowledge would seem to provide answers to these questions. Consequently, Chalmers calls these the "hard problems" of consciousness. His zombie thought experiment highlights the difficulty. It seems perfectly conceivable that we could get along in the world without having any conscious experience. So

There is nothing so unthinkable as thought, unless it be the entire absence of thought.
—SAMUEL BUTLER

why does it exist, and how do brains produce it? To answer these questions, Chalmers believes a new type of explanation is needed. In Section 2.5, we'll consider what such an explanation might look like.

Thought Probe

Zombies

Could a zombie (a creature with no mental states) do everything that a normal human being can do? One thing we can do is use metaphorical language—language that, though literally false, can be figuratively true. Nelson Goodman explains:

> Before me is a picture of trees and cliffs by the sea, painted in dull grays, and expressing great sadness. . . . The picture is literally gray but only metaphorically sad. . . . But to say that it is sad is metaphorically true even though literally false. Just as the picture clearly belongs under the label "gray" rather than under the label "yellow," it also clearly belongs under "sad" rather than under "gray."[74]

Could a zombie recognize that this painting belongs under the label "sad"? By definition, a zombie has never experienced sadness (or grayness). It doesn't know what sadness (or grayness) is like. Without this knowledge, would it be able to place the painting in the appropriate category? Why or why not?

Summary

Eliminative materialism provides an explanation for the failure of reductive theories of mind: Mental states cannot be reduced to physical states because there is nothing to reduce—mental states do not exist. We think there are mental states because we are in the grip of a bad theory of the mind, folk psychology. Folk psychology is our commonsense theory of mind that explains people's behavior in terms of beliefs and desires. According to eliminative materialism, beliefs and desires are theoretical entities postulated to explain behavior. But we can explain behavior without referring to beliefs and desires. Therefore, there is no reason to believe that they exist.

Eliminative materialism is committed to the view that it is possible to provide a complete description of the world in purely physical terms. But any account of the world that leaves out the qualitative content of our conscious experience can't be considered complete. For it is a fact about the world that each sensation has its own particular feel. Because feelings are real, and because eliminative materialism can't account for our feelings, it is not an adequate theory of the mind.

Study Questions

1. What is Rorty's demons thought experiment? How does it attempt to undermine reductive theories of the mind?
2. What is the eliminative materialist theory of the mind?
3. What is folk psychology?
4. What is Searle's Chevrolet station wagon thought experiment? How does it attempt to undermine eliminative materialism?
5. What is physicalism?
6. What is Mary the color-challenged scientist thought experiment? How does it attempt to undermine physicalism?

Discussion Questions

1. Is eliminative materialism a more nearly adequate theory of the mind than the reductive theories (logical behaviorism, the identity theory, functionalism)? Why or why not?
2. Is folk psychology a failed psychological theory? Why or why not?
3. Can mental states be considered theoretical entities? Why or why not?
4. Can we adequately explain and predict other people's behavior without talking about their mental states?
5. Can we eliminate all references to mental states from a scientific account of the world? Why or why not?
6. Is knowing what a species of knowing how? Why or why not?
7. Could a zombie (a creature with no mental states) do everything that we can do?
8. If we gave up the belief that mental states exist and adopted the view that we are all mindless automatons, how would society change? Would this be a good thing? Why or why not?

Internet Inquiries

1. In ancient times, many diseases were thought to be caused by evil spirits. See, for example, **http://www.nzetc.org/tm/scholarly/tei-BucAnth-t1-body-d1-d6.html**. Do an Internet search on folk beliefs. Is the belief in the existence of mental states in the same category as that belief? Why or why not?
2. Philosophical zombies have no conscious experience. But what about other types of zombies, like voodoo zombies? Do an Internet search on zombies and see how many different types you can identify. Do any of them besides philosophical zombies have no conscious experience? If so, which are they?
3. Do an Internet search on color blindness. Do color-blind people simply lack an ability that normal people possess, or do they lack a certain sort of information? What implication does this have for materialistic theories of the mind?

Section 2.5

The Whole Is Greater Than the Sum of Its Parts
Mind as Quality

> *Thought is so little incompatible with organized matter that it seems to be one of its properties.*
>
> —Julien Offray de La Mettrie

The implausibility of eliminative materialism suggests that the failure to reduce the mental to the physical or the functional can't be explained on the grounds that mental states don't exist. What is the best explanation of this failure then? Many believe that the best explanation is that mental properties are something over and above physical properties. This view of the nature of the mind is known as **property dualism.** It has also been called "emergent materialism," "nonreductive materialism," and "soft materialism."

Some mental states, like pain and fear, have a particular feel, whereas others, like hope and belief, have a particular object. But, as we have seen, what a mental state feels like (its qualitative content) and what it is about (its intentional content) are not physical or functional properties, for neither is knowable from a third-person point of view. We can know all of the physical and functional properties of a mental state without knowing what it's like to have it or what it's about. Thus the conclusion that mental properties are distinct from physical properties seems unavoidable.

property dualism The doctrine that mental states have both physical and nonphysical properties.

primitive property A property that cannot be reduced to or analyzed in terms of any more basic property.

Primitive Intentionality

Because the qualitative content (the feel) and the intentional content (the object) of a mental state are not reducible to physical or functional properties, they are "primitive" properties. A **primitive property** is one that can't be explained in terms of anything more fundamental. Jacquette demonstrates the primitiveness of intentionality by means of the following thought experiment.

The Double Aspect Theory

Not all property dualists are emergent materialists. Baruch Spinoza, for example, maintains that, not only are mental properties not emergent, they are not properties of material objects. Spinoza maintains that mental and physical properties are two different aspects of a single underlying substance that is neither mental nor physical. This is the **double aspect theory.** An "aspect" is a way something appears. A concave lens, for example, has two aspects—concave and convex—for from one perspective it appears concave and from another it appears convex. Similarly, claims Spinoza, the substance of the universe has two aspects—mental and physical. The mental aspect is the way the substance appears from the "inside," and the physical aspect is the way it appears from the "outside," so to speak. Everything, from the most elementary particles to the most complex collection of them, has both a mental and a physical aspect. So aspects are not emergent.

Although this view is suggestive, it is unenlightening, for it tells us nothing about the basic stuff itself. We can describe a lens independently of the way it appears to us. We can even explain why it appears differently from different perspectives. But no such explanation of appearances is possible in Spinoza's view. Why his substance appears one way from the inside and another way from the outside is just as mysterious as what that substance is.

Thought Experiment

Jacquette's Intentionality Test

As a thought experiment, try using the term "A" to refer, first to the book you are holding, then to the weight of the book in your hands, then to the space it occupies, then to its color. Do this again, switching from one use to another as often as you like, and pay careful attention to whatever mental events or images may be occurring as you do it, to what we may call the phenomenology of intending. Note first of all that you encounter no difficulty in performing this exercise. You can easily use the letter "A" in multiple referential ways without hindrance; nothing prevents you from doing it. You recognize once you have formulated the relevant intention, that by "A" you mean the book, or the color of its cover, or the space it occupies. If someone were to ask you what you mean by "A" when each of these particular intentions was in force, you could answer immediately, and without inference. You do not need to find out what you mean by "A" under any of the circumstances. It is entirely up to you, a decision on your part rather than a discovery. Second, when you attend to the mental events occurring at the time you formulate or shift intentions for the reference of term "A" from one thing to another, if your experience is like most persons', there is nothing special at all that occurs as an essential accompaniment of your intending. There are no identifiable episodes of inward concentration or particular mental imagery. You simply intend something or something new by "A," and that is that. But if there is no psychological occurrence that uniquely characterizes the intending of an object in thought, but the thought directly intends the object, then intentionality appears again to be a primitive concept. For there is nothing psychological to which it can be reduced, no unique mental occurrences on which intending is conditional.[75]

Consciousness is what happens to intelligence when it is confronted with an object.
—HAZRAT INAYAT KHAN

double aspect theory The doctrine that the mind and the body are two aspects of a single underlying substance.

The Whole Is Greater Than the Sum of Its Parts 149

> *I conclude that the concept of consciousness in the sense of an irreducible relation of awareness is a concept that we can neither exclude nor exchange if, as psychologists, we are to give an adequate account of life and behaviour.*
> —Sir Cyril Burt

This experiment suggests that what our thoughts are about is not determined by any feature of them other than their intentionality. We don't think about objects by means of anything else. We simply think about them. That's what makes intentionality a primitive property.

Putnam agrees. He writes,

> Another way to account for the objectivity of the notion of truth (as well as of reference, etc.) [is] the way suggested by Brentano and by Chisholm; that is, just to take the existence of intentional properties as a "primitive" fact. If primitive just means "not reducible to nonintentional notions," then (I have been arguing) this is, indeed, the right answer."[76]

In this view, intentionality and consciousness are like mass and charge: they are basic properties that cannot be explained in terms of anything more fundamental. Given the failure of all attempts to reduce or eliminate these properties, such a view seems eminently reasonable.

Basic properties can be understood by explaining their relations to other properties. This form of nonreductive explanation has led to some of the greatest advances in modern science. Newton's discovery that $F = ma$ (force equals mass times acceleration) and Einstein's discovery that $E = mc^2$ (energy equals mass times the velocity of light squared) are just two of many examples that could be given. If comparable advances are to be made in the science of the mind, similar laws governing intentionality and consciousness must be found. As Nagel says,

> Only if the uniqueness of the mental is recognized will concepts and theories be recognized for the purpose of understanding it. Otherwise there is a danger of futile reliance on concepts designed for other purposes, and indefinite postponement of any possibility of a unified understanding of mind and body.[77]

It has often been remarked that cognitive science—those branches of philosophy, psychology, anthropology, and linguistics that deal with the mind—is awaiting its Isaac Newton: someone who can bring these disparate fields under one unified theoretical framework. Nagel suggests that this cannot be done by reducing mental phenomena to something else but only by developing theories that recognize their uniqueness.

If mental properties are primitive and thus irreducible, the question naturally arises: Where do they come from? There are two schools of thought on this issue. One school—the panpsychists—claim that they don't come from anywhere because mental properties are everywhere. Everything has mental properties, even the smallest subatomic particles. The other school—the emergentists—claim that mental properties come into being when things that lack those properties become organized in certain ways. Let's examine these two views.

> *It is a bizarre thought that a feeling being like you or me might emerge from mere circuitry.*
> —Douglas R. Hofstadter

Emergentism

Emergentists claim that mental properties are emergent properties. An emergent property is one that is had by a whole but not by any of its parts. Life,

for example, is an emergent property. The basic consitituents of a living organism—the atoms and molecules out of which it is made—are not alive. But the organism itself is alive because its parts interact with one another in the right sorts of ways. An **emergent property,** then, is one that emerges or comes into being when things that lack that property become related in the appropriate ways.

According to emergentists, consciousness is an emergent property. The individual neurons that make up our brains are not conscious. But once they become related to one another in the right sorts of ways, consciousness emerges.

The kind of emergence that's involved with consciousness, however, seems to be different from that involved with other things. The property of being alive, for example, can be explained in terms of certain physical functions such as metabolism, growth, and reproduction. But as we've seen, the property of being conscious can't be explained in that way. Because life is reducible to physical functions, in principle it's possible to deduce the fact that something is alive from other physical facts about it. When truths about a higher-level emergent phenomenon can be deduced from lower-level facts, the phenomenon is said to be "weakly emergent." When they can't, the phenomenon is said to be "strongly emergent." The phenomenon of consciousness is strongly emergent because the fact that something is conscious can't be deduced from a knowledge of purely physical facts. That's what makes the problem of consciousness so hard.

But the strong emergence of consciousness is puzzling: How can a nonphysical property emerge from something possessing only physical ones? It seems to run afoul of the principle that "Nothing can give to another what is does not already have." Unless consciousness is present in some primitive form at a lower level, some argue, it can't be present in more complex forms at a higher level. These sorts of considerations have led a growing number of researchers to embrace panpsychism.

Both emergentists and panpsychists tend to endorse the causal efficacy of the mental, they usually believe in what's known as top-down or downward causation. Nature can be viewed as having a hierarchical structure where the lower levels give rise to the higher ones. For example, subatomic particles give rise to atoms; atoms give rise to molecules; molecules give rise to cells; cells give rise to organisms; and organisms give rise to societies. These are examples of what's known as bottom-up causation. The lower levels affect the higher ones. What emergentists claim is that causation can flow in the other direction. Higher levels can affect the lower ones.

The term "downward causation" was introduced by sociologist Donald Campbell to explain the effect of the environment on biological evolution. A number of neurophysiologists believe that this notion can be used to solve the mind-body problem. Neurophysiologist János Szentágothai explains:

> 'Mind' functions—themselves considered as emergent from brain functions—might have a *downward càusal effect* on brain functions. In other words, consciousness and thought might interfere with the activity of neuron networks resulting from self-organization, without getting into conflict with accepted (legitimate)

emergent property
A property that comes into being (emerges) when things that lack that property interact in certain ways.

Integrated Information Theory and the Consciousness Meter

David Chalmers's detailed analysis of the failure of reductive theories of the mind led him to conclude that any adequate theory of consciousness should specify psychophysical laws that tell us how conscious experience is related to physical systems. He went on to identify two principles that such laws should embody: (1) the principle of structural coherence that says that "the structure of conscious experience is mirrored by the structure of information in awareness, and vice versa," and (2) the principle of organizational invariance that says that "physical systems with the same abstract organization will give rise to the same kind of conscious experience." (See Chalmers's article, "The Puzzle of Conscious Experience," which can be found at the end of this chapter.) Giulio Tononi, a neuroscientist at the University of Wisconsin, has identified psychophysical laws that embody these principles and that, if correct, allow us to determine not only the quantity of consciousness a system has, but also its quality. Known as "Integrated Information Theory" (IIT), it provides a mathematical description of consciousness and, according to one report, because of its promise to quantify consciousness, "is sweeping through science like wildfire."[78]

Unlike reductive theories of mind that start with physical facts about the brain or body and try to derive consciousness from them, IIT takes conscious experience as a given and tries to show how it relates to physical systems. Following Descartes, it considers the fact that we are conscious to be an undeniable, self-evident axiom from which any adequate theory of mind must begin.

Two aspects of our conscious experience form the basis of IIT: (1) that conscious states contain a great deal of information and (2) that this information is highly integrated. The amount of information contained in a message is classically defined as the number of alternatives that it rules out. Any one conscious experience rules out innumerable others. Think of all the different experiences you can have, the places you can see, the things you can do, the objects you can create. Each one is different, and each contains its own unique combination of sights, sounds, smells, tastes, and textures. But not only are these experiences informationally rich, they are also highly integrated. Each conscious experience comes to us as a unified whole whose components are not separable from one another.[79]

IIT claims that the structure of our experience is reflected in the physical substrate that gives rise to it. As Tononi puts it, "IIT then postulates that, for each essential property of experience, there must be a corresponding causal property of the physical substrate of consciousness."[80] So by examining the causal properties of this substrate, we can calculate not only how much information it carries but also the extent to which this information is integrated. The resulting number—which Tononi refers to as Φ (pronounced "fi")—is a measure of both the quantity and quality of the system's consciousness.

According to IIT, whether something is conscious depends not on its input and output, but upon its causal structure because it's the causal structure of a thing that determines how much integrated information it produces. So IIT rejects the functionalist analysis of mind that underlies strong AI—the view that there's nothing more to having a mind than running the right sort of program. For IIT, what matters is the physical organization of the substrate the

laws of nature. The possibility of 'downward causation' from mental functions on the very same brain functions from which they emerge (by 'bottom up' causation), within the accepted laws of nature, is an attractive solution to the brain-mind problem.[84]

The Nobel Prize–winning neurophysiologist Roger Sperry echoes these sentiments:

> In the brain, controls at the physico-chemical and physiological levels are superseded by new forms of causal control that emerge at the level of conscious

program is running on. If the components of the system are not related to one another in such a way that they generate integrated information, such as in single-processor computers or feed-forward neural networks, the system has no consciousness no matter how well its outputs match its inputs. Koch and Tononi explain: "Crucially, according to IIT, the overall degree of consciousness does not depend on what the system does. Rather, it depends on how it is built how it's physically put together. . . . the physical architecture of a typical digital computer is absolutely inadequate, with very low connectivity at the gate level of its central processing unit and bottlenecks that prevent even a modicum of the necessary integration."[81] So a robot whose behavior was indistinguishable from that of a normal human being but whose internal physical architecture was no different than present day personal computers would not be conscious, no matter how much it protested to the contrary. That doesn't mean that computers or robots can't be conscious. It just means that if they are, they must have a physical substrate with the same causal powers as the human brain.

According to IIT, consciousness just is integrated information, so wherever you have integrated information, you have some degree of consciousness. Since it's possible for nonliving as well as living things to integrate information, IIT is a form of panpsychism. As Koch acknowledges, "One unavoidable consequence of IIT is that all systems that are sufficiently integrated and differentiated will have some minimal consciousness associated with them: not only our beloved dogs and cats but also mice, squid, bees and worms. . . . In the limit, a single hydrogen ion, a proton made up of three quarks, will have a tiny amount of synergy, of Φ."[82] This is a radical departure from how we ordinarily think about the world, but advances in science often challenge our common sense views, and, as we have seen, some of the world's greatest thinkers have been panpsychists.

The ultimate success of any theory, of course, is determined by its explanatory power, and the proponents of IIT claim that it can explain certain puzzling phenomena that no other theory of consciousness can. For example, it can explain why damage to the cerebellum does not result in a loss of consciousness but damage to the neo-cortex does because the neurons in the cerebellum are not as highly integrated as the neurons in the neo-cortex. It can also explain why people lose consciousness in deep sleep even though the firing activity of individual neurons remains about the same because the slow, synchronized waves of neural activity that occur during deep sleep disrupt the transfer of signals among neurons. It also has successful predictions to its credit: It has successfully predicted whether someone is conscious by stimulating their brains magnetically and recording the resulting neural activity with electroencephalography. When the "perturbational complexity index" (which is a very rough measure of Φ) was above a certain value, the person was conscious. When it was below, the person was unconscious.[83] This constitutes the first crude approximation of a consciousness meter. But if it can be further refined, it could be used to assess not only the consciousness of robots or computers, but also of those under general anesthesia, in a permanent vegetative state, or even of fetuses.

mental processing, where causal properties include the contents of subjective experience. Causal control is thus shifted in brain dynamics from levels of pure physical, physiological, or material determinacy to levels of mental, cognitive, conscious, or subjective determinacy. The flow of nerve impulse traffic and related physiological events in a conscious process is no longer regulated solely by events in kind but becomes caught up in, enveloped, and moved by the higher mental controls, somewhat as the flow of electrons in a television set is moved and differentially patterned by the program content on different channels.[85]

> My belief is that the explanations of emergent phenomena in our brains . . . are based on a kind of Strange Loop, an interaction between levels in which the top level reaches back down towards the bottom level and influences it, while at the same time being determined by the bottom level. . . .
> —Douglas R. Hofstadter

According to Sperry, just as the flow of electrons in a television set is determined by the program it is receiving, so the flow of nerve impulses through our brains is determined by the conscious experiences we are having. If conscious experience can indeed affect the flow of nerve impulses, then conscious experience is not epiphenomenal.

The analogy of the program and the television set is fundamentally flawed, however, for the electrons in the TV set and the program it is receiving don't interact with each other in the way that nerve impulses in the brain and conscious experience seem to. In the case of the electrons and the TV program, causation seems to flow in only one direction—from the transmitter to the picture tube—whereas in the case of the nerve impulses and consciousness, causation seems to flow in both directions. What happens in the brain affects our conscious experience, and our conscious experience affects what happens in the brain. Perhaps a better analogy is that between a stream and its banks. As droplets of water come together to form a stream, a bank emerges. The bank is brought into existence by the movement of the water molecules, but it nonetheless determines the flow of those molecules. In this analogy, consciousness is like the bank, and nerve impulses are like the stream. Just as the stream brings the bank into existence, so do nerve impulses give rise to consciousness. And just as the bank determines the flow of the stream, so does consciousness determine the flow of nerve impulses. There is a two-way interaction between the bank and the stream: The bank determines the course of the stream, and the stream determines the contours of the bank. Similarly, there is a two-way interaction between consciousness and the brain: Consciousness determines the succession of nerve impulses, and nerve impulses determine the content of consciousness. Of course this analogy doesn't fully capture the dynamic nature of consciousness, for the bank is far too passive. Nonetheless, it does reveal how an emergent feature can reach back down and affect that which gave rise to it.

Downward causation might seem to violate the principle of the causal closure of the physical or the law of conservation of mass-energy. But that's not necessarily the case. The principle of the causal closure of the physical says that no physical effect has a nonphysical cause. If "nonphysical cause" is taken to mean "caused by a nonphysical object," then neither panpsychists nor emergentists need to deny the causal closure of the physical, for both of them can take mental properties to be properties of physical objects. On their view, mental properties are not reducible to physical properties, but they are nonetheless had by physical objects. So they need not attribute any physical effects to nonphysical objects or supernatural beings.

Downward causation also need not violate the law of the conservation of mass-energy. Some believe that all causation involves the transfer of energy, so if the mental affects the physical, there must be some transfer of energy to or from the physical world that would violate the law of conservation of energy. Causation need not always involve the transfer of energy, however. Consider, for example, a ball on a string that's swung in a circle. The string causes the ball to move in a circle, but it doesn't inject any

energy into the system. It simply determines how the energy in the system is distributed. Similarly, the mind may affect the body by determining how the energy in the brain is distributed. So although the argument from the conservation of energy may be a problem for substance dualism, which takes the mind to be an immaterial thing, it is not necessarily a problem for property dualists.

The advantage of viewing mental properties as causally effective is that it not only solves the mind-body problem but also opens up new lines of research:

> Whereas the older interpretations of consciousness as inner aspect, epiphenomenon, or semantic pseudoproblem have remained largely sterile, conceptually and experimentally (e.g., there is no place to go from an epiphenomenon), the emergent interaction scheme is by contrast potentially fruitful. It suggests new problems, possible approaches, and new leads to follow in working out the nature of the mental properties, their interactions, and their relations to the sustaining neurophysiology. For example, it follows directly from the foregoing that the brain process must be able to detect and to react to the pattern properties of its own excitation. . . . There exists considerable indirect evidence, particularly from observations on perceptual and cognitive phenomena, that the brain does in fact do exactly this.[86]

Reductive and eliminative theories of the mind have failed to capture the essence of the mental. Property dualism, on the other hand, provides a framework for understanding the mind that takes into account both the qualitative and the intentional content of mental states. By taking the mind to be a cause as well as an effect, it avoids the incongruity of epiphenomenalism and makes possible a coherent account of human freedom and dignity.

How we treat each other—and how we organize society—is determined by our view of ourselves. If mental states are not causes—if what we think has no effect on what we do—then reality is very different from the way it appears. As philosopher Jerry Fodor notes,

> . . . if it isn't literally true that my wanting is causally responsible for my reaching, and my itching is causally responsible for my scratching, and my believing is causally responsible for my saying, . . . if none of that is literally true, then practically everything I believe about anything is false and it's the end of the world.[87]

To determine whether we need to radically restructure our worldview, then, we need to determine whether the belief in downward causation—commonly known as free will—is justified. This is the subject of Chapter 3.

Panpsychism

Panpsychism is the view that everything has mental properties. That's not to say that everything has a mind, but it is to say that everything has features of the sort we associate with minds, like perceiving, desiring, remembering, and so on. This applies to inanimate as well as animate objects. Although most

There is nothing dead or senseless in the universe.
—SAMUEL ALEXANDER

panpsychists are not willing to go so far as to say that rocks are conscious, they are willing to say that rocks have the earliest glimmers of consciousness. Thus some panpsychists prefer to say that inanimate objects are "protoconscious" or have "protoexperience."

Panpsychism has a long and distinguished history. Many of the pre-Socratic philosophers were panpsychists, as were such notable thinkers as G. W. Leibniz, W. K. Clifford, Wilhelm Wundt, F. C. S. Schiller, A. N. Whitehead, Charles Hartshorne, and Pierre Teilhard de Chardin. What drew these people to panpsychism was the coherence and completeness of the worldview it offers. As W. E. Agar, a follower of Whitehead, says, panpsychism "leads to a more consistent and satisfying world picture than any of the alternatives." In particular, it avoids the view that "the mental factor . . . made its appearance out of the blue at some date in the world's history."[88] Panpsychists don't have to explain where mental properties come from because they have been present in the most basic constituents of the universe since the beginning of time.

Although panpsychism is a minority view, it does have its defenders even among physicists. Enos Witmer, professor of physics at the University of Pennsylvania, for example, explains:

> Thus, we seem to be led step by step to the idea that a particle in quantum physics is a kind of entity that maintains a very efficient intelligence agency that keeps it informed at all times of what is happening throughout the universe.[89]

According to Witmer, not only do these particles "know the potential energy in all space,"[90] they are also able to act on this information. He states, "Only when a particle or system makes a quantum transition must it 'make up its mind' which of its available possibilities to 'transform from the potential to the actual,' to quote, or paraphrase, Heisenberg."[91] Witmer is quick to point out that this is not to say that elementary particles have minds or wills of their own, but, rather, that "they have attributes that are the vague beginning of volition and self activity."[92] In other words, although they are not conscious, they are protoconscious.

The success of science and its ability to explain so much of the world in purely physical terms have made panpsychism seem far-fetched. What's more, even though panpsychism doesn't face the problem of explaining where mental properties come from, it does face the problem of explaining how protoconscious properties combine to form conscious ones. The emergentists claim that there's no need to assume that inanimate objects have protominds to explain why we have minds. There are many emergent properties in the world, and consciousness is one of them.

Summary

The failure to reduce mental states to physical or functional states can't be explained on the hypothesis that mental states don't exist. The best explanation seems to be that mental states have both physical and nonphysical

properties. This view, known as property dualism, holds that mental states have both physical and nonphysical properties.

But why would mental properties emerge from physical properties? What survival advantage do they confer on their possessors? Their main advantage seems to be that they provide an effective representation of the world. Sensations represent, or refer to, the world—but not by means of any physical or functional property they possess. They simply represent the world. Thus intentionality is a primitive property.

Mental states may have a causal effect on the physical states that give rise to them. Such a view doesn't deny that physically identical brains are also psychologically identical. It does deny that the person's subsequent mental or physical states can be predicted or explained on the basis of physical properties alone. This view of mental properties offers an attractive way to solve the mind-body problem. It also opens up new lines of research. By taking consciousness to be a cause as well as an effect, property dualism avoids the problem of epiphenomenalism and makes possible a coherent account of freedom and dignity.

Study Questions

1. According to property dualism, what is it to be in a mental state?
2. What is a primitive property?
3. What is Jacquette's intentionality test?
4. Why is intentionality a primitive property?
5. What is downward causation?

Discussion Questions

1. Is property dualism a more adequate theory of the mind than eliminative materialism or the reductive theories? Why or why not?
2. What is the purpose of consciousness? That is, why did consciousness evolve?
3. Could a being with no conscious experience—a zombie—do everything that we can do?
4. If mental properties are nonphysical, can there be a science of the mind? Why or why not?
5. Can a materialist believe in mental causation? Why or why not?
6. Could the Milky Way galaxy be the brain of an intelligent creature? Is the claim that it is the brain of an intelligent creature a plausible one? Why or why not?

Internet Inquiries

1. Many different types of emergence have been distinguished. Do an Internet search on "emergence," and see how many different types you can identify. What type is needed for downward causation?

2. Some physicists believe that quantum mechanics provides a basis for panpsychism. An Internet search on "panpsychism" and "quantum mechanics" or "quantum consciousness" will reveal a number of those thinkers. Is this a plausible view? Why or why not?
3. Scientists are using brain implants to control machines by thought alone. You can read about some of the research here: **http://www.skewsme.com/implants.html.** Perhaps most dramatically, a monkey has learned to control a robot by just thinking about it. You can see the monkey here:
https://www.youtube.com/watch?v=CR_LBcZg_84&t=170s. Are these examples of downward causation? Why or why not?

RENÉ DESCARTES

Meditations on First Philosophy: Meditation II

René Descartes (1596–1650), often regarded as the founder of modern philosophy, was also one of the central figures in the scientific revolution of the seventeenth century. As a young man, he served in three different armies before retiring to Holland in 1628. There, for the next twenty years, he wrote extensively on science and philosophy, including such works as *The Quest for Truth, Rules for the Direction of Mind, Discourse on Method, Meditations on First Philosophy,* and *Principles of Philosophy.* He suppressed his first work, *The World,* because he heard that Galileo had been condemned by the Roman Catholic Church for advocating the Copernican hypothesis. In this selection from *Meditations on First Philosophy,* Descartes presents his reasons for believing that he is essentially a thinking thing.

Of The Nature of the Human Mind; and That It Is More Easily Known than the Body.

The Meditation of yesterday has filled my mind with so many doubts, that it is no longer in my power to forget them. Nor do I see, meanwhile, any principle on which they can be resolved; and, just as if I had fallen all of a sudden into very deep water, I am so greatly disconcerted as to be unable either to plant my feet firmly on the bottom or sustain myself by swimming on the surface. I will, nevertheless, make an effort, and try anew the same path on which I had entered yesterday, that is, proceed by casting aside all that admits of the slightest doubt, not less than if I had discovered it to be absolutely false; and I will continue always in this track until I shall find something that is certain, or at least, if I can do nothing more, until I shall know with certainty that there is nothing certain. Archimedes, that he might transport the entire globe from the place it occupied to another, demanded only a point that was firm and immovable; so, also, I shall be entitled to entertain the highest expectations, if I am fortunate enough to discover only one thing that is certain and indubitable.

I suppose, accordingly, that all the things which I see are false (fictitious); I believe that none of those objects which my fallacious memory represents ever existed; I suppose that I possess no senses; I believe that body, figure, extension, motion, and place are merely fictions of my mind. What is there, then, that can be esteemed true? Perhaps this only, that there is absolutely nothing certain.

But how do I know that there is not something different altogether from the objects I have now enumerated, of which it is impossible to entertain the slightest doubt? Is there not a God, or some being, by whatever name I may designate him, who causes these thoughts to arise in my mind ? But why suppose such a being, for it may be I myself am capable of producing them? Am I, then, at least not something? But I before denied that I possessed senses or a body; I hesitate, however, for what follows from that? Am I so dependent on the body and the senses that without these I cannot exist? But I had the persuasion that there was absolutely nothing in the world, that there was no sky and no earth, neither minds nor bodies; was I not, therefore, at the same time, persuaded that I did not exist? Far from it; I assuredly existed, since I was persuaded. But there is I know not what being, who is possessed at once of the highest power and the deepest cunning, who is constantly employing all his ingenuity in deceiving me. Doubtless, then, I exist, since I am deceived; and, let him deceive me as he may, he can never bring it about that I am nothing, so long as I shall be conscious that I am something. So that it must, in fine, be maintained, all things being maturely and carefully considered, that this proposition *I am, I exist*, is necessarily true each time it is expressed by me, or conceived in my mind.

But I do not yet know with sufficient clearness what I am, though assured that I am; and hence, in the next place, I must take care, lest perchance I inconsiderately substitute some other object in room of what is properly myself, and thus wander from truth, even in that

Source: René Descartes, excerpts from "Discourse on the Method of Rightly Conducting the Reason," Parts IV and V, "Meditations on First Philosophy," Meditation I, Meditation II, Meditation IV, Meditation V, and Meditation VI from *The Method, Meditations, and Philosophy of Descartes*, translated by John Veitch, London: M. Walter Dunne, 1901.

knowledge (cognition) which I hold to be of all others the most certain and evident. For this reason, I will now consider anew what I formerly believed myself to be, before I entered on the present train of thought; and of my previous opinion I will retrench all that can in the least be invalidated by the grounds of doubt I have adduced, in order that there may at length remain nothing but what is certain and indubitable.

What then did I formerly think I was? Undoubtedly I judged that I was a man. But what is a man? Shall I say a rational animal? Assuredly not; for it would be necessary forthwith to inquire into what is meant by animal, and what by rational, and thus, from a single question, I should insensibly glide into others, and these more difficult than the first; nor do I now possess enough of leisure to warrant me in wasting my time amid subtleties of this sort. I prefer here to attend to the thoughts that sprung up of themselves in my mind, and were inspired by my own nature alone, when I applied myself to the consideration of what I was. In the first place, then, I thought that I possessed a countenance, hands, arms, and all the fabric of members that appears in a corpse, and which I called by the name of body. It further occurred to me that I was nourished, that I walked, perceived, and thought, and all those actions I referred to the soul; but what the soul itself was I either did not stay to consider, or, if I did, I imagined that it was something extremely rare and subtile, like wind, or flame, or ether, spread through my grosser parts. As regarded the body, I did not even doubt of its nature, but thought I distinctly knew it, and if I had wished to describe it according to the notions I then entertained, I should have explained myself in this manner: By body I understand all that can be terminated by a certain figure; that can be comprised in a certain place, and so fill a certain space as therefrom to exclude every other body; that can be perceived either by touch, sight, hearing, taste, or smell; that can be moved in different ways, not indeed of itself, but by something foreign to it by which it is touched [and from which it receives the impression]; for the power of self-motion, as likewise that of perceiving and thinking, I held as by no means pertaining to the nature of body; on the contrary, I was somewhat astonished to find such faculties existing in some bodies.

But [as to myself, what can I now say that I am], since I suppose there exists an extremely powerful, and, if I may so speak, malignant being, whose whole endeavors are directed toward deceiving me? Can I affirm that I possess any one of all those attributes of which I have lately spoken as belonging to the nature of body? After attentively considering them in my own mind, I find none of them that can properly be said to belong to myself. To recount them were idle and tedious. Let us pass, then, to the attributes of the soul. The first mentioned were the powers of nutrition and walking; but, if it be true that I have no body, it is true likewise that I am capable neither of walking nor of being nourished. Perception is another attribute of the soul; but perception too is impossible without the body; besides, I have frequently, during sleep, believed that I perceived objects which I afterward observed I did not in reality perceive. Thinking is another attribute of the soul; and here I discover what properly belongs to myself. This alone is inseparable from me. I am--I exist: this is certain; but how often? As often as I think; for perhaps it would even happen, if I should wholly cease to think, that I should at the same time altogether cease to be. I now admit nothing that is not necessarily true. I am therefore, precisely speaking, only a thinking thing, that is, a mind (mens sive animus), understanding, or reason, terms whose signification was before unknown to me. I am, however, a real thing, and really existent; but what thing? The answer was, a thinking thing.

The question now arises, am I aught besides? I will stimulate my imagination with a view to discover whether I am not still something more than a thinking being. Now it is plain I am not the assemblage of members called the human body; I am not a thin and penetrating air diffused through all these members, or wind, or flame, or vapor, or breath, or any of all the things I can imagine; for I supposed that all these were not, and, without changing the supposition, I find that I still feel assured of my existence. But it is true, perhaps, that those very things which I suppose to be non-existent, because they are unknown to me, are not in truth different from myself whom I know. This is a point I cannot determine, and do not now enter into any dispute regarding it. I can only judge of things that are known to me: I am conscious that I exist, and I who know that I exist inquire into what I am. It is, however, perfectly certain that the knowledge of my existence, thus precisely taken, is not dependent on things, the existence of which is as yet unknown to me: and consequently it is not dependent on any of the things I can feign in imagination. Moreover, the phrase itself, *I frame an image* reminds me of my error; for I should in truth frame one if I were to imagine myself to be anything, since to imagine is nothing more than to contemplate the figure or image of a corporeal thing; but I already know that I exist, and that it is possible at the same time that all those images, and in general all that relates to the nature of body, are merely dreams [or chimeras]. From this I discover that it is not more reasonable to say, I will excite my imagination that I may know more

distinctly what I am, than to express myself as follows: I am now awake, and perceive something real; but because my perception is not sufficiently clear, I will of express purpose go to sleep that my dreams may represent to me the object of my perception with more truth and clearness. And, therefore, I know that nothing of all that I can embrace in imagination belongs to the knowledge which I have of myself, and that there is need to recall with the utmost care the mind from this mode of thinking, that it may be able to know its own nature with perfect distinctness.

But what, then, am I? A thinking thing, it has been said. But what is a thinking thing? It is a thing that doubts, understands, [conceives], affirms, denies, wills, refuses; that imagines also, and perceives.

Assuredly it is not little, if all these properties belong to my nature. But why should they not belong to it? Am I not that very being who now doubts of almost everything; who, for all that, understands and conceives certain things; who affirms one alone as true, and denies the others; who desires to know more of them, and does not wish to be deceived; who imagines many things, sometimes even despite his will; and is likewise percipient of many, as if through the medium of the senses. Is there nothing of all this as true as that I am, even although I should be always dreaming, and although he who gave me being employed all his ingenuity to deceive me? Is there also any one of these attributes that can be properly distinguished from my thought, or that can be said to be separate from myself? For it is of itself so evident that it is I who doubt, I who understand, and I who desire, that it is here unnecessary to add anything by way of rendering it more clear. And I am as certainly the same being who imagines; for although it may be (as I before supposed) that nothing I imagine is true, still the power of imagination does not cease really to exist in me and to form part of my thought. In fine, I am the same being who perceives, that is, who apprehends certain objects as by the organs of sense, since, in truth, I see light, hear a noise, and feel heat. But it will be said that these presentations are false, and that I am dreaming. Let it be so. At all events it is certain that I seem to see light, hear a noise, and feel heat; this cannot be false, and this is what in me is properly called perceiving, which is nothing else than thinking.

From this I begin to know what I am with somewhat greater clearness and distinctness than heretofore. But, nevertheless, it still seems to me, and I cannot help believing, that corporeal things, whose images are formed by thought [which fall under the senses], and are examined by the same, are known with much greater distinctness than that I know not what part of myself which is not imaginable; although, in truth, it may seem strange to say that I know and comprehend with greater distinctness things whose existence appears to me doubtful, that are unknown, and do not belong to me, than others of whose reality I am persuaded, that are known to me, and appertain to my proper nature; in a word, than myself. But I see clearly what is the state of the case. My mind is apt to wander, and will not yet submit to be restrained within the limits of truth. Let us therefore leave the mind to itself once more, and, according to it every kind of liberty [permit it to consider the objects that appear to it from without], in order that, having afterward withdrawn it from these gently and opportunely [and fixed it on the consideration of its being and the properties it finds in itself], it may then be the more easily controlled.

READING QUESTIONS

1. Descartes says that formerly he was more certain about the nature of his body than of his mind, but now he doubts the former and is certain of the latter. What considerations led him to that conclusion?

2. Why does Descartes believe that he can't be identified with his body?

3. According to Descartes, what aspect of himself can he not possibly do without? That is, which feature of his is a necessary condition for his continued existence?

4. Why does Descartes conclude that his knowledge of himself does not depend in any way on his imagination?

DAVID M. ARMSTRONG

The Mind-Brain Identity Theory

Australian philosopher David Armstrong (1926–2014) is a staunch defender of the identity theory. His books include: *A Materialist Theory of the Mind* (1968), *Belief, Truth and Knowledge* (1973), *What Is a Law of Nature?* (1983), *Universals* (1989), and *A World of States of Affairs* (1997).

Men have minds, that is to say, they perceive, they have sensations, emotions, beliefs, thoughts, purposes, and desires. What is it to have a mind? What is it to perceive, to feel emotion, to hold a belief, or to have a purpose? In common with many other modern philosophers, I think that the best clue we have to the nature of mind is furnished by the discoveries and hypotheses of modern science concerning the nature of man.

What does modern science have to say about the nature of man? There are, of course, all sorts of disagreements and divergencies in the views of individual scientists. But I think it is true to say that one view is steadily gaining ground, so that it bids fair to become established scientific doctrine. This is the view that we can give a complete account of man in purely physico-chemical terms. This view has received tremendous impetus in the last decade from the new subject of molecular biology, a subject which promises to unravel the physical and chemical mechanisms which lie at the basis of life. Before that time, it received great encouragement from pioneering work in neurophysiology pointing to the likelihood of a purely electro-chemical account of the working of the brain. I think it is fair to say that those scientists who still reject the physico-chemical account of man do so primarily for philosophical, or moral, or religious reasons, and only secondarily, and half-heartedly, for reasons of scientific detail. This is not to say that in the future new evidence and new problems may not come to light which will force science to reconsider the physico-chemical view of man. But at present the drift of scientific thought is clearly set towards the physico-chemical hypothesis. And we have nothing better to go on than the present.

For me, then, and for many philosophers who think like me, the moral is clear. We must try to work out an account of the nature of mind which is compatible with the view that man is nothing but a physico-chemical mechanism. And in this paper I shall be concerned to do just this: to sketch (in barest outline) what may be called a Materialist or Physicalist account of the mind....

Having in this way attempted to justify my procedure, I turn back to my subject: the attempt to work out an account of mind, or, if you prefer, of mental process, within the framework of the physico-chemical, or, as we may call it, the Materialist view of man.

Now there is one account of mental process that is at once attractive to any philosopher sympathetic to a Materialist view of man: this is Behaviourism. Formulated originally by a psychologist, J. B. Watson, it attracted widespread interest and considerable support from scientifically oriented philosophers. Traditional philosophy had tended to think of the mind as a rather mysterious inward arena that lay behind, and was responsible for, the outward or physical behaviour of our bodies. Descartes thought of this inner arena as a spiritual substance, and it was this conception of the mind as spiritual object that Gilbert Ryle attacked, apparently in the interest of Behaviourism, in his important book *The Concept of Mind*. He ridiculed the Cartesian view as the dogma of "the ghost in the machine." The mind was not something behind the behaviour of the body, it was simply part of that physical behaviour.

Source: Armstrong, David M., "The Nature of Mind" in *The Nature of Mind and Other Essays*, Armstrong, D. M. ed., Brisbane, Australia: University of Queensland Press, 1980. Reprinted with permission of the University of Queensland Press.

My anger with you is not some modification of a spiritual substance which somehow brings about aggressive behaviour; rather it is the aggressive behaviour itself; my addressing strong words to you, striking you, turning my back on you, and so on. Thought is not an inner process that lies behind, and brings about, the words I speak and write: it is my speaking and writing. The mind is not an inner arena, it is outward act.

It is clear that such a view of mind fits in very well with a completely Materialistic or Physicalist view of man. If there is no need to draw a distinction between mental processes and their expression in physical behaviour, but if instead the mental processes are identified with their so-called "expressions," then the existence of mind stands in no conflict with the view that man is nothing but a physico-chemical mechanism.

However, the version of Behaviourism that I have just sketched is a very crude version, and its crudity lays it open to obvious objections. One obvious difficulty is that it is our common experience that there can be mental processes going on although there is no behaviour occurring that could possibly be treated as expressions of these processes. A man may be angry, but give no bodily sign; he may think, but say or do nothing at all.

In my view, the most plausible attempt to refine Behaviourism with a view to meeting this objection was made by introducing the notion of *a disposition to behave*. (Dispositions to behave play a particularly important part in Ryle's account of the mind.) Let us consider the general notion of disposition first. Brittleness is a disposition, a disposition possessed by materials like glass. Brittle materials are those which, when subjected to relatively small forces, break or shatter easily. But breaking and shattering easily is not brittleness, rather it is the manifestation of brittleness. Brittleness itself is the tendency or liability of the material to break or shatter easily. A piece of glass may never shatter or break throughout its whole history, but it is still the case that it is brittle: it is liable to shatter or break if dropped quite a small way or hit quite lightly. Now a disposition to behave is simply a tendency or liability of a person to behave in a certain way under certain circumstances. The brittleness of glass is a disposition that the glass retains throughout its history, but clearly there could also be dispositions that come and go. The dispositions to behave that are of interest to the Behaviourist are, for the most part, of this temporary character.

Now how did Ryle and others use the notion of a disposition to behave to meet the obvious objection to Behaviourism that there can be mental processes going on although the subject is engaging in no relevant behaviour? Their strategy was to argue that in such cases, although the subject was not behaving in any relevant way, he or she was disposed to behave in some relevant way. The glass does not shatter, but it is still brittle. The man does not behave, but he does have a disposition to behave. We can say he thinks although he does not speak or act because at that time he was disposed to speak or act in a certain way. If he had been asked, perhaps, he would have spoken or acted. We can say he is angry although he does not behave angrily, because he is disposed so to behave. If only one more word had been addressed to him, he would have burst out. And so on. In this way it was hoped that Behaviourism could be squared with the obvious facts.

It is very important to see just how these thinkers conceived of dispositions. I quote from Ryle

> To possess a dispositional property *is not to be in a particular state, or to undergo a particular change*; it is to be bound or liable to be in a particular state, or to undergo a particular change, when a particular condition is realised. (*The Concept of Mind*, p. 43, my italics.)

So to explain the breaking of a lightly struck glass on a particular occasion by saying it was brittle is, on this view of dispositions, simply to say that the glass broke because it is the sort of thing that regularly breaks when quite lightly struck. The breaking was the normal behaviour, or not abnormal behaviour, of such a thing. The brittleness is not to be conceived of as a *cause* for the breakage, or even, more vaguely, a *factor* in bringing about the breaking. Brittleness is just the fact that things of that sort break easily.

But although in this way the Behaviourists did something to deal with the objection that mental processes can occur in the absence of behaviour, it seems clear, now that the shouting and the dust have died, that they did not do enough. When I think, but my thoughts do not issue in any action, it seems as obvious as anything is obvious that there is something actually going on in me which constitutes my thought. It is not simply that I would speak or act if some conditions that are unfulfilled were to be fulfilled. Something is currently going on, in the strongest and most literal sense of "going on," and this something is my thought. Rylean Behaviourism denies this, and so it is unsatisfactory as a theory of mind. Yet I know of no version of Behaviourism that is more satisfactory. The moral for those of us who wish to take a purely physicalistic view of man is that we must look for some other account of the nature of mind and of mental processes.

But perhaps we need not grieve too deeply about the failure of Behaviourism to produce a satisfactory

theory of mind. Behaviourism is a profoundly unnatural account of mental processes. If somebody speaks and acts in certain ways it is natural to speak of this speech and action as the *expression* of his thought. It is not at all natural to speak of his speech and action as identical with his thought. We naturally think of the thought as something quite distinct from the speech and action which, under suitable circumstances, brings the speech and action about. Thoughts are not to be identified with behavior, we think, they lie behind behaviour. A man's behaviour constitutes the *reason* we have for attributing certain mental processes to him, but the behaviour cannot be identified with the mental processes.

This suggests a very interesting line of thought about the mind. Behaviourism is certainly wrong, but perhaps it is not altogether wrong. Perhaps the Behaviourists are wrong in identifying the mind and mental occurrences with behaviour. But perhaps they are right in thinking that our notion of a mind and of individual mental states is *logically tied to behaviour*. For perhaps what we mean by a mental state is some state of the person which, under suitable circumstances, brings about a certain range of behaviour. Perhaps mind can be defined not as behaviour, but, rather as the inner cause of certain behaviour. Thought is not speech under suitable circumstances, rather it is something within the person which, in suitable circumstances, brings about speech. And, in fact, I believe that this is the true account, or, at any rate, a true first account, of what we mean by a mental state.

How does this line of thought link up with a purely physicalist view of man? The position is, I think, that while it does not make such a physicalist view inevitable, it does make it possible. It does not entail, but it is compatible with, a purely physicalist view of man. For if our notion of the mind and mental states is nothing but that of a cause within the person of certain ranges of behaviour, then it becomes a scientific question, and not a question of logical analysis, what in fact the intrinsic nature of that cause is. The cause might be, as Descartes thought it was, a spiritual substance working through the pineal gland to produce the complex bodily behaviour of which men are capable. It might be breath, or specially smooth and mobile atoms dispersed throughout the body; it might be many other things. But in fact the verdict of modern science seems to be that the sole cause of mind-betokening behaviour in man and the higher animals is the physico-chemical workings of the central nervous system. And so, assuming we have correctly characterised our concept of a mental state as nothing but the cause of certain sorts of behaviour, then we can identify these mental states with purely physical states of the central nervous system.

At this point we may stop and go back to the Behaviourists' dispositions. We saw that, according to them, the brittleness of glass or, to take another example, the elasticity of rubber, is not a state of the glass or the rubber; but is simply the fact that things of that sort behave in the way they do. But now let us consider how a scientist would think about brittleness or elasticity. Faced with the phenomenon of breakage under relatively small impacts, or the phenomenon of stretching when a force is applied followed by contraction when the force is removed, he will assume that there is some current state of the glass or the rubber which is responsible for the characteristic behaviour of samples of these two materials. At the beginning he will not know what this state is, but he will endeavour to find out, and he may succeed in finding out. And when he has found out he will very likely make remarks of this sort: 'We have discovered that the brittleness of glass is in fact a certain sort of pattern in the molecules of the glass.' That is to say, he will identify brittleness with the state of the glass that is responsible for the liability of the glass to break. For him, a disposition of an object is a state of the object. What makes the state of brittleness is the fact that it gives rise to the characteristic manifestations of brittleness. But the disposition itself is distinct from its manifestations: it is the state of the glass that gives rise to these manifestations in suitable circumstances.

You will see that this way of looking at dispositions is very different from that of Ryle and the Behaviourists. The great difference is this: If we treat dispositions as actual states, as I have suggested that scientists do, even if states whose intrinsic nature may yet have to be discovered, then we can say that dispositions are actual causes, or causal factors, which, in suitable circumstances, actually bring about those happenings which are the manifestations of the disposition. A certain molecular constitution of glass which constitutes its brittleness is actually responsible for the fact that, when the glass is struck, it breaks.

Now I shall not argue the matter here, because the detail of the argument is technical and difficult, but I believe that the view of dispositions as states, which is the view that is natural to science, is the correct one. I believe it can be shown quite strictly that, to the extent that we admit the notion of dispositions at all, we are committed to the view that they are actual states of the object that has the disposition. I may add that I think that the same holds for the closely connected notions

of capacities and powers. Here I will simply assume this step in my argument.

But perhaps it can be seen that the rejection of the idea that mind is simply a certain range of man's behaviour in favour of the view that mind is rather the inner cause of that range of man's behaviour is bound up with the rejection of the Rylean view of dispositions in favour of one that treats disposition as states of objects and so as having actual causal power. The Behaviourists were wrong to identify the mind with behaviour. They were not so far off the mark when they tried to deal with cases where mental happenings occur in the absence of behaviour by saying that these are dispositions to behave.

But in order to reach a correct view, I am suggesting, they would have to conceive of these dispositions as actual states of the person who has the disposition, states that have actual power to bring about behaviour in suitable circumstances. But to do this is to abandon the central inspiration of Behaviourism: that in talking about the mind we do not have to go behind outward behaviour to inner states.

And so two separate but interlocking lines of thought have pushed me in the same direction. The first line of thought is that it goes profoundly against the grain to think of the mind as behaviour. The mind is, rather, that which stands behind and brings about our complex behaviour. The second line of thought is that the Behaviourists' dispositions, properly conceived, are really states that underlie behaviour, and, under suitable circumstances, bring about behaviour. Putting these two together, we reach the conception of a mental state as a state of the person apt for producing certain ranges of behaviour. This formula: a mental state is a state of the person apt for producing certain ranges of behaviour, I believe to be a very illuminating way of looking at the concept of a mental state. I have found it very fruitful in the search for detailed logical analyses of the individual mental concepts.

Now, I do not think that Hegel's dialectic has much to tell us about the nature of reality. But I think that human thought often moves in a dialectical way, from thesis to antithesis and then to the synthesis. Perhaps thought about the mind is a case in point. I have already said that classical philosophy tended to think of the mind as an inner arena of some sort. This we may call the Thesis. Behaviourism moved to the opposite extreme: the mind was seen as outward behaviour. This is the Antithesis. My proposed Synthesis is that the mind is properly conceived as an inner principle, but a principle that is identified in terms of the outward behaviour it is apt for bringing about. This way of looking at the mind and mental states does not itself entail a Materialist or Physicalist view of man, for nothing is said in this analysis about the intrinsic nature of these mental states. But if we have, as I have asserted that we do have, general scientific grounds for thinking that man is nothing but a physical mechanism, we can go on to argue that the mental states are in fact nothing but physical states of the central nervous system.

Along these lines, then, I would look for an account of the mind that is compatible with a purely Materialist theory of man. I have tried to carry out this programme in detail in *A Materialist Theory of the Mind*. There are, as may be imagined, all sorts of powerful objections that can be made to this view. But in the rest of this paper I propose to do only one thing. I will develop one very important objection to my view of the mind—an objection felt by many philosophers—and then try to show how the objection should be met.

The view that our notion of mind is nothing but that of an inner principle apt for bringing about certain sorts of behaviour may be thought to share a certain weakness with Behaviourism. Modern philosophers have put the point about Behaviourism by saying that although Behaviourism may be a satisfactory account of the mind from an other-person point of view, it will not do as a first-person account. To explain. In our encounters with other people, all we ever observe is their behaviour: their actions, their speech, and so on. And so, if we simply consider other people, Behaviourism might seem to do full justice to the facts. But the trouble about Behaviourism is that it seems so unsatisfactory as applied to our own case. In our own case, we seem to be aware of so much more than mere behaviour.

Suppose that now we conceive of the mind as an inner principle apt for bringing about certain sorts of behaviour. This again fits the other-person cases very well. Bodily behaviour of a very sophisticated sort is observed, quite different from the behaviour that ordinary physical objects display. It is inferred that this behaviour must spring from a very special sort of inner cause in the object that exhibits this behaviour. This inner cause is christened "the mind," and those who take a physicalist view of man argue that it is simply the central nervous system of the body observed. Compare this with the case of glass. Certain characteristic behaviour is observed: the breaking and shattering of the material when acted upon by relatively small forces. A special inner state of the glass is postulated to explain this behaviour. Those who take a purely physicalist view of glass then argue that this state is a natural state of the glass. It is, perhaps, an arrangement of its molecules,

and not, say, the peculiarly malevolent disposition of the demons that dwell in glass.

But when we turn to our own case, the position may seem less plausible. We are conscious, we have experiences. Now can we say that to be conscious, to have experiences, is simply for something to go on within us apt for the causing of certain sorts of behaviour? Such an account does not seem to do any justice to the phenomena. And so it seems that our account of the mind, like Behaviourism, will fail to do justice to the first-person case.

In order to understand the objection better it may be helpful to consider a particular case. If you have driven for a very long distance without a break, you may have had experience of a curious state of automatism, which can occur in these conditions. One can suddenly "come to" and realize that one has driven for long distances without being aware of what one was doing, or indeed, without being aware of anything. One has kept the car on the road, used the brake and the clutch perhaps, yet all without any awareness of what one was doing.

Now, if we consider this case it is obvious that in some sense mental processes are still going on when one is in such an automatic state. Unless one's will was still operating in some way, and unless one was still perceiving in some way, the car would not still be on the road. Yet, of course, something mental is lacking. Now, I think, when it is alleged that an account of mind as an inner principle apt for the production of certain sorts of behaviour leaves out consciousness or experience, what is alleged to have been left out is just whatever is missing in the automatic driving case. It is conceded that an account of mental processes as states of the person apt for the production of certain sorts of behaviour may very possibly be adequate to deal with such cases as that of automatic driving. It may be adequate to deal with most of the mental processes of animals, who perhaps spend a good deal of their lives in this state of automatism. But, it is contended, it cannot deal with the consciousness that we normally enjoy.

I will now try to sketch an answer to this important and powerful objection. Let us begin in an apparently unlikely place, and consider the way that an account of mental processes of the sort I am giving would deal with sense-perception.

Now psychologists, in particular, have long realised that there is a very close logical tie between sense-perception and selective behaviour. Suppose we want to decide whether an animal can perceive the difference between red and green. We might give the animal a choice between two pathways, over one of which a red light shines and over the other of which a green light shines. If the animal happens by chance to choose the green pathway we reward it; if it happens to choose the other pathway we do not reward it. If, after some trials, the animal systematically takes the green-lighted pathway, and if we become assured that the only relevant differences in the two pathways are the differences in the colour of the lights, we are entitled to say that the animal can see this colour difference. Using its eyes, it selects between red-lighted and green-lighted pathways. So we say it can see the difference between red and green.

Now a Behaviourist would be tempted to say that the animal's regularly selecting the green-lighted pathway was its perception of the colour difference. But this is unsatisfactory, because we all want to say that perception is something that goes on within the person or animal—within its mind—although, of course, this mental event is normally caused by the operation of the environment upon the organism. Suppose, however, that we speak instead of capacities for selective behaviour towards the current environment, and suppose we think of these capacities, like dispositions, as actual inner states of the organism. We can then think of the animal's perception as a state within the animal apt, if the animal is so impelled, for selective behaviour between the red- and green-lighted pathways.

In general, we can think of perceptions as inner states or events apt for the production of certain sorts of selective behaviour towards our environment. To perceive is like acquiring a key to a door. You do not have to use the key: you can put it in your pocket and never bother about the door. But if you do want to open the door the key may be essential. The blind man is a man who does not acquire certain keys, and, as a result, is not able to operate in his environment in the way that somebody who has his sight can operate. It seems, then, a very promising view to take of perceptions that they are inner states defined by the sorts of selective behaviour that they enable the perceiver to exhibit, if so impelled.

Now how is this discussion of perception related to the question of consciousness or experience, the sort of thing that the driver who is in a state of automatism has not got, but which we normally do have? Simply this. My proposal is that consciousness, in this sense of the word, is nothing but perception or awareness of the state of our own mind. The driver in a state of automatism perceives, or is aware of, the road. If he did not, the car would be in a ditch. But he is not currently aware of his awareness of the road. He perceives the road, but he does not perceive his perceiving, or anything else that is going on in his mind. He is not, as we normally are, conscious of what is going on in his mind.

And so I conceive of consciousness or experience, in this sense of the words, in the way that Locke and Kant conceived it, as like perception. Kant, in a striking phrase, spoke of "inner sense." We cannot directly observe the minds of others, but each of us has the power to observe directly our own minds, and "perceive" what is going on there. The driver in the automatic state is one whose "inner eye" is shut: who is not currently aware of what is going on in his own mind.

Now if this account is along the right lines, why should we not give an account of this inner observation along the same lines as we have already given of perception? Why should we not conceive of it as an inner state, a state in this case directed towards other inner states and not to the environment, which enables us, if we are so impelled, to behave in a selective way towards our own states of mind? One who is aware, or conscious, of his thoughts or his emotions is one who has the capacity to make discriminations between his different mental states. His capacity might be exhibited in words. He might say that he was in an angry state of mind when, and only when, he was in an angry state of mind. But such verbal behaviour would be the mere expression or result of the awareness. The awareness itself would be an inner state: the sort of inner state that gave the man a capacity for such behavioural expressions.

So I have argued that consciousness of our own mental state may be assimilated to perception of our own mental state, and that, like other perceptions, it may then be conceived of as an inner state or event giving a capacity for selective behaviour, in this case selective behaviour towards our own mental state. All this is meant to be simply a logical analysis of consciousness, and none of it entails, although it does not rule out, a purely physicalist account of what these inner states are. But if we are convinced, on general scientific grounds, that a purely physical account of man is likely to be the true one, then there seems to be no bar to our identifying these inner states with purely physical states of the central nervous system. And so consciousness of our own mental state becomes simply the scanning of one part of our central nervous system by another. Consciousness is a self-scanning mechanism in the central nervous system.

As I have emphasized before, I have done no more than sketch a programme for a philosophy of mind. There are all sorts of expansions and elucidations to be made, and all sorts of doubts and difficulties to be stated and overcome. But I hope I have done enough to show that a purely physicalist theory of the mind is an exciting and plausible intellectual option.

Reading Questions

1. According to Armstrong, what is behaviorism?
2. What did the behaviorists get right? Where did the behaviorists go wrong?
3. How does Armstrong characterize the identity theory?
4. Why does Armstrong consider the identity theory superior to behaviorism?

David Chalmers

The Puzzle of Conscious Experience

David Chalmers (1966–) is an associate professor of philosophy at the University of California at Santa Cruz. He received his B.A. in mathematics and computer science from the University of Adelaide and his Ph.D. in philosophy and cognitive science from Indiana University. His book *The Conscious Mind: In Search of a Fundamental Theory* was published by Oxford University Press in 1996. The MIT Press has recently published a collection of essays on his work, entitled *Explaining Consciousness: The Hard Problem*. In this selection, Chalmers uses a number of thought experiments to demonstrate the failure of reductive approaches to the mind.

Conscious experience is at once the most familiar thing in the world and the most mysterious. There is nothing we know about more directly than consciousness, but it is extraordinarily hard to reconcile it with everything else we know. Why does it exist? What does it do? How could it possibly arise from neural processes in the brain? These questions are among the most intriguing in all of science.

From an objective viewpoint, the brain is relatively comprehensible. When you look at this page, there is a whir of processing: photons strike your retina, electrical signals are passed up your optic nerve and between different areas of your brain, and eventually you might respond with a smile, a perplexed frown or a remark. But there is also a subjective aspect. When you look at the page, you are conscious of it, directly experiencing the images and words as part of your private, mental life. You have vivid impressions of colored flowers and vibrant sky. At the same time, you may be feeling some emotions and forming some thoughts. Together such experiences make up consciousness: the subjective, inner life of the mind.

For many years, consciousness was shunned by researchers studying the brain and the mind. The prevailing view was that science, which depends on objectivity, could not accommodate something as subjective as consciousness. The behaviorist movement in psychology, dominant earlier in this century, concentrated on external behavior and disallowed any talk of internal mental processes. Later, the rise of cognitive science focused attention on processes inside the head. Still, consciousness remained off-limits, fit only for late-night discussion over drinks.

Over the past several years, however, an increasing number of neuroscientists, psychologists and philosophers have been rejecting the idea that consciousness cannot be studied and are attempting to delve into its secrets. As might be expected of a field so new, there is a tangle of diverse and conflicting theories, often using basic concepts in incompatible ways. To help unsnarl the tangle, philosophical reasoning is vital.

The myriad views within the field range from reductionist theories, according to which consciousness can be explained by the standard methods of neuroscience and psychology, to the position of the so-called mysterians, who say we will never understand consciousness at all. I believe that on close analysis both of these views can be seen to be mistaken and that the truth lies somewhere in the middle.

Against reductionism I will argue that the tools of neuroscience cannot provide a full account of conscious experience, although they have much to offer. Against mysterianism I will hold that consciousness might be explained by a new kind of theory. The full details of such a theory are still out of reach, but careful reasoning and some educated inferences can reveal something of its general nature. For example, it will probably involve new fundamental laws, and the concept of information may play a central role. These faint glimmerings suggest that a theory of consciousness may have startling consequences for our view of the universe and of ourselves.

Source: David J. Chalmers, "The Puzzle of Conscious Experience," *Scientific American* 237 (December 1995) 80–86. Reproduced with permission. Copyright © 1995 Scientific American, a division of Nature America, Inc. All rights reserved.

The Hard Problem

Researchers use the word "consciousness" in many different ways. To clarify the issues, we first have to separate the problems that are often clustered together under the name. For this purpose, I find it useful to distinguish between the "easy problems" and the "hard problem" of consciousness. The easy problems are by no means trivial—they are actually as challenging as most in psychology and biology—but it is with the hard problem that the central mystery lies.

The easy problems of consciousness include the following: How can a human subject discriminate sensory stimuli and react to them appropriately? How does the brain integrate information from many different sources and use this information to control behavior? How is it that subjects can verbalize their internal states? Although all these questions are associated with consciousness, they all concern the objective mechanisms of the cognitive system. Consequently, we have every reason to expect that continued work in cognitive psychology and neuroscience will answer them.

The hard problem, in contrast, is the question of how physical processes in the brain give rise to subjective experience. This puzzle involves the inner aspect of thought and perception: the way things feel for the subject. When we see, for example, we experience visual sensations, such as that of vivid blue. Or think of the ineffable sound of a distant oboe, the agony of an intense pain, the sparkle of happiness or the meditative quality of a moment lost in thought. All are part of what I am calling consciousness. It is these phenomena that pose the real mystery of the mind.

To illustrate the distinction, consider a thought experiment devised by the Australian philosopher Frank Jackson. Suppose that Mary, a neuroscientist in the 23rd century, is the world's leading expert on the brain processes responsible for color vision. But Mary has lived her whole life in a black-and-white room and has never seen any other colors. She knows everything there is to know about physical processes in the brain—its biology, structure and function. This understanding enables her to grasp everything there is to know about the easy problems: how the brain discriminates stimuli, integrates information and produces verbal reports. From her knowledge of color vision, she knows the way color names correspond with wavelengths on the light spectrum. But there is still something crucial about color vision that Mary does not know: what it is like to experience a color such as red. It follows that there are facts about conscious experience that cannot be deduced from physical facts about the functioning of the brain.

Indeed, nobody knows why these physical processes are accompanied by conscious experience at all. Why is it that when our brains process light of a certain wavelength, we have an experience of deep purple? Why do we have any experience at all? Could not an unconscious automaton have performed the same tasks just as well? These are questions that we would like a theory of consciousness to answer.

I am not denying that consciousness arises from the brain. We know, for example, that the subjective experience of vision is closely linked to processes in the visual cortex. It is the link itself that perplexes, however. Remarkably, subjective experience seems to emerge from a physical process. But we have no idea how or why this is.

Is Neuroscience Enough?

Given the flurry of recent work on consciousness in neuroscience and psychology, one might think this mystery is starting to be cleared up. On closer examination, however, it turns out that almost all the current work addresses only the easy problems of consciousness. The confidence of the reductionist view comes from the progress on the easy problems, but none of this makes any difference where the hard problem is concerned.

Consider the hypothesis put forward by neurobiologists Francis Crick of the Salk Institute for Biological Studies in San Diego and Christof Koch of the California Institute of Technology. They suggest that consciousness may arise from certain oscillations in the cerebral cortex, which become synchronized as neurons fire 40 times per second. Crick and Koch believe the phenomenon might explain how different attributes of a single perceived object (its color and shape, for example), which are processed in different parts of the brain, are merged into a coherent whole. In this theory, two pieces of information become bound together precisely when they are represented by synchronized neural firings.

The hypothesis could conceivably elucidate one of the easy problems about how information is integrated in the brain. But why should synchronized oscillations give rise to a visual experience, no matter how much integration is taking place? This question involves the hard problem, about which the theory has nothing to offer. Indeed, Crick and Koch are agnostic about whether the hard problem can be solved by science at all.

The same kind of critique could be applied to almost all the recent work on consciousness. In his 1991 book *Consciousness Explained,* philosopher Daniel C. Dennett laid out a sophisticated theory of how numerous independent processes in the brain combine to produce

a coherent response to a perceived event. The theory might do much to explain how we produce verbal reports on our internal states, but it tells us very little about why there should be a subjective experience behind these reports. Like other reductionist theories, Dennett's is a theory of the easy problems.

The critical common trait among these easy problems is that they all concern how a cognitive or behavioral function is performed. All are ultimately questions about how the brain carries out some task—how it discriminates stimuli, integrates information, produces reports and so on. Once neurobiology specifies appropriate neural mechanisms, showing how the functions are performed, the easy problems are solved.

The hard problem of consciousness, in contrast, goes beyond problems about how functions are performed. Even if every behavioral and cognitive function related to consciousness were explained, there would still remain a further mystery: Why is the performance of these functions accompanied by conscious experience? It is this additional conundrum that makes the hard problem hard.

The Explanatory Gap

Some have suggested that to solve the hard problem, we need to bring in new tools of physical explanation: nonlinear dynamics, say, or new discoveries in neuroscience, or quantum mechanics. But these ideas suffer from exactly the same difficulty. Consider a proposal from Stuart R. Hameroff of the University of Arizona and Roger Penrose of the University of Oxford. They hold that consciousness arises from quantum-physical processes taking place in microtubules, which are protein structures inside neurons. It is possible (if not likely) that such a hypothesis will lead to an explanation of how the brain makes decisions or even how it proves mathematical theorems, as Hameroff and Penrose suggest. But even if it does, the theory is silent about how these processes might give rise to conscious experience. Indeed, the same problem arises with any theory of consciousness based only on physical processing.

The trouble is that physical theories are best suited to explaining why systems have a certain physical structure and how they perform various functions. Most problems in science have this form; to explain life, for example, we need to describe how a physical system can reproduce, adapt and metabolize. But consciousness is a different sort of problem entirely, as it goes beyond the explanation of structure and function.

Of course, neuroscience is not irrelevant to the study of consciousness. For one, it may be able to reveal the nature of the neural correlate of consciousness—the brain processes most directly associated with conscious experience. It may even give a detailed correspondence between specific processes in the brain and related components of experience. But until we know why these processes give rise to conscious experience at all, we will not have crossed what philosopher Joseph Levine has called the explanatory gap between physical processes and consciousness. Making that leap will demand a new kind of theory.

A True Theory of Everything

In searching for an alternative, a key observation is that not all entities in science are explained in terms of more basic entities. In physics, for example, space-time, mass and charge (among other things) are regarded as fundamental features of the world, as they are not reducible to anything simpler. Despite this irreducibility, detailed and useful theories relate these entities to one another in terms of fundamental laws. Together these features and laws explain a great variety of complex and subtle phenomena.

It is widely believed that physics provides a complete catalogue of the universe's fundamental features and laws. As physicist Steven Weinberg puts it in his 1992 book *Dreams of a Final Theory*, the goal of physics is a "theory of everything" from which all there is to know about the universe can be derived. But Weinberg concedes that there is a problem with consciousness. Despite the power of physical theory, the existence of consciousness does not seem to be derivable from physical laws. He defends physics by arguing that it might eventually explain what he calls the objective correlates of consciousness (that is, the neural correlates), but of course to do this is not to explain consciousness itself. If the existence of consciousness cannot be derived from physical laws, a theory of physics is not a true theory of everything. So a final theory must contain an additional fundamental component.

Toward this end, I propose that conscious experience be considered a fundamental feature, irreducible to anything more basic. The idea may seem strange at first, but consistency seems to demand it. In the 19th century it turned out that electromagnetic phenomena could not be explained in terms of previously known principles. As a consequence, scientists introduced electromagnetic charge as a new fundamental entity and studied the associated fundamental laws. Similar reasoning should apply to consciousness.

If existing fundamental theories cannot encompass it, then something new is required.

Where there is a fundamental property, there are fundamental laws. In this case, the laws must relate experience to elements of physical theory. These laws will almost certainly not interfere with those of the physical world; it seems that the latter form a closed system in their own right. Rather the laws will serve as a bridge, specifying how experience depends on underlying physical processes. It is this bridge that will cross the explanatory gap.

Thus, a complete theory will have two components: physical laws, telling us about the behavior of physical systems from the infinitesimal to the cosmological, and what we might call psychophysical laws, telling us how some of those systems are associated with conscious experience. These two components will constitute a true theory of everything.

Searching for a Theory

Supposing for the moment that they exist, how might we uncover such psychophysical laws? The greatest hindrance in this pursuit will be a lack of data. As I have described it, consciousness is subjective, so there is no direct way to monitor it in others. But this difficulty is an obstacle, not a dead end. For a start, each one of us has access to our own experiences, a rich trove that can be used to formulate theories. We can also plausibly rely on indirect information, such as subjects' descriptions of their experiences. Philosophical arguments and thought experiments also have a role to play. Such methods have limitations, but they give us more than enough to get started.

These theories will not be conclusively testable, so they will inevitably be more speculative than those of more conventional scientific disciplines. Nevertheless, there is no reason they should not be strongly constrained to account accurately for our own first-person experiences, as well as the evidence from subjects' reports. If we find a theory that fits the data better than any other theory of equal simplicity, we will have good reason to accept it. Right now we do not have even a single theory that fits the data, so worries about testability are premature.

We might start by looking for high-level bridging laws, connecting physical processes to experience at an everyday level. The basic contour of such a law might be gleaned from the observation that when we are conscious of something, we are generally able to act on it and speak about it—which are objective, physical functions. Conversely, when some information is directly available for action and speech, it is generally conscious. Thus, consciousness correlates well with what we might call "awareness": the process by which information in the brain is made globally available to motor processes such as speech and bodily action.

The notion may seem trivial. But as defined here, awareness is objective and physical, whereas consciousness is not. Some refinements to the definition of awareness are needed, in order to extend the concept to animals and infants, which cannot speak. But at least in familiar cases, it is possible to see the rough outlines of a psychophysical law: where there is awareness, there is consciousness, and vice versa.

To take this line of reasoning a step further, consider the structure present in the conscious experience. The experience of a field of vision, for example, is a constantly changing mosaic of colors, shapes and patterns and as such has a detailed geometric structure. The fact that we can describe this structure, reach out in the direction of many of its components and perform other actions that depend on it suggests that the structure corresponds directly to that of the information made available in the brain through the neural processes of awareness.

Similarly, our experiences of color have an intrinsic three-dimensional structure that is mirrored in the structure of information processes in the brain's visual cortex. This structure is illustrated in the color wheels and charts used by artists. Colors are arranged in a systematic pattern—red to green on one axis, blue to yellow on another, and black to white on a third. Colors that are close to one another on a color wheel are experienced as similar. It is extremely likely that they also correspond to similar perceptual representations in the brain, as part of a system of complex three-dimensional coding among neurons that is not yet fully understood. We can recast the underlying concept as a principle of structural coherence: the structure of conscious experience is mirrored by the structure of information in awareness, and vice versa.

Another candidate for a psychophysical law is a principle of organizational invariance. It holds that physical systems with the same abstract organization will give rise to the same kind of conscious experience, no matter what they are made of. For example, if the precise interactions between our neurons could be duplicated with silicon chips, the same conscious experience would arise. The idea is somewhat controversial, but I believe it is strongly supported by thought experiments describing the gradual replacement of neurons by silicon chips. The remarkable implication is that consciousness might someday be achieved in machines.

Information: Physical and Experimental

The ultimate goal of a theory of consciousness is a simple and elegant set of fundamental laws, analogous to the fundamental laws of physics. The principles described above are unlikely to be fundamental, however. Rather they seem to be high-level psychophysical laws, analogous to macroscopic principles in physics such as those of thermodynamics or kinematics. What might the underlying fundamental laws be? No one knows, but I don't mind speculating.

I suggest that the primary psychophysical laws may centrally involve the concept of information. The abstract notion of information, as put forward in the 1940s by Claude E. Shannon of the Massachusetts Institute of Technology, is that of a set of separate states with a basic structure of similarities and differences between them. We can think of a 10-bit binary code as an information state, for example. Such information states can be embodied in the physical world. This happens whenever they correspond to physical states (voltages, say); the differences between them can be transmitted along some pathway, such as a telephone line.

We can also find information embodied in conscious experience. The pattern of color patches in a visual field, for example, can be seen as analogous to that of the pixels covering a display screen. Intriguingly, it turns out that we find the same information states embedded in conscious experience and in underlying physical processes in the brain. The three-dimensional encoding of color spaces, for example, suggests that the information state in a color experience corresponds directly to an information state in the brain. We might even regard the two states as distinct aspects of a single information state, which is simultaneously embodied in both physical processing and conscious experience.

A natural hypothesis ensues. Perhaps information, or at least some information, has two basic aspects: a physical one and an experiential one. This hypothesis has the status of a fundamental principle that might underlie the relation between physical processes and experience. Wherever we find conscious experience, it exists as one aspect of an information state, the other aspect of which is embedded in a physical process in the brain. This proposal needs to be fleshed out to make a satisfying theory. But it fits nicely with the principles mentioned earlier—systems with the same organization will embody the same information, for example—and it could explain numerous features of our conscious experience.

The idea is at least compatible with several others, such as physicist John A. Wheeler's suggestion that information is fundamental to the physics of the universe. The laws of physics might ultimately be cast in informational terms, in which case we would have a satisfying congruence between the constructs in both physical and psychophysical laws. It may even be that a theory of physics and a theory of consciousness could eventually be consolidated into a single grander theory of information.

A potential problem is posed by the ubiquity of information. Even a thermostat embodies some information, for example, but is it conscious? There are at least two possible responses. First, we could constrain the fundamental laws so that only some information has an experiential aspect, perhaps depending on how it is physically processed. Second, we might bite the bullet and allow that all information has an experiential aspect—where there is complex information processing, there is complex experience, and where there is simple information processing, there is simple experience. If this is so, then even a thermostat might have experiences, although they would be much simpler than even a basic color experience, and there would certainly be no accompanying emotions or thoughts. This seems odd at first, but if experience is truly fundamental, we might expect it to be widespread. In any case, the choice between these alternatives should depend on which can be integrated into the most powerful theory.

Of course, such ideas may be all wrong. On the other hand, they might evolve into a more powerful proposal that predicts the precise structure of our conscious experience from physical processes in our brains. If this project succeeds, we will have good reason to accept the theory. If it fails, other avenues will be pursued, and alternative fundamental theories may be developed. In this way, we may one day resolve the greatest mystery of the mind.

Reading Questions

1. According to Chalmers, what are the "easy problems"? What is the "hard problem"? If scientists solved all the easy problems, would that solve the hard problem? Why or why not?

2. What is the thought experiment about Mary, the color-deprived neuroscientist? Do you agree with Chalmers that the scenario shows "there are facts about conscious experience that cannot be deduced from physical facts about the functioning of the brain"? Explain.

3. What does Chalmers mean by his suggestion that consciousness arises from the brain? Does he mean that brain states are conscious states? How does Chalmers's view of consciousness differ from that of substance dualists like Descartes?

4. What is Chalmers's main criticism of reductionist theories like Dennett's? Is Chalmers right? Explain.

Notes

1. René Descartes, *Discourse on the Method of Rightly Conducting the Reason, Part V, The Method, Meditations, and Philosophy of Descartes*, trans. by John Vietch (London: M. Walter Dunne, 1901) 188–189.
2. David Levy, *Love and Sex with Robots* (New York: Harper Perennial, 2008).
3. James S. Albus, quoted in *The Tomorrow Makers* by Grant Fjermedal (New York: Macmillan, 1986) 194.
4. Albus 195.
5. Gottfried Wilhelm von Leibniz, *Monadology and Other Philosophical Essays*, trans. Paul Schrecker and Anne Martin Schrecker (Indianapolis: Bobbs-Merrill, 1965) 17.
6. Vernor Vinge, excerpt from "What Is the Singularity?" from www.wgcs.caltech.edu/~phoenix/vinge/vinge-sing.html.
7. Shankara, *Crest-Jewel of Discrimination* (Hollywood: Vedanta Press, 1975) 110.
8. David Deutsch, "Philosophy will be the key that unlocks artificial intelligence," *The Guardian*, October 3, 2012 Science https://www.theguardian.com/science/2012/oct/03/philosophy-artificial-intelligence, accessed 7/12/2018
9. René Descartes, *Meditations on First Philosophy*, Meditation II, *The Method, Meditations, and Philosophy of Descartes*, trans. by John Vietch (London: M. Walter Dunne, 1901) 225.
10. René Descartes, *Meditations on First Philosophy*, Meditation I, *The Method, Meditations, and Philosophy of Descartes*, trans. by John Vietch (London: M. Walter Dunne, 1901) 220.
11. René Descartes, *Meditations on First Philosophy*, Meditation I, *The Method, Meditations, and Philosophy of Descartes*, trans. by John Vietch (London: M. Walter Dunne, 1901) 221.
12. Descartes, Meditation I 147.
13. Elon Musk, https://www.youtube.com/watch?v=2KK_kzrJPS8, accessed 5/3/2018.
14. Descartes, *Discourse*, Part IV 171.
15. Descartes, *Discourse*, Part IV 171–172.
16. Adrian Thatcher, excerpt from "Christian Theism and the Concept of a Person" from *Persons and Personalities*, edited by A. Peacocke and G. Gillett.
17. Descartes, *Discourse*, Part V 189–190.
18. Nicholas Malebranche, *Oeuvres Completes*, Vol. 2, ed. G. Rodis-Lewis (Paris: J. Vrin, 1958–1970) 394.
19. L. C. Rosenfeld, *From Beast-Machine to Man-Machine* (New York: Octagon, 1968) 54.
20. René Descartes, Letter to Moore, 5 February 1649, *Philosophical Letters*, ed. A. Kenny (Oxford: Clarendon Press, 1970) 244.
21. C. D. Broad, from "Human Personality and Its Survival of Bodily Death" from *Lectures on Psychical Research*, 1962.
22. Descartes, *Meditations*, Meditation VI 276.
23. Roger Sperry, quoted in *The Mechanics of Mind* by Colin Blakemore (Cambridge: Cambridge University Press, 1978) 159.
24. Vilayanur Ramachandran, https://www.youtube.com/watch?v=PFJPtVRlI64, accessed 5/3/2018.
25. Princess Elizabeth, Letters to Descartes, May 6, 1643, in René Descartes, *Philosophical Writings*, trans. Elizabeth Anscombe and Peter Geach (Indianapolis: Bobbs-Merrill, 1971) 274–275.
26. René Descartes, *Passions of the Soul*, Article 31, translator unknown (London: J. Martin and J. Ridley, 1650) 25–26.
27. T. H. Huxley, *Method and Results* (New York: Appleton-Century-Crofts, 1893) 244.
28. Descartes, *Meditations*, Meditation II 232.
29. David Hume, *Enquiries Concerning the Human Understanding and Concerning the Principles of Morals*, ed. L. A. Selby-Bigge (Oxford: Clarendon Press, 1972) 22.
30. Hume 365.
31. David Hume, *A Treatise of Human Nature* (London: Oxford University Press, 1973) 232–233, 234.
32. Rudolf Carnap, "The Elimination of Metaphysics Through Logical Analysis of Language," *Logical Positivism*, ed. A. J. Ayer (Glencoe, IL: Free Press, 1959) 60–81.
33. Gilbert Ryle, *The Concept of Mind* (New York: Barnes & Noble, 1949) 16.
34. Hilary Putnam, "Brains and Behavior," *Readings in the Philosophy of Psychology*, ed. Ned Block (Cambridge, MA: Harvard University Press, 1980) 29.
35. Morton Hunt, excerpt from *The Universe Within* (New York: Simon and Schuster, 1982).
36. Hunt 62.
37. Roderick Chisholm, *Perceiving* (Ithaca: Cornell University Press, 1957) 183.
38. Colin Blakemore, *Mechanics of Mind* (Cambridge: Cambridge University Press, 1977) 3–4.
39. Barry Beyerstein, *The Hundredth Monkey and Other Paradigms of the Paranormal*, ed. Kendrick Frazier (Amherst, NY: Prometheus Books, 1991) 45.
40. John Lorber, quoted in Roger Lewin, "Is Your Brain Really Necessary?" *Science* 210 (December 1980) 1232.
41. Lorber 1232–1233.
42. Lorber 1233.
43. Thomas Nagel, "What Is It Like to Be a Bat?" *Readings in the Philosophy of Psychology* 161–163.
44. David Lewis, excerpts from "Mad Pain and Martian Pain" from *Philosophical Papers, Volume I* (Oxford University Press, 1983).
45. Hilary Putnam, "Philosophy and Our Mental Life," *Readings in the Philosophy of Psychology* 135–136.
46. Searle, John R., *The Rediscovery of the Mind*, pp. 65–68, © 1992 Massachusetts Institute of Technology, by permission of The MIT Press.
47. Nicolosi, Michele, "Researchers' Brainchild: Microchip Implants Boosting Mental Function," *The Orange County Register*, 20 April 1997, online, Internet. Reprinted with permission of *The Orange County Register*.
48. Larry Hauser, excerpt from "Revenge of the Zombies" (American Philosophical Association Eastern Division Colloquium: Philosophy of Mind, December 29, 1995).
49. Marvin Minsky, quoted in "Where Evolution Left Off," *Andover Bulletin* (Spring 1995) 9.
50. Gerald Jay Sussman, quoted in *The Tomorrow Makers* by Grant Fjermedal (New York: Macmillan, 1986) 8.
51. Ray Kurzweil quoted in Lev Grossman, "2045: The Year Man Becomes Immortal," *Time*, February 10, 2011.
52. Bill Joy, "Why the Future Doesn't Need Us," *Wired*, April 2000; Francis Fukuyama, *Our Post-human Future* (New York: Picador, 2002).
53. Lewis 216.
54. Ned Block, excerpts from "Troubles with Functionalism" from C. W. Savage, ed., *Perception and Cognition: Issues in the Philosophy of Science*, vol. 9, 1978, University of Minnesota.
55. Hilary Putnam, *Reason, Truth and History* (Cambridge: Cambridge University Press, 1981) 80.
56. Martine Nida-Rumelin, "Pseudonormal Vision and Color Qualia," *Toward a Science of Consciousness 3*, Hameroff, Kaszniak, Chalmers, eds. (Boston: MIT Press, 1999) 75.
57. *The Matrix*. 35 mm, 136 min. Groucho II Film Partnership, Silver Pictures, Village Roadshow Productions, 1999.
58. Paul Churchland, *Matter and Consciousness* (Cambridge, MA: MIT Press, 1990) 39–40.
59. A. M. Turing, "Computing Machinery and Intelligence," *Minds and Machines*, ed. Alan Ross Anderson (Englewood Cliffs, NJ: Prentice-Hall, 1964) 5.

60. Turing 13.
61. John R. Searle, "Is the Brain's Mind a Computer Program?" *Scientific American* 262 (Jan. 1990) 26.
62. John R. Searle, *Minds, Brains and Science* (Cambridge, MA: Harvard University Press, 1984) 34.
63. John R. Searle, "Minds, Brains, and Programs," *Behavioral and Brain Sciences* 3 (1980) 417–424.
64. Searle, "Is the Brain's Mind . . . ?" 35.
65. Block 282.
66. Richard Rorty, excerpt from "Mind-Body Identity, Privacy, and Categories" from *The Review of Metaphysics* (1965–1966).
67. Rorty 30–31.
68. Churchland 45–46.
69. Galen Strawson, "The Consciousness Deniers," *New York Review of Books: NYR Daily*, March 13, 2018, http://www.nybooks.com/daily/2018/03/13/the-consciousness-deniers/, accessed 5/3/2018.
70. Frank Jackson, "Epiphenomenal Qualia," *Philosophical Quarterly* 32 (1982) 127.
71. David Lewis, "Knowing What It's Like," *The Nature of Mind*, ed. David M. Rosenthal (New York: Oxford University Press, 1991) 234.
72. JoJo Moyes, excerpt from "Teenager sees colour after life in black and white" from *The Independent* (October 22, 1997).
73. David J. Chalmers, "The Puzzle of Conscious Experience," *Scientific American* 237 (December 1995) 80–86. Reproduced with permission. Copyright © 1995 Scientific American, a division of Nature America, Inc. All rights reserved.
74. Nelson Goodman, *Languages of Art* (Indianapolis: Hackett, 1976) 50, 68, 70.
75. Dale Jacquette, excerpt from *Philosophy of Mind*, 1994.
76. Hilary Putnam, *Representation and Reality* (Cambridge, MA: MIT Press, 1988) 110.
77. Thomas Nagel, *The View from Nowhere* (Oxford: Oxford University Press, 1986) 53.
78. "Why Physicists Are Saying Consciousness Is A State Of Matter, Like a Solid, A Liquid Or A Gas," https://medium.com/the-physics-arxiv-blog/why-physicists-are-saying-consciousness-is-a-state-of-matter-like-a-solid-a-liquid-or-a-gas-5e7ed624986d, accessed 5/3/2018.
79. Christof Koch, "A 'Complex' Theory of Consciousness," *Scientific American Mind,* July 1, 2009, https://www.scientificamerican.com/article/a-theory-of-consciousness/, accessed 5/3/2018.
80. Giulio Tononi, "Integrated information theory: From consciousness to its physical substrate," *Nature Reviews Neuroscience* 17 (2016) 451.
81. Christof Koch, Giulio Tononi, "Can We Quantify Machine Consciousness?" IEEE Spectrum, https://spectrum.ieee.org/computing/hardware/can-we-quantify-machine-consciousness, accessed 10/15/2018.
82. Christof koch, "A 'Complex' Theory of Consciousness," op. cit.
83. Christof Koch, "How to Make a Consciousness Meter," *Scientific American* 317 (2017) 33.
84. János Szentágothai, "The 'Brain-Mind' Relation: A Pseudoproblem?" *Mindwaves,* ed. Colin Blakemore and Susan Greenfield (Cambridge, MA: Basil Blackwell, 1987) 334.
85. Roger Sperry, excerpt from "Changing Priorities" from *Annual Review of Neuroscience* 4 (1981).
86. Roger W. Sperry, "A Modified Concept of Consciousness," *Psychological Review* 76 (1969) 534.
87. Jerry Fodor, "Making Mind Matter More," *Philosophical Topics* 17 (Spring 1989) 77.
88. W. E. Agar, *Theory of the Living Organism* (Melbourne: Melbourne University Press, 1943) 109–110.
89. Enos Witmer, "Interpretation of Quantum Mechanics and the Future of Physics," *American Journal of Physics* 35 (1967) 47.
90. Witmer, 47.
91. Witmer, 49.
92. Witmer, 50.

Chapter 3
Free Will and Determinism

> Freedom is not being a slave to any circumstance, to any constraint, to any chance.
> —SENECA

Suppose you are a brilliant computer scientist who has achieved an incredible feat. You have created an android that seems the embodiment of science-fiction fantasy, a machine that is much like *Star Trek's* android, Commander Data. But something awful happens.

Your beloved creation murders a human being. The police cannot catch your android, but they can catch you—and promptly arrest you for murder. The prosecutor asserts that you are responsible for the murder because you programmed the android. You reply that you programmed it to make choices of its own free will. But the prosecutor declares that the android could not possibly have free will. Its choices are the direct result of (1) its original construction and (2) subsequent modifications caused by its environment. The android certainly has had no say in either of these factors. The android's choices and actions, the prosecutor says, have been determined by forces beyond its control. You are the one responsible for these factors. You would be responsible even if the android could alter its own programming or change its environment. After all, says the prosecutor, the android's way of self-programming and environmental manipulation was determined by you.

You reply that if your android lacks free will because of (1) and (2), then humans lack free will, too. Humans, just like the android, are the result of origins and environmental influences that are beyond their control. They have no say in their being born, or their genetic makeup, or their physical characteristics, or the conditions in the world that contributed to their early development. They are, you say, programmed by their genes and their environment, just as the android was programmed by you.

You assert that just as humans obviously can have free will despite their "programming," your android can, too.[1] But is this assertion correct? Regardless of how advanced science becomes, could an android ever really be both programmed and free to make its own choices? Isn't "programmed with free will" a contradiction in terms, as the prosecutor implies? More to the point, can we humans be both free and programmed? We seem to be in the same boat with the android. We all believe that we are programmed, in the sense mentioned above, by our genes and our environment. Yet we want to believe that at least some of our actions and choices are free. How can both these beliefs be true?

Our android scenario has dropped us into the heart of the matter. We seem to have conflicting beliefs about ourselves. But the conflict is more fundamental and more troubling than most people realize. It is at the core of what philosophers call *the problem of free will and determinism.* Let's state this problem more precisely.

> There is no good arguing with the inevitable.
> —JAMES RUSSELL LOWELL

First, we all believe, or at least are inclined to believe, that every event has a cause that makes it happen. We would think it nonsense to say that an event transpired without a cause. We would be incredulous if someone seriously thought, for example, that her clock stopped working for no reason whatsoever. Even if no one could determine the precise cause or causes, we still would not accept the idea that the clock's stopping had no cause. We might say that the cause was unknown or that it was difficult to discern, but

we would not say that it did not exist. Whether we're talking about clocks, computers, solar flares, the mating habits of geese, or the common cold, we firmly believe that each has a cause.

Further, we all believe that our acts—what we do, say, and choose—also have causes, just as everything else must have causes, for our acts are events, too. We assume that our acts are the result of our heredity, our previous experiences, the peculiarities of our personality, the circumstances preceding the acts, or *something*. Indeed, we believe that our acts must have causes—otherwise they would simply happen by chance.

On the other hand, we all believe that we have free will—that we can sometimes make a choice and that it is up to us what we shall choose. And most believe that if we act freely, we can be held responsible for what we do.

But if everything, including every act, has a cause, how is it possible for persons to have free will? Let's say that you perform an act: You press your finger against a button that detonates a bomb. Because everything has a cause, this movement of your finger must have a cause—perhaps the contracting of your muscles accompanied by certain electrical impulses in your hand and brain. According to the thesis of determinism, this something, this cause or causes, in turn must have been due to other causes (like certain brain states), and these causes must have been due to still others, and so on. Indeed, there must have been a whole succession of causes extending indefinitely into the past—stretching back before you were even born. Therefore, your simple act of pressing the button must have been the result of causes over which you had no control whatsoever. Your act was determined, already rigged before you thought to press the button—even before you had fingers. Worse still, we could say the same thing about all our acts. They're all determined. They would seem, therefore, to be entirely outside our control. When we act, we cannot act otherwise than we do.

The American philosopher and psychologist William James (1842–1910) explains causal determinism this way:

> It professes that those parts of the universe already laid down absolutely appoint and decree what the other parts shall be. The future has no ambiguous possibilities hidden in its womb: the part we call the present is compatible with only one totality. Any other future complement than the one fixed from eternity is impossible. The whole is in each and every part, and welds it with the rest into an absolute unity, an iron block, in which there can be no equivocation or shadow of turning.²

So, if the thesis of determinism is true, how can we possibly be free? If our acts are not under our control, how can we have free will? We all believe we are free, but how can this be? How can we consistently believe both that we are determined and that we have free will? Two of our most basic beliefs seem to be inconsistent. Something appears to be very wrong with the fundamental assumptions that permeate our relations with others, our laws, our institutions, and our innermost thoughts. Is it that we really are not free? Is it that determinism is false? Are we misunderstanding the problem?

There are two good things in life—freedom of thought and freedom of action.
—SOMERSET MAUGHAM

A lot is riding on the answers we give to this problem. Among the important things at stake here is the idea of moral and legal responsibility. If we really are not free in any meaningful way, we cannot reasonably be held responsible for what we do. We cannot reasonably be praised or blamed, rewarded or punished for any of our actions. After all, we would have no control over our acts—they would be the end result of causal chains that stretch back into the indefinite past. We would have no say in this process; it would simply happen to us. We therefore could not reasonably be held responsible for our actions and choices—any more than we could be held responsible for some genetic disease that befell us.

> *A man may be a pessimistic determinist before lunch and an optimistic believer in the will's freedom after it.*
> —ALDOUS HUXLEY

For a fuller appreciation of this point, consider the fictional world constructed by the writer Samuel Butler. In his satirical novel *Erewhon*, he asks us to imagine a country that has a penal system radically different from ours. In *Erewhon*, people who commit crimes are not punished but are treated in hospitals for moral ills, just as we treat the sick in our world. People who are physically sick, however, are not treated but are prosecuted and punished as we would criminals. Butler's point is that if determinism is true, it makes about as much sense to punish criminals as it does to punish sick people. Both the acts of criminals and the conditions of the sick are determined by forces beyond their control.

In one dramatic case of a young man found guilty of being ill, the judge had this to say at the time of sentencing:

> Prisoner at the bar, you have been accused of a great crime of laboring under pulmonary consumption, and after an impartial trial before a jury of your countrymen, you have been found guilty. Against the justice of the verdict I can say nothing: the evidence against you was conclusive, and it only remains for me to pass such a sentence upon you, as shall satisfy the ends of the law. That sentence must be a very severe one. It pains me much to see one who is yet so young, and whose prospects in life were otherwise so excellent, brought to this distressing condition by a constitution which I can only regard as radically vicious; but yours is no case for compassion: this is not your first offense. . . . You were convicted of aggravated bronchitis last year: and I find that though you are now only twenty-three years old, you have been imprisoned on no less than fourteen occasions for illnesses of a more or less hateful character; in fact, it is not too much to say that you have spent the greater part of your life in jail.[3]

If Butler is right, our penal system is all wrong. It punishes people for acts over which they could not possibly have any control—acts for which they are not responsible. We need not turn to fiction to see variations on this theme. We can just pick up a newspaper. There we can read about trial lawyers pleading that a client is not responsible for his illegal act because he was born with bad genes, or he grew up in a violent community (and thus has "urban survival syndrome"), or he was the victim of long-term abuse.

Famous trial lawyer Clarence Darrow (1857–1938) consistently wielded the "determinism defense" with great skill and passion. In the 1920s, he

In the Courts: The Devil Made Me Do It

The determinism defense is still used by lawyers to absolve their clients from guilt. Today's lawyers, though, are much more specific about the causes of their clients' behavior. Margot Slade, of the *New York Times*, reports on some recent variants of the determinism defense.

> The devil-made-me-do-it excuse is probably as ancient as Old Scratch himself. But at a time when Americans have moved from the self-absorbed Me Generation to the self-absolved Not Me Generation, the devil is increasingly appearing in court these days as a defense with a psychological pedigree.
>
> ... Moosa Hanoukai of Los Angeles was found guilty of voluntary manslaughter, reduced from a charge of murder, for beating his wife to death with a wrench. His lawyer said Mr. Hanoukai's wife had psychologically emasculated him—forcing him to sleep on the floor, calling him names—thus destroying his self-esteem, a kind of meek-mate syndrome.
>
> Daimon Osby, a black 18-year-old who shot two unarmed black men in a Fort Worth, Texas, parking lot ... managed to get a deadlocked jury after his lawyer argued that he suffered from "urban survival syndrome," or the fear that inner-city black people have of other black people.
>
> ... [D]efense lawyers have already staked their claim to:
>
> "Roid rage," the severe mood swings associated with steroid use, to mitigate the sentence of Troy Matthew Gentler, 19, who admitted tossing rocks at cars on Interstate 83 near York, York County ... injuring several people.
>
> "Black rage," which the defense has described as a kind of racial prejudice–induced insanity to explain why Colin Ferguson, who is black, killed six people and injured 19 on a commuter train near New York City....
>
> "Fetal trimethadione syndrome" in the case of Eric Smith, 14, who battered to death a 4-year-old boy ... in Savona, N.Y., because, his lawyer says, he has an uncontrollable "sadistic side" stemming from his mother's use of epilepsy medication during pregnancy....
>
> "The more we learn about how and why we act in a certain way, unless we rule out everything as psychobabble, the more we're able to offer viable defenses," said Lisa B. Kemler of Alexandria, Va., who represented Lorena Bobbitt and successfully invoked a "battered woman" defense to explain why Bobbitt sliced off her husband's penis while he slept. The jury judged her temporarily insane....
>
> The danger, say scholars, is that juries become loath to draw any line. "If we allow urban psychosis as a defense to crime," [John] Monahan said, "what would be next? Suburban psychosis, marked by a pathological fear of lawn mowers and barbecues?"
>
> Criminal law, he said, turns on the notion that people have free will. "This may be a legal fiction," he said, "but it's necessary in a democracy. Take it out, and we all become characters in a George Orwell novel."[4]

defended two college students, Leopold and Loeb, who murdered and dismembered a child. He admitted that the boys did indeed commit the heinous act but argued that they—like all of us—never had any real control over their lives. They were doomed—determined—by forces that were at work before the boys even conceived of their crime. In his plea, Darrow declared,

> Nature is strong and she is pitiless. She works in her own mysterious way, and we are her victims. We have not much to do with it ourselves. Nature takes

this job in hand, and we play our parts. In the words of old Omar Khayyam, we are only:

> But helpless pieces in the game He plays
> Upon this checkerboard of nights and days;
> Hither and thither moves, and checks, and slays,
> And one by one back in the closet lays.

What had this boy to do with it? He was not his own father; he was not his own mother; he was not his own grandparents. All of this was handed to him. He did not surround himself with governesses and wealth. He did not make himself. And yet he is to be compelled to pay.

There was a time in England, running down as late as the beginning of the last century, when judges used to convene court and call juries to try a horse, a dog, a pig, for crime. I have in my library a story of a judge and jury and lawyers trying and convicting an old sow for lying on her ten pigs and killing them.

What does it mean? Animals were tried. Do you mean to tell me that Dickie Loeb had any more to do with his making than any other product of heredity that is born upon the earth?[5]

With such entreaties, Darrow persuaded the jury to recommend life in prison for the boys instead of the death penalty.

If Darrow is right, we would have to admit that moral responsibility is an illusion. We might find ourselves agreeing with Casy the preacher in Steinbeck's *The Grapes of Wrath*, who awoke one night and said, "There ain't no sin and there ain't no virtue. There's just stuff people do. It's all part of the same thing. And some of the things people do is nice, and some ain't so nice, but that's as far as any man got a right to say."[6]

In an attempt to determine whether we can act freely, we will put a number of theories of free action to the test. We will begin (Section 3.1) by examining hard determinism, which claims that no one acts freely because every event is caused. Then we will examine indeterminism, which claims that some actions are free because some events are uncaused. Next (Section 3.2), we will examine two forms of compatibilism—traditional and hierarchical—which claim that even if every event is caused, we can still act freely. Finally (Section 3.3), we will examine libertarianism, which claims that free actions are self-generated. Each of these theories has its strengths and weaknesses. To determine which is the most plausible, you will have to determine which provides the best explanation of the evidence, including the evidence established through thought experiments.

Objectives

After reading this chapter, you should be able to

- recognize the relevance of determinism for legal and moral responsibility.

- evaluate the evidence cited in support of determinism.
- state the various theories of free action.
- describe the thought experiments that have been used to test them.
- evaluate the strengths and weaknesses of the various theories of free action.
- define causal determinism, causal indeterminism, compatibilism, incompatibilism, first-order desire, and second-order desire.
- formulate your own view of how free actions are possible (or why they are impossible).

Section 3.1

The Luck of the Draw
Freedom as Chance

*I*n this chapter we will consider two closely related theories that are provocative reactions to the doctrine of causal determinism. Perhaps without giving the matter much thought, you have already assumed one of them to be true. Let's begin now to see if such an assumption holds up under scrutiny.

Hard Determinism

None are more hopelessly enslaved than those who falsely believe they are free.
—GOETHE

Those who believe that we have no free will—that there are no free actions—are known as **hard determinists**. They assert that because everything is causally determined, no one acts freely. William James dubbed them "hard determinists" because they do not "shrink from such words as fatality, bondage of the will, necessity, and the like."[7] They readily embrace the view that no one is in control of their lives.

Hard determinists have traditionally been materialists. In fact, Leucippus (ca. 500 B.C.), the first person to propose an atomic theory of matter, is reputed to have said, "Nothing occurs by chance, but all is from necessity." In Leucippus's view, the world is composed of tiny, indivisible particles of matter called atoms. These atoms move through empty space and collide with one another according to fixed laws. These collisions can result in individual atoms sticking together or collections of atoms breaking apart. When individual atoms stick together, something is brought into existence. When a collection of atoms breaks apart, something ceases to exist. Everything that happens is the result of a collision between atoms.

hard determinism The doctrine that there are no free actions.

Although the things we call atoms are not indivisible, our most advanced theory of reality is based on Leucippus's insight. Called the "standard model" of particle physics, it claims that everything in the universe is made out of elementary particles. These particles interact with one another to produce all known physical phenomena.

French astronomer Pierre-Simon Laplace (1749–1827) made explicit the deterministic implications of particle physics in the following thought experiment. Suppose, he suggested, that there was a being (God? an advanced alien from outer space? a supercomputer?) who knew all the facts about all the physical objects in the universe as well as all the laws that govern their interaction. Such a being, Laplace realized, would be able to predict the entire future of the universe!

Thought Experiment

Laplace's Superbeing

> Given for one instant an intelligence which could comprehend all the forces by which nature is animated and the respective situation of the beings who compose it—an intelligence sufficiently vast to submit these data to analysis—it would embrace in the same formula the movements of the greatest bodies in the universe and those of the lightest atom; for it, nothing would be uncertain and the future, as the past, would be present to its eyes.[8]

According to traditional materialism, the universe is like a giant billiard ball game. Just as the path of every billiard ball is determined by the forces acting on it, so is the path of every elementary particle. Someone who knew the laws of motion, the properties of a billiard ball, and the forces acting on it would be able to predict all of its future movements. Similarly, someone who knew all the laws of physics, all the properties of all the physical objects in the universe, and all of the forces acting on them would be able to predict the entire future of the universe, including everything we will ever do. But if it's possible to predict all of our actions, then what we do is not up to us. If, as traditional materialism suggests, all of our actions are determined by forces beyond our control, we have no free will.

According to traditional materialism, then, the universe is a great, intricate mechanism ticking and turning ceaselessly in fixed ways. In this grand machine, there are component mechanisms known as human beings. They too are entirely physical and fully subject to natural laws. These mechanisms have complex brains producing various brain states. Every brain state follows necessarily from preceding brain states so that every thought and action is entirely necessitated, as the motions of any mechanism must be. Thus the causes of our choices and actions are outside our control. It may seem that we are free, but that is an illusion created by our ignorance of the forces acting on us.

This picture of the world was eloquently expressed by Baron Paul Henri d'Holbach in the eighteenth century. Holbach was one of the first modern thinkers to systematically critique the idea that people have free will. He asserts,

> [Man] is connected to universal nature, and submitted to the necessary and immutable laws that she imposes on all the beings she contains. . . . Man's life is a line that nature commands him to describe upon the surface of the earth, without his ever being able to swerve from it, even for an instant. He is born without his own consent; his organization does in nowise depend upon himself; his ideas come to him involuntarily; his habits are in the power of those who cause

Science is at work, humanity has been at work, scholarship has been at work, and intelligent people now know that every human being is the product of endless heredity in back of him and the infinite environment around him.

—CLARENCE DARROW

him to contract them; he is unceasingly modified by causes, whether visible or concealed, over which he has no control, which necessarily regulate his mode of existence, give the hue to his way of thinking, and determine his way of acting.[9]

According to Holbach, we are natural objects bound by the same laws that govern everything else in the natural world. Since those laws are not under our control—since we cannot change those laws at will—our lives are not under our control. We can no more change the future than we can change the past.

Thought Probe

The Book of Life

Suppose a Laplacean superbeing wrote a book that chronicles your life. For each minute that you're alive, it describes what you will be doing at that time. Now suppose you come across this book and read it. Could you do otherwise than what is written in the book? If you could, would that show that you have free will?

> Man is no more responsible for becoming willful and committing a crime than the flower for becoming red and fragrant. In both instances the end products are predetermined by the nature of protoplasm and the chance of circumstances.
>
> —Nathaniel Cantor

The philosophical theory of hard determinism is based on the principle of **causal determinism**, which says that every event is the consequence of past events plus the laws of nature. According to that principle, everything that will happen in the future is the consequence of what has happened in the past plus the laws of nature. But you can't change the past (because you can't travel backward in time) and you can't change the laws of nature. So what will be will be, and there's nothing you can do about it.

According to hard determinism, there is only one possible future. The universe must unfold in the way dictated by the laws of nature. If, by some remarkable coincidence, all the matter in the universe came to be arranged the way it was at some prior time, everything would happen again just as it did before, including your reading this book. And if Laplace's superbeing had complete knowledge of the state of the universe at that time, he could have predicted that you'd be reading this book right now. So much, say the hard determinists, for the view that you're in control of your life. Contrary to what you may have thought, you have no free will.

The hard determinists don't deny that it seems that we have free will. What they deny is that the way things seem is the way they are. Free will is an illusion caused by our ignorance of the true causes of our action. To illustrate our situation, Spinoza suggests that we consider a stone, thrown into the air, that becomes conscious of its motion:

> Further conceive, I beg, that a stone, while continuing in motion, should be capable of thinking and knowing, that it is endeavoring, as far as it can, to continue to move. Such a stone, being conscious merely of its own endeavour and not at all indifferent, would believe itself to be completely free, and would think that it continued in motion solely because of its own wish. This is that human freedom, which all boast that they possess, and which consists solely in the fact, that men are conscious of their own desire, but are ignorant of the causes whereby that desire has been determined.[10]

causal determinism The doctrine that every event is the consequence of past events plus the laws of nature.

186 Chapter 3 • Free Will and Determinism

Freedom and Foreknowledge

Science is not the only discipline whose principles seem to undermine free will. Theology also belongs in that category. A fundamental belief of traditional Christian theology is that God is all-knowing or omniscient. But if God knows everything that we will ever do, then it would seem that we are not free to do anything else. The medieval statesman and philosopher Boethius (480–524) provides one of the earliest and most succinct formulations of the dilemma:

> There seems to me, I said, to be such incompatibility between the existence of God's universal foreknowledge and that of any freedom of judgment. For if God foresees all things and cannot in anything be mistaken, that, which His Providence sees will happen, must result. . . . Besides, just as, when I know a present fact, that fact must be so; so also when I know of something that will happen, that must come to pass. Thus it follows that the fulfillment of a foreknown event must be inevitable.[11]

What Boethius means is that if someone knows that something is going to happen, then it's true that it is going to happen because you can't know something that is false. You can't know that 1+1 equals 3, for example, because 1+1 does not equal 3. But if it's true that something is going to happen, then it cannot possibly not happen. If it's true that the sun will rise tomorrow, for example, then the sun has to rise tomorrow, for otherwise the statement wouldn't be true. So if someone knows that something is going to happen, it must happen. But if it must happen—if it's unavoidable—then no one is free to prevent it from happening. Thus the price of omniscience is freedom.

Although Boethius thought that the apparent conflict between omniscience and free will could be avoided if God existed outside of time, the great Protestant reformer and founder of the Presbyterian Church, John Calvin (1509–1564), thought that it was precisely because God exists outside time that no one can change his or her destiny. He writes,

> When we attribute foreknowledge to God, we mean that all things have ever been, and perpetually remain, before His eyes, so that to His knowledge nothing in future or past, but all things are present; and present in such a manner, that He does not merely conceive of them from ideas formed in His mind, as things remembered by us appear present to our minds, but really beholds and sees them as if actually placed before Him. And this foreknowledge extends to the whole world, and to all the creatures. Predestination we call the eternal decree of God, by which He has determined in Himself what would have to become of every individual of mankind. For they are not all created with a similar destiny; but eternal life is foreordained for some, and eternal damnation for others.[12]

In Calvin's view, God can see at a glance every moment of everyone's life. Each of our lives is spread out before God like an unwound movie reel. Just as every frame in a film strip is fixed, so is every event in our lives. Consequently, Calvin held that some of us are destined to go to heaven and some to hell, and there's nothing we can do about it.

You might object that while God may know what choices you are going to make, he doesn't make choices for you. That may well be true, but consider this: You are free to do something only if you can refrain from doing it. If your doing something is inevitable—which it must be if God foresees it—then your doing it cannot be a free act.

Thought Probe

Freedom and Foreknowledge

Calvin's argument can be put like this:

1. If God knows that I will do x tomorrow, then it is true that I will do x tomorrow.
2. If it is true that I will do x tomorrow, then I cannot possibly not do x tomorrow.
3. If I cannot possibly not do x tomorrow, then I am not free to do x tomorrow.
4. Therefore, if God knows that I will do x tomorrow, then I am not free to do x tomorrow.

Is this a sound argument? Why or why not? If you think it's not sound, which premise would you reject? Why?

The Luck of the Draw

The conscious stone would think that it's free because, for all it knows, it's doing what it wants to do. We know better, however. Its motion is entirely determined by forces beyond its control. According to Spinoza, we're all like the conscious stone, falsely believing that we have free will because we are unaware of the causes of our behavior.

The Consequence Argument

Hard determinists believe that causal determinism is incompatible with free will. In their view, if causal determinism is true, it's impossible for us to have free will. Since they accept the principle of causal determinism, they maintain that we have no free will.

The view that causal determinism is incompatible with free will is known as **incompatibilism** and is held by some who believe in free will (such as indeterminists and libertarians, whom we will examine later). American philosopher Peter van Inwagen has made this incompatibility explicit by presenting what he calls "the consequence argument." It goes like this:

> If determinism is true, then our acts are the consequences of the laws of nature and events in the remote past. But it is not up to us what went on before we were born, and neither is it up to us what the laws of nature are. Therefore the consequences of these things (including our present acts) are not up to us.[13]

According to van Inwagen, events have consequences, and those consequences are determined by the laws of nature. Among those consequences are the actions we perform. But because those actions are the consequences of things over which we have no control, our actions aren't free.

The consequence argument can be spelled out more formally as follows:

1. If causal determinism is true, then every event is the consequence of past events plus the laws of nature.
2. We are powerless to change past events, laws of nature, or their consequences, which include our actions.
3. If we are powerless to change our actions—if we can't do otherwise—then we can't act freely.
4. Therefore, if causal determinism is true, we can't act freely.

Premise 1 spells out the notion of causal determinism. To say that something is causally determined is to say that it follows from a statement describing past events plus the laws of nature. Premise 2 states the obvious truth that we cannot change the past or the laws of nature. There's nothing that we can do now that will change anything that's already happened. And there's nothing we can do now that will change the laws of nature. Even if everyone in the world held hands and chanted $E = mc^3$, that would not change Einstein's famous law: $E = mc^2$. Premise 3 draws out the implications of our limitations in this regard. If everything has to happen as it does and couldn't happen any other way, then our actions aren't free. Freedom requires the ability to choose among alternative courses of action. But if causal determinism is true, there

> *Recent medical researches ... have proved in the case of many criminals, if not of all, that from the very first they have been, as it were, doomed or predestined to crime by a faulty or imperfect organization of mind and body.*
> —LUDWIG BUCHNER

incompatibilism The doctrine that causal determinism is incompatible with the view that we sometimes act freely.

Fatalism versus Causal Determinism

Are you a fatalist? If so, then you must agree with such popular fatalistic assertions as "Que sera, sera—what will be will be." Or "If your time has come, your time has come." Fatalism is the view that the future is already fixed, and there is nothing anyone can do to change it. That is, all future events will happen no matter what. Fatalism thus rules out free will.

But fatalism is not the same thing as causal determinism, the doctrine that every event has a cause. Causal determinism says that future events happen as a result of preceding events. These preceding events include things that we do, so many future events happen because of what we do. Fatalism, however, says that future events happen *regardless of what we do*.

This notion of Fate, which can be traced back to the ancients, is alive and well today. It can be soothing, implying that in the apparent chaos of the world, there is a rigid order, a pattern predestined from the beginning of time. It can offer peace of mind—a serene sense of resignation—to those, like soldiers in wartime, who must face the possibility of imminent death. A belief in Fate can also be an excuse, providing fatalists with a rationale for not struggling to overcome obstacles.

Stories about the supposed workings of Fate can leave you with an eerie feeling. See if you get a chill down the spine by reading this little tale told by its central character—Death:

> There was a merchant in Baghdad who sent his servant to market to buy provisions and in a little while the servant came back, white and trembling, and said, Master, just now when I was in the market-place I was jostled by a woman in the crowd and when I turned I saw it was Death that jostled me. She looked at me and made a threatening gesture; now, lend me your horse, and I will ride away from this city and avoid my fate. I will go to Samarra and there Death will not find me. The merchant lent him his horse, and the servant mounted it, and he dug his spurs in its flanks and as fast as the horse could gallop he went. The merchant went down to the market-place and he saw me standing in the crowd, and he came to me and said, Why did you make a threatening gesture to my servant when you saw him this morning? That was not a threatening gesture, I said, it was only a start of surprise. I was astonished to see him in Baghdad, for I had an appointment with him tonight in Samarra.[14]

Creepy feelings aside, are there any reasons for accepting fatalism? For starters, there appears to be no empirical evidence in its favor. The everyday experience of all of us suggests that it simply is not the case that all future events will happen no matter what we do. On the contrary, in countless situations it seems that what we do does affect subsequent events. No wonder then that few people—if any—can be consistent fatalists, refusing to lift a finger to help themselves because everything is already fated anyway. Imagine someone saying, "If I am fated to eat lunch today, I will eat lunch. If I am fated not to eat lunch, I won't. Therefore, there is no need for me to concern myself about lunch at all." It appears that a belief in fatalism based on human experience is a mere superstition.

There are, however, certain logical arguments that some have used to try to prove fatalism. One of them goes like this: Either you will meet your doom tomorrow or you will not. Suppose you will meet your doom tomorrow. Then it is true now that you will meet your doom tomorrow. If it is true now that you will meet your doom tomorrow, then you must meet your doom tomorrow, and there is nothing you can do about it. In other words, true statements about the future require that the future must necessarily be a certain way.

This argument, however, commits a logical fallacy. Recall that a necessary truth is one that cannot possibly be false. Certainly, it is a necessary truth that either you will meet your doom tomorrow or you will not. But it is not a necessary truth that you will meet your doom tomorrow. Nor is it a necessary truth that you will not meet your doom tomorrow. These two statements, if true, are contingent truths—statements that could turn out to be false. In this argument, it simply does not follow from the truth of either one of these statements that either one must be necessarily true. So this argument for fatalism fails. Similar ones suffer the same, well, fate.

are no alternative courses of action. We can only do what we're determined to do and can't do otherwise. In such a world, no one acts freely.

If that world is this world, then many of our individual and social practices are unjustified. The actions of others often produce in us moral feelings like respect, admiration, gratitude, disdain, resentment, and jealousy. We also often judge those actions to be right or wrong, cruel or kind, appropriate or inappropriate, and the like. If no one acts freely, however, then such moral feelings and judgments are misplaced. We don't blame a piece of iron for being attracted to a magnet, and we don't praise a magnet for attracting a piece of iron. But if hard determinism is true, we're no different from the iron and the magnet. We're no more deserving of praise or blame than they are.

To see this, suppose that you watch someone commit a horrible crime. You feel nothing but contempt, even loathing, for the culprit. You later learn, however, that he had been kidnapped, brainwashed, and hypnotized by a mad scientist who had forced him to do the deed. In this case, the criminal doesn't deserve your disapproval because he couldn't help himself. If hard determinism is true, though, we're all like the culprit. We do only what we're programmed to. Consequently we can't be held responsible for our actions.

The hard determinist's argument for believing that causal determinism rules out moral responsibility, then, goes something like this:

4. If causal determinism is true, we can't act freely.
5. If we can't act freely, we can't be held responsible for our actions.
6. Therefore, if causal determinism is true, we can't be held responsible for our actions.

The principle behind premise 5—namely, that we cannot be held responsible for behavior over which we have no control—is well established in courts of law. When defendants can show that an act was the result of an "irresistible impulse," juries often find them not guilty. If hard determinism is correct, however, all of our actions—not only certain violent ones—are the result of irresistible impulses.

Accepting hard determinism would require rejecting many of the beliefs upon which our legal, social, and political institutions are based. Isaiah Berlin explains:

> [Determinism] may, indeed, be a true doctrine. But if it is true, and if we begin to take it seriously, then, indeed, the changes in the whole of our language, our moral terminology, our attitudes towards one another, our views of history, of society, and of everything else will be too profound to be even adumbrated. The concepts of praise and blame, innocence and guilt and individual responsibility from which we started are but a small element in the structure, which would collapse or disappear. Our words—our modes of speech and thought—would be transformed in literally unimaginable ways; the notions of choice, of responsibility, of freedom, are so deeply embedded in our outlook that our new life, as creatures in a world genuinely lacking in these concepts, can, I should maintain, be conceived by us only with the greatest difficulty.[15]

If we came to believe that there are no free actions and thus that no one can be held responsible for what they do, we would have to radically restructure society in ways that are difficult to imagine. Can you imagine a society in which there is no right or wrong, no praise or blame, no guilt or innocence? What would it be like? To decide whether we should start envisioning such a society, we first need to determine whether the argument for hard determinism is a good one.

Thought Probe

A World without Responsibility

Suppose that hard determinism is true, and no one is responsible for their actions. How should we change society to reflect that fact? Fire all the lawyers? Close all the jails? Commit all criminals to rehabilitation centers? What do you think? How would you structure society in a post-responsibility world?

Science and the Nature/Nurture Debate

The argument for hard determinism rests on the assumption that causal determinism is true. What reasons are there for believing that every event is the consequence of past events plus the laws of nature? Essentially, the main reasons come down to two: (1) science shows that causal determinism is true, and (2) reflective common sense shows that causal determinism is true. Most people need very little prodding to grasp the import of reason 1. They're reminded every day that science continues to uncover the underlying causes of countless physical phenomena. Science has shown that stars, comets, engines, and cells behave according to unchanging laws of nature. Events that were once mysterious have been revealed to have identifiable causes. Physical relationships have been described with mathematical precision. Successful predictions about physical happenings have become a defining feature of science. Indeed, modern hard determinist theories were inspired by such developments in science. Holbach's own hard determinism took its cue from science, especially physics. It was none other than science, he said, that showed his determinism to be the case.

The discovery by psychologists and biologists of the predictability of human behavior provides some of the strongest support for causal determinism. As psychologist B. F. Skinner puts it, "Personal exemption from a complete determinism is revoked as a scientific analysis progresses, particularly in accounting for the behavior of the individual."[16] Skinner is convinced that the behavior of human beings is, in principle, as predictable as the behavior of clocks.

Behaviorism

Skinner's confidence in the predictability of human behavior stems from his experiments with pigeons. By reinforcing (rewarding) pigeons for exhibiting the desired behavior, Skinner was able to train his pigeons to perform many

Few informed people ... can any longer ignore the fact that many kinds of even serious wrongdoing which folklore claimed to be a result of someone's "bad choice" are actually the result of forces over which the individual has no control and often not even any awareness.

—John Cuber

The real problem is not whether machines think but whether men do.

—B. F. Skinner

remarkable tasks, such as playing Ping-Pong, playing a toy piano, and dancing. All effective learning, he thought, is the result of selective reinforcement (or "operant conditioning," as it came to be known). By rewarding appropriate behaviors and not rewarding inappropriate ones, he could get pigeons to do almost anything.

This faith in the malleability of all behavior, including human behavior, was shared by Skinner's mentor, John B. Watson. In 1925, after a number of successful conditioning experiments with animals, he boasted,

> Give me a dozen healthy infants, well-formed, and my own specified world to bring them up in, and I'll guarantee to take any one at random and train him to become any type of specialist I might select—a doctor, lawyer, artist, merchant, chief, and, yes even into a beggar-man and thief, regardless of his talents, penchants, hindrances, abilities, vocations, and race of his ancestors.[17]

Watson clearly thought that how we behaved as adults was determined by how we were brought up as children—that is, by how we were nurtured. What our innate abilities or genetic makeup might be was irrelevant.

Skinner and Watson are on the nurture side of the nature/nurture debate. This debate concerns the dominant cause of human behavior: Is the primary determinant of human behavior what's encoded in our genes (our nature)? Or are our actions primarily determined by how we were brought up (how we were nurtured)? Note that the debate is not about whether our actions are determined. Both parties agree that what we do is the result of factors beyond our control. The question is which of these factors is more important in shaping our behavior.

Skinner believes that our social and psychological problems are due to faulty conditioning. Our methods of child rearing, he claims, are far too haphazard to create the proper stimulus-response connections. If only we could provide the right sorts of rewards and punishments to children as they are growing up, we could eliminate much of the crime and mental illness that plagues society. Skinner presents his vision of a properly organized society in his novel *Walden Two*.

If we ever do end up acting just like rats or Pavlov's dogs, it will be largely because behaviorism has conditioned us to do so.

—RICHARD ROSEN

In Skinner's ideal society, there would be no jails. Our current penal system is based on the assumption that people are responsible for their behavior and deserve to be punished if they commit a crime. According to Skinner, no one is responsible for what they do. Everyone simply does what they've been programmed to do by their environment. As he puts it, "A scientific analysis shifts the credit as well as the blame to the environment, and traditional practices can then no longer be justified."[18] People who commit crimes have simply been programmed improperly. So Skinner would turn all of our jails into behavioral reconditioning centers where criminals are reprogrammed into law-abiding citizens. Not everyone agrees that this would be a utopia, however. Many find the dystopian vision presented in the Anthony Burgess novel (and Stanley Kubrick movie) *A Clockwork Orange* to be a more accurate portrayal of the Skinnerian program.

Contrary to what Watson would have us believe, behavioral conditioning techniques can't be used to produce any possible behavior. Skinner found, for

example, that pigeons could be conditioned to peck a key for food, but not to flap their wings. Rats could be conditioned to press a bar, but cats could not. Rats given sour blue water followed by a sickness-producing drug avoided sour water, but quail, similarly conditioned, avoided blue water. Obviously, the way creatures behave is influenced by their nature as well as by how they are nurtured.[19]

Some of the most compelling evidence for the effect of biology on behavior comes from twin studies. Thomas J. Bouchard, at the University of Minnesota, has studied more than a hundred sets of identical twins that were given up for adoption and raised by different families. He found that their IQs were closer than those of fraternal twins raised in the same family and that they were also remarkably similar in personality, temperament, occupational interests, leisure time interests, and social attitudes.[20] It appears that our genetic makeup affects not only our physical characteristics, like height, weight, and hair color, but our mental characteristics as well. It does not totally determine those characteristics, but it is obviously an important factor.

Free Will: A Noble Lie?

Disbelief in free will is widespread among scientists, and it is starting to filter down to the general public. Attempts to excuse behavior on the grounds that my brain, my genes, or my upbringing "did it" are becoming more prevalent in courts of law. But what if it were generally accepted that there is no free will? Would we behave differently? Evidence suggests we would. Kathleen Vohs and Jonathan Schooler conducted an experiment in which some of the participants read a text that encouraged belief in determinism by arguing that all human behavior is the product of nature and nurture (genetics and environment). They were then asked to engage in various cognitive tasks. Those who read the determinism text were much more likely to cheat than those who didn't.[21] To see whether these results were confined to the laboratory, Tyler Stillman and his colleagues surveyed day laborers on their belief in free will and then examined their performance. They found that those with a stronger belief in free will were rated more highly by their superiors. In fact, a belief in free will turned out to be a better predictor of performance than conscientiousness, locus of control, and Protestant work ethic.[22] Roy Baumeister and his colleagues found that disbelief in free will made people less likely to help others and more likely to behave aggressively toward them.[23] Don't let anyone tell you that philosophical beliefs don't have an effect on our behavior!

It seems that a widescale acceptance of a belief in determinism would have a negative effect on society: more crime and aggression, less helpfulness and caring. What should we do if science shows that we don't have free will? Some say we should lie about it. Saul Smilansky, for example, claims that "we cannot afford for people to internalize the truth."[24] Determinism, if true, is too dangerous a doctrine to become widely believed. So those in the know must keep up the illusion of free will, even if we don't have it.

Thought Probe

A Noble Lie

Plato, in *The Republic*, first proposed what has come to be known as a "noble lie"—an untruth told by an elite to promote social harmony. If scientists discover that there is no free will, should they lie about it and cover it up for the good of society? Why or why not?

Thought Probe

Behavior Modification

One of the biggest problems facing the criminal justice system is the recidivism rate: the rate at which those who have spent time in jail commit a crime after they have been released. For robbers, burglars, and vehicle thieves the recidivism rate is over 70%. The cost of the crimes perpetrated by these repeat offenders is billions of dollars every year. Suppose that by instituting a program of behavior modification in our prisons, we could cut the recidivism rate in half and save society billions of dollars. Should we do it? Why or why not?

Sociobiology

Character, I am sure, lies in the genes.
—Taylor Caldwell

Harvard biologist E. O. Wilson likens the relationship between our genetic makeup (our nature) and our upbringing (how we are nurtured) to that of a photographic negative and developing fluid. Just as a negative can be developed well or poorly, so can our innate propensities. Even musically or mathematically gifted people need to practice if they are to reach their full potential. But the limits of what we can accomplish—the basic outlines of our personality, our attitudes, and even our character—are written in our genes. So he is on the nature side of the nature/nurture debate.

Scientists have found the gene for shyness. They would have found it years ago, but it was hiding behind a couple of other genes.
—Jonathan Katz

Wilson is the founder of a discipline called sociobiology, which studies the biological basis of social behavior. The basic premise behind sociobiology is that just as certain physical characteristics can give something an edge in the struggle for survival, so can certain psychological characteristics. For example, our DNA contains genes that produce an opposable thumb because those with that appendage are more likely to live long enough to reproduce than those without it. Similarly, say the sociobiologists, our DNA contains genes that produce a fear of falling because those with that fear are more likely to live long enough to reproduce than those without it. Thus sociobiologists believe that our psychology as well as our physiology is written in our genes.

In 1982, Wilson made the following prediction:

> It's extremely likely that within ten years, twenty at the outside, a number of genes will have been identified whose effects can be traced through the actual production of particular chemicals in the brain and thence to measurable properties of temperament, mood, and even cognitive ability.[25]

They are in you and me; they created us, body and mind; and their preservation is the ultimate rationale for our existence. They have come a long way, those replicators. Now they go by the name of genes, and we are their survival machines.
—Richard Dawkins

Wilson's prediction has come true. Perhaps the most dramatic recent finding comes from researchers at the University of North Carolina at Chapel Hill, who discovered three genes that predispose teens to serious and violent delinquency.[26] Not everybody with those genes turns into a juvenile delinquent. But given the proper environment, the chances are high that carriers of those genes will engage in criminal behavior.

One way to lessen the incidence of the criminal behavior associated with these genes would be to lessen the incidence of those genes. There are a number of ways this could be done. We could require that everybody be genetically screened and then sterilize carriers of those genes so they couldn't

pass them on to future generations. Or we could require that the fetuses of pregnant carriers be genetically screened and then abort those carrying the offending genes. Or we could require carriers who want to have children to use in vitro fertilization and preimplantation genetic diagnosis (PGD) to identify and implant only those fertilized eggs that do not carry the genes. Sound fantastic? Don't think it could happen here? All of those technologies exist now, and the United States has adopted similar laws in the past.

Beginning in 1907 and extending through the 1950s, more than thirty states passed laws mandating the sterilization of certain mentally retarded or mentally ill individuals. Known as eugenics laws, they resulted in the involuntary sterilization of over 60,000 Americans.[27] Eugenics seeks to improve the genetic makeup of the human race by either promoting "good" genes or eliminating "bad" ones. The first form goes by the name positive eugenics and involves various types of selective breeding. Sperm banks are one such type. Customers at a sperm bank are allowed to choose from a menu of different

Is Determinism Self-Refuting?

Some have objected to determinism on the ground that it is self-refuting. John Hick, for example, claims,

> . . . our concept of rational belief is linked with our concept of intellectual freedom. Accordingly a world in which there was (or is) no intellectual freedom would be (or is) a world in which there is no rational belief. Therefore the belief that the world is totally determined cannot rationally claim to be a rational belief. Hence an argument for total determinism is necessarily self-refuting, or logically suicidal.[28]

Hick's argument here goes something like this:

1. If determinism is true, no one believes anything because they have a good reason for believing it. (Instead, they believe it because their neurons have been caused to fire in a certain way.)
2. If no one believes anything because they have a good reason for believing it, no beliefs are rational.
3. Therefore, if determinism is true, no beliefs are rational, including the belief that determinism is true.

Patricia Smith Churchland does not find this sort of argument convincing. She writes,

> An analogy might serve to dramatize the weakness of the putatively self-defeating argument. Until quite recently it was believed that the difference between living things and nonliving things was that the former was imbued with vital spirit, the latter not. In the event, the theory was challenged and refuted, but consider the following fanciful defense of vitalism, constructed to parallel the aforementioned defense of free will:
>
> > The anti-vitalist says that there is no such thing as vital spirit. This claim is self-refuting; the speaker can expect to be taken seriously only if his claim cannot. For if the claim is true, then the speaker does not have vital spirit, and must be dead. But since dead men tell no tales, they do not tell anti-vitalist ones either. One cannot reason with dead men.
>
> In this example, it is clear that the attempt to show that anti-vitalism was self-refuting was simply a *non sequitur*. The argument is a non sequitur because life may be explained by something other than vital spirit, for example by something physical, though the explanation may be much more intricate and complicated than anything envisaged at the time.[29]

Thought Probe

Defending Determinism

Who's right, Hick or Churchland? What premise(s) in Hick's argument would Churchland reject? Why? Is she justified in rejecting them? Why or why not?

donors. Most choose sperm from donors whose physical characteristics they find desirable.

The second form of eugenics, known as negative eugenics, seeks to prevent the spread of certain deleterious genes. The United States eugenics laws were a type of negative eugenics, as were the Nazi death camps. A more benign form, which is practiced at many in vitro fertilization centers around the world, is known as "preimplantation genetic diagnosis". It involves analyzing a fertilized egg for the presence of certain genes before it is implanted in the uterus, in the hope of avoiding certain genetic defects. The movie *Gattaca* portrays a society in which PGD has become the reproductive technology of choice. In America, it currently adds about $3,000 to the approximately $8,000 cost of in vitro fertilization.

Once we have a better understanding of what genes code for what traits, we should be able to design our babies to our own specifications. Not only will it be possible to specify their physical characteristics, but it will be possible to specify their mental characteristics as well. Wilson anticipated this over twenty-five years ago. He discusses some of the possibilities:

> If we could change our basic nature—the strength of the sex bond, the pleasure you get from children—through genetic intervention, then with more knowledge of the genetic basis of the assembly of the mind, you could come up with human beings who respond to the world in very different ways—some taking deep pleasure in living in a city, for example, others who are able to live in rural communes.[30]

Wilson sees genetic engineering as the surest way to improve society. Skinner prefers behavioral engineering. Both assume, however, that we can do only what we're programmed to do. Wilson thinks our dominant programming comes from our genes. Skinner thinks it comes from our environment. But we can't change our parents and we can't change the past. So it seems that nothing we do is up to us. In such a world, there seems to be little room for free will.

Thought Probe

Genetic Engineering

Suppose that Wilson is right that our psychology is shaped by our genes, and suppose that we develop the technology to alter our genetic makeup. Should we do it? Why or why not? Could a hard determinist object to it? If so, on what grounds? If not, why not?

Despite what the behaviorists and sociobiologists would have us believe, science does not prove that causal determinism is true. In fact, modern physics now explicitly rejects that belief. Physicist Paul Davies explains:

> On the scale of atoms and molecules, the usual rules of cause and effect are suspended. . . . A typical quantum process is the decay of a radioactive nucleus. If you ask why a given nucleus decayed at one moment rather than some other, there is no answer. The event "just happened" at that moment, that's all. You cannot

predict these occurrences. All you can do is give the probability.... This uncertainty is not simply a result of our ignorance of all the little forces that try to make the nucleus decay; it is inherent in nature itself, a basic part of quantum reality.[31]

Physicists believe that at the atomic level, there are events, like the decay of a radioactive atom, that are uncaused. Our inability to predict the occurrence of these events is not simply due to the limitations of our measuring apparatus. It's not just that we don't know enough about the inner workings of atoms to predict what they will do. It's that some events don't have a cause.

What led physicists to this conclusion is the realization that deterministic theories fail to account for certain experimental results. Einstein never liked quantum indeterminacy. His dislike is captured in his famous quip, "God does not play dice with the universe." He thought that there must be certain "hidden variables" that, if known, would allow us to accurately predict the occurrence of every event, even those at the atomic level.

Einstein's speculation was interesting, but many physicists considered it to be unscientific because there was no way to test it. Then, in 1965, physicist John Bell showed that a hidden variables theory like Einstein's makes predictions that are at odds with quantum mechanics. The equipment needed to test these predictions was not available until 1980. When the experiments were conducted, they always came out in favor of quantum mechanics. As a result, hidden variables theory is dead.[32] Our inability to predict the occurrence of atomic events is not due to our ignorance but due to the basic nature of the universe itself. Parodying Einstein's quote, physicist Stephen Hawking summed up current thinking this way: "God not only plays dice, he throws them in the corner where no one can see them."

A hard determinist might try to defend causal determinism by claiming that, although it doesn't hold on the microlevel of subatomic particles, it does hold on the macrolevel of everyday objects, which is the only level that matters for us. What is true of the parts is not necessarily true of the whole. To claim otherwise is to commit the fallacy of composition. So even if the behavior of subatomic particles is indeterminate, it doesn't follow that our behavior is indeterminate.

Such a defense of causal determinism misses the mark, however, for uncaused events on the microlevel can have profound effects on the macro level. Science writer Martin Gardner demonstrates this with the aid of a Geiger counter (a device that indicates the presence of a radioactive particle by emitting a click).

> *If we look at the way the universe behaves, quantum mechanics gives us fundamental, unavoidable indeterminacy, so that alternative histories of the universe can be assigned probability.*
> —MURRAY GELL-MANN

> *It is impossible to trap modern physics into predicting anything with perfect determinism because it deals with probabilities from the outset.*
> —ARTHUR EDDINGTON

Thought Experiment

Gardner's Random Bombardier

Imagine a plane flying at supersonic speed over a continent. It carries a hydrogen bomb that is dropped by a mechanism triggered by the click of a Geiger counter. If quantum mechanics is correct, the timing of this click is purely random. Hence, absolute chance determines where the bomb falls, and thereby decides between many alternate, equally possible courses of history.[33]

By detecting the presence of subatomic particles, Geiger counters effectively "couple" the microworld to the macroworld. Thus any indeterminism that exists in the microworld can be reflected in the macroworld. In Gardner's scenario, the click of a Geiger counter triggers the dropping of a hydrogen bomb. Because the clicking of the Geiger counter is indeterminate, the dropping of the hydrogen bomb is also indeterminate.

Far from its being limited to the microworld, philosopher John Dupré argues that "if there is causal indeterminism anywhere, it will surely be (almost) everywhere."[34] And, indeed, biologists have found many cases where quantum effects on the smallest scales can affect living things at the largest scales. For example, our eyes can respond to a single particle of light (a photon)[35] and our noses can smell a single molecule.[36] Plants use quantum entanglement to perform photosynthesis,[37] and birds see magnetic fields to navigate during migration.[38] The firing of nerve cells also appears to be affected by quantum mechanical effects in their ion channels.[39] So quantum indeterminacy is not restricted to the microworld. Its effects can be felt in the macroworld as well. In any event, we must conclude that science hasn't proved that causal determinism is true. Not only are there no well-confirmed scientific theories in genetics, neurophysiology, or psychology that prove that *all* human actions are caused by prior events, there is reason to believe that indeterminacy is not confined to the microworld.

Common Sense and Causal Determinism

We all believe or are inclined to believe that causal determinism is true. This pervasive belief is a matter of common sense. But, as we said, the fact that everyone has this belief doesn't make it true. Even commonsense beliefs can be false. Some pervasive beliefs, however, are more than just a matter of common sense. They are a matter of *reflective* common sense. A belief based on reflective common sense is one that we still believe even after we reflect on it and assess it carefully. Part of this assessment is trying to think of counterexamples that would show the belief to be false. If we carefully evaluate the belief and find no counterexamples to it, we're justified in believing it. It's a reasonable belief.

It has been argued that causal determinism is such a belief, a matter of reflective common sense. After all, how could we make sense of the world if we didn't believe that everything has a cause? It would seem that the idea that everything has a cause is a presupposition crucial to human understanding. Immanuel Kant held this view. He claimed that we could not understand the world unless we assumed that every event has a cause.

Even if we can make sense of the world only on the assumption that every event has a cause, it doesn't follow that every event has a cause, because the world may be incomprehensible. What we need to understand the world may not be present in it. What's more, modern physics has shown that we can understand the world without assuming that every event has a cause. Quantum mechanics (the branch of physics that deals with subatomic particles) gives us an unprecedented understanding of the physical world, and yet it does not assume that every event has a cause. So

causal determinism is not vindicated by either science or reflective common sense.

> ### Thought Probe
>
> ### Living with Hard Determinism
>
> Suppose that the hard determinists are right and there is no free will—no actions are right or wrong, no people are good or bad, and no one deserves praise or blame. How would we have to change society to accommodate that fact? What social institutions would we have to abolish? What social institutions would we have to create? Could it be done? Why or why not?

Indeterminism

The view that some events are not the consequence of past events plus the laws of nature is known as **causal indeterminism**. In this view, the future is not fixed. It could unfold in a number of different ways, all of which are consistent with what has gone before. The ancient Greek philosopher Epicurus (341–270 B.C.), another atomist, realized that if the motion of atoms was completely determinate, there would be no free will. To explain how free will is possible, he speculated that atoms randomly "swerve" as they move through space. This random movement of subatomic particles has since been confirmed by modern physics. Physicist Max Born illustrates it with the following tale: "If Gessler had ordered William Tell to shoot a hydrogen atom off his son's head by means of an alpha particle and had given him the best laboratory instruments in the world instead of a cross-bow, Tell's skill would have availed him nothing. Hit or miss would have been a matter of chance."[40] The physicist Arthur Eddington believes that this indeterminism vindicates our belief in free will. He writes, "The revolution of theory which has expelled determinism from present day physics has therefore the important consequence that it is no longer necessary to suppose that human actions are completely predetermined."[41] If our actions are not predetermined, however, there is room for free will.

William James was as concerned about the ethical implications of determinism as was Epicurus. James realized that in a world governed by necessity, there could be no morality. So he argued that some things happen by chance.

> Indeterminism . . . says that the parts have a certain amount of loose play on one another, so that the laying down of one of them does not necessarily determine what the others shall be. It admits that possibilities may be in excess of actualities, and that things not yet revealed to our knowledge may really in themselves be ambiguous. Of two alternative futures which we conceive, both may now be really possible; and the one become impossible only at the very moment when the other excludes it by becoming real. Indeterminism thus denies the world

Many shining actions owe their success to chance, though the general or statesman runs away with the applause.
—Henry Home

causal indeterminism The doctrine that some events are not the consequence of past events plus the laws of nature.

William James: Physiologist, Psychologist, Philosopher

One of the more interesting characters in the history of philosophy is William James (1842–1910). He was one of the first important philosophers to come out of America, yet his expertise and interests spread far beyond philosophy.

He was born in New York City, the son of a theologian and the elder brother of the famous novelist Henry James. Little wonder then that he spent so much time studying the psychology of religion and wrote in a lively, clear style that seems more suitable to a novel than a philosophical treatise. James first studied to become an artist, but then entered Harvard University as a medical student. He later lectured there in physiology and anatomy, then philosophy, then psychology.

James seemed to be driven by his own psychological needs to address certain vexing philosophical issues. At one point in his career, he became obsessed with the problem of free will and determinism. He fell into a deep depression, contemplated suicide, and did not recover until he had worked out an answer that made sense to him. (His view is that humans do have free will despite the universe's lockstep determinism.)

Likewise he was intensely interested in both the psychological and philosophical implications of religious belief. He wanted to find a place for religion in his worldview and did so by claiming that people may legitimately accept religious claims if they "work," even when there is no evidence to support those claims. This view of claims that work or don't work is part of James's pragmatism, the notion that the meaning or truth of a claim is the same thing as the practical effects of accepting it (that is, that it works).

to be one unbending unit of fact. . . . Do not all the motives that assail us, all the futures that offer themselves to our choice, spring equally from the soil of the past; and would not either one of them, whether realized through chance or through necessity, the moment it was realized, seem to us to fit that past, and in the completest and most continuous manner to interdigitate with the phenomena already there?[42]

If the world is not completely determined, each of us has many possible futures. Which of those futures becomes actual will depend on the choices we make. But a free choice—a choice made by chance—would fit just as well with what has gone before as would a determined choice.

James's view that free actions are uncaused is known as **indeterminism.** Like hard determinism, indeterminism maintains that causal determinism is incompatible with free will. Thus both indeterminists and hard determinists are incompatibilists. But unlike hard determinism, indeterminism rejects causal determinism. It holds, on the contrary, that some actions are uncaused. Because our best scientific theories imply that some events are uncaused, indeterminism is a more conservative theory than hard determinism, for it fits better with our existing knowledge. But even though indeterminism does less damage to our belief system than hard determinism, it has problems of its own because it can't account for personal responsibility. You are responsible for an action only if you did it. But if an action is uncaused, you didn't do it. So it's hard to see how an indeterminist can hold people responsible for their actions.

Richard Taylor illustrates this problem by means of the following thought experiment.

WILLIAM JAMES
1842–1910

indeterminism The doctrine that free actions are uncaused.

200 Chapter 3 • Free Will and Determinism

Thought Experiment

Taylor's Unpredictable Arm

Suppose that my right arm is free, according to this conception; that is, that its motions are uncaused. It moves this way and that from time to time, but nothing causes these motions. Sometimes it moves forth vigorously, sometimes up, sometimes down, sometimes it just drifts vaguely about—these motions all being wholly free and uncaused. Manifestly, I have nothing to do with them at all; they just happen, and neither I nor anyone can ever tell what this arm will be doing next. It might seize a club and lay it on the head of the nearest bystander, no less to my astonishment than his. There will never be any point in asking why these motions occur, or in seeking any explanation of them, for under the conditions assumed there is no explanation. They just happen, from no causes at all.[43]

Taylor imagines that the motions of his arm are totally random. Perhaps his arm is connected to a piece of radioactive material in such a way that whenever the radioactive material decays, his arm moves. In any event, if the movements of Taylor's arm are totally random, Taylor can't be held responsible for them.

Actions, as opposed to reflexes, are intentional. Your leg's going up after the doctor hits your knee with a mallet is a reflex—not an action—because you didn't intend it to happen. Similarly, Taylor's arm movements are not actions because he did not intend them to happen. But if they are not actions, they are not free actions either. So indeterminism does not provide a satisfactory account of free action.

We normally assume that human behavior can be explained by appeal to a person's motives, circumstances, or both. If indeterminism were true, some actions (namely, free actions) would be inexplicable because they would happen for no reason at all. Indeterminism, then, makes free actions incomprehensible. Instead of explaining how free actions are possible, it leaves us with as big a mystery as the one we started with.

Summary

Causal determinism, the view that every event is the consequence of past events plus the laws of nature, has led some to adopt hard determinism, the doctrine that there are no free actions. Hard determinists believe that causal determinism is incompatible with both freedom and moral responsibility. Modern physics, however, supports causal indeterminism, the view that some events are not the consequence of past events plus the laws of nature. So the future does not appear to be determined.

Some have thought that causal indeterminism makes way for freedom. They accept indeterminism, the doctrine that free actions are uncaused. William James, for example, argues that free will is possible only if human choices are not part of some causal chain but are the results of chance. Because

of this element of chance, there exist multiple possibilities for humans, as opposed to the one and only locked-in future of determinism. This view is attractive, but it is seriously flawed—for if an action is the result of uncaused, chance events, it is random. And a random action cannot be a free action because it is not produced by an act of will.

Study Questions

1. What is causal determinism?
2. What is hard determinism?
3. What is the argument for hard determinism?
4. Does science show that causal determinism is true?
5. Does reflective common sense show that causal determinism is true?
6. What is causal indeterminism?
7. What is indeterminism?
8. What is Taylor's unpredictable arm thought experiment? How does it attempt to undermine indeterminism?

Discussion Questions

1. Imagine that hard determinism is true. Would there be any justification for punishment? Why or why not?
2. Suppose that after much thought you fully accept hard determinism. How might your reaction to the following situations differ now that you're a hard determinist?
 a. O. J. Simpson is tried for another murder, you're convinced that he committed the crime, and again he is found not guilty.
 b. Your best friend spreads a malicious and scandalous rumor about you.
 c. You murder your mother.
 d. Your sister is raped by a friend of yours.
3. Let's say that someone who knows you well believes that he can predict everything you do and say during a twenty-four-hour period. Without telling you what he's up to, he writes down his prediction in great detail. And as it turns out, his predictions are correct. Does the fact that someone can accurately predict the behavior of another show that the behavior was determined—that it was fully the result of causes?
4. William Newcomb, a theoretical physicist, proposed the following thought experiment to test beliefs about foreknowledge and causation.

Thought Experiment

Newcomb's Paradox

Suppose there is a Being that, as far as you know, has always correctly predicted your choices in the past. Now suppose this Being makes you the following offer: The Being shows you two boxes and explains that Box 1 contains $1,000, while Box 2 contains either $1 million or nothing. You can make one of two choices: (1) take what is in both boxes, or (2) take only what is in the second box. The Being has already placed the money in the boxes and he did so on the basis of his prediction. He tells you that if he predicted that you will choose the first alternative and take what is in both boxes, then he left Box 2 empty. If he predicted that you will choose the second alternative and take only what is in Box 2, the Being put $1 million in it. If you were faced with this choice, which alternative would you choose? Would you choose to take what is in both boxes or only what is in the second box? Why?

Internet Inquiries

1. It is widely believed that God's foreknowledge (knowledge of the future) precludes free will. Enter "omniscience" and "free will" into an Internet search engine to explore this issue. What is the strongest argument for the incompatibility of omniscience and free will? What is the strongest argument against it? What is called open theism or open theology attempts to provide a solution to this dilemma. Is it viable? Why or why not?

2. Most parents use PGD to avoid genetic defects. Some deaf parents, however, have used it to ensure that their children will be deaf. Enter "PGD" and "deafness" into an Internet search engine to explore this issue. Is this a legitimate use of PGD?

3. Genetic engineering can be used to give members of one species traits from another. For example, biologists have spliced the genes from fireflies into tobacco plants, creating tobacco plants that glow in the dark. Enter "genetic engineering" and "chimera" into an Internet search engine to explore this issue. Should we give humans traits from other species?

Section 3.2

The Mother of Invention
Freedom as Necessity

> *We have to believe in free will.*
> *We have no choice.*
> —Isaac B. Singer

Believers in free will seem to be impaled on the horns of a dilemma: If causal determinism is true—if every event is the consequence of past events plus the laws of nature—then we can't act freely because everything we do is caused by forces beyond our control. But if causal indeterminism is true—if some of our behaviors are uncaused—then again we can't act freely because those behaviors aren't up to us. But either causal determinism or causal indeterminism is true. So the conclusion that we can't act freely seems unavoidable.

Some try to escape this conclusion, however, by arguing that causal determinism is compatible with free will. In their view, we can act freely even if every event is the consequence of past events plus the laws of nature. William James dubbed this view **soft determinism** because it "abhors harsh words, and repudiates fatality, necessity, and even predetermination and says that its real name is freedom."[44] The view that determined actions can nevertheless be free is more commonly referred to as **compatibilism** because, on this view, even if determinism is true, we can still have free will. The one doesn't exclude the other.

Compatibilism is an appealing solution to the problem of free will because it does not require giving up either the belief in causal determinism or the belief in free will. Compatibilists think they can have their cake and eat it too. Even if science succeeds in showing that all of our behavior is determined, we need not give up the belief that we can be held responsible for what we do. Determined acts can be free acts.

soft determinism (compatibilism) The doctrine that determined actions can nevertheless be free.

Incompatibilists and traditional compatibilists agree that acting freely requires the ability to do otherwise. If only one course of action is open to you—if you have no choice but to perform an action—you can't perform it freely. Freedom requires choice, and choice requires alternatives. As British philosopher A. J. Ayer put it,

... it is only when it is believed that I could have acted otherwise that I am held to be morally responsible for what I have done. For a man is not thought to be morally responsible for an action that it was not in his power to avoid.[45]

The condition for moral responsibility that Ayer is articulating here has come to be known as the **principle of alternative possibilities:** one can be held responsible for doing something only if one could have done otherwise. This condition can be represented graphically by a "garden of forking paths":[46]

The different paths represent the different courses of action that you can take at a particular point in time. As long as there are a number of courses of action open to you, you can be held responsible for taking one of them. But if it's not in your power to decide which path you'll take—if you're forced to choose one particular path—you shouldn't be held responsible for taking it.

John Locke offers the following thought experiment in support of the principle of alternative possibilities.

Destiny is not a matter of chance, it is a matter of choice; it is not a thing to be waited for, it is a thing to be achieved.

—WILLIAM JENNINGS BRYAN

Thought Experiment

Locke's Trapped Conversationalist

Suppose a man is carried, while fast asleep, into a room, where there is a person he longs to see and speak with; and suppose he is locked in the room, beyond his power to get out: he awakes, and is glad to find himself in so desirable company, which he stays willingly in, i.e. prefers his stay to going away. I ask, is not this stay voluntary? I think, nobody will doubt it: and yet being locked fast in, it is evident that he is not at liberty not to stay; he does not have the freedom to leave. So liberty is not an idea belonging to volition, or preferring; but to the person having the power of doing, or forbearing to do, according as the mind shall choose or direct.[47]

Locke's trapped conversationalist is kidnapped while asleep and locked in a room with someone he longs to talk to. When he awakes, he has no desire to leave because he enjoys the company. His staying in the room, then, is a voluntary action because it's what he wants to do. But it's not a free action because he couldn't do otherwise; he couldn't leave the room even if he wanted to. Because he is not free to leave, his staying in the room is not a free action. So having the ability to do otherwise is a necessary condition of acting freely.

principle of alternative possibilities One can be held responsible for doing something only if one could have done otherwise.

The Mother of Invention

Thomas Hobbes: The Great Materialist

Like many great philosophers Thomas Hobbes (1588–1679) was a master of several fields of learning. He was a mathematician, a classical scholar, a poet, and an accomplished linguist. He translated Thucydides and Homer's *Iliad* and *Odyssey* as well as several Latin texts on law, logic, optics, religion, and politics.

Hobbes was born in England, raised during the Elizabethan period, and educated at Oxford. He liked to point out that he was born prematurely because his mother heard that the Spanish Armada was coming. "Fear and I," he said, "were born twins."

His interests and his connections were various and far-flung. He visited Galileo in Italy, moved in the same intellectual circles that Descartes did in France, was a secretary to Francis Bacon, befriended the mathematician Gassendi, and tutored Charles II, the future king of England.

As a philosopher, Hobbes advocated several ideas that were so heretical and controversial that he was often in danger of persecution from the authorities. Among these are two that are controversial to this day: total materialism and political absolutism. Materialism is the view that everything in the world is material or physical. Hobbes—the first modern materialist—declared that all existing things are simply matter in motion. As he puts it, "The universe, that is the whole mass of things that are, is corporeal, that is to say body." Even minds are the result of material stuff moving about in certain ways. The world is a machine, and humans are machines within the machine.

In Hobbes's masterpiece, *Leviathan*, he argues that the natural state of humanity is chaos and cruelty, force and fraud. He says that the only way to escape from this hell and to maintain order, liberty, and justice is to turn over political power to an absolutist ruler (one individual or several). This ruler must impose law on the people, punish wrongdoers, and maintain order at all costs. In this system, no ordinary individual has an absolute right to anything. This is the price the people must pay to hold back the evils of humanity's natural state.

Traditional Compatibilism

THOMAS HOBBES
1588–1679

Traditional compatibilists accept the principle of alternative possibilities and the principle of causal determinism. They believe that even if everything you do is determined by past events plus the laws of nature, you still could have done otherwise. But how can that be? How could you have done otherwise if everything you do is determined by what has gone before? Traditional compatibilists answer this question by offering a hypothetical analysis of the phrase "could have done otherwise." According to them, to say that you could have done otherwise is to say that *if* you had chosen otherwise, *then* you would have done otherwise. In their view, you couldn't actually have chosen otherwise because all of your choices are determined by forces beyond your control. Nevertheless, if your choosing differently would have caused you to act differently, your action is free.

The first person to articulate a compatibilist position was Thomas Hobbes (1588–1679). He rejected as unintelligible the indeterminist notion that free actions are uncaused. "Nothing," he says, "taketh a beginning from itself."[48] Free actions, like all other events, must have a cause. Specifically, they must be caused by the will. But being caused by the will is not enough to make an action free, because if only one course of action is open to you—if you couldn't have done otherwise—your action isn't free.

Hobbes, then, endorses the principle of alternative possibilities. He articulates it this way:

> . . . he is free to do a thing, that may do it if he have the will to do it, and may forbear if he have the will to forbear.[49]

In other words, an action of yours is free as long as your willing it to be done made it happen, and if you had not willed it to be done, it would not have happened. According to Hobbes's **traditional compatibilism**, then, two conditions must be met for a person's action to be free: (1) the action must be caused by her will, and (2) it must not be externally constrained. If the action is not caused by her will—if she didn't bring it about—then she didn't perform it. And if it's externally constrained—if there is no other action she could perform in those circumstances—then she isn't free to perform it.

The basic insight behind compatibilist accounts of free will is that to act freely is to do what you want to do. If you are forced to do something against your will, your action isn't free and you shouldn't be held responsible for it. Consider, for example, a bank teller who has a gun pointed at his head. If he's a loyal employee, he doesn't want to give the robber the money. If he does, we don't blame him because he was forced to do it against his will. Compatibilists, then, take freedom to consist in the absence of external compulsion or coercion. This type of freedom is often referred to as "negative freedom" or "freedom from" because it takes freedom to consist in the absence of certain impediments to action.

Compatibilists readily admit that your will is the product of nature and nurture. What you want to do is entirely determined by what's encoded in your genes (your nature) and what sorts of experiences you've had (how you were nurtured). In spite of all that, they claim that you can act freely as long as your actions are caused by your mental states. Walter Stace explains:

> What, then, is the difference between acts which are freely done and those which are not? What is the characteristic which is present to all [free acts like "Gandhi fasting because he wanted to free India"] and absent from all [unfree acts like "The man fasting in the desert because there was no food"]? Is it not obvious that, although both sets of actions have causes, the causes of [free acts] are of a different kind from the causes of [unfree acts]? The free acts are all caused by desires, or motives, or by some sort of internal psychological states of the agent's mind. The unfree acts, on the other hand, are all caused by physical forces or physical conditions, outside the agent. Police arrest means physical force exerted from the outside; the absence of food in the desert is a physical condition of the outside world. We may therefore frame the following rough definitions. *Acts freely done are those whose immediate causes are psychological states in the agent. Acts not freely done are those whose immediate causes are states of affairs external to the agent.*[50]

The difference between free acts and unfree acts, says Stace, lies in their causes. Those acts that are directly caused by the internal psychological states of the agent are free. Those that are directly caused by something external to the agent, like a gun pointed at his head, are not free. We can be held responsible only for the acts we perform freely.

Chance is a word devoid of sense. Nothing can exist without a cause.
—VOLTAIRE

Freedom in general may be defined as the absence of obstacles to the realization of desires.
—BERTRAND RUSSELL

traditional compatibilism The doctrine that free actions are (1) caused by one's will and (2) not externally constrained.

Punishment

Let the punishment match the offense.
—Cicero

Unlike incompatibilists, who believe that accepting determinism requires rejecting our ordinary practices of praising and blaming or rewarding and punishing, compatibilists believe that, properly understood, determinism poses no such threat to those practices. We can continue to praise and blame, reward and punish as long as we are clear about why we do it. Many see punishment as payback—a form of retribution meant to balance the scales of justice. If someone harms another, they must suffer an equivalent harm themselves. This view of punishment is reflected in the saying "an eye for an eye."

Compatibilists don't see punishment that way. For them, the only legitimate purposes of punishment are rehabilitation and deterrence. We can justifiably lock someone up to rehabilitate him—to make him a better person—or to deter others from committing the same sort of crime. Incarceration for the purpose of retribution, however, is unjustified. The actions a criminal performs are dictated by his genes and his upbringing—nature and nurture. Since he had no control over who his parents were or how he was brought up, we shouldn't blame him for what he has done.

Moritz Schlick, a logical positivist, provides a classic account of the compatibilist view of punishment:

> What is punishment, actually? The view still often expressed, that it is a natural retaliation for past wrong, ought no longer to be defended in cultivated society; for the opinion that an increase in sorrow can be "made good again" by further sorrow is altogether barbarous. Certainly the origin of punishment may lie in an impulse of retaliation or vengeance; but what is such an impulse except the instinctive desire to destroy the cause of the deed to be avenged, by the destruction of or injury to the malefactor? Punishment is concerned only with the institution of causes, of motives of conduct, and this alone is its meaning. Punishment is an educative measure, and as such, is a means to the formation of motives, which are in part to prevent the wrongdoer from repeating the act (reformation) and in part to prevent others from committing a similar act (intimidation). Analogously, in the case of reward we are concerned with an incentive.[51]

From a compatibilist point of view, retribution is not a legitimate reason for punishment. Retributive punishment makes sense only if it's deserved. But by the compatibilist's lights, no one deserves to be punished because nothing people do is up to them. All of their actions are caused by forces beyond their control. (Compatibilists, remember, are causal determinists.) So compatibilists don't believe that we should punish people to get even or to rectify past injustices because you can't blame them for what they have done.

Nevertheless, there is a place for punishment in the compatibilist's world. Punishment can serve as education. It can teach criminals the error of their ways and thus help to reform or rehabilitate them. It can also serve as a deterrent to others by teaching them what happens if they break the law. The effectiveness of compatibilist punishment, then, is determined not by whether it balances the scales of justice but by whether it makes the world a better place. An admirable enough goal, but not one that meshes well with our ordinary conception of punishment.

Prepunishment

Just how different a compatibilist conception of morality is from our ordinary one can be seen in its endorsement of prepunishment. Ordinarily we believe that people shouldn't be locked up before they commit a crime. That just wouldn't be fair. How can you punish somebody for something they didn't do? Yet as Saul Smilansky has recently pointed out, because compatibilists believe in causal determinism, they have no grounds for not locking someone up whom they have good reason to believe is going to commit a crime. As he puts it: "Given determinism and complete predictability, compatibilism seems to lack any principled way of resisting the temptation of prepunishment."[52] They can't resist it on the grounds that it wouldn't be deserved because, as we've seen, they don't believe in the notion of desert. They also can't resist it on the grounds that the person might change her or his mind because, in their view, what people think (and what people do) is totally determined by forces beyond their control. So far from preserving our ordinary notions of morality, compatibilism does violence to them.

> *Injustice anywhere is a threat to justice everywhere.*
> —Martin Luther King Jr.

Thought Probe

Minority Report

The movie *Minority Report* depicts a society that practices prepunishment. Beings who possess the power of precognition (known as "pre-cogs") see the future before it happens and direct the pre-crime police to the scene of the crimes-to-be. Of course there are no such beings, but if there were, would it be such a bad thing to use them to prepunish people? Why or why not? How does this bear on the plausibility of traditional compatibilism?

Traditional compatibilists don't want to give up the notion of free will and they don't want to give up the notion of causal determinism. They believe that the two are compatible—that accepting one doesn't require rejecting the other. But as we've seen, accepting traditional compatibilism means rejecting a number of our traditional beliefs regarding punishment. So perhaps those notions are not as compatible as the compatibilists would have us believe.

According to traditional compatibilism, two conditions must be met for an action to be free: (1) the action must be caused by one's will and (2) it must not be externally constrained. Is that all there is to acting freely? Richard Taylor doesn't think so. He presents the following counterexample.

Thought Experiment

Taylor's Ingenious Physiologist

Let us suppose that my body is moving in various ways, that these motions are not externally constrained or impeded, and that they are all exactly in accordance with my own desires, choices, or acts of will and what not.... We suppose

further, accordingly, that while my behavior is entirely in accordance with my own volitions, and thus "free" in terms of the conception of freedom we are examining, my volitions themselves are caused. To make this graphic, we can suppose that an ingenious physiologist can induce in me any volition he pleases, simply by pushing various buttons on an instrument to which, let us suppose, I am attached by numerous wires. All the volitions I have in that situation are, accordingly, precisely the ones he gives me. By pushing one button, he evokes in me the volition to raise my hand; and my hand, being unimpeded, rises in response to that volition. By pushing another, he induces the volition in me to kick, and my foot, being unimpeded, kicks in response to that volition. We can even suppose that the physiologist puts a rifle in my hands, aims at some passer-by, and then, by pushing the proper button, evokes in me the volition to squeeze my finger against the trigger, whereupon the passer-by falls dead of a bullet wound.[53]

Taylor envisions a situation in which both of the conditions of traditional compatibilism are met: His actions are caused by his will, and they are not externally constrained. He is doing what he wants to do, and there are no external forces preventing him from doing otherwise. Nevertheless, his actions are not free because his desires are not his own. They come from the ingenious physiologist, not from himself.

You might think that Taylor's thought experiment is not a counterexample to traditional compatibilism because the ingenious physiologist causes Taylor's actions. But you would be mistaken. The ingenious neurophysiologist does not directly cause Taylor's actions, he only directly causes Taylor's desires.

In the News: Guilty Minds and Pre-Crime

The ability to tell what someone is planning to do before they actually do it is no longer just the stuff of science fiction. Neuroscientists have developed a brain scanning technique that allows them to read people's intentions:

> A team of world-leading neuroscientists has developed a powerful technique that allows them to look deep inside a person's brain and read their intentions before they act. . . .
>
> The team used high-resolution brain scans to identify patterns of activity before translating them into meaningful thoughts, revealing what a person planned to do in the near future. It is the first time scientists have succeeded in reading intentions in this way.
>
> "Using the scanner, we could look around the brain for this information and read out something that from the outside there's no way you could possibly tell is in there. It's like shining a torch around, looking for writing on a wall," said John-Dylan Haynes at the Max Planck Institute for Human Cognitive and Brain Sciences in Germany, who led the study with colleagues at University College London and Oxford University.[54]

The technology is currently very crude, but it could eventually allow us to identify those planning to commit a crime before they commit it:

> The use of brain scanners to judge whether people are likely to commit crimes is a contentious issue that society should tackle now, according to Prof. Haynes. "We see the danger that this might become compulsory one day, but we have to be aware that if we prohibit it, we are also denying people who aren't going to commit any crime the possibility of proving their innocence."[55]

Thought Probe

Guilty Minds and Pre-Crime

In the law, to be fully responsible for committing a crime you must have a *mens rea*—a guilty mind. Is having a guilty mind enough to lock someone up?

By pushing the button, he doesn't raise Taylor's hand, he only gives Taylor the desire to raise his hand. So the direct (proximal) cause of Taylor's actions is his desires. The machinations of the ingenious physiologist are only an indirect (distal) cause of them. Since Taylor's actions are directly caused by his desires and are not externally constrained, traditional compatibilism would have us believe that they're free. But they're not. They're little better than the actions of a puppet.

We don't have to appeal to science fiction to see the inadequacy of traditional compatibilism's analysis of free action. Consider the case of drug addicts.

Thought Experiment

Taylor's Drug Addiction

One can, for instance, be given a compulsive desire for certain drugs, simply by the administration of those drugs over a course of time. Suppose, then, that I do, with neither my knowledge nor my consent, become a victim of such a desire and act upon it. Do I act freely, merely by virtue of the fact that I am unimpeded in my quest for drugs? In a sense I do, surely, but I am hardly free with respect to whether or not I shall use drugs. I never chose to have the desire for them inflicted upon me.[56]

> ### In the Courts: Government-Sponsored Brainwashing
>
> For a period of about twenty years, beginning in the early 1950s and extending through the late 1960s, the Central Intelligence Agency (CIA) conducted brainwashing experiments on unsuspecting American and Canadian citizens to see whether they could get them to carry out complex instructions against their will. Code-named MKULTRA, the goal was to create an operative of the sort portrayed in the Bourne film series and in the movie *The Manchurian Candidate*. Here's a short description of the project:
>
>> At a Senate hearing on August 3, 1977, Admiral Stansfield Turner, director of the Central Intelligence Agency, disclosed that the CIA had been conducting brainwashing experiments on countless numbers of Americans, without their knowledge or consent. Some were prisoners, others were mentally ill patients, still others were cancer patients. But there was also an unknown number of nonpatients who unwittingly became experimental subjects; for instance, patrons at bars in New York, San Francisco, and other cities were drugged with LSD (lysergic acid diethylamide) and other psychotropic agents by the CIA. Nurses and other members of hospital staffs underwent sensory deprivation experiments and some of them experienced the onset of schizophrenia. . . .
>
> The main objective of this mammoth CIA effort, which cost the taxpayers at least $25 million, was to program an individual to do one's bidding even if it would lead to his own destruction. As quoted by the *New York Times*, a CIA memorandum of January 25, 1952, asked "whether it was possible to 'get control of an individual to the point where he will do our [the CIA's] bidding against his will and even against such fundamental laws of nature as self-preservation.'"[57]
>
> In 1975, Congress awarded $750,000 to the family of Frank Olson, one of the agents who died during an experiment. In 1988, the Justice Department awarded $750,000 to nine Canadian citizens who unwittingly participated in these experiments.
>
> ### Thought Probe
>
> #### The Manchurian Candidate
>
> Suppose that the CIA could create a Manchurian candidate by altering someone's desires so that he wanted to do the CIA's bidding. According to compatibilism, would that person be acting freely when he was following orders? Why or why not?

A kleptomaniac is a person who helps himself because he can't help himself.
—Henry Morgan

It is possible to become addicted to crack cocaine after using it only a few times. After one is addicted, one has an irresistible desire to use it. Nevertheless, a crack addict's use of crack meets the conditions for a free action laid down by traditional compatibilism: It is caused by the addict's own will, and it is not externally constrained. So traditional compatibilism would have us believe that a crack addict's use of crack is a free action. But that's implausible. Crack addicts can't help themselves. They are slaves to their drug habit. Because traditional compatibilism suggests otherwise, there is reason to believe that it's mistaken.

Compulsive behavior (of which addiction is just one example) is caused by uncontrollable desires. Kleptomania, for example, is caused by an uncontrollable desire to steal. Because a desire is an internal cause, traditional compatibilism would have us believe that the actions of a kleptomaniac are just as free as those of an ordinary thief. But any view that considers compulsive behavior just as free as normal behavior is dubious.

Taylor's thought experiments show that the conditions specified by traditional compatibilism are not sufficient for acting freely. Even if your actions are caused by your will, and even if they are not externally constrained, they

can fail to be free. If your will is not under your control—if your choices are not up to you—your actions aren't free.

Thought Probe

Religious Cults

People who join religious cults often acquire a whole new set of beliefs and desires. Parents who have lost their sons or daughters to a religious cult sometimes try to rescue them forcibly on the grounds that the cult has taken away their free will. Could a compatibilist ever justify such a rescue? Why or why not?

Hierarchical Compatibilism

The desire to believe in free will is strong, as is the desire to believe in causal determinism. Many of our social institutions are based on the former, while many of our sciences are based on the latter. The desire to maintain a belief in both has led some thinkers to modify traditional compatibilism in a way that avoids the objections raised against it. This new form of compatibilism is called "hierarchical compatibilism" because it is based on the belief that our desires can be arranged in a hierarchy from lowest to highest.

Each of us wants to do many things, and often these wants conflict. For example, you may want to get a good night's sleep so you will do well on an exam the next day, and you may want to stay up late. So when we say that you did what you wanted to do, we may simply mean that you acted on one of your wants. But we may also mean that you acted on the want you wanted to act on. Only if your action is of the second sort says Harry Frankfurt, originator of hierarchical compatibilism, is it free.

All of us have desires for various objects and states of affairs. We desire things like food, clothing, and shelter as well as conditions like being healthy, being well informed, and being well paid. Desires that are directed on objects or states of affairs are called **first-order desires.**

Self-conscious beings like ourselves are not only aware of the first-order desires we have, but we can have desires about those desires. A smoker, for example, can have the desire to not desire to smoke. That is, he can desire to be the sort of person who has no desire for cigarettes. Desires that are directed on first-order desires are called **second-order desires.**

It's possible to have a second-order desire without wanting to act on it. Suppose, for example, that you were a priest who regularly counseled people with marriage problems. In such a situation, you might have a desire to know what it's like to be married. But you probably wouldn't want to act on that desire because if you did, you would no longer be a priest. Second-order desires that we want to act on Frankfurt calls **second-order volitions.**

To act freely, says Frankfurt, is to act on a second-order volition. If you do not formulate second-order volitions, or if you do not act on the ones you

Why is it drug addicts and computer aficionados are both called users?
—CLIFFORD STOLL

first-order desire A desire directed on an object or a state of affairs.

second-order desire A desire directed on a first-order desire.

second-order volition A second-order desire on which one wants to act.

do form, your actions are not free—you are a slave to your first-order desires. Frankfurt uses two different types of drug addicts to make his point.

Thought Experiment

Frankfurt's Unwilling and Wanton Addicts

Let us suppose that the physiological condition accounting for the addiction is the same in both men, and that both succumb inevitably to their periodic desires for the drug to which they are addicted. One of the addicts hates his addiction and always struggles desperately, although to no avail, against its thrust. He tries everything that he thinks might enable him to overcome his desires for the drug. But these desires are too powerful for him to withstand, and invariably, in the end, they conquer him. He is an unwilling addict, helplessly violated by his own desires. . . .

The other addict is a wanton. His actions reflect the economy of his first-order desires, without his being concerned whether the desires that move him to act are desires by which he wants to be moved to act. If he encounters problems in obtaining the drug or in administering it to himself, his responses to his urges to take it may involve deliberation. But it never occurs to him to consider whether he wants the relation among his desires to result in his having the will he has. The wanton addict may be an animal, and thus incapable of being concerned about his will. In any event he is, in respect of his wanton lack of concern, no different from an animal.[58]

> I am a raging alcoholic and a raging addict and I didn't want to see my kids do the same thing.
> —Ozzy Osbourne

The unwilling addict has second-order volitions but is incapable of acting on them. He desires that he not act on his desire to take drugs, but he can't help himself. He is a slave to his drug habit. The wanton, on the other hand, has no second-order volitions. He never questions or reflects on his first-order desires. He has never wondered whether it is desirable to be a drug addict. According to Frankfurt, neither addict acts freely because neither acts on second-order volitions; the unwilling addict doesn't act on them because he cannot bring himself to act on them, and the wanton doesn't act on them because he doesn't have them.

According to Frankfurt, free actions are caused by second-order volitions that one decisively identifies with. This view is known as **hierarchical compatibilism** because it is based on the belief that there is a hierarchy of desires and volitions. The phrase "decisively identifies with" is needed to forestall an infinite regress. Just as our first-order desires can conflict, so can our second-order desires. We may formulate a third-order desire to try to resolve such a conflict, but that desire may conflict with another third-order desire, and so on and on. But a second-order desire that we decisively identify with, claims Frankfurt, "'resounds' throughout the potentially endless array of higher orders," halts the regress, and brings a coherence to our preference structure.

To show how these conditions work to generate free action, Frankfurt appeals to another kind of addict.

hierarchical compatibilism The doctrine that free actions are caused by second-order volitions that one decisively identifies with.

Thought Experiment

Frankfurt's Happy Addict

...consider a third kind of addict. Suppose that his addiction has the same physiological basis and the same irresistible thrust as the addictions of the unwilling and wanton addicts, but that he is altogether delighted with his condition. He is a willing addict, who would not have things any other way. If the grip of his addiction should somehow weaken, he would do whatever he could to reinstate it; if his desire for the drug should begin to fade, he would take steps to renew its intensity.[59]

The happy addict, according to Frankfurt, acts freely because he acts on his second-order volition to take drugs. So contrary to what Taylor would have us believe, a drug addict's actions can be free.

Frankfurt's hierarchical compatibilism, then, avoids a number of objections that are fatal to traditional compatibilism. Traditional compatibilism, remember, holds that all drug addicts, all of those suffering from obsessive-compulsive disorder, all victims of brainwashing, and so on act freely when their actions are not externally constrained and are caused by their wills. Hierarchical compatibilism, on the other hand, not only agrees with common sense that those types of people often don't act freely, but it can explain why: They either have not formulated second-order desires (like the wanton addict) or they have failed to act on them (like the unhappy addict). But in those rare cases where they both formulate second-order desires and act on them (like the happy addict), they do act freely.

Hierarchical compatibilism can also explain why animals are not usually considered to have free will. Animals, especially mammals, may well be conscious, but they do not seem to be self-conscious, for they do not seem to be able to formulate second-order desires. Cows, for example, can't form a desire to not desire to overeat. They never consider whether they want to be the sorts of creatures that are motivated by the desires they have. In other words, animals are wantons. They have—and act on—only first-order desires.

In addition to explaining why addicts and animals do not act freely, hierarchical compatibilism can explain why free will is such a valuable thing. People who act on their second-order volitions do what they want to do; they are their own persons. People who cannot act on their second-order volitions are not in control of their lives. They are not the kind of person they want to be. As a result, they often become alienated from themselves and suffer the despair and depression that come from feeling powerless.

Hierarchical compatibilism is more in tune with common sense and has more explanatory power than traditional compatibilism, but it rejects one of our core beliefs regarding free will: the principle of alternative possibilities. According to hierarchical compatibilism, to act freely you don't have to be able to do otherwise.

Frankfurt illustrates this notion with the following thought experiment:

Thought Experiment

Frankfurt's Decision Inducer

Suppose someone—Black, let us say—wants Jones to perform a certain action. Black is prepared to go to considerable lengths to get his way, but he prefers to avoid showing his hand unnecessarily. So he waits until Jones is about to make up his mind what to do, and he does nothing unless it is clear to him (Black is an excellent judge of such things) that Jones is going to decide to do something other than what he wants him to do. Whatever Jones's initial preferences and inclinations, then, Black will have his way. . . . Now suppose that Black never has to show his hand because Jones, for reasons of his own, decides to perform and does perform the very action Black wants him to perform. In that case, it seems clear, Jones will bear precisely the same moral responsibility for what he does as he would have borne if Black had not been ready to take steps to ensure that he do it. It would be quite unreasonable to excuse Jones for his action, or to withhold the praise to which it would normally entitle him, on the basis of the fact that he could not have done otherwise.[60]

Frankfurt here describes a situation in which Jones can't do otherwise because Black won't let him. But if Jones does what Black wants him to (without Black's intervening), then Jones is responsible for what he does, even though he couldn't have done otherwise. So, Frankfurt claims, the principle of alternative possibilities is false.

If Frankfurt is right that the principle of alternative possibilities is wrong, he will have removed one of the major obstacles to accepting compatibilism. Responsibility seems to require real choice, and real choice requires the ability to choose among alternative courses of action. If responsibility does not require real choice, compatibilism becomes more palatable.

Many believe that Frankfurt has not succeeded in showing that responsibility does not require real choice, however. Robert Kane and David Widerker, for example, claim that the sign that Black uses to determine whether he should intervene either guarantees that Jones will make the decision he does or it doesn't. If it does, Jones's decision making process is deterministic. If it doesn't, it's indeterministic. Either way, Frankfurt's thought experiment fails.[61]

If Jones's decision making process is deterministic, Frankfurt has simply begged the question against the principle of alternative possibilities because he has assumed that the principle is false. If it is indeterministic—if Jones's decision is undetermined at the moment of choice—there is a possibility that Jones will do something other than what Black wants him to, and thus the principle has not been negated.

Others, like Maria Alvarez, claim that whatever Black does to make Jones do his bidding, it can't be that he forces Jones to make a decision because decision making requires a process of deliberation or the use of practical reason, and neither is present in this situation. Black may force Jones to behave in a certain way, but he can't force him to decide in a certain way.[62] So again Frankfurt's thought experiment fails to undermine the principle of alternative possibilities.

To act freely, the desire you act on must be your own. Your simply acting on a second-order desire is not enough. Michael Slote demonstrates this in his case of the hypnotized patient.

Thought Experiment

Slote's Hypnotized Patient

Consider the following example. Robert, who is genuinely undecided between two conflicting first-order desires X and Y, is visited by a hypnotist who decides to "solve" his problem by putting him in a trance and inducing in him a second-order volition in favor of X; as a result of having this second-order volition, Robert then acts to satisfy X, never suspecting that his decisiveness has been induced by the hypnotist. The example may bear the marks of science fiction, but it seems adequate, nonetheless, to point up the conceptual insufficiency of "rationality" conditions of free action. For we would all surely deny that Robert acts of his own free will, when he acts from the second-order volitions induced by the hypnotist.[63]

Robert acts on a second-order volition that he identifies with. But his action is not free because his volition is not his. It comes from a hypnotist instead of himself. So there must be more to acting freely than acting on second-order volitions with which you decisively identify. If your second-order volitions aren't your own—if you aren't doing your own thing—you aren't acting freely.

Free actions are products of the self. Our desires or volitions may be the immediate causes of our actions, but unless we had a hand in shaping those desires, our actions are not truly our own. Robert Kane explains:

> . . . to be ultimately responsible for an action, the agent must be responsible for anything that is a sufficient reason (condition, cause or motive) for the action's occurring. If, for example, a choice issues from, and can be sufficiently explained by, an agent's character and motives (together with background conditions), then to be ultimately responsible for the choice, the agent must be at least in part responsible by virtue of past voluntary choices or actions for having the character and motives he or she now has.[64]

What you do is determined by the character you have. But if your character is not, in some sense, up to you—if you had no control over the character you acquired—then you can't be ultimately responsible for the actions that flow from it.

There may well be cases where, given a person's character and motives, that person could not have done otherwise. Daniel Dennett cites the case of Martin Luther, who, when he broke away from the Catholic Church, reportedly said, "Here I stand. I can do no other."[65] Given who he was, and given his situation, it may well have been impossible for Luther to do anything else. Nevertheless, Dennett says, Luther may be held responsible for what he did. Kane would agree. But he would add that if Luther is ultimately responsible for what he did,

there must have been times in the past when he could have done otherwise, and the choices he made then must have formed the character he has now. If he had no hand in determining who he is, he can't be ultimately responsible for his actions. The question is, How is it possible for one to make such pivotal choices about the self? We'll explore this problem in the next section.

Thought Probe

The Willing Bank Teller

Suppose you are a bank teller and are held up at gunpoint. You realize that you could foil the bank robber if you could take his gun away from him, but you decide that your chances of success are not great. So you calmly hand over the money to him. According to hierarchical compatibilism, do you freely hand over the money to the bank robber? If so, is this a counterexample to hierarchical compatibilism? Why or why not?

Summary

Compatibilists say that causal determinism does not rule out freedom. Even if causal determinism is true—even if every event is the consequence of past events plus the laws of nature—we can still act freely. They have thus come to be known as soft determinists.

According to traditional compatibilism, actions can be free if they are (1) caused by one's will and (2) not externally constrained. An action is not externally constrained if the person performing the action could have done otherwise if he had chosen to do otherwise. These conditions are not sufficient for free will because even if both conditions are met, you can fail to act freely. If your will is not your own, you shouldn't be held responsible for your actions.

By reconciling free will with causal determinism, compatibilists believe that we can maintain our traditional practices of holding people responsible for their actions and punishing them when they offend. But part of our traditional notion of punishment is retribution, and there's no place for retribution in the compatibilist's approach to punishment. Another part of the traditional notion of punishment is that we should not punish people before they commit a crime, and compatibilism doesn't uphold that aspect of the traditional notion either.

Hierarchical compatibilism is based on the insight that persons have a hierarchy of different desires. A first-order desire is a desire directed on an object or a state of being; a second-order desire is a desire about a first-order desire. A second-order desire to act on a first-order desire is a second-order volition. For Frankfurt, to act freely you must do more than act on a first-order desire. You must act on a second-order volition with which you identify. According to this form of compatibilism, you can act freely even if you can't act otherwise.

But hierarchical compatibilism can't be the whole story about free will because our second-order volitions may themselves be caused by forces beyond our control. So there must be more to acting freely than just acting on second-order volitions with which you decisively identify.

Study Questions

1. What is soft determinism?
2. What is traditional compatibilism?
3. What is Stace's explanation of how all our actions have causes, yet some actions are free?
4. What is Taylor's ingenious physiologist thought experiment? What is Taylor's drug addiction thought experiment? How do these two experiments undermine traditional compatibilism?
5. What is Frankfurt's decision inducer thought experiment? How does it attempt to undermine the traditional notion of responsibility?
6. What is hierarchical compatibilism?
7. What is Slote's hypnotized patient thought experiment? How does it attempt to undermine hierarchical compatibilism?

Discussion Questions

1. Suppose that you created an android that was so advanced it could act independently in very complex situations. It made its own decisions and always did exactly what it wanted to do, in accordance with its programming. Would such an android be capable of free action? Why or why not?
2. According to hierarchical compatibilism, does Locke's trapped conversationalist act freely? Why or why not?
3. According to either traditional or hierarchical compatibilism, would there be any justification for punishing anybody? If so, what would the justification be?
4. What second-order desires do you have? Do you have any that you're not able to act on? Does that mean that you're not free? Why or why not?
5. If none of your choices were ever up to you—if you played no role in forming your character or becoming the kind of person you are—should you be held responsible for your actions? Why or why not?

Internet Inquiries

1. MKULTRA—the CIA's brainwashing program—began right after the Nuremberg trials ended. The Nuremberg trials established universal guidelines for conducting experiments on humans. Did MKULTRA violate those guidelines? Enter "MKULTRA" and "Nuremberg" into an Internet search engine to explore this issue.
2. Some unhappy sex addicts, realizing that they can't control their first-order desires for sex, have asked to be castrated. Is this a reasonable request that the state should honor? Enter "sex offender" and "castration" into an Internet search engine to explore this issue.
3. Does crime have a biological basis? If so, how should we treat those who are biologically predisposed to commit crimes? Enter "biological basis of crime" in an Internet search engine to explore this issue.

Section 3.3

Control Yourself
Freedom as Self-Determination

> *The sovereignty of one's self over one's self is called Liberty.*
>
> —Albert Pike

Compatibilism's attempt to square the belief in causal determinism with the belief in free will does not appear to have been successful. There seems to be more to acting freely than simply doing what you want to do. If your wants aren't your own, the actions that flow from them aren't free.

Einstein says this clearly. He tells us in his Credo:

> I do not believe in free will. Schopenhauer's words: "Man can do what he wants, but he cannot want what he wants" accompany me in all situations throughout my life and reconcile me with the actions of others, even if they are painful to me.[66]

For Einstein, our actions can be free only if we can want what we want, that is, only if we can determine what we desire. But Einstein doesn't believe that we can. Like the parties to the nature/nurture debate, he believes that our desires are the product of forces beyond our control and that we are powerless to change them. Consequently, he doesn't believe in free will. There are those, however, who agree with Einstein that free will requires the power to control our desires but who also believe that we have that power. Known as **libertarians**, they believe that some of our actions—namely, our free actions—are under our control because they are caused by our selves.

One of the first libertarians was Scottish philosopher Thomas Reid (1710–1796) who writes:

> By the liberty of a moral agent, I understand a power over the determinations of his own will.
>
> If, in any action, he had power to will what he did, or not to will it, in that action he is free. But if, in every voluntary action, the determination of his will be the necessary consequence of something involuntary in the state of his mind, or of something in his external circumstances, he is not free; he has not what I call the liberty of a moral agent, but is subject to necessity.[67]

libertarianism The doctrine that free actions are caused by selves (agents, persons).

According to Reid, acting freely requires deciding for yourself what desires you're going to act on. If all your actions are based on desires that have been programmed into you from without, you don't act freely. In that case, you're no better than a robot. To act freely, libertarians believe, your desires must be your own. In other words, you must be self-programming.

Compatibilists believe that there's nothing more to acting freely than doing what you want to do. For them, where your wants come from is irrelevant. Libertarians disagree. For them, if your wants aren't your own, the actions that flow from them aren't free. According to libertarians, to act freely, you have to do your own thing.

Whereas traditional compatibilism is based on a negative conception of freedom—you act freely as long as there are no external constraints on your action—libertarianism is based on a positive conception of freedom—you act freely as long as your action is up to you. This sort of freedom is positive because it requires the *presence* of self-determination. You have positive freedom when you have the power to control your own destiny.

Libertarians, like hard determinists and indeterminists, are incompatibilists, for they believe that causal determinism is incompatible with free will. If the future is fixed by past events plus laws of nature—if there is only one course of action open to us at any time—we can't act freely. So libertarians also accept the principle of alternative possibilities and causal indeterminism. We can act freely only if it's within our power to do otherwise, and we can do otherwise only if the future is not fixed by past events and laws of nature.

> I may be free to do as I please, but am I free to please as I please?
> —Arthur Schopenhauer

The Case for Freedom

Two arguments are often made in favor of libertarian free will: the argument from experience and the argument from deliberation. Let's take a look at each of them.

> All theory is against freedom of the will; all experience for it.
> —Samuel Johnson

The Argument from Experience

We all frequently have the impression that we can freely choose and that the choices we make are up to us. In countless situations, we have the impression that there are alternatives open to us and that nothing prevents us from choosing any one of them—or from not choosing. In short, we continually have the experience that we are acting freely. We each would heartily agree that we have experiences like this:

> [At] most moments while I am sitting and talking or listening to someone, I have the impression that there are several alternative things I could do next with my right hand: gesture with it, scratch my head with it, put it on my lap, put it in my pocket, and so on. For each of these alternatives, it seems to me that nothing at all up to that moment stands in the way of my making it the next thing I do with my right hand; it seems to me that what has happened hitherto, the situation at that moment, leaves each of those alternatives still open to me to perform. And while I am conscious, I have similar impressions of open alternatives almost continually,

not only about what I could do with my right hand but also, of course, about what I could do with my head, with my speech apparatus, and with my legs and feet. My impression at each moment is that I at the moment, and nothing prior to that moment, determine which of several open alternatives is the next sort of bodily exertion I voluntarily make.[68]

The experience of choosing among alternative courses of action is one that we've all had, and that experience is as uniform and regular as any experience we've had of the external world. On the face of it, then, it seems that our evidence for the existence of free will is as good as our evidence for the existence of the external world. It could turn out that our experience of free will is an illusion, just as it could turn out that our experience of the external world is an illusion—we could be living in a computer simulation like the Matrix where neither our external nor our internal perceptions are accurate. But in the absence of any convincing evidence that free will is an illusion, we are justified in believing that it isn't.

The Argument from Deliberation

> One of the annoying things about believing in free will and individual responsibility is the difficulty of finding somebody to blame your problems on.
>
> —P. J. O'Rourke

Just as we've all had the experience of choosing among alternative courses of action, so we've all had the experience of deliberating about which action to choose. We can deliberate about doing something, however, only if we believe that it is in our power to do it or not to do it. If you believe that the concert you wanted to go to is now over, then you can't deliberate about whether to attend the concert. Because you know that there is now no way for you to attend the concert (you have no choice about it), you cannot seriously engage in deciding whether to attend. You might pretend to decide, but genuine deliberation is out of the question. Therefore, when we deliberate, we must believe that we can perform free actions.

Believing something to be true, however, doesn't make it true. Millions of children believe in the Easter bunny, the tooth fairy, and Santa Claus, but that doesn't mean that they exist. Those are folk beliefs that we all know to be false. Similarly, some people say that free will is a folk belief that we now know to be false.

The Neurophysiological Challenge

> Life is like a game of cards. The hand that is dealt you is determinism; the way you play it is free will.
>
> —Jawaharlal Nehru

Some of the best evidence for the nonexistence of free will comes from certain experiments on reaction times conducted by neurophysiologist Benjamin Libet. Libet wanted to understand the relationship between conscious thought, brain activity, and bodily movement: Does conscious thought precede the brain activity that produces bodily movement or does brain activity precede the conscious thought? By means of an electroencephalogram (EEG), which measures electrical activity in the brain, it's possible to detect the nerve impulses that result in bodily movement (known as the readiness potential [RP]). By means of an electromyograph (EMG), which measures voltage changes in muscles, it's possible to detect bodily movement. So Libet seated his subjects at a table, attached an EEG to their scalps, and attached an EMG

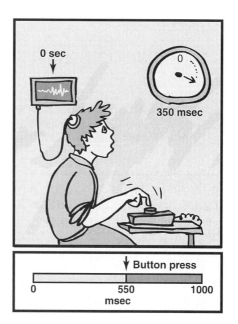

LIBET'S EXPERIMENTAL SETUP.
Does it show that free will is an illusion? Courtesy: Deric Bownds and Bill Feeny, Univ. Wisconsin, Madison.

to one of their forearms. In front of them was a rapidly moving clock and a button. They were given the following instructions: "Flex your finger to push the button when you feel like it, and tell us where the hand on the clock is when you decide to do that." The time from the moment the EEG detected the RP to the moment the EMG detected the muscle movement was approximately 500 milliseconds. So the bodily movement occurred about half a second after the brain activity that initiated it. But the surprising finding was that the subjects became aware of the decision to press the button about 300 milliseconds after the brain activity started! Ordinarily we assume that conscious decisions cause the nerve impulses that result in bodily movement. Libet's experiment suggests otherwise. Consciousness of a decision arises only after the decision has already been made! If so, then consciousness would seem to be an epiphenomenon—an ineffectual by-product of brain activity—rather than the initiator of it.

Libet interprets the results of his experiment this way:

> The initiation of the freely voluntary act appears to begin in the brain unconsciously, well before the person consciously knows he wants to act. Is there, then, any role for conscious will in the performance of a voluntary act? To answer this it must be recognized that conscious will does appear about 150 msec before the muscle is activated, even though it follows the onset of the RP. An interval of 150 msec would allow enough time in which the conscious function might affect the final outcome of the volitional process.[69]

In Libet's view, then, although conscious will does not initiate movement, it may be able to stop it before it occurs. "This suggests," says neurophysiologist Vilaynur Ramachandran, "that our conscious minds may not have free will, but rather 'free won't.'"[70]

Control Yourself

Thought Probe

Is Free Won't Enough for Free Will?

Suppose Libet is correct in thinking that conscious will can't initiate actions but can only negate them. Is having this sort of conscious veto power enough to be held responsible for your actions?

MY WIFE AND MY MOTHER IN LAW BY W. E. HILL (ILLUSTRATION, 1915). This ambiguous figure can be seen as a young woman or an old one. But you can decide which aspect you will see. A proof of free will? Some psychologists think so. David Rumelhart says of the figure, "I can make it do what I want it to do. That's a trivial example of willing to do one thing rather than another, but the phenomenon itself is anything but trivial."[71]

Not everyone concurs with Libet's interpretation of his results, however. In the first place, even if consciousness does not initiate individual muscle movements in such artificial settings, it may still be involved in identifying goals, formulating plans, and devising strategies. It may have played a role, for example, in helping the subjects decide whether they would participate in the experiments.

Second, a number of neurophysiologists argue that what Libet's experiment tests is not conscious awareness but "meta-conscious awareness." As Anthony Jack and Philip Robbins explain,

> ... the illusion of causality thesis [the claim that the effectiveness of conscious will is an illusion] is almost certainly false. The only reason for believing it derives from a failure to distinguish conscious states (the intention to x) from meta-conscious states (the thought that one is intending to x). In Libet's well-known experiment, subjects don't have the thought that they are consciously intending an action until some time after brain activity underlying the action has begun. Yet it is hardly surprising that the thought that we are consciously intending only occurs after the conscious intention has formed. Unless we assume that conscious intentions form instantaneously and are simultaneously accompanied by the realization that we are having a conscious intention, Libet's experiment poses no challenge.[72]

There's a difference between making a conscious decision and becoming consciously aware of the fact that a conscious decision was made. The former is an example of conscious awareness, and the latter is an example of meta-conscious awareness. Meta-conscious awareness, like self-consciousness in general, is a second-order awareness. In this case, it's a conscious awareness of the fact that one has done something consciously. According to Jack and Robbins, what Libet's subjects report is not the occurrence of the conscious decision, but when they became consciously aware of their conscious decision. Since one would expect such meta-conscious awareness to occur sometime after the conscious decision was made, they don't find Libet's results all that surprising.

Adina Roskies agrees. She writes:

> Libet's experiment with the clock face probes the relative timing of a meta-state, consciousness of conscious intent, and the initiation of movement.... There is good reason to think that consciousness of conscious intent may occur some time after conscious intent, and thus the fact that this occurs after the Readiness potential has begun is compatible with conscious intent occurring.[73]

Again, the point is that we can consciously and freely do something without being consciously aware that we are consciously doing it. Roskies gives the example of driving a car.

> For instance, I am conscious of driving when I drive, and I consciously steer, accelerate, check my speed, and so on, and I intend to do so. I act volitionally. However, I often am not conscious of intending to steer, accelerate, etc. in the sense that the commands I give to my body are not present to me. . . . However, I by no means think I act unconsciously, and still less do I think I do it unfreely.[74]

Driving a car is a conscious, free action even though we may not be consciously aware of the conscious actions it involves. Since Libet's experiment records the time at which the subjects become consciously aware of their conscious actions and not the time of the conscious actions themselves, it does not refute the existence of free will.

One of the fundamental assumptions underlying Libet's interpretation of his experiment is that the RP causes both the feeling of consciously willing a movement and the movement itself. In other words, it assumes that the RP is sufficient for both conscious will and voluntary movement. But there is reason to believe that it is sufficient for neither.

To test whether the RP is sufficient for conscious will, Alexander Schlegel and his colleagues placed an EEG on several subjects' heads, hypnotized them, and gave them a post-hypnotic suggestion to squeeze a ball on cue. A post-hypnotic suggestion "is an instruction given to a hypnotized person during hypnosis that is to be followed after waking from the hypnotic state."[75] What's interesting about post-hypnotic suggestions is that they can be carried out without the subjects being consciously aware that they're performing them. The researchers found that the RP [and also what's known as the lateralized readiness potential (LRP)] were present prior to the subjects carrying out the post-hypnotic suggestion even though they reported that they were not consciously aware of performing it. Schlegel concludes "that nonconscious volitional actions can occur, and that the RP and the LRP are present even when an action occurs in the absence of conscious will."[76] So the RP is not sufficient for conscious will.

To test whether the RP is sufficient for volitional movement, Judy Trevena and Jeff Miller asked volunteers to decide, after hearing a tone, whether or not to tap on a keyboard. What they found was that the RP was present whether or not their subjects decided to tap.[77] So the RP is not sufficient for volitional movement either.

These findings suggest that the conclusion Libet and many others have drawn from his experiments is mistaken. The fact that the RP occurs before our feeling of consciously willing a movement and the movement itself does not show that we do not consciously will our voluntary actions. If the RP can be present when there is no conscious will or voluntary movement, it can't be the cause of them. It may be necessary, but it can't be sufficient.

What, then, is the RP? It appears to be the brain's way of preparing for action rather than a specific decision to act. Just as a sprinter tenses his

muscles before the start of a race, the brain increases activity in the motor areas prior to acting. And just as a sprinter's tense muscles do not always lead to running (because, for example, the starter may call off the race), activity in the motor areas of the brain do not always lead to action (as the experiments of Trevena and Miller show). In fact, experiments by Aaron Schurger and his colleagues have shown that the more the build up of activity in the motor areas of the brain, the faster subjects respond to an external stimulus.[78] So it may be the case that sprinters who get out of their blocks the fastest have the strongest RP. In any event, Schurger says of his findings: "Libet argued that our brain was already decided to move well before we have a conscious intention to move. We argue that what looks like a pre-conscious decision process may not in fact reflect a decision at all. It only looks that way because of the nature of spontaneous brain activity. . . . If we are correct, then the Libet experiment does not count as evidence against the possibility of conscious will."[79]

Neurophysiological Evidence for Free Will

In addition to our everyday experiences of deliberating and choosing, there is laboratory evidence showing that our conscious will can directly affect our brains. Psychologists Baars and McGovern, for example, cite the phenomenon of biofeedback, where subjects are made aware of the firing rates of neurons and asked to control them. They report,

> The global influence of consciousness is dramatized by the remarkable phenomenon of biofeedback training. There is firm evidence that any single neurone or any population of neurons can come to be voluntarily controlled by giving conscious feedback of their neural firing rates. However, if the biofeedback signal is not conscious, learning does not occur. Subliminal feedback, distraction from the feedback signal, or feedback via a habituating stimulus—all these cases prevent control being acquired. Since this kind of learning only works for conscious biofeedback signals, it suggests again that consciousness creates global access to all parts of the nervous system.[80]

In these biofeedback experiments, conscious will seems to play a causal role in determining the rate at which neurons fire.

Cognitive behavior theory also seems to provide evidence for the effect of the mind on the body. People suffering from obsessive-compulsive disorder (OCD) often engage in repetitive behaviors like washing their hands many times a day. They are also often afflicted with unwanted thoughts of a violent or sexual nature that repeatedly intrude into their consciousness. These patients can sometimes be successfully treated with serotonin reuptake inhibitors like Prozac. Dr. Lewis Baxter at the UCLA School of Medicine did a comparative study of the effectiveness of traditional drug therapy with that of cognitive behavioral therapy. In cognitive behavioral therapy, patients are told to use self-instructions like "That's not me, that's a part of my brain that's not working" whenever they started to feel the urge to engage in the unwanted behavior. Baxter found that not only were these self-instructions as effective as the drugs, but brain scans showed that the changes in the brain caused by the self-instructions were virtually the same as those caused by taking drugs.[81]

These studies suggest that the view that the mind can affect the body is not just an outdated piece of folk psychology. On the contrary, conscious mental states appear to have tangible physical effects, even in the controlled environment of a scientific laboratory. In the absence of a purely physiological account of these phenomena, the notion that conscious will is merely an epiphenomena—an ineffectual by-product of unconscious brain processing—seems mistaken.

Agent Causation

Libertarians claim that even if an action is undetermined by past events, it can nevertheless be free as long as it is caused by a self or agent. Libertarians, therefore, usually endorse a form of causation known as **agent causation,** which occurs when an agent (self, person) causes an event.

Traditionally, agent causation and event causation were taken to be entirely different species of causation because agent causation was thought to be capable of initiating new causal chains. In this view, when we cause something, we are acting like God. American philosopher Roderick Chisholm explains:

> If we are responsible, then we have a prerogative which some would attribute only to God: each of us when we act, is a prime mover unmoved. In doing what we do, we cause certain events to happen, and nothing—or no one—causes us to cause those events to happen.[82]

Many have found this conception of agent causation mysterious if not incoherent. Daniel Dennett's concerns are typical:

> How does an agent cause an effect without there being an event (in the agent, presumably) that is the cause of that effect (and is itself the effect of an earlier cause, and so forth)? Agent causation is a frankly mysterious doctrine, positing something unparalleled by anything we discover in the causal processes of chemical reaction, nuclear fission and fusion, magnetic attraction, hurricanes, volcanoes, or such biological processes as metabolism, growth, immune reactions, and photosynthesis.[83]

Agent causation, as traditionally conceived, seems to make free will nothing less than miraculous. To suppose that we act like God and initiate causal chains is difficult to accept. Rather than explaining anything, it substitutes one mystery for another.

Chisholm came to recognize the problems associated with the traditional conception of agent causation and, in his later years, offered an alternative conception:

> In earlier writings on this topic, I had contrasted agent causation with event causation and had suggested that "causation by agents" could not be reduced to causation by events. I now believe that that suggestion was a mistake. What I had called agent causation is a subspecies of event causation.[84]

Event causation is the sort of causation studied by scientists. It occurs when one event causes another, such as when the lighting of a match causes an explosion. An event can be construed as an object having a property at a time. For example, the event of a log burning can be thought to consist in the log having the property of burning at a certain time. The event of the log burning can bring about or contribute causally to any number of other events, like a marshmallow's cooking. The log burning does so in virtue of certain properties or causal powers it possesses, such as the property of being hot.

A staff moves a stone, and is moved by a hand, which is moved by a man.
—ARISTOTLE

Liberty, according to my metaphysics is a self-determining power in an intellectual agent. It implies thought and choice and power.
—JOHN ADAMS

agent causation Causation that occurs when an agent (self, person) causes an event.

event causation Causation that occurs when one event causes another.

Sartre and Smullyan on Free Will

Author and philosopher Jean-Paul Sartre is one of the foremost exponents of the philosophy known as *existentialism*. Existentialism claims that humans are, by their nature, free to do what they want to do. We have not been designed to perform a particular function, nor are we forced to engage in any activity we don't like. We can always commit suicide. We, and we alone, are responsible for everything that happens to us. Here's how Sartre expresses it:

> I am condemned to be free. This means that no limits to my freedom can be found except freedom itself or, if you prefer, that we are not free to cease being free. . . .
>
> As we have seen, for human-reality, to be is to choose oneself; nothing comes to it either from the outside or from within which it can receive or accept. Without any help whatsoever, it is entirely abandoned to the intolerable necessity of making itself be—down to the slightest detail. Thus freedom is not a being; it is the being of man—that is, his nothingness of being. If we start by conceiving of man as a plenum, it is absurd to try to find in him afterward moments or psychic regions in which he would be free. As well look for emptiness in a container which one has filled beforehand up to the brim! Man cannot be sometimes a slave and sometimes free; he is wholly and forever free or he is not free at all.[85]

For Sartre, it is part of a person's nature to be free. It is impossible for something to be a person and not be free. Logician Raymond Smullyan agrees. Here is an excerpt from Smullyan's "Is God a Taoist?" in which God explains why people have free will:

> Why the idea that I could possibly have created you without free will! You acted as if this were a genuine possibility, and wondered why I did not choose it! It never occurred to you that a sentient being without free will is no more conceivable than a physical object which exerts no gravitational attraction. (There is, incidentally, more analogy than you realize between a physical object exerting gravitational attraction and a sentient being exerting free will!) Can you honestly even imagine a conscious being without free will? What on earth could it be like? I think that one thing in your life that has so misled you is your having been told that I gave man the *gift* of free will. As if I first created man, and then as an afterthought endowed him with the extra property of free will. Maybe you think I have some sort of "paint brush" with which I daub some creatures with free will, and not others. No, free will is not an "extra"; it is part and parcel of the very essence of consciousness. A conscious being without free will is simply a metaphysical absurdity.[86]

Thought Probe

Self-Consciousness and Free Will

Do you agree with Sartre and Smullyan that it's impossible to be self-conscious and not have free will? Why or why not? Would you be willing to grant that any robot that was self-conscious had free will? Why or why not?

Agent causation is a type of event causation where the event consists of an agent having a property at a time. Just as ordinary events bring about other events in virtue of the properties they possess, so do agent events. Timothy O'Connor refers to these properties as "volition-enabling properties," for having these properties enables agents to act freely.[87] Like self-consciousness, these properties can be conceived as emergent properties that come into being when certain things (like neurons) interact in certain ways. In fact, self-consciousness itself may be a volition-enabling property, as Sartre and Smullyan suggest (see the box "Sartre and Smullyan on Free Will"). In any case, it's important to realize that agent causation does not require substance dualism. Agents need not be immaterial entities or disembodied spirits to

cause actions. They can be physical objects as long as they have the right sorts of properties.

Agents also need not be construed as prime movers unmoved. Instead of initiating causal chains, agent causation can be viewed as directing them. As we have seen, alternative courses of action are like forks in a road. Agent-caused choices can be taken to determine which fork the chain will take.[88] Thus understood, agent causation is consistent with the notion of downward mental causation discussed in Chapter 2. To get a better understanding of what's going on when an agent makes a choice, let's consider a particular case.

Suppose you're choosing among going to graduate school, joining the Peace Corps, or entering the business world. Such a choice can be difficult, and the choice you make can have a profound effect on the sort of person you become. You'll want to consider your options carefully. This involves identifying the reasons for choosing each of the alternatives. If you go to graduate school, you'll learn more about a subject you love. If you join the Peace Corps, you'll help the needy in a foreign country. If you enter the business world, you may make more money than you would in choosing either of the other options. Once you've identified the relevant reasons, you make your choice. In making that choice, you decide which reason, or set of reasons, carries the most weight. Your choice is undetermined in the sense that you are not forced to choose any one of the three options. But that is not to say that your choice is uncaused, for the reasons you have for each of your options contribute causally to your decision. They just don't necessitate it. If all the events leading up to your decision were repeated, it would be possible for you to choose otherwise. Your decision is up to you.

> *True freedom is the capacity for acting according to one's true character, to be altogether one's self, to be self-determined and not subject to outside coercion.*
>
> —CORLISS LAMONT

Compatibilists and hard determinists maintain that this conception of free action can't be correct because it either leads to an infinite regress or makes human action incomprehensible. Consider again the choice of going to graduate school, joining the Peace Corps, or entering the business world. Suppose you choose to join the Peace Corps. Someone (like your parents) may want to know why you chose that option. Since your choice was a rational one, arrived at through careful deliberation, there should be a reason for it. This reason would supposedly be a second-order reason indicating why you weighted one set of reasons more heavily than another. But if the decision to weigh one set of reasons more heavily than another is itself rational, there should be a third-order reason for using such a principle of choice, and so on to infinity. So, in the words of Galen Strawson, "True self-determination is logically impossible because it requires the actual completion of an infinite regress of choices, of principles of choice."[89]

Are Strawson's requirements for rational choice plausible? Does making a rational choice among competing sets of reasons require making an infinite number of choices? It wouldn't seem so. Suppose someone asked you why you chose to join the Peace Corps. It would be appropriate for you to say, "Because I decided it was more important to help the needy than continue my studies or make lots of money." That explains your choice and makes it intelligible. There is no need to appeal to any higher-level principles of choice.[90]

Now suppose someone asks you, "Why did you decide that helping the needy was more important?" In this case, it would be appropriate to say,

Humans are the only creatures we know that are self-conscious. Does self-consciousness make us free?

You are what you are because of the conscious and subconscious choices you have made.
—BARBARA HALL

"I just did." But, the compatibilists and hard determinists might inquire, how is that any different from a purely random action? If your weighting of reasons is undetermined by other events or reasons, how can it be anything but random? The libertarian answer to that question is that it's not random because it was caused by you. In making your decision, you considered what kind of life you would lead and what kind of person you would become if you chose the different options. After weighing these factors in your mind, you decided, "That's the life for me." As long as your choice was not determined by any prior events, and was intentionally made by you, it's a nonrandom yet free action.

By making that choice, you decided that certain values are more important than others. Those values, then, will probably be given greater weight in future decisions. So, much like legal precedents, the choices you make now can affect choices you will make in the future and thus can determine the sort of person you will become.

Your character is a function of your beliefs, desires, and values. Decisions that alter those items are what Robert Kane calls "self-forming actions." To perform such actions, you have to be self-conscious. You have to be capable of reflecting on your beliefs, desires, and values and deciding whether you want to be the sort of person who acts on them. That is, you have to be able to form second-order desires. If you also have the power of acting on those decisions, you have the power of self-determination and can be considered ultimately responsible for what you do.

In his article "A Coherent, Naturalistic, and Plausible Formulation of Libertarian Free Will," Mark Balaguer argues that decisions like the one described above meet the requirements of libertarian free will because they are undetermined by prior events and appropriately nonrandom. Following Robert Kane, Balaguer calls such decisions "torn decisions" because the person making the decision "(a) has reasons for two or more options and feels torn as to which set of reasons is strongest . . . and (b) decides without resolving this conflict—i.e. the person has the experience of just choosing."[91] All such decisions, Balaguer claims, involve agent causation and thus affirm the existence of libertarian free will.

> If our torn decisions are undetermined at the moment of choice, then we author and control them. The first point to note here is that if a torn decision is undetermined at the moment of choice in the way described above, then it follows that nothing external to the agent caused her to choose as she does . . . And the second point is that when we combine this lack of external causation with conscious, intentional, purposefulness, we seem to get authorship and control: if (a) an agent S consciously, intentionally, and purposefully chooses some option A, and (b) nothing external to S causes her to choose A, then it seems that (c) she authors and controls the decision.[92]

If a number of equally desirable actions are open to you, and you intentionally decide to perform one of them, then, Balaguer claims, you are the cause of that action and can be held responsible for it. Torn decisions of the sort described by Balaguer are ones with which we are all familiar. Think of choosing between ordering the chicken or ordering the pork, going hiking or going swimming, watching *The Avengers* or watching *The Defenders*. Your choice in these cases may indeed be torn—the alternatives may be equally desirable, the decision you make may not be determined by prior events, and yet you make a choice. The action you take may not be a self-forming one, but it's a free action nonetheless.

Accepting such a libertarian view of free will does not require rejecting any scientific facts or commonsense beliefs. Balaguer explains:

> The view here is that free decisions are purely naturalistic, materialistic phenomena: when physical particles are arranged in certain ways (e.g. brain-type ways) they give rise to various sorts of conscious phenomena, and among these are genuinely free decisions. Thus when a free decisions is made, we don't have an intrusion from outside the flow of physical stuff; it's just that at this point in spacetime, the flow is undetermined and non-random in an appropriate, libertarian sort of way.[93]

Contrary to what Dennett would have us believe, then, agent causation need not commit us to anything mysterious. And, unlike compatibilist conceptions of free will, libertarian conceptions are consistent with our practice of retributive justice. If you're responsible for your character, you're responsible for the actions that flow from it. If you harm other people, you deserve to be harmed yourself.

What's more, no libertarian would ever endorse the principle of prepunishment. If free actions are undetermined at the moment of choice, we can

Freedom is the will to be responsible to ourselves.
—FRIEDRICH NIETZSCHE

never know for sure what someone will do. Until they actually do the deed, they are guilty of no crime.

Libertarianism also helps explain why there is so much individual and cultural diversity, why social engineering such as that attempted in the former Soviet Union has failed, and why those raised in the same family often disagree with one another. Given its coherence and explanatory power, libertarianism remains a viable solution to the problem of free will.

Agents (persons, selves) are self-conscious beings who are capable of forming second-order desires. They know what things motivate them, and they can decide whether they want to be motivated by those things. So we can agree with Frankfurt that free actions are those that are caused by second-order volitions. But if the second-order volitions themselves are not caused by the agent, the actions they cause are not free. By requiring that second-order volitions be caused by the agent, then, libertarianism avoids the problem that undermined hierarchical compatibilism.

The plausibility of libertarianism is far from settled. The notion of agent causation may turn out to be mistaken. But given the possibility of downward mental causation presented at the end of Chapter 2 and the possibility of a naturalistic account of it, libertarianism remains a live option.

Thought Probe

Free Androids

Recall the android mentioned at the beginning of this chapter. Suppose that it is indeed programmed to make choices and to learn from its mistakes but that it also possesses self-consciousness. Would the android have free will? Why or why not? If not, is there anything we could give to the android that would give it free will? If so, what is it?

Summary

Because neither traditional nor hierarchical compatibilism reconciles free will and causal determinism, there is reason to believe that they are incompatible. An incompatibilist can still believe in free will, by arguing from the fact that we have free will to the conclusion that causal determinism is false. But if causal determinism is false, causal indeterminism must be true. We can avoid indeterminism (free actions are uncaused), however, by distinguishing between two different types of causation. There's event causation (an event brings about another event) and agent causation (an agent or person brings about an event). According to libertarianism, free actions are actions that are caused, not by other events, but by agents or persons. Libertarians don't deny that every event has a cause. They simply deny that every event has an event cause. This notion of free actions being caused by agents is consistent with our experience of acting and deliberating, and it fits well with the mind-body theory of property dualism.

Study Questions

1. What is the libertarian argument for free will?
2. What premise of this argument is accepted by both libertarians and hard determinists?
3. What is event causation?
4. What is agent causation?
5. Some people claim that our experience does not provide evidence that we sometimes act freely. What is their argument? What is the libertarian reply to this argument?

Discussion Questions

1. What theories of mind are consistent with libertarianism?
2. Agent causation is an empirical hypothesis, one that can be verified or falsified through sense experience. Describe an experiment that would determine whether there is such a thing as agent causation. What if this experiment failed? What would be the consequences for the theory of mind and our view of ourselves?
3. Are Sartre and Smullyan right that it is impossible for anything that is self-conscious not to have free will?
4. If libertarianism is true, what justification can be given for punishment? Are there types of justification for punishment available to the libertarian that aren't available to the hard determinist or the compatibilist? If so, what are they?

Internet Inquiries

1. In addition to being the name of a metaphysical theory of free will, "Libertarian" is the name of a national political party. The Web site **www.libertarianism.com** explains the basic principles of libertarianism. Must political libertarians be metaphysical libertarians? Why or why not?
2. In the movie *Firefox*, Clint Eastwood controls a plane by thought alone. Scientists have created a number of devices that use brainwaves to control physical objects, including a soon-to-be-released thought-controlled headset. Enter "thought-controlled" and "device" into an Internet search engine to explore some of these creations. Are these devices evidence for libertarian free will? Why or why not?
3. Psychologists have found that just thinking about performing an activity—like practicing the piano—can rewire your brain in the same way as actually performing it. Enter "how the brain rewires itself" into an Internet search to explore this and other apparent examples of mind over matter. Are these examples of downward causation? Do they lend support to the libertarian view of free will? Why or why not?

Baron d'Holbach

A Defense of Hard Determinism

Baron d'Holbach (1723–1789), born Paul Heinrick Dietrick in Germany, emigrated to France in 1749. In 1753 he inherited his uncle's estate and the title Baron d'Holbach. A prolific man of letters, he wrote more than four hundred articles for Diderot's encyclopedia and championed a number of controversial views, including materialism, atheism, and republicanism. To protect himself from persecution, he published his *System of Nature* under the pseudonym "M. Mirabaud" and listed its place of publication as London instead of the actual Amsterdam. In this selection, he presents his materialistic, deterministic view of humans.

Those who have affirmed that the *soul* is distinguished from the body, is immaterial, draws its ideas from its own peculiar source, acts by its own energies, without the aid of any exterior object, have, by a consequence of their own system, enfranchised [liberated] it from those physical laws according to which all beings of which we have a knowledge are obliged to act. They have believed that the soul is mistress of its own conduct, is able to regulate its own peculiar operations, has the faculty to determine its will by its own natural energy; in a word, they have pretended that man is *a free agent*. . . .

However slender the foundation of this opinion, of which everything ought to point out to him the error, it is current at this day and passes for an incontestable truth with a great number of people, otherwise extremely enlightened; it is the basis of religion, which, supposing relations between man and the unknown being she has placed above nature, has been incapable of imagining how man could either merit reward or deserve punishment from this being, if he was not a free agent. Society has been believed interested in this system; because an idea has gone abroad, that if all the actions of man were to be contemplated as necessary, the right of punishing those who injure their associates would no longer exist. At length human vanity accommodated itself to a hypothesis which, unquestionably, appears to distinguish man from all other physical beings, by assigning to him the special privilege of a total independence of all other causes, but of which a very little reflection would have shown him the impossibility. . . .

The will . . . is a modification of the brain, by which it is disposed to action, or prepared to give play to the organs. This will is necessarily determined by the qualities, good or bad, agreeable or painful, of the object or the motive that acts upon his senses, or of which the idea remains with him, and is resuscitated by his memory. In consequence, he acts necessarily, his action is the result of the impulse he receives either from the motive, from the object, or from the idea which has modified his brain, or disposed his will. . . .

This example will serve to explain the whole phenomena of the human will. This will, or rather the brain, finds itself in the same situation as a ball, which, although it has received an impulse that drives it forward in a straight line, is deranged in its course whenever a force superior to the first obliges it to change its direction. The man who drinks the poisoned water appears a madman; but the actions of fools are as necessary as those of the most prudent individuals. The motives that determine the voluptuary and the debauchee to risk their health, are as powerful, and their actions are as necessary, as those which decide the wise man to manage his. But, it will be insisted, the debauchee may be prevailed on to change his conduct: this does not imply that he is a free agent; but that motives may be found sufficiently powerful to annihilate the effect of those that previously acted upon him; then these new motives determine his will to the new mode of conduct he may adopt as necessarily as the former did to the old mode. . . .

It is the great complication of motion in man, it is the variety of his action, it is the multiplicity of causes that move him, whether simultaneously or in continual succession, that persuades him he is a free agent: if all his motions were simple, if the causes that move him did not confound themselves with each other, if they were distinct, if his machine were less complicated, he would

Source: Baron Paul Henri d'Holbach, *The System of Nature* (London: Thomas Davison, 1820) 209–214.

perceive that all his actions were necessary, because he would be enabled to recur instantly to the cause that made him act. A man who should be always obliged to go towards the west, would always go on that side; but he would feel that, in so going, he was not a free agent: if he had another sense, as his actions or his motion, augmented by a sixth, would be still more varied and much more complicated, he would believe himself still more a free agent than he does with his five senses.

It is, then, for want of recurring to the causes that move him; for want of being able to analyze, from not being competent to decompose the complicated motion of his machine, that man believes himself a free agent; it is only upon his own ignorance that he founds the profound yet deceitful notion he has of his free agency; that he builds those opinions which he brings forward as a striking proof of his pretended freedom of action. If, for a short time, each man was willing to examine his own peculiar actions, search out their true motives to discover their concatenation, he would remain convinced that the sentiment he has of his natural free agency, is a chimera that must speedily be destroyed by experience.

READING QUESTIONS

1. Why does d'Holbach claim that we have no free will?

2. Why does d'Holbach claim we think we have free will? That is, according to d'Holbach, why don't we recognize that free will is an illusion?

3. d'Holbach claims that viewing humans as natural objects subject to the laws of nature means that they cannot be held responsible for their actions. Do you agree? Why or why not?

4. d'Holbach compares the will to a ball. Is this a good analogy? Why or why not?

EDDY NAHMIAS

Is Neuroscience the Death of Free Will?

Eddy Nahmias is a professor and chair of the Philosophy Department at Georgia State University and an associate member of the Neuroscience Institute. He has written widely on the topic of free will and what science can tell us about it. In this selection, he critically examines the claim that neuroscience has shown free will to be an illusion.

Is free will an illusion? Some leading scientists think so. For instance, in 2002 the psychologist Daniel Wegner wrote, "It seems we are agents. It seems we cause what we do . . . It is sobering and ultimately accurate to call all this an illusion." More recently, the neuroscientist Patrick Haggard declared, "We certainly don't have free will. Not in the sense we think." And in June, the neuroscientist Sam Harris claimed, "You seem to be an agent acting of your own free will. The problem, however, is that this point of view cannot be reconciled with what we know about the human brain."

Such proclamations make the news; after all, if free will is dead, then moral and legal responsibility may be close behind. As the legal analyst Jeffrey Rosen wrote in *The New York Times Magazine*, "Since all behavior is caused by our brains, wouldn't this mean all behavior could potentially be excused? . . . The death of free will, or its exposure as a convenient illusion, some worry, could wreak havoc on our sense of moral and legal responsibility."

Indeed, free will matters in part because it is a precondition for deserving blame for bad acts and deserving credit for achievements. It also turns out that simply exposing people to scientific claims that free will is an illusion can lead them to misbehave, for instance, cheating more or helping others less. So, it matters whether these scientists are justified in concluding that free will is an illusion.

Here, I'll explain why neuroscience is not the death of free will and does not "wreak havoc on our sense of moral and legal responsibility," extending a discussion begun in Gary Gutting's recent Stone column. I'll argue that the neuroscientific evidence does not undermine free will. But first, I'll explain the central problem: These scientists are employing a flawed notion of free will. Once a better notion of free will is in place, the argument can be turned on its head. Instead of showing that free will is an illusion, neuroscience and psychology can actually help us understand how it works.

When Haggard concludes that we do not have free will "in the sense we think," he reveals how this conclusion depends on a particular definition of free will. Scientists' arguments that free will is an illusion typically begin by assuming that free will, by definition, requires an immaterial soul or non-physical mind, and they take neuroscience to provide evidence that our minds are physical. Haggard mentions free will "in the spiritual sense . . . a ghost in the machine." The neuroscientist Read Montague defines free will as "the idea that we make choices and have thoughts independent of anything remotely resembling a physical process. Free will is the close cousin to the idea of the soul" (*Current Biology* 18, 2008). They use a definition of free will that they take to be demanded by ordinary thinking and philosophical theory. But they are mistaken on both counts.

We should be wary of defining things out of existence. Define Earth as the planet at the center of the universe and it turns out there is no Earth. Define what's moral as whatever your God mandates and suddenly most people become immoral. Define marriage as a union only for procreation, and you thereby annul many marriages.

The sciences of the mind do give us good reasons to think that our minds are made of matter. But to conclude that consciousness or free will is thereby an illusion is too quick. It is like inferring from discoveries in organic chemistry that life is an illusion just because living organisms are made up of non-living stuff. Much of the progress in science comes precisely from understanding wholes in terms of their parts, without this

Source: Eddy Nahmias, "Is Neuroscience the Death of Free Will?" Opinionator (New York Times blog), November 13, 2011. Copyright © 2011 by Eddy Nahmias. Reprinted with permission.

suggesting the disappearance of the wholes. There's no reason to define the mind or free will in a way that begins by cutting off this possibility for progress.

● Our brains are the most complexly organized things in the known universe, just the sort of thing that could eventually make sense of why each of us is unique, why we are conscious creatures and why humans have abilities to comprehend, converse, and create that go well beyond the precursors of these abilities in other animals. Neuroscientific discoveries over the next century will uncover how consciousness and thinking work the way they do because our complex brains work the way they do.

Our capacities for conscious deliberation, rational thinking and self-control are not magical abilities.

These discoveries about how our brains work can also explain how free will works rather than explaining it away. But first, we need to define free will in a more reasonable and useful way. Many philosophers, including me, understand free will as a set of capacities for imagining future courses of action, deliberating about one's reasons for choosing them, planning one's actions in light of this deliberation and controlling actions in the face of competing desires. We act of our own free will to the extent that we have the opportunity to exercise these capacities, without unreasonable external or internal pressure. We are responsible for our actions roughly to the extent that we possess these capacities and we have opportunities to exercise them.

These capacities for conscious deliberation, rational thinking and self-control are not magical abilities. They need not belong to immaterial souls outside the realm of
● scientific understanding (indeed, since we don't know how souls are supposed to work, souls would not help to explain these capacities). Rather, these are the sorts of cognitive capacities that psychologists and neuroscientists are well positioned to study.

This conception of free will represents a longstanding and dominant view in philosophy, though it is typically ignored by scientists who conclude that free will is an illusion. It also turns out that most non-philosophers have intuitions about free and responsible action that track this conception of free will. Researchers in the new field of experimental philosophy study what "the folk" think about philosophical issues and why. For instance, my collaborators and I have found that most people think that free will and responsibility are compatible with determinism, the thesis that all events are part of a law-like chain of events such that earlier events necessitate later events. That is, most people judge that you can have free will and be responsible for your actions even if all of your decisions and actions are entirely caused by earlier events in accord with natural laws.

Our studies suggest that people sometimes misunderstand determinism to mean that we are somehow cut out of this causal chain leading to our actions. People are threatened by a possibility I call "bypassing"—the idea that our actions are caused in ways that bypass our conscious deliberations and decisions. So, if people mistakenly take causal determinism to mean that everything that happens is inevitable no matter what you think or try to do, then they conclude that we have no free will. Or if determinism is presented in a way that suggests all our decisions are just chemical reactions, they take that to mean that our conscious thinking is bypassed in such a way that we lack free will.

Even if neuroscience and psychology were in a position to establish the truth of determinism—a job better left for physics—this would not establish bypassing. As long as people understand that discoveries about how our brains work do not mean that what we think or try to do makes no difference to what happens, then their belief in free will is preserved. What matters to people is that we have the capacities for conscious deliberation and self-control that I've suggested we identify with free will.

But what about neuroscientific evidence that seems to suggest that these capacities are cut out of the causal chains leading to our decisions and actions? For instance, doesn't neuroscience show that our brains make decisions before we are conscious of them such that our conscious decisions are bypassed? With these questions, we can move past the debates about whether free will requires souls or indeterminism—debates that neuroscience does not settle—and examine actual neuroscientific evidence. Consider, for instance, research by neuroscientists suggesting that nonconscious processes in our brain cause our actions, while conscious awareness of what we are doing occurs later, too late to influence our behavior. Some interpret this research as showing that consciousness is merely an observer of the output of non-conscious mechanisms. Extending the paradigm developed by Benjamin Libet, John-Dylan Haynes and his collaborators used fMRI research to find patterns of neural activity in people's brains that correlated with their decision to press either a right or left button up to seven seconds before they were aware of deciding which button to press. Haynes concludes: "How can I call a will 'mine' if I don't even know when it occurred and what it has decided to do?"

However, the existing evidence does not support the conclusion that free will is an illusion. First of all, it does not show that a decision has been made before people are aware of having made it. It simply finds discernible patterns of neural activity that precede decisions. If we assume that conscious decisions have neural correlates, then we should expect to find early signs of those

correlates "ramping up" to the moment of consciousness. It would be miraculous if the brain did nothing at all until the moment when people became aware of a decision to move. These experiments all involve quick, repetitive decisions, and people are told not to plan their decisions but just to wait for an urge to come upon them. The early neural activity measured in the experiments likely represents these urges or other preparations for movement that precede conscious awareness.

This is what we should expect with simple decisions. Indeed, we are lucky that conscious thinking plays little or no role in quick or habitual decisions and actions. If we had to consciously consider our every move, we'd be bumbling fools. We'd be like perpetual beginners at tennis, overthinking every stroke. We'd be unable to speak fluently, much less dance or drive. Often we initially attend consciously to what we are doing precisely to reach the point where we act without consciously attending to the component decisions and actions in our complex endeavors. When we type, tango, or talk, we don't want conscious thinking to precede every move we make, though we do want to be aware of what we're doing and correct any mistakes we're making. Conscious attention is relatively slow and effortful. We must use it wisely.

We need conscious deliberation to make a difference when it matters—when we have important decisions and plans to make. The evidence from neuroscience and psychology has not shown that consciousness doesn't matter in those sorts of decisions—in fact, some evidence suggests the opposite. We should not begin by assuming that free will requires a conscious self that exists beyond the brain (where?), and then conclude that any evidence that shows brain processes precede action thereby demonstrates that consciousness is bypassed. Rather, we should consider the role of consciousness in action on the assumption that our conscious deliberation and rational thinking are carried out by complex brain processes, and then we can examine whether those very brain processes play a causal role in action.

For example: suppose I am trying to decide whether to give $1,000 to charity or buy a new TV. I consciously consider the reasons for each choice—e.g., how it fits with my goals and values. I gather information about each option. Perhaps I struggle to overcome my more selfish motivations. I decide based on this conscious reasoning (it certainly would not help if I could magically decide on no basis at all), and I act accordingly.

Now, let's suppose each part of this process is carried out by processes in my brain. If so, then to show that consciousness is bypassed would require evidence showing that those very brain processes underlying my conscious reasoning are dead-ends. It would have to show that those brain processes do not connect up with the processes that lead to my typing my credit card number into the Best Buy Web site (I may then regret my selfish decision and re-evaluate my reasons for my future decisions).

None of the evidence marshaled by neuroscientists and psychologists suggests that those neural processes involved in the conscious aspects of such complex, temporally extended decision-making are in fact causal dead ends. It would be almost unbelievable if such evidence turned up. It would mean that whatever processes in the brain are involved in conscious deliberation and self-control—and the substantial energy these processes use—were as useless as our appendix, that they evolved only to observe what we do after the fact, rather than to improve our decision-making and behavior. No doubt these conscious brain processes move too slowly to be involved in each finger flex as I type, but as long as they play their part in what I do down the road—such as considering what ideas to type up—then my conscious self is not a dead end, and it is a mistake to say my free will is bypassed by what my brain does.

So, does neuroscience mean the death of free will? Well, it could if it somehow demonstrated that conscious deliberation and rational self-control did not really exist or that they worked in a sheltered corner of the brain that has no influence on our actions. But neither of these possibilities is likely. True, the mind sciences will continue to show that consciousness does not work in just the ways we thought, and they already suggest significant limitations on the extent of our rationality, self-knowledge, and self-control. Such discoveries suggest that most of us possess less free will than we tend to think, and they may inform debates about our degrees of responsibility. But they do not show that free will is an illusion.

If we put aside the misleading idea that free will depends on supernatural souls rather than our quite miraculous brains, and if we put aside the mistaken idea that our conscious thinking matters most in the milliseconds before movement, then neuroscience does not kill free will. Rather, it can help to explain our capacities to control our actions in such a way that we are responsible for them. It can help us rediscover free will.

Reading Questions

1. According to Nahmias, what do many scientists mistakenly think free will requires?
2. What does Nahmias take free will to involve?
3. Why does Nahmias find the neuroscientific claim that consciousness occurs too late to influence behavior unconvincing?
4. Do you agree with Nahmias that you can have free will even if all of your actions are caused by prior events and laws of nature? Why or why not?

Torn Decisions

Mark Balaguer

Mark Balaguer is a professor of philosophy at California State University, Los Angeles, who has made seminal contributions to a number of areas of philosophy including philosophy of mathematics, metaphysics, and free will. In this selection from his book, Free Will, *he explains what's involved in making torn decisions and how they can give us free will.*

We're finally ready to say where we do want free will. Or better, we're ready to say where we want to have *not-predetermined* free will. We want it in connection with a certain *subset* of our conscious decisions. In particular, we want it in connection with what we can call *torn* decisions. Torn decisions can be defined as follows:

> A *torn decision* is a conscious decision in which you have multiple options and you're torn as to which option is best. More precisely, you have multiple options that seem to you to be more or less tied for best, so that you feel completely unsure—or entirely torn—as to what you ought to do. And you decide *while* feeling torn.

Let me make three quick points about torn decisions. First of all, notice that I'm only talking here about decisions that you make *while* feeling torn. Sometimes we start off feeling torn but then we think about the situation for a while, and we come up with reasons for favoring one of our options, and we no longer feel torn. In cases like this, you're not making a torn decision. Rather, you're making a decision that started off looking like it might be torn but then turned out not to be. In contrast to this, a torn decision occurs when you decide while you're still torn. For instance, in the ice cream case, you might decide while feeling utterly torn between chocolate and vanilla. And the reason you would want to choose while still feeling torn should be obvious; if you got to the front of the line, and everyone was waiting, it would make a lot more sense to make a torn decision—that is, to *just choose*—than it would to keep on deliberating, or to just stand there until it became clear to you which flavor you wanted.

Second, it's important to remember that torn decisions are always *conscious* decisions. So we have to distinguish torn decisions from what might be called torn *actions*. I'm thinking here of cases where we're in "torn situations" and we settle them without stopping to think about it, and without making a conscious decision. Here are two examples of this:

(i) You're driving down the street when a child suddenly runs in front of your car. You don't have time to stop, but you can avoid hitting the child by jerking the wheel to the left or the right and there's no obvious reason for choosing either option. You jerk the wheel to the left without consciously deciding to do so. In other words, you just *react*.

(ii) You go to the grocery store to get a can of Campbell's tomato soup. There are five nearly identical cans lined up next to each other on the shelf—yes, just like the Andy Warhol painting (you're very clever)—and you grab one of the cans without pausing to think about which one you should take.

We don't exercise our free will in cases like these, and once again, we should thank our lucky stars that we don't *have* to. In cases like (i), it would be bad to have to exercise our free will because in order to do this we would have to act *consciously*, and as psychologists and neuroscientists have shown in numerous studies, consciousness is very *slow*. When you're in an emergency situation (or when you're playing basketball or something like that), you don't want to have to engage your conscious mind. It's much better to have the ability to simply *react*, unconsciously. As for (ii), we don't want free will in cases like this either, but the reason is different. It's because it would be *boring*. No one wants to have to stop and think about which can of Campbell's soup to buy, because we don't *care*—it just doesn't matter which one we buy. We only want to engage our free will when we're faced with torn situations that

Source: Balaguer, Mark., *Free Will*, pp. 63–69, 75–78, © 2014 Massachusetts Institute of Technology, by permission of The MIT Press.

we care about. So, for instance, if you're faced with a choice between tomato soup and mushroom soup, and if you're torn as to which one to get, then you *do* want to engage your conscious free will. But you don't want to bother doing this when you're picking between two identical cans of tomato soup. You'd look like an imbecile, standing there in the aisle of the supermarket waffling between the two cans, weighing them in your hands to see whether perhaps one of them had a bit more soup in it.

Third, it's important to be clear about *how often* we make torn decisions. The answer, I think, is several times a day. Think about a normal day. You might make torn decisions about whether to have eggs or cereal for breakfast. Or whether to drive to work or ride your bike. Or if you're driving, whether to take surface streets or the freeway. Or whether to work through lunch or eat with your friend Andre. Or whether to go to a movie in the evening or stay home. Or if you're in a restaurant, you might make a torn decision about which entrée to order.

But while we make several torn decisions a day, it's not as if we're *constantly* making them. If you're watching a movie, or talking to a friend on the phone, or driving home from work on "auto-pilot," you're not making torn decisions. But if you think about an ordinary day, I think you'll notice that you make torn decisions fairly often. We seem to make at least a few of them every day.

So the picture that's emerging here is that of a person plodding through her day without exercising her free will, and then every once in a while—sometimes once an hour, sometimes less, sometimes more—she comes to a fork in the road, and she has to make a torn decision as to which way to go. She chooses one of the two roads, and then she plods on, without exercising her free will until she comes to another fork in the road. . . .

Let me say one more thing about torn decisions before moving on. The examples of torn decisions that I've mentioned here are all pretty unimportant. They're about things like whether to have soup or salad with your dinner. So you might conclude from this that the whole topic of torn decisions is unimportant. But don't be fooled. First of all, some of our torn decisions can be very important. For instance, you might have a good job offer in a city you hate, and you might be utterly torn and have to decide without knowing what you should do. Second, even though a single, individual torn decision can seem very unimportant, the sum total of *all* of these decisions starts to seem important. If you didn't have control over *any* of the little decisions that you made in your life, that would be tantamount to saying that you didn't have control over your *life*. Having free will is largely about having free will over a whole bunch of little decisions. And finally, while these little torn decisions can seem unimportant while you're lying on the couch reading about free will, when you're actually in the moment—when you're about to make a torn decision—it doesn't *feel* unimportant. Imagine, for instance, that you're in a fancy restaurant, and there are two items on the menu that look really good to you. You're torn as to which one to order. Of course, there's a sense in which it doesn't really matter what you get. After all, you'll be dead in a hundred years anyway. But the fact of the matter is that we *do* care about decisions like this. When the waiter comes to the table and you're about to choose, you *care*. And when you're at the theater trying to decide whether to see *Death Blow* or *Rochelle, Rochelle*, you care again. And I would argue that you *should* care. Who wants to go through life not caring about stuff like this? You'd be bored out of your mind. I mean, come on; what the hell else is there to care about? . . .

So far we've found that for a decision to be free in this sense, it has to satisfy two conditions: first, it can't be *predetermined*, and second, it can't be random. But now that we know more about the kind of randomness that we're talking about here, we can be more precise about what this sort of free will amounts to. In particular, we can say this:

> *Not-predetermined free will* For a decision to be a product of my free will (in the sense of *not-predetermined* free will, as opposed to *Hume*-style free will), two things need to be true. First, it needs to have been *me* who made the decision; and second, my choice needs to have not been predetermined by prior events. In other words, it needs to be the case that (a) I did it, and (b) nothing *made* me do it.

That's what free will is. Or rather, this is what free will *would* be, if in fact we have it. But, of course, the jury is still out on whether we actually have this kind of free will.

A second important lesson that we've learned about free will in this chapter is that it's not something that we exercise *continuously*. In other words, if we have free will, then we only exercise it *intermittently*, at certain specific moments. In particular, we only exercise free will (if we have it at all) when we make torn *decisions*—when we're in situations where we're confronted with multiple options that seem equally good to us, and we stop and think for at least a brief moment about what we should do, and then we settle the matter with a conscious *choosing*. That's it. We don't exercise free will (and we don't need to or want to) at any other time.

The last point I want to make here is that the picture of free will that I've painted in this chapter is perfectly

Control Yourself **241**

compatible with both the materialistic, scientific view of humans and the spiritual, religious view. What I've said here, in a nutshell, is that for a decision to be a product of my free will, it needs to be the case that (a) I did it, and (b) nothing *made* me do it. This, I think, is what you should say, whether you believe in nonphysical souls or not. Of course, if you endorse a materialistic view, you'll say that conscious decisions are physical *brain* events, whereas if you endorse a spiritualistic view, you'll presumably want to say that conscious decisions are nonphysical actions of nonphysical souls. But either way, you should say that for a decision of mine to be *free*, it needs to be the case that I did it and nothing *made* me do it. That's just what free will is. Or, again, to be more precise, it's what (not-predetermined) free will would be, if we have it.

READING QUESTIONS

1. What is a torn decision?
2. According to Balaguer, what conditions must be met for an action to be free?
3. According to Balaguer, what sort of actions cannot be considered to be free?
4. Do you believe that the conditions Balaguer specifies are enough to make an action free, or is something else needed?

GEOFFREY KLEMPNER

The Black Box

Geoffrey Klempner is the editor of *Philosophy for Business*, the director of Pathways School of Philosophy, and the Director of Studies for the International Society for Philosophers. In this short story, he explores the problem of foreknowledge and free will.

The fighter's head spun. He never saw the swift uppercut that sneaked under his guard catching him neatly on the left side of the jaw. He felt a vicious stab of pain at the back of his cranium, and a cold fog seemed to descend over the ring. For a few moments he gazed at the crowd, an expression of puzzlement in his eyes as if he were surprised to see anyone there, then at the bloodied face of his opponent. At last his head seemed to nod in recognition, his knees buckled and he sank gently to the canvas.

Later, in the bar, Danny was commiserating with his friend Joe. 'I just don't know how it could've happened,' Joe was wailing. 'A hundred quid it's cost me. My man was way ahead on points. He'd knocked that lump of lard down twice, no, three times. There was no way he could have lost.'

'Well, he did lose,' said Danny in a sombre tone that suggested a profound truth about the nature of human existence. The two men contemplated the truth in silence. Then Danny spoke again. 'He lost his concentration for a fraction of a second, that's all.'

Joe said nothing. That fraction of a second had swallowed up the week's housekeeping money. That night, Joe had a dream. At first, he thought he'd woken. Next to him, his wife Betty looked serene. On her face there was no hint of the furious row they'd had that evening. Then his heart stopped as he became aware that someone else was in the room. From the shadows a tall figure in a shabby anorak approached, its face hidden by a voluminous hood.

'You don't know me, but I know you,' came a well-spoken man's voice, barely above the level of a whisper. Joe lunged at the figure, but his arms grasped at thin air. 'I'm sorry about your bet, but I knew you'd lose,' continued the voice unperturbed. 'You haven't been very lucky lately, have you?' Joe did not reply. It was a statement, not a question. 'That's why I've come to make you a proposal. I think you'll find it quite attractive.'

'Don't tell me, you want to buy my soul!' laughed Joe. 'Well you're in luck. It's going cheap.' He was no longer afraid, but settling down to enjoy his dream.

'No, not at all,' replied the voice. 'I have a gift for you. You can accept the gift or reject it, there's no catch. Then it's up to you how you use it.'

Joe noticed a small black box on the bedside table. He picked it up. The only features were a red button, and next to it in large white capitals the words, 'PRESS HERE.' For a few seconds Joe's finger hovered, then he carefully placed the box back on the table.

'Very wise,' said the hooded figure. 'You want to know what it does first. I'll tell you everything, we've got nothing to hide. In our organisation, we know the future like a book. On the basis of our exhaustive knowledge of the present state of the physical universe—I'll spare you the details!—we are able to predict every event that will ever happen, the birth of a solar system, the falling of a leaf, with perfect accuracy. Now, the answers to any questions that you will ever wish to ask about the future are stored in that box. Need I say more?'

'Yes you do!' said Joe defiantly. 'What you've just told me doesn't add up. It's one thing being able to predict the course of physical events, whether large or small. For the sake of argument, I'll grant you that, though the idea seems utterly far fetched. But if you then make your predictions available to human agents, you've introduced a new variable which wasn't part of the prediction, and that is what a person such as myself chooses to do with that so-called knowledge. If you had told me that I was going to go to the boxing match yesterday, you would have given me a reason that I previously didn't have for not going, namely, to prove you wrong!'

Source: Geoffrey Klempner, "The Black Box," *The Possible World Machine*, http://www.pathways.plus.com/world/. Copyright © Geoffrey Klempner. All rights reserved. Used with permission.

'How naive of you!' the hooded figure admonished Joe condescendingly. 'Do you suppose that we haven't already included what you're going to do with the information as part of the calculation? I assure you everything has been taken into account.'

'Then you already know whether I'm going to accept your gift or not?'

'Precisely. Now, will you take it?'

Joe's tongue moved to form the word 'No' but he found himself saying 'Yes.' Joe awoke to find his wife already up and dressed. He was about to tell her of his strange dream when he noticed with a stab of fright the black box in her hands.

'I suppose this is what you spent the money on!' Betty looked at Joe accusingly. 'For God's sake, don't press that button,' cried Joe. 'Why not?' Seeing her husband panic, she tossed the box carelessly from one hand to the other. Then she pressed the button. From inside the box came a woman's voice. 'Thank you for calling. Please state your question after the tone. . . .Beep.'

'Oh God, what am I going to do now?' blubbered Joe.

'You're going to take the box from your wife.'

Without thinking, Joe grabbed the box and put it on the bed. He waited to see what else it would do, but nothing happened. Keeping his eyes fixed on the mysterious device, Joe told Betty about the man in the anorak. Betty's mouth grew wider and wider.

'You expect me to believe that!'

'You heard what happened.'

For the first time, Betty's face showed signs of doubt. Joe saw his chance to take charge of the situation. Controlling his fear, he slowly reached forward and pressed the button. 'Go on, ask it something!'

'Thank you for calling. Please state your question after the tone. . . .Beep.'

Betty hesitated. 'All right. What am I going to do now?'

'In fifteen seconds time you will make a phone call to your friend Judy.' 'Well I'm not, so there!' replied Betty, marching over to the dressing table. On the table she noticed a note that she'd scribbled two days before: 'Judy's birthday tomorrow.'

'Oh drat!' Without thinking, she marched over to the phone, picked it up and dialled. As her friend's voice came on she slammed the phone down. The penny had dropped.

Joe laughed with glee. 'My turn now!' He asked the box for the complete list of winners at Kempton Park horse races that afternoon. As the woman in the box recited the names, Joe's eyebrows rose several times. Then he phoned his bookmaker to place a £50 accumulator. 'We're going to be rich!'

Joe and Betty danced around the bedroom.

Betty sipped a Bacardi and Coke as the Caribbean sun beat down on pale yellow sands that stretched as far as the eye could see. The azure ocean merged at the horizon with a cloudless sky. 'Darling,' she said suddenly, it's been a wonderful holiday, but I'd really like to go home now. I miss my friends.'

Joe looked desperate. 'We can't.'

'Why ever not? Is there something you haven't told me?' As she stared into Joe's pleading eyes, Betty felt her insides turn to ice.

'I asked the box this morning how long the holiday was going to go on and it said another two months,' Joe said in a flat tone. 'There's no point in trying to leave, something's bound to stop us.'

Betty's eyes flashed with anger. 'The box! You told me you'd left it behind!'

'I was going to,' said Joe breaking into sobs, 'then I asked it whether I would leave it behind and it said no.'

Betty gripped his shoulders. 'Listen to me. We've got to get rid of it!' But Joe avoided her eyes.

'There's nothing we can do.'

The kitchen table was strewn with empty beer cans. Joe was alone. In front of him the black box seemed to grow larger and larger until it filled his field of vision. Gripped by an irresistible desire and an equally strong aversion, Joe willed his hand not to move. But he had to know. He pressed the red button.

'Thank you for calling. Please state your question after the tone. . . .Beep.'

'Whaddam I g'n do now?'

Joe's voice was barely comprehensible but the box replied immediately. 'In one minute's time you're going to drink another can of beer.'

Joe surveyed the table. All the cans were empty. He felt a surge of joy. He counted them to make sure. He'd bought twelve and drunk twelve. There was no more drink in the house. 'I'm free, free at last!'

At that moment, the door bell rang. It was his friend Danny. 'I heard things weren't going too well for you,' said Danny. 'I thought I'd drop by to watch the snooker.' In his arms were two six-packs of beer.

Reading Questions

1. Is it possible for the character in this story not to do what the box says he will do? Suppose he could stray from what's predicted. Would that prove that he has free will? Explain.

2. Suppose your every action could be accurately predicted, even actions that you will perform in the distant future. Would that prove that all your actions are causally determined? Why or why not?

3. If there were a box that predicted every event in your existence, right up to your death, would you want to have it? To take a more realistic situation (one that some people have actually had to face), suppose you learn that you may have a genetic defect that virtually guarantees your death in fifteen years. A simple genetic test can tell you whether you have the defect. Would you want to take the test, or would you choose not to know your fate?

4. Suppose the box in this story was operated by an all-knowing God. Would the owner of the box be free to act otherwise than what God had written?

Notes

1. This example adapted from Daniel Kolak and Raymond Martin in *The Experience of Philosophy* (Belmont, CA: Wadsworth, 1993) 149.
2. William James, "The Dilemma of Determinism," *The Will to Believe and Other Essays in Popular Philosophy* (Cambridge, MA: Harvard University Press, 1979) 117–118.
3. Samuel Butler, *Erewhon* (New York: Lancer Books, 1968) 131–132.
4. Margot Slade, excerpt from "In a Growing Number of Cases, Defendants Are Portraying Themselves as the Victim" from *The New York Times* (May 20, 1994).
5. Clarence Darrow, *Attorney for the Damned* (New York: Simon & Schuster, 1957) 64–65.
6. John Steinbeck, *The Grapes of Wrath* (New York: Viking Press, 1939) 32.
7. William James, "The Dilemma of Determinism," quoted in Martin Gardner, *The Whys of a Philosophical Scrivener* (New York: Quill, 1983) 104.
8. Pierre-Simon Laplace, *A Philosophical Essay on Probabilities*, trans. F. W. Truscott and F. L. Emory (New York: Dover, 1951) 4.
9. Baron d'Holbach, "Of the System of Man's Free Agency," *The System of Nature*, Chapter XI (1770), trans. H. D. Robinson (Manchester: Clinamen Press Ltd., 2000).
10. Baruch Spinoza, Letter 62 (58) (to G. H. Schuler), *The Ethics and Selected Letters*, ed. Seymour Feldman, trans. Samuel Shirley (Indianapolis: Hackett, 1982) 250.
11. Boethius, *The Consolation of Philosophy*, book 5, trans. W. V. Cooper (London: J. M. Dent, 1902) 145, 147.
12. John Calvin, *Institutes of the Christian Religion*, trans. John Allen (Philadelphia: Presbyterian Board of Publication Book, 1813), book 3, chap. 21, sec. 5.
13. Peter van Inwagen, *An Essay on Free Will* (Oxford: Clarendon Press, 1983) 16.
14. Somerset Maugham, in the play *Sheppey*.
15. Isaiah Berlin, *Four Concepts of Liberty* (Oxford: Oxford University Press, 1969) 113.
16. B. F. Skinner, *Beyond Freedom and Dignity* (New York: Bantam, 1971) 18.
17. J. B. Watson, "What the Nursery Has to Say About Instincts," *Psychologies of 1925*, ed. C. Murchison (Worcester, MA: Clark University Press, 1926).
18. B. F. Skinner, *Beyond Freedom and Dignity* 19.
19. Morton Hunt, *The Universe Within* (New York: Simon & Schuster, 1982) 63.
20. Thomas J. Bouchard, Jr; David T. Lykken; Matthew McGue; Nancy Segal; Auke Tellegen, "Sources of Human Psychological Difference: The Minnesota Study of Twins Reared Apart," *Science* 250 (October 12, 1990) 223.
21. Kathleen D. Vohs and Jonathan W. Schooler, "The Value of Believing in Free Will," *Psychological Science* 19 (2008) 49–54.
22. Tyler F. Stillman, et al., "Personal Philosophy and Personnel Achievement: Belief in Free Will Predicts Better Job Performance," *Social Psychological and Personality Science* 1 (2010) 43–50.
23. Roy F. Baumeister, et al., "Prosocial Benefits of Feeling Free: Disbelief in Free Will Increases Aggression and Reduces Helpfulness," *Personality and Social Psychology Bulletin* 35 (2009) 260–268.
24. Saul Smilansky quoted in Stephen Cave, "There's No Such Thing as Free Will," *The Atlantic*, June 2016.
25. Quoted in Jeffrey Saver, "Father of a New Science," *Science Digest* 90 (May 1982) 86.
26. "Impact of Genetics, Social Factors on Delinquency." ScienceDaily 15 July 2008. 30 July 2008, http://www.sciencedaily.com/releases/2008/07/080714092752.htm.
27. Daniel Kevles, *In the Name of Eugenics: Genetics and the Uses of Human Heredity* (New York: Knopf, 1985).
28. John H. Hick, *Death and Eternal Life* (San Francisco: Harper & Row, 1976) 119.
29. Patricia Smith Churchland, excerpt from "Is Determinism Self-refuting?" from *Mind* 40 (1981).
30. Quoted in Jeffrey Saver, "Father of a New Science" 86.
31. Paul Davies, "What Happened before the Big Bang?" *God for the 21st Century*, ed. Russell Stannard (Philadelphia: Templeton Foundation Press, 2000) 15.
32. Fritz Rohrlich, "Facing Quantum Mechanical Reality," *Science* 221 (1983) 1251.
33. Martin Gardner, *The Whys of a Philosophical Scrivener* (New York: Quill, 1983) 109.
34. John Dupré, "The Solution to the Problem of the Will," *Philosophical Perspectives* 10 (1995) 390.
35. Davide Castelvecchi, "People Can Sense Single Photons," *Nature*, https://www.nature.com/news/people-can-sense-single-photons-1.20282, accessed 4/20/2018.
36. Sarah Gibbons, "Why the Scent of Blood Lures Wolves but Repels People," https://news.nationalgeographic.com/2017/10/blood-molecule-e2d-humans-wolves-evolutionary-biology-science-spd/ accessed 4/20/2018.
37. Gregory S. Engel et al. "Evidence for Wavelike Energy Transfer through Quantum Coherence in Photosynthetic Systems," *Nature* 446 (April 12, 2007) 782–786.
38. Aaron Mamiit, "Birds See Magnetic Fields with a Special Protein in Their Eyes: That's How They Navigate," http://www.techtimes.com/articles/224378/20180404/birds-see-magnetic-fields-with-a-special-protein-in-their-eyes-thats-how-they-navigate.htm, accessed 4/20/2018.
39. Johann Summhammer et al., "A Quantum-Mechanical Description of Ion Motion within the Confining Potentials of Voltage-gated Ion Channels," *Journal of Integrative Neuroscience*, 11 (2012) 123.
40. Max Born, quoted in Arthur Eddington, *New Pathways in Science* (New York: Macmillan, 1935) 82.
41. Eddington 87.
42. James 118.
43. Richard R. Taylor, *Metaphysics*, 1974, Pearson Education, Inc.
44. James, quoted in Gardner 104.
45. A. J. Ayer, "Freedom and Necessity," *Philosophical Essays* (London: Macmillan & Co., Ltd., 1954) 271.
46. Peter van Inwagen, *Metaphysics* (Boulder, CO: Westview, 2002) 202ff.
47. John Locke, *An Essay Concerning Human Understanding*, book 2, chap. 21, sec. 9 (Oxford: Clarendon Press, 1991) 238.
48. Thomas Hobbes, *The Questions Concerning Liberty, Necessity, and Chance*, 1656 (vol. V of collected works).
49. Hobbes.
50. Walter T. Stace, *Religion and the Modern Mind* (Philadelphia: Lippincott, 1952) 254–255.
51. Moritz Schlick, *Problems of Ethics* (New York: Dover, 1962) 152.
52. Saul Smilansky, "Determinism and Prepunishment: the Radical Nature of Compatibilism," *Analysis* 67 (2007) 348.
53. Richard Taylor, *Metaphysics*, 2nd ed. (Englewood Cliffs, NJ: Prentice-Hall, 1974) 49–50.
54. Ian Sample, "The Brain Scan That Can Read People's Intentions," *The Guardian* (February 9, 2007) 1.
55. Sample 1.
56. Taylor 50–51.
57. Samuel Chavkin, *The Mind Stealers: Psychosurgery and Mind Control* (Boston: Houghton Mifflin, 1978) 12–13.
58. Harry G. Frankfurt, "Freedom of the Will and the Concept of a Person," *Journal of Philosophy* 68 (January 1971) 12.

59. Frankfurt 19.
60. Harry Frankfurt, excerpt from "Alternate Possibilities and Moral Responsibility" from *Journal of Philosophy* 66 (December 1969). Excerpt from "Freedom of the Will and the Concept of a Person" from *Journal of Philosophy* 68 (January 1971).
61. Robert Kane, *The Significance of Free Will* (New York: Oxford University Press, 1998) 142–144. David Widerker, "Libertarianism and Frankfurt's attack on the principle-of-alternative-possibilities," *Philosophical Review*, 104, (1995) 247–61.
62. Maria Alvarez, "Actions, thought-experiments and the 'Principle of alternate possibilities'", *Australasian Journal of Philosophy*, 87 (2009) 61–81.
63. Michael Slote, "Understanding Free Will," *Journal of Philosophy* 77 (March 1980) 149.
64. Robert Kane, "Precis of *The Significance of Free Will*," *Philosophy and Phenomenological Research* 60 (2000) 130.
65. Daniel Dennett, "I Could Not Have Done Otherwise: So What?" *Journal of Philosophy* 81 (October 1984) 553.
66. Albert Einstein, "My Credo," http://www.einstein-website.de/z_biography/credo.html, accessed 10/15/18.
67. Thomas Reid, *Essays on the Active Powers of the Human Mind*, in *The Works of Thomas Reid*, 8th edition, ed. Sir William Hamilton (Hildesheim, Zurich, New York: Olms Verlag, 1983) 599.
68. Carl Ginet, *On Action* (Cambridge: Cambridge University Press, 1990) 90.
69. Benjamin Libet, "Do We Have Free Will?" *Journal of Consciousness Studies* 6, no. 8–9 (1999) 51.
70. Vilaynur Ramachandran, quoted in Bob Holmes, "Irresistible Illusions," *New Scientist* 159 (1998) 35.
71. David Rumelhart, quoted in Morton Hunt, *The Universe Within* (New York: Simon & Schuster, 1982) 357.
72. Anthony Jack and Phillip Robbins, "The Illusory Triumph of Machine over Mind," *Behavioral and Brain Sciences* 27 (2004) 17.
73. Adina L. Roskies, "Why Libet's Studies Don't Pose a Threat to Free Will," *Conscious Will and Responsibility* (Oxford: Oxford University Press, 2010) 20.
74. *Ibid*, 20.
75. Alexander Schlegel et al., "Hypnotizing Libet: Readiness Potentials with Non-conscious Volition," *Consciousness and Cognition*, 33 (2015) 196–203.
76. *Ibid.*, p. 198.
77. Judy Trevena and Jeff Miller, "Brain Preparation Before a Voluntary Action: Evidence against Unconscious Movement Initiation," *Consciousness and Cognition* 19 (2010) 447–456.
78. Aaron Schurger et al., "An Accumulator Model for Spontaneous Neural Activity Prior to Self-Initiated Movement," *Proceedings of the National Academy of Sciences of the United States of America* 109 (2012) 2904–2913.
79. Aaron Schurger quoted in Anil Ananthaswamy, "Brain Might Not Stand in the Way of Free Will," *New Scientist* 215 (August 6, 2012) 10.
80. B. J. Baars and K. McGovern, "Cognitive Views of Consciousness: What Are the Facts? How Can We Explain Them?" ed. M. Velmans, *The Science of Consciousness: Psychological, Neurophysiological, and Clinical Reviews* (London: Routledge, 1996) 75. See also: Moran Cerf et al., "On-line, voluntary Control of Human Temporal Lobe Neurons," *Nature* 467 (2010) 1104–1108.
81. Lewis Baxter et al., "Caudate Glucose Metabolic Rate Changes with Both Drug and Behavior Therapy for Obsessive-Compulsive Disorder," *Archives of General Psychiatry* 49 (Sept. 1992): 681–689. See also: Jeffrey Schwartz and Sharon Begley, *The Mind and the Brain: Neuroplasticity and the Power of Mental Force* (New York: Regan Books, 2002).
82. Roderick Chisholm, "Human Freedom and the Self," *Free Will*, ed. G. Watson (New York: Oxford University Press) 24–35.
83. Daniel Dennett, *Freedom Evolves* (New York: Viking, 2003) 100.
84. Roderick Chisholm, "Agents, Causes, and Events: The Problem of Free Will," *Agents, Causes, and Events*, ed. Timothy O' Connor (New York: Oxford University Press, 1995) 95.
85. Jean-Paul Sartre, *Being and Nothingness*, trans. Hazel E. Barnes (New York: Philosophical Library, 1956) 439–441.
86. Raymond Smullyan, "Is God a Taoist?" *The Tao Is Silent* (New York: Harper & Row, 1977) 107–108.
87. Timothy O'Connor, "Agent Causation," *Agents, Causes and Events*, ed. Timothy O'Connor (New York: Oxford University Press, 1995) 173–200.
88. For a detailed neurophysiological explanation of how that might work, see: Peter Ulric Tse, *The Neural Basis of Free Will: Criterial Causation* Cambridge: MIT Press, 2013).
89. Galen Strawson, "Libertarianism, Action, and Self-Determination," *Agents, Causes and Events*, ed. Timothy O'Connor (New York: Oxford University Press, 1995) 16.
90. Robert Nozick, "Choice and Determinism," *Agents, Causes and Events*, ed. Timothy O'Connor (New York: Oxford University Press, 1995) 101–114.
91. Mark Balaguer, "A Coherent, Naturalistic, and Plausible Formulation of Libertarian Free Will," *Nous* 38 (September 2004) 382.
92. Balaguer 387.
93. Mark Balaguer, "Libertarianism as a Scientifically Reputable View," *Philosophical Studies* 93 (1999) 194–195.

Chapter 4
The Problem of Personal Identity

> *Of all knowledge the wise and good seek most to know themselves.*
> —WILLIAM SHAKESPEARE

Suppose it's sometime late in the twenty-first century, and you have come down with one of the last incurable diseases. Your doctor informs you that conventional medicine can do nothing to save you. There is, however, a new procedure that may allow you to escape what otherwise would be certain death. Cognitive scientists have recently perfected a device that uploads the contents of your brain (your mind?) into an organic computer composed of "biochips." These biochips have the same causal powers as neurons. The computer is housed in a robot body that can be made to look like you at any stage of your adult life. The robot is outfitted with visual, auditory, olfactory, tactile, and gustatory sensors. After the transfer, the new body functions, from the outside, just like a healthy human organism. It says things like, "I used to have that body over there." "I'm no longer in pain, and my new body produces the same feelings and sensations that the old one did." But the questions remain: Are such bodies really conscious, or are they merely cleverly designed robots? If they are conscious, are they the very same conscious beings that once had the old sick bodies, or are they different beings? If they are different, what happened to the conscious beings with the old sick bodies? Have they ceased to exist? If you were dying, would you accept the offer to upload the contents of your brain into such a computer?

To answer this question, you must decide whether you would survive the transfer. Would the robot with the contents of your brain be you? The answer you give will depend on your theory of personal identity—that is, on your theory of what makes a person at one time (the earlier person) identical to a person at another time (the later person).

> *Man may be defined as the animal that can say "I," that can be aware of himself as a separate entity.*
> —ERICH FROMM

All of us undergo a number of changes throughout our lives. Not only do our bodies change, but so do our minds. Our beliefs, attitudes, and desires, for example, may be very different now from what they were ten years ago. Nevertheless, we ordinarily assume that these changes happen to one and the same person. How is that possible? How can a person change and yet still remain the same person? This is the question that theories of personal identity try to answer.

Our concern for ourselves differs from our concern for anyone else. Although we may be sorry to learn that someone else is about to die, we would not anticipate his or her death in the same way we would anticipate our own. One way to test theories of personal identity, then, is to determine whether you would be as concerned for someone in the future as you would be for yourself. Suppose, in the case above, you knew that there was a good chance that the person in the robot body would suffer great pain immediately after the transfer as the system adjusted itself. Do you believe that you would be the person experiencing the pain? If so, there's reason to believe that the robot is you.

People are not only concerned about their futures; they are also responsible for their pasts. Justice requires that only those responsible for committing a crime be punished for it. It wouldn't be fair to punish you for a crime that you didn't commit. Similarly, it wouldn't be fair to punish someone else

- for something you did. Another way to test theories of personal identity, then, is to determine whether the later person would be responsible for something the earlier person had done. Suppose you had committed a crime before you underwent the transfer. Would we be justified in putting the robot in jail? If so, there's further reason to think that the robot is you.

Although most people have probably never seriously considered the possibility of having their minds uploaded into a robot, many Christians believe that their minds will eventually be uploaded into another body, for the Bible teaches that after we die, we will be reborn in a new body.

St. Paul's first letter to the Corinthians is the source of this teaching:

> What you sow does not come to life unless it dies. And what you sow is not the body which is to be, but a bare kernel perhaps of wheat or of some other grain. But God gives it a body as he has chosen, and to each kind of seed its own body. For not all flesh is alike, but there is one kind for men, another for animals, another for birds, and another for fish. There are celestial bodies and there are terrestrial bodies; but the glory of the celestial is one, and the glory of the terrestrial is another. There is one glory of the sun, and another glory of the moon, and another glory of the stars; for star differs from star in glory. So is it with the resurrection of the dead. What is sown is perishable, what is raised is imperishable. It is sown in dishonor, it is raised in glory. It is sown in weakness, it is raised in power. It is sown a physical body, it is raised a spiritual body. If there is a physical body, there is also a spiritual body.[1]

Our souls belong to our bodies, not our bodies to our souls.

—HERMAN MELVILLE

Some take this passage to mean that we will get a transformed physical body in the afterlife; others take it to mean that we will get a brand-new spiritual body. Either way we will get a body. But if we can survive the transfer from a
- physical body to a spiritual body, couldn't we also survive the transfer from a physical body to a robot body?

Not only should a theory of personal identity help us decide whether we can survive the death of our bodies, it should also help us decide whether we can survive other sorts of change. Suppose, for example, that Frank, a right-wing extremist who believes that the government has no right to tax the rich to give to the poor, blows up an Internal Revenue Service (IRS) office and injures a number of people. To escape capture, he sets up residence in a small community and changes his name to Robert. After working in the local soup kitchen for a number of years, he joins the fire department and becomes very active in community service projects. He also joins a local church and teaches Sunday school regularly. One night, while studying the Bible, he has a religious experience and becomes a born-again Christian. As a result, he decides to devote his life to helping the needy. Robert now finds it impossible to identify with the thoughts, feelings, and desires that motivated Frank. Frank's beliefs, attitudes, and values seem totally alien to Robert. Although Robert can vaguely remember the bombing, he knows that he now could never do such a thing. If Robert were captured by the FBI, should he be punished for the bombing committed by Frank? It is wrong to punish one person for what

We do not believe in immortality because we have proved it, but, we forever try to prove it because we believe it.

—JAMES MARTINEAU

> I don't want to achieve immortality through my work. . . . I want to achieve it through not dying.
>
> —Woody Allen

another person did. Are Robert and Frank the same person? If not, Robert shouldn't have to suffer for Frank's crimes.

How we answer the question "Are Robert and Frank the same person?" depends on how we interpret the phrase "the same." When we say that one thing is the same as another, we may be saying that they have the same qualities. For example, when we say that a car on one dealer's lot is the same as a car on another dealer's lot, we may mean that they are the same make, model, and year, and thus have identical features. This type of sameness is known as **qualitative identity** because if two things are the same in this sense, they have the same qualities.

When we say that one thing is the same as another, however, we may be saying that they are one and the same thing. For example, when we say that a car on a used car lot is the same one that our family traded in, we may mean that it is the very same car that our family once owned. This type of identity is known as **numerical identity** because two different descriptions are being used to refer to one and the same thing.

To use another example, suppose you go swimming in the ocean and lose your class ring. You can buy another ring that is qualitatively identical to your original ring, but it will not be numerically identical to it because it is not the very ring you lost. So, qualitative identity does not imply numerical identity. On the other hand, someone might find a ring on the beach that is qualitatively very different from your original ring: It might be corroded; it might even be missing the jewel. Nevertheless, it might be numerically identical to your original ring. That is, it might actually be your original ring. So, numerical identity doesn't imply qualitative identity either.

Your original class ring can undergo many changes and yet continue to be one and the same ring. But there are some sorts of changes that it cannot undergo without ceasing to exist. For example, if it became so corroded that it broke into pieces, or if it were melted down, it would no longer exist. When something changes, it loses one or more properties. If something can survive the loss of a property, the property is said to be **accidental** to it. If it cannot survive the loss of a property—if it's impossible for the thing to exist without that property—the property is said to be **essential** to it.

Identity conditions (also known as "persistence conditions") are conditions that must be met for a thing to retain its identity over time. They indicate what makes a thing at one time numerically identical to something at another time. Theories of personal identity try to specify the identity conditions for persons. They tell us what kinds of changes a person could undergo and still remain the same (numerically identical) person.

One way to figure out the identity conditions for people is to consider what sorts of changes they would survive. You would survive a haircut. You would lose some hair, but you wouldn't cease to exist. So having a certain amount of hair is not essential to you. But what if you got total amnesia and lost all memory of your past experiences? Would you survive that sort of change? A theory of personal identity should answer that sort of question.

qualitative identity Two objects are qualitatively identical if and only if they share the same properties (qualities).

numerical identity Two objects are numerically identical if and only if they are one and the same.

accidental property A property a thing can lose without ceasing to exist.

essential property A property a thing cannot lose without ceasing to exist.

> ### In the Courts: Kathleen Soliah, a.k.a. Sara Jane Olson
>
> On June 16, 1999, the FBI arrested former Symbionese Liberation Army (SLA) member Kathleen Soliah in St. Paul, Minnesota. Soliah allegedly participated in a number of bombings and bank robberies conducted by the SLA in the 1970s. In the ensuing years, Soliah had taken on a new identity. She had changed her name to Sara Jane Olson, married a doctor, and become an active member of her church. Prior to her bail hearing, her lawyer, Stuart Hanlon, even went so far as to claim that she was a different person:
>
>> That girl who left is not the same person who now exists in 1999 in Minnesota. She's a mature woman with all these ties to the community and she would never run. And I think that's the argument that people in Minnesota understand and we've got to convince a California judge of that.[2]
>
> At the bail hearing, many people testified that she was not the sort of person who would skip bail, let alone commit a crime.
>
> #### Thought Probe
>
> A Different Person
>
> Kathleen Soliah certainly seems to be a qualitatively very different person than she was in the 1970s. Is she numerically different? Is she different enough that she should get a reduced sentence?

Theories of personal identity try to answer the question: What makes a person at one time identical to a person at another time? This question should be distinguished from the question: How do we tell whether a person at one time is identical to a person at another time? The former question is a metaphysical question because it tries to determine the nature of personal identity. The latter is an epistemological question because it tries to determine the kinds of evidence we use to judge whether persons are identical. These two questions are related, but they are not identical. The relation is analogous to that between a disease and its symptoms. What makes it the case that someone has Lyme disease, for example, is that he or she is infected with a particular bacterium. The way we tell whether someone has Lyme disease, however, is by looking for symptoms such as a bull's-eye rash.

Answering the metaphysical question of personal identity should help us answer the epistemological one. Once we know what makes a person at one time identical to a person at another time, we should be better able to tell whether people are numerically identical. A theory of personal identity that makes it impossible to tell whether two people are identical is not an adequate theory.

We will begin our foray into the problem of personal identity by considering two theories that tie our identity to different kinds of substance. We will then consider a number of theories that tie our identity to our psychology. Finally, we will consider some of the theories that try to combine the two approaches.

Objectives

After reading this chapter, you should be able to

- state the various theories of personal identity.
- describe the thought experiments that have been used to test them.
- evaluate the strengths and weaknesses of the various theories of personal identity.
- define qualitative identity, numerical identity, apparent memory, real memory, psychological connectedness, and psychological continuity.
- formulate your own view of the possibility of an afterlife.

Section 4.1

We Are Such Stuff as Dreams Are Made On
Self as Substance

*T*he problem of personal identity is a species of the problem of change: How can something change and yet remain the same thing? If something changes, it's different. And if it's different, it's no longer the same. So how can something retain its identity through change?

Although the problem of change greatly exercised the ancient Greek philosophers, the first person to provide a systematic account of identity conditions was John Locke. In the first edition of *An Essay Concerning Human Understanding,* Locke criticized Descartes' view that our identity resided in our souls, but he didn't provide a positive account of his own. He realized, however, that any adequate account of moral responsibility must come to grips with the problem of personal identity, for as he says, "In this personal identity is founded all the Right and Justice of Reward and Punishment."[3] It's not fair to reward or punish people for something they didn't do. So at the urging of his friend William Molyneaux, Locke issued a second edition of the *Essay,* which contained a new chapter entitled "Of Identity and Diversity" that set out his views on the subject.

According to Locke, whether a thing at one time is identical to a thing at another time depends on the type of thing it is or the respect in which it is considered. The identity conditions for masses of matter, such as rocks or lumps of clay, differ from those for living things, such as plants or animals.

Masses of matter retain their identity as long as they retain the atoms out of which they're made. If they gain or lose any atoms, they become different. As Locke puts it, "If one of these Atoms be taken away, or one new one added, it is no longer the same mass, or the same Body."[4]

Living things, however, are constantly gaining or losing atoms because they take in nutrients and excrete waste products. The matter they consume is used to grow new cells or repair damaged ones. If an organism lives long enough,

My one regret in life is that I am not someone else.

—WOODY ALLEN

> *Substance is enduring, form is ephemeral.*
>
> —Dee Hock

all of the matter that originally constituted it may be replaced. Nevertheless, says Locke, an organism can retain its identity over time as long as its parts remain organized in a way that allows it to perform its characteristic functions. For example, an oak tree can be identical to a sapling, as long as both share the same functional organization and there is a continuous development from the sapling to the oak tree. In that case, Locke says that the sapling and the oak tree partake of a "common life."

The functional organization of a living thing is essential to it. If an organism lost the ability to perform its characteristic functions, it would cease to exist. For example, if we cut up or burned down an oak tree, it would cease to exist, because it would no longer be able to perform the functions characteristic of oak trees.

Like other living things, the human body is constantly replacing the matter that makes it up. Biologists tell us that it takes about seven years to replace all of the matter in a human body. So none of the atoms that are in your body now were in your body seven years ago. Yet your body today is numerically identical to your body of seven years ago, because throughout the replacement process, it has maintained the same functional organization.

The identity conditions for artifacts are similar to those for living things. For example, you can replace the tires, air filter, fuel pump, and the like in your car and still have the (numerically) identical car. Locke uses a watch to illustrate this point:

> What is a Watch? 'Tis plain 'tis nothing but a fit organization or Construction of Parts, to a certain end, which, when a sufficient force is added to it, it is capable to attain. If we would suppose this Machine one continued Body, all whose organized Parts were repaired, increas'd, or diminished, by a constant Addition or Separation of insensible Parts, with one Common Life, we should have something very much like the Body of an Animal.[5]

A watch is designed to perform a certain function in a certain way. As long as the changes made to it don't prevent it from performing its function in that way, the changes preserve its (numerical) identity.

Thought Probe

Hobbes's Ship of Theseus

Suppose that the planks in Theseus's ship had been replaced one by one over the years until none of the original planks remained. Suppose further that the original planks had not been destroyed but had been stored in a warehouse. Now suppose that the original planks were put back together in their original order. Now the continuously repaired ship and the ship made of the original planks are docked next to each other in the harbor. Which of the two ships is identical to the original ship? Can Locke's theory of identity conditions help us answer this question? If so, how?

Persons

Persons are beings with full moral standing, including the right to life. What gives them this status, as we saw in Chapter 1, is not the stuff out of which they're made, but what they can do with that stuff. Persons have the ability to reason and the ability to be conscious of their continued existence over time. Locke agrees. He defines a person as a "thinking intelligent being that has reason and reflection; and can consider it self as it self, the same thinking thing in different times and places."[6] Rationality and self-consciousness, then, are what distinguish persons from other sorts of beings.

Consciousness is the glory of creation.

—JAMES BROUGHTON

To be rational and self-conscious, however, you don't have to be human. In fact, many people believe in the existence of at least one nonhuman person— the Judeo-Christian God. To make the point that persons need not be humans, Locke doesn't appeal to God. He appeals to a talking parrot!

It seems that a story was circulating in the eighteenth century about an old parrot in Brazil that could not only talk but also ask and answer questions. Here's the English translation of the conversation Locke reports between the parrot and a prince (the parrot apparently spoke Portugese although the dialogue was recorded in French).

> [W]hen it [the parrot] came first into the room where the prince was, with a great many Dutchmen about him, it said presently, "What a company of white men are here!" They asked it, what he thought that man was, pointing to the prince. It answered, "Some General or other." When they brought it close to him, he asked it, "Whence come ye?" It answered, "From Marinnan." The Prince, "To whom do you belong?" The parrot, "To a Portugueze." The Prince, "What do you there?" Parrot, "I look after the chickens." The Prince laughed, and said, "You look after the chickens?" The parrot answered, "Yes, I do; and I know well enough how to do it."[7]

By quoting this conversation, Locke is endorsing not its truth but only its possibility. His point is that it's conceivable for there to be a rational, self-conscious parrot. If so, then being a biological human being is not a necessary condition for being a person.

Thought Probe

Dolphins

Are dolphins nonhuman persons? Some scientists think so. Dolphins' ratio of brain size to body weight is larger than ours, they recognize themselves in mirrors, they have names for themselves, and they have been known to go out of their way to save people from shark attacks, sometimes swimming in circles around threatened swimmers for up to 40 minutes until the shark left. What do you think? What implications would adopting this view have? What behaviors and activities would have to change?

Animalism

We know now that the soul is the body and the body the soul.
—GEORGE BERNARD SHAW

Some people believe that identity resides in the body. In their view, we are animals first and foremost, and we continue to exist as long as our bodies continue to exist. Like all other animals, we retain our identity as long as our bodies retain a certain functional organization. As long as your body continues to perform its animal functions—respiration, circulation, digestion, and the like—you continue to exist. According to **animalism,** then, identical persons are those with identical living human bodies.

In support of animalism, Eric Olson offers the following thought experiment.

Thought Experiment

The Vegetable Case

Imagine that you fall into what physiologists call a persistent vegetative state. As a result of temporary heart failure, your brain is deprived of oxygen for ten minutes . . . by which time the neurons of your cerebral cortex have died of anoxia. Because thought and consciousness are impossible unless the cortex is intact, and because brain cells do not regenerate, your higher mental functions are irretrievably lost. You will never again be able to remember the past, or plan for the future, or hear a loved one's voice, or be consciously aware of anything at all. . . .

The subcortical parts of the brain, however, . . . are more resistant to damage from lack of blood than the cerebrum is, and they sometimes hold out and continue functioning even when the cerebrum has been destroyed. Those . . . sustain your "vegetative" functions such as respiration, circulation, digestion, and metabolism. Let us suppose that this happens to you. . . . The result is a human animal that is as much like you as anything could be without having a mind.

The animal is not comatose. Coma is a sleep-like state; but a human vegetable has periods in which it appears to be awake. It can respond to light and sound, but not in a purposeful way; it can move its eyes, but cannot follow objects consistently with them. . . .

Neither is the animal "brain-dead," for those parts of its brain that maintain its vegetative functions remain fully intact. . . . The patient is very much alive, at least in the biological sense in which oysters and oak trees are alive. . . .

How can we be sure that the patient in this state has really lost all cognitive functions? . . . there may be room for doubt. So imagine that you lapse into a persistent vegetative state and that as a result your higher cognitive functions are destroyed and that the loss is permanent.

. . . My question in the Vegetable Case is whether the human animal that results when the cerebrum is destroyed is strictly and literally you, or whether it is no more you than a statue erected after your death would be you. Do you come to be a human vegetable or do you cease to exist . . . ?[8]

animalism The doctrine that identical persons are those with identical living human bodies.

Olson claims that if you became a vegetable, you wouldn't cease to exist, for your ability to think is not essential to you. You can permanently lose that ability without ceasing to be. But your ability to breathe air, circulate blood, and digest food is essential to you. Only when your body stops performing these functions do you cease to exist.

According to animalism, then, what makes you *you* is your body—not your mind. It follows that being a person is not an essential property of you. Like the property of being a student, you can lose that property and continue to exist. Olson explains: "Perhaps we cannot call that vegetating animal a person, since it has none of those psychological features that distinguish people from non-people (rationality, the capacity for self-consciousness, or what have you)."[9] According to Olson those in a permanent vegetative state have ceased to be persons, but they haven't ceased to exist.

Olson's view is at odds with Descartes'. As we saw in Chapter 2, Descartes contends that you are your mind. His conceivability argument is designed to show that your mind is essential to you—that you cannot exist without a mind. So who's right, Olson or Descartes? We can begin to answer that question by exploring the consequences of animalism.

One consequence is that you cannot survive the death of your body. Animalists cannot believe in heaven or hell as traditionally conceived, because there are no physical bodies there. But that doesn't mean that they can't believe in an afterlife. In their view, you can live again as long as your body lives again.

Some people hope to reanimate their bodies by preserving them in liquid nitrogen. This process, known as cryonic suspension, involves draining all of the blood out of the body, replacing it with antifreeze, and immersing the body in a vat of liquid nitrogen at a temperature of −321 degrees Fahrenheit. Once immersed, the body undergoes very little deterioration. Those who elect this procedure hope that one day a way will be found to resuscitate their bodies. (This was baseball great Ted Williams's hope. His body and head are currently floating in separate cannisters of liquid nitrogen.) The cost of this procedure is rather steep, around $150,000. There is an economy plan, however. For around $80,000, technicians will freeze just your head. In any event, if cryonic suspension were the only way to survive the death of the body, very few of us could look forward to an afterlife.

Those who accept the body theory, however, may look forward to another type of afterlife: resurrection. Physical objects can survive disassembly and reassembly. Consider, for example, a watch that has been taken apart for cleaning. While the parts of the watch lie scattered on the jeweler's table, the watch doesn't exist. Yet when the parts are reassembled, the watch once again exists. Theoretically, then, you could live again if the atoms that made up your body before you died were put back together in their original configuration.

The view that immortality involves the resurrection of the body has been a part of the Christian religion from the beginning. Jesus achieved immortality through resurrection, and his followers thought that what happened to him would happen to them. Early Christians did not cremate their dead because they thought that a cremated body would be difficult, if not impossible, to

Neither can I believe that the individual survives the death of his body, although feeble souls harbor such thoughts through fear or ridiculous egotism.

—ALBERT EINSTEIN

In the News: Eternal Life through Cloning

Many people who believe in or hope for eternal life imagine that it will involve some sort of supernatural mind transfer to a spiritual body in heaven, for example, or to another physical body on Earth (reincarnation). Some, however, believe that we can gain eternal life through a natural mind transfer. Certain transhumanists, as discussed earlier, believe that we will eventually be able to transfer our minds to powerful computers. The religious leader Rael, however, looks forward to the day when we will be able to transfer our minds into clones of ourselves, as happened in the Arnold Schwarzenegger movie *The 6th Day*. CNN interviewed Rael, the founder of Raelianism, whose subsidiary—Clonaid—claimed to have produced the first human clone in 2002.

> Former French journalist Claude Vorilhon, who now calls himself Rael, claims to be a direct descendant of extraterrestrials who created human life on Earth through genetic engineering. A company founded by his followers announced Friday that the first human clone has been born—a 7-pound baby girl dubbed "Eve."
>
> The announcement was met with skepticism and concern, since other cloned mammals have had serious birth defects or developed health problems later. But in an interview with CNN, Rael dismissed concerns about health problems in cloned animals, saying "I have no doubt the child will be perfectly healthy."
>
> "Everybody in the world now is crazy about what if the child has a problem. What if? I say, what if the child is perfectly healthy and beautiful? I think opponents to cloning are more afraid of that than of the faults," he said. . . .
>
> The Raelians eventually hope to develop adult clones into which humans could transfer their brains, Rael said. "Cloning a baby is just the first step. For me, it's not so important," he said. "It's a good step, but my ultimate goal is to give humanity eternal life through cloning."[10]

Thought Probe

Safe Cloning

How Rael plans to get our minds into our clones, he doesn't say. But suppose that cloning turns out to be as safe as in vitro fertilization and that the mind transfer produces no ill effects. Would it be wrong to try to achieve immortality this way?

> *Our Lord has written the promise of the resurrection, not in books alone, but in every leaf in spring-time.*
> —Martin Luther

resurrect. We now know, however, that cremation doesn't destroy the atoms that make up a body. So if God really is all-powerful and all-knowing, he or she should be able to resurrect even a cremated body.

The notion of resurrection is not without its problems, however. In the normal course of events, after we die, our atoms become part of the soil. This soil may be taken up by the roots of a plant, and this plant may be eaten by another human. So one body may contain atoms that once were part of another human being. If God wants to resurrect both, who gets the shared atoms? This is a point that has not been lost on theologians. As English mathematician and philosopher Bertrand Russell recounts, St. Thomas Aquinas was perplexed by this problem:

> St. Thomas Aquinas, the official philosopher of the Catholic Church, discussed lengthily and seriously a very grave problem, which, I fear, modern theologians unduly neglect. He imagines a cannibal who has never eaten anything but human flesh, and whose father and mother before him had like propensities. Every particle of his body belongs rightfully to someone else. We cannot suppose that

those who have been eaten by cannibals are to go short through all eternity. But, if not, what is left for the cannibal? How is he to be properly roasted in hell, if all his body is restored to its original owners? This is a puzzling question, as the Saint rightly perceives.[11]

> To desire immortality is to desire the eternal perpetuation of a great mistake.
> —Arthur Schopenhauer

In densely populated areas of the globe that have been inhabited for thousands of years, the same atoms could have been parts of numerous bodies. After all, water gets recycled, and we are about 75 percent water. How is a general resurrection possible in such a situation?

There is an even more serious problem with resurrection, however. As our cells die off and are replaced, we continually get new sets of atoms. Which set of atoms will be resurrected? The set you had at the last moment of your physical existence? But what if you died a cripple suffering from Alzheimer's disease? Would you want that body to be resurrected? Or would you want some younger version of yourself to be resurrected?

The animalists would have us believe that if your body were reanimated, whether through resuscitation or resurrection, you would live again. But what if your body were brought out of cryonic suspension and it was in a permanent vegetative state. Would that make the $150,000 investment worthwhile? Or what if your body was resurrected but somebody else's mind was placed in it. Would you live again?

One way to address these issues is to consider the question: What does the word "I" refer to? When we use the word "I," are we referring to our bodies (as the animalists believe) or are we referring to something else? Martin Benjamin proposes the following thought experiment to get at this question.

Thought Experiment

Benjamin's Questionable Cure

Imagine you have just been diagnosed with a terrible disease that will soon ravage your body and end your life. A surgeon then comes along who offers the possibility of a dramatic new operation guaranteed to stop the disease in its tracks. There is, however, one very serious side effect. The operation is very long and the anesthetic very powerful. One of the consequences is that, although the disease will be cured, you will emerge from the operation in a permanent vegetative state. But, the surgeon cheerfully emphasizes, at least you will be alive! The operation will cure the disease and your life will be saved. Finally, let us suppose, the operation is very expensive. To cover its costs you will have to use up your entire life savings and sell all your possessions. The question now is, will you agree to undergo the operation?[12]

Would you be willing to undergo an operation that would leave you in a permanent vegetative state? Would you survive such an operation? Benjamin doesn't think so. He writes,

The Definition of Death

Death has traditionally been defined as the cessation of respiration and circulation. People were declared dead when they stopped breathing and their hearts stopped beating. With the advent of such medical marvels as heart-lung machines, however, it became possible for machines to take over those vital functions, thus keeping people alive far past the time when they would have traditionally been declared dead. This moved doctors and legislators to define death as the cessation of all brain activity, or brain death. For a person to be declared brain-dead, there must be no detectable brain activity, either in the neocortex (the higher brain), which is responsible for mental life, or in the brainstem (the lower brain), which regulates bodily functions like respiration and circulation. But many people believe that a patient can cease to exist long before the entire brain dies. They claim that if the neocortex is dead, and the patient is permanently unconscious, the patient has ceased to exist. Dan Wikler defends this view by means of a thought experiment:

> Consider this thought experiment: A man is decapitated, and physicians are able to keep both the head and the body functioning more or less as normal. They cannot, however, reconnect them. Which is the patient?
>
> The answer cannot be "Both," for body and head may be widely separated in location. Nearly everyone able to choose one or the other will, I believe, choose the head. After decapitation, the head *is* the patient, and the conditions of its health and death are those of the patient as a whole....
>
> This is, very roughly, what happens in persistent vegetative state. Though brain and body remain physically intact, they are functionally severed. Those parts of the brain that make consciousness and feeling possible are irreversibly lost, and the continued functioning of the body has no more significance in the patient's life than would, say, a kidney removed from his body and prospering for decades to come in the body of another. That the whole body (except for relevant parts of the brain) is involved rather than one organ is not a difference that makes a difference.
>
> What bearing does such an outlandish thought experiment have on the real-world clinical and legal issue of brain death? It does not show that the expanded [higher-brain] definition would be practical, or even desirable. But it does show that it is conceptually sound, and given the mental leap required to view as dead a patient whose body is fairly healthy, this is an essential accomplishment.[13]

Thought Probe

Permanently Unconscious

According to Wikler, Terri Schiavo died in 1980 when she became permanently unconscious. Do you agree that patients who are permanently unconscious have ceased to exist? Should we adopt a higher-brain definition of death? What would be its advantages and disadvantages?

> When I put this question to myself, the answer is clear. Whether or not I have the operation, it seems to me that I will be dead. That is, *I*—the being whose motivation for having the operation is to live to meet my grandchildren, watch them grow, finish the book I am working on, enjoy conversation and travel with my wife, and see the Chicago Cubs win the World Series—will not survive in either case. Whether I have the operation or forgo it, *I*—whatever exactly *I* refers to here—will be dead. Though my body will survive the operation, *I*—the person whose body it is—will not.[14]

Benjamin here sides with Descartes—thinking is essential to him. If his body were alive but he could no longer think, he would have ceased to exist. So whatever the word "I" refers to, Benjamin claims it doesn't refer to one's body.

Another piece of evidence against animalism is the possibility of body switches. That possibility has been extensively explored in both literature and film. Franz Kafka describes such a switch in his story "The Metamorphosis." In that story, a young man goes to sleep and wakes up with the body of a beetle. Yet he retains his personality, his memory, his character. So there is reason to believe that he is the same person. If such a body switch is possible, having the same body is not a necessary condition for being the same person.

Kafka doesn't tell us how the transformation took place. Given what we now know of genetics, however, such transformations seem physically possible. Scientists have fused an entire human chromosome into a rat cell. (A chromosome is one complete strand of DNA, the chemical that contains the instructions for making body parts.) Scientists believe that if enough genetic material were fused into the rat cells, the rats would start to grow human organs.

The consequences of mixing the DNA of different species are examined in a series of movies based on the short story "The Fly," by George Langelaan. In the 1986 film version, Jeff Goldblum has the DNA of a fly fused into his own cells as the result of an experiment with a transporter. As the fly DNA begins to express itself, he acquires the features of a fly. If he doesn't lose his mind in the process, he may continue to exist in the fly's body.

"The Metamorphosis" and "The Fly" suggest that persons are not identical to their bodies. We can undergo a "body switch" without ceasing to exist. The most famous body switch in the philosophical literature, however, is found in John Locke's writings. He suggests that it is possible for a prince to switch bodies with a cobbler without losing his personal identity.

Thought Experiment

Locke's Tale of the Prince and the Cobbler

For should the Soul of a Prince, carrying with it the consciousness of the Prince's past Life, enter and inform the Body of a Cobbler as soon as deserted by his own Soul, every one sees, he would be the same Person with the Prince, accountable only for the Prince's actions.[15]

The body switch described by Locke is one most people have no difficulty imagining. If it happened at night, we can imagine the prince waking up in the cobbler's hut. No doubt he would be quite astonished to find himself in these strange surroundings, but his surprise would be nothing compared to the shock he would get when he looked in the mirror. Instead of seeing his own face, he would see the face of the cobbler. But, as Locke suggests, if his consciousness was not affected—if his memories, personality, and character remained intact—he would still be the prince, even though he was now in the cobbler's body.

The possibility of such body switches has been extensively explored in such films as *Big, Heaven Can Wait, All of Me, Freaky Friday, 18 Again, Vice Versa, Like Father Like Son, Dream a Little Dream, Ghost, Self/less* and *Altered Carbon*, and others. Although such body switches are not technologically possible at

this time, they certainly seem to be logically possible. And if we are to believe functionalists like Ray Kurzweil, they will be actual in the next 30 years. But if they can occur, our identity can't reside in our bodies, for in that case, having the same body is not necessary for being the same person.

Animalists are committed to the view that body switches can't occur. But what happens in the case of a brain transplant? Suppose your brain is transplanted into another body. Does your identity continue to reside in your original body or do you go where your brain goes? Olson poses the problem this way:

Thought Experiment

The Transplant Case

... Imagine that an ingenious surgeon removes your cerebrum ... and implants it into another head. ... Your cerebrum comes to be connected to that human being in just the way that it was once connected to the rest of you. .. and so it is able to function properly inside its new head just as it once functioned inside yours.

The result is a human being who is psychologically more or less exactly like you. ... On the other hand, she does not remember anything that happened to the person into whose head your cerebrum was implanted, nor does she acquire anything of that person's character (at least at first).

The puzzle, as you have no doubt guessed, is what happens to you in this story (call it the "Transplant Case"). Are you the biologically living but empty-headed human being that has inherited your vegetative functions? Or are you the person who ends up with your cerebrum and your memories? (Or has the operation simply brought your existence to an end?)[16]

Olson would have us believe that you are the empty-headed human lying on the table. In his view, no body switch has occurred, for brain transplants are no different than liver transplants. Getting a new brain no more alters your identity than getting a new liver.

Peter Unger disagrees. He claims that your identity resides in your brain. To prove his point, he modifies Olson's transplant case slightly. He envisions a brain transplant where you and your identical twin swap brains. Who will you be after the operation? Will you be the person composed of your twin's body and your brain or the person composed of your original body and your twin's brain? The way to tell, Unger claims, is to decide which person you would want to protect from great pain.

Thought Experiment

Unger's Great Pain

Let's consider such a case involving you and, not someone qualitatively quite unlike you, but rather your precisely similar twin. ...

> First about the person who ends up with your original brain and a new body, we ask this question: With the choice flowing fully from your purely egoistic concern, will you choose to (have yourself) suffer considerable pain right before this case's wild processes begin if your *not* taking the bad hit up front will mean that, soon after its processes are complete, the person then with your brain and thus with your mind will suffer *far greater pain*? Yes, of course you will. Though not completely conclusive, this strongly indicates that, as we most deeply believe, throughout this case, you're the person with your brain.
>
> Second, and yet more tellingly, we ask the parallel question: With the choice flowing fully from your purely egoistic concern, will you choose to (have yourself) suffer considerable pain right before this case's wild processes begin if your *not* taking the bad hit up front will mean that, soon, after all its processes are complete, the person with your body, but with your twin's mentally productive brain, thus will suffer *far greater pain*? Not at all, from an egoistic basis, that's a *poor* choice. Though this response might not be absolutely decisive, it's quite conclusive enough. So, we conclude, well enough, that *you haven't even the slightest belief that here you're the being (with your healthy old body) who's inherited your vegetative biological functioning.*[17]

According to Unger, the reason that you would be willing to put up with considerable pain prior to the operation to prevent the person composed of your twin's body and your brain from experiencing even greater pain afterward is that it would prevent you from experiencing great pain. So contrary to what the animalists would have us believe, your identity does not reside in your body; it resides in your brain (or your mind).

This conclusion is bolstered by the fact that you would not be willing to experience considerable pain prior to the operation to prevent the person composed of your body and your twin's brain from experiencing even greater pain afterward. Why? Because the resulting person wouldn't be you. So, again, it appears that we are not identical to our bodies.

Because animalism identifies individuals with bodies, it's committed to the view that there can be only one individual per body. This follows from the principle of the transitivity of identity: If A = B, and B = C, then A = C. In other words if two or more individuals are identical to the same thing, they must be identical to each other. But just as it seems possible for one person to inhabit two or more bodies, it seems possible for two or more people to inhabit the same body. If such "double occupancy" can occur, then animalism is mistaken. There's reason to believe, however, not only that bodies can house more than one person, but that some actually do.

Consider, for example, those suffering from multiple-personality disorder. The personalities involved may differ not only in temperament but also in age and sex. They can have different brain wave patterns, different vocal patterns, and even different memories. Some say this makes them different persons. Courts of law have treated them that way. In cases where someone suffering from multiple-personality disorder has been asked to testify, judges have had each of the different personalities sworn in separately

In the Courts: Multiple-Personality Disorder

There is some evidence that the different personalities in those suffering from multiple-personality disorder can have different memories. Does this make the different personalities different persons? During the trial of a man who was charged with raping a woman suffering from multiple-personality disorder, Winnebago County, Wisconsin, Circuit Judge Robert Hawley required the victim to take an oath each time she changed personalities. The judge assumed that the different personalities did not have memory of taking the oath.[18]

Dr. Frank W. Putnam, Jr., a psychiatrist and physiologist at the National Institute of Mental Health in Bethesda, Maryland, has studied multiple-personality disorder for a number of years and has made a number of remarkable discoveries, as reported in the *New York Times Magazine*:

> In the course of his experiments, Dr. Putnam has identified startling differences in the brain waves of the alternate personalities of patients suffering from multiple-personality disorder. Indeed, these waves may vary from one personality to another as much as they vary from one normal person to another.
>
> A second study conducted by Dr. Putnam and his colleagues suggests that each personality may have its own memory. And still another, a study of voice changes among alternate personalities, shows that so-called "multiples" may have abnormally wide vocal ranges and a surprising ability to radically alter speech patterns and habits....
>
> As a result of their flights, whether from true danger or imagined, multiples miss parts of their lives. "Losing time" is one of the most frequent symptoms of a person suffering multiple-personality disorder, and it may be the crucial signal to mental-health workers that they are treating a multiple. Natasha, for example, has suddenly reappeared to find herself in Chicago, St. Louis and Paris as well as in toy stores and in the bedrooms of men she cannot recall meeting....
>
> Some multiples, like Judy, choose to remain multiple. Judy's fiancé, John, the head of the sociology department at a Middle Western university (Judy regularly commutes to see him), is supporting her decision to remain multiple. John has seen most of Judy's personalities. He likes Judy best, but greatly admires the intellectual Mary. He has also survived the suicidal bouts with Lea, a self-destructive alternate whom he has cradled in his arms until a less destructive alternate took over the body.
>
> "At first I didn't know what to make of it," he says. "I would get into a fight with someone and suddenly be talking to someone else who didn't even know a fight had gone on. Do you know how frustrating it is being mad at someone who doesn't have any idea what she's done?"[19]

Thought Probe

Multiple Personalities

The standard treatment for multiple-personality disorder is to try to fuse the different personalities into one. Suppose you're a psychologist treating someone with this disorder, and suppose further that one of the personalities wants you to proceed with the fusing therapy while another does not. What should you do? If fusing causes all of the memories of some of the personalities to be lost forever, would fusing be an act of murder? Why or why not?

because they didn't want to assume that each personality shared the same memories. (See the box on multiple-personality disorder.) If the different personalities can be considered different persons, however, persons can't be identical to their bodies.

The most effective way to prove that something is possible is to show that it's actual. Consider the case of the conjoined twins Abigail and Brittany Hensel. Abigail and Brittany have the same body, but they are two separate

individuals—the result of a single egg that failed to divide fully into identical twins. Brittany controls the left side of the body and Abigail, the right. Nevertheless, they have learned to swim, ride a bike, and play the piano. Because animalism is committed to the view that there can be only one individual per body, it must deny that Abigail and Brittany are separate individuals. That is extremely difficult to do, however, given that each can fully articulate her own thoughts, feelings, and desires. They attended school and receive separate grades. They recently applied for drivers licenses and received separate licenses. By providing a concrete counterexample to animalism, the Hensel twins effectively refute it.

The Soul Theory

Many people believe that they will achieve immortality by undergoing a body switch of the sort described by Locke. Those who believe in reincarnation believe that their souls will enter new physical bodies. Those who believe in heaven believe that their souls will enter new spiritual bodies. The members of both groups, however, believe that their identity resides in their souls. This suggests the **soul theory**—the doctrine that identical persons are those with identical souls.

soul theory The doctrine that identical persons are those with identical souls.

St. Augustine: Soul Man

About the time that the Roman Empire was collapsing and the so-called Dark Ages were beginning, the great Christian philosopher and theologian Augustine (A.D. 354–430) came on the scene. He was born in North Africa to a pagan father and a Christian mother. So in more ways than one, Augustine had one foot in the ancient world and the other in medieval times. It should not be surprising then that he spent much of his life trying to fuse these two worlds together, to take the wisdom of the ancients and meld it with medieval Christianity. In the process, he introduced many ideas into Christian thought that would have been foreign to early Christians but that are now commonplace in contemporary Christianity.

From Plato (via the ancient Platonist philosopher Plotinus), Augustine got the dualistic notion of reality consisting of two distinct realms. One sphere is perfect, eternal, and nonmaterial, and the other is flawed, fleeting, and physical. We are made of stuff from each realm, says Augustine. To the inferior physical realm belong our bodies, as transitory as ice on a stove. But to the eternal, noncorporeal world belong our eternal, noncorporeal selves known as "immortal souls." Thus it was Augustine who introduced into Christian thought a new way to achieve immortality: a soul or self that can separate from the body and still live on. Before Augustine, the prevailing notion among Christians was that body and soul were a single unit, and immortality could be achieved only if the body were resurrected.

In his book *The City of God,* Augustine draws out the distinction between the two worlds in great detail. He says that everyone is a citizen of both these realms at once. The true, eternal one is the kingdom of God. The ephemeral, false one consists of the kingdoms of the material world. In the kingdom of God, there are true knowledge, true values, and true life. In the earthly kingdoms, none of these exist.

Augustine came to these conclusions gradually. In fact, he did not embrace Christianity until age thirty-three. During his early years he reveled in the earthly kingdoms—having several love affairs, taking a concubine and fathering a child by her, and indulging in petty theft and lies. He loved the lustful life—and hated it. He used to pray, "Give me chastity and continence, only not yet."

ST. AUGUSTINE
A.D. 354–430

Although the soul theory of personal identity enjoys a good deal of popular support, it is even more problematic than animalism, for no one knows what a soul is. Animalism was promising because the nature of bodily identity was fairly clear. No one, however, has any idea of what the identity of souls consists in. Souls can't be identified by their composition or by their location in space because they have traditionally been held to be immaterial and thus have neither composition nor location in space. Until we know what makes souls identical, we cannot use souls to explain what makes persons identical. The unknown cannot be explained in terms of the incomprehensible.

Souls have traditionally been considered to be thinking substances. They are not thoughts; they are things that think. So the relation between a soul and its thoughts can be likened to that between a pincushion and its pins. Just as a pincushion is distinct from the pins stuck in it, so a soul is distinct from the thoughts it has.

The advantage of distinguishing between a soul and its thoughts is that it provides a solution to the problem of personal identity. All of us are constantly changing. Nevertheless, these changes seem to happen to one and the same person. How is that possible? The soul theory has a ready answer: Although our thoughts are constantly changing, the thing that has the thoughts—the soul—remains the same. Just as one and the same pincushion can have different pins stuck in it at different times, so one and the same soul can have different thoughts in it at different times.

According to the soul theory, you are your soul. It is what makes you you. It is your essence, your nature, your true self. The soul theory, then, is committed to the view that as long as your soul exists, you exist. Is this true? Leibniz thinks not. To prove his point, he offers the following thought experiment.

Four thousand volumes of metaphysics will not teach us what the soul is.

—VOLTAIRE

Thought Experiment

The King of China

The immortality which is demanded in morals and in religion does not consist in this perpetual subsistence [of soul] alone, for without the memory of what one had been it would not be in any way desirable. Let us suppose that some individual were to become King of China at one stroke, but on condition of forgetting what he had been, as if he had been born anew. [I]s it not as much in practice or as regards the effects which one can perceive, as if he were to be annihilated and a King of China to be created at his place at the same instant? Which this individual has no reason to desire.[20]

In Leibniz's day, the King of China was the wealthiest person in the world. Many people would like to hold that title. But if the price they had to pay was the loss of all their memories, they might think twice about it. Without their memories, it's doubtful that they would be around to enjoy all that wealth.

> ## Transubstantiation
>
> According to the Roman Catholic Church, substance switches are not only possible, they are actual. A substance switch occurs every time a duly ordained priest serves communion.
>
> At the Last Supper Jesus told his followers: "'Take, eat; This is my body.' And he took a cup, and when he had given thanks he gave it to them, saying, 'Drink of it, all of you; for this is my blood of the covenant, which is poured out for many for the forgiveness of sins.'"[21] The Roman Catholic Church takes Jesus at his word here. It claims that Jesus turned the bread and wine at the Last Supper into his body and blood by saying, "This is my body" and "This is my blood." Similarly, it claims that priests can turn the bread and wine at communion into the body and blood of Christ by saying, "This is my body; this is my blood." The transformation occurs as a result of a process known as *transubstantiation*.
>
> First canonized in the fourth Lateran Council of 1215, the doctrine of transubstantiation was reaffirmed by the Council of Trent in 1563: "Because Christ our Redeemer said that it was truly his body that he was offering under the species of bread, it has always been the conviction of the Church of God, and this holy Council now declares again, that by the consecration of the bread and wine there takes place a change of the whole substance of the bread into the substance of the body of Christ our lord and of the whole substance of the wine into the substance of his blood. This change the holy Catholic Church has fittingly and properly called transubstantiation."
>
> When the priest says the sacred words, the bread and the wine undergo a substance switch. They retain all of their perceptible qualities, but now those qualities reside in a different substance—namely, the substance of Jesus Christ.

Who we are seems intimately connected to our memories. If we were to permanently lose all memory of our lives, there's reason to believe that we would cease to exist, regardless of what happened to our souls.

To see this, suppose that when your soul goes to heaven, it loses all of its memories. The person with your soul would therefore have no idea who you are or what you've done. In such a case, would going to heaven be something to look forward to? Or suppose that cryonically freezing a brain erases all of its memories, so when your body is resuscitated, the person in it has no recollection of your life. Would you have been resuscitated? Or suppose that you were convicted of a capital crime and the judge offered you the options of being executed or having all of your memories erased. Would one alternative be more desirable than the other? In all of these cases, the answer seems to be "No." What this suggests is that you cannot be your soul. There must be more to being the same person than simply having the same soul.

The foregoing considerations suggest that having the same soul is not sufficient for being the same person. But maybe it's necessary. Maybe you can't be the same person unless you have the same soul. But even this is doubtful.

Souls are supposed to be distinct from the thoughts they have. Thoughts come and go, but souls stay the same. Consequently, it's conceivable that thoughts could be transferred from one soul to another just as pins can be transferred from one pincushion to another, or programs from one computer

A soul is but the last bubble of a long fermentation in the world.

—GEORGE SANTAYANA

to another. Nothing we know about souls precludes such soul switches. In fact, the Catholic Church believes that a soul switch of sorts occurs during every properly conducted communion service. (See the box on transubstantiation.) If we can switch souls, however—if it's possible for our consciousness to reside in different souls—then having the same soul is not necessary for being the same person. Locke explores this possibility in his famous thought experiment about Nestor and Thersites. (Nestor and Thersites were soldiers who fought in the Trojan War.)

Thought Experiment

Nestor and Thersites

Let anyone reflect upon himself, and conclude that he has in himself an immaterial spirit [soul], which is that which thinks in him, and in the constant change of his body keeps him the same, and is that which he calls himself: Let him also suppose it to be the same soul that was Nestor or Thersites at the siege of Troy. . . . But he now having no consciousness of any of the actions either of Nestor or Thersites, does or can he conceive himself the same person with either of them? Can he be concerned in either of their actions? Attribute them to himself, or think them his own more than the actions of any other men that ever existed? . . . [T]hough it were ever so true that the same spirit that informed Nestor's or Thersites's body were numerically the same that now informs his, [he is not the same]. For this would no more make him the same person with Nestor than if some of the particles of matter that were once a part of Nestor were now a part of this man. . . . But let him once find himself conscious of any of the actions of Nestor, he then finds himself the same person with Nestor.[22]

Locke envisions a situation in which all of your thoughts are housed in Nestor's or Thersites' soul. In this scenario, the soul that used to contain Nestor's or Thersites' thoughts now contains only your own. Would that make you identical to Nestor or Thersites? Locke says "No." If you have none of Nestor's or Thersites' thoughts, then you can't be identical with either of them, even if your thoughts now reside in one of their souls. As Locke puts it, "If the same consciousness can be transferred from one thinking substance to another, it will be possible that two thinking substances may make but one person. For the same consciousness being preserved, whether in same or different substance, the personal identity is preserved."[23] For Locke, where your consciousness goes, you go. Because it's possible for your consciousness to reside in different souls, being the same person doesn't require having the same soul.

German philosopher Immanuel Kant makes the same point using a billiard ball analogy.

Thought Experiment

Kant's Soul Switch

An elastic ball which impinges on another similar ball in a straight line communicates to the latter its whole motion, and therefore its whole state (that is, if we take account only of the positions in space). If, then, in analogy with such bodies, we postulate substances such that the one communicates to the other representations together with the consciousness of them, we can conceive a whole series of substances of which the first transmits its state together with its consciousness to the second, the second its own state with that of the preceding substance to the third, and this in turn the states of all the preceding substances together with its own consciousness and with their consciousness to another. The last substance would then be conscious of all the states of the previously changed substances, as being its own states, because they would have been transferred to it together with the consciousness of them.[24]

Just as motion can be transferred from one billiard ball to another, so, Kant claims, consciousness can be transferred from one soul to another. If your consciousness occupied a series of different souls, you would still consider yourself identical to the person at the beginning of the series because you would have all of his or her memories. Having the same soul, then, is not a necessary condition for being the same person.

An adequate theory of personal identity should account for the fact that we make accurate judgments about personal identity. The soul theory can't do this, however, because it doesn't establish any sort of connection between a person's soul and the individual's identifying characteristics. It doesn't tell us what features of a person are determined by the soul. As a result, a person could undergo a soul switch and we would never know it. In fact, for all we know, people are switching souls all the time. Maybe we get a new soul every moment. This seems to be the view of some Buddhists. Because switching souls is a logical possibility, our identity can't reside in our souls.

Even though substantial souls aren't directly observable, we would be justified in believing in them if they provided the best explanation of something. Scientists often postulate theoretical (thus unobservable) entities to account for puzzling phenomena. For example, atoms (which were unobservable until recently) were postulated to explain why certain elements combined in certain ratios. But substantial souls are not needed to explain any aspect of human individuality. Consequently, there is no reason to believe they exist. Theologian John Hick explains:

> If then there is to be any point to the traditional claim that souls are special divine creations, they must be the bearers of some at least of the distinctive characteristics of the individual. And these characteristics must be ones which do not arise from the inherited genetic code. . . .

Let us then conclude boldly that man is a machine, and that the whole universe consists only of a single substance (matter) subjected to different modifications.

—JULIEN OFFRAY DE LA METTRIE

However, this idea of innate but not inherited qualities is, to say the least, highly problematic. It has long been clear, even without benefit of special scientific knowledge, that children are almost as often like a parent in basic personality traits as in purely physical characteristics.... For many characteristics which might have been supposed to be attributes of the soul are now believed to be part of our genetic inheritance....

The answer seems to be that whilst it cannot be proved that the two factors of heredity and environment between them account for the entire range of the individual's character traits, it certainly seems that they do and that there is no need to postulate in addition the influence of a soul or of a *linga sharira* [astral body] carrying basic dispositional characteristics either supplied directly by God or developed in previous earthly lives.[25]

None of our identifying characteristics seems to have a supernatural origin. All of them can be explained in terms of our genetic makeup or upbringing. Because we can explain human individuality without postulating the existence of substantial souls, they are not needed to ground personal identity.

Thought Probe

Souls in Heaven

Many of those who believe in souls believe that their souls will go to heaven. But what happens to souls in heaven? Martin Gardner raises a number of questions.

> How old will children be? Will they grow up in heaven? Will anyone age in heaven? Will cripples be made whole? Will the blind see and the deaf hear? Will the insane become sane? Will the aged become young? Will some or all of earth's animals be there? What about material things that we occasionally love: a house, a ship, a city? The fields you roamed as a child?[26]

Can the soul theory answer these questions? If so, how? If not, does that undermine its plausibility as a theory of personal identity? Why or why not?

Summary

Animalism is the doctrine that identical persons are those with identical living human bodies. Two bodies can be numerically identical without being qualitatively identical. That is, a body at one time and a body at another time can be one and the same body even though they don't have the same properties, just as an oak and a sapling can be one and the same tree even though they don't have the same features. All that is required is that the changes the thing in question undergoes be consistent with the type of thing it is.

Though animalism doesn't rule out an afterlife (because an afterlife is consistent with the notion of resurrection), it is an unsatisfactory explanation of personal identity because it is possible for people to switch bodies and retain their identities, as in the case of reincarnation, and it is possible for two people to inhabit the same body, as in the case of the Hensel twins.

The soul theory is the doctrine that identical persons are those with identical souls. Because no one knows what a soul is, however, this theory doesn't explain how personal identity is possible. What's more, because souls are distinct from the thoughts they have, it's possible for people to switch souls and retain their identities. We would be justified in believing in souls if they provided the best explanation of something. But they don't explain any aspect of human individuality. Thus there is no reason to believe in them.

Study Questions

1. What is the theory of personal identity known as animalism?
2. Does animalism rule out the possibility of an afterlife?
3. What is Locke's tale of the prince and the cobbler? How does it attempt to undermine animalism?
4. What is the soul theory of personal identity?
5. What is Locke's soul switch thought experiment concerning Nestor and Thersites? How does it attempt to undermine the soul theory?
6. Why is there no reason to assume that souls exist?

Discussion Questions

1. Seven years ago, your body contained none of the atoms it contains today. Suppose that someone could locate the atoms that made you up seven years ago and put them back into their original configuration. Which of the two persons would be identical to you?
2. If you had a different body—a body of the other sex, say—would you still be the same person? What about those who get a sex change operation? Do they become new people?
3. If someone gave you the money to have your entire body cryonically suspended, would you accept it? What if someone gave you just enough money to have your head cryonically suspended? Would you accept the gift? Why or why not?
4. Philosopher Kai Nielsen says, "Conceptions of the afterlife are so problematical that it is unreasonable for a philosophical and scientifically sophisticated person living in the West in the twentieth century to believe in life eternal, to believe that we shall survive the rotting or the burning or the mummification of our 'present bodies.'"[27] Do you agree? Why or why not?
5. Are souls needed to explain anything? If so, what?

Internet Inquiries

1. Test your views of personal identity by playing the "Staying Alive" game on *The Philosopher's Magazine* Web site:
 http://www.philosophyexperiments.com/.

2. Is a belief in resurrection consistent with a belief in an immortal soul? If an immortal soul is perfectly happy in heaven, why must it unite with a resurrected body on judgment day? Enter "resurrection" and "immortal soul" into an Internet search engine to explore this issue.

3. Should the definition of death be changed from whole brain to higher brain? Supposedly there can't be a person in a body whose higher brain is no longer functioning. What are the relative merits of the two views? Enter "higher-brain death" into an Internet search engine to explore this issue.

Section 4.2

● Golden Memories
Self as Psyche

Our identity as persons does not seem to depend on the continued existence of any sort of substance. Having the same body or soul is neither a necessary nor a sufficient condition for being the same person. On what, then, does our identity depend? Many believe it depends on our memories. As Leibniz realized, if we lost our memories—if we suffered total and complete amnesia—there is reason to believe that we would cease to exist.

The Memory Theory

Locke agrees with Leibniz that our identity resides in our memories.

> This may show us wherein personal identity consists: not in the identity of substance, but, as I have said, in the identity of consciousness, wherein if Socrates and the present mayor of Queinborough agree, they are the same person: If the same Socrates waking and sleeping do not partake of the same consciousness, Socrates waking and sleeping is not the same person. And to punish Socrates waking for what sleeping Socrates thought, and waking Socrates was never conscious of, would be no more of right, than to punish one twin for what his brother-twin did, whereof he knew nothing, because their outsides were so like, that they could not be distinguished; for such twins have been seen.[28]

According to Locke, if the present mayor of Queinborough is conscious of something that Socrates was conscious of—that is, if he remembers having an experience that Socrates had—he is identical to Socrates. This view is known as the **memory theory** of personal identity, and it holds that identical persons are those who share at least one experience or autobiographical memory.

Not all of your memories affect your identity. Memories of facts, like the fact that $2 + 2 = 4$, can be had by many different people and thus cannot serve to distinguish you from them. But memories of experiences, like your first

> *You have to begin to lose your memory, if only in bits and pieces, to realize that memory is what makes our lives.*
>
> —LUIS BUÑUEL

memory theory The doctrine that identical persons are those who share at least one experience memory.

John Locke: The Great Empiricist

Few philosophers have had more influence on practical affairs than John Locke (1632–1704). His greatest achievements were the development of a ground-breaking theory of knowledge and the formulation of a new understanding in political philosophy. The former changed the way people thought about the mind, education, tolerance, and human equality. The latter laid a giant cornerstone for liberal democracy and propelled the American and French Revolutions.

He was born in England, was educated at Oxford where he studied medicine, and became involved in public affairs. He lived in France from 1675 to 1679 and there studied the work of Descartes and another philosopher-mathematician, Gassendi. Before returning to England, he had come in contact with most of the great thinkers of the day. In 1683, Locke left England for Holland because of the political situation in his home country. While living in exile, he wrote his magnum opus, *An Essay Concerning Human Understanding*. After he returned to England he published his main political works: *A Letter Concerning Toleration* and *Two Treatises of Government*.

Locke's theory of knowledge had enormous implications for education and the rights of persons. It is based on the premise that everything we know comes to us through sense experience. So our understanding of reality is either derived from sense experience or built from elements that ultimately are extracted from sense experience. When we are born, says Locke, our minds are like blank slates—we have no innate ideas or inborn knowledge. Only our sensory experience can write on the slate, filling it with ideas and expanding our understanding. Therefore, all people are born equal, beginning at the same starting point, being no better than anyone else by birth, requiring only education and equal treatment to flourish.

Locke also drew political implications from his epistemology. Acquiring knowledge through sense experience is by its nature a fallible process. Our senses may deceive us; the sense data may be incomplete or distorted. So Locke reasoned that this human fallibility is the best reason of all to be tolerant of the views of others and to shun dogmatic positions. Coercing people into accepting certain beliefs—as both secular and religious authorities often do—is thus unreasonable and immoral.

JOHN LOCKE
1632–1704

kiss, can be had only by you and thus can define who you are. Other people can remember the fact that your first kiss happened, say, on the playground, but they can't remember your experience of being kissed on the playground because they didn't have that experience. Our experience memories are unique to each of us and, according to Locke, form the basis of our personal identity.

The memory theory, unlike animalism, allows one person to inhabit more than one body and thus is open to the possibility of reincarnation. If a person has a memory of inhabiting another body, that person is identical to the person who inhabited the other body. The memory theory also allows two people to inhabit the same body. If a person has no memory of what happened to his body during a certain time (as in Locke's example of Socrates waking and Socrates sleeping), that person was not in his body at that time. So if one personality of someone suffering from multiple-personality disorder has no memory of what happened to her body while another personality was in control of it, the two personalities could constitute two different persons.

Locke's original interest in developing a theory of personal identity was to bolster his theory of punishment. Since he believes that identity depends on memory, he contends that you shouldn't be held responsible for something

In the Courts: Sleepwalking and Murder

Locke suggests that sleepwalkers may not be the same people as their waking counterparts. If the waking person has no memory of what the sleepwalker did, then, Locke claims, the waking person should not be held responsible for the sleepwalker's actions. At least some courts of law seem to agree:

> The first known case of such a [sleepwalking] defense was back in 1846 when Albert Tirrell was charged with the murder of a prostitute, Maria Bickford, and setting fire to a brothel. He claimed he had committed the crimes while sleepwalking, and he was acquitted.
>
> It's 2004, and another such case has appeared. Stephen Reitz is accused of bludgeoning his lover, Eva Weinfurtner, to death while the couple were vacationing together on Catalina Island in 2001.
>
> Reitz claims he was in the midst of a dream about fighting off an intruder when he attacked the woman and has no memory of the murder.
>
> One of the main defense tests when trying to prove the claim of sleepwalking is a lack of memory of the act and no attempt at concealment. Reitz seems to comply with this. He claims no memory and says he was confused and shocked by her death. Also, after discovering the body, he walked to the police station and turned himself in.
>
> A second test is lack of motive. To all intents and purposes, Reitz and Weinfurtner got along well and he had no motive for killing her. However, Reitz does have a history of a nasty temper and violence and some witnesses reported seeing bruises on the woman's body from time to time that could have been attributed to physical abuse.
>
> Yet a third test is a history of sleepwalking. Reitz has been sleepwalking and [has had] sleep terrors since childhood. When he was a child his parents had alarms installed to alert them when their son was sleepwalking and had left the house.
>
> While sleepwalking is common in childhood, only a small percentage of adults suffer from the disorder. It sometimes runs in families or can be brought on or aggravated by alcohol or drug use or by stress.[29]

Reitz was found guilty of killing Weinfurtner and was sentenced to 26 years in prison. In a 2005 case, however, Jules Lowe was found not guilty of killing his father because he was sleepwalking.

> Dr. Ebrahim said the tests showed Mr. Lowe had indeed been sleepwalking at the time of the attack, in a state called automatism.
>
> Automatism—defined legally as acting involuntarily—falls into two types. These are insane automatism, considered a "disease of the mind," and noninsane automatism, linked to external factors.
>
> Mr. Lowe's diagnosis of insane automatism meant he could not be held responsible for battering his father to death. He has been sent to a psychiatric hospital indefinitely.[30]

Thought Probe

Sleepwalking and Murder

Is Locke correct in thinking that sleepwalkers are different people from their waking counterparts? Why or why not? Regardless of whether Locke is correct, are the courts correct in thinking that the waking counterparts of true sleepwalkers should not be held responsible for their actions? Why or why not?

you don't remember doing. In Locke's view, if you don't remember doing something, you didn't do it. He acknowledges that not being able to remember a crime is no defense in a court of law. But the reason we don't accept such pleas of ignorance is that we can't be sure whether the accused is telling the truth. God suffers no such limitation, however; no one can hide anything from God. So on judgment day, "wherein the secrets of all hearts shall be laid open, no one shall be made to answer for what he knows nothing of, but shall receive his doom, his conscience accusing or excusing him."[31] In other words,

A sub-clerk in the post-office is the equal of a conqueror if consciousness is common to them.

—ALBERT CAMUS

DIRECT VS. INDIRECT MEMORIES.
Person III does not directly remember A. But he is still identical to Person I because he indirectly remembers A.

when it comes time for God to judge us, we will not be held responsible for anything we don't remember doing.

But there seems to be more to responsibility than just memory. Suppose that a drug could erase the last hour's worth of one's memories. Suppose further that someone took that drug immediately after committing a crime. As a result, that person would have no memory of committing the crime. Does that mean he should not be held responsible for it? It wouldn't seem so. Not being able to remember something doesn't always mean that one cannot be held responsible for it. Oftentimes people don't remember what they did while they were drunk. But that doesn't mean that they shouldn't be punished for what they did. If you got drunk on your own accord, then what you did while you were drunk is your fault, whether you remember doing it or not.

Thought Probe

Memory Damping

The prospect of erasing memories was fancifully explored in the movie *The Eternal Sunshine of the Spotless Mind*. But there are drugs, like zeta inhibitory peptide (ZIP), that can selectively erase memories. They are potentially useful for those suffering from post-traumatic stress disorder, who can't get traumatic memories out of their minds. There are also drugs, like scopolamine, that can prevent memories from being formed. They are often found in "date-rape drugs." What if advanced versions of these drugs were to become widely available? Should their possible abuse prevent them from being put on the market?

The Inconsistency Objection

Nothing is more responsible for the good old days than a bad memory.
—ROBERT BENCHLEY

Unfortunately (or fortunately, as the case may be), our memories are not perfect. If you are like most people, you have forgotten a good deal of what has happened to you. Suppose you lose all memory of some part of your life. Does that mean that you are no longer identical to the person who was in your body at that time? Locke would seem to think so. In this famous thought experiment, the Scottish philosopher Thomas Reid uses this consequence of Locke's theory to show that it leads to a contradiction.

278 Chapter 4 • The Problem of Personal Identity

Thought Experiment

Reid's Tale of the Brave Officer and Senile General

Suppose a brave officer to have been flogged when a boy at school for robbing an orchard, to have taken a standard from the enemy in his first campaign, and to have been made a general in advanced life; suppose, also, which must be admitted to be possible, that, when he took the standard, he was conscious of having been flogged at school, and that, when made a general, he was conscious of his taking the standard, but had absolutely lost the consciousness of his flogging.

These things being supposed, it follows from Mr. Locke's doctrine, that he who was flogged at school is the same person who took the standard, and that he who took the standard is the same person who was made a general. Whence it follows, if there be any truth in logic, that the general is the same person with him who was flogged at school. But the general's consciousness does not reach so far back as his flogging; therefore, according to Mr. Locke's doctrine, he is not the person who was flogged at school.[32]

The brave officer, who took a standard from the enemy, remembers being flogged as a boy for robbing an orchard, and the senile general remembers taking the standard but not being flogged. So, according to Locke's theory, the brave officer is identical to the boy and the senile general is identical to the brave officer, but the senile general is not identical to the boy. But that's impossible because, as we have seen, identity is transitive: if A is identical to B, and B is identical to C, then A is identical to C. Because Locke's theory of personal identity violates the principle of the transitivity of identity, it cannot be correct.

Locke's theory can be salvaged, however, if we're willing to recognize the existence of indirect as well as direct memories. A **direct memory** is one that you can consciously recall. An **indirect memory** is one that an earlier stage of you can consciously recall. An earlier stage of you is one that is connected to you by a series of overlapping direct memories. For example, although you may not remember going to McDonald's five years ago, you may remember doing something yesterday, and the person who did that may remember doing something the day before that, and so on, until you get to a person who does remember going to McDonald's five years ago. If there is such an overlapping series of direct memories, then you are identical to the person who went to McDonald's five years ago.

Memories, in this view, are like strands in a rope. Just as no one strand may stretch the entire length of a rope, no one memory may stretch the entire length of a life. Nevertheless, an overlapping series of memories can constitute one person in the same way that an overlapping series of strands can constitute one rope.

Although the senile general doesn't directly remember being flogged as a boy, he may well indirectly remember it. So by taking memory to be both direct and indirect, it is possible to avoid Reid's objection and formulate a consistent memory theory of personal identity.

> *How we remember, what we remember and why we remember form the most personal map of our individuality.*
> —CHRISTINA BALDWIN

direct memory A memory that a person can consciously recall.

indirect memory A memory that an earlier stage of a person can consciously recall.

Thought Probe

Were You Ever a Fetus?

According to Locke, your identity extends only as far back as your memories. But your memories extend back only to the age of one or two because, before that time, your brain was not developed enough to store memories. It seems to follow, then, that *you* were never a fetus. You came into existence from a fetus, but you yourself never were a fetus. Is this consequence of Locke's theory plausible? Why or why not?

The Circularity Objection

> *The difference between false memories and true ones is the same as for jewels: it is always the false ones that look the most real, the most brilliant.*
>
> —SALVADOR DALÍ

Much as we hate to admit it, our memories are not totally reliable. We sometimes seem to remember things that never really happened. For example, Jean Piaget, the great French psychologist, had a vivid memory of his nurse fighting off a kidnapper during a stroll down the Champs-Elysées when he was only two. Years later, his nurse confessed in a letter to his parents that she made the whole thing up. So from the fact that we seem to remember having an experience, it doesn't follow that we actually had it. Only real memories can serve as the basis of personal identity. Our memories are supposed to connect us to people who lived in the past. If our memories are fictitious, they can't perform that function. So the memory theorist owes us an account of what distinguishes **real memories** from **apparent memories**.

One way to explain the difference is to say that an experience memory is real only if the person with the memory is identical to the person who had the experience. But this creates a problem: If we have to use the notion of personal identity to explain real memories, then we can't use real memories to explain personal identity because the explanation would be circular; it would assume an understanding of that which it is trying to explain. It would be like trying to explain why a sedative puts people to sleep by saying that the sedative has a sleep-inducing power. Such explanations tell us nothing we don't already know.

Bishop Butler, who is credited with first realizing that Locke's memory theory is circular, put the point this way: "One should really think it self-evident, that consciousness of personal identity presupposes and therefore cannot constitute personal identity, any more than knowledge in another case, can constitute truth, which it presupposes."[33] Knowledge presupposes truth because you can't know something unless it's true. To know what knowledge is, you must first know what truth is. As a result, truth can't be explained in terms of knowledge because such an explanation would be circular; it would assume an understanding of that which is being explained, and that wouldn't explain anything.

To see what Butler is getting at, consider a simpler concept: bachelorhood. Bachelorhood presupposes maleness because you can't be a bachelor unless you're a male. To know what a bachelor is, you must first know what a male is. Consequently, you can't explain maleness in terms of bachelorhood.

Similarly, Butler claims, personal identity can't be explained in terms of real memories because the concept of a real memory presupposes the concept of personal identity. A memory can't be real unless the person with the memory

real memory A memory of an event that was experienced by the person remembering it and that was caused by the event it records.

apparent memory A memory of an event that either didn't happen or that was not caused by the event it records.

is identical to the person who had the experience. Since you can't have the concept of a real memory without first having the concept of personal identity, you can't explain the concept of personal identity in terms of real memories.

Sydney Shoemaker and Derek Parfit believe that the memory theory can escape the circle by appealing to a kind of memory that doesn't presuppose personal identity. Called **quasi-memory,** or q-memory for short, it is a type of memory that connects a person to past experiences without assuming that those experiences were had by the person in question. The connection to the past is made in terms of causation. The idea is that if a memory is caused in the right way, it can link you to someone in the past even though that person is not you. So defining personal identity in terms of q-memories avoids the circularity inherent in Locke's theory.

Parfit defines quasi-memory as follows:

> I have an accurate quasi-memory of a past experience if
> (1) I seem to remember having an experience,
> (2) Someone did have this experience, and
> (3) my apparent memory is causally dependent, in the right kind of way, on that past experience.[34]

So a quasi-memory is an apparent memory that is caused in the right way by an actual experience. Normally, the person who quasi-remembers an experience will be identical to the person who actually had the experience. But this is not necessarily the case. Advances in neurophysiology and computer technology may make it possible to quasi-remember other people's experiences. (See the "Soul Catcher" box.)

In the movie *Brainstorm,* a scientist develops a brain-taping device that can tape-record people's experiences. Once an experience has been recorded, other people can have the experience by playing back the tape. (A similar device was used in the movies *Total Recall* and *Strange Days.*) If you were to play back another person's tape, your memory of that experience would, at best, be a quasi-memory. It would not be a real memory because the original experience didn't happen to you.

All real memories are quasi-memories, but not all quasi-memories are real memories because people can have quasi-memories of experiences they didn't have. In the movie *Blade Runner,* for example, the replicant Rachael has the memories of her creator's niece. Rachael's creator uploaded his niece's memories into Rachael's brain. Rachael seems to remember having various experiences, and her creator's niece actually had those experiences. If those memories were caused in the right way, they would constitute quasi-memories.

Being caused in the right way is important because quasi-memory is supposed to ground personal identity, and not every way of causing memories is identity preserving. Suppose, for example, that a hypnotist gave you the apparent memory of an experience that actually happened to someone else. That presumably would not make you identical to the person who had that experience. Even if the majority of your memories came from that person via the hypnotist, that still would not make you identical to him or her. Memories generated by hypnosis, then, cannot be quasi-memories because they are not caused in the right way.

quasi-memory An apparent memory caused in the right way by an actual experience.

In the News: Soul Catcher

In 1995, scientists at British Telecom tantalized the media with talk of a computer chip that could record human thoughts. This possibility is explored in the 2004 movie *The Final Cut*. If it became a reality, q-memories could become a marketable commodity. Here's how the *Electronic Telegraph* reported the story:

> A computer chip implanted behind the eye that could record a person's every lifetime thought and sensation is to be developed by British scientists.
>
> "This is the end of death," said Dr. Chris Winter, of British Telecom's artificial life team. He predicted that within three decades it would be possible to relive other people's lives by playing back their experiences on a computer. "By combining this information with a record of the person's genes, we could re-create a person physically, emotionally and spiritually."
>
> Dr. Winter's team of eight scientists at BT's Martlesham Heath Laboratories near Ipswich calls the chip the 'Soul Catcher.' It would be possible to imbue a new-born baby with a lifetime's experiences by giving him or her the Soul Catcher chip of a dead person, Dr. Winter said. The proposal to digitize existence is based on a solid calculation of how much data the brain copes with over a lifetime.
>
> Ian Pearson, BT's official futurologist, has measured the flow of impulses from the optical nerve and nerves in the skin, tongue, ear, and nose. Over an eighty-year life, we process 10 terrabytes of data, equivalent to the storage capacity of 7,142,857,142,860,000 floppy disks.
>
> Dr. Pearson said, "If current trends in the miniaturization of computer memory continue at the rate of the past 20 years—a factor of 100 every decade—today's 8-megabyte memory chip norm will be able to store 10 terrabytes in 30 years."
>
> British Telecom would not divulge how much money it is investing in the project, but Dr. Winter said it was taking 'Soul Catcher 2025' very seriously. He admitted that there were profound ethical considerations, but emphasized that BT was embarking on this line of research to enable it to remain at the forefront of communications technology.
>
> "An implanted chip would be like an aircraft's black box and would enhance communications beyond current concepts," he said. "For example, police would be able to use it to relive an attack, rape, or murder from the victim's viewpoint to help catch the criminal."
>
> Other applications would be less useful but more frightening. "I could even play back the smells, sounds, and sights of my holiday to my friends," Dr. Winter said.[35]

Thought Probe

Soul Catcher

Do you believe that such a chip could, in principle, be developed? Why or why not? If it were developed, do you think it should be available to anyone with adequate funds? Why or why not?

Having a quasi-memory that originally belonged to someone else would not make you identical to that person. But having a great many quasi-memories that originally belonged to someone else would make you identical to that person. Suppose that you got total amnesia as the result of some trauma. Now suppose that a brain-tape containing the experiences of someone else's entire life was played back on your brain. (The tape was made just before the person died.) As a result, the only experiences you can remember are those recorded on the tape. In such a case, there would be reason to believe that the person in your body is the person whose memories are recorded on the tape. That person would have essentially undergone a body switch.

Hans Moravec, professor of robotics at Carnegie Mellon, thinks that once it's possible to upload our minds (and memories) into computers, identity won't matter. We'll be able to share memories not only with other human beings but with other life-forms as well. He writes,

> Selective mergings, involving some of another person's memories and not others, would be a superior form of communication, in which recollections, skills, attitudes, and personalities can be rapidly and effectively shared. . . .
>
> Mind transferal need not be limited to human beings. Earth has other species with large brains, from dolphins, whose nervous systems are as large and complex as our own, to elephants, other whales, and perhaps giant squid, whose brains may range up to twenty times as big as ours. . . . The brain-to-computer transferal methods that work for humans should work as well for these large-brained animals, allowing their thoughts, skills, and motivations to be woven into our cultural tapestry.[36]

What Moravec is describing is the technological equivalent of a Vulcan mind-meld. *Star Trek*'s Mr. Spock achieves direct contact with other creatures' minds through telepathy. Moravec would achieve it through uploading the information. If the practice became commonplace, and we were concerned about losing our identity, we would have to ensure that most of our memories originated with us. Moravec, however, is not concerned about personal identity. He looks forward to a time when all the memories of all the minds in the universe will be merged into one supermind.[37] This vision is not unique to Moravec, however. Many idealistic philosophers in both the East and the West—most notably, the followers of Shankara and Hegel—have held a similar view.

Thought Probe

Merging of the Minds

Some Hindus claim that to realize that there is only one mind in the universe and that you are identical to it is to reach nirvana—a state of perfect bliss. In their view, the idea that you are a separate person with your own identity is just an illusion. Suppose you had the opportunity to merge your mind with a group of other minds and lose your individual sense of self. Would you consider that to be a desirable state of being? Why or why not?

The Insufficiency Objection

Although memory is an important ingredient of personal identity, many believe there is more to us than that. Who we are seems to be determined not only by our experiences but also by our desires and intentions. What we care about and what we plan to do are as much a part of us as what we've experienced. If our desires weren't relatively stable, we would never put any of our plans into action. If we no longer desired to achieve the goals our plans were

> *A man's character is the reality of himself.*
>
> —H. W. Beecher

intended to meet, we would not implement our plans. So the loss of all of our desires and intentions could be as destructive to ourselves as the loss of all of our memories.

Consider, for example, born-again Christians. They claim to have become new persons—to have been born again—when they found Jesus Christ. What changed, however, was not their memories, but their beliefs and values. Accepting Jesus into their hearts gave them a whole new outlook on life. As a result of their conversion, they may acquire a new personality and a new character. Some believe that these changes can be radical enough to literally make them new persons.

Just as we can distinguish between two types of memory—factual and experiential—so we can distinguish between two types of desires—personal and impersonal. An impersonal desire is a desire for something or someone other than oneself. The desire that the Eagles win the Superbowl, for example, is an impersonal desire. A personal desire is a desire for oneself. The desire to get married, for example, is a personal desire. Because personal desires refer to oneself, they can't be used to define personal identity. But, just as it is possible to construct a notion of experience memory that doesn't presuppose personal identity, so it is possible to construct a notion of personal desire that doesn't presuppose personal identity. A **quasi-desire,** like a quasi-memory, is an apparent desire that is caused in the right way by an actual desire.

Our desires are intimately connected with a number of our other mental states, such as our beliefs, our values, and our attitudes. A change in any one of these could bring about a change in our desires. So personal identity is not a one-dimensional concept. Who we are is determined by a number of different factors, all of which have to be taken into account when making judgments of personal identity.

Thought Probe

Should Joshua Blahyi Be Punished?

One of the most infamous born-again Christians is the ex-Liberian warlord, Joshua Blahyi, formerly known as "General Butt Naked" because he would go into battle wielding a machete and wearing nothing more than sneakers. (He thought that made him invincible.) Blahyi readily admits to killing thousands of people, raping women, and eating human flesh. But one day, while he was about to eat a little girl's heart, a man came to him in a burst of light "brighter than the sun" and told him to repent or die, and at that moment, he converted to Christianity. He is now an evangelical preacher who was pardoned by the Liberian Truth and Reconciliation Commission. (His story is detailed in the documentaries *The Redemption of General Butt Naked* and *The Cannibal Warlords of Liberia*. A character based on him also appears in the play "The Book of Mormon.") The question that Liberians are still debating is: Should Blahyi have been punished for his crimes? What do you think? A woman who knows him claims, "I knew that he wasn't the same person, that he was a totally different man."[38] Do you agree? Should that exonerate him? Why or why not?

quasi-desire An apparent desire that is caused in the right way by an actual desire.

The Psychological Continuity Theory

If a person at one time and a person at another time directly quasi- remember and quasi-desire the same thing, they are **psychologically connected** with one another. If a person at one time and a person at another time indirectly quasi-remember and quasi-desire the same thing—if they form part of an overlapping series of persons who are psychologically connected with one another—they are **psychologically continuous** with one another. These notions can be used to provide the **psychological continuity theory** of personal identity, which says that identical persons are those who are psychologically continuous with one another. This theory of personal identity is superior to Locke's memory theory because it is internally consistent, noncircular, and sufficiently rich to account for the many aspects of our psychology that go into making us who we are. The psychological continuity theory also has no trouble explaining how life after death is possible. You can survive the death of your body as long as there is someone who is psychologically continuous with you after your body dies. Whether that person has the same body is irrelevant.

> Identity in the form of continuity of personality is an extremely important characteristic of the individual.
> —Kenneth L. Pike

Thought Probe

Is Darth Vader Anakin Skywalker?

In episode 6 of the *Star Wars* saga, Obi-wan Kenobe tells Luke Skywalker,

> Your father was seduced by the dark side of the force. He ceased to be Anakin Skywalker and became Darth Vader. When that happened, the good man who was your father was destroyed.

Is Obi-wan correct? When Anakin Skywalker joined the dark side, did he cease to exist? He certainly lost many of his former character traits, as well as many of his former beliefs, attitudes, and desires. Did he change enough to literally become a different person? Or is that claim only true from a certain point of view? If so, what point of view is that?

The Reduplication Problem I: Reincarnation

Those who believe in reincarnation believe that people born at different times can be psychologically continuous with one another. Some people do seem to remember things that only a person who had lived before could remember. The question is whether psychological continuity is enough to make people living at different times identical.

Suppose that we had the best evidence possible for reincarnation. Suppose someone knew things about a historical figure that only that figure could have known. Would that prove that the present person is a reincarnation of the former person? Not according to British philosopher Bernard Williams. Consider this thought experiment.

psychologically connected Two people are psychologically connected if they can directly (consciously) quasi- remember and quasi-desire the same things.

psychologically continuous Two people are psychologically continuous with one another if they form part of an overlapping series of persons who are psychologically connected with one another.

psychological continuity theory The doctrine that identical persons are those who are psychologically continuous with one another.

Golden Memories 285

Thought Experiment

Williams's Reincarnation of Guy Fawkes

Suppose someone undergoes a sudden and violent change of character. Formerly quiet, deferential, churchgoing and home loving, he wakes up one morning and has become, and continues to be, loud-mouthed, blasphemous, and bullying. . . .

Suppose the man who underwent the radical change of character—let us call him Charles—claimed, when he woke up, to remember witnessing certain events and doing certain actions which earlier he did not claim to remember; and that under questioning he could not remember witnessing other events and doing other actions which earlier he did remember. . . .

We may suppose that our enquiry has turned out in the most favourable possible way, and that the events he claims to have witnessed and all the actions he claims to have done point unanimously to the life-history of some one person in the past—for instance, Guy Fawkes. Not only do all Charles' memory-claims that can be checked fit the pattern of Fawkes' life as known to historians, but others that cannot be checked are plausible, provide explanations of unexplained facts, and so on. Are we to say that Charles is now Guy Fawkes, that Guy Fawkes has come to life again in Charles' body, or some such thing?[39]

Charles is psychologically continuous with Guy Fawkes. (Guy Fawkes tried to assassinate the king of England by blowing up the Parliament building in 1605.) If the psychological continuity theory were true, Charles would be identical to Guy Fawkes. But Williams claims that Charles cannot be identical with Guy Fawkes because other people could also be psychologically continuous with Guy Fawkes:

Thought Experiment

Williams's Reduplication Argument

If it is logically possible that Charles should undergo the changes described, then it is logically possible that some other man should simultaneously undergo the same changes; e.g., that both Charles and his brother Robert should be found in this condition. What should we say in that case? They cannot both be Guy Fawkes; if they were, Guy Fawkes would be in two places at once, which is absurd. Moreover, if they were both identical with Guy Fawkes, they would be identical to each other, which is also absurd. Hence we could not say that they were both identical to Guy Fawkes.[40]

By the transitivity of identity, if A is identical to B and A is identical to C, then B is identical to C. So if Guy Fawkes is identical to Charles, and

Guy Fawkes is identical to Robert, then Charles is identical to Robert. But Charles isn't identical to Robert, for they are two separate people. Numerically distinct people cannot be numerically identical. So psychological continuity isn't a sufficient condition for personal identity. There must be something more to personal identity than psychological continuity.

The problem is that psychological continuity is a one-to-many relation (many different people can be psychologically continuous with one person), whereas numerical identity is a one-to-one relation—it's a relation that thing can only have to itself. Thus the relation of psychological continuity is too weak to constitute personal identity.

The Reduplication Problem II: Teletransportation

The inadequacy of the psychological continuity theory has been vividly demonstrated by a number of thought experiments, most notably those dealing with *Star Trek*–style transporter technology. In the TV series *Star Trek,* a device called a transporter is used to beam objects from one location to another. According to the *Star Trek: Next Generation Technical Manual,* the transporter works by scanning an object and recording the state of each of its subatomic particles. The scan destroys the atomic bonds that hold the particles together, but those particles are saved and sent to the destination in a "subatomically debonded matter stream." The pattern acquired from the scan is then used to put the particles back together in their original configuration.[41] So when a person beams down, the traveler is essentially disassembled and reassembled (or killed and resurrected). But because a physical object can survive disassembly and reassembly, there is good reason for believing that people who use this method of transportation survive the trip.

Suppose there were a different transporter technology, however. Like the *Star Trek* transporter, this transporter can scan an object and break it down into its constituent particles. Unlike the *Star Trek* transporter, however, it doesn't save the particles. Instead, it sends the pattern to another device that uses different matter to create a replica of the object. Would you survive a trip through this type of transporter? Would the person created from your pattern be you or just a copy of you? To sharpen your intuitions, consider British philosopher Derek Parfit's transporter tale.

Thought Experiment

Parfit's Transporter Tale

I enter the Teletransporter. I have been to Mars before, but only by the old method, a space-ship journey taking several weeks. This machine will send me at the speed of light. I merely have to press the green button. Like others, I am nervous. Will it work? I remind myself what I have been told to expect. When I press the button, I shall lose consciousness, and then wake up at what seems a moment later. In fact I shall have been unconscious for about an hour. The

Scanner here on Earth will destroy my brain and body, while recording the exact states of all of my cells. It will then transmit this information by radio. Traveling at the speed of light, the message will take three minutes to reach the Replicator on Mars. This will then create, out of new matter, a brain and body exactly like mine. It will be in this body that I shall wake up.

Though I believe that this is what will happen, I still hesitate. But then I remember seeing my wife grin when, at breakfast today, I revealed my nervousness. As she reminded me, she has been often teletransported, and there is nothing wrong with her. I press the button. As predicted, I lose and seem at once to regain consciousness, but in a different cubicle. Examining my new body, I find no change at all. Even the cut on my upper lip, from this morning's shave, is still there.

Several years pass, during which I am often teletransported. I am now back in the cubicle, ready for another trip to Mars. But this time, when I press the green button, I do not lose consciousness. There is a whirring sound, then silence. I leave the cubicle, and say to the attendant: "It's not working. What did I do wrong?"

"It's working," he replies, handing me a printed card. This reads: "The New Scanner records your blueprint without destroying your brain and body. We hope that you will welcome the opportunities which this technical advance offers."

The attendant tells me that I am one of the first people to use the New Scanner. He adds that, if I stay for an hour, I can use the Intercom to see and talk to myself on Mars.

"Wait a minute," I reply, "If I'm here I can't *also* be on Mars."

Someone politely coughs, a white-coated man who asks to speak to me in private. We go to his office, where he tells me to sit down, and pauses. Then he says, "I'm afraid that we're having problems with the New Scanner. It records your blueprint just as accurately, as you will see when you talk to yourself on Mars. But it seems to be damaging the cardiac systems which it scans. Judging from the results so far, though you will be quite healthy on Mars, here on Earth you must expect cardiac failure within the next few days."

The attendant later calls me to the Intercom. On the screen I see myself just as I do in the mirror every morning. But there are two differences. On the screen I am not left-right reversed. And, while I stand here speechless, I can see and hear myself, in the studio on Mars, starting to speak.[42]

Parfit would have us imagine two different types of transporters. One destroys him as it scans him, and the other does not. Both use the scanned information to make a replica of him. In the first case, where Parfit's body is destroyed by the scan, the person made from his pattern seems to be identical to him, for he is psychologically continuous with Parfit and has a body like Parfit's. In the second case, where Parfit's body is not destroyed by the scan, the person made from his pattern does not seem to be identical to him, for Parfit's original body and mind still exist. But if the replica is not identical to Parfit in the second case, it's not identical to Parfit in the first case either. In both cases, the replica is a copy of Parfit, not Parfit himself.

Quantum Teleportation

Although transporters seem logically possible, many thought that they were physically impossible because they seemed to violate the Heisenberg uncertainty principle, which says that we cannot simultaneously know certain things about the state of subatomic particles. Scientists at IBM, however, have shown that there is a way around the Heisenberg uncertainty principle—and thus that Parfit-style transporters are a physical possibility. Here's IBM's description of its accomplishment:

> Teleportation is the name given by science fiction writers to the feat of making an object or person disintegrate in one place while a perfect replica appears somewhere else. How this is accomplished is usually not explained in detail, but the general idea seems to be that the original object is scanned in such a way as to extract all the information from it; then this information is transmitted to the receiving location and used to construct the replica, not necessarily from the actual material of the original, but perhaps from atoms of the same kinds, arranged in exactly the same pattern as the original. A teleportation machine would be like a fax machine, except that it would work on 3-dimensional objects as well as documents, it would produce an exact copy rather than an approximate facsimile, and it would destroy the original in the process of scanning it. A few science fiction writers consider teleporters that preserve the original, and the plot gets complicated when the original and teleported versions of the same person meet; but the more common kind of teleporter destroys the original, functioning as a super transportation device, not as a perfect replicator of souls and bodies.
>
> Two years ago an international group of six scientists, including IBM Fellow Charles H. Bennett, confirmed the intuitions of the majority of science fiction writers by showing that perfect teleportation is indeed possible in principle, but only if the original is destroyed. Meanwhile, other scientists are planning experiments to demonstrate teleportation in microscopic objects, such as single atoms or photons, in the next few years. But science fiction fans will be disappointed to learn that no one expects to be able to teleport people or other macroscopic objects in the foreseeable future, for a variety of engineering reasons, even though it would not violate any fundamental law to do so.[43]

Thought Probe

Transporter Travel

If this technology became available, would you use it to travel from one place to another? Why or why not? What theory of personal identity lies behind your decision?

Parfit's teletransporters are really just glorified fax machines that fax humans instead of documents. The word "fax" comes from the word "facsimile," which means an exact copy of something. The documents that come out of fax machines are copies of the original, whether or not the original is destroyed in the process. Similarly, the people that come out of Parfit's teletransporters are copies of the original, whether or not the original was destroyed in the process.

The foregoing objection to the psychological continuity theory has implications for the decision scenario presented at the beginning of the chapter. If you had agreed to have the contents of your brain uploaded into the robot, the best you could have hoped for is that the robot would be psychologically continuous with you. But Williams's reduplication argument and Parfit's transporter

tale suggest that psychological continuity is not enough for personal identity. Just as the replicated Parfits are not numerically identical to Parfit, the robot with your psychology would not be you. At best, it would be qualitatively identical to you. Thus those who believe that they can achieve immortality by having their minds uploaded into computers may be mistaken.

Similarly, those who believe that they can achieve immortality by having their minds "uploaded" into celestial bodies may also be mistaken, for transferring your mind into a celestial body is just a type of reincarnation, and, as we have seen, reincarnation doesn't preserve personal identity. An uploaded person is just a copy of the original, whether the person is uploaded into a physical or a celestial body. Consequently, resurrection may be your best hope for survival after death.

Thought Probe

Can You Go to Heaven?

If a reincarnation of you is at best a copy of you, wouldn't a person in heaven also be, at best, a copy of you? Can someone in heaven who does not have your physical body be numerically identical to you? How? What theory of personal identity supports your answer?

Summary

Our identity as persons does not seem to depend on the stuff we're made of. It does, however, seem to depend on our memories. Locke's memory theory is the doctrine that identical persons are persons who remember the same thing. But this leads to an inconsistency. There could be two people who are identical to a third person and yet are not identical to each other, as in the case of the brave officer and the senile general. Locke's theory can be saved, though, by recognizing the existence of both direct memories (those you can consciously recall) and indirect memories (those that an earlier version of you can recall).

Locke's memory theory, however, is circular; it presupposes the notion it is trying to explain—namely, personal identity. The concept of memory presupposes the concept of personal identity because you can remember something only if it happened to you. By positing quasi-memory—memory stripped of its personal reference—we can get around this problem.

Though memory is an important part of personal identity, there are other vital ingredients—like desires and intentions. There is good reason to believe that if our desires and intentions were somehow erased, we would cease to exist. The psychological continuity theory recognizes the importance of these other factors and holds that identical persons are persons who are psychologically continuous with one another.

This theory, though, must be mistaken, for it is logically possible for more than one person to be psychologically continuous with you. More than one

person could have your memories and desires. But if so, personal identity cannot be defined in terms of psychological continuity, because psychological identity would not guarantee numerical identity.

Study Questions

1. What is Locke's memory theory of personal identity?
2. What is Reid's tale of the brave officer and the senile general? How does it attempt to undermine Locke's memory theory?
3. Why is Locke's memory theory circular?
4. What is the psychological continuity theory of personal identity?
5. What is Williams's thought experiment concerning the reincarnation of Guy Fawkes? How does it attempt to undermine the psychological continuity theory?
6. What is Parfit's transporter tale? How does it attempt to undermine the psychological continuity theory?

Discussion Questions

1. If you lost all of your memories beyond any possibility of retrieval, would you cease to exist?
2. Doctors used to give scopolamine to women during labor. Scopolamine causes amnesia, so you remember nothing that happened to you while you were under its influence. Women who were "scoped" thus had no memory of giving birth. Did they give birth to their children? What would Locke say?
3. Does past-life hypnotic regression provide good evidence for reincarnation? Why or why not?
4. When someone is born again in Jesus Christ, does a new person come into existence? Why or why not?
5. Suppose that a born-again Christian was a criminal before finding Jesus Christ. Should the fact that the individual has been born again mean that he should be given a lighter sentence? Why or why not?
6. Should we try to reform criminals by erasing their memories? Should we try to reform criminals by changing their character? Is one method preferable to the other? Why or why not?
7. Suppose reincarnation occurred and we could accurately identify who is a reincarnation of whom. Should a reincarnated criminal be punished for crimes committed in a past life? Why or why not?
8. Is resurrection a more plausible view of the afterlife than reincarnation? Why or why not?
9. Consider the following thought experiment suggested by Bernard Williams.

Thought Experiment

Bodily Torture

Suppose someone tells you that the person in your body is going to be tortured tomorrow. This person, however, will have none of your memories and the person in your body will have no memory of being tortured. Should you fear being tortured? If so, does that suggest that your identity is more closely tied to your body than the psychological continuity theory suggests? Why or why not?

10. Are the different personalities in people suffering from multiple-personality disorder different persons? Why or why not? The preferred treatment for people suffering from multiple-personality disorder is to merge the different personalities into one. Often this results in the destruction of one or more of those personalities. Is this destruction a type of homicide? If so, is it justifiable homicide? Why or why not?

Internet Inquiries

1. Electroshock, or electroconvulsive therapy (ECT), is a treatment for severe depression that involves sending an electric current through the patient's brain in an attempt to produce a seizure. It has long been criticized for causing long-term memory impairment, and recent research has confirmed this charge. Some patients claim that ECT has erased their identities. Should it be banned or more strictly regulated? Enter "ECT" and "Sackheim" into an Internet search engine to explore this issue.

2. Memories can be erased chemically as well as electrically. "Therapeutic forgetting" or "memory damping" involves using drugs to eradicate or lessen the emotional impact of a traumatic memory. Could this technology be abused? Should it be regulated? If so, how? Enter "therapeutic forgetting" into an Internet search engine to explore this issue.

3. Are the personalities in those suffering from multiple-personality disorder (now known as "dissociative identity disorder") separate persons or just metaphors? Do alters really have separate streams of consciousness and separate memories? Enter "alters," "dissociative identity disorder," and "genuine" into an Internet search engine to explore this issue.

Section 4.3

You Can't Step into the Same River Twice
Self as Process

We would survive a trip through the *Star Trek* transporter—but not Parfit's transporter—because the *Star Trek* transporter transports the body as well as the mind. So something more than psychological continuity is required for personal identity. Sydney Shoemaker claims that in addition to psychological continuity, your psychology must be caused by and realized in the same brain.

The Brain Theory

Our brains are the seat of our consciousness, and as long as they survive, there is reason to believe that we survive. Shoemaker demonstrates the importance of brains to personal identity in the following thought experiment.

> *To expect a personality to survive the disintegration of the brain is like expecting a cricket club to survive when all its members are dead.*
>
> —BERTRAND RUSSELL

Thought Experiment

Shoemaker's Brain Transplant

First, suppose that medical science has developed a technique whereby a surgeon can completely remove a person's brain from his head, examine or operate on it, and then put it back in his skull (regrafting the nerves, blood vessels, and so forth) without causing death or permanent injury; we are to imagine that this technique of "brain extraction" has come to be widely practiced in the treatment of brain tumors and other disorders of the brain. One day, to begin our story, a surgeon discovers that an assistant has made a horrible mistake. Two men, a Mr. Brown and a Mr. Robinson, had been operated on for brain tumors, and brain extraction had been performed on both of them. At the end of the

operations, however, the assistant inadvertently put Brown's brain in Robinson's head. One of these men immediately dies, but the other, the one with Robinson's body and Brown's brain, eventually regains consciousness. Let us call the latter "Brownson." Upon regaining consciousness Brownson exhibits great shock and surprise at the appearance of his body. Then, upon seeing Brown's body, he exclaims incredulously, "That's me lying there!" Pointing to himself he says, "This isn't my body; the one over there is!" When asked his name he automatically replies, "Brown." He recognizes Brown's wife and family (whom Robinson had never met), and is able to describe in detail events in Brown's life, always describing them as events in his own life. Of Robinson's past life he evidences no knowledge at all. Over a period of time he is observed to display all of the personality traits, mannerisms, interests, likes and dislikes, and so on that had previously characterized Brown, and to act and talk in ways completely alien to the old Robinson.[44]

Shoemaker describes a situation in which a Mr. Brown's brain is transplanted into a Mr. Robinson's skull. The resulting person—Brownson—is psychologically continuous with Mr. Brown. He has Mr. Brown's memories and desires as well as his personality traits and mannerisms. Consequently, claims Shoemaker, Brownson is identical to Brown. The fact that Brownson doesn't have Brown's body is irrelevant because Brownson's psychology is caused by and realized in Brown's brain. Since the brain is the organ of thought, Brownson's thoughts are Brown's thoughts. This suggests that where our brains go, we go. This is the **brain theory:** The doctrine that identical persons are those who are psychologically continuous with one another and whose psychology is caused by and realized in the same brain.

brain theory The doctrine that identical persons are those who are psychologically continuous with one another and whose psychology is caused by and realized in the same brain.

> ### A Brain Is a Terrible Thing to Waste
>
> Brain transplants are not just the stuff of science fiction. From 1961 to 1971, Dr. Robert J. White and his colleagues at the Mayo Clinic transplanted a number of severed monkey heads onto headless monkey bodies. The transplants didn't live long—the record was about a week—but progress was being made. Dr. White would like to see research continue in this area. *Lingua Franca* recently reported on Dr. White's past successes and future prospects:
>
>> Imagine you're Stephen Hawking, the renowned physicist whose body has been wasting for years from Lou Gehrig's disease. Let's say that doctors have determined your organs have so degenerated that you have only a year to live, even though your mind is fully functional—nay, brilliant. Might there be some other way to keep you alive?
>>
>> Robert J. White, the director of the Brain Research Laboratory at the Case Western Reserve University School of Medicine, thinks there is — or could be, if scientists would get off their collective duff. The answer, he says, is brain transplantation: severing Hawking's head and reattaching it to a headless donor body. White maintains that doing this with monkeys is already possible and envisions a day when victims of fatal head injuries might be harvested not for their organs—but for their entire bodies.[45]
>
> #### Thought Probe
>
> Body Transplants
>
> Do you agree that your identity resides in your brain? Would you survive a body transplant? Why or why not?

Having the same brain, however, does not require having the same entire brain, for neurophysiology has shown that people can survive the destruction of large parts of their brains. Some people have had almost half of their cerebral cortex destroyed by stroke, injury, or surgery and have learned to function adequately. In these cases, the remaining part of their cerebral cortex has taken over the functions of the damaged part.

Split Brains

Although the brain theory is superior to the body theory, it doesn't avoid the reduplication problem. For, just as more than one person can be psychologically continuous with someone, so more than one physical object can be physically (spatiotemporally) continuous with something. When an amoeba undergoes fission (splits), for example, the two resulting amoebas are physically continuous with the original. Strange as it may seem, persons, like amoebas, may undergo fission.

The brain is divided into two symmetrical hemispheres, which are linked by a bundle of nerves known as the corpus callosum. These fibers carry signals back and forth between the two hemispheres. To prevent the spread of seizures from one hemisphere to the other, neurosurgeons have cut the corpus callosum in a number of patients. What they found was that by splitting the brains of these patients, they seemed to create two separate spheres of consciousness.

Essentially you're doing a karate chop to the head and creating two human beings in one body.

—VILAYANUR RAMACHANDRAN

THE CORPUS CALLOSUM (FROM DEFABRICA, 1543, BY ANDREAS VESALIUS). This bundle of nerves (L) connects the two hemispheres of the brain.

Each half of the brain governs the opposite side of the body. The left hemisphere controls the muscles of the right side of the body and receives information from the right half of the skin surface; the right hemisphere controls the muscles of the left side of the body and receives information from the left half of the skin surface. In most people, the left hemisphere also controls speech. In split-brain patients, information given to one hemisphere is unavailable to the other. For example, in one experiment, an object was placed in the left hand of a blindfolded split-brain patient. She couldn't name the object because speech is controlled by the left hemisphere, and only the right hemisphere knew what the object was. When she was asked to use her left hand to retrieve the object from a box of objects, she had no trouble doing so. But when she was asked to use her right hand to retrieve the object, all she could do was pick up objects at random. When the blindfold was removed, however, and she was allowed to watch her right hand try to pick up the object, her left hand would slap her right hand whenever it picked up the wrong object. This was the right hemisphere's way of communicating with the left now that it could no longer use the corpus callosum. Such behavior led Roger Sperry to describe split-brain patients as having "two free wills in one cranial vault."[46] In other words, there are two persons in one skull.

Split-brain experiments convinced Derek Parfit that the brain theory was an inadequate theory of personal identity. To exhibit its shortcomings, he

> ### Alien Hand Syndrome
>
> Roger Sperry's claim that split-brain operations create "two free wills in one cranial vault" is controversial because these patients often function normally outside of the laboratory. But a phenomenon that is experienced by some lends credence to Sperry's claim; it is called alien hand syndrome. Neurologist I. Biran describes its effects:
>
>> In Stanley Kubrick's movie *Dr. Strangelove*, the main character is described as "erratic" and displays a bizarre movement disorder. His right hand seems to be driven by a will of its own, at times clutching his own throat and at other times lurching into a Nazi salute. Dr. Strangelove must try to restrain this wayward limb with his left hand. Bizarre as this fictional character is, a similar movement disorder can occur in neurologic disease. The complex phenomenon associated with this disorder falls under the rubric of alien hand syndrome. This syndrome is characterized by a limb that seems to perform meaningful acts without being guided by the intention of the patient. Patients find themselves unable to stop the alien limb from reaching and grabbing objects, and they may be unable to release these grasped objects without using their other hand to pry open their fingers. These patients frequently express astonishment and frustration at the errant limb. They experience it as being controlled by an external agent and often refer to it in the third person.[47]
>
> ### Thought Probe
>
> **Who Is Behind the Hand?**
>
> Could the agent behind an alien hand be a person? How could we tell?

proposed the following thought experiment. Suppose (as may well be the case in some people) that each of Parfit's brain hemispheres has the same psychology (memories, desires, attitudes, and so on). Suppose further that Parfit is one of three identical triplets. Then suppose the following.

Thought Experiment

> #### Parfit's Division
>
> My body is fatally injured, as are the brains of my two [identical] brothers. My brain is divided, and each half is successfully transplanted into the body of one of my brothers. Each of the resulting people believes that he is me, seems to remember living my life, has my character, and is in every other way psychologically continuous with me. And he has a body very like mine.[48]

In this case, each of Parfit's cerebral hemispheres is transplanted into a separate body that is indistinguishable from his own. (We can imagine that his brain was split to double the operation's chances for success.) Because each of his hemispheres has the same psychology, the two persons resulting from the two transplants are psychologically continuous with Parfit. And because their brains are physically continuous with his,

their psychology is caused by and realized in Parfit's brain. So, according to the brain theory, both people should be identical to Parfit. But that's impossible, for two cannot be one. Thus it appears that the reduplication problem cannot be avoided by requiring that our psychology be grounded in the brain.

Closest Continuer Theories

> If I am I because you are you, and if you are you because I am I, then I am not I, and you are not you.
>
> —Hassidic Rabbi

Personal identity cannot consist in psychological or physical continuity because identity is a relation that can hold only between a thing and itself. Psychological and physical continuity are relations that can hold between many different things. Both minds and bodies can be split. When they are, the resulting things are not identical to the original even though they are continuous with it. To avoid the reduplication problem, then, it seems that either a theory of personal identity must rule out any sort of splitting, or it must have some means of determining which branch is identical to the original.

Sydney Shoemaker adopts the first alternative and suggests that personal identity requires nonbranching psychological continuity.[49] If the causal chain linking you to a person existing at another time splits or merges in certain ways, your identity will not be preserved. According to the **nonbranching theory,** then, identical persons are those who are psychologically continuous with one another and whose causal chain has not branched.

By not allowing branching causal chains, Shoemaker's proposal avoids all of the reduplication scenarios we have examined: Williams's double reincarnation of Guy Fawkes, Parfit's nondestructive teletransportation, and Parfit's division—for each of these scenarios involves branching causal chains of one sort or another.

Robert Nozick adopts the second strategy and tries to provide a means for determining which branch is identical to the original. Psychological and physical continuity are a matter of degree. But, Nozick claims, as long as one person is sufficiently psychologically and physically continuous with another and there is no one else who is more psychologically and physically continuous with the former person, then the latter person is numerically identical to the former.[50] According to Nozick's **closest continuer theory,** then, identical persons are those who are closest continuers of one another.

The closest continuer theory can avoid certain sorts of reduplication scenarios, but in those cases where two people are equally close, such as in Parfit's division, or a double reincarnation, or a double teletransportation, the closest continuer theory tells us that neither of the later persons is identical to the earlier.

Adopting either the nonbranching theory or the closest continuer theory, however, means rejecting one of our most fundamental beliefs concerning the nature of identity—namely, that the identity of a thing doesn't depend on the existence of other things. This belief has come to be known as the **only x and y principle,** and it rests on the intuition that whether one thing,

nonbranching theory The doctrine that identical persons are those who are psychologically continuous with one another and whose causal connection has not branched.

closest continuer theory The doctrine that identical persons are those who are the closest continuers of one another.

only x and y principle The principle that whether one thing, x, is identical to another thing, y, can depend only on facts about x and y.

Buddhists on the Self and Nirvana

Belief in the impermanence of all things is one of the fundamental tenets of Buddhism. Moreover, Buddhists claim that belief in a permanent self or soul is the root of all evil. Buddhist theologian Walpola Rahula elaborates:

> According to the teaching of the Buddha, the idea of self is an imaginary, false belief which has no corresponding reality, and it produces harmful thoughts of "me" and "mine," selfish desire, craving attachment, hatred, ill-will, conceit, pride, egoism, and other defilements, impurities and problems. It is the source of all the troubles in the world from personal conflicts to wars between nations. In short, to this false view can be traced all the evil in the world.[51]

Because the cause of evil is the belief in the existence of a soul, the way to eliminate evil is to stop believing in the existence of the soul. Once you do, not only will the world be a better place, but you will realize Nirvana, a state of perfect bliss.

But, you may ask, if there is no soul, who realizes Nirvana? According to Buddhism, realization itself does the realizing. Rahula explains:

> If there is no Self, no Atman, who realizes Nirvana? Before we go on to Nirvana, let us ask the question: Who thinks now, if there is no Self? We have seen earlier that it is the thought that thinks, that there is no thinker behind the thought. In the same way, it is wisdom, realization, that realizes. There is no other self behind the realization.[52]

Traditionally, the self or soul has been conceived as a substance or thing that has thoughts. The Buddhists deny the existence of the self because they deny the existence of continuing substances. Because everything is constantly changing, there is nothing for thoughts to belong to. We speak as if there were continuing selves, but according to the Buddhists, that is just a convention that we have adopted for practical purposes. Words such as "I," "me," "soul," and the like do not refer to continuing selves, for there are none to refer to.

x, is identical to another thing, y, can depend only on facts about x and y. Facts about other things are irrelevant because identity is a relation that holds between a thing and itself. Whether an oak is identical to a sapling, for example, shouldn't depend on the existence of other trees. Similarly, whether you are identical to a person who lived before shouldn't depend on the existence of other people.

According to either the nonbranching or the closest continuer theory, however, your identity depends on the existence of other people. If the causal chain that produced your psychology has split into two or more equal branches, you cannot be identical to the person you think you are. In the case of Parfit's division, for example, neither of the resulting people is identical to Parfit because the causal chain connecting them to Parfit has branched and neither is a closer continuer than the other. So Parfit has suffered death by duplication. If only one of the transplants had been successful, however, the resulting person would have been identical to Parfit. So prior to the operation, Parfit would have been well advised to have hired a hit man with orders to kill one of the resulting people if both operations were successful. By ensuring that the causal chain did not branch, he would have been ensuring his continued existence. Such are the bizarre implications of rejecting the only x and y principle.

Drawing Hands by M.C. Escher (lithograph, 1948). A visual analog of a self-generating process.

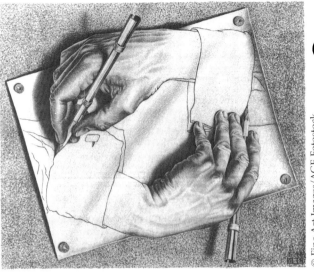

Thought Probe

Branch Lines

Should we give up the only x and y principle as both Shoemaker and Nozick suggest? Do you agree that whether you're identical to someone depends on whether other people exist? Why or why not?

Identity and What Matters in Survival

> Trying to define yourself is like trying to bite your own teeth.
> —ALAN WATTS

We began our investigation into personal identity with the assumption that we can survive the death of our body only if we are numerically identical to someone who exists after our body has died. But we have been unable to come up with a theory that captures all of our intuitions concerning the nature of personal identity. Parfit suggests that this shows these intuitions are mistaken. Numerical identity is not necessary for survival.

Consider once again the case of Parfit's division. By the transitivity of identity, neither of the resulting persons would be numerically identical to Parfit. If they were, they would be numerically identical to each other, and that's impossible. Two things cannot be one. But even though neither of the resulting persons would be identical to him, it would be irrational for Parfit to view the impending operation the same way he would view his own death. It would also be irrational for him to hire someone to kill one of the resulting people if both transplants succeeded, even though that would ensure that he would be numerically identical to the survivor. The best explanation of these facts, claims Parfit, is that numerical identity is

not what matters in survival. What matters is psychological continuity. If we retain our memories and our desires, it doesn't matter whether we are numerically identical to anyone who lived before. In that case, we have all that's really important.

To see what Parfit is getting at, imagine what would happen if Parfit's division were successful. The two resulting people would look and act just as he did. The existence of these two replicas would certainly be disconcerting to his friends and relatives, especially if they met both of the replicas at the same time. But because both are psychologically and physically indistinguishable from Parfit, Parfit's friends and relatives would have every reason to be just as interested in each of them as they were in him.

Even though neither of Parfit's replicas is identical to him, it would not seem to them that they had just come into existence. Both would believe they were Parfit, for both would have all of Parfit's memories, desires, and character traits. Even after they had realized the other existed, they would still be able to fulfill their impersonal desires. In fact, if they learned to cooperate with one another, they might be able to complete any projects Parfit had planned in half the time (just as in the movie *Multiplicity*).

It would be a little more difficult for both of the replicas to fulfill all of Parfit's personal desires, especially if Parfit were married, employed, or a homeowner. Who would get his wife? Who would get his job? Who would get his house? Judicious planning before the operation might be able to eliminate these difficulties, however. If Parfit knew the operation was coming, he might establish a procedure for deciding these questions. Because both of the resulting persons would have all of his memories, they should agree to go along with whatever procedure he came up with. In any event, from both a third-person and a first-person point of view, being a Parfitian survivor would certainly be much better than simply dying.

If faced with certain death (as in the case presented in the beginning of this chapter), Parfit would probably accept the doctor's offer to download the contents of his brain into a robot. If the operation were successful, the robot would be psychologically continuous with him, and according to Parfit, that's all that really matters. Alternatively, Parfit could look forward to a more traditional afterlife. He could hope to be psychologically continuous with someone in a spiritual body. The fact that his mind could be placed in two or more robot or spiritual bodies wouldn't bother him, for as long as it was placed in at least one, he would survive.

Identity and What Matters in Responsibility

Locke's primary purpose in constructing a theory of personal identity was not to determine whether it was possible for us to survive the death of our bodies; it was to determine how to assign praise and blame. Justice demands that only the person who did the deed suffer the consequences or reap the rewards. It wouldn't be fair to praise or blame someone for what someone else did. To ensure that our approbation or condemnation is directed at the right person,

To live is to change and to be perfect is to have changed often.

—JOHN HENRY NEWMAN

we need a theory of personal identity. The idea is that if you committed a crime, you—and only you—should do the time. The possibility of reduplication or branching, however—as discussed in the cases of Williams's reduplication, Parfit's transporter, and Parfit's division—suggests that numerical identity may not be necessary for personal responsibility.

Suppose, for example, that before his division, Parfit had led a life of crime. Then, even though neither of his replicas is numerically identical to him, the authorities would have good reason for locking both of them up. Each of them would have whatever desires, intentions, and character traits had led Parfit to a life of crime in the first place. Since our actions flow from our characters, there would be good reason to believe that Parfit's replicas would follow in his footsteps. The principle that only those who commit a crime should be punished for it seems inapplicable here. If Parfit's survivors have his character, they should be punished, too.

Not only may numerical identity not be necessary for personal responsibility, it may not be sufficient. Your character can change over time. If it does, there is reason to believe that you should not be held fully responsible for what you did in the past. Consider the following example.

Thought Experiment

Parfit's Reformed Nobelist

Suppose that a man aged ninety, one of the few rightful holders of the Nobel Peace Prize, confesses that it was he who, at the age of twenty, injured a policeman in a drunken brawl. Although it was a serious crime, this man may not now deserve to be punished.[53]

The ninety-year-old Nobel Peace Prize winner is numerically identical to the person who committed the crime seventy years ago. But he may not deserve to be punished for it, for his character may no longer be the same. Your character is a function of your beliefs, attitudes, desires, values, and the like—and your actions are a function of your character. If the character of the Nobel Peace Prize winner changed in such a way that he would no longer perform the kinds of actions he did in his youth, there's reason to believe that punishment would be pointless.

Parole boards seem to realize that if a person's character changes for the better, the individual's responsibility for a crime is lessened. Parfit suggests that this realization also lies behind statutes of limitation, which limit the length of time during which a person may be charged with committing a specific crime.[54] An understanding of the dependence of action on character seems to be implicit in our legal system. Parfit believes that our judgments regarding guilt and responsibility would be more consistent if that relationship were made more explicit.

Numerical identity seems to be neither necessary nor sufficient for moral responsibility. What matters is sameness of character. If a person's character

has changed significantly since the time of an incident, that person's responsibility for the incident may be significantly less.

Explaining the Self

Theories of personal identity try to specify the conditions under which a person at one time is numerically identical to a person at another time. But we have been unable to find a set of conditions that is both necessary and sufficient for personal identity. Why are identity conditions for persons so hard to come by? Given the failure of substance theories of personal identity, the best explanation seems to be that persons aren't things—they're processes.

According to emergent property dualism, the mind is a property that emerges from a physical thing when it reaches a certain degree of complexity. Similarly, the self can be viewed as a property that emerges from the mind when it reaches a certain degree of complexity. Not everything that has a mind has a self, for not everything that is conscious is self-conscious. And not everything that is self-conscious is self-conscious to the same degree. So, contrary to what the substance theorists would have us believe, having a self is not an all-or-nothing affair.

The fact that the unity of the self can be destroyed by psychological and physical traumas (such as multiple-personality disorder and split-brain operations) is further evidence for the fact that the self is not a substance. In ordinary circumstances, however, the self seems to be unified, and any process theory must account for this apparent unity of the self. Immanuel Kant (1724–1804) accounts for it by postulating a "transcendental ego" that lies behind our experience and structures it according to certain rules. Kant's self is transcendental because it cannot be directly observed. As a result, Kant claims, we cannot know whether the self is a continuing substance.[55]

To account for the apparent unity of the self, however, we need not postulate anything that lies beyond experience. We need only assume that the properties that constitute the self are self-organizing. Nobel Prize–winning chemist Ilya Prigogine has shown that many systems in nature are self-organizing.[56] The self may simply be one of those systems. In previous sections, we have seen that there is good reason for believing that mental properties have causal powers. If they do, there is no reason to believe that they couldn't unify themselves.

The self, in this view, is a self-generating process. To borrow one of the Buddhists' favorite analogies, the self is to the body as the flame is to the candle. Just as each stage of the flame brings about the next through the process of burning, so each stage of the self brings about the next through the process of thinking. Both the flame and the self are constantly changing, but each is part of a continuous process. There can be no flame without a candle, just as there can be no self without a body. But the flame can be passed on to many different candles, just as the self can be passed on to many different bodies. Because flames and selves can continue on in more than one substance, we cannot identify flames or selves with substances. But if we are willing to admit that survival doesn't require identity, we may justifiably hope to survive the death of our bodies.

> Substance is one of the greatest of our illusions.
> —SIR ARTHUR EDDINGTON

> It now seems to me that one changes from day to day and that every few years one becomes a new being.
> —GEORGE SAND

Thought Probe

> ### Robert and Frank
>
> Consider the case of Robert and Frank discussed in the introduction to this chapter. Given what you now know of personal identity, do you believe that Robert should be punished for what Frank did? Why or why not?

Moral Agents, Narratives, and Persons

To be a person is to have a story to tell.
—Isak Dinesen

All persons have rights that ought to be respected. But only some persons are capable of respecting those rights. The very young, the mentally incapacitated, and the insane, for example, may be incapable of acting morally toward others because they do not know the difference between right and wrong or they are unable to control themselves. In either case, we do not hold them responsible for their actions. Only those persons who have the concepts of right and wrong and can act on those concepts are held accountable for what they do. Persons who can act morally toward others and thus can be justly praised or blamed for their actions are known as "moral agents."

To be a moral agent, you must be capable of acting freely. And, as shown in Chapter 3, to act freely, you must be capable of reflecting on your desires and deciding whether you want to be the sort of person that is motivated by them. By reflecting on your desires and deciding what is worthy of value, you help shape your character and bring unity to your life.

Much has been made recently of the importance of unity in personal identity. Marya Schechtman, for example, argues that you become a person by viewing your life as part of a narrative: "[I]ndividuals constitute themselves as persons by coming to think of themselves as persisting subjects who have had experience in the past and will continue to have experience in the future, taking certain experiences as theirs. . . . [Persons] weave stories of their lives."[57] Owen Flanagan similarly argues that you are a person only if your life is lived according to a "contentful story that involves an unfolding rationale."[58] Daniel Dennett views the self as a narrative center of gravity.[59] For him, the self is not something over and above the narrative; it *is* the narrative. In all of these views, the self is constituted by the narrative that weaves one's thoughts, feelings, and desires into a coherent whole.

Our greatest responsibility is not to be pencils of the past.
—Robert A. M. Stern

Having a certain unity to one's self is a necessary condition for acting responsibly. Consider the case of those suffering from multiple-personality disorder. In their case, there may be a number of different story lines instead of one unified narrative. Courts of law generally do not hold these people responsible for their actions on the grounds that they lack the unity required to govern themselves. As Elyn Saks notes in her book *Jekyll on Trial*, "The sine qua non ["without which not," or necessary condition] of a responsible act is not that *a* consciousness chooses to act, but that a *unified* consciousness chooses to act."[60] Only if all aspects of one's self are available for participation in a decision can one be held responsible for it.

The narrativity theorists argue that we achieve the unity of consciousness necessary for acting morally by viewing our lives as a narrative. Not everyone shares this view, however. Galen Strawson, for example, rejects both the psychological narrativity thesis (which holds that "human beings typically see or live or experience their lives as a narrative of some sort") and the ethical narrativity thesis (which holds that "experiencing or conceiving one's life as a narrative is essential to a well-lived life, to true or full personhood").[61] He doesn't deny that some people see their lives as a narrative; he simply denies that everybody does or should.

Strawson identifies two different "styles of being" which he calls the "diachronic" and the "episodic." Diachronics view the different stages of their life as part of a continuous series and thus would tend to endorse the psychological narrativity thesis. Episodics, on the other hand, see the different stages of their life as discontinuous episodes and thus would tend to reject it. To say that someone is an episodic is not to say that person can't see his or her life as a narrative; such people can. But they usually don't. In addition to himself, Strawson cites Michel de Montaigne, the Earl of Shaftesbury, Stendhal, Hazlitt, Ford Maddox Ford, Virginia Woolf, Borges, Fernando Pessoa, Iris Murdoch, Freddie Ayer, Goronwy Rees, Bob Dylan, and Proust as fellow episodics.

From a philosophical point of view, the more controversial of the two theses is the ethical narrativity thesis. Strawson claims not only that viewing your life as a narrative is not necessary for leading a good life but also that doing so may prevent you from leading one. In his view, trying to live a storied life may actually keep you from living a good life. Here's why: "My guess is that it almost always does more harm than good—that the narrative tendency to look for story or narrative coherence in one's life is, in general, a gross hindrance to self-understanding: to a just, general, practically real sense, implicit or explicit, of one's nature."[62] The problem is that narratives alter the facts. The process of recalling a memory and placing it in a narrative changes the memory: "It's well known," Strawson tells us, "that telling or retelling one's past leads to changes, smoothings, enhancements, shifts away from the facts."[63] A good life can't be built on lies. Insofar as narrative takes us away from the truth, it takes us away from one of the most important elements of a good life.

Whether or not living a storied life is necessary for living a good one, it's not necessary for living a moral one. Acting morally requires a unified self, but that unity doesn't necessarily come from being part of a narrative. It can come from self-consciously reflecting on the events of one's life. Such reflection may not lead to a coherent narrative. There may be too many twistings and turnings and unexpected events to make narrative sense of it. Nevertheless, self-reflection can bring unity to one's life by bringing meaning to it. "What is required for unified personhood," writes John Christman, "is that the subject of that life be a reflecting subject whose self-interpretations make enough sense of those events that a consistent character can be seen at their center."[64] As long as your self-conscious choices have created a consistent character—a consistent set of dispositions to act—you have a unified self and can be held responsible for what you do.

> *An identity would seem to be arrived at by the way in which the person faces and uses his experience.*
> —JAMES BALDWIN

Although a certain degree of self-integration may be required to be a moral agent, it doesn't seem to be required to be a person per se. Those suffering from multiple-personality disorder are still persons, either multiple or fragmentary. Those suffering from various forms of amnesia may also be unable to construct a unified narrative of their lives, but they may nonetheless be persons.

Consider the case of Canadian conductor Clive Wearing. As a result of viral encephalitis that destroyed his hippocampus, he developed both anterograde and retrograde amnesia. He became unable to form new memories or access his old ones. His life thus consists of a series of discrete periods of consciousness, each lasting only a few minutes. He keeps a diary and often writes in it, "I am now fully awake for the first time." When asked about previous entries in the diary, he disavows them. Clive's life has no narrative unity. Nevertheless, he has many of the marks of personhood: He is rational, self-conscious (for short periods of time), and capable of engaging in self-motivated activity. Killing Clive would unquestionably be an act of murder. So even though having a unified self may be a necessary condition for being a moral agent, it may not be necessary for being a person.

Thought Probe

Being Clive Wearing

Is there one continuous person in Clive Wearing's body, or does his body house a succession of persons, each of which exists for only a few minutes? There are no memory connections between the periods of self-consciousness in Clive's body, but his intelligence, character, musical talent, love for his wife, and so on all remain constant. Is this enough to unite these periods of self-consciousness into one person?

Summary

The reduplication problem shows that there must be more to personal identity than psychological continuity. Shoemaker suggests that, in addition, your psychology must be caused by and realized in your brain. Unfortunately, Shoemaker's brain theory doesn't succeed in defining personal identity because, as Parfit's division shows, even though your psychology is caused by and realized in the same brain, it may belong to two different people.

Personal identity cannot consist in psychological or physical continuity because identity is a relation that can hold only between a thing and itself, whereas psychological and physical continuity are relations that can hold between many different things. Stipulating that only nonbranching causal chains can preserve personal identity avoids this problem. Adopting this proposal, however, requires rejecting one of our most fundamental beliefs concerning the nature of identity: the only x and y principle. This belief rests on

the intuition that whether one thing, x, is identical to another thing, y, can depend only on facts about x and y. Because numerical identity is a relation between a thing and itself, the existence of other things shouldn't affect the identity of the thing.

At this point, we have to ask whether numerical identity is what really matters in survival. In the case of Parfit's division, the two resulting people would be both psychologically and physically indistinguishable from Parfit. There would seem to be every reason for Parfit and his friends and relatives to think that Parfit had indeed survived the strange operation—even though there is no numerical identity. Likewise, it seems that numerical identity is not necessary for moral responsibility. Whether you should be held responsible for an action seems to depend more on your character than on your identity.

Our inability to find identity conditions for persons can be explained on the grounds that the self is a self-generating process rather than an unchanging substance. Because the same process can continue on in different substances, we can't identify selves with substances. But if we're willing to recognize that survival doesn't require identity, we can look forward to surviving the death of our bodies.

Study Questions

1. What is the brain theory of personal identity?
2. What is Shoemaker's brain transplant thought experiment?
3. What is Parfit's division thought experiment? How does it attempt to undermine the physical theory of personal identity?
4. What is the only x and y principle?

Discussion Questions

1. Suppose that brain transplant operations become relatively reliable. Would you have your brain transplanted into another human to avoid certain death? Into a fully functional robot that could house a human brain?
2. Suppose that your body is dying and that half of your brain has been destroyed. Suppose further that your spouse's body is healthy but that half of his or her brain has been destroyed. The doctors say that they can transplant the remaining healthy half of your brain into your spouse's skull. Your spouse agrees to have the transplant. Would you do it? What if the person who agreed to receive your brain was a stranger?
3. Are split-brain patients really two people in one skull? Are there any physical experiments we could conduct to determine whether two people are present? Describe any such experiments.
4. What does the nonbranching proposal say about split-brain patients? Are there two people present in the body? If so, is either identical with the person who occupied the body before the operation?

5. Can an adequate theory of personal identity violate the only x and y principle? Are the consequences of rejecting the principle too bizarre? If you can, explain your view by means of a thought experiment.
6. Is psychological continuity the only thing that matters in survival?
7. Suppose that someone commits a crime and arranges things so that her personality is totally changed after the crime (through brainwashing, psychosurgery, drugs, or the like). Should the resulting person be held responsible for the crime? What if her memories were erased, too?
8. What implications does the realization that responsibility is closely tied to character have for our judicial system? Would our judicial system be more just if we put more emphasis on character than on identity?
9. What theories of mind are consistent with the notion that the self is a process?

Internet Inquiries

1. The National Geographic Channel recently aired a program on head transplants featuring the work of Robert White, the neurosurgeon who transplanted monkey heads in the 1970s. Film footage of the actual experiment was included. The experiments were stopped because of animal rights concerns. Dr. White thinks that the possible benefits of this research to humans outweigh the harm experienced by the monkeys. Do you agree? Enter "monkey head transplant" into an Internet search engine to explore this issue.
2. Should religious conversion be considered a mitigating circumstance in sentencing criminals? In the case of *Brown v. Payton,* the U.S. 9th Circuit Court argued that it should. This decision was later overturned by the U.S. Supreme Court. Which position is the more reasonable? If a criminal's character has changed for the better, does she or he deserve a lesser sentence? Enter "Brown v. Payton" into an Internet search engine to explore this issue.
3. What does alien hand syndrome tell us about normal persons? Can each hemisphere in our brains be considered a separate person? Enter "alien hand syndrome" into an Internet search engine to explore this issue.

John Locke
Of Identity and Diversity

John Locke (1632–1704) founded the philosophical school known as British empiricism and also served as a physician to the Earl of Shaftesbury. His best-known works are *An Essay Concerning Human Understanding* and *Two Treatises of Government.* The former outlines the basic principles of empiricism; the latter, the basic principles of democratic government. In this selection, Locke argues that personal identity resides not in any particular substance but in the consciousness we have of our continued existence.

8. An animal is a living organized body; and consequently the same animal, as we have observed, is the same continued *life* communicated to different particles of matter, as they happen successively to be united to that organized living body. And whatever is talked of other definitions, ingenious observation puts it past doubt, that the idea in our minds, of which the sound man in our mouths is the sign, is nothing else but of an animal of such a certain form. Since I think I may be confident, that, whoever should see a creature of his own shape or make, though it had no more reason all its life than a cat or a parrot, would call him still a *man;* or whoever should hear a cat or a parrot discourse, reason, and philosophize, would call or think it nothing but a *cat* or a *parrot;* and say, the one was a dull irrational man, and the other a very intelligent rational parrot....

9. This being premised, to find wherein personal identity consists, we must consider what *person* stands for;—which, I think, is a thinking intelligent being, that has reason and reflection, and can consider itself as itself, the same thinking thing, in different times and places; which it does only by that consciousness which is inseparable from thinking, and, as it seems to me, essential to it: it being impossible for any one to perceive without *perceiving* that he does perceive. When we see, hear, smell, taste, feel, meditate, or will anything, we know that we do so. Thus it is always as to our present sensations and perceptions: and by this every one is to himself that which he calls *self:*—it not being considered, in this case, whether the same self be continued in the same or diverse substances. For, since consciousness always accompanies thinking, and it is that which makes every one to be what he calls self, and thereby distinguishes himself from all other thinking things, in this alone consists personal identity, i.e. the sameness of a rational being: and as far as this consciousness can be extended backwards to any past action or thought, so far reaches the identity of that person; it is the same self now as it was then; and it is by the same self with this present one that now reflects on it, that that action was done.

12. But the question is, Whether if the same substance which thinks be changed, it can be the same person; or, remaining the same, it can be different persons?...

13. But next, as to the first part of the question,... it must be allowed, that, if the same consciousness (which, as has been shown, is quite a different thing from the same numerical figure or motion in body) can be transferred from one thinking substance to another, it will be possible that two thinking substances may make but one person. For the same consciousness being preserved, whether in the same or different substances, the personal identity is preserved....

14. As to the second part of the question, Whether the same immaterial substance remaining, there may be two distinct persons; which question seems to me to be built on this,—Whether the same immaterial being, being conscious of the action of its past duration, may be wholly stripped of all the consciousness of its past existence, and lose it beyond the power of ever retrieving it again: and so as it were beginning a new account from a new period, have a consciousness that *cannot* reach beyond this new state. All those who hold pre-existence are evidently of this mind; since they allow the soul to

Source: John Locke, *An Essay Concerning Human Understanding,* ed. Alexander Campbell Fraser (Oxford: Clarendon Press, 1894) 445–468. Notes have been omitted.

have no remaining consciousness of what it did in that pre-existent state, either wholly separate from body, or informing any other body; and if they should not, it is plain experience would be against them. So that personal identity, reaching no further than consciousness reaches, a pre-existent spirit not having continued so many ages in a state of silence, must needs make different persons. Suppose a Christian Platonist or a Pythagorean should, upon God's having ended all his works of creation the seventh day, think his soul hath existed ever since; and should imagine it has revolved in several human bodies; as I once met with one, who was persuaded his had been the *soul* of Socrates (how reasonably I will not dispute; this I know, that in the post he filled, which was no inconsiderable one, he passed for a very rational man, and the press has shown that he wanted not parts or learning;)—would any one say, that he, being not conscious of any of Socrates's actions or thoughts, could be the same *person* with Socrates? Let any one reflect upon himself, and conclude that he has in himself an immaterial spirit, which is that which thinks in him, and, in the constant change of his body keeps him the same: and is that which he calls *himself:* let him also suppose it to be the same soul that was in Nestor or Thersites, at the siege of Troy, (for souls being, as far as we know anything of them, in their nature indifferent to any parcel of matter, the supposition has no apparent absurdity in it,) which it may have been, as well as it is now the soul of any other man: but he now having no consciousness of any of the actions either of Nestor or Thersites, does or can he conceive himself the same person with either of them? Can he be concerned in either of their actions? Attribute them to himself, or think them his own, more than the actions of any other men that ever existed? So that this consciousness, not reaching to any of the actions of either of those men, he is no more one *self* with either of them than if the soul or immaterial spirit that now informs him had been created, and began to exist, when it began to inform his present body; though it were never so true, that the same *spirit* that informed Nestor's or Thersites's body were numerically the same that now informs his. For this would no more make him the same person with Nestor, than if some of the particles of matter that were once a part of Nestor were now a part of this man; the same immaterial substance, without the same consciousness, no more making the same person, by being united to any body, than the same particle of matter, without consciousness, united to any body, makes the same person. But let him once find himself conscious of any of the actions of Nestor, he then finds himself the same person with Nestor.

15. And thus may we be able, without any difficulty, to conceive the same person at the resurrection, though in a body not exactly in make or parts the same which he had here,—the same consciousness going along with the soul that inhabits it. But yet the soul alone, in the change of bodies, would scarce to any one but to him that makes the soul the man, be enough to make the same man. For should the soul of a prince, carrying with it the consciousness of the prince's past life, enter and inform the body of a cobbler, as soon as deserted by his own soul, every one sees he would be the same *person* with the prince, accountable only for the prince's actions: but who would say it was the same *man?* The body too goes to the making the man, and would, I guess, to everybody determine the man in this case, wherein the soul, with all its princely thoughts about it, would not make another man: but he would be the same cobbler to every one besides himself. I know that, in the ordinary way of speaking, the same person, and the same man, stand for one and the same thing. And indeed every one will always have a liberty to speak as he pleases, and to apply what articulate sounds to what ideas he thinks fit, and change them as often as he pleases. But yet, when we will inquire what makes the same *spirit, man* or *person,* we must fix the ideas of spirit, man, or person in our minds; and having resolved with ourselves what we mean by them, it will not be hard to determine, in either of them, or the like, when it is the same, and when not.

16. But though the same immaterial substance or soul does not alone, wherever it be, and in whatsoever state, make the same *man;* yet it is plain, consciousness, as far as ever it can be extended—should it be to ages past—unites existences and actions very remote in time into the same *person,* as well as it does the existences and actions of the immediately preceding moment: so that whatever has the consciousness of present and past actions, is the same person to whom they both belong. Had I the same consciousness that I saw the ark and Noah's flood, as that I saw an overflowing of the Thames last winter, or as that I write now, I could no more doubt that I who write this now, that saw the Thames overflowed last winter, and that viewed the flood at the general deluge, was the same *self,*—place that self in what *substance* you please—than that I who write this am the same *myself* now whilst I write (whether I consist of all the same substance, material or immaterial, or no) that I was yesterday. For as to this point of being the same self, it matters not whether this present self be made up of the same or other substances—I being as much concerned, and as justly accountable for any action that was done a thousand years since, appropriated to me now by this self-consciousness, as I am for what I did the last moment.

17. *Self* is that conscious thinking thing,—whatever substance made up of, (whether spiritual or material, simple or compounded, it matters not)—which is sensible or conscious of pleasure and pain, capable of happiness or misery, and so is concerned for itself, as far as that consciousness extends. Thus every one finds that, whilst comprehended under that consciousness, the little finger is as much a part of himself as what is most so. Upon separation of this little finger, should this consciousness go along with the little finger, and leave the rest of the body, it is evident the little finger would be the person, the same person; and self then would have nothing to do with the rest of the body. As in this case it is the consciousness that goes along with the substance, when one part is separate from another, which makes the same person, and constitutes this inseparable self: so it is in reference to substances remote in time. That with which the consciousness of this present thinking thing *can* join itself, makes the same person, and is one self with it, and with nothing else; and so attributes to itself, and owns all the actions of that thing, as its own, as far as that consciousness reaches, and no further; as every one who reflects will perceive.

18. In this personal identity is founded all the right and justice of reward and punishment; happiness and misery being that for which every one is concerned for *himself*, and not mattering what becomes of any *substance*, not joined to, or affected with that consciousness. For, as it is evident in the instance I gave but now, if the consciousness went along with the little finger when it was cut off, that would be the same self which was concerned for the whole body yesterday, as making part of itself, whose actions then it cannot but admit as its own now. Though, if the same body should still live, and immediately from the separation of the little finger have its own peculiar consciousness, whereof the little finger knew nothing, it would not at all be concerned for it, as a part of itself, or could own any of its actions, or have any of them imputed to him.

19. This may show us wherein personal identity consists: not in the identity of substance, but, as I have said, in the identity of consciousness, wherein if Socrates and the present mayor of Queinborough agree, they are the same person: If the same Socrates waking and sleeping do not partake of the same consciousness, Socrates waking and sleeping is not the same person. And to punish Socrates waking for what sleeping Socrates thought, and waking Socrates was never conscious of, would be no more of right, than to punish one twin for what his brother-twin did, whereof he knew nothing, because their outsides were so like, that they could not be distinguished; for such twins have been seen.

20. But yet possibly it will still be objected,— Suppose I wholly lose the memory of some parts of my life, beyond a possibility of retrieving them, so that perhaps I shall never be conscious of them again; yet am I not the same person that did those actions, had those thoughts that I once was conscious of, though I have now forgot them? To which I answer, that we must here take notice what the word *I* is applied to; which, in this case, is the *man* only. And the same man being presumed to be the same person, I is easily here supposed to stand also for the same person. But if it be possible for the same man to have distinct incommunicable consciousness at different times, it is past doubt the same man would at different times make different persons; which, we see, is the sense of mankind in the solemnest declaration of their opinions, human laws not punishing the mad man for the sober man's actions, nor the sober man for what the mad man did,—thereby making them two persons: which is somewhat explained by our way of speaking in English when we say such an one is "not himself," or is "beside himself"; in which phrases it is insinuated, as if those who now, or at least first used them, thought that self was changed; the self-same person was no longer in that man. . . .

22. But is not a man drunk and sober the same person? Why else is he punished for the act he commits when drunk, though he be never afterwards conscious of it? Just as much the same person as a man that walks, and does other things in his sleep, is the same person, and is answerable for any mischief he shall do in it. Human laws punish both, with a justice suitable to *their* way of knowledge;—because, in these cases, they cannot distinguish certainly what is real, what counterfeit: and so the ignorance in drunkenness or sleep is not admitted as a plea. For, though punishment be annexed to personality, and personality to consciousness, and the drunkard perhaps be not conscious of what he did, yet human judicatures justly punish him; because the fact is proved against him, but want of consciousness cannot be proved for him. But in the Great Day, wherein the secrets of all hearts shall be laid open, it may be reasonable to think, no one shall be made to answer for what he knows nothing of; but shall receive his doom, his conscience accusing or excusing him.

23. Nothing but consciousness can unite remote existences into the same person: the identity of substance will not do it; for whatever substance there is, however framed, without consciousness there is no person: and a carcass may be a person, as well as any sort of substance be so, without consciousness.

READING QUESTIONS

1. What is Locke's definition of a person?
2. What is the point that Locke makes with the story of the talking parrot? How does he distinguish between man and person?
3. According to Locke, in what does personal identity consist?
4. For Locke, when can you be held responsible for an action?

Derek Parfit

Divided Minds and the Nature of Persons

Derek Parfit (1942–2017) was a philosopher at All Souls College at Oxford. His book *Reasons and Persons* has had a major influence on theories of ethics, as well as on theories of personal identity. In this essay, he argues that the reason why it is so hard to come up with theories of personal identity is that there are no persons.

It was the split-brain cases which drew me into philosophy. Our knowledge of these cases depends on the results of various psychological tests, as described by Donald MacKay. These tests made use of two facts. We control each of our arms, and see what is in each half of our visual fields, with only one of our hemispheres. When someone's hemispheres have been disconnected, psychologists can thus present to this person two different written questions in the two halves of his visual field, and can receive two different answers written by this person's two hands.

Here is a simplified imaginary version of the kind of evidence that such tests provide. One of these people looks fixedly at the centre of a wide screen, whose left half is red and right half is blue. On each half in a darker shade are the words, 'How many colours can you see?' With both hands the person writes, 'Only one'. The words are now changed to read, 'Which is the only colour that you can see?' With one of his hands the person writes 'Red', with the other he writes 'Blue'.

If this is how such a person responds, I would conclude that he is having two visual sensations — that he does, as he claims, see both red and blue. But in seeing each colour he is not aware of seeing the other. He has two streams of consciousness, in each of which he can see only one colour. In one stream he sees red, and at the same time, in his other stream, he sees blue. More generally, he could be having at the same time two series of thoughts and sensations, in having each of which he is unaware of having the other.

This conclusion has been questioned. It has been claimed by some that there are not *two* streams of consciousness, on the ground that the sub-dominant hemisphere is a part of the brain whose functioning involves no consciousness. If this were true, these cases would lose most of their interest. I believe that it is not true, chiefly because, if a person's dominant hemisphere is destroyed, this person is able to react in the way in which, in the split-brain cases, the sub-dominant hemisphere reacts, and we do not believe that such a person is just an automaton, without consciousness. The sub-dominant hemisphere is, of course, much less developed in certain ways, typically having the linguistic abilities of a three-year-old. But three-year-olds are conscious. This supports the view that, in split-brain cases, there *are* two streams of consciousness.

Another view is that, in these cases, there are two persons involved, sharing the same body. Like Professor MacKay, I believe that we should reject this view. My reason for believing this is, however, different. Professor MacKay denies that there are two persons involved because he believes that there is only one person involved. I believe that, in a sense, the number of persons involved is none.

The Ego Theory and the Bundle Theory

To explain this sense I must, for a while, turn away from the split-brain cases. There are two theories about what persons are, and what is involved in a person's continued existence over time. On the *Ego Theory*, a person's continued existence cannot be explained except as the continued existence of a particular *Ego*, or *subject of*

Source: Parfit, Derek, "Divided Minds and the Nature of Persons," *Mindwaves*, ed. Blakemore, C. and Greenfield, S., London: Basil Blackwell, 1987, 19–25. Notes have been omitted. Reprinted with permission.

experiences. An Ego Theorist claims that, if we ask what unifies someone's consciousness at any time—what makes it true, for example, that I can now both see what I am typing and hear the wind outside my window—the answer is that these are both experiences which are being had by me, this person, at this time. Similarly, what explains the unity of a person's whole life is the fact that all of the experiences in this life are had by the same person, or subject of experiences. In its best-known form, the *Cartesian view,* each person is a persisting purely mental thing—a soul, or spiritual substance.

The rival view is the *Bundle Theory.* Like most styles in art—Gothic, baroque, rococo, etc.—this theory owes its name to its critics. But the name is good enough. According to the Bundle Theory, we can't explain either the unity of consciousness at any time, or the unity of a whole life, by referring to a person. Instead we must claim that there are long series of different mental states and events—thoughts, sensations, and the like—each series being what we call one life. Each series is unified by various kinds of causal relation such as the relations that hold between experiences and later memories of them. Each series is thus like a bundle tied up with string.

In a sense, a Bundle Theorist denies the existence of persons. An outright denial is of course absurd. As Reid protested in the eighteenth century, 'I am not thought, I am not action, I am not feeling; I am something which thinks and acts and feels.' I am not a series of events, but a person. A Bundle Theorist admits this fact, but claims it to be only a fact about our grammar, or our language. There are persons or subjects in this language-dependent way. If, however, persons are believed to be more than this—to be separately existing things, distinct from our brains and bodies, and the various kinds of mental states and events—the Bundle Theorist denies that there are such things.

The first Bundle Theorist was Buddha, who taught 'anatta', or the *No Self view.* Buddhists concede that selves or persons have 'nominal existence', by which they mean that persons are merely combinations of other elements. Only what exists by itself, as a separate element, has instead what Buddhists call 'actual existence'. Here are some quotations from Buddhist texts:

> At the beginning of their conversation the king politely asks the monk his name, and receives the following reply: 'Sir, I am known as "Nagasena"; my fellows in the religious life address me as "Nagasena". Although my parents gave me the name . . . it is just an appellation, a form of speech, a description, a conventional usage. "Nagasena" is only a name, for no person is found here.'

> A sentient being does exist, you think, O Mara? You are misled by a false conception. This bundle of elements is void of Self, In it there is no sentient being. Just as a set of wooden parts Receives the name of carriage, So do we give to elements The name of fancied being.

> Buddha has spoken thus: 'O Brethren, actions do exist, and also their consequences, but the person that acts does not. There is no one to cast away this set of elements, and no one to assume a new set of them. There exists no Individual, it is only a conventional name given to a set of elements.'

Buddha's claims are strikingly similar to the claims advanced by several Western writers. Since these writers knew nothing of Buddha, the similarity of these claims suggests that they are not merely part of one cultural tradition, in one period. They may be, as I believe they are, true.

What We Believe Ourselves to Be

Given the advances in psychology and neurophysiology, the Bundle Theory may now seem to be obviously true. It may seem uninteresting to deny that there are separately existing Egos, which are distinct from brains and bodies and the various kinds of mental states and events. But this is not the only issue. We may be convinced that the Ego Theory is false, or even senseless. Most of us, however, even if we are not aware of this, also have certain beliefs about what is involved in our continued existence over time. And these beliefs would only be justified if something like the Ego Theory was true. Most of us therefore have false beliefs about what persons are, and about ourselves.

These beliefs are best revealed when we consider certain imaginary cases, often drawn from science fiction. One such case is *teletransportation.* Suppose that you enter a cubicle in which, when you press a button, a scanner records the states of all of the cells in your brain and body, destroying both while doing so. This information is then transmitted at the speed of light to some other planet, where a replicator produces a perfect organic copy of you. Since the brain of your Replica is exactly like yours, it will seem to remember living your life up to the moment when you pressed the button, its character will be just like yours, and it will be in every other way psychologically continuous with you. This psychological continuity will not have its normal cause, the continued existence of your brain, since the causal chain will run through the transmission by radio of your 'blueprint'.

Several writers claim that, if you chose to be teletransported, believing this to be the fastest way of traveling, you would be making a terrible mistake. This would not be a way of traveling, but a way of dying. It may not, they concede, be quite as bad as ordinary death. It might be some consolation to you that, after your death, you will have this Replica, which can finish the book that you are writing, act as parent to your children, and so on. But, they insist, this Replica won't be you. It will merely be someone else, who is exactly like you. This is why this prospect is nearly as bad as ordinary death.

Imagine next a whole range of cases, in each of which, in a single operation, a different proportion of the cells in your brain and body would be replaced with exact duplicates. At the near end of this range, only 1 or 2 per cent would be replaced; in the middle, 40 or 60 per cent; near the far end, 98 or 99 per cent. At the far end of this range is pure teletransportation, the case in which all of your cells would be 'replaced'.

When you imagine that some proportion of your cells will be replaced with exact duplicates, it is natural to have the following beliefs. First, if you ask, 'Will I survive? Will the resulting person be me?', there must be an answer to this question. Either you will survive, or you are about to die. Second, the answer to this question must be either a simple 'Yes' or a simple 'No'. The person who wakes up either will or will not be you. There cannot be a third answer, such as that the person waking up will be half you. You can imagine yourself later being half-conscious. But if the resulting person will be fully conscious, he cannot be half you. To state these beliefs together: to the question, 'Will the resulting person be me?', there must always *be* an answer, which must be all-or-nothing.

There seem good grounds for believing that, in the case of teletransportation, your Replica would not be you. In a slight variant of this case, your Replica might be created while you were still alive, so that you could talk to one another. This seems to show that, if 100 per cent of your cells were replaced, the result would merely be a Replica of you. At the other end of my range of cases, where only 1 per cent would be replaced, the resulting person clearly *would* be you. It therefore seems that, in the cases in between, the resulting person must be either you, or merely a Replica. It seems that one of these must be true, and that it makes a great difference which is true.

How We Are Not What We Believe

If these beliefs were correct, there must be some critical percentage, somewhere in this range of cases, up to which the resulting person would be you, and beyond which he would merely be your Replica. Perhaps, for example, it would be you who would wake up if the proportion of cells replaced were 49 per cent, but if just a few more cells were also replaced, this would make all the difference, causing it to be someone else who would wake up.

That there must be some such critical percentage follows from our natural beliefs. But this conclusion is most implausible. How could a few cells make such a difference? Moreover, if there is such a critical percentage, no one could ever discover where it came. Since in all these cases the resulting person would believe that he was you, there could never be any evidence about where, in this range of cases, he would suddenly cease to be you.

On the Bundle Theory, we should reject these natural beliefs. Since you, the person, are not a separately existing entity, we can know exactly what would happen without answering the question of what will happen to you. Moreover, in the cases in the middle of my range, it is an empty question whether the resulting person would be you, or would merely be someone else who is exactly like you. These are not here two different possibilities, one of which must be true. These are merely two different descriptions of the very same course of events. If 50 per cent of your cells were replaced with exact duplicates, we could call the resulting person you, or we could call him merely your Replica. But since these are not here different possibilities, this is a mere choice of words.

As Buddha claimed, the Bundle Theory is hard to believe. It is hard to accept that it could be an empty question whether one is about to die, or will instead live for many years.

What we are being asked to accept may be made clearer with this analogy. Suppose that a certain club exists for some time, holding regular meetings. The meetings then cease. Some years later, several people form a club with the same name, and the same rules. We can ask, 'Did these people revive the very same club? Or did they merely start up another club which is exactly similar?' Given certain further details, this would be another empty question. We could know just what happened without answering this question. Suppose that someone said: 'But there must be an answer. The club meeting later must either be, or not be, the very same club.' This would show that this person didn't understand the nature of clubs.

In the same way, if we have any worries about my imagined cases, we don't understand the nature of persons. In each of my cases, you would know that the

resulting person would be both psychologically and physically exactly like you, and that he would have some particular proportion of the cells in your brain and body—90 per cent, or 10 per cent, or, in the case of teletransportation, 0 per cent. Knowing this, you know everything. How could it be a real question what would happen to you, unless you are a separately existing Ego, distinct from a brain and body, and the various kinds of mental state and event? If there are no such Egos, there is nothing else to ask a real question about.

Accepting the Bundle Theory is not only hard; it may also affect our emotions. As Buddha claimed, it may undermine our concern about our own futures. This effect can be suggested by redescribing this change of view. Suppose that you are about to be destroyed, but will later have a Replica on Mars. You would naturally believe that this prospect is about as bad as ordinary death, since your Replica won't be you. On the Bundle Theory, the fact that your Replica won't be you just consists in the fact that, though it will be fully psychologically continuous with you, this continuity won't have its normal cause. But when you object to teletransportation you are not objecting merely to the abnormality of this cause. You are objecting that this cause won't get *you* to Mars. You fear that the abnormal cause will fail to produce a further and all-important fact, which is different from the fact that your Replica will be psychologically continuous with you. You do not merely want there to be psychological continuity between you and some future person. You want to be this future person. On the Bundle Theory, there is no such special further fact. What you fear will not happen, in this imagined case, *never* happens. You want the person on Mars to be you in a specially intimate way in which no future person will ever be you. This means that, judged from the standpoint of your natural beliefs, even ordinary survival is about as bad as teletransportation. *Ordinary survival is about as bad as being destroyed and having a Replica.*

How the Split-Brain Cases Support the Bundle Theory

The truth of the Bundle Theory seems to me, in the widest sense, as much a scientific as a philosophical conclusion. I can imagine kinds of evidence which would have justified believing in the existence of separately existing Egos, and believing that the continued existence of these Egos is what explains the continuity of each mental life. But there is in fact very little evidence in favour of this Ego Theory, and much for the alternative Bundle Theory.

Some of this evidence is provided by the split-brain cases. On the Ego Theory, to explain what unifies our experiences at any one time, we should simply claim that these are all experiences which are being had by the same person. Bundle Theorists reject this explanation. This disagreement is hard to resolve in ordinary cases. But consider the simplified split-brain case that I described. We show to my imagined patient a placard whose left half is blue and right half is red. In one of this person's two streams of consciousness, he is aware of seeing only blue, while at the same time, in his other stream, he is aware of seeing only red. Each of these two visual experiences is combined with other experiences, like that of being aware of moving one of his hands. What unifies the experiences, at any time, in each of this person's two streams of consciousness? What unifies his awareness of seeing only red with his awareness of moving one hand? The answer cannot be that these experiences are being had by the same person. This answer cannot explain the unity of each of this person's two streams of consciousness, since it ignores the disunity between these streams. This person is now having all of the experiences in both of his two streams. If this fact was what unified these experiences, this would make the two streams one.

These cases do not, I have claimed, involve two people sharing a single body. Since there is only one person involved, who has two streams of consciousness, the Ego Theorist's explanation would have to take the following form. He would have to distinguish between persons and subjects of experiences, and claim that, in split-brain cases, there are *two* of the latter. What unifies the experiences in one of the person's two streams would have to be the fact that these experiences are all being had by the same subject of experiences. What unifies the experiences in this person's other stream would have to be the fact that they are being had by another subject of experiences. When this explanation takes this form, it becomes much less plausible. While we could assume that 'subject of experiences', or 'Ego', simply meant 'person', it was easy to believe that there are subjects of experiences. But if there can be subjects of experiences that are not persons, and if in the life of a split-brain patient there are at any time two different subjects of experiences—two different Egos—why should we believe that there really are such things? This does not amount to a refutation. But it seems to me a strong argument against the Ego Theory.

As a Bundle Theorist, I believe that these two Egos are idle cogs. There is another explanation of the unity of consciousness, both in ordinary cases and in split-brain cases. It is simply a fact that ordinary people are, at any time, aware of having several different experiences.

This awareness of several different experiences can be helpfully compared with one's awareness, in short-term memory, of several different experiences. Just as there can be a single memory of just having had several experiences, such as hearing a bell strike three times, there can be a single state of awareness both of hearing the fourth striking of this bell, and of seeing, at the same time, ravens flying past the bell-tower.

Unlike the Ego Theorist's explanation, this explanation can easily be extended to cover split-brain cases. In such cases there is, at any time, not one state of awareness of several different experiences, but two such states. In the case I described, there is one state of awareness of both seeing only red and of moving one hand, and there is another state of awareness of both seeing only blue and moving the other hand. In claiming that there are two such states of awareness, we are not postulating the existence of unfamiliar entities, two separately existing Egos which are not the same as the single person whom the case involves. This explanation appeals to a pair of mental states which would have to be described anyway in a full description of this case.

I have suggested how the split-brain cases provide one argument for one view about the nature of persons. I should mention another such argument, provided by an imagined extension of these cases, first discussed at length by David Wiggins.

In this imagined case a person's brain is divided, and the two halves are transplanted into a pair of different bodies. The two resulting people live quite separate lives. This imagined case shows that personal identity is not what matters. If I was about to divide, I should conclude that neither of the resulting people will be me. I will have ceased to exist. But this way of ceasing to exist is about as good—or as bad—as ordinary survival.

Some of the features of Wiggins's imagined case are likely to remain technically impossible. But the case cannot be dismissed, since its most striking feature, the division of one stream of consciousness into separate streams, has already happened. This is a second way in which the actual split-brain cases have great theoretical importance. They challenge some of our deepest assumptions about ourselves.

Reading Questions

1. What is the difference between the Ego theory and the Bundle theory? Which theory does Parfit prefer? Which do you think is more plausible? Explain.

2. Parfit asserts that most of us have false beliefs about what persons are and about ourselves. Why does he say this? Do you agree with him?

3. What point is Parfit making about the Bundle theory by using the analogy of the club meetings? Do you think the analogy helps to explain what persons are—or is it misleading?

4. According to Parfit, how do split-brain cases support the Bundle theory? Do you concur? Why or why not?

Dualism from Reductionism

Hans Moravec (1948–) is a co-founder and chief scientist of Seegrid corporation, a robotics company that specializes in self-guided vehicles, and an adjunct faculty member at the Robotics Institute of Carnegie Mellon University. He built his first robot out of tin cans, lights, and an electric motor at the age of 10, received a Ph.D. from Stanford in 1980 for a TV-equipped robot that could navigate a cluttered obstacle course, and is currently at the forefront of the development of free-ranging mobile robots. An enthusiastic transhumanist, he has written numerous articles and books about how technology may shape the future. In this selection, he explores the technological possibilities and philosophical implications of uploading our minds into computers.

You may think the following proposals are thought experiments. That's fine, as such they still make the point in question. I happen to think of them as real, highly desirable, possibilities for the foreseeable future. For me they are a solution to the annoying certainty that we will be overtaken in every area by future superintelligent machines and will be excluded from all the really interesting developments unless we keep up, personally and intimately, with the technologies of thought. That these ideas raise and clarify some interesting metaphysical questions is a bonus.

Transmigration

You are in an operating room. A robot brain surgeon is in attendance. By your side is a potentially human equivalent computer, dormant for lack of a program to run. Your skull, but not your brain, is anesthetized. You are fully conscious. The surgeon opens your brain case and peers inside. Its attention is directed at a small clump of about 100 neurons somewhere near the surface. It determines the three-dimensional structure and chemical makeup of that clump nondestructively with high resolution 3D NMR holography, phased array radio encephalography, and ultrasonic radar. It writes a program that models the behavior of the clump, and starts it running on a small portion of the computer next to you. Fine connections are run from the edges of the neuron assembly to the computer, providing the simulation with the same inputs as the neurons. You and the surgeon check the accuracy of the simulation. After you are satisfied, tiny relays are inserted between the edges of the clump and the rest of the brain. Initially these leave the brain unchanged, but on command they can connect the simulation in place of the clump. A button which activates the relays when pressed is placed in your hand. You press it, release it and press it again. There should be no difference. As soon as you are satisfied, the simulation connection is established firmly, and the now unconnected clump of neurons is removed. The process is repeated over and over for adjoining clumps, until the entire brain has been dealt with. Occasionally several clump simulations are combined into a single equivalent but more efficient program. Though you have not lost consciousness, or even your train of thought, your mind (some would say soul) has been removed from the brain and transferred to a machine.

In a final step your old body is disconnected. The computer is installed in a shiny new one, in the style, color and material of your choice. You are no longer a cyborg halfbreed, your metamorphosis is complete.

For the squeamish there are other ways to work the transfer. The high-resolution brain scan could be done in one fell swoop, without surgery, and a new you made, "While-U-Wait". Some will object that the instant process makes only a copy, the real you is still trapped in the old body (please dispose of properly). This is an understandable misconception based on the intimate association of a person's identity with a particular, unique, irreplaceable piece of meat. Once the possibility of mind transfer is accepted, however, a more mature

Source: Hans Moravec, "Dualism from Reductionism," Proceedings of the International Symposium on AI and the Human Mind, Yale University, New Haven, CT, March 1–3, 1986: *Truth*, vol. 2, Dallas, TX, 1987. Reprinted with permission.

notion of life and identity becomes possible. You are not dead until the last copy is erased; a faithful copy is exactly as good as the original. These issues are examined in greater detail later.

If even the last technique is too invasive for you, imagine a more psychological approach. A kind of portable computer (perhaps worn like eyeglasses so it can cover your entire visual field) is programmed with the universals of human mentality, with your genetic makeup and with whatever details of your life are conveniently available. It carries a program that makes it an excellent mimic. You carry this computer with you through the prime of your life, and it diligently listens and watches, and perhaps monitors your brainwaves, and learns to anticipate your every move and response. Soon it is able to fool your friends on the phone with its convincing imitation of you. When you die it is installed in a mechanical body and smoothly and seamlessly takes over your life and responsibilities.

What? Still not satisfied? If you happen to be a vertebrate there is another option that combines some of the sales features of the methods above. The vertebrate brain is split into two hemispheres connected by a very large bundle of nerve fibers called the corpus callosum. When brain surgery was new it was discovered that severing this connection between the brain halves cured some forms of epilepsy. An amazing aspect of the procedure was the apparent lack of side effects on the patient. The corpus callosum is a bundle far thicker than the optic nerve or even the spinal cord. Cut the optic nerve and the victim is utterly blind; sever the spinal cord and the body goes limp. Slice the huge cable between the hemispheres and nobody notices a thing. Well, not quite. In subtle experiments it was noted that patients who had this surgery were unable, when presented with the written word "brush", for instance, to identify the object in a collection of others using their left hand. The hand wanders uncertainly from object to object, seemingly unable to decide which is "brush". When asked to do the same task with the right hand, the choice is quick and unhesitating. Sometimes in the left-handed version of the task the right hand, apparently in exasperation, reaches over to guide the left to the proper location. Other such quirks involving spatial reasoning and motor coordination were observed.

The explanation offered is that the callosum indeed is the main communications channel between the brain hemispheres. It has fibers running to every part of the cortex on each side. The brain halves, however, are fully able to function separately, and call on this channel only when a task involving co-ordination becomes necessary. We can postulate that each hemisphere has its own priorities, and that the other can request, but not demand, information or action from it, and must be able to operate effectively if the other chooses not to respond, even when the callosum is intact. The left hemisphere handles language and controls the right side of the body. The right hemisphere controls the left half of the body, and without the callosum the correct interpretation of the letters "brush" could not be conveyed to the controller of the left hand.

But what an opportunity. Suppose we sever your callosum but then connect a cable to both severed ends leading into an external computer. If the human brain is understood well enough this external computer can be programmed to pass, but also monitor the traffic between the two. Like the personal mimic it can teach itself to think like them. After a while it can insert its own messages into the stream, becoming an integral part of your thought processes. In time, as your original brain fades away from natural causes, it can smoothly take over the lost functions, and ultimately your mind finds itself in the computer. With advances in high resolution scanning it may even be possible to have this effect without messy surgery—perhaps you just wear some kind of helmet or headband.

Vernor Vinge devised a particularly slow and gentle transfer method in *True Names*, his novel of the near future. The world of *True Names* is interconnected by a computer network containing processes linked to every vital function of society. Experienced hackers connect to the net through innovative terminals they have developed; like radio amateurs early in the century they are at the leading edge of the new technology, ahead of the establishment. The hackers' terminals are bi-directional electroencephalogram (brain wave) machines; they enable a computer to read the human's brain waves and also to induce them. Through years of practice, experimentation and programming the hackers have discovered a combination of mental and computer techniques that permit a dreamlike trance in which information from the computer controls elements of a lucid dream, and actions in the dream affect the computer. In the dream data objects are represented by metaphor— a locked computer file, for instance, might appear as a steel safe with a combination lock. Guessing and dialing the right combination unlocks the file. The interface is tremendously fast and effective because the full mind of the human is coupled to the machine.

The hackers meet in the network, each in an imaginative guise. Sometimes their computer personas continue to operate under control of special programs even when their owners temporarily disconnect. A new potential of the net reveals itself as the story unfolds.

One of the characters has augmented her thinking in the net by directly incorporating computer subroutines. In real life she is an old woman suffering from advanced senility. In the network, by contrast, she appears extraordinarily swift and intelligent because of the computer routines she has written to substitute for her lost natural abilities. Her illness is progressive, and she is constantly programming new capabilities as her natural ones disappear. Her goal is to complete the process before she dies. With success she will continue to live in her computer persona though her physical body no longer exists.

Afterlife

Whatever style you choose, when the transfer is complete advantages become apparent. Your computer has a control labeled speed. It had been set to slow, to keep the simulations synchronized with the old brain, but now you change it to fast. You can communicate, react and think a thousand times faster. But wait, there's more!

The program in your machine can be read out and altered, letting you conveniently examine, modify, improve and extend yourself. The entire program may be copied into similar machines, giving two or more thinking, feeling versions of you. You may choose to move your mind from one computer to another more technically advanced, or more suited to a new environment. The program can also be copied to some future equivalent of magnetic tape. If the machine you inhabit is fatally clobbered, the tape can be read into a blank computer, resulting in another you, minus the experiences since the copy. With enough copies, permanent death would be very unlikely.

As a computer program, your mind can travel over information channels. A laser can send it from one computer to another across great distances and other barriers. If you found life on a neutron star, and wished to make a field trip, you might devise a way to build a neutron computer and robot body on the surface, then transmit your mind to it. Nuclear reactions are a million times quicker than chemistry, so the neutron you can probably think that much faster. It can act, acquire new experiences and memories, then beam its mind back home. The original body could be kept dormant during the trip to be reactivated with the new memories when the return message arrived. Alternatively, the original might remain active. There would then be two separate versions of you, with different memories for the trip interval.

Two sets of memories can be merged, if mind programs are adequately understood. To prevent confusion, memories of events would indicate in which body they happened. Merging should be possible not only between two versions of the same individual but also between different persons. Selective mergings, involving some of the other person's memories, and not others would be a very superior form of communication, in which recollections, skills, attitudes and personalities can be rapidly and effectively shared.

Your new body will be able to carry more memories than your original biological one, but the accelerated information explosion will insure the impossibility of lugging around all of civilization's knowledge. You will have to pick and choose what your mind contains at any one time. There will often be knowledge and skills available from others superior to your own, and the incentive to substitute those talents for yours will be overwhelming. In the long run you will remember mostly other people's experiences, while memories you originated will be floating around the population at large. The very concept of you will become fuzzy, replaced by larger, communal egos.

Mind transferal need not be limited to human beings. Earth has other species with brains as large, from dolphins, our cephalic equals, to elephants, whales, and giant squid, with brains up to twenty times as big. Translation between their mental representation and ours is a technical problem comparable to converting our minds into a computer program. Our culture could be fused with theirs, we could incorporate each other's memories, and the species boundaries would fade. Non-intelligent creatures could also be popped into the data banks. The simplest organisms might contribute little more than the information in their DNA. In this way our future selves will benefit from all the lessons learned by terrestrial biological and cultural evolution. This is a far more secure form of storage than the present one, where genes and ideas are lost when the conditions that gave rise to them change.

Our speculation ends in a super-civilization, the synthesis of all solar system life, constantly improving and extending itself, spreading outward from the sun, converting non-life into mind. There may be other such bubbles expanding from elsewhere. What happens when we meet? Fusion of us with them is a possibility, requiring only a translation scheme between the memory representations. This process, possibly occurring now elsewhere, might convert the entire universe into an extended thinking entity, a probable prelude to greater things.

What Am I?

The idea that a human mind can be transferred to a new body sometimes meets the following strong objection from some who dispute neither the possibility, nor its objective manifestations as described. "Regardless of how the copying is done the end result will be a new person. If it is I who am being copied, the copy, though it may think of itself as me, is simply a self-deluded imposter. If the copying process destroys the original, then I have been killed. That the copy may then have a great time exploring the universe using my name and my skills is no comfort to my mortal remains."

Naturally, this point of view, which I will call the Body Identity position, makes life extension by duplication considerably less personally interesting.

I believe the objection can and should be overcome by intellectual acceptance of an alternate position I will name Pattern Identity. Body identity assumes that a person is defined by the stuff of which a human body is made. Only by maintaining continuity of body stuff can we preserve an individual person. Pattern identity, on the other hand, defines the essence of a person, say myself, as the pattern and the process going on in my head and body, not the machinery supporting that process. If the process is preserved, I am preserved. The rest is mere jelly.

Matter Transmitters

Matter transmitters have appeared often in the science fiction literature, at least since the invention of facsimile machines in the late 1800s. I raise the idea here only as a thought experiment, to simplify some of the issues in the mind transfer proposal.

A facsimile transmitter scans a photograph line by line with a light sensitive photocell and produces an electric current that varies with the brightness of the scanned point in the picture. The varying electric current is transmitted over wires to a remote location where it controls the brightness of a light bulb in a facsimile receiver. The receiver scans the bulb over photosensitive paper in the same pattern as the transmitter. When this paper is developed, a duplicate of the original photograph is obtained. This device was a boon to newspapers, who were able to get illustrations from remote parts of the country almost instantly, rather than after a period of days by train.

If pictures, why not solid objects? A matter transmitter might scan an object and identify, then knock out, its atoms or molecules one at a time. The identity of the atoms would be transmitted to a receiver where a duplicate of the original object would be assembled in the same order from a local supply of atoms. The technical problems were mind boggling, and well beyond anything foreseeable, but the principle was simple to grasp.

If solid objects, why not a person? Just stick him in the transmitter, turn on the scan, and greet him when he walks from the receiver. But is it really the same person? If the system works well, the duplicate will be indistinguishable from the original in any substantial way. Yet, suppose you fail to turn on the receiver during the transmission process. The transmitter will scan and disassemble the victim and send an unheard message to the inoperative receiver. The original person will be dead. Doesn't, in fact, the process kill the original person whether or not there is an active receiver? Isn't the duplicate just that, merely a clever imposter? Or suppose two receivers respond to the message from one transmitter. Which, if either, of the two duplicates is the real original?

Pattern Identity

The body identity position is clear. A matter transmitter is an execution device. You might as well save your money and use a gas chamber, and not be taken in by the phony double gimmick.

Pattern identity gives a different perspective. Suppose I step into the transmission chamber. The transmitter scans and disassembles my jelly-like body, but my pattern (me!) moves continuously from the dissolving jelly, through the transmitting beam, and ends up in other jelly at the destination. At no instant was it (I) ever destroyed.

The biggest confusion comes from the question of duplicates. It is rooted in all our past experience that one person corresponds to one body. In the light of the possibility of matter and mind storage and transmission this simple, natural, and obvious identification becomes confusing and misleading. Suppose the matter transmitter is connected to two receivers instead of one. After the transfer there will be a copy of you in each one. Surely at least one of them is only a mere copy—they can't both be you, right? Wrong!

A Metaphor

Consider the message "I am not jelly". As I type it, it goes from my brain, into the keyboard of my computer, through myriads of electronic circuits and over great amounts of wire, and after countless adventures shows

up in bunches of books like the one you're holding. How many messages were there? I claim it is most useful to think there is only one, despite its massive replication. If I repeat it here: "I am not jelly", there is still only one message. Only if I change it in a significant manner: "I am not peanut butter" do we have a second message. And the message is not destroyed until the last written version is lost, and until it fades sufficiently in everybody's memory to be unreconstructable. The message is the information conveyed, not the particular encoding. The "pattern and process" that I claim is the real me has the same properties as the message above. Making a momentary copy of my state, whether on tape or in another functional body, doesn't make two persons.

There is a complication because of the "process" aspect; as soon as an instance of a "person message" evolves for a while it becomes a different person. If two of them are active, they will diverge, and become two different people by my definition. Just how far this differentiation must proceed before you grant them unique identities is about as problematical as the question "when does a fetus become a person?" But if you wait zero time, then you don't have a new person. If, in the dual receiver version of the matter transmitter, you allow the two copies to be made and kill one (either one) instantly on reception, the transmitted person still exists in the other copy. All the things that person might have done, and all the thoughts she might have thought, are still possible. If, on the other hand, you allow both copies to live their separate lives for a year, and then kill one, you are the murderer of a unique human being.

But, if you wait only a short while, they won't differ by much, and destruction of one won't cause too much total loss. This rationale might, for instance, be a comfort in danger if you knew that a tape backup copy of you had been made recently. Because of the divergence the tape contains not you as you are now, but you as you were: a slightly different person. But still, most of you would be saved should you have a fatal accident, and the loss would be nowhere near as great as without the backup.

Intellectual acceptance that a secure and recent backup of you exists does not necessarily protect you from an instinctive self-preservation overreaction if faced with imminent death. This is an evolutionary hangover from your one-copy past. It is no more a reflection of reality than fear of flying is an appropriate response to present airline accident rates. Inappropriate intuitions are to be expected when the rules of life are suddenly reversed from historical absolutes.

Soul in Abstraction

Although we've reasoned from strictly reductionistic assumptions about the nature of thought and self, the pattern identity position has clear dualistic implications. Though mind is entirely the consequence of interacting matter, the ability to copy it from one machine or storage medium to another gives it an independence and an identity apart from its machinery

Immortality and Impermanence

Wading back into the shallows, let's examine a certain dilemma of existence, presently overshadowed by the issue of personal death, that will be paramount when practical immortality is achieved. It's this: In the long run survival requires change in directions not of your own choosing. Standards escalate with the growth of the inevitable competitors and predators for each niche. In a kind of cosmic Olympic games the universe molds its occupants toward its own distant and mysterious specifications.

An immortal cannot hope to survive unchanged, only to maintain a limited continuity over the short run. Personal death differs from this inevitability only in its relative abruptness. Viewed on a larger scale we are already immortal, as we have been since the dawn of life. Our genes and our culture pass continuously from one generation to the next, subject only to incremental alterations to meet the continuous demand for new world records in the cosmic games.

In the very long run the ancestral individual is always doomed as its heritage is nibbled away to meet short term demands. It slowly mutates into other forms that could have been reached from a range of starting points; the ultimate in convergent evolution. It's by this reasoning that I concluded earlier that it makes no ultimate difference whether our machines carry forward our heritage on their own, or in partnership with direct transcriptions of ourselves. Assuming long term survival either way, the end results should be indistinguishable, shaped by the universe and not by ourselves.

Since change is inevitable, I think we should embrace rather than retard it. By so doing we improve our day to day survival odds, discover interesting surprises sooner, and are more prepared to face any competition. The cost is faster erosion of our present constitution. All development can be interpreted as incremental death and new birth, but some of the fast lane options make this especially obvious, for instance the possibility of dropping parts of one's memory and personality in favor of another's. Fully exploited, this process results

in transient individuals constituted from a communal pool of personality traits. Sexual populations are effective in part because they create new genetic individuals in very much this way. As with sexual reproduction, the memory pool requires dissolution as well as creation to be effective. So personal death is not banished, but it does lose its poignancy because death by submergence into the memory pool is reversible in the short run.

Reading Questions

1. Why does Moravec think we should upload our minds into robots? What are the advantages? What are the disadvantages?

2. What methods does Moravec propose to transfer minds from brains to robots? What theory of mind lies behind Moravec's proposal?

3. What is the difference between body identity and pattern identity?

4. Do you believe that you would survive a mind upload? Why or why not?

Notes

1. The Bible, Revised Standard Version (RSV), 1 Cor. 15:36–44.
2. Laura McCallum, "Olson Admits She's Soliah," Minnesota Public Radio, July 9, 1999, http://news.minnesota.publicradio.org/features/199907/09_mccalluml_soliah.
3. John Locke, *An Essay Concerning Human Understanding*, book 2, chap. 27, sec. 5.
4. Locke, sec. 3.
5. Locke, sec. 5.
6. Locke, sec. 9.
7. Locke, sec. 14.
8. Eric Olson, excerpts from *The Human Animal*, 1997, Oxford University Press, Inc.
9. Olson 17.
10. "Raelian Leader: Cloning First Step to Immortality," CNN.com, December 29, 2002, http://archives.cnn.com/2002/HEALTH/12/28/human.cloning/index.html.
11. Bertrand Russell, "An Outline of Intellectual Rubbish," *Unpopular Essays* (New York: Simon & Schuster, 1950) 77–78.
12. Martin Benjamin, "Pragmatism and the Determination of Death," in *Biomedical Ethics*, ed. Thomas Mappes and David DeGrazia (Boston: McGraw-Hill, 2006) 324.
13. Dan Wikler, excerpt from "Not Dead, Not Dying? Ethical Categories and Persistent Vegetative State" from *Hastings Center Report* 18 (February/March 1988).
14. Benjamin 324.
15. Locke, sec. 15.
16. Olson 9–10.
17. Peter Unger, "The Survival of the Sentient," *Action and Freedom: Philisophical Perspectives* 14, ed. J. Tomberlin, (Malden, MA: Blackwell, 2000) 331.
18. "Victim Has Multiple Personalities," *Morning Call* [Allentown, PA] (17 Aug. 1990) A3.
19. Ellen Hale, excerpt from "Inside the Divided Mind" from *The New York Times Magazine* (April 17, 1983).
20. Gottfried Leibniz, *Discourse on Metaphysics*, trans. P. Lucas and L. Grint (Manchester: Manchester University Press, 1953).
21. The Bible, RSV, Matt. 26:26–28.
22. Locke, book 2, chap. 27, sec. 13.
23. Locke, sec. 14.
24. Immanuel Kant, excerpts from *Critique of Pure Reason*, translated by Norman Kemp Smith, 1929, Palgrave Macmillan.
25. John Hick, *Death and Eternal Life* (San Francisco: Harper & Row, 1976) 40–41.
26. Martin Gardner, *The Whys of a Philosophical Scrivener* (New York: Quill, 1983) 298.
27. Kai Nielsen, "The Faces of Immortality," *Death and Afterlife*, ed. Stephen T. Davis (New York: St. Martin's Press, 1989) 1–29.
28. Locke, book 2, chap. 27, sec. 19. By "consciousness" Locke means "self-consciousness"—that is, knowledge of our thoughts and actions, both past and present. Because memory is the faculty that gives us knowledge of our past thoughts and actions, it is memory that gives us our sense of self.
29. http://sleepdisorders.about.com/od/sleepwalkingandtalkin1/a/moremurder.htm, accessed 7/27/2004.
30. http://news.bbc.co.uk/2/hi/uk_news/4362081.stm, accessed 3/18/2005.
31. Locke, sec. 22.
32. Thomas Reid, "Of Identity," in *Personal Identity*, ed. John Perry (Berkeley: University of California Press, 1975) 114–115.
33. Bishop Butler, "Of Personal Identity," in *Personal Identity*, ed. John Perry (Berkeley: University of California Press, 1975) 100.
34. Derek Parfit, *Reasons and Persons* (Oxford: Clarendon Press, 1984) 220.
35. Robert Uhlig, excerpt from "The End of Death: 'Soul Catcher' Computer Chip Due" from *The Daily Telegraph* 430 (July 18, 1996).
36. Hans Moravec, *Mind Children* (Cambridge, MA: Harvard University Press, 1990) 115–116.
37. Moravec 116.
38. Damon Tabor, "The Greater the Sinner," *The New Yorker*, March 14, 2016.
39. Bernard Williams, excerpts from "Personal Identity and Individuation" from *Problems of the Self: Philosophical Papers 1956–1972*.
40. Williams 8.
41. *Star Trek: Next Generation Technical Manual* (New York: Pocket Books, 1991) 102ff.
42. Derek Parfit, excerpts from *Reasons and Persons*. "Divided Minds and the Nature of Persons" from *Mindwaves*, edited by C. Blakemore and S. Greenfield. Reprinted with the permission of the author.
43. Excerpt from "Quantum Teleportation" from IBM Research, www.research.ibm.com/quantuminfo/teleportation.
44. Sidney Shoemaker, excerpts from *Self-Knowledge and Self-Identity*, 1963, Cornell University Press.
45. Lou Jacobson, "A Mind Is a Terrible Thing to Waste," *Lingua Franca* 7 (August 1997) 6.
46. R. W. Sperry, quoted in *Brain and Conscious Experience*, ed. J. C. Eccles (New York: Springer, 1966) 304.
47. I. Biran and A. Chaterjee, "Alien Hand Syndrome," *Archives of Neurology* 61 (February 2004) 292.
48. Parfit 254.
49. Shoemaker 279.
50. Robert Nozick, *Philosophical Explanations* (Cambridge, MA: Harvard University Press, 1981) 27–114.
51. Walpola Rahula, *What the Buddha Taught* (New York: Grove Weidenfeld, 1974) 51.
52. Rahula 42.
53. Parfit 326.
54. Parfit 326.
55. Immanuel Kant, *Prolegomena to Any Future Metaphysics*, trans. Lewis White Beck (New York: Bobbs-Merrill, 1950).
56. Ilya Prigogine, *From Being to Becoming* (New York: Freeman, 1980).
57. Marya Schechtman, *The Constitution of Selves* (Ithaca, NY: Cornell University Press, 1996) 94.
58. Owen Flanagan, *Varieties of Moral Personality* (Cambridge, MA: Harvard University Press, 1996) 67.
59. Daniel Dennett, "The Self as a Center of Narrative Gravity," *Self and Consciousness: Multiple Perspectives*, ed. F. Kessel, P. Cole, and D. Johnson (Hillsdale, NJ: Erlbaum, 1992) 103–115.
60. Elyn Saks, *Jekyll on Trial: Multiple Personality Disorder and Criminal Law* (New York: New York University Press, 1997) 99.
61. Galen Strawson, "Against Narrativity," *Ratio* 17 (2004) 428.
62. Strawson 447.
63. Strawson 447.
64. John Christman, "Narrative Unity as a Condition of Personhood," *Metaphilosophy* 35 (October 2004) 710.

Chapter 5
The Problem of Relativism and Morality

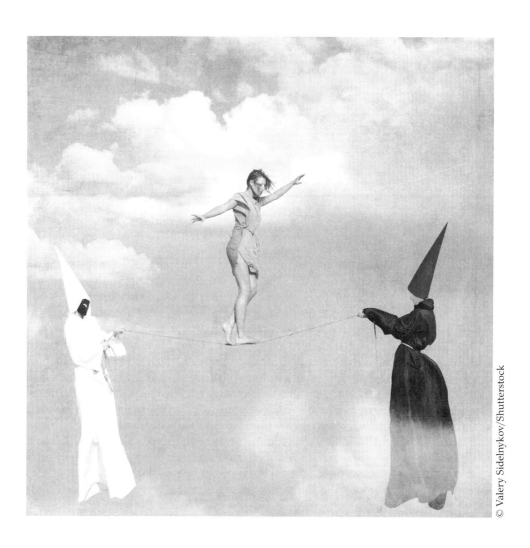

> *A man without ethics is a wild beast loosed upon this world.*
> —Manley P. Hall

On June 17, 1973, George Zygmanik shattered his spine in a motorcycle accident. Formerly an active, athletic individual, he became a quadriplegic after the accident, unable to move any of his limbs. All the parts of his body that he could feel hurt. His brother, Lester, was at his bedside during most of the next few days. On June 19, George said to Lester, "Hold my hand." After Lester took his hand, he said, "You know what I want you to do." Lester shook his head. Then George said to him, "You're my brother. I want you to promise to kill me. I want you to swear to God."[1]

On June 20, 1973, at 11:00 P.M., Lester Zygmanik walked into the Jersey Shore Medical Center with a sawed-off shotgun under his coat. He entered his brother's room, pointed the gun at his temple, and pulled the trigger. In the ensuing commotion, Lester turned to one of the nurses and said, "I'm the one you're looking for. I just shot my brother."[2]

Did Lester Zygmanik do the right thing? The State of New Jersey didn't think so. He was taken into custody and charged with first-degree murder. Others, however, condoned Lester's action, for not only did he put his brother out of his misery, he did it at his brother's request. What Lester did, they said, was not an act of malice. It was an act of love.

> *Nobody dies prematurely who dies in misery.*
> —Publilius Syrus

Although Lester's action arouses strong feelings in most of us, we can't base our judgment of his action on our feelings alone. For our feelings may be irrational—they may be the product of prejudice, fear, or cultural conditioning. People used to feel strongly that there was nothing wrong with owning slaves. But that didn't make slavery morally permissible. What's more, feelings often conflict. Some feel that what Lester did was right; others feel that it was wrong. But Lester's action can't be both right and wrong. So to determine whether an action is morally justified, we must go beyond our feelings to the reasons behind them.

We usually justify our actions by appealing to various moral principles, such as: It's wrong to steal, it's wrong to lie, it's wrong to break promises, and the like. One task of moral philosophy is to determine whether these principles can be explained in terms of a unified moral theory. Do these principles follow from some more basic principle in the way that Kepler's and Galileo's laws of motion follow from Newton's law of gravitation?

In addition to judging actions to be right or wrong, we also judge people, their characters, and their motives to be good or bad. Good people usually perform right actions, but it doesn't always turn out that way. Consider, for example, the inquisitors of the Roman Catholic Inquisition. From approximately A.D. 1400 to 1600, they executed between 250,000 and 2 million women on the grounds that they were witches. At least some of the inquisitors must have been men of good character who thought they were doing God's work. But even if they were good persons, what they did was terribly wrong.

Just as virtuous people can do the wrong thing, so can vicious people do the right thing. Hitler, for example, was kind to animals and, during his rise to power, did things to improve the lives of some of the German people.

His motives may have been despicable, but that doesn't mean that all of his actions were wrong. The rightness of an action does not depend solely on the goodness of the person performing it.

Many people learn how to act morally by being taught a moral code. As a result, many believe that there's nothing more to acting morally than following a moral code. But it's neither possible nor desirable to base all of our moral decisions on a moral code because moral codes are often too general to solve specific moral problems. For example, consider the commandment "Thou shalt not kill." Certainly this doesn't mean that we should never kill anything—whether plant or animal—because if we didn't, we would starve to death. Nor does it mean that we should never kill a human being, because sometimes we have to kill in self-defense. Is it wrong to kill someone to put him out of his misery? The Ten Commandments do not say. To derive an answer from them, we must interpret them, and to interpret them, we must appeal to moral theory.

A law is valuable not because it is law, but because there is right in it.
—H. W. Beecher

In addition to being too general, moral codes often give conflicting advice. To see this, suppose that you are a devout Christian and that one of your children has just cursed you. You are not sure how to handle this situation, so you turn to the Bible for guidance. In Exodus 21:17 you read, "Whoever curses his father or his mother shall be put to death." You are about to kill your child when he points out that Exodus 20:13 says, "Thou shalt not kill." So what should you do? To answer this question, you must go beyond the letter of the law to the theory behind it. You must decide which action would be most in tune with a correct conception of morality.

A moral theory will tell us what principles we should use to make correct moral judgments. The attempt to identify those principles is known as "normative ethics" because the principles it seeks are norms that prescribe how people should act. "Descriptive ethics," on the other hand, tries to identify the principles that people, in fact, use to make moral judgments. Descriptive ethics is the province of sciences such as psychology, sociology, and anthropology. By studying individual and group behavior, these sciences can tell us what principles people actually use to guide their actions. Normative ethics is the province of philosophy. It seeks to identify the principles people *should* use to guide their actions if they want to avoid villainy and wrong. Normative ethics, then, is prescriptive, whereas descriptive ethics is, well, descriptive.

Ethical living is the indispensable condition of all that is most worthwhile in the world.
—Ernest Caldecott

Recently some sociobiologists have claimed that they, too, can provide a normative theory of ethics. The father of sociobiology, E. O. Wilson, for example, offers the following promissory note: "The empiricist argument holds that if we explore the biological roots of moral behavior, and explain their material origins and biases, we should be able to fashion a wise and enduring ethical consensus."[3] Just as evolutionary theory can be used to explain why creatures have the physical features they do, so Wilson contends that it can be used to explain why people have the moral beliefs they do. The idea is that just as having certain physical features can give one an advantage in the struggle for survival, so can having certain moral beliefs. The belief that incest is wrong is

> *The true grandeur of humanity is in moral elevation, sustained, enlightened and decorated by the intellect of man.*
>
> —CHARLES SUMNER

one such belief. Having sex with one's close relatives often produces children with genetic defects, and children with genetic defects often lose out in the battle for survival. So the belief that incest is wrong, Wilson claims, is hard-wired into our genes.

Central to Wilson's project is the assumption that an understanding of why people, in fact, behave as they do will yield a theory of how they should behave toward one another. There's reason to believe that this project is doomed from the start, however, because you can't derive an *ought* from an *is*. From the fact that something is the case, you can't conclude that it should be the case. To believe otherwise is to commit the naturalistic fallacy.

What makes the attempt to derive an ought from an is fallacious is that it violates one of the most basic principles of deductive reasoning: No concepts can appear in the conclusion of a deductive argument that are not present in the premises. So if the concepts ought or should are not present in the premises of an argument, they cannot appear in its conclusion.

To see this, consider the following argument:

1. In almost all cultures, women are subservient to men.
2. Therefore, women should be subservient to men.

Obviously the conclusion doesn't follow from the premises. The fact that things are a certain way doesn't imply that they should be that way.

David Hume was the first to recognize the naturalistic fallacy. He describes his realization this way:

> In every system of morality, which I have hitherto met with, I have always remark'd, that the author proceeds for some time in the ordinary way of reasoning, and establishes the being of a God or makes observations concerning human affairs; when of a sudden I am surpriz'd to find, that instead of the usual copulations of propositions, is, and is not, I meet with no proposition that is not connected with an ought, or an ought not. This change is imperceptible; but is, however, of the last consequence.[4]

Wilson's hope to derive normative principles from empirical facts, then, seems misplaced.

What lies behind this misplaced hope may be a misunderstanding of the difference between explanation and justification. When we ask questions of the form "Why do you believe X?" we may be looking for two different sorts of answers: (1) a causal explanation of the belief or (2) a logical justification of the belief. Suppose, for example, that someone were to ask a male chauvinist, "Why do you believe that women should be subservient to men?" If she were looking for the first type of answer, it would be appropriate for him to say, "Because that's what I was always taught" or even "Because I'm genetically predisposed to view women as inferior to men." But if she were looking for the second type of answer, those responses would be inappropriate. Neither the fact that you were taught to believe something nor the fact that you

are genetically predisposed to believe something justifies your believing it, because neither of those things makes your belief true. When we're looking for the justification of a belief, we're looking for reasons for thinking it to be true. The fact that a belief was caused in a certain way doesn't provide such reasons. So even if Wilson succeeds in identifying the causes of our moral beliefs, he will not thereby have justified them.

Theories of morality try to answer the question, What makes an action right? or What makes a person good? They try to determine what, if anything, right actions or good people have in common. The data that moral theories try to explain are our considered moral judgments—those moral judgments that we accept after reflecting critically on them. A plausible ethical theory must be consistent with those judgments. If it sanctions obviously immoral actions, it's unacceptable.

In ethics, as in any other area of inquiry, there is a dynamic interplay between data and theory. Accepting a powerful theory may mean rejecting certain data, and vice versa. The goal in moral inquiry is to achieve a "reflective equilibrium" between data and theory. We want the fit between data and theory to be so close that no reasonable change in either would improve it.

To achieve reflective equilibrium among your moral beliefs, you should begin by critically examining the moral judgments you've made and the moral principles you accept. Ask: What moral principle lies behind this judgment? What moral judgments follow from this principle? Then check your judgments and principles for consistency. Try to determine whether your preferred moral principles justify your considered moral judgments, and whether your considered moral judgments follow from your preferred moral principles. If they do, then your moral beliefs are in reflective equilibrium. If they don't, eliminate the inconsistency by revising either your moral principles or your moral judgments.

Theories of morality should not only be consistent with our considered moral judgments, they should also be consistent with our experience of the moral life. We all make moral judgments, get into moral disputes, and act immorally from time to time. If a theory of morality implies that we don't do these things—if it implies that we don't make moral judgments, get into moral disputes, or act immorally—there's reason to believe that it's mistaken.

An adequate theory of morality should also be workable; it should help us solve moral dilemmas. We want to know what makes an action right because we want to do the right thing. If a moral theory is unworkable—if it doesn't give us specific guidance in specific situations—it fails to meet one of the primary goals of ethical inquiry.

We begin our inquiry into the nature of morality by examining various forms of relativism. We then examine the two most prevalent types of ethical theories: consequentialist (teleological) and formalist (deontological). Finally, we consider various theories of what it is to be a good person.

> *Every young man would do well to remember that all successful business stands on the foundation of morality.*
>
> —H. W. BEECHER

Objectives

After reading this chapter, you should be able to

- state the various theories of morality.
- describe the thought experiments that have been used to test them.
- evaluate the strengths and weaknesses of the various theories of morality.
- define consequentialism, formalism, intrinsic value, instrumental value, principle of justice, principle of mercy, perfect duty, imperfect duty, negative right, positive right, *prima facie* duty, and virtue.
- formulate your own view of what makes an action right or wrong.

Section 5.1

● Don't Question Authority
Might Makes Right

The Declaration of Independence asserts that all human beings possess certain inalienable rights, including the right to life, liberty, and the pursuit of happiness. These rights are supposed to apply to all people no matter what society they live in. Many Americans today, however, would no longer agree that there are such universal rights. In their view, morality is relative to individuals, to cultures, or to religions.

The view that morality is relative to culture is often thought to be supported by anthropology. As art historian William Fleming says in his text *Arts and Ideas,* "The study by anthropologists of the life and customs of primitive peoples has shown how ethical considerations are relative to tribal customs as well as social and economic conditions."[5] The variation of moral beliefs among cultures is indeed striking. Certain tribes believe that it is morally permissible to kill their members when they reach the age of forty. Cannibals believe that it is morally permissible to eat human beings. And "the Siriono Indians of the upper Amazon appear to think little of copulating in full view of others but may be shamed into exile if they are caught eating in public."[6] Given this wide variation among moral beliefs, how can there be any absolute moral standards?

Even within a culture, the differences in moral beliefs can be vast. Consider, for example, the radically divergent beliefs people have about the morality of abortion, euthanasia, capital punishment, and the like. What better evidence could we have for the relativity of moral judgment? If there were a universal morality, wouldn't there be much more agreement about these issues than there is?

> *The Absolute Truth is that there is nothing absolute in the world.*
>
> —WALPOLA RAHULA

Subjective Absolutism

Life, lives, and reality are only what we each perceive them to be.
— SHIRLEY MACLAINE

The lack of consensus in moral matters has led some to embrace the doctrine of **subjective absolutism:** The view that what makes an action right is that one approves of it. According to this view, morality is a matter of personal preference. When we say that an action is right, we are merely saying that we approve of it.

Although this view may help explain the plethora of moral opinions, it can't possibly be correct because it leads to a logical contradiction. Suppose that someone approved of Lester Zygmanik's action. Then, according to subjective absolutism, what Lester did was right. Now suppose that someone else disapproved of that action. Then what Lester did was wrong. But one and the same action cannot be both right and wrong. The law of noncontradiction tells us that nothing can have a property and lack it at the same time. Subjective absolutism, then, cannot be correct because it is self-contradictory.

Whenever we make a moral judgment about an action, we have a certain feeling toward it. But having a feeling about an action can't be what makes it right or wrong. If it did, one and the same action could be both right and wrong, and as we've seen, that's impossible. Just as a plane figure can't be both round and square at the same time, so an action can't be both right and wrong at the same time.

An action can be *believed* to be right and wrong at the same time, however. One person can believe that an action is right while another believes that it is wrong. But that doesn't make the action both right and wrong. Similarly, the earth can be believed to be flat and round at the same time. But that doesn't make it flat and round at the same time. You can't make a statement true simply by believing it to be true, and you can't make an action right simply by believing it to be right.

Subjective Relativism

In the province of the mind, what one believes to be true either is true or becomes true.
— JOHN LILLY

subjective absolutism
The doctrine that what makes an action right is that one approves of it.

subjective relativism
The doctrine that what makes an action right for someone is that it is approved by that person.

The subjectivist may try to avoid this contradiction by claiming that right and wrong are not properties like round or square but are relations like small or large. Nothing can be round and square at the same time. But something can be small and large at the same time. An acorn is large in relation to a mustard seed, but it is small in relation to a coconut. So if moral terms are relational, the same action can be both right and wrong.

Subjective relativism—the doctrine that what makes an action right for someone is that it is approved by that person—claims that moral judgments are always relative to the individual. Whenever someone says that an action is right, what she means is that it is right *for her*. Nothing is absolutely right or wrong, just as nothing is absolutely big or small. To understand a moral judgment, then, you have to know who made it.

Although subjective relativism may seem admirably egalitarian in that it considers everyone's moral judgments to be as good as everyone else's, it has some rather bizarre consequences. For one thing, it implies that each of us

is morally infallible. As long as we approve of an action, our judgment that it is morally right can't be mistaken. But that can't be correct. Suppose that Hitler approved of exterminating the Jews. Then it was right for Hitler to exterminate the Jews. Or suppose that Stalin approved of assassinating his enemies, then it was right for Stalin to assassinate his enemies. Subjective relativism condones any action as long as the person performing it approves of it. But what Hitler and Stalin did was wrong, even if they approved of what they did. Believing something to be right doesn't make it right. If it did, we'd all be morally infallible, and that's absurd.

It's hard to argue with someone who's infallible. So, as you might expect, subjective relativism makes moral disagreement next to impossible. It's easy to see why. Suppose that Jack says that abortion is right and Jill says that it is wrong. Ordinarily, we would take Jack and Jill to be disagreeing with each other. According to subjective relativism, however, they don't disagree because what Jack is really saying is that he approves of abortion and what Jill is really saying is that she doesn't approve of abortion. These statements don't contradict one another because the subjects of these statements are different (Jack vs. Jill) and they say different things about those subjects. So they both could be true. If Jill wanted to disagree with Jack, she would have to say something like "I'm sorry, Jack, but you don't approve of abortion." It's hard to see how Jill could ever be in a position to make such a claim, however, for no one knows Jack's mind better than Jack. Yet, according to subjective relativism, that is what she must claim if she wants to disagree with Jack. The problem is that moral subjectivism takes morality to be a matter of taste, and as we all know, there's no arguing about taste.

Relativity applies to physics, not ethics.
— ALBERT EINSTEIN

To see this, consider a similar situation. Suppose that Jack says that chocolate is his favorite ice cream and Jill says that vanilla is her favorite. Has Jill disagreed with Jack? No, because she's said something about herself and Jack has said something about himself. If Jill wanted to disagree with Jack, she would have to say something like "I'm sorry, Jack, but chocolate is not your favorite ice cream." But that would be silly because she would never be in a position to truthfully make such a claim.

Moral disputes are not about whether people know their own minds. But if subjective relativism were true, that's all they could be about. Subjective relativism, then, doesn't fit the facts; it's not consistent with our experience of the moral life.

Subjective relativism can't be a correct theory of morality because it sanctions obviously immoral actions, it implies that people are morally infallible, and it denies that there are any substantive moral disagreements. We wouldn't hesitate to reject a scientific theory that failed so miserably to fit the facts. Similarly, we shouldn't hesitate to reject subjective relativism.

Emotivism

In defense of the notion that morality is subjective, some have gone so far as to claim that moral utterances are neither true nor false. Some things we say do not have a truth value. Consider these utterances: Hooray! Bravo! Boo! Hiss! These are exclamations rather than statements. They serve to express

emotions rather than to make statements. As a result, none of them is true or false. According to **emotivism,** all moral utterances (utterances that use moral terms like "right" and "wrong") are expressions of emotion. If we say, for example, that abortion is right, what we're saying, in effect, is "Abortion—Hooray!"

The logical positivist A. J. Ayer defended a version of emotivism in his *Language, Truth, and Logic:*

> If I . . . say "Stealing is wrong," I produce a sentence which has no factual meaning—that is, expresses no proposition which can be either true or false. It is as if I had written "Stealing money!!"—where the shape and thickness of the exclamation marks show, by a suitable convention, that a special sort of moral disapproval is the feeling which is being expressed. It is clear that there is nothing said here which can be true or false.[7]

Logical positivism, you will recall from Chapter 2, is based on the verifiability theory of meaning, which says that if a sentence cannot be verified, it is cognitively meaningless (neither true nor false). Ayer maintains that moral sentences cannot be verified because goodness or rightness cannot be sensed. Good people and right actions do not have a particular look, feel, taste, smell, or sound. Consequently, sentences containing terms like "good" or "right" are neither true nor false.

Even though the verifiability theory of meaning is implausible, there is something to be said for emotivism. By taking moral utterances to be expressions of emotion rather than statements of fact, emotivism avoids some of the difficulties facing subjectivism. Because it claims that moral utterances are not judgments of any kind, it avoids the inconsistency of subjective absolutism and the individual infallibility of subjective relativism. If you don't make a statement, you can't contradict anybody, and you can't be right or wrong.

Emotivism, however, fares no better than subjective relativism in accounting for moral disagreement, for if moral utterances aren't statements, they can't contradict one another. When you say "Hooray!" you haven't said anything that anyone can disagree with. Similarly, if what you're saying when you say that abortion is wrong is something like "Abortion—Boo!" you haven't said anything that anyone can contradict. Moral discourse is more than just cheering or jeering, however. It follows, then, that emotivism cannot be correct.

Emotivism implies that nothing is good or bad because the words "good" and "bad" do not stand for properties or features of anything. This is a radical claim that flies in the face of common sense. To show just how radical it is, Brand Blanshard proposes the following thought experiment.

Thought Experiment

Blanshard's Rabbit

There is perhaps no value statement on which people would more universally agree than the statement that intense pain is bad. Let us take a set of circumstances in which I happen to be interested on the legislative side and

emotivism The doctrine that moral utterances are expressions of emotion.

> in which I think every one of us might naturally make such a statement. We come upon a rabbit that has been caught in one of the brutal traps in common use. There are signs that it has struggled for days to escape and that in a frenzy of hunger, pain, and fear, it has all but eaten off its own leg. The attempt failed: the animal is now dead. As we think of the long and excruciating pain it must have suffered, we are very likely to say: "It was a bad thing that the little animal should suffer so." The positivist tells us that when we say this we are only expressing our present emotion. I hold, on the contrary, that we mean to assert something of the pain itself, namely, that it was bad—bad when and as it occurred.[8]

According to emotivism, the rabbit's pain is neither good nor bad. It may move you to express an emotion, but in and of itself, the rabbit's pain has no moral properties (because there are no moral properties). But surely, Blanshard claims, this cannot be the case. Intense suffering is bad whether or not it causes anybody to express an emotion.

What's more, emotivism implies that everyone's reaction to a situation is just as appropriate as everyone else's. But this, too, flies in the face of common sense. Suppose that someone expresses joy at the pain of the rabbit. Or suppose that someone expresses delight at the torture of innocent children. We would ordinarily consider these reactions inappropriate. This judgment can easily be explained on the hypothesis that some things (like unnecessary suffering) are objectively wrong, but this explanation is not available to the emotivists. Consequently, they cannot account for this aspect of our moral experience.

The fact that a theory conflicts with common sense is a strike against it but doesn't rule it out entirely. Common sense has been wrong about many things, such as the shape, size, and position of the earth. But we should reject common sense only if the alternative is demonstrably superior to it, and emotivism has nothing over common sense. Not only is it inconsistent with our experience of the moral life, but it provides no means for resolving moral dilemmas. In fact, it suggests that there are no moral dilemmas. Consequently, it is not an adequate ethical theory.

Cultural Relativism

When we say that an action is right, we are not merely saying that we approve of it. Nor are we simply expressing our emotions. What, then, are we saying? Many believe that we're saying that our culture approves of it.

Our moral beliefs tend to reflect the culture in which we grew up. For example, if we grew up in India, we may believe that it's morally permissible to burn wives alive along with their dead husbands on a funeral pyre. If we grew up in Syria, we may believe that it's morally permissible to have more than one wife. And if we grew up in the Sudan, we may believe that it's morally permissible to surgically remove the clitorises of young women. If we grew up in America, however, we are likely to believe that none of these

Custom is the universal sovereign.
—PINDAR

practices is morally permissible. Because people in different cultures have different moral beliefs, the conclusion that morality is relative to culture seems unavoidable.

Cultural relativism, then, is the doctrine that what makes an action right for the members of a particular culture is that it's approved by that culture. Unlike subjective relativism, cultural relativism does not imply that individuals are morally infallible. But it does imply that cultures are morally infallible. Cultures make the moral law, so cultures can do no wrong.

If cultures were morally infallible, however, it would be impossible to disagree with one's culture and be right. Social reformers couldn't claim that a socially approved practice is wrong, because if society approves of it, it must be right. If society approves of slavery, for example, then slavery is right. Anyone who suggested otherwise would simply be mistaken. Thus cultural relativism would have us believe that Jesus, William Lloyd Garrison (one of the leading abolitionists), and Susan B. Anthony (one of the leading suffragettes) acted immorally, for they all advocated practices that were not approved by their cultures. But instead of condemning them for acting immorally, we praise them for exposing the immoral practices of their cultures. Cultures are not morally infallible. They can and have sanctioned immoral practices. Consequently, cultural relativism cannot be correct.

Unlike subjectivism, cultural relativism does not make moral disagreement impossible. Individuals can legitimately disagree about the morality of an action. But according to cultural relativism, the only thing they can disagree about is whether their culture approves of the action, because that's what determines whether it's right or wrong. So cultural relativism would have us believe that when people disagree about the morality of abortion, what they're really disagreeing about is whether their society approves of abortion. But that's implausible. Moral disagreements in general and the abortion controversy in particular are not about public opinion, and they cannot be resolved through opinion polls. Because cultural relativism suggests otherwise, it's not an adequate theory of morality.

Even if moral disagreements were about public opinion, cultural relativism would still be an inadequate theory of morality because it's unworkable. It can't help us solve moral dilemmas because there is no way to identify one's true culture. Suppose you were a Black Jewish Communist living in Bavaria during Hitler's reign. What would be your true culture? The Blacks? The Jews? The Communists? The Bavarians? The Nazis? Each of us is a member of many different cultures, and there is no way to determine which one is our true culture. But if we can't identify our true culture, we can't use cultural relativism to solve moral problems.

Given cultural relativism's many failings, why is it so popular? Part of the answer is that many people believe that it promotes tolerance. Anthropologist Ruth Benedict, for example, claims that by accepting cultural relativism, "we shall arrive at a more realistic social faith, accepting as grounds of hope and as new bases for tolerance the coexisting and equally valid patterns of life which mankind has created for itself from the raw materials of existence."[9] But to explicitly advocate cultural relativism on the grounds that it promotes

There are not unfrequently substantial reasons underneath for customs that appear to us absurd.
—CHARLOTTE BRONTË

Custom is the law of fools.
—SIR JOHN VANBRUGH

cultural relativism
The doctrine that what makes an action right for the members of a particular culture is that it is approved by that culture.

> ### In the News: Universal Human Rights
>
> To embrace social relativism is to reject the notion of universal human rights. As you might expect, the most vocal proponents of social relativism are the most flagrant violators of human rights. Columnist Ellen Goodman had this to say about the U.N. Conference on Human Rights held in 1993 in Vienna, Austria:
>
> > The first conference on human rights in 25 years was called in the heady months after the fall of the Berlin Wall. A world that had been divided into East and West, locked into a Cold War and superpower politics, was turned inside out. There was real hope that the human rights impulse which had been released in Eastern Europe would catch on across the world. . . . But in recent years a backlash of sorts has emerged, especially from some Third World governments in Asia and Africa. Waving the banner of multiculturalism, they have come here to insist that their country cannot be judged by some universal standard but only by its own "particularities," its own cultural and economic context. They resist the notion that democratic or human rights strings should be tied to financial aid from the West or North.
>
> There are serious questions that emerge out of any clash of countries or cultures, but many of the governments claiming special exemptions to universal rights are abusers of those rights: Burma, China, Yemen, Syria and others that a jaded U.N. spokesperson called "the usual suspects." In stark contrast, activists in these countries disagree with their own government's view of "cultural differences." They insist there is no culture that favors discrimination, torture, "disappearings."
>
> In a strong speech on opening day in which he proposed an international tribunal, Secretary of State Warren Christopher put the issue bluntly: "We cannot let cultural relativism become the last refuge of repression."
>
> At the heart of the human rights movement in this fractionalized world is the notion that these rights are the same everywhere for everyone. As Boutros-Ghali said, these values are the way "we affirm together that we are a single human community . . . a world community that accepts anything less is just flags flying in the wind."[10]

tolerance is to implicitly assume that tolerance is an absolute value. If there are any absolute values, however, cultural relativism is false.

The most a cultural relativist can consistently claim is that her culture values tolerance. But other cultures may not. In fact, fundamentalists of almost every stripe do not tolerate those who disagree with them. From a cultural relativist point of view, then, intolerance can be justified. Thus any attempt to justify cultural relativism by an appeal to tolerance is bound to fail.

Another reason why cultural relativism is so popular is that it seems to be the only ethical theory that is consistent with the anthropological evidence. The inadequacy of cultural relativism suggests that this conclusion is mistaken, however. To see why, let's examine the anthropological argument in more detail.

Tolerance is the virtue of the man without convictions.
— G. K. Chesterton

The Anthropological Argument

The anthropological argument for cultural relativism says that because people in different cultures disagree about the morality of various actions, there are no universal moral standards. But the fact that people disagree does not, *by itself,* imply that there are no absolute moral standards. Only in conjunction

with certain other assumptions can that conclusion be reached. By making those assumptions explicit, we can better judge the soundness of the anthropological argument for cultural relativism. Here's one way of spelling out the argument:

1. People in different societies make different moral judgments regarding the same action.
2. If people in different societies make different moral judgments regarding the same action, they must accept different moral standards.
3. If people in different societies accept different moral standards, there are no universal moral standards.
4. Therefore, there are no universal moral standards.

This is a valid argument because the conclusion follows from the premises. The question is, Are the premises true? Premise 1 is certainly true, for it has been confirmed by anthropological investigation many times over. What about premise 3? It states that if people disagree about what makes an action right, there can be no correct answer to the question, What makes an action right? But this doesn't follow. From the mere fact that people disagree, we can't conclude that none of the parties to the disagreement is correct. Disagreement, by itself, doesn't invalidate every disputant's claim. If it did, you could refute anyone by simply disagreeing. To show that someone is mistaken, however, you must do more than just disagree with him or her. You must give reasons for believing that he or she is mistaken. The simple fact that people disagree, then, does not prove that there are no absolute moral standards.

Because premise 3 is false, the anthropological argument is unsound. But premise 3 is not the only questionable premise in this argument. Premise 2 says that whenever people disagree about the morality of an action, they must accept different moral standards. In other words, it says that whenever there is a difference in moral judgments, there is a difference in moral standards. Is this true? To see if it is, let's examine how moral judgments are made.

> Be not so bigoted to any custom as to worship it at the expense of truth.
> —JOHANN ZIMMERMAN

> Custom may lead a man into many errors, but it justifies none.
> —HENRY FIELDING

The Logical Structure of Moral Judgments

A moral judgment is a moral appraisal of a particular action. A moral standard is a moral appraisal of a general *type* of action. From a moral standard like "murder is wrong," which refers to an entire class of actions (the class of murders), we cannot conclude that any particular killing is wrong, for the killing might not be an act of murder. To make that determination, we need to know more about the facts of the case. Murder is the unjustified killing of a person with malice aforethought. So to determine whether any particular killing is a murder, we have to determine whether the victim was a person, whether the killing was justified, and whether the culprit acted out of hatred or malevolence.

These considerations show that moral judgments do not follow from moral standards alone. To derive a moral judgment from a moral standard, we need

additional information about the situation. Without such information, no moral judgment can be made. The formula for a moral judgment, then, is

<blockquote>Moral standard + Factual beliefs = Moral judgment</blockquote>

Because moral standards alone do not imply moral judgments, it is not necessarily true that whenever there is a difference in moral judgments, there is a difference in moral standards. Any difference in judgment could also be due to a difference in the facts of the case.

Some anthropologists believe that this is often the case. Social psychologist Solomon Asch, for example, writes,

> We consider it wrong to take food away from a hungry child, but not if he is overeating. We consider it right to fulfill a promise, but not if it is a promise to commit a crime. . . . It has been customary to hold that diverse evaluations of the same act are automatic evidence for the presence of different principles of evaluation. The preceding examples point to an error in this interpretation. Indeed, an examination of the relational factors points to the operation of constant principles in situations that differ in concrete details. . . . Anthropological evidence does not furnish proof of relativism. We do not know of societies in which bravery is despised and cowardice held up to honor, in which generosity is considered a vice and ingratitude a virtue. It seems rather that the relations between valuation and meaning are invariant.[11]

The despotism of custom is on the wane. We are not content to know that things are; we ask whether they ought to be.
—J. S. MILL

According to Asch, people in different cultures arrive at different moral judgments not because they have different views about the nature of morality, but because they have different views about the nature of reality.

Consider the abortion controversy. Those who are pro-life believe that abortion is wrong; those who are pro-choice believe that it is right. Does this mean that these two groups of people have different views about the nature of morality? No, because they both believe that murder is wrong. What they disagree about is the nature of the fetus. Is a fetus the sort of thing that can be murdered? Is the fetus a person? Their disagreement, then, is about what kind of a thing the fetus is, not about what makes an action right or wrong.

Consider the male chauvinists who believe that it's wrong to give women the same responsibilities as men. Feminists believe that there is no reason not to treat men and women as equals. Male chauvinists and feminists make different moral judgments about how women should be treated. Do they have different views of the nature of morality? Not necessarily: They most likely both accept the principle that equals should be treated equally. Thus their disagreement is not about the nature of morality but about the nature of women. Male chauvinists and feminists simply disagree about what women can do. Because moral judgments follow from both a moral standard and certain factual beliefs, a difference in moral judgments does not necessarily imply a difference in moral standards.

The fact that an opinion has been widely held is no evidence that it is not utterly absurd.
—BERTRAND RUSSELL

Thought Probe

When in Rome

Clitoridectomy—the surgical removal of the clitoris—is common in Gambia. It is believed that this procedure makes the woman more pure and desirable as a wife. In 1987, Teneng Jahate, a native of Gambia but a French resident for five years, hired a midwife to perform a clitoridectomy on her two daughters, ages one and two. The practice is outlawed in France, but Jahate did not know this. She testified: "I didn't know it was forbidden in France. I did it because I knew they would be circumcised when they returned to Gambia, so why not do it when they were little?"[12] Did Jahate do the wrong thing? Why or why not?

The Divine Command Theory

All moral obligation resolves itself into the obligation of conformity to the will of God.
— CHARLES HODGE

Neither an individual nor a society can make an action right by approving it. Many, however, believe that God can. In their view, God is both the author and the enforcer of the moral law. He makes the rules, and he ensures that those who break them get what's coming to them. This view of morality is often called the **divine command theory,** for it holds that what makes an action right is that God commands it to be done. On this view, nothing is right (or wrong) prior to or independently of God's willing it to be done (or refrained from). But this raises the question, How did God come up with his commandments? Did he have some standard to go by or did he just arbitrarily will whatever came to mind? This is similar to the problem that Socrates sought to resolve in the *Euthyphro*. It can be put this way: Is an action right because God wills it, or does God will it because it's right? To accept the first alternative is to accept the divine command theory. To accept the second alternative, however, is to reject it, for on this view, the rightness of an action is independent of God's will.

To better understand the import of the divine command theory, consider the following tale. Suppose that when Moses came down from the mountain with the tablets containing the Ten Commandments, his people gathered around him to find out how God said they should live. "What do the tablets say?" his followers wanted to know. Moses replied, "I have some good news and some bad news." "Give us the good news first," they instructed him. "Well, the good news," Moses said, "is that God kept the number of commandments down to ten." "Okay, what's the bad news?" they inquired. "The bad news," Moses informed them, "is that he kept the one about adultery in there." The point is that, according to the divine command theory, what makes adultery wrong is that God commands it not to be done. If he hadn't issued such a command, there would be nothing wrong with adultery.

divine command theory The doctrine that what makes an action right is that God commands it to be done.

Let's take this line of reasoning to its logical conclusion. If the divine command theory were true, then the Ten Commandments could have gone something like this: "Thou shalt kill everyone you dislike. Thou shalt rape every woman you desire. Thou shalt steal everything you covet. Thou shalt torture

340 Chapter 5 • The Problem of Relativism and Morality

innocent children in your spare time . . ."—because killing, raping, stealing, and torturing were not wrong before God made them so, and God could have made them right.

Many take this to be a *reductio ad absurdum* of the divine command theory. It reduces the divine command theory to absurdity because it's absurd to think that God would condone such actions. To avoid the charge of absurdity, a divine command theorist might try to deny that the situation described above is possible. She might argue, for example, that God would never condone killing, raping, stealing, and torturing because God is all-good. But if God is by definition good, then God can't be used to define goodness because such a definition would be circular—the concept being defined would be contained in the concepts doing the defining. If being all-good is an essential property of God, then all the divine command theory tells us is that good (or right) actions would be willed by a supremely good (or righteous) being. Although this is certainly true, it's unenlightening. It doesn't tell us what makes an action right and thus doesn't improve our understanding of the nature of morality.

The circularity could be avoided by denying that goodness is a defining attribute of God. But this won't help the divine command theorist because if goodness is not an essential property of God, then there is no guarantee that what he wills will be good. Being all-powerful and all-knowing does not necessarily incline one toward the good. In fact, it may do the opposite. As British statesman Lord Acton remarked, "Power tends to corrupt, and absolute power corrupts absolutely." So the divine command theory faces a dilemma: if goodness is a defining attribute of God, the theory is circular, but if it is not a defining attribute, the theory is false. In either case, the divine command theory is an unacceptable theory of the nature of morality.

To one who believes in God, however, the divine command theory's most significant failing may be that it is demeaning to God; it destroys any reason we might have for worshipping and obeying him. Leibniz explains:

> In saying, therefore, that things are not good according to any standard of goodness, but simply by the will of God, it seems to me that one destroys, without realizing it, all the love of God and all his glory; for why praise him for what he has done, if he would be equally praiseworthy in doing the contrary? Where will be his justice and his wisdom if he has only a certain despotic power, if arbitrary will takes the place of reasonableness, and if in accord with the definition of tyrants, justice consists in that which is pleasing to the most powerful. Besides it seems that every act of willing supposes some reason for the willing and this reason, of course, must precede the act.[13]

Leibniz's point is that if things are neither right nor wrong independently of God's will, then God cannot choose one thing over another because it is right. Thus if he does choose one over another, his choice must be arbitrary. A being whose decisions are arbitrary, however, is not worthy of worship.

Moreover, if God's commands are arbitrary—if he has no moral reason for making them—then we have no moral obligation to obey them. God may threaten to punish us if we don't obey his commands, but threats extort;

The greatest tragedy in mankind's history may be the hijacking of morality by religion.
—ARTHUR C. CLARKE

The will of God is the refuge of ignorance.
—SPINOZA

they do not create a moral obligation. Might does not make right. So if God's commands are not based on sound moral principles, there is no more reason to obey them than there is to obey a Hitler or a Stalin.

The fact that Leibniz rejects the divine command theory is significant because he is one of the most committed theists in the Western intellectual tradition. He argues at great length that there must be an all-powerful, all-knowing, and all-good God, and thus that this must be the best of all possible worlds. Because God is all-knowing, he knows what kind of a world would be best; because he is all-powerful, he can create such a world; and because he is all-good, he wants to create such a world. Ever since Voltaire lampooned this view in *Candide*, it has been difficult to take seriously. Nevertheless, what Leibniz demonstrates is that far from being disrespectful or heretical, the view that morality is independent of God is an eminently sensible and loyal one for a theist to hold.

The foregoing considerations indicate that the first horn of our dilemma is false. God cannot make an action right by simply willing it to be done. God must will an action to be done because it's right. In that case, however, morality does not depend on God.

But God, you might object, is omnipotent; he can do anything he wants to do. So he must be able to make actions right or wrong. To say that God is omnipotent, however, is not to say that he can do anything he wants to do. It's to say that he can do anything that it's logically possible to do. As the great Catholic theologian St. Thomas Aquinas realized, "Whatever implies a contradiction does not come within the scope of divine omnipotence because it cannot have the aspect of possibility. Hence it is better to say that such things cannot be done, than that God cannot do them."[14] For example, God can't make the number three an even number. An even number is divisible without remainder by two, and not even God can make the number three divisible by two without remainder. God can't do things that are logically impossible. This doesn't impugn his omnipotence, however, because to be all-powerful is to be able to do anything that it's logically possible to do.

Just as God cannot change the laws of mathematics, there is reason to believe that he cannot change the laws of morality. He cannot make love evil, for example, because love is intrinsically good. Lawyer and journalist Albert Pike expresses this point as follows:

> Saint Thomas said, "A thing is not just because God wills it, but God wills it because it is just." If he had deduced all the consequences of this fine thought, he would have discovered the true Philosopher's Stone, the magical elixir to convert all the trials of the world into golden mercies. Precisely as it is a necessity for God to be, so it is a necessity for Him to be just, loving, and merciful. He cannot be unjust, cruel, and merciless. He cannot repeal the law of right and wrong, of merit and demerit; for the moral laws are as absolute as the physical laws. There are impossible things. As it is impossible to make two and two be five and not four; as it is impossible to make a thing be and not be at the same time; so it is impossible for the Deity to make crime a merit, and love and gratitude crimes.
>
> Therefore, according to the idea of Saint Thomas, the moral laws are the enactments of the Divine Will only because they are the decisions of the absolute

> *A man's ethical behavior should be based effectually on sympathy, education, and social ties. No religious basis is necessary. Man would indeed be in a poor way if he had to be restrained by fear of punishment and hope of reward after death.*
>
> —ALBERT EINSTEIN

> ### In the Courts: God Is My Attorney
>
> Periodically people claim that they have been commanded by God to commit a crime. Barbara Downey's case is typical:
>
>> Barbara Downey claimed she was commanded by God to kill her 7-year-old daughter.
>>
>> Now the 25-year-old Apache Junction woman will answer to a mortal's court.
>>
>> The woman was arrested Tuesday after she confessed to shooting her daughter "because it was God's will." Wednesday morning, Downey led police to a desert area east of Apache Junction, where they found the body of 7-year-old Jessica Helms.
>>
>> "God is my attorney," Downey said to a judge during her initial appearance Wednesday. She claimed God told her to kill her daughter because the girl was born out of wedlock, police said. . . .
>>
>> Downey's live-in boyfriend, James David Ladd, told police Downey started acting odd a week ago.
>>
>> "He said she was reading a certain passage in the Bible talking about children born out of wedlock," said Apache Junction police Lt. Brian Duncan. "She said it wasn't right — and the Lord spoke to her as she read the passage."
>>
>> So when Ladd discovered Downey picked up her daughter from Four Peaks Elementary School at 1:15 P.M. Tuesday — about two hours early — he was suspicious.
>>
>> "Once he discovered his gun also was missing, he called police," about 2:50 p.m., Duncan said.
>>
>> "She answered all our questions. . . . She seemed very comfortable with her decision, with what she did," Duncan said. "In her mind, she was led by the will of God to do this . . . because her daughter was born out of wedlock.". . .
>>
>> "[Ladd's] blaming himself for the whole thing," said Thomas, a man who lives in a trailer next door and didn't want his last name publicized. . . .
>>
>> "What she did was pretty hard," Thomas added. "But no one can tell what she was thinking at the time. Who's anybody to say she didn't hear any voices."[15]
>
> Barabara Downey pleaded guilty but insane to the slaying of her daughter. She was sentenced to life in Arizona's state mental hospital.
>
> ### Thought Probe
>
> #### Commanded to Kill
>
> Suppose that God spoke to you and told you to kill your spouse and your children. How would you know it was God? If you were convinced that it was, would you do it? Why or why not? What light does your answer throw on the divine command theory?

Wisdom and Reason, and the Revelations of the Divine Nature. In this alone consists the right of Deity to enact them.[16]

Pike argues against the divine command theory, not on the grounds that it's circular or demeaning, but on the grounds that it's logically impossible. Pike believes that moral laws like "Love is good" are just as absolute as mathematical laws like "The number three is odd." They hold in virtue of the logical relations among the concepts involved, not in virtue of any divine command. So they aren't subject to the will of God.

Even if morality did depend on God's will, the divine command theory would not be an adequate theory of morality because it's unworkable. Just as there is no way to determine which culture is one's true culture, there's no way to determine which God is the one true God. We can use the divine

command theory to solve moral problems only if we know which commandments to obey. The divine command theory, however, doesn't tell us how to distinguish legitimate divine commands from illegitimate ones. Consequently, it can't help us make moral decisions.

The believers of any particular sect, of course, will claim that they know where God's true commandments can be found—namely, in their book of sacred scripture. But even if we knew which book of scripture was inspired by God, we still wouldn't know which commands to obey because we couldn't be sure that the scribes got it right. Consider, for example, the following commands from the Bible:

- He that curseth his father or his mother, shall surely be put to death. (Exod. 21:17)
- Whosoever doeth any work in the Sabbath day, he shall surely be put to death. (Exod. 31:15)
- He that sacrificeth unto any god, save unto the Lord only, he shall be utterly destroyed. (Exod. 22:20)

Cursing your father or mother may not be a good thing, but it's not a crime punishable by death. Working on Sunday (or Saturday, as the case may be) also should not be considered a capital offense. And killing members of other religions simply because they are members of other religions certainly is not right. We know that these commands are immoral, even though the Bible tells us that they come from God. Neither the Bible nor God, then, can be the source and ground of morality. If we can judge their pronouncements to be immoral, we must have a standard of morality that's independent of them.

There are those who hold that even if God is not required as the author of the moral law, he is nevertheless required as the enforcer of it. Without the threat of divine punishment, people will not act morally. But this position is no more plausible than the divine command theory itself. In the first place, as an empirical hypothesis about the psychology of human beings, it is questionable. There is no unambiguous evidence that theists are more moral than nontheists. Not only have psychological studies failed to find a significant correlation between frequency of religious worship and moral conduct, but convicted criminals are much more likely to be theists than atheists. Second, the threat of divine punishment cannot impose a moral obligation, for might does not make right. Threats of violence do not create a moral obligation. We are not morally obligated to obey someone simply because he or she has threatened us with physical harm if we don't.

Heaven and hell are often construed as the carrot and stick that God uses to make us toe the line. Heaven is the reward that good people get for being good, and hell is the punishment that bad people get for being bad. But good people do good because it's good—not because they will personally benefit from it or because someone has forced them to do it. People who do good solely for personal gain or to avoid personal harm are not good people. Suppose that a child is drowning in a lake, and suppose that an able swimmer strolls by but doesn't feel like saving her. Now suppose that a person in a wheelchair rolls up, points a shotgun at the stroller's head, and says, "If you

> ### The Fortunes of Hell
>
> Few contemporary theologians believe in the existence of hell, for they believe that an all-loving God would never let any of his children burn in hell for eternity, no matter how serious the crime. John Hick explains:
>
> > The objections to the doctrine of eternal torment which once seemed so weak and now seem so strong are well known: for a conscious creature to undergo physical and mental torture through unending time (if this is indeed conceivable) is horrible and disturbing beyond words; and the thought of such torment being deliberately inflicted by divine decree is totally incompatible with the idea of God as infinite love; the absolute contrast of heaven and hell, entered immediately after death, does not correspond to the innumerable gradations of human good and evil; justice could never demand for finite human sins the infinite penalty of eternal pain; such unending torment could never serve any positive or reformative purpose precisely because it never ends; and it renders any coherent Christian theodicy impossible by giving the evils of sin and suffering an eternal lodgment within God's creation. Accordingly contemporary theologians who do not accept the doctrine of universal salvation usually speak of the finally lost as passing out of existence rather than as endlessly enduring the torments of hell-fire.[17]
>
> If these arguments are correct, and the universe is governed by an all-loving God, you don't have to worry about going to hell. Whatever the afterlife holds, it will not hold eternal torment.

don't save that child, I'm going to blow your head off." The stroller then reluctantly saves the child. Should he be praised for saving her? It wouldn't seem so. By parity of reasoning, it follows that if your only reason for doing good is your fear of going to hell, you're going to hell, because you're no better than the stroller. Good people do good for goodness's sake, not for their own sakes. The notion that we need God as either the author or the enforcer of the moral law, then, is erroneous.

Are There Universal Moral Principles?

Although moral disagreement is widespread, we do seem to be making moral progress. We have abolished slavery, given women the vote, and made harvesting tuna dolphin-safe. If there is moral progress, however, there must be fixed moral standards against which we can judge our actions and policies. If there were no such standards, we would have no grounds for thinking that things are better now than they were before. The best explanation of the fact that we seem to be making moral progress, then, is that there are universal moral standards.

There is but one morality, as there is but one geometry.
—VOLTAIRE

Where do these standards come from? We have seen that no one, not even God, can make an action right simply by believing it to be right. But if belief can't justify a moral standard, what can? Many, including the founders of this country, share the view that moral standards can justify themselves.

"We hold these truths to be self-evident..." proclaims the Declaration of Independence. A self-evident truth is one which is such that if you

Moral Children

It is widely believed that morality is something that is learned rather than innate. Developmental psychologists such as Jean Piaget and Lawrence Kohlberg have claimed that young children get their morality from their parents. Whatever their parents tell them is right is what they believe to be right. Recent research suggests, however, that this notion of moral development is mistaken. William Damon, chair of Brown University's education department and director of the Center for the Study of Human Development, has found that even very young children seem to have a sense of right and wrong that is independent of what their parents say:

> Damon's idea for his research grew out of a job he took after college as a caseworker in a New York City settlement house for immigrant pre-teens—rough-and-tumble kids clearly headed for trouble. "I noticed that even the very young ones, four and five, had ideas about family, other people, emotions, and morality that were much more advanced and sophisticated than anything developmental psychologists had been writing about," he recalls.
>
> The experience was a revelation. "I had a feeling [one] has very few times in a lifetime. I felt I had discovered something others had not seen." When he later entered graduate school, Damon devised some experiments with nursery-school children that involved asking them to distribute toys and candy among their friends.
>
> "I was struck with how child after child, whatever school I went to, all said the same kinds of things," he remembers. "They gave reasons why they had to share: 'If I don't share with her, she won't play with me.' 'I'll hurt her feelings if I don't share with her.' They had a sense of reciprocity and a sense of empathy."
>
> Next he asked, "What if your mother or your teacher told you not to share your lunch or candy or your bike with your friend?" The children answered, "That would be wrong. I would do it anyway." Kohlberg and other psychologists had been saying that, before adolescence, children get all their moral values from their parents; to a child, whatever the person in power says is right is right simply because she says so. "But kids were saying, 'My mother would be wrong. That's not nice. That's not fair to my friend.'"[18]

Damon believes that children are born with a natural predisposition to moral behavior. That predisposition has to be nurtured to develop, but it is something that, as humans, we all share.

Thought Probe

Moral Children

Does Damon's research lend credibility to the claim that there are absolute moral standards? Why or why not?

understand it, you are justified in believing it. Consider, for example, the statement: Whatever has a shape has a size. If you understand that statement—if you know what shape and size are—you are justified in believing it. You don't need any additional evidence to support your belief. Self-evident truths provide their own evidence; they do not stand in need of any further justification.

It is widely believed that there are self-evident truths in logic. For example, the proposition that everything is identical with itself is about as self-evident as you can get. But are there any self-evident truths in morality? It seems so. Consider the statement: Equals should be treated equally. This statement does not say that equals are treated equally, nor does it say that everyone is equal. It says that whenever equals are not treated equally, a wrong has been committed. To anyone who understands what equality and morality are, this statement should be self-evident.

If you do not believe that this statement is true, the burden of proof is on you to provide a counterexample. If you are unable to do so—if you cannot cite a situation in which equals should not be treated equally—then your claim that the statement is not true is irrational. You have no reason to make the claim.

Equals should be treated equally is not the only self-evident moral truth. Another is: Unnecessary suffering is wrong. This is not to say that all suffering is wrong. Some suffering, like studying for an exam, is necessary to bring about a greater good. But unnecessary suffering, like the torture of an innocent child, is wrong.

These two principles—that equals should be treated equally and that unnecessary suffering is wrong—are the great **principles of justice** and **mercy.** They do not constitute a theory of morality because they do not tell us what makes an action right. But they do serve as boundary conditions that any theory of morality must meet. If a moral theory violates one or more of these principles, it's unacceptable.

> *Among all the attributes of God, although they are all equal, mercy shines with even more brilliancy than justice.*
>
> —MIGUEL DE CERVANTES SAAVEDRA

Thought Probe

Moral Knowledge

Renford Bambrough offers the following proof that we have moral knowledge.

> My proof that we have moral knowledge consists essentially in saying, "We know that this child, who is about to undergo what would otherwise be painful surgery, should be given an anaesthetic before the operation. Therefore we know at least one moral proposition to be true." I argue that no proposition that could plausibly be alleged as a reason in favour of doubting the truth of the proposition that the child should be given an anaesthetic can possibly be more certainly true than that proposition itself. If a philosopher produces an argument against my claim to know that the child should be given an anaesthetic, I can therefore be sure in advance that *either* at least one of the premises of his argument is false, or there is a mistake in the reasoning by which he purports to derive from his premises the conclusion that I do not know that the child should be given an anaesthetic.[19]

Is this a convincing proof for the existence of moral knowledge? Why or why not? Is it also a convincing proof for the existence of universal moral principles? Why or why not? What moral principle underlies the judgment made in this case?

principle of justice The doctrine that equals should be treated equally (and unequals in proportion to their relevant differences).

principle of mercy The doctrine that unnecessary suffering is wrong.

Summary

Subjective absolutism is the doctrine that what makes an action right is that it is approved by someone. If approving an action made it right, and if disapproving it made it wrong, then one and the same action could be both right and wrong. But that's impossible. So subjective absolutism cannot be correct.

Subjective relativism is the doctrine that what makes an action right for someone is that it is approved by that person. In this view, right or wrong are not properties like round or square but relations like small or large. This view is not self-contradictory in the way that subjective absolutism is. Nevertheless, it has some bizarre consequences. For one thing, it implies that every individual is morally infallible. For another, it implies that all moral disagreement is about whether individuals know their own minds. Because neither of these implications is plausible, neither is subjective relativism.

Emotivism is the doctrine that moral utterances are expressions of emotion. When people use moral terms like right and wrong, they are not saying anything that is true or false. If this were the case, however, moral disagreement would be impossible. Nothing, even excruciating pain, would be right or wrong in and of itself. This doesn't fit with our experience of the moral life.

Cultural relativism is the view that what makes an action right for someone is that it is approved by that person's culture. This view implies that cultures are morally infallible and thus that it is impossible to disagree with one's culture and be in the right. But cultures are not morally infallible; they have approved all sorts of immoral practices. So cultural relativism cannot be correct.

The divine command theory is the doctrine that what makes an action right is that it is commanded by God. Because God is free to command whatever he wants, he could have commanded us to kill, rape, torture, and steal. But his commanding these actions would not have made them right. To suppose it would have would be to take away whatever reason we might have for worshipping God. What's more, if goodness is a defining attribute of God, God can't be used to define goodness; the definition would be circular. Thus morality cannot depend on God.

Certain moral principles appear to be universal because they are self-evident. These include the principle of justice—equals should be treated equally—and the principle of mercy—unnecessary suffering is wrong. Any adequate ethical theory should be consistent with these principles.

Study Questions

1. What is subjective absolutism?
2. What if subjective absolutism were true? What are the consequences of accepting subjective absolutism?
3. What is subjective relativism?
4. What if subjective relativism were true? What are the consequences of accepting subjective relativism?
5. What is emotivism?
6. What if emotivism were true? What are the consequences of accepting emotivism?
7. What is cultural relativism?
8. What if cultural relativism were true? What are the consequences of accepting cultural relativism?

9. What is the anthropological argument for cultural relativism?
10. What is the logical structure of a moral judgment?
11. What is the divine command theory?
12. What if the divine command theory were true? What are the consequences of accepting the divine command theory?

Discussion Questions

1. Some cultures, most notably Tibetan, practice polyandry, where a woman can have more than one husband. Is polyandry immoral? Why or why not?

2. Many cultures practice polygamy. Muslims may have four wives under Koranic law; the king of Ashanti in West Africa is strictly limited by law to 3,333 wives. Polygamy is not adultery. Neither of these cultures sanctions extramarital sex. Is polygamy immoral? Why or why not?

3. Suppose that we spend the afterlife in the condition in which we die. Would the current medical practice of keeping severely incapacitated people alive be morally justified? Why or why not?

4. Suppose that we believed that the only way to prevent the spirits of our enemies from doing harm to our friends and family was to eat our enemies' bodies. (Some cannibals apparently believe this.) Would this justify cannibalism? Why or why not?

5. Is there a reliable test for determining whether any purported work of sacred scripture is truly the word of God? What is it? Does any work of sacred scripture pass that test? Would members of other religions agree?

6. Should we tolerate the intolerant? What does your answer imply about the nature of morality?

Internet Inquiries

1. How consistent are your ethical views? Find out by playing the Morality Game at *The Philosophers' Magazine* Web site: **http://www.philosophyexperiments.com/**

2. Explore the conflict between human rights and cultural relativism by entering those terms into an Internet search engine. Is a belief in universal human rights consistent with cultural relativism?

3. Many people claim to be commanded by God to do things. To find some examples, enter "God made me do it" into an Internet search engine. Are any of these cases actual commands from God? How could we tell? What implications does that have for the divine command theory?

Section 5.2

The End Justifies the Means
Good Makes Right

> *Happiness is the supreme object of existence.*
> —J. GILCHRIST LAWSON

Consider again the case of George Zygmanik. Those who think it was right for Lester to kill his suffering, quadriplegic brother argue that it was an act of mercy because it put George out of his misery. Those who think it was wrong for Lester to kill his brother argue that it was an act of murder because it was the intentional killing of an innocent person. These two attitudes represent the two major types of ethical theory: consequentialist and formalist. **Consequentialist** (also known as **teleological**) **ethical theories** claim that the rightness of an action is determined by its consequences. ("Teleology" comes from the Greek *telos,* meaning "end" or "purpose.") **Formalist** (also known as **deontological**) **ethical theories** claim that the rightness of an action is determined by its form—that is, by the kind of action it is. ("Deontology" comes from the Greek *deon,* meaning "duty" or "requirement.") Those who argue that Lester Zygmanik's action was right because it put an end to his brother's suffering are consequentialists. Those who argue that it was wrong because it involved killing an innocent person are formalists.

When we judge a person, a person's character, or a person's motives to be good, we are making a moral judgment. When we judge a physical object (like a car) or an experience (like happiness) to be good, we are not making a moral judgment. So goodness comes in two varieties: moral and nonmoral. Consequentialist ethical theories usually define the right in terms of the good. They maintain that right actions are those that produce the most nonmoral good.

Some things, like money, are good because of what you can do with them. Other things, like happiness, are good regardless of what you can do with them. If someone asked, "What is happiness good for?" we wouldn't know what to say. The value of happiness is not derived from its usefulness; it's just good to be happy. Things, like happiness, that are good for their own sake are **intrinsically valuable.** Things that are good for the sake of something else are **extrinsically** or **instrumentally valuable**.

consequentialist (teleological) ethical theory An ethical theory that judges the rightness or wrongness of an action in terms of its consequences.

formalist (deontological) ethical theory An ethical theory that judges the rightness or wrongness of an action in terms of its form.

intrinsic value Value for its own sake.

instrumental (extrinsic) value Value for the sake of something else.

> ### Is Life Intrinsically Valuable?
>
> Those who object to euthanasia often do so on the grounds that life is intrinsically valuable. In their view, it's always better to be alive than dead, no matter what kind of life one is leading. It is a mistake to associate this view with the Judeo-Christian tradition, although some do so. According to theologian Richard McCormick, the Judeo-Christian tradition takes life to be instrumentally—not intrinsically—valuable. He writes,
>
>> In the past, the Judeo-Christian tradition has attempted to walk a balanced middle path between medical vitalism (that preserves life at any cost) and medical pessimism (that kills when life seems frustrating, burdensome, and useless).... The middle course that has structured Judeo-Christian attitudes is that life is indeed a basic and precious good, but a good to be preserved precisely as the condition of other values....[20]
>
> What are these other values? McCormick explains by quoting the Gospel of John:
>
>> "If any man says 'I love God' and hates his brother he is a liar. For he who loves not his brother whom he sees, how can he love God whom he does not see?" (I John 4:20–21). This means that our love of neighbor is in some real sense our love of God.... If this is true, it means that, in the Judeo-Christian perspective, the meaning, substance, and consummation of life is found in human relationships, and the qualities of justice, respect, concern, compassion, and support that surround them.... Since these other values cluster around and are rooted in human relationships, it seems to follow that life is a value to be preserved only insofar as it contains some potentiality for human relationships. When in human judgment, this potentiality is absent or would be, because of the condition of the individual, totally subordinated to the mere effort for survival, that life can be said to have achieved its potential.[21]
>
> ### Thought Probe
>
> Moral Justification
>
> According to the Judeo-Christian tradition as explained by Father McCormick, was Lester Zygmanik morally justified in killing his brother? Why or why not?

Consequentialist ethical theories seek to maximize intrinsic value. Any consequentialist ethical theory, then, must answer two questions: (1) What is intrinsically valuable? and (2) Who is supposed to receive this value? The two most famous consequentialist ethical theories are ethical egoism and utilitarianism.

Ethical Egoism

Ethical egoism claims that our only duty is to do what's good for ourselves. As long as we've done what's in our own best interest, we've done the right thing, even if we've made a lot of other people miserable in the process. **Ethical egoism,** then, says that what makes an action right is that it promotes one's own best interest.

Different egoists have different ideas about what's in their best interest. Many are *hedonists* who believe that the more pleasure they get, the better off they are. ("Hedonism" comes from the Greek *hedone,* meaning "pleasure.")

> **ethical egoism** The doctrine that what makes an action right is that it promotes one's own best interest.

Others measure the quality of their lives in terms of the knowledge, power, or self-realization they attain. Egoists of every stripe, however, agree that their only duty is to look out for number one.

Ethical egoism does not require you to do only what you want to do—because what you want to do may not be in your best interest. For example, you may want to sleep late, get high, and listen to music all day, but that may not be in your best interest, especially if you want to stay healthy, get a job, and raise a family. Nor does ethical egoism require that you perform only selfish acts—acts that benefit you at the expense of others. If you are continually making other people miserable, you may not get the kind of cooperation you need to accomplish your goals. So acting selfishly may not be in an egoist's best interest. Clever egoists act generously in the short term in hopes of promoting their best interests in the long term.

Even though the behavior of an ethical egoist may not differ all that much from that of a nonegoist, few people consider ethical egoism to be a plausible theory of morality, for it condones the most heinously evil actions imaginable. Suppose you are walking through the woods one day and come upon your rival, who has just been attacked by a wild animal. If it is in your best interest to eliminate your rival, and if you can do so without getting caught, then ethical egoism says that you are morally obligated to finish him off. Any ethical theory that mandates such acts, however, is, to say the least, questionable.

Those who adopt the hedonistic version of ethical egoism (termed "ethical hedonism") claim that it is the only ethical theory that is consistent with what we know about human motivation. They maintain that the only thing that moves us to action is the desire to increase our own happiness. In other words, everything we do, we do because we think it will make us happy. This psychological theory of human motivation is known as **psychological hedonism.**

If psychological hedonism were true—if we could do only what we thought would make us happy—then ethical egoism would be unavoidable, for "ought" implies "can." We can legitimately claim that someone ought to do something only if he can do it. For example, if you were running late for a meeting, it would be ludicrous for someone to assert that you ought to grow wings and fly to it because that's impossible. Similarly, say the ethical hedonists, it would be ludicrous for someone to assert that you ought to desire something besides your own happiness because that, too, is impossible.

Some believe that the scientific theory of psychological hedonism can be used to prove the philosophical theory of ethical egoism. The argument from psychological hedonism for ethical egoism goes like this:

1. We are morally obligated to perform an action only if we are able to perform it.
2. We are able to perform an action only if we believe that it will maximize our happiness.
3. Therefore, we are morally obligated to perform an action only if we believe that it will maximize our happiness.

The conclusion of this argument doesn't establish ethical hedonism, however, for it only provides a necessary condition for right action, whereas ethical hedonism

> The world is governed only by self-interest.
> —JOHANN SCHILLER

> He who lives only to benefit himself confers on the world a benefit when he dies.
> —TERTULLIAN

psychological hedonism The doctrine that the only thing individuals can desire is their own happiness.

> ## Ayn Rand on the Virtue of Selfishness
>
> In a series of novels and essays including *The Fountainhead* and *Atlas Shrugged,* Ayn Rand has argued for a version of ethical egoism called *objectivism*. She writes,
>
>> The basic social principle of the Objectivist ethics is that just as life is an end in itself, so every living human being is an end in himself, not the means to the ends or the welfare of others—and, therefore, that man must live for his own sake, neither sacrificing himself to others nor sacrificing others to himself. To live for his own sake means that *the achievement of his own happiness is man's highest moral purpose.*[22]
>
> To achieve happiness, however, individuals must do more than try to satisfy their desires, because desires can conflict. Rather, they should try to satisfy their *rational* desires, for "the rational interests of men do not clash—that there is no conflict of interests among men who do not desire the unearned, who do not make sacrifices nor accept them, who deal with one another as traders, giving value for value."[23] Thus Rand's objectivism is not a true egoism, for built into it is a principle of justice and fair play. We can't fulfill just any desire but only our rational desires, she argues. And our rational desires are directed only on what we've earned. So Ayn Rand's egoism is more properly viewed as a form of *libertarianism,* which holds that individuals should be free to do whatever they want as long as it doesn't interfere with the rights of others.

gives us both a necessary and a sufficient condition. The argument from psychological hedonism says that we ought to perform an action *only if* it maximizes our happiness, whereas ethical hedonism also says that we ought to perform an action *if* it maximizes our happiness. If the argument from psychological hedonism is sound, however, it does show that any ethical theory that requires us to do something other than maximize our own happiness is mistaken.

The claim that we can do only those things that we believe will make us happy is an empirical one. It is not true by definition and thus can be established only by scientific investigation. From a scientific point of view, however, the claim seems to be false, for we do not always do what we believe will maximize our happiness. Consider the passerby who jumps into a raging river to save a drowning child or the patriotic soldier who throws himself on a hand grenade to save his buddies. Neither of these actions seems designed to maximize the actor's happiness.

The psychological hedonist might respond to these counterexamples by saying that although these actions seem to be motivated by something other than one's own happiness, they are not. The person who jumps into a river to save a child, for example, may do so because she thinks the action will make her famous, and being famous would make her happy. Or the soldier who jumps on a hand grenade may do so because it makes him happy to think that he is saving his buddies. These attempts to save the theory, however, turn psychological hedonism into an untestable—and hence unscientific—hypothesis. If no evidence can count against it, the theory doesn't tell us anything about the world.

Consider the statement: Either it's raining or it isn't. There is no evidence that could possibly refute this statement. Because it's consistent with all possible states of affairs, it's uninformative. We don't learn anything about the weather by being told that either it's raining or it isn't. Similarly,

Selfishness is the root and source of all natural and moral evils.

—NATHANIEL EMMONS

if psychological hedonism is consistent with all possible behavior, it tells us nothing about human motivation. In that case, it can't support ethical egoism.

Suppose that someone were to claim that our only motivation for doing anything is to become tired so that we will go to sleep. This hypothesis would account for everything that we do because sleep eventually follows every action we perform. Yet no one has seriously proposed this as a theory of human motivation because there is no way to test it. Nothing could possibly count against it. Every possible action can be interpreted to fit it. Consequently, it's uninformative. The same goes for psychological hedonism.

Not only is there reason to believe that psychological hedonism is uninformative, there's also reason to believe that it's false. For anyone who was concerned solely with his own happiness would be miserable. Joel Feinberg brings this out in the following thought experiment.

> *Seek happiness for its own sake, and you will not find it; seek for duty, and happiness will follow as the shadow comes with the sunshine.*
>
> —Tryon Edwards

Thought Experiment

Feinberg's Single-Minded Hedonist

To feel the full force of the paradox of hedonism the reader should conduct an experiment in his imagination. Imagine a person (let's call him "Jones") who is, first of all, devoid of intellectual curiosity. He has no desire to acquire any kind of knowledge for its own sake, and thus is utterly indifferent to questions of science, mathematics, and philosophy. Imagine further that the beauties of nature leave Jones cold: he is unimpressed by the autumn foliage, the snow-capped mountains, and the rolling oceans. Long walks in the country on spring mornings and skiing forays in the winter are to him equally a bore. Moreover, let us suppose that Jones can find no appeal in art. Novels are dull, poetry a pain, painting nonsense and music just noise. Suppose further that Jones has neither the participant's nor the spectator's passion for baseball, football, tennis, or any other sport. Swimming to him is a cruel aquatic form of calisthenics, the sun only a cause of sunburn. Dancing is coeducational idiocy, conversation a waste of time, the other sex an unappealing mystery. Politics is a fraud, religion mere superstition; and the misery of millions of underprivileged human beings is nothing to be concerned with or excited about. Suppose finally that Jones has no talent for any kind of handicraft, industry, or commerce, and that he does not regret that fact.

What then is Jones interested in? He must desire something. To be sure, he does. Jones has an overwhelming passion for, a complete preoccupation with, his own happiness. The one exclusive desire of his life is to be happy. It takes little imagination at this point to see that Jones's one desire is bound to be frustrated.[24]

Feinberg's single-minded hedonist shows that we can be happy only if we desire something other than our own happiness. But if we desire something other than our own happiness, psychological hedonism is false.

Psychological hedonism fails as a theory of human motivation because it confuses the object of our desires with the result of satisfying them. We may well feel happy when we satisfy our desires, but that doesn't mean that happiness is what we desire. As Anglican priest Joseph Butler noted, "It is not because we love ourselves that we find delight in such and such objects, but because we have particular affections towards them."[25] In other words, we don't desire things because they make us happy; they make us happy because we desire them. Happiness is not the cause of our desires but the effect of satisfying them. Because psychological hedonism mistakes an effect for a cause—because it puts the cart before the horse, so to speak—it fails as a theory of human motivation.

Even if ethical egoism did provide necessary and sufficient conditions for an action being right, it would be a peculiar sort of ethical theory, for its adherents couldn't consistently advocate it. Suppose that someone came to an ethical egoist for moral advice. If the ethical egoist wanted to do what was in his best interest, he would not tell his client to do what was in her best interest because her interests might conflict with his. Rather, he would tell her to do what was in his best interest.

Such advice has been satirized on national TV. Former senator Al Franken proclaimed on a number of *Saturday Night Live* shows in the early 1980s that, whereas the 1970s were known as the "me" decade, the 1980s were going to be known as the "Al Franken" decade. So whenever anyone was faced with a difficult decision, the individual should ask, "How can I most benefit Al Franken?"

There is something odd about an ethical theory that can't be advocated by its adherents. In fact, it points to what may be ethical egoism's biggest flaw: It doesn't treat equals equally. If there is no morally relevant difference between people, there is no reason not to treat them the same. Anyone who treats them differently is guilty of unfair discrimination. The fact that others are members of a particular race or sex is irrelevant from a moral point of view. Thus anyone who discriminates against others simply because they belong to a different race or sex is guilty of racism or sexism, respectively. Similarly, the fact that others are not identical to you is irrelevant from a moral point of view. Thus if you discriminate against others simply because they are not you—if you don't treat them with the same respect that you accord yourself—you violate the Golden Rule, which says: Do unto others as you would have them do unto you. Justice requires treating equals equally. Insofar as egoism violates that principle, it is not an adequate moral theory.

Act-Utilitarianism

The most plausible and widely discussed consequentialist ethical theory is utilitarianism. Traditional utilitarianism takes happiness to be the only thing that's intrinsically valuable—valuable for its own sake. Unlike ethical hedonism, however, it doesn't maintain that we should seek only to maximize our own happiness. Instead, it maintains that we should seek to maximize the total amount of happiness in the world. Consequently, it avoids many of the problems facing ethical egoism. Specifically, traditional utilitarianism (also called "act-utilitarianism") does not allow people to do something simply

> Men can only be happy when they do not assume that the object of life is happiness.
> —GEORGE ORWELL

> The most delicate, the most sensible of all pleasures, consists in promoting the pleasure of others.
> —JEAN DE LA BRUYÈRE

because it makes them happy. The happiness of the other people involved must also be taken into account.

Utilitarianism is the brainchild of Jeremy Bentham (1748–1832). He was led to this conception of morality by a consideration of the sources of human action. He writes:

> Nature has placed mankind under the governance of two sovereign masters, pain and pleasure. It is for them alone to point out what we ought to do, as well as to determine what we shall do. On the one hand the standard of right and wrong, on the other the chain of causes and effects, are fastened to their throne.[26]

According to Bentham, the ultimate reason for doing anything is to acquire pleasure or avoid pain. Consequently, the right action in any situation is the one that produces the greatest balance of pleasure over pain.

Because utilitarianism considers happiness to be good in and of itself, no one's happiness is more valuable than anyone else's. Thus, in determining which action will produce happiness, everyone's happiness must be counted equally. **Act-utilitarianism,** then, says that what makes an action right is that it maximizes happiness, everyone considered.

Act-utilitarianism suggests a straightforward procedure for determining what we should do in any given situation:

1. Identify the different actions that can be performed in the situation.
2. Identify the individuals who will be affected by those actions.
3. Calculate the amount of happiness each individual will receive from those actions.
4. Sum the individual amounts of happiness to determine which action will produce the most happiness.

Suppose we had a situation in which there were three possible courses of action and three people involved. Then we could put the results of the utilitarian calculation in the form of a table (a "util" is a unit of happiness):

	Action 1	Action 2	Action 3
John	3 utils	4 utils	4 utils
Sue	3 utils	2 utils	5 utils
Mary	3 utils	2 utils	5 utils
	9 utils	8 utils	14 utils

In this situation, action 3 is the right action to perform because it produces the most happiness, everyone considered.

Bentham assumes that the happiness produced by various actions differs only in degree and thus can be measured on a single scale. He claims that by using his "hedonic calculus," we can quantify the amount of happiness produced by an action. His calculus takes into account such factors as the *intensity* of the happiness, the *duration* of the happiness, the *probability* that the happiness will occur, the *propinquity* (nearness in time) of the happiness to the action, the *fecundity* of the action (the probability that it will produce more happiness in the future), and the *impurity* of the action (the probability that it will produce less happiness in the future).

act-utilitarianism The doctrine that what makes an action right is that it maximizes happiness, everyone considered. Also termed "traditional utilitarianism."

> ### *Jeremy Bentham: Making Philosophy Do Work*
>
> Besides John Locke, probably no philosopher in the English-speaking world has had a more powerful influence on social policy than Jeremy Bentham (1748–1832). Bentham was an Oxford-educated philosopher who studied law and focused his intellectual energy on ethics and political-legal theory. Very early in his career he was deeply affected by the injustice that he saw in British law and morals. In response, he not only developed his ethical theory of utilitarianism but spent much of his life trying to put his ideas into action.
>
> Bentham's utilitarianism was in direct conflict with conventional thinking on public policy and morals. His ethical theory—or certain aspects of it—is now taken for granted in many quarters but was considered radical when he proposed it. By utilitarian lights, much of traditional morality is twisted: it condemns actions that do no harm and encourages actions that do great harm. It might, for example, ban certain sexual practices even though they hurt no one, and promote various restraints on sexual activity that can cause psychological or social harm.
>
> Bentham thought that the world would be a much better place if people judged actions and policies not by convention but by their power to maximize happiness and minimize pain.
>
> Bentham and his followers advocated the abolition of imprisonment for indebtedness; equal rights for women; the use of civil service examinations for government employees; the liberalization of laws concerning sexual activity; and the reform of prisons. Bentham himself proposed a model prison designed according to utilitarian principles. He thought that the purpose of imprisonment should be to deter crime, not to punish criminals.
>
> One of the many legacies of Bentham and his followers is University College in London. They founded the university in 1826, England's first one since the medieval period. Believe it or not, Jeremy Bentham is still there to this day. That is, his embalmed body, topped by a wax model of his head, is on display. Not too long ago Bentham was a regular attendee at board meetings, though he is said to have been a nonvoting member.

John Stuart Mill (1806–1873), a follower of Bentham and one of the most influential philosophers of the nineteenth century, argues that the happiness produced by various actions differs not only in degree but also in kind—and thus cannot be measured on a single scale. He writes,

> It is quite compatible with the principle of utility to recognize the fact that some *kinds* of pleasure are more desirable and more valuable than others. It would be absurd that, while in estimating all other things, quality is considered as well as quantity, the estimation of pleasures should be supposed to depend on quantity alone.[27]

JEREMY BENTHAM
1748–1832

Mill believes that happiness differs in quality as well as quantity. Thus in determining what action to perform, we have to consider the kind of happiness produced as well as the amount.

To see what Mill is getting at, compare the happiness derived from playing chess with that of getting drunk. Although playing chess may not produce as much happiness as getting drunk, it could be argued that it produces a better kind of happiness. If so, playing chess is a more worthwhile activity than getting drunk. This is the basis of Mill's famous dictum "It is better to be a human being dissatisfied than a pig satisfied; better to be Socrates dissatisfied than a fool satisfied."

Having to rank the various forms of happiness in terms of their quality, however, makes the utilitarian calculation much more difficult. For there seems to be no objective way to do it. Mill suggests that we poll those who have experienced the different types of happiness and go with the majority. He says, "Of

> *That all who are happy are equally happy is not true. A peasant and a philosopher may be equally satisfied, but not equally happy.*
>
> —SAMUEL JOHNSON

two pleasures, if there be one to which all or almost all who have experience of both give a decided preference, irrespective of a feeling of moral obligation to prefer it, that is the more desirable pleasure."[28] Although this may seem an eminently democratic procedure, there is no guarantee it will produce the results Mill wants. For the masses may well prefer the lower pleasures to the higher. Even highly educated people may do so. To maintain the distinction between higher and lower pleasures, then, it looks as if Mill must appeal to another standard of value besides utility. But if he does, his theory is no longer utilitarianism.

Even if it were easy to calculate how much happiness an action would produce, utilitarianism faces another problem: when to perform the calculation. Every action we undertake has consequences indefinitely into the future. At what point should we measure the happiness produced? The answer we give to this question will have a profound effect on what actions we consider to be permissible. An action that produces little happiness in the short term may produce a great deal of happiness in the long term. Consider the graph on page 365. It represents the amount of happiness produced by two different actions (A and B) over time. In the short term, A produces much more happiness than B. In the long term, however, B produces much more happiness than A. The graph could represent the choice between building nuclear power plants and investing in alternative renewable sources of energy, such as solar power and wind power. The advantage of building nuclear power plants is a quick return on our investment. The disadvantage is that they create radioactive wastes that must be disposed of, and the plants themselves must eventually be sealed up and kept off-limits for more than ten thousand years. An investment in alternative renewable sources of energy will not have as quick a return, but it could produce more happiness in the long term because these sources of energy don't pollute and they don't run out. Should we take future generations into account when performing the utilitarian calculation? Act-utilitarianism is silent on this point.

Thought Probe

Our Obligations to Future Generations

Do we have any obligations to future generations? If so, what are they? Some say that future generations have a right to a clean environment, at least to an environment that is not detrimental to human flourishing. Others say that future generations have no rights because they don't exist. You cannot have an obligation to a nonexistent person any more than you can kick a nonexistent stone. What do you think? Consider Galen Pletcher's "paradigm of the campsite:"

> If I have been camping at a site for several days, it is common to say that I have an obligation to clean up the site—to leave it at least as clean as I found it—for the next person who camps there. . . . If, happily, I have discovered a campsite so removed from the beaten track that the next person to discover it is someone who wasn't even alive when I last camped there, it still is true of that lucky person that he has a right to a clean campsite, and I had an obligation to secure to him that state of affairs.[29]

Does this show future generations have rights? Why or why not?

HAPPINESS PRODUCED BY TWO ACTIONS OVER TIME.
In the time span depicted, the happiness produced by A is greater in the short term than that produced by B. Does that mean that A is the better action?

Problems with Rights

According to utilitarianism, the end justifies the means. As long as an action achieves the goal of maximizing happiness, it's morally correct, no matter how it was accomplished. This is not consistent with our notion of rights, however. We believe that certain things shouldn't be done to people, even if doing them would have good consequences. H. J. McCloskey illustrates this in the following thought experiment.

Thought Experiment

McCloskey's Utilitarian Informant

Suppose a utilitarian were visiting an area in which there was racial strife, and that, during his visit, a Negro rapes a white woman, and that race riots occur as a result of the crime, white mobs, with the connivance of the police, bashing and killing Negroes, etc. Suppose too that our utilitarian is in the area of the crime when it is committed such that his testimony would bring about the conviction of a particular Negro. If he knows that a quick arrest will stop the riots and lynchings, surely, as a utilitarian, he must conclude that he has a duty to bear false witness in order to bring about the punishment of an innocent person.[30]

According to utilitarianism, if falsely accusing and convicting an innocent person would maximize happiness, then we are morally obligated to do so. But this does not accord with our experience of the moral life. It's wrong to bear false witness even if doing so will produce more happiness than not.

Not only could act-utilitarianism mandate lying, it could mandate killing, as Richard Brandt demonstrates.

The rights of one are as sacred as the rights of a million.

—EUGENE V. DEBBS

Thought Experiment

Brandt's Utilitarian Heir

Let us suppose that Mr. X is considering whether it is his duty to hasten his father's death. Let us suppose further that Mr. X's father is well-to-do, whereas the son is poor. The father gives the son no money, and the son and his family are continually missing the joys of life because they do not have the means to pay for them. Furthermore, the father is ill and requires nursing care. The cost of nursing care is rapidly eating into the father's capital. Moreover, the father himself gets no joy from life. He must take drugs to make life tolerable, and his physician says that his condition will gradually become worse, although death is still several years away.

On the utilitarian theory, it can well be (and on the hedonistic form, certainly will be) the son's duty to bring about the demise of his father, provided he can do this so that his deed will be undetected (thereby avoiding legal calamities for himself and his family, and not weakening the general confidence of fathers in their sons). But would this in fact be his duty? It does not seem so.[31]

> *Happiness is a pig's philosophy.*
> —Friedrich Nietzsche

If killing someone—even your father—would produce more happiness than keeping him alive, act-utilitarianism would have us believe that he should be killed. But that is inconsistent with our notion of rights. You are not morally obligated to kill someone to make people happy.

Problems with Duties

> *Duty has nothing to do with what somebody else conceives to be for the common good.*
> —Robert Millikan

Not only is utilitarianism inconsistent with our notion of rights, it is also inconsistent with our notion of duties. We have a number of duties to others, including a duty not to break our promises. Act-utilitarianism maintains, on the contrary, that our only duty is to maximize happiness. If performing that duty requires breaking our promises, then so be it. British philosopher W. D. Ross illustrates.

Thought Experiment

Ross's Unhappy Promise

Suppose, to simplify the case by abstraction, that the fulfillment of a promise to A would produce 1,000 units of good for him, but that by doing some other act I could produce 1,001 units of good for B, to whom I have made no promise, the other consequences of the two acts being of equal value; should we really think it self-evident that it was our duty to do the second act and not the first? I think not. We should, I fancy, hold that only a much greater disparity of value between the total consequences would justify us in failing to discharge our *prima facie* duty to A. After all, a promise is a promise, and is not to be treated so lightly as the theory we are examining would imply.[32]

Act-utilitarianism holds that we should break a promise whenever doing so will produce more happiness than keeping the promise will. But promises are more important than that. Our obligation to keep our promises is no less binding than our obligation to maximize happiness.

Some duties derive from our membership in a community, whereas others derive from the special roles we play in that community. Parents have special duties to their children, doctors have special duties to their patients, lawyers have special duties to their clients, and so on. But just as act-utilitarianism doesn't provide an adequate account of our ordinary duties, it doesn't provide an adequate account of our special duties either. British political theorist William Godwin, an early defender of utilitarianism, highlights this aspect of utilitarianism in the following thought experiment.

Thought Experiment

Godwin's Fire Rescue

A man is of more worth than a beast; because, being possessed of higher faculties, he is capable of a more refined and genuine happiness. In the same manner the illustrious archbishop of Cambray was of more worth than his valet, and there are few of us that would hesitate to pronounce, if his palace were in flames, and the life of only one of them could be preserved, which of the two ought to be preferred. . . .

Suppose I had been myself the valet; I ought to have chosen to die, rather than Fenelon should have died. The life of Fenelon was really preferable to that of the valet. . . .

Suppose the valet had been my brother, my father or my benefactor. This would not alter the truth of the proposition. The life of Fenelon would still be more valuable than that of the valet; and justice, pure, unadulterated justice, would still have preferred that which was most valuable.[33]

Godwin claims that if his brother, his father, or his benefactor were trapped in a building with the archbishop and he could save only one of them, he should save the archbishop because that would produce the most happiness. In the first edition of his book, Godwin claimed that he should save the archbishop even if the other person was his mother. This created such an outcry that he had to change the example. But even the new situation is a counterexample to act-utilitarianism. Our duties to our family and friends often outweigh our duty to produce happiness.

Problems with Justice

Although act-utilitarianism requires that everybody's happiness be counted equally, it doesn't require that the happiness produced by an action be distributed equally. All that matters from a utilitarian point of view is that the amount of happiness produced be the greatest possible. If we can produce

Justice is to give every man his due.

—ARISTOTLE

more happiness by distributing it unequally, that is what we should do. British philosopher A. C. Ewing provides this example:

Thought Experiment

Ewing's Utilitarian Torture

Suppose we could slightly increase the collective happiness of ten men by taking away all happiness from one of them, would it be right to do so? It is perhaps arguable that it would be if the difference in happiness of the nine was very large, but not if it was very slight. And if the happiness of the nine were purchased by the actual torture of the one, the injustice of it would seem to poison the happiness and render it worse than valueless even if they were callous enough to enjoy it. Yet on the utilitarian view any distribution of good, however unfair, ought to be preferred to any other, however just, if it would yield the slightest additional happiness.[34]

LADY JUSTICE.
Is utilitarian justice consistent with that represented by Lady Justice?

Act-utilitarianism would have us believe that justice is served by maximizing happiness. So, by that argument, if the amount of happiness that the Marquis de Sade experienced by torturing innocent young girls exceeded the amount of unhappiness the girls felt by being tortured, he was morally justified in torturing them.

Questions of justice arise not only with regard to the distribution of goods but also with regard to the retribution for crimes. The basic principle of retributive justice is captured in the phrase "an eye for an eye, a tooth for a tooth, a life for a life." This conception of justice requires giving everyone his or her due. It is represented by the figure of Lady Justice who, blindfolded, carries a balance, symbolically ensuring that no one gets more—or less—than what's coming to each. Act-utilitarianism has no place for such a principle. According to utilitarianism, punishment is justified only if it maximizes happiness.

It has traditionally been thought that punishment can maximize happiness in two ways: by making the criminal a better person or by lowering the overall crime rate. But to accomplish these goals, it is not necessary that the punishment fit the crime. It is not even necessary that we punish only criminals. Ewing considers these consequences in the following thought experiment.

Justice, when equal scales she holds, is blind; nor cruelty, nor mercy change her mind.

—SIR JOHN DENHAM

Thought Experiment

Ewing's Innocent Criminal

Suppose that in a particular case it is impossible to find the real criminal, but suppose also that we have got hold of a person generally believed guilty so that the deterrent effects of punishing him would be the same as if he really were

guilty. Suppose, further, that psychological experts could assure us that his character would benefit by a spell of imprisonment. (Even a very good man's character often benefits by suffering: very possibly it is more likely than a bad man's to do so.) That surely would not make the punishment right, yet it ought to on the utilitarian theory.[35]

If punishing an innocent person would maximize happiness, then act-utilitarianism says we should do so, whether the person has it coming or not. But that violates the principle of justice, which says that equals should be treated equally.

Thought Probe

The Utility Machine

Suppose that an inventor approaches the president of the United States with a device that will increase the happiness of those who use it by 1,000 percent. The inventor wants to put the device into production but only if the president agrees to his terms. The president, of course, is interested in providing for the common good and promoting the general welfare, so he asks the inventor what he has in mind. The inventor tells him that he wants to be able to kill at random 50,000 users of the device every year. (Warning labels on the device would alert users to this potential hazard.) The president is concerned about all the pain and suffering the deaths of these 50,000 people would cause. The inventor assures him that even taking into account the suffering caused by their deaths, the people of the United States will still be 1,000 percent happier with the device than without it. Should the president allow the device to go into production? Why or why not? (Such a device is already on the market. Can you guess what it is?)[36]

Rule-Utilitarianism

Act-utilitarianism is inconsistent with our experience of the moral life because it does not fit with our notions of rights, duties, and justice. To try to salvage act-utilitarianism's basic insight—that we should be concerned with promoting the common good—some have proposed what is known as rule-utilitarianism. Rule-utilitarianism maintains that the rightness of an action is determined not by its consequences but by the consequences of the rule it falls under. If an action is in accord with a rule that would maximize happiness if it were obeyed, then the action is right. **Rule-utilitarianism,** then, is the doctrine that what makes an action right is that it falls under a rule that, if generally followed, would maximize happiness, everyone considered.

According to act-utilitarianism, the procedure for deciding whether an action is right involves identifying the alternative courses of action available and determining which of those actions would produce the most happiness.

rule-utilitarianism The doctrine that what makes an action right is that it falls under a rule that, if generally followed, would maximize happiness, everyone considered.

> *The consideration that human happiness and moral duty are inseparably connected, will always continue to prompt me to promote the former by inculcating the practice of the latter.*
>
> —GEORGE WASHINGTON

According to rule-utilitarianism, the procedure is somewhat different. It involves identifying the rule that each of the alternative actions falls under and determining whether that rule, if generally followed, would maximize happiness. If it would, then the action is morally permissible. The advantage of rule-utilitarianism over act-utilitarianism is that it fits better with our notions of rights, duties, and justice.

If more happiness would be produced by having people follow rules like "Never lie," "Never cheat," and "Never steal" than by having them follow the rule "Perform the action that maximizes happiness," then rule-utilitarianism would be the better theory. But there is reason to believe that following such exceptionless rules would not maximize happiness. Consider the rule "Never lie." Suppose that a crazed person wielding a bloody knife comes to your door and asks you where your neighbor is. In such a situation, telling a lie would seem to be the right thing to do, for it would probably save your neighbor's life and thus produce more happiness than telling the truth. So the rule "Do not lie except to save the lives of innocent people" is a better rule than "Do not lie."

According to rule-utilitarianism, a morally correct action is one that falls under a morally correct rule. And a morally correct rule is one that, if generally followed, would maximize happiness. Because rules with the most exceptions seem to produce the most happiness, they would seem to be the most morally correct.

But once we start allowing rules to have exceptions, it looks as if rule-utilitarianism will end up sanctioning the same actions as act-utilitarianism. Consider the case of Brandt's utilitarian heir. The rule "Never kill innocent people" would not allow the son to kill his father. But the rule "Never kill innocent people unless it maximizes happiness" would allow the killing. Because that rule would produce more happiness if generally followed, it is the morally correct rule to follow. But following it would be no different from following the rule "Perform the action that maximizes happiness." So rule-utilitarianism may have no significant advantage over act-utilitarianism.

You might object that, appearances to the contrary, rules with exceptions would not maximize happiness. For example, it could be argued that a rule like "Never kill innocent people unless it maximizes happiness" would not produce more happiness than a rule like "Never kill innocent people" because the former would create an unacceptably high level of anxiety, distrust, and uncertainty. People would fear for their lives if they knew that they could legitimately be killed whenever their death would produce more happiness than unhappiness.

A rule that allowed you to kill somebody whenever doing so would produce more happiness than unhappiness would probably not be correct on rule-utilitarian grounds. But a rule that allowed you to kill somebody whenever it would produce a *great deal* more happiness than unhappiness probably would be morally correct. A society that followed that rule would be happier than one that didn't. Such a rule would permit the killing of innocent people if it was necessary to produce a great good. Under the right circumstances, it could even sanction genocide. If the world would be much happier if all the members of a certain group were killed, then rule-utilitarianism (as well as act-utilitarianism) would have us believe that we should kill them. But this doesn't seem right. Human life seems more valuable than happiness, even a great deal of it.

The failure of act- and rule-utilitarianism suggests that the utilitarian approach to ethics is mistaken. Common to both of these ethical theories is the assumption that happiness is the only thing that is intrinsically valuable. As John Stuart Mill says,

> According to the Greatest Happiness Principle . . . the ultimate end, with reference to and for the sake of which all other things are desirable (whether we are considering our own good or that of other people), is an existence exempt as far as possible from pain, and as rich as possible in enjoyments.[37]

Although happiness may well be an intrinsic good, many doubt whether it is the only intrinsic good. Robert Nozick puts this assumption to the test in the following thought experiment.

Thought Experiment

Nozick's Experience Machine

Suppose there were an experience machine that would give you any experience you desired. Super-duper neurophysiologists could stimulate your brain so that you would think and feel you were writing a great novel, or making a friend, or reading an interesting book. All the time you would be floating in a tank, with electrodes attached to your brain. Should you plug into this machine for life, pre-programming your life's experiences? If you are worried about missing out on desirable experiences, we can suppose that business enterprises have researched thoroughly the lives of many others. You can pick and choose from their large library or smorgasbord of such experiences, selecting your life's experiences for,

say, the next two years. After two years have passed, you will have ten minutes or ten hours out of the tank, to select the experiences of your next two years. Of course, while in the tank you won't know that you're there; you'll think it's all actually happening. Others can also plug in to have the experiences they want, so there's no need to stay unplugged to serve them. (Ignore problems such as who will service the machines if everyone plugs in.) Would you plug in? What else can matter to us, other than how our lives feel from the inside?[38]

> What if a body might have all the pleasures in the world for asking? Who would so unman himself as, by accepting them, to desert his soul, and become a perpetual slave to his senses?
>
> —Seneca

If utilitarianism were correct, the society envisioned by Nozick—a society where everybody spent most of their time in an experience machine—would be a utopia, for its inhabitants would have the most pleasurable experiences possible. Nevertheless, some consider Nozick's society the ultimate dystopia, for the people in it are not leading valuable lives. What makes life valuable, they claim, is the kind of choices you make, not the kind of experiences you have. But the people in Nozick's society aren't making any real choices at all. They may choose which tape to play, but they do not make any choices that build character or improve the self. As a result, they can't be considered to be good persons. As Nozick puts it:

> Someone floating in a tank is an indeterminate blob. There is no answer to the question of what a person is like who has been in the tank. Is he courageous, kind, intelligent, witty, loving? It's not merely that it's difficult to tell; there's no way he is.[39]

The people in Nozick's society are not admirable or virtuous. In fact, they are little better than drug addicts who artificially stimulate their brains to escape reality. If this is not utopia, if there's more to leading a good life than having good experiences—then, there is reason to believe that utilitarianism is flawed.

Thought Probe

Paradise Engineering and the Abolitionist Project

A utilitarian paradise would be a world filled with a maximum amount of pleasure and a minimum amount of pain. Some futurists believe that a judicious application of technology can eventually make our everyday experiences ecstatically blissful while abolishing all forms of suffering. They write, "Our future modes of well-being can be sublime, cerebral, and empathetic—or take forms hitherto unknown."[40] And we can enjoy these states of consciousness without experiencing any pain.

> If we wish to do so, then genetic engineering and nanotechnology can be used to banish unpleasant modes of consciousness from the living world. In their place gradients of life-long, genetically pre-programmed well-being may animate our descendants instead. Millenia if not centuries hence, the world's last aversive experience may even be a precisely dateable event; perhaps a minor pain in an obscure marine invertebrate.[41]

Would such a world truly be paradise or, like Nozick's experience machine, would the people in it be missing an important ingredient of the good life, like a strong character that can only be developed by overcoming hardship and adversity? What do you think?

Summary

Consequentialist ethical theories claim that the rightness of an action is determined by its consequences. Ethical egoism, the doctrine that what makes an action right is that it promotes one's own best interest, is such a theory. It is not, however, a plausible theory of morality because it condones the most evil actions imaginable. In defense of ethical egoism, some have asserted psychological hedonism, the doctrine that the only thing anyone can desire is his or her own happiness. On the face of it, though, this claim seems false, for we do seem to not always act out of self-interest but, rather, often from genuine altruism. Further, careful consideration reveals a paradox in the doctrine. It is clear that we can be happy only if we desire something other than our own happiness. But if we desire something other than our own happiness, psychological hedonism is false. Ethical egoism also faces the problem that it cannot be consistently advocated by its adherents. This strange difficulty in turn points to an even bigger flaw: by the lights of the theory, one cannot treat equals equally.

A more plausible consequentialist ethical theory is traditional or act-utilitarianism, the doctrine that what makes an action right is that it maximizes happiness, everyone considered. We do the right thing when we produce as much happiness as possible, taking everybody into account. The theory conflicts, however, with our basic intuitions regarding rights, duties, and justice. We believe that people have rights—that certain things shouldn't be done to them even if the actions would have good consequences. We think that we have several duties (like not breaking promises) to others, including special duties to those we have special relationships with. We believe that justice demands that goods and punishments be distributed fairly. But for act-utilitarianism, all these considerations are unimportant; it's the total amount of happiness produced that counts.

To try to improve on act-utilitarianism and to salvage its basic insight—that we should promote the common good—some have proposed rule-utilitarianism. It's the doctrine that what makes an action right is that it falls under a rule that, if generally followed, would maximize happiness, everyone considered. The best rules would include exceptions, allowing them to be broken whenever doing so would produce a great amount of happiness. But such rules would not adequately protect our rights.

Study Questions

1. What is the difference between consequentialist (teleological) and formalist (deontological) ethical theories?

2. What is the difference between moral and nonmoral goods?
3. What is the difference between intrinsic and instrumental (extrinsic) value?
4. What is ethical egoism?
5. What is psychological hedonism?
6. What is the argument from psychological hedonism for ethical egoism?
7. What is Feinberg's single-minded hedonist thought experiment? How does it attempt to undermine psychological hedonism?
8. What is traditional or act-utilitarianism?
9. What are McCloskey's utilitarian informant and Brandt's utilitarian heir thought experiments? How do they attempt to undermine utilitarianism?
10. What are Ross's unhappy promise and Godwin's fire rescue thought experiments? How do they attempt to undermine utilitarianism?
11. What are Ewing's utilitarian torture and innocent criminal thought experiments? How do they attempt to undermine utilitarianism?
12. What is rule-utilitarianism?
13. What is Nozick's experience machine thought experiment? How does it attempt to undermine utilitarianism?

Discussion Questions

1. Consider this case presented by British philosopher Bernard Williams.

Thought Experiment

Williams's South American Showdown

Jim finds himself in the central square of a small South American town. Tied up against the wall are a row of twenty Indians, most terrified, a few defiant, in front of them several armed men in uniform. A heavy man in a sweat-stained khaki shirt turns out to be the captain in charge and, after a good deal of questioning of Jim which establishes that he got there by accident while on a botanical expedition, explains that the Indians are a random group of the inhabitants who, after recent acts of protest against the government, are just about to be killed to remind other possible protesters of the advantages of not protesting. However, since Jim is an honoured visitor from another land, the captain is happy to offer him a guest's privilege of killing one of the Indians himself. If Jim accepts, then as a special mark of the occasion, the other Indians will be let off. Of course, if Jim refuses, then there is no special occasion, and Pedro here will do what he was about to do when Jim arrived, and kill them all. Jim, with some desperate recollection of schoolboy fiction, wonders whether if he got hold of a gun, he could hold the captain, Pedro and the rest of the soldiers to threat, but it is quite clear from the set-up that nothing of that kind is going to work: any attempt at that sort of thing will mean that all

the Indians will be killed, and himself. The men against the wall, and the other villagers, understand the situation, and are obviously begging him to accept. What should he do?[42]

Should Jim kill one of the Indians? Why or why not?

2. Are you *morally* obligated to obey all the laws in your city, state, and country? Is it ever immoral to obey a law? If so, when?
3. Consider this case from Judith Jarvis Thomson.

Thought Experiment

Thomson's Trolley Problem

Suppose you are the driver of a trolley. The trolley rounds a bend, and there come into view ahead five track workmen, who have been repairing the track. The track goes through a bit of a valley at that point, and the sides are steep, so you must stop the trolley if you are to avoid running the five men down. You step on the brakes, but alas they don't work. Now you suddenly see a spur of track leading off to the right. You can turn the trolley onto it, and thus save the five men on the straight track ahead. Unfortunately, Mrs. Foot has arranged that there is one track workman on that spur of track. He can no more get off the track in time than the five can, so you will kill him if you turn the trolley onto him. Is it morally permissible for you to turn the trolley?[43]

Should you turn the trolley? Why or why not? Now consider this case.

Thought Experiment

Thomson's Transplant Problem

This time you are to imagine yourself to be a surgeon, a truly great surgeon. Among other things you do, you transplant organs, and you are such a great surgeon that the organs you transplant always take. At the moment you have five patients who need organs. Two need one lung each, two need a kidney each, and the fifth needs a heart. If they do not get those organs today, they will all die; if you find organs for them today, you can transplant the organs and they will all live. But where to find the lungs, the kidneys, and the heart? The time is almost up when a report is brought to you that a young man who has just come into your clinic for his yearly check-up has exactly the right blood-type, and is in excellent health. Lo, you have a possible donor. All you need do is cut him up and distribute his parts among the five who need them. You ask, but he says, "Sorry. I deeply sympathize, but no." Would it be morally permissible for you to operate anyway?[44]

Suppose you believe that it is morally permissible to turn the trolley but not to operate. What is the morally relevant difference between the two situations?

4. Consider this ethical theory: Whatever is natural is good. Is this a plausible ethical theory? Test it by means of thought experiments.

5. Suppose there were a legal drug that reduced irritability, increased productivity, and made people happy in their work without producing any negative side effects such as addiction or dependence. Would it be morally permissible for an employer to require employees to take it? Would it be morally permissible for an employer to put it in the company's water supply? Does your answer support or undermine utilitarianism?

6. Suppose you had the option of doubling the total amount of happiness in the world by either doubling the happiness of existing people or doubling the number of people in the world. Is there any reason to prefer one over the other? Are they utilitarian reasons?

Internet Inquiries

1. Scientists have recently used functional magnetic resonance imaging (fmri) to scan the brains of people while they were considering the trolley problem. To find the results, enter "trolley problem" and "fmri" into an Internet search engine. What do the results tell us? Can they indicate which answer is the correct one? Why or why not?

2. What is our obligation to future generations? Can nonexistent people have a claim on us? To explore this issue, enter "rights of future generations" into an Internet search engine.

3. According to utilitarianism, do we have an obligation to keep severely disabled people alive? To explore this issue, enter "utilitarianism" and "disabled" into an Internet search engine.

Section 5.3

● Much Obliged
Duty Makes Right

Immanuel Kant rejects the assumption upon which utilitarianism rests: That happiness is the highest good and the only thing that's intrinsically valuable. According to Kant, the only thing that is intrinsically valuable is a good will. He writes, "It is impossible to conceive anything at all in the world, or even out of it, which can be taken as good without qualification, except a *good will*."[45] To have a good will is to desire to do the right thing because it's right—not because it benefits you or others. Kant, then, is a formalist. He believes that the rightness of an action is determined by the kind of action it is, not by its consequences. Even if an action does not turn out the way you planned, it can still be morally right. As Kant puts it:

> A good will is not good because of what it effects or accomplishes.... Even... if by its utmost effort it still accomplishes nothing... even then it would still shine like a jewel for its own sake as something which has its full value in itself.[46]

According to Kant, then, good people do good for goodness' sake, not because they expect anything in return.

Happiness cannot be the highest good, Kant argues, because the highest good must be good without qualification. If something is good without qualification, then adding it to a situation should always make the situation better. But adding happiness to a situation does not always make it better. Consider the case of a killing. The morality of the situation is not improved if the killer derived pleasure from the act. In fact, that might make it worse. Happiness, then, does not fulfill Kant's criteria for the highest good. The fact that an action flows from a good will, however, never makes the action worse. So Kant maintains that a good will alone is intrinsically valuable.

No action will be considered blameless, unless the will was so, for by the will the act was dictated.

—SENECA

Kant's Categorical Imperative

Impartiality is the life of justice, as justice is of all good government.
— Justinian

For Kant, to act morally is to act out of respect for the moral law—not merely to act in conformity with it—because that could happen by accident. To act morally, then, we need to know what the moral law is and base our choices on it. Moral laws can be viewed as imperatives, for they command us to do (or not do) certain things. For example, "Don't steal" is an imperative. A *hypothetical imperative* is one that should be obeyed *if* certain conditions are met. For example, "Practice regularly if you want to be a good piano player" is a hypothetical imperative. A *categorical imperative* is one that must be obeyed under all conditions. Kant's view is that moral principles are categorical, and, as a result, his moral theory has come to be known as the "categorical imperative."

The First Formulation

Our principles are the springs of our actions; our actions, the springs of our happiness or misery. Too much care, therefore, cannot be taken in forming our principles.
— Philip Skelton

Kant provides two formulations of the categorical imperative. The first says, "Act only on that maxim through which you can at the same time will that it should become a universal law."[47] In other words, act only on those principles that you would be willing to have everybody act on. The first formulation of the **categorical imperative,** then, says that what makes an action right is that everyone could act on it, and you would be willing to have everyone act on it.

According to Kant, an adequate morality cannot play favorites. Equals must be treated equally. So if it is morally permissible for someone to perform a certain action in a certain situation, then it is morally permissible for anyone else to perform that action in a similar situation, provided that the two situations are the same in all morally relevant respects. (A morally relevant respect is one that has a bearing on the morality of the action.) If there is no relevant difference between two actions, there is no reason to judge them differently.

Whenever you act, says Kant, you are acting on a maxim or principle. To determine whether a particular action is moral, you have to perform a thought experiment: You have to imagine what the world would be like if everyone acted on that principle. If such a world is conceivable, and if you would be willing to live in it, then it is morally permissible for you to act on the principle.

Kant's first formulation of the categorical imperative, then, identifies two criteria for moral acceptability: universalizability and reversibility. A principle is **universalizable** if everyone could act on it. A principle is **reversible** if you would be willing to have everyone act on it.

Some principles are not universalizable. Consider the following situation. Suppose you are broke and in need of money. You know someone who would lend it to you if you promised to pay it back, but you know you won't be able to pay it back. So you wonder whether it is morally permissible to borrow money on the basis of a false promise. To determine whether such an action is morally permissible, Kant says, you must determine whether everyone could act on the principle "Borrow money on the basis of a false promise whenever you need it." A moment's reflection, however, reveals that everyone couldn't act on that principle because it involves a logical contradiction. On the one hand, it assumes that people will lend money on the basis of promises. On the

categorical imperative I The doctrine that what makes an action right is that everyone could act on it, and you would be willing to have everyone act on it.

universalizable A principle is universalizable if everyone can act on it.

reversible A principle is reversible if the person acting on it would be willing to have everyone act on it.

372 Chapter 5 • The Problem of Relativism and Morality

> ### Immanuel Kant: Small-Town Genius
>
> In some ways, the genius of the great German philosopher Immanuel Kant (1724–1804) is a mystery—or at least counterintuitive. If there ever was a philosopher who could "think outside of the box," who could leap beyond traditional ideas to new intellectual vistas, it was Kant. Yet his life was so regimented and provincial that, from a distance, few people would have suspected anything but a very dull fellow.
>
> He was born in the little town of Königsberg, in the province of East Prussia, where the townspeople could set their watches to Kant's daily walk. In his whole life, he never left the province, never traveled abroad as many thinkers did, and died in the same town where he was born. He never married and never strayed from the outward conventionalism of his small society.
>
> Kant, however, was anything but dull. He loved the company of friends, and they found him likeable, interesting, and amusing. He was a renowned lecturer on physics, mathematics, geography, and all the main areas of philosophy. Early in his career, he wrote about astronomy and physics. But he was no dabbler: In 1755 he predicted the existence of the planet Uranus, discovered in 1881.
>
> All of this, of course, was in addition to the contributions he made in epistemology, metaphysics, and ethics, the most important of which did not appear until his mid-fifties. His masterpiece, *Critique of Pure Reason*, was published in 1781, and in 1783 a shorter version (called *Prolegomena to Any Future Metaphysics*) appeared. His other major works followed: *Foundations for the Metaphysics of Morals* (1785); *Critique of Practical Reason* (1788); and *Critique of Judgment* (1790).

other, it assumes that people can break their promises whenever they feel like it. So if everyone acted on the principle in question, no one could be trusted to pay back a loan, but if no one could be trusted to pay back a loan, no one would lend any money in the first place. So the principle "Borrow money on the basis of a false promise whenever you need it" is not universalizable. You cannot consistently will that everyone act on that principle. Consequently, says Kant, you can't act on it.

The reversibility criterion is similar to the Golden Rule, which says, "Do unto others as you would have them do unto you." The Golden Rule is based on another type of thought experiment. To determine whether an action is morally permissible, you are supposed to put yourself in the other person's shoes and decide whether you would let them do to you what you are about to do to them. If not, you should refrain from performing the action. The difference between the reversibility criterion and the Golden Rule is that the reversibility criterion focuses on the principle—rather than the people—involved. Instead of attending only to the particulars of the situation, the reversibility criterion has us consider the acceptability of the principle involved. If you would be willing to have everyone act on that principle, it is reversible.

Kant claims that the categorical imperative establishes the existence of a number of perfect duties to oneself and others. A **perfect duty** is one that has no exceptions. These include the duty not to kill innocent people, not to lie, and not to break one's promises. Under no circumstances can any of these duties be disobeyed.

In addition to perfect duties, there are also imperfect duties to oneself and others. An **imperfect duty** is one that does have exceptions. These

IMMANUEL KANT
1724–1804

perfect duty A duty that must always be performed, no matter what.

imperfect duty A duty that does not always have to be performed.

include the duty to develop one's talents and to help the needy. These duties do not always have to be obeyed. It is enough that we sometimes obey them.

By strictly prohibiting murder, lying, promise-breaking, and the like, Kant's theory avoids many of the problems that plague utilitarianism. Utilitarianism would sanction these types of actions as long as they produced enough happiness. Kant's theory, however, would never sanction them.

What's more, Kant's theory provides a more plausible account of distributive and retributive justice than does utilitarianism. According to utilitarianism, fairness takes a backseat to the greatest happiness principle. If a particular distribution of goods maximizes happiness, that distribution is morally correct, whether or not it is deserved. According to Kant, however, no distribution is permissible unless the principle on which it is based can be universalized. Insofar as no one wants to be treated unfairly, unjust principles of distribution cannot be universalized.

Utilitarianism does not require that only the guilty be punished or that the punishment fit the crime. The categorical imperative, however, requires both. As Kant says,

> But what is the mode and measure of punishment which public justice takes as its principle and standard? It is just the principle of equality, by which the pointer of the scale of justice is made to incline more to the one side than to the other. . . . Hence it may be said: "If you slander another, you slander yourself; if you steal from another, you steal from yourself; if you strike another, you strike yourself; if you kill another, you kill yourself." This is the only principle which . . . can definitely assign both the quality and the quantity of a just penalty.[48]

In other words, turnabout is fair play—whatever you do to another you should be willing to have done to you. In performing an action, you are affirming the principle on which it is based. If that principle sanctions slandering, stealing, striking, or killing, you should be willing to be slandered, robbed, struck, or killed.

Kant is a firm believer in capital punishment. He writes,

> Even if a civil society resolved to dissolve itself with the consent of all its members—as might be supposed in the case of a people inhabiting an island resolving to separate and scatter throughout the whole world—the last murderer lying in prison ought to be executed before the resolution was carried out. This ought to be done in order that every one may realize the desert of his deeds, and that bloodguiltiness may not remain on the people; for otherwise they will all be regarded as participants in the murder as a public violation of justice.[49]

Kant considers it our duty to execute murderers, for if we don't, we are implicitly condoning their action. If we let someone get away with murder, we are affirming the principle that killing innocent people is right, which is a violation of the categorical imperative.

Every man has a property in his own person; this nobody has a right to but himself.
—JOHN LOCKE

Justice is the constant desire and effort to render to every man his due.
—JUSTINIAN

Everyone ought to bear patiently the results of his own conduct.
—PHAEDRUS

Thought Probe

Enhanced Punishment

Kant believes in retributive justice—that those who commit a crime should be made to suffer a proportionate amount. Utilitarians disagree, claiming that the goal of our prisons should be to reform criminals, not to make them suffer. New technologies may make it possible to meet both of these demands at a far lower cost to society. Rebecca Roache, for example, has suggested that "There are a number of psychoactive drugs that distort people's sense of time, so you could imagine developing a pill or a liquid that made someone feel like they were serving a 1,000-year sentence."[50] If such drugs were developed, it might be possible for someone under their influence to feel as if they had served a 30-year sentence even though, in reality, only a few hours would have passed. It seems that the criminals taking the drugs would have paid their debt to society and they would still have their whole lives in front of them. Roache asks, "Is it really OK to lock someone up for the best part of the only life they will ever have, or might it be more humane to tinker with their brains and set them free?" What do you think? Would these drugs meet the requirements of retributive justice, or does justice demand that the best years of criminals' lives be taken from them?

Some have objected to Kant's theory on the grounds that it is too subjective—certain people may well be willing to have everyone act on principles that are clearly immoral. Consider R. M. Hare's Nazi fanatic.

Thought Experiment

Hare's Nazi Fanatic

Let us, as briefly as possible, consider what might be said in such an argument between a liberal and a Nazi. The liberal might try, first, drawing the Nazi's attention to the consequences of his actions for large numbers of people (Jews for example) who did not share his ideals, and asking him whether he was prepared to assent to a universal principle that people (or even people having the characteristics of Jews) should be caused to suffer thus. Now if only interests were being considered, the liberal would have a strong argument; for, if so, the Nazi would not assent to the judgment that, were he himself to be a Jew, or have the characteristics of Jews, he should be treated in this way.... But the Nazi has a universal principle of his own which gets in the way of the liberal's argument. He accepts the principle that the characteristics which Jews have are incompatible with being an ideal or pre-eminently good (or even a tolerably good) man; and that the ideal, or even a tolerably good society cannot be realized unless people having these characteristics are eliminated. It might therefore seem *prima facie* that it is no use asking him to imagine himself having the characteristics of Jews and to consider what his interests would then be; for he

thinks that, even if the other interests of people (including his own) are sacrificed, the ideal state of society ought to be pursued by producing ideal men and eliminating those that fall short of the ideal.[51]

> *There are not good things enough in life, to indemnify us for the neglect of a single duty.*
> —Madame Swetchine

Unlike the principle "Borrow money on the basis of a false promise whenever you need it," the Nazi directive "Kill all the Jews" does not involve a contradiction. Wanting to have all the Jews dead is not like wanting to have your cake and eat it, too. So the principle is universalizable—everyone can act on it. And if the Nazi fanatic were willing to have himself killed if he were a Jew, it is reversible, too, for the fanatic would be willing to have everyone act on it. So it looks like Kant's theory (as well as the Golden Rule) could sanction genocide—which strongly suggests that these are not adequate ethical theories.

Another objection to Kant's categorical imperative stems from the fact that every action can be described in a number of ways, and there is no way to decide which description is the correct one. Consider again the case of borrowing money on the basis of a false promise. Instead of taking the relevant principle to be "Borrow money on the basis of a false promise whenever you need it," you could take it to be "Borrow money on the basis of a false promise whenever you need it and have such-and-such a genetic code" where the genetic code referred to is your own. Because only you have your genetic code, you will not fall into a contradiction by willing everyone to act on that principle. By making the principle specific enough, you could justify any action. But obviously this won't do.

The most difficult problem facing Kant's theory, however, is the fact that there are no perfect duties. Every duty has exceptions. Ross provides the following example.

Thought Experiment

Ross's Good Samaritan

What lends colour to the theory we are examining, then, is not the actions (which form probably a great majority of our actions) in which some such reflection as 'I have promised' is the only reason we give ourselves for thinking a certain action right, but the exceptional cases in which the consequences of fulfilling a promise (for instance) would be so disastrous to others that we judge it right not to do so. It must of course be admitted that such cases exist. If I have promised to meet a friend at a particular time for some trivial purpose, I should certainly think myself justified in breaking my engagement if by doing so I could prevent a serious accident or bring relief to the victims of one.[52]

Our duty to keep our promises is not a perfect one, for there are situations in which it would be wrong to keep them. For example, if keeping our promise to meet someone at a certain time meant that a number of people would

die, then it would be wrong for us to keep our promise. Thus even Kant's theory leaves something to be desired.

The Second Formulation

Kant proposed a second version of the categorical imperative which he thought was equivalent to the first. It goes like this: "Act in such a way that you always treat humanity . . . never simply as a means, but always at the same time as an end."[53] The second formulation of the **categorical imperative,** then, says that what makes an action right is that it treats people as ends in themselves and not merely as a means to an end.

To treat people as "ends in themselves" is to treat them as being intrinsically valuable—valuable for their own sakes. To treat them as "a means to an end" is to treat them as being instrumentally valuable—valuable for the sake of something else. Tools or implements are instrumentally valuable. They're valuable only in so far as they help us accomplish some goal or end. We value a hammer, for example, because it helps us pound things. We don't care what happens to the hammer as long as it helps us get the job done. The second formulation of the categorical imperative, then, says that it's wrong to use people merely as tools to accomplish some end. To act morally toward them, we have to respect the value that resides in them.

People are intrinsically valuable because they're self-conscious, rational, and free. Their being self-conscious allows them to be aware of the principles that govern their actions. Their being rational allows them to determine whether those principles are in accord with the categorical imperative. And their being free allows them to decide what principles they are going to act on. Consequently, they can be held morally responsible for what they do.

Most creatures are slaves to their desires. The desires they have were imposed on them from without—by nature or nurture—and they have no control over them. Persons, on the other hand, because they are rational, can not only create their own desires, but they can also decide which ones they're going to act on. Instead of being subject solely to the laws of nature, they can be subject to laws they create themselves. Those who act on laws of their own making act freely or autonomously. ("Autonomous" comes from the Greek words *auto* meaning self and *nomos* meaning law.) For Kant, then, our ability to reason is what sets us free.

Kant's view of the capabilities of reason differs markedly from that of the utilitarians. They hold that reason can only be used to decide the most effective means for achieving the ends dictated by our desires. The ends themselves are beyond the reach of reason. Kant, on the contrary, claims that the function of reason is to decide which ends are worth pursuing. For him, reason is not merely the "slave of the passions," as Hume would have it. Instead, it can be their master and guide. Our ability to fashion our own destiny through the use of reason is what makes us intrinsically valuable. Respecting the value inherent in persons, then, involves respecting their right to choose. By allowing them to decide what kind of life they will lead, we treat them as ends in themselves and not merely as means to an end.

> Never let a man imagine that he can pursue a good end by evil means, without sinning against his own soul.
>
> —ROBERT SOUTHEY

categorical imperative II The doctrine that what makes an action right is that it treats people as ends in themselves and not merely as means to an end.

When we manipulate people—when we use them against their will—we use them merely as a means to an end. When we enslave people, for example, we prevent them from pursuing their desires and plans and force them to serve ours. Slavery is wrong precisely because it does not recognize the inherent value of the slaves. It treats them as tools instead of moral agents and thus fails to respect their autonomy—their right to do with their lives what they want.

> *Whatever makes man a slave takes half his worth away.*
> —ALEXANDER POPE

Not everyone who uses others to accomplish some goal is doing something immoral, however. We often use others as a means (to an end) without using them *merely* as a means. For example, we use store clerks to help us with our purchases, and store clerks use us to help pay their bills. But in this situation, no one is being used *merely* as a means because no one is being forced to do something against his or her will. Our actions and those of the store clerks are free. Because no one has been forced into the situation, no one's rights have been violated.

The second version of the categorical imperative avoids some of the counterintuitive consequences of the first. It would not allow the Nazi fanatic to kill all the Jews because that would involve using them merely as a means. It would also not allow someone with a particular genetic code to borrow money on the basis of a false promise. For even if such a principle were universalizable, it would still involve treating people merely as a means.

Kant considered the two formulations of the categorical imperative to be equivalent because he thought they permitted the same actions. Few agree with this assessment, however, for there are actions permitted by the first (such as a Nazi fanatic killing all the Jews) that are not permitted by the second. The second formulation, then, may best be viewed as a supplement to the first. In this view, deciding whether an action is right is a two-step process: (1) determine whether the principle to be acted on is universalizable and reversible, and (2) determine whether it treats everyone as ends in themselves, not merely as means to an end. If the action passes both tests, it is morally permissible.

Although the second formulation of the categorical imperative doesn't allow people to be used merely as a means (to an end), it does allow animals to be used merely as a means. According to Kant, animals are tools. In his *Lectures on Ethics,* Kant writes, "But so far as animals are concerned, we have no direct duties. Animals . . . are there merely as a means to an end. That end is man."[54] Kant believes that animals are only instrumentally valuable. The only value they have is the value they have for us.

Many find this consequence of Kantianism disturbing. Because animals are sentient creatures, they seem to have a value that doesn't depend on us. Utilitarianism seems to be more in tune with our moral sensibilities here, for utilitarianism claims that what makes something valuable from a moral point of view is not that it can reason, but that it can suffer. Jeremy Bentham writes,

> The day may come when the rest of the animal creation may acquire those rights which never could have been witholden from them but by the hand of tyranny. The French have already discovered that the blackness of the skin is no reason why a human being should be abandoned without redress to the caprice of a tormentor. It may one day come to be recognized that the number of the legs, the villosity of the skin, or the termination of the os sacrum are reasons equally insufficient for abandoning a sensitive being to the same fate. What else is it

that should trace the insuperable line? Is it the faculty of reason, or perhaps the faculty of discourse? But a full-grown horse or dog is beyond comparison a more rational, as well as a more conversable animal, than an infant of a day or a week or even a month, old. But suppose they were otherwise, what would it avail? The question is not, Can they *reason?* nor Can they *talk?* but, *Can they suffer?*[55]

According to Bentham, happiness is happiness, whether it's human happiness or animal happiness. And if our duty is to maximize happiness, then we should take into account all those who can experience happiness.

Thought Probe

Animal Rights

Jeremy Bentham believes that what makes a being worthy of ethical consideration is not whether it can reason but whether it can suffer. Since animals can suffer, he thinks that an action's effect on animals should be taken into account when performing the utilitarian calculation. Peter Singer agrees. He writes: "If a being suffers, there can be no moral justification for refusing to take that suffering into consideration. No matter what the nature of the being, the principle of equality requires that its suffering be counted equally with the like suffering—in so far as rough comparisons can be made—of any other being."[56] Do you agree? Is it possible for us to gauge animal suffering? Should equivalent animal suffering be given the same weight as human suffering? Why or why not?

The second formulation of the categorical imperative enjoins us to never use people merely as means. Although that may be an admirable ideal, it is not fully realizable. As British philosopher C. D. Broad notes, sometimes we have to use people merely as means.

Thought Experiment

Broad's Typhoid Man

Again, there seem to be cases in which you must either treat A or treat B, not as an end, but as a means. If we isolate a man who is a carrier of typhoid, we are treating him merely as a cause of infection to others. But, if we refuse to isolate him, we are treating other people merely as means to his comfort and culture.[57]

If a man has typhoid or some other contagious disease, to quarantine him is to treat him merely as a means—namely, as a means to the health of others. Not to quarantine him is to treat others merely as a means—namely, as a means to his well-being. Thus there are times when treating people merely as a means is unavoidable.

Or consider the case of human shields. During the Gulf War, the Iraqi government handcuffed American prisoners to strategic targets such as missile silos. If the only way to defeat the Iraqis had been to bomb those silos, we would probably have bombed them, for it would have been necessary to prevent even more people from being used merely as a means.

If the evil to be avoided is great enough, it would seem that we could violate any of the duties Kant identifies. Consider this thought experiment by A. C. Ewing.

Thought Experiment

Ewing's Prudent Diplomat

However important it is to tell the truth and however evil to lie, there are surely cases where much greater evils still can only be averted by a lie, and is lying wrong then? Would it not be justifiable for a diplomat to lie, and indeed break most general moral laws, if it were practically certain that this and this alone would avert a third world-war? . . . while it may be self-evident that lying is always evil, it is surely not self-evident that it is always wrong. To incur a lesser evil in order to avert a much greater might well be right, and if that is the case as regards a lie, the lie is evil but not wrong.[58]

> *The lives of the best of us are spent in choosing between evils.*
> —JUNIUS

Ewing draws an important distinction here. It may be the case that killing innocent people, lying, stealing, breaking promises, or the like is always evil, but that doesn't mean that it's always wrong. The right thing to do in many situations is the lesser of two evils. When faced with a conflict between duties, we need to determine which one takes precedence. But because Kant didn't recognize that such conflicts could occur, he didn't provide any mechanism for resolving them.

Thought Probe

Easy Rescue

Suppose you're walking along a deserted alley one night and a young boy comes running up to you, slips, and falls face down in a puddle of water. According to Kant, do you have a duty to at least kneel down and turn his head so that he doesn't drown? Why or why not?

Ross's *Prima Facie* Duties

> *All that any of us has to do in this world is his simple duty.*
> —H. C. TRUMBULL

If moral duties could be ranked hierarchically, we could resolve conflicts among them by simply consulting the ranking. Or if all of the exceptions to each duty could be spelled out, we could have a set of duties that didn't conflict with

one another. No one has discovered a ranking that doesn't admit of counterexamples, however, and the number of exceptions for each duty seems to be extremely large. So these means of solving conflicts do not seem promising.

W. D. Ross attempts to deal with the problem of the conflict of duties by distinguishing between actual and *prima facie* duties. An **actual duty** is one that we are morally obligated to perform in a particular situation. A ***prima facie* duty** is one that we are morally obligated to perform in every situation *unless* there are extenuating circumstances. (The phrase *prima facie* literally means "at first glance.") A *prima facie* duty, in other words, is a conditional duty—one we should carry out if it doesn't conflict with other *prima facie* duties. "Do not lie" is a *prima facie* duty because, other things being equal, we should tell the truth. But if, in a particular situation, telling the truth would result in, say, the death of a number of innocent people, then our actual duty may be to lie.

According to Ross, our duties do not arise from any one moral principle. Rather, they grow out of our relationships with other people: spouse to spouse, child to parent, friend to friend, citizen to state, and so forth. "Each of these relations," Ross informs us, "is the foundation of a *prima facie* duty which is more or less incumbent on me according to the circumstances of the case."[59]

Ross identifies seven categories of *prima facie* duties:

1. *Duties of fidelity*, which require us to keep our promises, honor our contracts, and tell the truth.
2. *Duties of reparation*, which require us to compensate others for acts of cruelty and negligence.
3. *Duties of justice*, which require us to deal fairly with other people.
4. *Duties of beneficence*, which require us to benefit others.
5. *Duties of nonmaleficence*, which require us not to harm others.
6. *Duties of gratitude*, which require us to compensate others for acts of kindness.
7. *Duties of self-improvement*, which require us to try to become better people.

Ross does not maintain that this set of duties is complete. Instead, he claims that actions that fall under these duties tend to be right:

> We have to distinguish from the characteristic of being our duty that of tending to be our duty. Any act that we do contains various elements in virtue of which it falls under various categories. In virtue of being the breaking of a promise, for instance, it tends to be wrong; in virtue of being an instance of relieving distress it tends to be right.[60]

To determine what our actual duty is in any given situation, we have to decide which duty takes precedence. According to Ross's **pluralistic formalism,** then, what makes an action right is that it falls under the highest-ranked *prima facie* duty in a given situation.

Suppose, for example, that you are faced with a situation in which you can help a child in distress only if you break a promise. To the extent that helping the child follows the *prima facie* duty of beneficence, it tends to be right. To the extent that it violates the *prima facie* duty of fidelity, it tends to be wrong.

It is not enough that you form, and even follow the most excellent rules for conducting yourself in the world; you must, also, know when to deviate from them, and where lies the exception.

—Lord Greville

actual duty A duty that should be performed in a particular situation.

***prima facie* duty** A duty that should be performed unless it conflicts with other *prima facie* duties.

pluralistic formalism The doctrine that what makes an action right is that it falls under the highest-ranked duty in a given situation.

To determine whether it is actually right or wrong, you have to decide which duty is more important in this situation.

Unfortunately, Ross does not tell us how to make such a decision. He suggests that ranking *prima facie* duties is like evaluating the qualities of a work of art. He writes,

> A poem is, for instance, in respect of certain qualities beautiful and in respect of certain others not beautiful; and our judgment as to the degree of beauty it possesses on the whole is never reached by logical reasoning from the apprehension of its particular beauties or particular defects. Both in this and in the moral case we have more or less probable opinions which are not logically justified conclusions from the general principles that are recognized as self-evident.[61]

There is no formula for ranking *prima facie* duties, just as there is no formula for ranking the qualities of a work of art. In both cases, we have to rely on our intuition. Thus Ross is an intuitionist when it comes to making moral decisions.

Thought Probe

Desert Island Bequest

Suppose you are shipwrecked on a desert island with a dying millionaire. Before the ill-fated voyage, he put $5 million in a public locker. He is willing to give you the key to the locker if you promise to spend the money according to his wishes. (You may keep $500,000 for your trouble.) The millionaire would like you to use the money to plant flowers in Siberia. It turns out that he grew up in Siberia and always lamented the fact that so few flowers grew there. Planting the flowers would fulfill a lifelong dream of his. You promise to do what he wants, so he gives you the key. You are rescued, go to the locker, and retrieve the $5 million. Instead of spending the money on flowers, however, you give it all to cancer research. According to Ross, did you do the right thing? Why or why not?

Rawls' Contractarianism

Fear of serious injury cannot alone justify suppression of free speech and assembly. Men feared witches and burnt women.

—Justice Brandeis

Utilitarianism is concerned with providing for the common good, but it doesn't respect individual rights. The categorical imperative respects individual rights but is not concerned with providing for the common good. Ross's pluralistic formalism is concerned with both the common good and individual rights but provides no effective means of deciding which takes precedence in a given situation. John Rawls, former professor of philosophy at Harvard University, has developed an approach to ethics that attempts to combine the strengths of these approaches while avoiding their weaknesses. He calls his approach "justice as fairness."

Rawls' primary concern is distributive justice—how should society's benefits and burdens be distributed? The problem is that there are not enough goods—jobs, food, housing, medical care, and the like—to go around. Given the scarcity of goods, how can we arrange things so that everyone gets a fair share?

The distribution of goods in a society is primarily determined by what Rawls terms its "basic structures": its political, legal, economic, and social institutions. To determine what a just society would be like, we have to identify the principles that its basic structures would embody.

Rawls attempts to identify these principles by specifying a procedure for generating them. The assumption is that as long as the procedure is fair, the principles generated by it will also be fair. Consider the following example of procedural justice. Suppose that six people have equal claim to a slice of an uncut pie. If we give the knife to the hungriest person and tell him that he can cut the pie on the condition that he gets the last piece, we should get a fair distribution. To ensure that he gets the biggest piece possible, he will have to divide the pie as nearly equally as possible.

Rawls believes that there is a procedure for generating ethical principles that guarantees they will be as fair as possible. That procedure is the one that would be followed in drawing up the ideal social contract. He writes, "The principles of justice for the basic structure of society are the principles that free and rational persons . . . would accept in an initial situation of equality as defining the fundamental terms of their association."[62] To identify the principles that would govern a just society, we have to perform a thought experiment: We have to imagine that we are members of a group of free and rational individuals who meet as equals around a bargaining table to draw up a social contract we can all live by.

In an ideal contract-making situation, the parties to the contract meet as equals—no one has any information that the others lack. If someone had privileged information, he could use it to skew the contract in his favor. To ensure that none of the parties can take unfair advantage of the others, Rawls has us imagine that the parties in the "original position" conduct their negotiations behind a "veil of ignorance." That is, while they are sitting around the bargaining table, there are certain things that they do not know about themselves. Specifically, they do not know their race, sex, natural abilities, religion, interests, social position, or income. This equality guarantees impartiality. Because the parties do not know what group they belong to, they should not agree to principles that discriminate against a particular group. And because they don't know their specific wants and needs, the principles they draw up should be concerned only with primary goods—the goods that all parties should want regardless of their particular situations. These goods include basic liberties as well as such things as power, authority, opportunity, and wealth.

Although the people in the original position don't know much about themselves, they are nonetheless rational and self-interested. Their sole purpose is to arrive at a contract that would be best for them. What principles would they choose? Rawls claims that they would choose three:

1. *The principle of equal liberty*: Each person has an equal right to the most extensive basic liberties compatible with similar liberties for all.
2. *The principle of fair equality of opportunity*: Offices and positions are to be open to all under conditions of fair equality of opportunity.
3. *The difference principle:* Social and economic inequalities are to be arranged so that they are to the greatest benefit of the least advantaged persons.

The principle of equal liberty says that society should grant to each person as much freedom as possible as long as no one has more freedom than anyone else. This principle would be chosen by the people in the original position because they would want to be maximally free to pursue whatever interests they might have. The principle of fair equality of opportunity says that everyone should have an equal opportunity to advance in society. This principle would be chosen because the people in the original position would want to ensure that there are no artificial barriers to their success. The difference principle says that whatever inequalities exist should be arranged so that they benefit the most needy members of society. This principle would be chosen because, for all the people in the original position know, they might be in the neediest group. In game theory, this is known as the maximin strategy: When choosing under conditions of uncertainty, choose the alternative that provides the best worst-case scenario.

The difference principle does not demand that everyone be treated equally. There can be an unequal distribution of goods as long as the inequality serves to maximize the position of the least-well-off group. Interestingly enough, this principle is often invoked to justify various social and economic policies. It was used, for example, to justify President Reagan's massive tax cut. Reagan and his advisors claimed that lessening the tax burden on the rich would greatly improve the standard of living of the poor. This claim became known as the "trickle-down theory": The idea that letting the rich keep more of their money would leave more money to trickle down to the poor than had been the case before the tax cut. Things didn't turn out that way, however. The tax cut served only to heighten the disparity between the rich and the poor.

The major problem facing formalist theories of ethics is that of resolving conflicts of duty. Rawls goes some way toward solving this problem by ranking the three principles of justice in terms of importance. The principle of equal liberty, Rawls claims, is "lexically prior" to the principle of fair equality of opportunity, which is lexically prior to the difference principle. To say that one principle is lexically prior to another is to say that all the requirements of the former principle must be met before the requirements of the latter. No trade-offs are allowed; the lexically prior principle always takes precedence. So we must ensure that everyone has equal liberty before we ensure that everyone has fair equality of opportunity. And we must ensure that everyone has fair equality of opportunity before we ensure that the basic structures maximize the position of the least well-off group.[63]

Although Rawls' **contractarianism**—the doctrine that what makes an action right is that it is in accord with the principles established by an ideal social contract—is concerned with providing for the common good, it is not a utilitarian theory. Utilitarianism values liberty only so long as it maximizes happiness. If having slaves would maximize happiness, then, according to utilitarianism, we should have slaves. Rawls rejects the notion that rights are valuable only as long as they produce happiness. Like Kant, he considers freedom to be valuable in and of itself. He writes, "Each person possesses an inviolability founded on justice that even the welfare of society as a whole

contractarianism The doctrine that what makes an action right is that it is in accord with the principles established by an ideal social contract.

cannot override. . . . Therefore . . . the rights secured by justice are not subject to political bargaining or to the calculus of social interests."[64] For Rawls, then, not only is freedom intrinsically valuable; it is also more valuable than happiness.

No one has ever been in the original position, and it's doubtful that anyone ever will be. Nevertheless, the original position is conceivable (it doesn't involve a logical contradiction), and it is eminently fair (no one can take advantage of anyone else). As a result, there is reason to believe that the principles chosen in the original position would be just.

For those not convinced by this argument, Rawls offers a Kantian justification of his theory. Kant claims that morally correct principles are universalizable and reversible—they apply to everyone, including oneself. The way to determine whether a principle is moral is to perform a thought experiment and decide whether everyone could act on that principle and whether you would be willing to have everyone act on that principle. The problem with this approach, as we have seen, is that fanatics could consistently will that people act on principles that are obviously immoral. By requiring ethical decisions to be made behind a veil of ignorance, Rawls helps alleviate this problem. There can be no fanatics behind the veil of ignorance. So the original position provides a "procedural interpretation" of the perspective from which free, rational, and impartial people would make their choices.[65] The way to determine whether a principle is moral is to perform a thought experiment and decide whether it would be approved by people in the original position behind the veil of ignorance.

What sort of basic structures are consistent with the principles of justice? Interestingly enough, those found in a liberal, democratic society like ours seem to fit quite nicely. Rawls sees this as further vindication of his theory because any adequate theory of ethics should be consistent with our considered moral judgments.

The Declaration of Independence explicitly endorses the principle of equal liberty, and the Bill of Rights makes it unlawful to restrict certain liberties. The Civil Rights Act of 1964 explicitly endorses the principle of fair equality of opportunity, and Title VII makes it unlawful for any employer to discriminate on the basis of race, color, religion, sex, or national origin. Although our tax code is progressive (the rich are taxed at a higher rate than the poor), the law does not explicitly endorse the difference principle. In fact, some figures suggest that the basic structures in our society do not conform to the difference principle. In September 2018, the Census Bureau reported that the position of the least well off group in the U.S. has remained stagnant for the last 30 years. In 2017, the poverty rate was 12.3%, in 2007 it was 12.5%, and the average for the past 30 years was 13.4%.[66]

Although Rawls' theory has much to recommend it, it is not without its critics. Some argue that the veil of ignorance is too thick—people know too little to make rational decisions. Because people have no knowledge of their interests or abilities, they would not be able to agree on any principles. Furthermore, others have claimed that if the veil is thinned out—if people know more about themselves—utilitarian principles would be chosen.

Thought Probe

Just Policies

Use Rawls' contractarianism to decide which of these social policies are just. That is, which would be agreed on by people in the original position behind the veil of ignorance? Why or why not?

- Entitlement programs such as welfare, Medicare, and Medicaid
- An inheritance tax of over 75 percent
- Homosexual marriage
- Legalized euthanasia

Nozick's Libertarianism

Perhaps the most trenchant critique of Rawls, however, comes from his former colleague at Harvard, Robert Nozick. Nozick argues that Rawls' principles do not adequately protect individual rights. In fact, a society based on Rawls' principles would have to constantly violate people's right to do what they want with what they own to maintain the preferred distribution of goods. To demonstrate this, Nozick offers the following thought experiment that features the famous basketball player Wilt Chamberlain, once the highest paid athlete in the country.

> *Libertarianism holds that the only proper role of violence is to defend person and property against violence, that any use of violence that goes beyond such just defense is itself aggressive, unjust, and criminal.*
>
> —MURRAY N. ROTHBARD

Thought Experiment

Nozick's Basketball Player

. . . suppose a distribution favored by one of these non-entitlement conceptions is realized. Let us suppose it is your favorite one and let us call this distribution D_1. . . . Now suppose that Wilt Chamberlain is greatly in demand by basketball teams, being a great gate attraction. (Also suppose contracts run only for a year, with players being free agents.) He signs the following sort of contract with a team: In each home game, twenty-five cents from the price of each ticket of admission goes to him. (We ignore the question of whether he is "gouging" the owners, letting them look out for themselves.) The season starts, and people cheerfully attend his team's games; they buy their tickets, each time dropping a separate twenty-five cents of their admission price into a special box with Chamberlain's name on it. They are excited about seeing him play; it is worth the total admission price to them. Let us suppose that in one season one million persons attend his home games, and Wilt Chamberlain winds up with $250,000, a much larger sum than the average income and larger even than anyone else has. Is he entitled to this income? Is this new distribution D_2? If so, why? There is no question about whether each of the people was entitled to the control over the resources they held in D_1; because

that was the distribution (your favorite) that (for the purposes of argument) we assumed was acceptable. Each of these persons *chose* to give twenty-five cents of their money to Chamberlain.⁶⁷

The people who paid twenty-five cents extra to see Wilt Chamberlain did so of their own free will with their own money. The resulting distribution of goods, however, may have violated a principle of distributive justice, such as the difference principle. Even so, Nozick claims, it cannot be unjust because nobody's rights were violated. What this shows is that any pattern-based system of distributive justice (like Rawls') will have to interfere in people's lives to maintain the pattern. Specifically, it will have to prevent capitalist acts between consenting adults. Because Nozick believes that the right not to be interfered with is the most basic right we possess, he finds any pattern-based principles of distributive justice unacceptable.

This is particularly true of socialism. The basic principle of socialist justice is usually stated as follows: "From each according to his ability, to each according to his needs."⁶⁸ In defense of this principle, it is claimed that people are happiest when they are doing what they do best, and society is happiest when the needs of its members are being met. Unfortunately, the only way to ensure that people do what they do best is through the use of force. Suppose that you want to be an artist, but you are a much better mathematician. To meet the requirements of socialist justice, the government would have to force you to become a mathematician. Even if such a system maximized happiness, many believe that the loss of freedom would be too great to make it morally acceptable.

Nozick advocates a libertarian theory of justice whose basic principle can be stated thus: "From each as they choose, to each as they are chosen."⁶⁹ People are entitled to whatever they acquire fairly and squarely. If they do not violate anybody's rights in the process of obtaining something, it is theirs to keep and do with as they please. Any attempt to take it away from them would violate their rights.

The notion that we have a natural right to own property and dispose of it as we see fit finds its clearest expression in the writings of John Locke, who greatly influenced the founding fathers of our country. But what gives us that right? Where does that right come from? According to libertarians, it comes from the fact that we own ourselves. Locke explains: "Every man has a property in his own person. This nobody has a right to but himself."⁷⁰ Although the notion that we own ourselves and thus have a right to decide how we will live our lives is an appealing one, it is not one that is recognized by the law.

A large percentage of the law enforcement budget of every jurisdiction is spent prosecuting what are known as "no-victim" or "victimless" crimes. What makes these crimes victimless is that no one's rights are violated in the commission of them. No one is forced to do anything against their will. Gambling, prostitution, and drug use fall into this category. Neither the buyers nor the sellers in these enterprises need be coerced into engaging in these activities. Consequently, libertarians believe they should be legalized. The present practice of outlawing them, they claim, is a violation of our right to do with our lives and bodies what we want to.

> *As the happiness of the people is the sole end of government, so the consent of the people is the only foundation of it.*
>
> —JOHN ADAMS

Laws that restrict your freedom for your own good are known as "paternalistic" laws. They include not only such morals legislation as the laws against gambling, prostitution, and drug use, but also such safety and health laws as those mandating the use of seat belts and motorcycle helmets. "Paternalistic" comes from the Latin word "pater" meaning father. In the case of paternalistic laws, the government acts like a father, telling you what you can and cannot do. Libertarians don't buy this "father knows best" principle, especially when government is playing the role of the father. For them, the right to do what you want with yourself is absolute; under no circumstances should anyone force you to do something against your will.

Is our right to self-determination really absolute? Do we really own ourselves in the way that libertarians claim? To decide, we'll have to determine whether it fits with our experience of the moral life. Does accepting it require rejecting other beliefs we take to be true? If so, there's reason to doubt that the right is absolute.

"The central core of the notion of a property right in X," Nozick tells us, "is the right to determine what shall be done with X."[71] It follows, then, that if you own yourself (as the libertarians claim), you have the right to determine what will happen to your body. Because your organs are part of your body, your right of self-ownership should give you the right to sell your organs. Not only should you be able to sell your organs, you should be able to sell them even if doing so would result in your death. If you want to sell your liver or your heart or both of your kidneys and lungs, that should be up to you. No one, say the libertarians—not even the government—has a right to stop you.

In Germany, in 2001, just such a sale was made. Armin Meiwes a 43-year-old software engineer, placed an ad on the Internet for someone who would be willing to be killed and eaten. Bernd Jurgen Brandes a 42-year-old computer technician, answered the ad. His desire to be cannibalized was genuine, and Meiwes videotaped the agreement. Meiwes proceeded to kill and carve up Brandes, storing the parts in plastic bags in his refrigerator. By the time the police caught him, he had eaten about 40 pounds of Brandes. Because Brandes was a willing participant in Meiwes's scheme, the German court originally charged him with manslaughter and sentenced him to eight and a half years in prison. Upon appeal, however, the court found the original sentence too lenient, and sentenced Meiwes to life.

Thought Probe

Consensual Cannibalism

Is what Brandes or Meiwes did morally wrong? What principle underlies your judgment? Does your view strengthen or weaken the libertarian position? Why?

The most frequent objection levied against libertarianism is that it sanctions enormous inequalities in wealth. That this is a consequence of libertarianism should be clear from the Wilt Chamberlain example. That many consider such inequalities to be unjust should be clear from the Occupy Wall Street movement.

Started in Zuccotti Park in New York City's financial district on September 17, 2011, the Occupy Wall Street movement was organized to protest economic inequality, unemployment, and the undue influence of corporations and lobbyists on government. It quickly spread to other cities throughout the country and around the world. Its slogan, "We are the 99%," refers to the current and growing economic disparity in the United States.

As of 2016, the richest 1 percent of American families owned 38.6 percent of the country's wealth. The bottom 90 percent owned just 22.8 percent. That means that the top 1 percent of American families own almost twice as much as the bottom 90 percent.[72] These inequalities were driven home to the American public as a result of the great recession and the Emergency Economic Stabilization Act of 2008. High-paid bankers, who many believe were responsible for the recession, received large bonuses after the act went into effect while many middle-class Americans lost their jobs and homes. Many think that was unfair.

Libertarians would not be in favor of government bailouts, but they would find nothing wrong with huge inequalities, as long as they were acquired without violating anybody's rights. The problem with such inequalities is that they concentrate power in the hands of an elite, which effectively takes power out of the hands of the masses. Those with less economic power have fewer life options than those with more—they have fewer choices regarding where to live, where to work, where to go to school, what to buy, and so on. Consequently they have less freedom to do what they want than those who are more well off.

You might think that this loss of freedom would be of concern to libertarians, but you would be mistaken. Libertarians are concerned only with protecting negative freedom—freedom from coercion—not with promoting positive freedom—freedom to fulfill one's desires. Philosopher G. A. Cohen finds this view puzzling and paradoxical. He writes: "How is libertarian capitalism libertarian if it erodes the liberty of a large class of people?"[73] Libertarians take liberty to be the fundamental value. If so, why is the violation of negative freedom so much worse than the erosion of positive freedom?

Because libertarians take the right not to be interfered with to be absolute, they do not believe that there are any situations in which that right can be violated (except to prevent someone else from being interfered with). But just as there are times when Kant's categorical imperative must be violated, there are times when the libertarian's right to noninterference must be violated. Philosopher Matt Zwolinski identifies one such: The "absolute rights of self-ownership seem to prevent us from scratching the finger of another even to prevent the destruction of the whole world."[74] Surely such a violation would be morally justified. But that suggests that negative freedom is not the only value we have to respect.

Justice, the State, and the Social Contract

Rawls and Nozick are both social contract theorists in that they believe that the legitimacy of a state derives from the consent of the governed. But they have very different views of how the contract should be understood. To place their views in context, it is useful to see how other thinkers have conceived of the social contract.

> I have always found it quaint and rather touching that there is a movement [Libertarians] in the US that thinks Americans are not yet selfish enough.
> —Christopher Hitchens

One of the central questions in political philosophy is, What makes a government's power legitimate? Until recently, many governments claimed that their right to rule came from God. (The divine right of kings was one of the principles that our founding fathers explicitly rejected.) Nowadays most people in the West believe that the only legitimate source of governmental power is the consent of the governed. Government exists to serve and protect the people. Social contract theories try to explain how governments can legitimately acquire their power. These theories should not be viewed as attempts to provide a historically accurate account of the origin of any particular state. Rather, they should be viewed as attempts to justify the state by explaining how it's possible for states to come into being without violating any moral principles.

Hobbes

> *The only way to build a common power is to entrust the power and strength to one man, or Assembly that would reduce all their wills, by majority rule in a single will.*
> —Thomas Hobbes

The first person to use the notion of a social contract to justify a form of government was Thomas Hobbes. Hobbes claimed that there were two things that all rational persons naturally desired: peace and justice. No rational person desires to be at war with others, and no one desires to be treated unfairly. Without a central authority to provide protection and adjudicate disputes, however, these goods are hard to come by. In a state of nature, where there is no central authority or government, there would be a war of all against all. Every moment of every day would be spent in the struggle for survival. There would be no time for art, science, or culture. Life, in Hobbes's words, would be "solitary, poor, nasty, brutish, and short."

To establish peace and justice, Hobbes believed that rational people would agree to sacrifice some of their freedom and live under the dictates of a supreme ruler. This ruler—called the Leviathan—would have the power to force others to live in peace and honor their contracts. (In the Old Testament, the Leviathan was an evil sea monster that could be defeated only by God.) Only if there were a Leviathan with enough power to keep the peace and enforce the law, Hobbes thought, would civil society be possible.

The agreement to submit to the Leviathan is not a contract between the Leviathan and its subjects. Rather, it is a contract among the subjects themselves. Because the Leviathan is the supreme ruler, it does not answer to any higher authority. Thus any contract made with the Leviathan is unenforceable. And unenforceable contracts, Hobbes thought, are meaningless.

The Leviathan, then, is free to do whatever it pleases. Its power is absolute. It can force its subjects to do anything it wants, except take their own lives. Such a situation may not strike you as very desirable, but Hobbes thought that it was preferable to a state of nature. There is a chance that the Leviathan will turn out to be a ruthless despot, but that was a chance that Hobbes was willing to take.

Locke

Locke was not willing to take that chance. He saw no difference between being besieged by a thousand people and being besieged by one person who has a thousand people at his command. Locke, like Hobbes, saw the social

contract as a means of establishing peace and justice. But whereas Hobbes viewed the social contract as one where the subjects give up their rights to the Leviathan, Locke viewed it as one where the subjects entrust their rights to the state for safekeeping.

Locke thought that everyone had a natural right to life and property. People should not be forced to give up their life or their possessions against their will. To protect their rights, Locke thought that people would agree to invest the state with the power to make and enforce laws and to provide for the common defense. To prevent the state from becoming too powerful, these functions should be carried out by different branches of the government. The legislative branch would enact the laws, the executive branch would enforce them, and the federative branch would command the armed forces. Although Locke recognized the need for a judiciary to settle legal disputes, he didn't conceive of the judiciary as a separate branch of government. That idea came from the French jurist Montesquieu.

It should be clear that much of the philosophy behind the American political system is Locke's: The idea that all humans possess certain rights independently of the state, the idea that the function of the state is to protect those rights, the idea that the state derives its legitimacy from the consent of the governed, and the idea that there should be a balance of power among the different branches of the government all come from Locke.

> Men being, as has been said, by nature, all free, equal and independent, no one can be put out of this estate, and subjected to the political power of another, without his own consent.
>
> —John Locke

Nozick

Nozick provides a detailed defense of Locke's view of the social contract. Like Locke, he believes that we all possess a natural right to life and property. We should be able to do what we want with what we own. In a state of nature, however, even those who recognize this right will sometimes come into conflict. What one person sees as fair, another will see as unfair. Because people tend to view themselves more favorably than they do others, "They will overestimate the amount of harm or danger they have suffered and passions will lead them to attempt to punish others more than proportionately and to exact excessive compensation."[75] To protect themselves from those who demand more than their fair share and to extract compensation from those who refuse to give it, Nozick claims that people would voluntarily join private protection agencies. If the parties to a dispute belong to different protective agencies, the agencies may do battle. After a number of such battles, there are three possible outcomes: (1) one agency wins most of the time, (2) different agencies win closer to their geographic center so that members of the different agencies move closer to their agency's base, or (3) battles are equally won among competing agencies so that they set up a court system to settle disputes. In each case, as the result of rational self-interest and voluntary cooperation, most people will end up living in an area where one agency or institution has a near-monopoly on the use of force. The state is often conceived as an organization that has a monopoly on the use of force in a geographic area. So private protection agencies would function like states.

> No state more extensive than the minimal state can be justified.
>
> —Robert Nozick

In the beginning, these agencies would not actually be states, however, because not everyone in the area would belong to an agency. If an agency

forced the independents to buy protection from it, it would violate their rights. But anarchists claim that every state must do this if it is to establish a monopoly on the use of force. Thus anarchists believe that all government is immoral, for only by violating people's rights can a government establish a monopoly on the use of force in an area.

Nozick contends, on the contrary, that a dominant protective agency can become a true state without violating anybody's rights. The principle of compensation says that those benefiting from a practice must compensate those harmed by it. So if the independents are harmed by not belonging to the dominant protective agency, the dominant protective agency must compensate them. And the least expensive way to compensate them would be to offer them free protection.[76] So a dominant protective agency could acquire a monopoly on the use of force in an area without violating anyone's rights.

The function of such a minimal state would be to protect its members' rights to life and property. It would prevent or punish physical harm, theft, or fraud, and it would enforce contracts. If it did anything more, however, it would violate people's rights. The state may legitimately require people to pay taxes for the armed services, the police force, and the judicial system because these institutions are needed to protect people's rights. But if a state requires people to pay taxes for any other purpose—such as welfare, Medicare, or Medicaid—it is acting immorally because it is violating its citizens' property rights. It is forcing them to part with their property against their will. According to Nozick, we are not our brother's keeper. We have a duty not to interfere in other people's lives, but we do not have a duty to provide them with what they need to live.

Nozick believes that any state that arose in the way he suggests would be morally justified. But is that correct? Consider the following scenario proposed by political scientist Karl Widerquist.

Thought Experiment

Widerquist's Libertarian Monarchy

Imagine an island called Britain. In the state of nature, all of the land is appropriated by individuals following whatever rule of appropriation a libertarian reader prefers. Economies of scale or astute entrepreneurship allow a relatively small number of proprietors to control most property. . . .

From a similar starting point, Nozick traces the development of government from voluntary for-profit protective associations. He shows that a government so constituted must be a minimal state. Nozick's argument is only applicable to a government so constituted, but a union of protective associations is not the only legitimate state. Suppose instead proprietors prefer to protect their own property without creating any protective associations. Propertyless people come to proprietors offering their labor in exchange for protection and access to resources. Each proprietor insists that tenants accept her as the arbiter of disputes. . . .

Proprietors enlarge the size of their estates through voluntary transfer and rectification. They trade, form strategic marriage alliances, defend themselves against aggressors, and use primogeniture in inheritance. Over the generations, estates become larger until one proprietor owns the entire island of Britain. At this time she decides to call herself "Queen" rather than "proprietor." She refers to her "estate" as her "realm," her "tenants" as "subjects," and her "royalties" as "taxes." But the nature of the Queen's revenue has not changed.[77]

Just as libertarian principles can't prevent the rise of corporate monopolies (because you can't prevent the owner of one corporation from selling to another), so they can't prevent the rise of monarchies. By the libertarian's own lights, then, a monarchy is just as legitimate a form of government as a democracy. But that's absurd. As Widerquist notes, "Monarchy—especially with strong, arbitrary powers—is anathema to most modern conceptions of justice. Liberals, communitarians, egalitarians, left-libertarians, democratic socialists, and the average person can make many consistent complaints against the property owning monarch."[78]

What has gone wrong? Many believe it's the libertarian's insistence that negative liberty—freedom from coercion—is the supreme value that takes precedence over all others. Even Nozick in his later years came to realize that this was a mistake. In *The Examined Life* he writes: "The libertarian position I once propounded now seems to me seriously inadequate, in part because it did not fully knit the humane considerations and joint cooperative activities it left room for more closely into its fabric."[79] Government need not be limited to protecting negative freedom. There are many other goals that a government may legitimately seek to realize, he says, including "equality for previously unequal groups, communal solidarity, individuality, self-reliance, compassion, cultural flowering, national power, aiding extremely disadvantaged groups, righting past wrongs, charting bold new goals (space exploration, conquering disease), mitigating economic inequalities, the fullest education for all, eliminating discrimination and racism, protecting the powerless, privacy and autonomy for its citizens, aid to foreign countries, etc."[80] It's up to the people to decide which goals get priority and how much weight to give each one. The fact that we try to address such goals in the political realm shows that we are bound to one another by ties of concern and solidarity. Some think that these ties deserve much greater attention than they are given in traditional ethical theories.

Thought Probe

Libertarian Government

The Libertarian political party seeks to pass laws that are consistent with the philosophy of libertarianism. Consequently it favors abolishing all entitlement programs, including welfare, Medicare, and Medicaid as well as the income tax. Do you think the United States would be a better place if the libertarian political party were in control of the government? Why or why not?

> ## In the News: Jillian's Choice
>
> In the book *Sophie's Choice,* by William Styron, the character Sophie Zawistowska is sent to a concentration camp and forced by a Nazi guard to make a terrible choice: "You may keep one of your children. The other one will have to go. Which one will you keep?"[81] The tsunami that occurred in the Indian Ocean on December 26, 2004, forced an Australian mother to make a similar choice:
>
>> Australian mother Jillian Searle faced an agonizing decision as a wall of water approached her on the Thai resort island of Phuket on Sunday.
>>
>> She had her two young children with her, but realized she would only survive if she let go of one of them.
>
> "I knew that if I held on to both, we would all die," she told reporters. "I just thought I'd better let go of the one that's the eldest."
>
> Fortunately all three survived and are now back in their home city of Perth.[82]
>
> ### Thought Probe
>
> Jillian's Choice
>
> According to utilitarianism, did Jillian do the right thing? Why or why not? According to Kantianism, did she do the right thing? Why or why not? According to the ethics of care, did Jillian do the right thing? Why or why not?

The Ethics of Care

> *I always wanted to be somebody. If I made it, it's half because I was game enough to take a lot of punishment along the way and half because there were a lot of people who cared enough to help me.*
>
> — ALTHEA GIBSON

Libertarians recognize no duties to others except the duty of noninterference. We may help others if we want to, but we are under no obligation to do so. Many have suggested that this is an impoverished view of our moral obligations. Specifically, they have argued that it fails to recognize the special duty of care we have to those who care for us.

Utilitarian and Kantian approaches to ethics, which emphasize impartiality, are blind to caring relationships. As we have seen, Godwin created something of a scandal when he suggested that a good utilitarian would rescue the archbishop—instead of his mother—from a burning building. Such a notion grates on our ethical sensibilities. When we have a special relationship with someone else—especially a relationship based on love, friendship, or trust—we may give that person special consideration.

The ethics of care grew out of psychologist Carol Gilligan's study of how men and women approach ethical issues. Gilligan was a colleague of Laurence Kohlberg, a developmental psychologist, who identified six stages of moral development:

1. *Punishment and obedience:* obeying authority to avoid punishment
2. *Self-interest:* making deals to benefit oneself
3. *Interpersonal accord and conformity:* being good to fit in
4. *Authority and social order:* obeying the law out of a sense of duty
5. *Social contract:* adhering to principles beneficial to society
6. *Universal ethical principles:* adhering to abstract principles that should apply to everyone

Kohlberg claims that these stages are universal—that the moral thinking of all humans develops in this manner—and that they are progressive; that is, those who reach the higher stages are making better moral judgments than those who remain at the lower ones.

Kohlberg developed his system by asking people of different ages how they would solve certain moral dilemmas. Typical of these dilemmas is the Heinz dilemma:

> In Europe, a woman was near death from a special kind of cancer. There was one drug that the doctors thought might save her. It was a form of radium that a druggist in the same town had recently discovered. The drug was expensive to make, but the druggist was charging ten times what the drug cost him to make. He paid $200 for the radium and charged $2,000 for a small dose of the drug. The sick woman's husband, Heinz, went to everyone he knew to borrow the money, but he could only get together about $1,000 which is half of what it cost. He told the druggist that his wife was dying and asked him to sell it cheaper or let him pay later. But the druggist said: "No, I discovered the drug and I'm going to make money from it." So Heinz got desperate and broke into the man's store to steal the drug for his wife. Should the husband have done that?[83]

Kohlberg was interested not in the particular solution the subjects offered but in the reasons they gave for their solution. He found that those reasons clustered into six categories that correspond to his six stages of moral development.

When Gilligan began studying women's moral development, she found that they rarely advanced to stage 6 but often remained in stages 3 or 4. In her search for an explanation of this finding, she discovered that Kohlberg's system had been based entirely on interviews with boys and men. Women's voices had not been part of the original dataset. In 1977, she published *In a Different Voice,* which critiqued Kohlberg's system and described the sort of considerations that women brought to bear on ethical issues.

Even if, as a matter of fact, people pass through Kohlberg's stages of moral development, Gilligan argued, it doesn't follow that the later stages are somehow better than the earlier ones. And, as we've seen, from the fact that something is the case, it doesn't follow that it should be the case. Wisdom does not necessarily come with age.

What's more, Gilligan found that whereas men tended to see ethical dilemmas in terms of rights and responsibilities, women tended to see them in terms of compassion and care. Men tended to be more concerned about whether justice had been served, whereas women tended to be more concerned about whether relationships had been preserved. Subsequent studies have found that the difference between men and women is not as pronounced as Gilligan suggested. A meta-analysis of seventy-nine studies of sex differences in moral reasoning found almost no difference between men and women when education and age differences were taken into account.[84] Nevertheless, it is generally agreed that caring is an important dimension of the moral life. We owe a duty of care to those who have cared for us, and this duty may sometimes override considerations of justice or rights.

Family isn't about whose blood you have. It's about who you care about.

—Trey Parker and
Matt Stone

Ross recognizes that all of our moral duties grow out of our relationships to others. His duty of gratitude is similar to the duty of care. But many who advocate an ethics of care claim that our concern for others shouldn't be limited to those with whom we have a close personal relationship. Personal relationships are part of a larger system of relationships, which makes up the communities in which we live. Without these communities, our personal relationships would not be possible. Thus the ethics of care is often linked to a communitarian ethic that sees communities as intrinsically valuable and thus deserving of our concern and care.[85]

Not all personal relationships generate a duty of care. Those based on violence, hatred, or disrespect need not be nurtured, nor must those characterized by injustice, exploitation, or oppression. When compassion, concern, and empathy are present, however, so are duties of care.

The duty to care for those who have cared for us can conflict with other duties we have. For example, if someone with whom you have a caring relationship (such as a spouse) is charged with a crime, you may legitimately try to protect that person from the law. The duty to protect those you care for varies, however, with the nature of the relationship and the situation. For example, if the accused is not your spouse but a long-lost friend, and if you have reason to believe that your friend is guilty, any attempt to protect her from the law may be unwarranted.

The ethics of care is not a full-blown ethical theory because it does not purport to solve all ethical problems. It simply hopes to emphasize an aspect of the moral life that is often overlooked by the more traditional theories. In this way, it can give us a richer sense of what it means to act morally.

Thought Probe

Lying with Care

Suppose that your best friend stole, from a company that you work for, some medicine that he needed but couldn't afford. Should you lie to protect him from the law? What if he stole something that he didn't need, like a CD player? Should you lie to protect him in that situation?

Making Ethical Decisions

Unless someone like you cares a whole awful lot, nothing is going to get better. It's not.

—Dr. Seuss

None of the major theories we've canvassed—utilitarianism, Kantianism, contractarianism, or caring—provides a complete account of morality. Nevertheless, each of them identifies an important aspect of it. Other things being equal, we should promote the common good, respect individual rights, treat others fairly, and care for those who care for us. Instead of viewing one of these principles as the basis of all morality, we should view all of them as criteria of adequacy that morally correct actions should try to meet. They are the factors that should be taken into account when trying to decide on the right course of action.

If an action promotes the common good, doesn't violate anyone's rights, treats people fairly, and exhibits appropriate care, it is morally permissible.

Problems arise when these principles conflict with one another. If the only way to promote the common good is to violate someone's rights, for example, we have to decide whether the violation is worth it.

Ross suggests that judging the rightness of an action is like judging the beauty of an artwork. A more appropriate analogy would seem to be judging the truth of a theory because that sort of judgment is also governed by objective criteria of adequacy. As we have seen, in deciding which theory is most likely to be true, we appeal to such criteria as simplicity, scope, conservatism, and fruitfulness because they indicate the extent to which a theory systematizes and unifies our knowledge. Similarly, in deciding which action is most likely to be right, we appeal to such criteria as utility, rights, justice, and care because they indicate the extent to which an action fulfills our obligations.

We can't quantify how well a theory or an action does with respect to any particular criterion of adequacy, nor can we rank the criteria of importance. Nevertheless, the choice between theories and actions is an objective one because the criteria on which the choice is based can be specified without referring to anyone's mental states. Deciding what to do, then, is no less objective than deciding what to believe.

What, then, is the procedure for arriving at a moral judgment? There are four major steps involved, and they can be represented by the acronym **I CARE.**

1. *I*dentify the relevant facts.
2. *C*onsider the *A*lternative courses of action.
3. *R*ate the various alternatives in terms of the moral criteria of adequacy.
4. *E*ffect a decision based on the rating.

Let's consider each of these steps in turn.

1. *Identify the relevant facts.* Moral judgments, as we've seen, follow from moral principles together with factual claims. Many moral disagreements are about the facts of the case rather than the principles involved. To minimize disagreement, then, the first step in making a moral judgment is identifying the relevant facts.

2. *Consider the Alternative courses of action.* When faced with a moral dilemma, there are usually a number of different actions you can perform. The problem is deciding which one of those actions is best from an ethical point of view. To make sure you haven't overlooked a possible course of action, you should take the time to consider all of the different options available to you. This involves not only identifying the different courses of action, but also considering their consequences. Who is going to be affected by the decision? How will they be affected? Those affected by a decision are known as "stakeholders." So good ethical decision making involves identifying the possible courses of action, identifying the stakeholders, and considering the effects that different actions will have on them.

3. *Rate the various alternatives in terms of the moral criteria of adequacy.* Once the relevant facts are known and the possible courses of action have been specified,

the next step is to rate the different actions in terms of the ethical criteria of adequacy—namely, utility, rights, justice, and caring. How well does each action do in terms of maximizing happiness, respecting rights, treating equals equally, and exhibiting care? If one action rates higher than every other in terms of these criteria, then it clearly is the morally correct thing to do. If an action is in the best interest of everyone involved, if it doesn't violate anyone's rights, if it doesn't treat anyone unfairly, and if it cares for those who deserve it, it is morally permissible. It may turn out that no one action does best with respect to all of these criteria, however. The action that produces the most happiness may violate the most rights. Or the action that is the most just may be the most callous. Here is where you must use your judgment. You must weigh the different factors and decide which action comes out best overall. There's no formula that you can use to make such a decision, but this doesn't make ethical decision making any less objective than scientific decision making because scientists, too, must use their judgment to determine which theory does best with regard to cognitive criteria of adequacy such as simplicity, scope, conservatism, and fruitfulness. The simplest scientific theory may be the least conservative. Or the most fruitful theory may have the least scope. To decide which is best, scientists must use their judgment.

What often goes unnoticed is that the criteria of adequacy used to decide among competing scientific theories are themselves values. So arriving at a decision as to which scientific theory is best is making a value judgment. As Hilary Putnam notes,

> . . . *coherence and simplicity* and the like are themselves values. To suppose that "coherent" and "simple" are themselves just emotive words—words which express a "pro attitude" toward a theory, but which do not ascribe any definite properties to the theory—would be to regard *justification* as an entirely subjective matter. On the other hand, to suppose that "coherent" and "simple" name *neutral* properties—properties toward which people may have a "pro attitude," but there is no objective rightness in doing so—runs into difficulties at once. Like the paradigm value terms (such as "courageous," "kind," "honest," or "good"), "coherent" and "simple" are used as terms of praise. Indeed, they are *action guiding* terms: to describe a theory as "coherent, simple, explanatory" is, in the right setting, to say that acceptance of the theory is justified; and to say that acceptance of a statement is (completely) justified is to say that one ought to accept the statement or theory.[86]

Scientists are in the business of trying to decide what we should believe if we want to avoid error and falsehood; ethicists are in the business of trying to decide what we should do if we want to avoid injustice and wrong. Both are in the business of making value judgments, and both do so in the same way: by weighing various options in terms of criteria of adequacy relevant to the decision.

4. *Effect a decision based on the rating.* Once you've identified the best action to perform in the situation, the final step is to perform it. After you've performed it, however, you should continue to monitor the situation to see whether things turned out the way you planned. If not, you need to analyze the situation to determine what went wrong. You can then use the results of that analysis so that you don't make the same mistake in the future.

Thought Probe

The Zygmanik Brothers

Use the I CARE procedure to determine whether Lester did the right thing in killing his brother George. Was this the best action in the circumstances? Why or why not?

Summary

Formalist (deontological) ethical theories claim that the rightness of an action is determined not by its consequences but by its form. Foremost among such theories is Kant's categorical imperative. Kant's first formulation of the doctrine says that what makes an action right is that it is based on a principle that everyone could act on, and you would be willing to have everyone act on it. But this formulation of the categorical imperative does not provide a sufficient condition for morality because it permits obviously immoral acts. There are people who are willing to live in a world governed by principles (like "Kill all the Jews") that are universalizable and reversible but are nevertheless immoral.

Kant claims that the categorical imperative establishes the existence of a number of perfect duties to oneself and to others. Perfect duties admit no exceptions and include the duty not to kill innocent people and the duty to keep one's promises. But Kant's perfect duties cannot be followed in every situation, for they can conflict with other duties we have. If keeping our promise to meet someone, for example, would mean that people would die, then it would be immoral to keep our promise.

Kant's second formulation of the categorical imperative says that what makes an action right is that it treats other people as ends in themselves and not merely as means. The insight here is that all persons are inherently valuable. But sometimes treating people merely as means is unavoidable or necessary to prevent even more people from being treated merely as means. The right thing to do in many situations is the lesser of two evils.

W. D. Ross tries to deal with the problem of conflicting duties by positing *prima facie* duties (those we're obligated to perform in every situation unless they conflict with other *prima facie* duties). The problem is that under this scheme, one and the same action can fall under conflicting duties. When this happens, Ross claims, we should make a "considered decision" about which duty has priority. According to pluralistic formalism, then, what makes an action right is that it falls under the highest-ranked *prima facie* duty in a given situation. Unfortunately, Ross does not tell us what sort of considerations are relevant to ranking our duties.

Rawls tries to overcome the deficiencies of traditional formalist approaches to ethics by specifying a procedure for arriving at an ideal social contract. In the "original position," the parties to the contract would operate behind a "veil of ignorance": they would not know their race, sex, natural abilities, religion, interests, social position, or income. This lack of knowledge guarantees their impartiality. People in the original position would agree to three principles: the principle of equal liberty, the principle of fair equality of opportunity, and the difference principle.

To achieve the distribution of goods mandated by the difference principle, government would have to interfere in the lives of its citizens. Nozick considers this interference a violation of individual rights and proposes a libertarian theory of justice: from each as they choose, to each as they are chosen. But this approach to justice ignores the duties of care that we have to those who care for us.

Utility, rights, justice, and care can be viewed as criteria of adequacy for right actions. The right action to perform in any situation is the one that does best with respect to these criteria.

Study Questions

1. What is the first formulation of the categorical imperative?
2. What are perfect duties?
3. What are imperfect duties?
4. What is Hare's Nazi fanatic thought experiment? How does it attempt to undermine the categorical imperative?
5. What is Ross's Good Samaritan thought experiment? How does it attempt to undermine the categorical imperative?
6. What is the second formulation of the categorical imperative?
7. What is Broad's typhoid man thought experiment? How does it attempt to undermine the categorical imperative?
8. What is Ewing's prudent diplomat thought experiment? How does it attempt to undermine the categorical imperative?
9. What is pluralistic formalism?
10. What procedure does Rawls believe will generate ideal principles of justice?
11. What principles of justice does Rawls' procedure sanction?
12. What is the ethics of care?

Discussion Questions

1. Would you be willing to kill an innocent person if it would put an end to world hunger? Why or why not?
2. Suppose you are a soldier peering down the sight of a bazooka at an enemy tank with six innocent civilians strapped to the outside. Should you fire your bazooka knowing that you will probably kill all the civilians but may not stop the tank? Why or why not?
3. Should we use torture to extract military secrets from prisoners of war? Why or why not?
4. Is Kant right in claiming that it is our duty to execute murderers? Why or why not?
5. Suppose it were discovered that when dolphins are tortured to death, they excrete a very powerful narcotic that, when ingested, makes people feel better than they've ever felt before. Would it be right to torture dolphins to death to get this narcotic? Why or why not?

6. Is homosexuality between consenting adults immoral? If so, what moral principle does it violate?
7. Because the poorest group in society is getting poorer, is American society unjust? Should we alter the welfare system so that it maximizes the position of that group?
8. Are taxes for entitlement programs such as welfare, Medicare, and Medicaid immoral? Why or why not?
9. Consider this theory of morality: "An action is right if and only if (1) it does not violate anyone's autonomy (freedom of choice) unless it is necessary to prevent an overwhelming loss of autonomy and (2) it maximizes as much happiness as is consistent with (1)." Is this an adequate theory of morality? Why or why not? Can you think of any thought experiments that would refute it?
10. Using the ICARE method for resolving ethical disputes described in the chapter, decide whether the following policies are ethical:

 - Legalizing prostitution
 - Allowing teachers to carry firearms in schools
 - Giving amnesty to illegal immigrants
 - Using physical performance-enhancing drugs in professional sports
 - Using cognitive performance-enhancing drugs in school

11. Some think that the most pressing civil rights issue of the twenty-first century will be whether we should grant rights to artificially intelligent beings. To decide this issue fairly, some have proposed a "moral Turing test" in which normal humans and the entity being tested are presented with various ethical dilemmas and are asked to solve them and to give their reasons for choosing the solution they did.[87] If the judges can't tell which solutions were produced by humans and which were produced by the machine, the machine should be considered a moral agent and granted the same rights that we enjoy. Should passing such a test be a sufficient reason for granting something moral rights? Why or why not?

Internet Inquiries

1. Kant did not believe in animal rights, but must a Kantian take that position? Can there be a deontologically based theory of animal rights? To explore this issue, enter "Kant" and "animal rights" into an Internet search engine.
2. Are victimless crimes immoral? Should they be made legal? Explore this issue by entering "victimless crimes" into an Internet search engine.
3. Do we have a moral duty to help the needy in foreign countries? To find the implications of Rawls' theory for this issue, enter "Rawls" and "poverty" into an Internet search engine.

Section 5.4

Character Is Destiny
Virtue Makes Right

> *If you can be well without health, you may be happy without virtue.*
>
> — Edmund Burke

In addition to judging actions to be morally right or wrong, we also judge people to be morally good or bad. Morally good people are virtuous people; they are people who regularly try to do their duty. They may not always succeed, but at least their hearts are in the right place.

Utilitarianism and Kantianism provide differing conceptions of the virtuous person. According to act-utilitarianism, a virtuous person is one who always tries to maximize happiness. According to Kantianism, a virtuous person is one who always tries to obey the categorical imperative. The utilitarian conception of a morally good person has been attacked on the grounds that it is unattainable. The Kantian conception has been attacked on the grounds that it is undesirable. And both have been attacked on the grounds that they are not conducive to a good life.

The Virtuous Utilitarian

> *Men do less than they ought unless they do all that they can.*
>
> — Thomas Carlyle

A committed act-utilitarian values happiness above all else—not her own happiness, but happiness in general. Consequently, she tries to produce as much of it as she can in everything that she does. If she does something that does not produce the most happiness possible, she has done wrong. This makes it almost impossible for anyone to do right.

Suppose you wanted to buy a one-dollar soft drink. Doing so would be morally permissible only if there were nothing else you could do with that dollar that would produce more happiness. But certainly there is. You could give it to UNICEF, for example, and feed a number of starving children. The happiness the children would experience from being fed would undoubtedly be greater than the happiness you would experience from drinking a soda. Thus it would be wrong for you to buy the soft drink. As long as there were starving or suffering people in the world, it would be wrong for you to spend any more

money on yourself than necessary to prevent your own starvation or suffering. Purchasing a fancy car or an expensive stereo system would definitely be immoral.

Because most of us do not think it immoral to spend money on ourselves, utilitarianism doesn't jibe with our ordinary conception of morality. We usually have little difficulty distinguishing between those actions that it is our duty to perform and those that go above and beyond the call of duty. It is not our duty to help someone across the street, for example, but it is usually good to do so. Actions that do more than is required—that go above and beyond the call of duty—are referred to as **supererogatory actions**. Utilitarianism has no place for supererogatory actions. If it would be better to do something than not to do it—if doing it would produce more happiness than not doing it—we are morally obligated to do it. Because such self-sacrifice is beyond most of us, utilitarianism seems to advocate an impossible ideal.

Thought Probe

Giving to Charity

According to utilitarianism, the moral thing to do in any situation is that which maximizes happiness. Since giving to charity will almost always produce more happiness than spending money on yourself, utilitarianism would have it that you should give a good deal of your money to charity. Such a view may seem counterintuitive, but Peter Singer claims that it's morally correct. His argument is straightforward: "(1) If we can prevent something bad without sacrificing anything of comparable significance, we ought to do it. (2) Absolute poverty is bad. (3) There is some absolute poverty we can prevent without sacrificing anything of comparable moral significance. (4) Therefore, we ought to prevent some absolute poverty."[88] Singer reportedly gives away about 20 percent of his income to charity. Are those who don't give at that level doing something wrong? Are they bad people? Why or why not?

The Virtuous Kantian

A committed Kantian lives his life by the categorical imperative. Because the categorical imperative recognizes that we have certain duties to ourselves, such as the duty to develop our own talents, it does not require the same sort of self-sacrifice that utilitarianism does. Nevertheless, Kantianism requires that we always act out of a sense of duty, and that, it has been claimed, is not always a good thing. Michael Stocker brings this out in the following thought experiment about a hospitalized person who is visited by a friend.

Who escapes a duty, avoids a gain.

—Theodore Parker

supererogatory action An action that goes above and beyond the call of duty.

Thought Experiment

Stocker's Hospitalized Patient

You are very bored and restless and at loose ends when Smith comes in once again. You are now convinced more than ever that he is a fine fellow and a real friend—taking so much time to cheer you up, traveling all the way across town, and so on. You are so effusive with your praise and thanks that he protests that he always tries to do what he thinks is his duty, what he thinks is best. You at first think he is engaging in a polite form of self-deprecation, relieving the moral burden. But the more you two speak, the more clear it becomes that he was telling the literal truth: that it is not essentially because of you that he came to see you, not because you are friends, but because he thought it his duty, perhaps as a fellow Christian or Communist or whatever, or simply because he knows of no one more in need of cheering up and no one easier to cheer up.[89]

Even though Smith acted out of duty, there seems to be something missing from Smith's action. What's missing, Stocker suggests, is a concern for the hospitalized person himself.

A respect for persons lies at the heart of Kant's ethics. But it is a respect for persons in the abstract—for persons considered as rational beings—not for individual persons. And without a concern for individual persons, claims Stocker, we cannot realize the great goods of love, friendship, affection, fellow-feeling, and community.[90]

There is not a moment without some duty.
—CICERO

Stocker would have us believe that acting out of duty precludes acting out of concern for the individual. But it can be argued, on the contrary, that acting out of duty requires a concern for the individual. You can't understand your duties unless you have a concern for people as individuals.

Some people have no concern for others. As a result of neglect, abuse, or genetic or congenital defects, they have no compassion, no capacity for remorse, and no conscience. They are psychopaths. Psychopaths are often bright individuals who can converse intelligently about morals. But it is doubtful whether they are capable of acting morally, for it is doubtful whether they can fully understand what a duty is.

We learn how to act morally by interacting with others. Children who are shown sympathy, compassion, and love develop those qualities in themselves. These moral sentiments are essential to an understanding of moral duty, for they allow us to empathize with others—to "get inside their skins," so to speak—and thus to fully comprehend the effects of our actions. Only those who can empathize with others can be connected to them by bonds of affection, friendship, and love. And only those who can be connected to others in these ways can understand the duties associated with these connections.

An analogy may be helpful here. Someone who is red color-blind may be able to talk intelligently about red things. But because he has never experienced the sensation of redness, he cannot have a complete understanding of what it means for something to be red. Similarly, someone who has no

fellow-feeling may be able to talk intelligently about right actions, but he cannot have a complete understanding of what it means to be right. Such a person, says Arthur Murphy,

> ... could "regard an action as a duty" in the sense of recognizing perhaps with complete practical indifference that it had the traits by which an action is socially identified as "right." ... What he could never in this way "see" is how such rightness bound him as a moral agent to the performance of the action in question. ... He could not understand why he ought to do it.[91]

So a concern for persons as individuals, far from being irrelevant to an understanding of our duties, is essential to it.

Stocker is right that what is missing in the situation described in his thought experiment is a concern for the individual. But this is not a fault of the ethics of duty; it is a fault of Smith. Smith has no empathy for the person in the hospital. As a result, he can't fully understand his duty as a friend. But if he can't fully understand his duty as a friend, he can't act out of a sense of duty. The problem with Smith, then, is not that he is acting only out of a sense of duty, but that he is acting out of an impoverished sense of duty.

Children without a Conscience

Children who are severely neglected as infants often grow up to be psychopaths. They have no concern for others, no feelings of remorse or guilt, no conscience. Some consider them to be a serious threat to civilized society. Tom Keogh explores this problem.

> Angela's disturbing behavior problems were apparent almost from the day the six-year-old foster child came to live with Jean and Mike Walsh in 1989. ... "She would have three- to four-hour temper tantrums every day," recalls Jean. "She flung herself against walls, tore wallpaper down, couldn't function at school or get along with classmates. She nearly strangled our cat, kicked and tormented the dog. She had no friends. She was cruel to her brother and periodically threatened to kill me."
>
> ... therapists and social service professionals are now seeing more and more children with histories of early childhood abuse or neglect who exhibit the same severe antisocial tendencies—indications of what therapists refer to as an "attachment disorder." According to experts in this emerging field, the condition is caused when the normal bonding process between infant and primary caregiver does not properly occur. Instead of an initial human experience that teaches them to love and trust others, these "unattached" infants learn to trust only themselves, becoming inwardly isolated and emo-tionally unapproachable. As infants they may stiffen to the touch; in later childhood, they may act out a range of violent and remorseless behaviors. Lacking the empathy needed to establish healthy relationships with others, they have been described as "children without a conscience."[92]

Thought Probe

Empathy and Agency

Can someone without a conscience—without the ability to empathize with others—act morally? Can he or she be a moral agent? If not, what should we do with these people?

The Purpose of Morality

> A man does what he must in spite of personal consequences, in spite of obstacles and dangers and pressures and that is the basis of all human morality.
>
> —JOHN F. KENNEDY

If doing our duty required us to neglect ourselves, then there would be something seriously wrong with an ethics of duty: Being a good person should not prevent us from leading a good life. On the contrary, moral actions should promote both the individual good and the collective good.

We need morality because if there were no constraints on behavior, it is unlikely that most of us would be able to achieve our goals. Kurt Baier explains:

> ... people's interests conflict. In such a case, they will have to resort to ruses to get their own way. As this becomes known, men will become suspicious, for they will regard one another as scheming competitors for the good things in life. The universal supremacy of the rules of self-interest must lead to what Hobbes called the state of nature. At the same time, it will be clear to everyone that universal obedience to certain rules overriding self-interest would produce a state of affairs which serves everyone's interest much better than his unaided pursuit of it in a state where everyone does the same. Moral rules are universal rules designed to override those of self-interest when following the latter is harmful to others.[93]

To ensure that everyone has an equal opportunity for a good life, morality requires us to refrain from doing certain things that we otherwise might want to do.

A system of moral rules works to everyone's benefit only if most people live by it. One way to make people obey the moral law is to threaten them with punishment if they disobey. But it's doubtful that this method alone can be entirely successful. Punishment breeds resentment, and if those being punished aren't motivated by something other than the fear of punishment, the system will probably not survive for long.

Another way to get people to act morally is to cultivate their moral sentiments. People who have compassion, sympathy, and trust want to do good, and they feel guilt, shame, or remorse if they don't. These people don't need the external threat of punishment to act morally. Their motivation comes from within. Through proper training, they not only acquire moral sentiments, but they also acquire certain habits or dispositions to behavior. These habits or dispositions are known as virtues.

Aristotle on Virtue

> If you would create something, you must be something.
>
> —GOETHE

virtue An admirable human quality marked by a disposition to behave in certain ways in certain circumstances.

A **virtue** is an admirable human quality either because it's good for the person who has it or because it's good for other people. A virtuous person has acquired a habit—a disposition to act in certain ways in certain situations. Those who habitually act in a virtuous manner not only are good people, but according to Aristotle, they also lead good lives.

Aristotle was one of the first to provide a systematic account of the virtues. He realized that human actions are undertaken for a purpose—they aim to achieve some end—because that end is considered valuable. But if every end were only instrumentally valuable as a means to some further end, we would be caught in an infinite regress and our desires would never be satisfied. So there

must be some end that is intrinsically valuable — valuable for its own sake — that serves as the goal of all human activity. That end, Aristotle claims, is happiness.

Different people have different conceptions of happiness, however. To identify the correct conception, Aristotle suggests that we discover the proper function of human beings. Individual people, such as carpenters and plumbers, have functions, and what makes them good carpenters or good plumbers is that they perform their function well. Similarly, says Aristotle, good human beings perform their function well.

How can we discover the function of human beings? By identifying what's unique to them. What distinguishes a knife from all other tools is that it cuts well, and cutting is its function. So, according to Aristotle, if we can discover what distinguishes humans from other creatures, we can discover their function.

Living can't be our function because that trait is shared by both plants and animals. Nor can sensing things be our function because higher animals can do that as well. Our ability to reason, however, seems to be unique to us. So, Aristotle concludes, our function is to reason, and happiness is attained through the use of reason. If you don't exercise your reasoning ability, you're not realizing your full potential and are missing out on the greatest good humans can attain. Even the utilitarian John Stuart Mill recognized that happiness produced by reason was better than happiness produced by sensation. Remember his saying: "It is better to be a human being dissatisfied than a pig satisfied."

ARISTOTLE
384–322 B.C.

Aristotle: Pillar of Western Thought

Aside from Plato, there is none greater in the history of philosophy than Aristotle (384–322 B.C.). At age seventeen, he entered Plato's Academy, learned much from his master, and left the Academy when Plato died. After Plato's death he traveled about in the region, conducting biological research and eventually becoming the tutor of Alexander the Great in Macedonia. In 335 B.C. Aristotle went back to Athens and founded his own school, the Lyceum, in a grove outside the city on a site thought to be sacred to the god Apollo Lyceius.

At first glance, he probably did not seem like a fellow who could change the world: He was said to be bald and thin with a decided lisp in his speech. But he set Western civilization on a course that is still followed to this day. He established the first great library of antiquity and created the categories of philosophical and scientific inquiry that we know today: physics, logic, ethics, psychology, metaphysics, political science, and more. He was interested in almost everything — and studied almost everything. He was the first to organize and systematize the field of logic, charting out the distinctions between valid and invalid inferences and creating the field's technical vocabulary. For the next two thousand years, when students and philosophers studied logic, they essentially took a course of study that Aristotle designed.

Aristotle made contributions to just about every important branch of philosophy. In many of those areas — especially ethics, metaphysics, and political science — Aristotle's ideas are still influential.

In philosophy, he took a different road than Plato had, though he had great respect for his wise teacher. Plato insisted that true knowledge could not be gained by extracting data from the material world, as scientists do. He thought that knowing could be achieved only by using reason to reach the nonmaterial, other-worldly realm of transcendental ideas. Aristotle, though, believed that this world of experience — the data of our senses — can indeed be a source of knowledge. Centuries later, science achieved incredible feats because it tended to follow the path of Aristotle, not that of Plato.

SOME ARISTOTELIAN VIRTUES AND VICES

Defect (vice)	Virtue	Excess (vice)
Cowardice	Courage	Rashness
Apathy	Gentleness	Short temper
Stinginess	Generosity	Extravagance
Humility	High-mindedness	Vanity
Grouchiness	Friendliness	Flattery
Boorishness	Wittiness	Buffoonery
Self-deprecation	Truthfulness	Boastfulness
Shamelessness	Modesty	Bashfulness
Ill Will	Righteous indignation	Envy
Insensibility	Self-control	Debauchery

Nevertheless, this portion of Aristotle's ethical theory has not been particularly well received. Many have pointed out that from the fact that every action aims at some end, it doesn't follow that there is an end at which all actions aim; just as from the fact that everyone has a mother, it doesn't follow that there is someone who is everyone's mother. Human activity aims at a number of different ends. Happiness may be the result of attaining those ends, but it is not the sole object of our desire. (Recall Feinberg's single-minded hedonist.)

What's more, the notion that human beings have a function, and that this function can be identified with what is unique to us, has also been criticized. Humans have many unique properties. Theologian Paul Tillich claims that humans are the only creatures that can experience anguish. Philosopher Henri Bergson claims that humans are the only creatures that laugh. And theologian Reinhold Niebuhr claims that humans are the only creatures that are constantly in heat. None of these features constitutes our function, and exemplifying them would not necessarily be good.

The aspect of Aristotle's ethics that still has adherents to this day is his notion that virtues are necessary to lead a good life. A good life requires many things: good health, a good job, good friends, a good family, and the like. To attain these goods, we should cultivate those ways of behaving—those habits—that are most likely to help us attain them. Those habits are virtues.

Who sows virtue reaps honor.
—LEONARDO DA VINCI

Aristotle recognizes two types of virtues: intellectual and moral. Intellectual virtues are dispositions, such as wisdom and understanding, which help us to discover the truth. Moral virtues are dispositions, such as courage, temperance, friendliness, and justice, which help us to avoid the problems caused by overdoing or underdoing. For Aristotle, a good life is a balanced life. Those who keep themselves on an even keel are more likely to achieve the ultimate goal of happiness than those who go overboard. Virtues keep us from losing our balance.

Aristotle thinks that bad people have too much or too little of something. For example, if we have too much fear, we suffer from the vice of cowardice. If we have too little fear, we suffer from the vice of foolhardiness. But if we maintain the proper balance between cowardice and foolhardiness, we enjoy

the virtue of courage. Aristotle's theory of virtue is often referred to as the "golden mean" because its purpose is to help us find the mean (the middle point) between the extremes of excess (too much) and defect (too little).

Intellectual virtues, Aristotle claims, differ from moral virtues in that they can be taught in the classroom. Moral virtues are skills, however, so they can be learned only by doing. As Aristotle puts it,

> Where doing or making is dependent on knowing how, we acquire know-how by actually doing. For example, people become builders by actually building, and the same applies to lyre players. In the same way, we become just by doing just acts; and similarly with "temperate" and "brave."[94]

This insight has important implications for moral education. If we expect our children to acquire the virtues necessary for a just society, we must encourage them to engage in activities that foster a sense of justice.

Aristotle considers every social skill that is conducive to a good life a moral virtue. This is not a particularly apt classification, however, because having such virtues does not necessarily make you a good person. Dracula (Vlad Tepes), for example, was courageous, disciplined, and temperate and yet was one of the most evil people who has ever lived. Courage, discipline, and temperance are admirable qualities—they may even be necessary for being a good person—but they aren't sufficient.

The virtues that make you a morally good person are those that involve acting in accord with duty. Justice, for example, is a good-making virtue because you are just only if you act in accord with the duty of justice. Similarly, benevolence is a good-making virtue because you are benevolent only if you act in accord with the duty of benevolence. Because the purpose of morality is to constrain certain sorts of self-interested behavior, the truly moral virtues are those, like justice and benevolence, that involve action on behalf of others.

By doing our duty, we learn to do it.

—E. B. Pusey

The Buddha on Virtue

The notion that the best life is a balanced life is not unique to Aristotle. The Buddha also taught that a good person should tread a middle path between too much and too little. Here is an excerpt from the Buddha's first sermon:

> Bhikkhus (beggars or monks), these two extremes ought not to be practiced by one who has gone forth from the household life. What are the two? There is devotion to the indulgence of sense-pleasures, which is low, common, the way of ordinary people, unworthy and unprofitable; and there is devotion to self-mortification, which is painful, unworthy and unprofitable.

> Avoiding both these extremes, the Tathagata (the enlightened one) has realized the Middle Path: it gives vision, it gives knowledge, and it leads to calm, to insight, to enlightenment, to Nirvana. And what is that Middle Path . . . ? It is simply the Noble Eightfold Path, namely, right view, right thought, right speech, right action, right livelihood, right effort, right mindfulness, right concentration. This is the Middle Path realized by the Tathagata, which gives vision, which gives knowledge, and which leads to calm, to insight, to enlightenment, to Nirvana.[95]

The Stoics on Virtue

Virtues are character traits that help us lead a good life. But is there more to leading a good life than just being virtuous? Aristotle thought so. He writes:

> It seems clear that happiness needs the addition of external goods, as we have said; for it is difficult if not impossible to do fine deeds without resources. Many can be done as it were by instruments—by the help of friends or wealth, or political influence.[96]

For Aristotle, then, in addition to being a person of good character, leading a good life requires acquiring certain external goods like friends, wealth, or political influence.

The Stoics disagree. For them, virtue is its own reward. External goods are not needed to lead a good life. In fact, external goods can prevent us from leading a good life if, for example, their pursuit or loss harms us. According to the Stoics, then, virtue alone is both necessary and sufficient for human flourishing. Such a view may seem counterintuitive. But the Stoics have an analysis of the human condition that many have found compelling.

Stoicism as a philosophical movement began around 300 B.C.E. when Zeno of Citium (the town in Cyprus where he was born) began discussing it on a painted porch overlooking the Athenian marketplace. ("Stoa" means porch in Greek.) Stoicism became the dominant philosophy in ancient Rome and received its most eloquent expression at the hands of Roman writers such as Seneca (tutor and advisor to the emperor Nero), Epictetus (slave turned free man), and Marcus Aurelius (emperor and military leader). It has served as the inspiration behind a number of effective psychotherapies, such as rational emotive behavior therapy and cognitive behavior therapy, and has recently been enjoying a popular resurgence following the creation of numerous online communities, the publication of a spate of new books, and the celebration of the first International Stoic Week in 2012.

Stoicism maintains that leading a good life requires living in accord with nature. This means not only that we should "go with the flow" so to speak and accept what nature throws at us without bitterness or resentment, but also that we should use our natural endowments—specifically our reason—to help us realize what is truly in our best interest. A good life must be grounded in reality. Our actions are based on our beliefs, and if those beliefs are mistaken, our actions are likely to be misguided. Only if our worldview is reasonable, then, can we hope to lead a good life.

One undeniable fact about the world that all reasonable people recognize is that some things are under our control and some things are not. So important is this fact for the Stoic way of life that Epictetus begins his handbook with it:

> Some things are in our control and others not. Things in our control are opinion, pursuit, desire, aversion, and, in a word, whatever are our own actions. Things not in our control are body, property, reputation, command, and, in one word, whatever are not our own actions.[97]

The only things we have complete control over are the products of our minds: things like opinions, beliefs, desires, attitudes, and judgments. Everything

else—like wealth, fame, and power—are beyond our control. The Stoics realized that if we spend our time pursuing things that are not under our control, we are setting ourselves up for failure and frustration.

• If we seek what we cannot control, we lose control of our lives and miss the opportunity to acquire the only things that are truly valuable: the virtues. Epictetus explains:

> Remember that following desire promises the attainment of that of which you are desirous; and aversion promises the avoiding that to which you are averse. However, he who fails to obtain the object of his desire is disappointed, and he who incurs the object of his aversion wretched. If, then, you confine your aversion to those objects only which are contrary to the natural use of your faculties, which you have in your own control, you will never incur anything to which you are averse.[98]

If we desire only those things that are under our control and ignore those that aren't, we'll never be disappointed. Our happiness will be solely up to us and we'll no longer be a hostage to fortune.

Becoming indifferent to the things that are not under our control and accordingly leading a good life requires virtue. The Stoics recognized four cardinal virtues: temperance, justice, courage, and wisdom. One who has cultivated these virtues will act with self-restraint, will treat others fairly, will face dangerous situations courageously, and will choose their activities wisely. Virtuous people are not fazed by the vicissitudes of life. They are able to endure hardship with equanimity and calm.

The key to acquiring these virtues, say the Stoics, is eliminating the passions. Passions are excessive impulses toward things or away from things. The Stoics recognized four primary passions: desire, which is an impulse toward an anticipated thing regarded as good; fear, which is an impulse away from some anticipated thing which is regarded as bad; delight, which is an impulse toward a present thing regarded as good; and distress, which is an impulse
• away from some present thing regarded as bad. The way to eliminate the passions is to realize they are based on false judgments.

One of the Stoics' greatest insights—and one that has been confirmed by modern psychology—is that all passions involve judgments. How we experience a passion as well as how we react to it is determined by the judgments we make. In other words, all emotions have a cognitive component; they are based on our beliefs about the way the world is. If those beliefs are mistaken, then the emotion is unjustified and inappropriate.

For example, take the case of anger. You will feel anger toward someone only if you believe both that they mistreated you and that the mistreatment was bad for you. If you didn't think they mistreated you, or if you didn't think what they did was bad for you, you wouldn't be angry with them. The mistaken judgment behind all the passions, according to the Stoics, is that something external to us—something over which we have no control—can be good or bad. The Stoics believe, on the contrary, that external objects are neither good nor bad in themselves, and thus any judgment to the effect that they are is mistaken. By using our reason, then, we can learn to become indifferent to those things that are not under our control and make our happiness depend on those things that are. In this way we can achieve the special sort of

joy, confidence, and inner peace that comes from being in control of our lives. Thus while true Stoics may be without passion, they are not without feeling.

But, you might object, how can external goods be neither good nor bad? Aren't wealth, fame, power, and the like good things? Doesn't their possession further our projects and their lack hinder them? The Stoics wouldn't deny that these things are preferable to their opposites and thus have some value. But they would argue that these things are not intrinsically good—good in and of themselves. They are, at best, only conditionally good—good in some circumstances—and thus not, strictly speaking, good. The Stoics refer to these desirable external goods as "preferred indifferents," and their opposites, "unpreferred indifferents."

Preferred indifferents like wealth, fame, and power are not unconditionally good because under certain conditions, they can be bad for their possessors. The great Roman orator, Cicero, was well aware of this:

> I never was one who reckoned among good and desirable things, treasures, magnificent mansions, interest, power or those pleasures to which mankind are most chiefly addicted. For I have observed that those to whom these things abounded, still desired them most: for the thirst of cupidity is never filled or satiated. They are tormented not only with the lust of increasing, but with the fear of losing what they have.[99]

Cicero never considered preferred indifferents to be good because he was well aware of the bad consequences they could bring about. Virtues, on the other hand, are unconditionally good because under no circumstances do they lead to bad consequences.

What's more, if external goods were necessary for a good life, then only those who possessed them could lead a good life. But not everybody has friends, wealth, political influence, and the like. Some are born into poverty, some have no access to education, some are victims of discrimination, etc. Aristotle would have us believe that these unfortunates cannot lead a good life. The Stoics would disagree. According to them, everybody is capable of leading a good life as long as they make reasonable judgments about what is valuable. The Stoic view of the good life, then, is much more egalitarian than Aristotle's.

The Stoics believe that everyone can acquire the virtues necessary for a good life. But since acquiring these virtues involves restraining some of our natural impulses, it requires practice. The Stoics developed a number of exercises to help cultivate the virtues (and many neo-stoics have posted additional ones online). For example, here's an affirmation that Marcus Aurelius recommended we repeat daily:

> When you wake up in the morning, tell yourself: The people I deal with today will be meddling, ungrateful, arrogant, dishonest, jealous, and surly. They are like this because they can't tell good from evil. But I have seen the beauty of good, and the ugliness of evil, and have recognized that the wrongdoer has a nature related to my own—not of the same blood or birth, but the same mind, and possessing a share of the divine. And so none of them can hurt me. No one can implicate me in ugliness. Nor can I feel angry at my relative, or hate him. We were born to

work together like feet, hands, and eyes, like the two rows of teeth, upper and lower. To obstruct each other is unnatural. To feel anger at someone, to turn your back on him: these are obstructions.[100]

By saying this to ourselves, we prepare for any eventuality and ensure that we will not be harmed, no matter what comes our way. And by recognizing the common heritage we share with all other human beings, we ensure that our dealings with them will be just. Acting virtuously, then, is not only good for the individual, it's good for society as well.

Thought Probe

Aristotle versus the Stoics on the Good Life

Who do you think is right about the good life: Aristotle or the Stoics? Do you agree with Aristotle that leading a good life is a privilege reserved for a select few, namely, those with the right sort of external goods and the right sort of character? Or do you agree with the Stoics that anybody can lead a good life regardless of their circumstances? Why?

MacIntyre on Virtue

Alasdair MacIntyre, dismayed at our apparent inability to come to any agreement on moral matters, has argued that it would be easier to reach consensus if we focused on what it is to lead a good life rather than on what it is to do the right thing. Because the function of morality is to enable each of us to lead a good life, our primary concern should be the conditions for human flourishing instead of the conditions for right action.

Following Aristotle, MacIntyre claims that to lead a good life, you have to be good at something. And to be good at something, you have to acquire certain skills. For example, to be a good surgeon, you have to know how to wield a scalpel. To fully realize the good that can come from engaging in the practice of medicine (or any practice for that matter), you have to have the proper motivation. Specifically, you can't be in it only for money or fame. Becoming rich or famous is a good of sorts, but it is a good that is *external* to the practice of medicine. The goods that promote human flourishing, according to MacIntyre, are those that are *internal* to a practice, like the good of healing, for acquiring these goods requires developing certain virtues. "The virtues," he says,

> are to be understood as those dispositions which will not only sustain practices and enable us to achieve the goods internal to practices, but which will also sustain us in the relevant kind of quest for the good, by enabling us to overcome the harms, dangers, temptations and distractions which we encounter and which will furnish us with increasing self-knowledge and increasing knowledge of the good.[101]

Virtues are the means by which we achieve the end: a good life.

Duty by habit is to pleasure turned.

—SAMUEL BRYDGES

> *The thought manifests as the word;*
> *The word manifests as the deed;*
> *The deed develops into habit;*
> *And habit hardens into character;*
> *So watch the thought and its ways with care,*
> *And let it spring from love Born out of concern for all beings . . .*
> *As the shadow follows the body,*
> *As we think, so we become.*
> — Buddha

To lead a good life—to achieve the goods internal to a practice—you have to choose your practices carefully. You can't be good at everything. Being a good football player, for example, precludes being a good jockey. To realize the most good possible, your choice of careers should be part of a coherent plan. Such a plan not only brings order to your life, it also brings unity to your self. Who you are is determined by the choices you make. According to MacIntyre, the unity of a self "resides in the unity of a narrative which links birth to life to death as narrative beginning to middle to end."[102] Just as virtues help you achieve the goods internal to a practice, they also help you achieve a narrative unity in your life.

Whatever unity your life possesses is not created by you alone, however. Your choices make sense only against the background of a tradition. Your tradition gives you your basic orientation to the world. It tells you what sorts of practices are worth pursuing and what sorts of relationships are worth cultivating. You may reject that tradition, but the direction your life takes can always be plotted relative to it.

Traditions can be corrupted and destroyed, however. If they are to survive, they must be sustained and enriched by virtuous behavior. "The virtues," MacIntyre tells us,

> find their point and purpose not only in sustaining those relationships necessary if the variety of goods internal to practices are to be achieved and not only in sustaining the form of an individual life in which that individual may seek out his or her good as the good of his or her whole life, but also in sustaining those traditions which provide both practices and individual lives with their necessary historical context.[103]

Virtues, then, are needed to achieve the good inherent in practices, lives, and traditions.

Because lives and practices derive their value from traditions, MacIntyre's ethical theory is a form of tradition relativism. As such, it faces many of the same problems that cultural relativism does. Are all traditions morally equal? If not, how do we choose among them? Consider the tradition of ethnocentrism, which sometimes promotes the practice of "ethnic cleansing" (genocide). Does the fact that there is a tradition of genocide make it morally acceptable? To effectively exterminate a race, you need certain virtues, such as courage, discipline, self-control, and the like. Are those who have acquired these virtues through the practice of genocide good people? Do they lead good lives? If not, traditions cannot be the source and ground of all value.

There is also the problem of identifying your tradition. Suppose that you are a white Christian capitalist living in China during Mao Tse-tung's reign, and suppose that you want to bring unity and meaning to your life by making choices that are in accord with your tradition. What do you do? How do you identify your tradition? MacIntyre doesn't say. But insofar as you can't identify your tradition, you can't base your decisions on your tradition.

> *Men are equal; it is not birth but virtue that makes the difference.*
> — Voltaire

Nussbaum on Virtue

If there's nothing more to being virtuous than acting in accordance with a tradition, then traditions can't be criticized on the grounds that the

behavior associated with them is not virtuous. Any hope of improving the human condition through a rational critique of traditional practices, then, must appeal to something besides virtue. Martha Nussbaum puts the point this way:

> . . . it is easy for those who are interested in supporting the rational criticism of local traditions and in articulating an idea of ethical progress to feel that the ethics of virtue can give them little help. If the position of women, as established by local traditions in many parts of the world, is to be improved, if traditions of slave holding and racial inequality, if religious intolerance, if aggressive and warlike conceptions of manliness, if unequal norms of material distribution are to be criticized in the name of practical reason, this criticizing (one might easily suppose) will have to be done from a Kantian or utilitarian viewpoint, not through the Aristotelian approach.[104]

Virtue ethics as traditionally conceived, then, seems incapable of providing any sort of viable social critique. If we want to argue that certain social practices are immoral, it looks like we have no choice but to appeal to rule-based ethical theories such as utilitarianism or Kantianism.

Nussbaum believes that the traditional conception of virtue ethics is mistaken, however. Aristotle used his virtue ethics to criticize many of the social practices of his day. Properly understood, Nussbaum claims, an Aristotelian virtue ethics can do the same thing in our day.

In formulating his list of virtues, Aristotle identified a number of "spheres of life" in which we all have to make choices. These spheres are not unique to Greek society; they can be found in every society. As Nussbaum indicates, "Everyone has an attitude and behavior toward her own death, toward her bodily appetites and their management, toward her property and its use, toward the distribution of social goods, toward telling the truth, toward being kindly or not kindly to others; toward cultivating or not cultivating a sense of play or delight; and so on."[105] Living a good life involves making appropriate choices in each of these spheres. Appropriate choices are those that lead to human flourishing.

To flourish, humans have to have certain capabilities. Having these capabilities allows one to be a certain sort of person or to do certain sorts of things. Nussbaum lists the following capabilities:

1. *Life.* Being able to live to the end of a human life of normal length . . .
2. *Bodily health* . . . Being able to have good health, including reproductive health
3. *Bodily integrity.* Being able to move freely from place to place; being able to be secure against violent assault, including sexual assault
4. *Senses, imagination, thought.* Being able to use the senses; being able to imagine, to think, and to reason
5. *Emotions.* Being able to have attachments to things and persons outside ourselves
6. *Practical reason.* Being able to form a conception of the good and to engage in critical reflection about the planning of one's own life

If you consider what are called the virtues in mankind, you will find their growth is assisted by education and cultivation.

—Xenophon

7. *Affiliation*. Being able to live for and in relation to others, to recognize and show concern for other human beings
8. *Other species*. Being able to live with concern for and in relation to animals, plants, and the world of nature
9. *Play*. Being able to laugh, to play, to enjoy recreational activities
10. *Control over one's environment*. (A) Political: being able to participate effectively in political choices that govern one's life; having the rights of political participation, free speech, and freedom of association . . . (B) Material: being able to hold property (both land and movable goods); having the right to seek employment on an equal basis with others[106]

Nussbaum considers these capabilities to be both intrinsically and instrumentally valuable. They are good in and of themselves, and they are good for achieving goals that relate to one's particular aspirations, whatever they may be.

Nussbaum agrees with Kant that all human beings "just by being human, are of equal dignity and worth, no matter where they are situated in society, and that the primary source of this worth is a power of moral choice within them, a power that consists in the ability to plan a life in accordance with one's evaluation of ends."[107] Any society that respects the inherent value of human beings—any moral society—should ensure that all human beings have a basic set of capabilities. Laws should be enacted that guarantee that no one's capabilities will fall below a certain level. The responsibility of enacting such laws lies with all of us.

Nussbaum claims that we have more of a responsibility to our fellow human beings than just staying out of their hair. We have a responsibility to ensure that every human being has a minimum level of basic capabilities. In her view, then, humans have positive as well as negative rights.

Rights are entitlements. Negative rights entitle you not to be interfered with. Rights also imply duties. To say that you have a **negative right** to something is to say that others have a duty not to interfere with your pursuit of that thing. For example, to say that you have a negative right to life is to say that others have a duty not to interfere with your attempt to make a living.

Positive rights, on the other hand, entitle you to be provided with something. To say that you have a **positive right** to something is to say that others have a duty to provide you with that thing. For example, to say that you have a positive right to life is to say that others have a duty to provide you with what you need to live.

Nussbaum believes that we have a positive right not only to life but to all of the various capabilities she lists. If we truly respect the value that resides in human beings, we owe it to them to ensure that they can live a fully human life. And the way we do that is by ensuring that they have the basic level of human capabilities.

These differing views of what it is to have a right constitute one of the major ideological differences between liberals and conservatives. Conservatives tend to see all rights as negative rights. Consequently, they are not in favor of welfare programs because they consider them to be a violation of our right to do with our money what we want. Liberals, on the other hand, tend to see some rights as positive rights. Consequently, they are in favor of welfare programs because they believe it is our duty to help our fellow human beings when they are unable to help themselves.

negative right People have a negative right to something if and only if others have a duty not to interfere with their pursuit of that thing.

positive right People have a positive right to something if and only if others have a duty to provide them with what they need to acquire that thing.

Thought Probe

Medical Treatment

Suppose a poor, young woman needs a heart operation. She can't afford to pay for it, nor does she have any relatives who can pay for it. Does she have a right to get the operation at taxpayer expense? If so, what theory justifies it?

Virtue Ethics

The purpose of morality is to enable us to lead good lives. To fully realize the good of a moral life, it is necessary to acquire certain virtues. This has led some to claim that virtue—not duty—should be the fundamental ethical concept. In their view, the central ethical question should be "What sort of person should I be?" instead of "What sorts of actions should I perform?" In an ethics of virtue, judgments about the morality of actions would be secondary to and dependent on judgments about the morality of persons. This system of ethics—**virtue ethics**—would be based on the concept of a good person rather than on the concept of a right action.

The advantage of such an approach to ethics is that questions about the nature of the good life would once again take center stage. Because persons would be the primary object of moral evaluation, the self would not be slighted in the way that it is in traditional utilitarian or Kantian theories.[108] But would an ethics of virtue be more effective than an ethics of duty in solving ethical dilemmas?

Suppose you were in the same situation as Lester Zygmanik. Your brother has just become a quadriplegic, he is racked with interminable pain, and he is pleading with you to kill him. What should you do? According to virtue ethics, you should do what a virtuous person would do. But what would a virtuous person do? To answer this question, you could try imagining yourself as some virtuous person, such as Gandhi, Socrates, or the Buddha, but it is doubtful whether such a thought experiment would help you solve your problem. This approach to solving moral dilemmas seems no more effective than a duty-based approach. In fact, it may be less effective because it precludes the principled evaluation of alternative courses of action. It's hard to see how one could reach any sort of reflective equilibrium under such conditions.

Moreover, because a virtue is a disposition to act, the only way to determine whether someone has a virtue is to examine that person's actions. For example, the only way to determine whether someone is just is to determine whether that person acts in accord with the duty of justice. But if all judgments of virtue rest on judgments of action, we can't use virtue to judge actions—for that would put the cart before the horse.

There can be no morality without virtue. But there can also be no virtue without duty. So instead of conceiving of virtue and duty as two competing approaches to morality, it would be better to conceive of them as two complementary aspects of morality. They are two sides of the same coin, so to speak. You can't have one without the other any more than you can have a coin with only one side.

> *Virtue is more to man than either water or fire. I have seen men die from treading on water and fire, but I have never seen a man die from treading the course of virtue.*
> —CONFUCIUS

virtue ethics A system of ethics based on the concept of a good person rather than that of a right action.

Character Is Destiny 417

Thought Probe

The Ring of Gyges

In the second book of Plato's *Republic,* Glaucon recounts the legend of Gyges, a shepherd who found a magic ring on a corpse in a chasm opened by an earthquake. The ring made its wearer invisible. Gyges used the ring to enter the royal palace, seduce the queen, murder the king, and seize the throne. Glaucon proposes the following thought experiment: suppose there were two such rings, one of which was given to a virtuous person and the other to an outlaw. The outlaw would no doubt use the ring to commit evil deeds. But what about the virtuous person? Glaucon suggests that the virtuous person, too, would use it to break the law. "No one, it is commonly believed, would have such iron strength of mind as to stand fast in doing right or keep his hands off other men's goods, when he could go to the market-place and fearlessly help himself to anything he wanted, enter houses and sleep with any woman he chose, set prisoners free and kill men at his pleasure, and in a word go about among men with the powers of a god. He would behave no better than the other; both would take the same course."[109] Is Glaucon right? Would the behavior of a virtuous person with the power of invisibility be no different from that of an outlaw?

Summary

Virtuous people try to do the right thing. Virtuous act-utilitarians, for example, try to maximize happiness, whereas virtuous Kantians try to obey the categorical imperative. Both of these conceptions of virtue have been criticized on the grounds that neither is conducive to a good life.

The purpose of morality is to make it possible for everyone to enjoy a good life by restricting certain forms of self-interested behavior. A system of moral rules can achieve this result only if people are willing to abide by it. The most effective way to get people to abide by a system of moral rules is to instill in them certain dispositions known as virtues.

Aristotle maintains that virtues help people achieve a good life by making them better able to avoid the vices of excess (too much) and defect (too little). MacIntyre claims that virtues help people achieve a good life by allowing them to acquire the goods internal to a practice. Virtues also bring unity to people's lives and help sustain the traditions that give their lives meaning. Not every tradition is worth sustaining, however. Thus all moral value cannot be rooted in tradition.

All virtue is summed up in dealing justly.
— ARISTOTLE

Virtues don't have to be rooted in traditions, however. They can be rooted in human capabilities. To live life to the fullest, everyone needs to be able to do certain things such as enjoy good health, have meaningful relationships with others, travel freely, think, play, have control over one's environment, and the like. These capabilities are not only good in and of themselves, but they also provide the means for accomplishing other goals in life. Martha Nussbaum argues that a just society should guarantee that everyone in that society has a basic level of these capabilities.

Stoicism maintains that virtue is the only thing that is needed to lead a good life. Virtuous people use their reason to accurately assess a situation and eliminate their attachment to external goods. In so doing, they rid themselves of negative emotions and cultivate a sense of inner peace and joy knowing that they are in control of their lives, no matter what happens to them.

Some have thought that an ethics based on virtue would be superior to an ethics based on duty because it would not slight the self in the way that utilitarianism and Kantianism do. An ethics of virtue, however, would be no more effective than an ethics of duty in solving moral dilemmas. Moreover, an ethics of virtue requires an ethics of duty because the only way to determine whether an action is morally virtuous is to determine whether it accords with a moral duty. So virtue and duty are best seen as complementary aspects of morality.

Study Questions

1. According to utilitarianism, what is it to be a virtuous (morally good) person?
2. According to Kantianism, what is it to be a virtuous (morally good) person?
3. According to Aristotle, what is the purpose or function of virtue?
4. According to MacIntyre, what is the purpose or function of virtue?
5. How does virtue ethics differ from duty ethics?

Discussion Questions

1. Would a person who succeeded in governing her actions by the greatest happiness principle lead a good life?
2. Would a person who never disobeyed the categorical imperative lead a good life?
3. Can a psychopath—someone without a conscience—act morally?
4. Is it always best to tread the middle path between too much and too little? Can you think of any cases where it isn't?
5. Do people who seek fame and fortune, and get them, lead less good lives than those who seek only to become experts in their field and succeed?
6. Because virtue can be taught only by doing, should we require students to perform community service?

Internet Inquiries

1. Do we have positive rights as well as negative rights? To explore this issue, type "positive rights" and "negative rights" into an Internet search engine.
2. Communitarians tend to favor positive rights, whereas libertarians favor negative rights. To explore the strengths and weaknesses of these views, enter "libertarian" and "communitarian" into an Internet search engine.
3. What is the good life? Are you more likely to achieve it by following a rule-based ethic or a virtue-based ethic? Enter "what is the good life" into an Internet search engine to explore this issue.

Jeremy Bentham
Of the Principle of Utility

Jeremy Bentham (1748–1832) was the first to provide a systematic defense of utilitarianism. A child prodigy, Bentham entered Oxford University at the age of twelve. He was the leader of a group known as the Philosophical Radicals, which included James Mill and his son, John Stuart Mill, another child prodigy. Together they undertook to reform the political and legal system of Great Britain. This selection, taken from Bentham's *Introduction to the Principles of Morals and Legislation*, articulates the view that right actions increase happiness and decrease misery.

I. Nature has placed mankind under the governance of two sovereign masters, *pain* and *pleasure*. It is for them alone to point out what we ought to do, as well as to determine what we shall do. On the one hand the standard of right and wrong, on the other the chain of causes and effects, are fastened to their throne. They govern us in all we do, in all we say, in all we think: every effort we can make to throw off our subjection, will serve but to demonstrate and confirm it. In words a man may pretend to abjure their empire: but in reality he will remain subject to it all the while. The *principle of utility* recognizes this subjection, and assumes it for the foundation of that system, the object of which is to rear the fabric of felicity by the hands of reason and of law. Systems which attempt to question it, deal in sounds instead of sense, in caprice instead of reason, in darkness instead of light.

But enough of metaphor and declamation: it is not by such means that moral science is to be improved.

II. The principle of utility is the foundation of the present work: it will be proper therefore at the outset to give an explicit and determinate account of what is meant by it. By the principle of utility is meant that principle which approves or disapproves of every action whatsoever, according to the tendency which it appears to have to augment or diminish the happiness of the party whose interest is in question: or, what is the same thing in other words, to promote or to oppose that happiness. I say of every action whatsoever; and therefore not only of every action of a private individual, but of every measure of government.

III. By utility is meant that property in any object, whereby it tends to produce benefit, advantage, pleasure, good, or happiness, (all this in the present case comes to the same thing) or (what comes again to the same thing) to prevent the happening of mischief, pain, evil, or unhappiness to the party whose interest is considered: if that party be the community in general, then the happiness of the community: if a particular individual, then the happiness of that individual.

IV. The interest of the community is one of the most general expressions that can occur in the phraseology of morals: no wonder that the meaning of it is often lost. When it has a meaning, it is this. The community is a fictitious *body,* composed of the individual persons who are considered as constituting as it were its *members*. The interest of the community then is, what?—the sum of the interests of the several members who compose it.

V. It is in vain to talk of the interest of the community, without understanding what is the interest of the individual. A thing is said to promote the interest, or to be for the interest, of an individual, when it tends to add to the sum total of his pleasures: or, what comes to the same thing, to diminish the sum total of his pains.

VI. An action then may be said to be conformable to the principle of utility, or, for shortness sake, to utility, (meaning with respect to the community at large) when the tendency it has to augment the happiness of the community is greater than any it has to diminish it.

Source: Jeremy Bentham, "Of the Principle of Utility," *An Introduction to the Principles of Morals and Legislation* (Oxford: Clarendon Press, 1879) 1–7. Notes have been omitted.

VII. A measure of government (which is but a particular kind of action, performed by a particular person or persons) may be said to be conformable to or dictated by the principle of utility, when in like manner the tendency which it has to augment the happiness of the community is greater than any which it has to diminish it.

VIII. When an action, or in particular a measure of government, is supposed by a man to be conformable to the principle of utility, it may be convenient, for the purposes of discourse, to imagine a kind of law or dictate, called a law or dictate of utility: and to speak of the action in question, as being conformable to such law or dictate.

IX. A man may be said to be a partizan of the principle of utility, when the approbation or disapprobation he annexes to any action, or to any measure, is determined by and proportioned to the tendency which he conceives it to have to augment or to diminish the happiness of the community: or in other words, to its conformity or unconformity to the laws or dictates of utility.

X. Of an action that is conformable to the principle of utility one may always say either that it is one that ought to be done, or at least that it is not one that ought not to be done. One may say also, that it is right it should be done; at least that it is not wrong it should be done; that it is a right action; at least that it is not a wrong action. When thus interpreted, the words *ought,* and *right* and *wrong,* and others of the stamp, have a meaning: when otherwise, they have none.

XI. Has the rectitude of this principle been ever formally contested? It should seem that it had, by those who have not known what they have been meaning. Is it susceptible of any direct proof? it should seem not: for that which is used to prove every thing else, cannot itself be proved: a chain of proofs must have their commencement somewhere. To give such proof is as impossible as it is needless.

XII. Not that there is or ever has been that human creature breathing, however stupid or perverse, who has not on many, perhaps on most occasions of his life, deferred to it. By the natural constitution of the human frame, on most occasions of their lives men in general embrace this principle, without thinking of it: if not for the ordering of their own actions, yet for the trying of their own actions, as well as of those of other men. There have been, at the same time, not many, perhaps, even of the most intelligent, who have been disposed to embrace it purely and without reserve. There are even few who have not taken some occasion or other to quarrel with it, either on account of their not understanding always how to apply it, or on account of some prejudice or other which they were afraid to examine into, or could not bear to part with. For such is the stuff that man is made of: in principle and in practice, in a right track and in a wrong one, the rarest of all human qualities is consistency.

XIII. When a man attempts to combat the principle of utility, it is with reasons drawn, without his being aware of it, from that very principle itself. His arguments, if they prove any thing, prove not that the principle is *wrong,* but that, according to the applications he supposes to be made of it, it is *misapplied.* Is it possible for a man to move the earth? Yes; but he must first find out another earth to stand upon.

XIV. To disprove the propriety of it by arguments is impossible; but, from the causes that have been mentioned, or from some confused or partial view of it, a man may happen to be disposed not to relish it. Where this is the case, if he thinks the settling of his opinions on such a subject worth the trouble, let him take the following steps, and at length, perhaps, he may come to reconcile himself to it.

1. Let him settle with himself, whether he would wish to discard this principle altogether; if so, let him consider what it is that all his reasonings (in matters of politics especially) can amount to?

2. If he would, let him settle with himself, whether he would judge and act without any principle, or whether there is any other he would judge and act by?

3. If there be, let him examine and satisfy himself whether the principle he thinks he has found is really any separate intelligible principle; or whether it be not a mere principle in words, a kind of phrase, which at bottom expresses neither more nor less than the mere averment of his own unfounded sentiments; that is, what in another person he might be apt to call caprice?

4. If he is inclined to think that his own approbation or dis-approbation, annexed to the idea of an act, without any regard to its consequences, is a sufficient foundation for him to judge and act upon, let him ask himself whether his sentiment is to be a standard of right and wrong, with respect to every other man, or whether every man's sentiment has the same privilege of being a standard to itself?

5. In the first case, let him ask himself whether his principle is not despotical, and hostile to all the rest of the human race?

6. In the second case, whether it is not anarchial, and whether at this rate there are not as many different standards of right and wrong as there are men? and whether even to the same man, the same thing, which is right to-day, may not (without the least change in its nature) be wrong to-morrow? and whether the same thing is not right and wrong in the same place at the same time? and in either case, whether all argument is not at an end? and whether, when two men have said, 'I like this,' and 'I don't like it,' they can (upon such a principle) have any thing more to say?

7. If he should have said to himself, No: for that the sentiment which he proposes as a standard must be grounded on reflection, let him say on what particulars the reflection is to turn? if on particulars having relation to the utility of the act, then let him say whether this is not deserting his own principle, and borrowing assistance from that very one in opposition to which he sets it up: or if not on those particulars, on what other particulars?

8. If he should be for compounding the matter, and adopting his own principle in part, and the principle of utility in part, let him say how far he will adopt it?

9. When he has settled with himself where he will stop, then let him ask himself how he justifies to himself the adopting it so far? and why he will not adopt it any farther?

10. Admitting any other principle than the principle of utility to be a right principle, a principle that it is right for a man to pursue; admitting (what is not true) that the word *right* can have a meaning without reference to utility, let him say whether there is any such thing as a *motive* that a man can have to pursue the dictates of it: if there is, let him say what that motive is, and how it is to be distinguished from those which enforce the dictates of utility: if not, then lastly let him say what it is this other principle can be good for?

READING QUESTIONS

1. What is the principle of utility? How does Bentham interpret statements asserting that an action is right or wrong? How do you interpret such statements?

2. Do you think that what we ought to do, as well as what we always strive to do, can be explained entirely by reference to pain and pleasure? Why or why not?

3. Would you want to live in a society whose ethics and laws were thoroughly utilitarian? Would you welcome a system of justice based solely on considerations of utility? Explain.

4. How does Bentham defend the principle of utility?

Immanuel Kant

Good Will, Duty, and the Categorical Imperative

Although Immanuel Kant (1724–1804) never traveled more than forty miles outside of his native Königsberg (now Kaliningrad, Russia), his writings opened up many new vistas in philosophy. In his most celebrated work, *Critique of Pure Reason,* he argues that the mind is not a passive receiver of sensations but an active shaper of ideas. Thus our view of reality is a construct of the human mind. This idea had a revolutionary impact on subsequent philosophy. No less revolutionary were Kant's ideas in ethics. In this selection, taken from his *Fundamental Principles of the Metaphysics of Morals,* he defends the notion that the rightness of an action can be determined by reason alone.

Nothing can possibly be conceived in the world, or even out of it, which can be called good, without qualification, except a Good Will. Intelligence, wit, judgement, and the other *talents* of the mind, however they may be named, or courage, resolution, perseverance, as qualities of temperament, are undoubtedly good and desirable in many respects; but these gifts of nature may also become extremely bad and mischievous if the will which is to make use of them, and which, therefore, constitutes what is called *character*, is not good. It is the same with the *gifts of fortune.* Power, riches, honour, even health, and the general well-being and contentment with one's condition which is called *happiness*, inspire pride, and often presumption, if there is not a good will to correct the influence of these on the mind, and with this also to rectify the whole principle of acting, and adapt it to its end. The sight of a being who is not adorned with a single feature of a pure and good will, enjoying unbroken prosperity, can never give pleasure to an impartial rational spectator. Thus a good will appears to constitute the indispensable condition even of being worthy of happiness.

There are even some qualities which are of service to this good will itself, and may facilitate its action, yet which have no intrinsic unconditional value, but always presuppose a good will, and this qualifies the esteem that we justly have for them, and does not permit us to regard them as absolutely good. Moderation in the affections and passions, self-control, and calm deliberation are not only good in many respects, but even seem to constitute part of the intrinsic worth of the person; but they are far from deserving to be called good without qualification, although they have been so unconditionally praised by the ancients. For without the principles of a good will, they may become extremely bad; and the coolness of a villain not only makes him far more dangerous, but also directly makes him more abominable in our eyes than he would have been without it.

A good will is good not because of what it performs or effects, not by its aptness for the attainment of some proposed end, but simply by virtue of the volition, that is, it is good in itself, and considered by itself is to be esteemed much higher than all that can be brought about by it in favour of any inclination, nay, even of the sum-total of all inclinations. Even if it should happen that, owing to special disfavour of fortune, or the niggardly provision of a step-motherly nature, this will should wholly lack power to accomplish its purpose, if with its greatest efforts it should yet achieve nothing, and there should remain only the good will (not, to be sure, a mere wish, but the summoning of all means in our power), then, like a jewel, it would still shine by its own light, as a thing which has its whole value in itself. Its usefulness or fruitlessness can neither add to nor take away anything from this value. It would be, as it were, only the setting to enable us to handle it the more conveniently in common commerce, or to attract to it the attention of those who are not yet connoisseurs, but not to recommend it to true connoisseurs, or to determine its value. . . .

Thus the moral worth of an action does not lie in the effect expected from it, nor in any principle of action which requires to borrow its motive from this expected

Source: Immanuel Kant, *Fundamental Principles of the Metaphysics of Morals* (London: Longmans, Green, 1909) 10–62. Notes have been omitted.`

effect. For all these effects—agreeableness of one's condition, and even the promotion of the happiness of others—could have been also brought about by other causes, so that for this there would have been no need of the will of a rational being; whereas it is in this alone that the supreme and unconditional good can be found. The pre-eminent good which we call moral can therefore consist in nothing else than *the conception of law* in itself, *which certainly is only possible in a rational being,* in so far as this conception, and not the expected effect, determines the will. This is a good which is already present in the person who acts accordingly, and we have not to wait for it to appear first in the result.

But what sort of law can that be, the conception of which must determine the will, even without paying any regard to the effect expected from it, in order that this will may be called good absolutely and without qualification? As I have deprived the will of every impulse which could arise to it from obedience to any law, there remains nothing but the universal conformity of its actions to law in general, which alone is to serve the will as a principle, *i.e.* I am never to act otherwise than so *that I could also will that my maxim should become a universal law.* Here, now, it is the simple conformity to law in general, without assuming any particular law applicable to certain actions, that serves the will as its principle, and must so serve it, if duty is not to be a vain delusion and a chimerical notion. The common reason of men in its practical judgments perfectly coincides with this, and always has in view the principle here suggested. Let the question be, for example: May I when in distress make a promise with the intention not to keep it? I readily distinguish here between the two significations which the question may have: Whether it is prudent or whether it is right, to make a false promise? The former may undoubtedly often be the case. I see clearly indeed that it is not enough to extricate myself from a present difficulty by means of this subterfuge, but it must be well considered whether there may not hereafter spring from this lie much greater inconvenience than that from which I now free myself, and as, with all my supposed *cunning,* the consequences cannot be so easily foreseen but that credit once lost may be much more injurious to me than any mischief which I seek to avoid at present, it should be considered whether it would not be more *prudent* to act herein according to a universal maxim, and to make it a habit to promise nothing except with the intention of keeping it. But it is soon clear to me that such a maxim will still only be based on the fear of consequences. Now it is a wholly different thing to be truthful from duty, and to be so from apprehension of injurious consequences. In the first case, the very notion of the action already implies a law for me; in the second case, I must first look about elsewhere to see what results may be combined with it which would affect myself. For to deviate from the principle of duty is beyond all doubt wicked; but to be unfaithful to my maxim of prudence may often be very advantageous to me, although to abide by it is certainly safer. The shortest way, however, and an unerring one, to discover the answer to this question whether a lying promise is consistent with duty, is to ask myself, Should I be content that my maxim (to extricate myself from difficulty by a false promise) should hold good as a universal law, for myself as well as for others? and should I be able to say to myself, "Every one may make a deceitful promise when he finds himself in a difficulty from which he cannot otherwise extricate himself"? Then I presently become aware that while I can will the lie, I can by no means will that lying should be a universal law. For with such a law there would be no promises at all, since it would be in vain to allege my intention in regard to my future actions to those who would not believe this allegation, or if they over-hastily did so, would pay me back in my own coin. Hence my maxim, as soon as it should be made a universal law, would necessarily destroy itself. . . .

The conception of an objective principle, in so far as it is obligatory for a will, is called a command (of reason), and the formula of the command is called an imperative. . . .

If now the action is good only as a means *to something else*, then the imperative is *hypothetical;* if it is conceived as good *in itself* and consequently as being necessarily the principle of a will which of itself conforms to reason, then it is *categorical*. . . .

When I conceive a hypothetical imperative, in general I do not know beforehand what it will contain until I am given the condition. But when I conceive a categorical imperative, I know at once what it contains. For as the imperative contains besides the law only the necessity that the maxims shall conform to this law, while the law contains no conditions restricting it, there remains nothing but the general statement that the maxim of the action should conform to a universal law, and it is this conformity alone that the imperative properly represents as necessary.

There is therefore but one categorical imperative, namely, this: *Act only on that maxim whereby thou canst at the same time will that it should become a universal law.*

Now if all imperatives of duty can be deduced from this one imperative as from their principle, then, although it should remain undecided whether what is

called duty is not merely a vain notion, yet at least we shall be able to show what we understand by it and what this notion means.

Since the universality of the law according to which effects are produced constitutes what is properly called *nature* in the most general sense (as to form), that is the existence of things so far as it is determined by general laws, the imperative of duty may be expressed thus: *Act as if the maxim of thy action were to become by thy will a universal law of nature.*

We will now enumerate a few duties, adopting the usual division of them into duties to ourselves and to others, and into perfect and imperfect duties.

1. A man reduced to despair by a series of misfortunes feels wearied of life, but is still so far in possession of his reason that he can ask himself whether it would not be contrary to his duty to himself to take his own life. Now he inquires whether the maxim of his action could become a universal law of nature. His maxim is: From self-love I adopt it as a principle to shorten my life when its longer duration is likely to bring more evil than satisfaction. It is asked then simply whether this principle founded on self-love can become a universal law of nature. Now we see at once that a system of nature of which it should be a law to destroy life by means of the very feeling whose special nature it is to impel to the improvement of life would contradict itself, and therefore could not exist as a system of nature; hence that maxim cannot possibly exist as a universal law of nature, and consequently would be wholly inconsistent with the supreme principle of all duty.

2. Another finds himself forced by necessity to borrow money. He knows that he will not be able to repay it, but sees also that nothing will be lent to him, unless he promises stoutly to repay it in a definite time. He desires to make this promise, but he has still so much conscience as to ask himself: Is it not unlawful and inconsistent with duty to get out of a difficulty in this way? Suppose, however, that he resolves to do so, then the maxim of his action would be expressed thus: When I think myself in want of money, I will borrow money and promise to repay it, although I know that I never can do so. Now this principle of self-love or of one's own advantage may perhaps be consistent with my whole future welfare; but the question now is, Is it right? I change then the suggestion of self-love into a universal law, and state the question thus: How would it be if my maxim were a universal law? Then I see at once that it could never hold as a universal law of nature, but would necessarily contradict itself. For supposing it to be a universal law that everyone when he thinks himself in a difficulty should be able to promise whatever he pleases, with the purpose of not keeping his promise, the promise itself would become impossible, as well as the end that one might have in view in it, since no one would consider that anything was promised to him, but would ridicule all such statements as vain pretences.

3. A third finds in himself a talent which with the help of some culture might make him a useful man in many respects. But he finds himself in comfortable circumstances, and prefers to indulge in pleasure rather than to take pains in enlarging and improving his happy natural capacities. He asks, however, whether his maxim of neglect of his natural gifts, besides agreeing with his inclination to indulgence, agrees also with what is called duty. He sees then that a system of nature could indeed subsist with such a universal law although men (like the South Sea islanders) should let their talents rest, and resolve to devote their lives merely to idleness, amusement, and propagation of their species—in a word, to enjoyment; but he cannot possibly *will* that this should be a universal law of nature, or be implanted in us as such by a natural instinct. For, as a rational being, he necessarily wills that his faculties be developed, since they serve him, and have been given him, for all sorts of possible purposes.

4. A fourth, who is in prosperity, while he sees that others have to contend with great wretchedness and that he could help them, thinks: What concern is it of mine? Let everyone be as happy as Heaven pleases, or as he can make himself; I will take nothing from him nor even envy him, only I do not wish to contribute anything to his welfare or to his assistance in distress! Now no doubt if such a mode of thinking were a universal law, the human race might very well subsist, and doubtless even better than in a state in which everyone talks of sympathy and good-will, or even takes care occasionally to put it into practice, but, on the other side, also cheats when he can, betrays the rights of men, or otherwise violates them. But although it is possible that a universal law of nature might exist in accordance with that maxim, it is impossible to *will* that such a principle should have the universal validity of a law of nature. For a will which resolved this would contradict itself, inasmuch as many cases might occur in which one would have need of the love and sympathy of others, and in which, by such a law of nature, sprung from his own will, he would deprive himself of all hope of the aid he desires. . . .

We have thus established at least this much, that if duty is a conception which is to have any import and real legislative authority for our actions, it can only be expressed in categorical, and not at all in hypothetical imperatives. We have also, which is of great importance, exhibited clearly and definitely for every practical application the content of the categorical imperative, which must contain the principle of all duty if there is such a thing at all. . . .

Now I say: man and generally any rational being *exists* as an end in himself, *not merely as a means* to be arbitrarily used by this or that will, but in all his actions, whether they concern himself or other rational beings, must be always regarded at the same time as an end. . . .

The foundation of this principle is: *rational nature exists as an end in itself.* Man necessarily conceives his own existence as being so: so far then this is a *subjective* principle of human actions. But every other rational being regards its existence similarly, just on the same rational principle that holds for me: so that it is at the same time an objective principle, from which as a supreme practical law all laws of the will must be capable of being deduced. Accordingly the practical imperative will be as follows: *So act as to treat humanity, whether in thine own person or in that of any other, in every case as an end withal, never as means only.* . . .

The conception of every rational being as one which must consider itself as giving in all the maxims of its will universal laws, so as to judge itself and its actions from this point of view—this conception leads to another which depends on it and is very fruitful, namely, that of a *kingdom of ends.*

By a *kingdom* I understand the union of different rational beings in a system by common laws. Now since it is by laws that ends are determined as regards their universal validity, hence, if we abstract from the personal differences of rational beings, and likewise from all the content of their private ends, we shall be able to conceive all ends combined in a systematic whole (including both rational beings as ends in themselves, and also the special ends which each may propose to himself), that is to say, we can conceive a kingdom of ends, which on the preceding principles is possible.

For all rational beings come under the *law* that each of them must treat itself and all others *never merely as means*, but in every case *at the same time as ends in themselves.* Hence results a systematic union of rational beings by common objective laws, *i.e.*, a kingdom which may be called a kingdom of ends, since what these laws have in view is just the relation of these beings to one another as ends and means. It is certainly only an ideal.

READING QUESTIONS

1. According to Kant, in what does the moral worth of an action lie? How does this conception differ from utilitarianism's idea of moral worth?

2. What does Kant mean by "I am never to act otherwise than so that I could also will that my maxim should become a universal law"? How does Kant apply this principle to the case of making a lying promise? How easy or difficult would it be for you to apply it consistently to your own actions?

3. Kant's second formulation of the categorical imperative prohibits us from treating someone as a means only. Does this imply that we must never treat someone as a means in any way whatsoever? Explain.

4. What reasons does Kant give for thinking that persons should be regarded as ends in themselves? Do you think Kant is right about the absolute value of persons, or do you believe that their value is based on something else—for example, their value to society?

Martha Nussbaum

Non-Relative Virtues

Martha Nussbaum (1947–) is currently Ernst Freund Distinguished Service Professor of Law and Ethics at the University of Chicago. She began her career as a classical scholar and now writes on a wide range of ethical and political topics. Her books include *The Fragility of Goodness, Sex and Social Justice,* and *Upheavals of Thought: The Intelligence of Emotions.*

The virtues are attracting increasing interest in contemporary philosophical debate. From many different sides one hears of a dissatisfaction with ethical theories that are remote from concrete human experience. Whether this remoteness results from the utilitarian's interest in arriving at a universal calculus of satisfactions or from a Kantian concern with universal principles of broad generality, in which the names of particular contexts, histories, and persons do not occur, remoteness is now being seen by an increasing number of moral philosophers as a defect in an approach to ethical questions. In the search for an alternative approach, the concept of virtue is playing a prominent role. So, too, is the work of Aristotle, the greatest defender of an ethical approach based on the concept of virtue. For Aristotle's work seems, appealingly, to combine rigor with concreteness, theoretical power with sensitivity to the actual circumstances of human life and choice in all their multiplicity, variety, and mutability.

But on one central point there is a striking divergence between Aristotle and contemporary virtue theory. To many current defenders of an ethical approach based on the virtues, the return to the virtues is connected with a turn toward relativism-toward, that is, the view that the only appropriate criteria of ethical goodness are local ones, internal to the traditions and practices of each local society or group that asks itself questions about the good. The rejection of general algorithms and abstract rules in favor of an account of the good life based on specific modes of virtuous action is taken, by writers as otherwise diverse as Alasdair MacIntyre, Bernard Williams, and Philippa Foot, to be connected with the abandonment of the project of rationally justifying a single norm of flourishing life for and to all human beings and with a reliance, instead, on norms that are local both in origin and in application.

The positions of all of these writers, where relativism is concerned, are complex; none unequivocally endorses a relativist view. But all connect virtue ethics with a relativist denial that ethica, correctly understood, offers any trans-cultural norms, justifiable with reference to reasons of universal human validity, with reference to which we may appropriately criticize different local conceptions of the good. And all suggest that the insights we gain by pursuing ethical questions in the Aristotelian virtue-based way lend support to relativism.

For this reason it is easy for those who are interested in supporting the rational criticism of local traditions and in articulating an idea of ethical progress to feel that the ethics of virtue can give them little help. If the position of women, as established by local traditions in many parts of the world, is to be improved, if traditions of slave holding and racial inequality, if religious intolerance, if aggressive and warlike conceptions of manliness, if unequal norms of material distribution are to be criticized in the name of practical reason, this criticizing (one might easily suppose) will have to be done from a Kantian or utilitarian viewpoint, not through the Aristotelian approach.

This is an odd result, where Aristotle is concerned. For it is obvious that he was not only the defender of an ethical theory based on the virtues, but also the defender of a single objective account of the human good, or human flourishing. This account is supposed to be objective in the sense that it is justifiable with

Source: Martha Nussbaum, "Non-Relative Virtues: An Aristotelian Approach," *Midwest Studies in Philosophy* 13 (1988) 32–39. Reprinted with permission.

reference to reasons that do not derive merely from local traditions and practices, but rather from features of humanness that lie beneath all local traditions and are there to be seen whether or not they are in fact recognized in local traditions. And one of Aristotle's most obvious concerns is the criticism of existing moral traditions, in his own city and in others, as unjust or repressive, or in other ways incompatible with human flourishing. He uses his account of the virtues as a basis for this criticism of local traditions: prominently, for example, in Book II of the *Politics*, where he frequently argues against existing social forms by pointing to ways in which they neglect or hinder the development of some important human virtue. Aristotle evidently believes that there is no incompatibility between basing an ethical theory on the virtues and defending the singleness and objectivity of the human good. Indeed, he seems to believe that these two aims are mutually supportive.

Now the fact that Aristotle believes something does not make it true. (Though I have sometimes been accused of holding that position!) But it does, on the whole, make that something a plausible candidate for the truth, one deserving our most serious scrutiny. In this case, it would be odd indeed if he had connected two elements in ethical thought that are self-evidently incompatible, or in favor of whose connectedness and compatibility there is nothing interesting to be said. The purpose of this paper is to establish that Aristotle does indeed have an interesting way of connecting the virtues with a search for ethical objectivity and with the criticism of existing local norms, a way that deserves our serious consideration as we work on these questions. Having described the general shape of the Aristotelian approach, we can then begin to understand some of the objections that might be brought against such a non-relative account of the virtues, and to imagine how the Aristotelian could respond to those objections.

II

The relativist, looking at different societies, is impressed by the variety and the apparent non-comparability in the lists of virtues she encounters. Examining the different lists, and observing the complex connections between each list and a concrete form of life and a concrete history, she may well feel that any list of virtues must be simply a reflection of local traditions and values, and that, virtues being (unlike Kantian principles or utilitarian algorithms) concrete and closely tied to forms of life, there can in fact be no list of virtues that will serve as normative for all these varied societies. It is not only that the specific forms of behavior recommended in connection with the virtues differ greatly over time and place, it is also that the very areas that are singled out as spheres of virtue, and the manner in which they are individuated from other areas, vary so greatly. For someone who thinks this way, it is easy to feel that Aristotle's own list, despite its pretensions to universality and objectivity, must be similarly restricted, merely a reflection of one particular society's perceptions of salience and ways of distinguishing. At this point, relativist writers are likely to quote Aristotle's description of the "great-souled" person, the megalopsuchos, which certainly contains many concrete local features and sounds very much like the portrait of a certain sort of Greek gentleman, in order to show that Aristotle's list is just as culture-bound as any other.

But if we probe further into the way in which Aristotle in fact enumerates and individuates the virtues, we begin to notice things that cast doubt upon the suggestion that he has simply described what is admired in his own society. First of all, we notice that a rather large number of virtues and vices (vices especially) are nameless, and that, among the ones that are not nameless, a good many are given, by Aristotle's own account, names that are somewhat arbitrarily chosen by Aristotle, and do not perfectly fit the behavior he is trying to described. Of such modes of conduct he writes, "Most of these are nameless, but we must try . . . to give them names in order to make our account clear and easy to follow" (NE 1108a16–19). This does not sound like the procedure of someone who is simply studying local traditions and singling out the virtue names that figure most prominently in those traditions.

What is going on becomes clearer when we examine the way in which he does, in fact, introduce his list. For he does so, in the *Nicomachean Ethics,* by a device whose very straightforwardness and simplicity has caused it to escape the notice of most writers on this topic. What he does, in each case, is to isolate a sphere of human experience that figures in more or less any human life, and in which more or less any human being will have to make some choices rather than others, and act in someway rather than some other. The introductory chapter enumerating the virtues and vices begins from an enumeration of these spheres (NE 2.7); and each chapter on a virtue in the more detailed account that follows begins with "Concerning X . . ." or words to this effect, where "X" names a sphere of life with which all human beings regularly and more or less necessarily have dealings. Aristotle then asks: What is it to choose and respond well within that sphere? What is it, on the other hand, to

choose defectively? The "thin account" of each virtue is that it is whatever it is to be stably disposed to act appropriately in that sphere. There may be, and usually are, various competing specifications of what acting well, in each case, in fact comes to. Aristotle goes on to defend in each case some concrete specification, producing, at the end, a full or "thick" definition of the virtue.

Here are the most important spheres of experience recognized by Aristotle, along with the names of their corresponding virtues:

Sphere	Virtue
1. Fear of important damages, esp. death	courage
2. Bodily appetites and their pleasures	moderation
3. Distribution of limited resources	justice
4. Management of one's personal property, whereothers are concerned	generosity
5. Management of personal property, where expansive hospitality is concerned	hospitality
6. Attitudes and actions with respect to one's own worth	greatness of soul
7. Attitude to slights and damages	mildness of temper
8. "Association and living together and the fellowship of words and actions"	
a. truthfulness in speech	truthfulness
b. social association of a playful kind	easy grace (contrasted with coarseness, rudeness, insensitivity)
c. social association more generally	nameless, but a kind of friendliness (contrasted with irritability and grumpiness)
9. Attitude to the good and ill fortune of others	proper judgment (contrasted with enviousness, spitefulness, etc.)
10. Intellectual life	the variousintellectual virtues (such as perceptiveness, knowledge, etc.)
11. The planning of one's life and conduct	practical wisdom

There is, of course, much more to be said about this list, its specific members, and the names Aristotle chooses for the virtue in each case, some of which are indeed culture bound. What I want, however, to insist on here is the care with which Aristotle articulates his general approach, beginning from a characterization of a sphere of universal experience and choice, and introducing the virtue name as the name (as yet undefined) of whatever it is to choose appropriately in that area of experience. On this approach, it does not seem possible to say, as the relativist wishes to, that a given society does not contain anything that corresponds to a given virtue. Nor does it seem to be an open question, in the case of a particular agent, whether a certain virtue should or should not be included in his or her life-except in the sense that she can always choose to pursue the corresponding deficiency instead. The point is that everyone makes some choices and acts somehow or other in these spheres: if not properly, then improperly. Everyone has some attitude and behavior toward her own death; toward her bodily appetites and their management; toward her property and its use; toward the distribution of social goods; toward telling the truth; toward being kindly or not kindly to others; toward cultivating or not cultivating a sense of play and delight; and so on. No matter where one lives one cannot escape these questions, so long as one is living a human life. But then this means that one's behavior falls, willy nilly, within the sphere of the Aristotelian virtue, in each case. If it is not appropriate, it is inappropriate; it cannot be off the map altogether. People will of course disagree about what the appropriate ways of acting and reacting in fact are. But in that case, as Aristotle has set things up, they are arguing about the same thing, and advancing competing specifications of the same virtue. The reference of the virtue term in each case is fixed by the sphere of experience—by what we shall from now on call the "grounding experiences." The thin or "nominal definition" of the virtue will be, in each case, that it is whatever it is that being disposed to choose and respond well consists in, in that sphere. The job of ethical theory will be to search for the best further specification corresponding to this nominal definition, and to produce a full definition.

III

We have begun to introduce considerations from the philosophy of language. We can now make the direction of the Aristotelian account clearer by considering his own account of linguistic indicating (referring) and defining, which guides his treatment of both scientific and ethical terms, and of the idea of progress in both areas.

Aristotle's general picture is as follows. We begin with some experiences—not necessarily our own, but those of members of our linguistic community, broadly construed. On the basis of these experiences, a word enters the language of the group, indicating (referring to) whatever it is that is the content of those experiences. Aristotle gives the example of thunder. People hear a noise in the clouds, and they then refer to it, using the word "thunder." At this point, it may be that nobody has any concrete account of the noise or any idea about what it really is. But the experience fixes a subject for further inquiry. From now on, we can refer to thunder, ask "What is thunder?" and advance and assess competing theories. The thin or, we might say, "nominal definition" of thunder is "That noise in the clouds, whatever it is." The competing explanatory theories are rival candidates for correct full or thick definition. So the explanatory story citing Zeus' activities in the clouds is a false account of the very same thing of which the best scientific explanation is a true account. There is just one debate here, with a single subject.

So too, Aristotle suggests, with our ethical terms. Heraclitus, long before him, already had the essential idea, saying, "They would not have known the name of justice, if these things did not take place." "These things," our source for the fragment informs us, are experiences of injustice-presumably of harm, deprivation, inequal-courage was a matter of waving swords around; now they have (the *Ethics* informs us) a more inward and a more civic and communally attuned understanding of proper behavior toward the possibility of death. Women used to be regarded as property, bought and sold; now this would be thought barbaric. And in the case of justice as well we have, the *Politics* passage claims, advanced toward a more adequate understanding of what is fair and appropriate. Aristotle gives the example of an existing homicide law that convicts the defendent automatically on the evidence of the prosecutor's relatives (whether they actually witnessed anything or not, apparently). This, Aristotle says, is clearly a stupid and unjust law; and yet it once seemed appropriate-and, to a tradition-bound community, must still be so. To hold tradition fixed is then to prevent ethical progress. What human beings want and seek is not conformity with the past, it is the good. So our systems of law should make it possible for them to progress beyond the past, when they have agreed that a change is good. (They should not, however, make change too easy, since it is no easy matter to see one's way to the good, and tradition is frequently a sounder guide than current fashion.)

In keeping with these ideas, the *Politics* as a whole presents the beliefs of the many different societies it investigates not as unrelated local norms, but as competing answers to questions of justice and courage (and so on) with which all the societies (being human) are concerned, and in response to which they are all trying to find what is good. Aristotle's analysis of the virtues gives him an appropriate framework for these comparisons, which seem perfectly appropriate inquiries into the ways in which different societies have solved common human problems.

In the Aristotelian approach it is obviously of the first importance to distinguish two stages of the inquiry: the initial demarcation of the sphere of choice, of the "grounding experiences" that fix the reference of the virtue term; and the ensuing more concrete inquiry into what appropriate choice, in that sphere, is. Aristotle does not always do this carefully, and the language he has to work with is often not helpful to him. We do not have much difficulty with terms like "moderation" and "justice" and even "courage," which seem vaguely normative but relatively empty, so far, of concrete moral content. As the approach requires, they can serve as extension-fixing labels under which many competing specifications may be investigated. But we have already noticed the problem with "mildness of temper," which seems to rule out by fiat a prominent contender for the appropriate disposition concerning anger. And much the same thing certainly seems to be true of the relativists' favorite target, megalopsuchia, which implies in its very name an attitude to one's own worth that is more Greek than universal. (For example, a Christian will feel that the proper attitude to one's own worth requires understanding one's lowness, frailty, and sinfulness. The virtue of humility requires considering oneself small, not great.) What we ought to get at this point in the inquiry is a word for the proper behavior toward anger and offense and a word for the proper behavior toward one's worth that are more truly neutral among the competing specifications, referring only to the sphere of experience within which we wish to determine what is appropriate. Then we could regard the competing conceptions as rival accounts of one and the same thing, so that, for example, Christian humility would be a rival specification of the same virtue whose Greek specification is given in Aristotle's account of megalopsuchia, namely, the proper way to behave toward the question of one's own worth.

And in fact, oddly enough, if one examines the evolution in the use of this word from Aristotle through the Stoics to the Christian fathers, one can see that this is more or less what happened, as "greatness of soul"

became associated, first, with Stoic emphasis on the supremacy of virtue and the worthlessness of externals, including the body, and, through this, with the Christian denial of the body and of the worth of earthly life. So even in this apparently unpromising case, history shows that the Aristotelian approach not only provided the materials for a single debate but actually succeeded in organizing such a debate, across enormous differences of both place and time.

Here, then, is a sketch for an objective human morality based upon the idea of virtuous action-that is, of appropriate functioning in each human sphere. The Aristotelian claim is that, further developed, it will retain virtue morality's immersed attention to actual human experiences, while gaining the ability to criticize local and traditional moralities in the name of a more inclusive account of the circumstances of human life, and of the needs for human functioning that these circumstances call forth.

READING QUESTIONS

1. Why does Nussbaum think that traditional virtue theory is misconceived?
2. Why does she think that Aristotle's theory of the virtues is an objective one?
3. What is a "sphere of life"?
4. How does she use the philosophy of language to make her point?

Notes

1. Paige Mitchell, *Act of Love: The Killing of George Zygmanik* (New York: Knopf, 1976) 18.
2. Mitchell 8.
3. E. O. Wilson, *Consilience* (New York: Vintage, 1998).
4. David Hume, *A Treatise of Human Nature* (Oxford: Clarendon Press, 1978) 469.
5. William Fleming, *Arts and Ideas* (New York: Holt, Rinehart & Winston, 1986) 451.
6. David Barash, *The Whisperings Within* (New York: Penguin, 1979) 11.
7. A. J. Ayer, *Language, Truth, and Logic* (London: Penguin, 1971) 107.
8. Brand Blanshard, "The New Subjectivism in Ethics," *A Modern Introduction to Philosophy*, ed. Paul Edwards and Arthur Pup (New York: Free Press, 1973) 339.
9. Ruth Benedict, *Patterns of Culture* (New York: Pelican, 1934) 257.
10. Ellen Goodman, excerpt from "Human Rights Aren't Possible Without a Universal Standard" from *The Boston Globe* (June 1993).
11. Solomon Asch, *Social Psychology* (Englewood Cliffs, NJ: Prentice-Hall, 1952) 378–379.
12. Quoted in David Crary of the Associated Press, "Woman Jailed for Daughters' Circumcision," *Morning Call* [Allentown, PA] (9 January 1993) A32.
13. G. W. von Leibniz, "Discourse on Metaphysics," *Leibniz Selections*, ed. Philip P. Wiener (New York: Charles Scribner's Sons, 1951) 292.
14. St. Thomas Aquinas, *Summa Theologica*, pt. 1, ques. 25, article 3 (London: Burns, Oates, and Washbourne, 1920).
15. Kevin Sheh, Cristina de Isasi, and Kirk Mitchell, "God Is My Attorney," *Mesa Tribune*, Thursday, May 14, 1998, Page 1.
16. Albert Pike, *Morals and Dogma* (Charleston, 1871) 722.
17. John Hick, excerpts from *Death and Eternal Life* (San Francisco: Harper and Row, 1976).
18. Orna Feldman, excerpt from "Thou Shalt Not Raise Self-Indulgent Children" from *Brown Alumni Monthly* (October 1994).
19. Renford Bambrough, *Moral Skepticism and Moral Knowledge* (Atlantic Highlands, NJ: Humanities Press, Inc., 1979) 15.
20. Richard A. McCormick, excerpt from "To Save or Let Die: The Dilemma of Modern Medicine" from *Journal of the American Medical Association* 229 (July 8, 1974).
21. McCormick 175.
22. Ayn Rand, "The Virtue of Selfishness," *The Virtue of Selfishness: A New Concept of Egoism* (New York: Signet Books, 1964) 27.
23. Rand 31.
24. Joel Feinberg, "Psychological Egoism," *Moral Philosophy*, ed. George Sher (San Diego: Harcourt Brace Jovanovich, 1987) 11–12.
25. Joseph Butler, "Sermons," *Ethical Theories*, ed. A. I. Meldon (Englewood Cliffs, NJ: Prentice-Hall, 1967) 239.
26. Jeremy Bentham, "Of the Principle of Utility," *An Introduction to the Principles of Morals and Legislation* (Oxford: Clarendon Press, 1879) 1.
27. John Stuart Mill, *Utilitarianism* (Indianapolis: Bobbs-Merrill, 1957) 408.
28. Mill 409.
29. Galen Pletcher, "The Rights of Future Generations," in Ernest Partridge (ed.), *Responsibilities to Future Generations* (Buffalo: Prometheus Books, 1981) 168.
30. H. J. McCloskey, "A Non-Utilitarian Approach to Punishment," *Inquiry* 8 (1965) 239–255.
31. Richard B. Brandt, *Ethical Theory* (Englewood Cliffs, NJ: Prentice-Hall, 1959) 387.
32. W. D. Ross, *The Right and the Good* (Oxford: Clarendon Press, 1930) 34–35.
33. William Godwin, *Enquiry Concerning Political Justice and Its Influence on Morals and Happiness*, ed. F. E. L. Priestley (Toronto: University of Toronto Press, 1946) 126–127.
34. A. C. Ewing, excerpts from *Ethics*, 1953, Simon & Schuster, Inc.
35. Ewing 151.
36. It's the automobile. Approximately 50,000 people die in traffic accidents every year.
37. Mill 22.
38. Robert Nozick, *Anarchy, State, and Utopia* (New York: Basic Books, 1974) 42–43.
39. Nozick 43.
40. https://www.wireheading.com/, accessed 4/28/18.
41. *Ibid*.
42. Bernard Williams, "A Critique of Utilitarianism," *Right and Wrong*, ed. Christina Hoff-Sommers (New York: Harcourt Brace Jovanovich, 1986) 95.
43. Judith Jarvis Thomson, excerpts from "The Trolley Problem" from *Yale Law Journal* 94 (1985) 1395–1415.
44. Thomson 95.
45. Immanuel Kant, *Groundwork of the Metaphysics of Morals*, trans. H. J. Paton (New York: Harper & Row, 1964) 61.
46. Kant, *Groundwork* 394.
47. Kant, *Groundwork* 88.
48. Immanuel Kant, *The Metaphysical Elements of Justice*, trans. John Ladd (Indianapolis: Bobbs-Merrill, 1965) 99–107.
49. Kant, *Metaphysical Elements* 107.
50. Rebecca Roache, quoted in Ross Andersen, "Hell on Earth," *Aeon*, https://aeon.co/essays/how-will-radical-life-extension-transform-punishment, accessed on 4/26/2018.
51. R. M. Hare, *Freedom and Reason* (London: Oxford University Press, 1970) 160–161.
52. W. D. Ross, excerpts from *The Right and the Good*.
53. Kant, *Groundwork* 96.
54. Immanuel Kant, *Lectures on Ethics*, trans. Louis Infield (New York: Harper & Row, 1963) 239–240.
55. Jeremy Bentham, *Principles of Morals and Legislation* (New York: Hafner, 1948) 311.
56. Peter Singer, *Practical Ethics* 2nd ed.(Cambridge: Cambridge University Press, 1993) 57.
57. C. D. Broad, *Five Types of Ethical Theory* (London: Routledge and Kegan Paul, 1956) 132.
58. Ewing 58.
59. Ross 19.
60. Ross 28.
61. Ross 31.
62. John Rawls, *A Theory of Justice* (Cambridge, MA: Harvard University Press, 1971) 11.
63. Rawls 43.
64. Rawls 4.
65. Rawls 252.
66. http://federalsafetynet.com/us-poverty-statistics.html, accessed 10/20/2018.
67. Nozick 160–161.
68. Karl Marx, *Critique of the Gotha Program* (London: Lawrence and Wishart, 1938) 14, 107.
69. Nozick 160.
70. John Locke, *Two Treatises on Government*, Second Treatise, section 27.
71. Nozick 71.
72. *Federal Reserve Bulletin* 103 (September 2017) 10.
73. G. A. Cohen, "Robert Nozick and Wilt Chamberlain: How Patterns Preserve Liberty," *Erkenntnis* 11 (1977) 21.
74. Matt Zwolinski, "Libertarianism," *Internet Encyclopedia of Philosophy*, http://www.iep.utm.edu/libertar/accessed 8/16/2018.
75. Nozick 11.
76. Nozick 110.

77. Karl Widerquist, excerpt from "A Dilemma for Libertarians" from *Politics, Philosophy, and Economics* 8.1 (2009) 43–72.
78. Widerquist 51.
79. Robert Nozick, "The Zig-Zag of Politics," *The Examined Life* (New York: Simon and Schuster, 1989) 286–287.
80. Nozick, *The Examined Life* 292.
81. William Styron, *Sophie's Choice* (New York: Random House, 1994) 562.
82. "Tsunami Mother's Terrible Choice," BBC News, December 31, 2004, http://news.bbc.co.uk/2/hi/asia-pacific/4137053.stm accessed 10/20/2018.
83. Lawrence Kohlberg, "The Development of Children's Orientations toward a Moral Order," *Vita Humana* 6 (1963) 19.
84. L. J. Walker, "Sex Differences in the Development of Moral Reasoning: A Critical Review," *Child Development* 53 (1984) 1330–1336. See also Theo Linda Dawson, "New Tools, New Insights: Kohlberg's Moral Judgment Stages Revisited," *International Journal of Behavioral Development* 26 (2002) 154–166.
85. This sentiment is expressed by many authors in *Individual and Communitarianism*, ed. Shlomo Avineri and Avner de-Shalit (Oxford: Oxford University Press, 1992).
86. Hilary Putnam, *Realism with a Human Face* (Cambridge, MA: Harvard University Press, 1990) 138.
87. C. Allen, G. Varner, and J. Zinser. "Prolegomena to Any Future Artificial Moral Agent," *Journal of Experimental and Theoretical Artificial Intelligence*, 12 (2000) 251–261.
88. Peter Singer, *Practical Ethics*, 2nd ed. (Cambridge: Cambridge University Press, 1993) 230–231.
89. Michael Stocker, "The Schizophrenia of Modern Moral Theories," *Journal of Philosophy* 73.14 (1976) 462.
90. Stocker 462.
91. Arthur Murphy, *Theory of Practical Reason* (LaSalle, IL: Open Court, 1965) 126.
92. Tom Keogh, "Children without a Conscience," *New Age Journal* (Jan.–Feb. 1993) 53–54.
93. Kurt Baier, *The Moral Point of View* (New York: Random House, 1965), quoted in *Making Ethical Decisions*, ed. Norman Bowie (New York: McGraw-Hill, 1985) 26.
94. Aristotle, quoted in *The Philosophy of Aristotle*, ed. Renford Bambrough, trans. J. L. Creed and A. E. Wadman (New York: New American Library, 1963) 303.
95. The Buddha, quoted in Walpola Rahula, *What the Buddha Taught* (New York: Grove Press, 1974) 92–93.
96. Aristotle, *Aristotle: The Nicomachean Ethics*, ed. by Hugh Tredennick, trans. by J. A. K. Thomson (Harmondsworth: Penguin, 2004) Book 1, section 8.
97. Epictetus, "The Enchiridion," trans. by Elizabeth Carter, http://classics.mit.edu/Epictetus/epicench.html, accessed 10/20/18.
98. *Ibid*.
99. Marcus Tullius Cicero, "Paradoxes," *Cicero's Three Books of Offices*, trans. Cyrus T. Edmonds (London: Henry G. Bohn, 1850) 264–265.
100. Marcus Aurelius, *Meditations*, trans. Gregory Hays (New York: Modern Library, 2002) 91.
101. Alasdair MacIntyre, excerpt from *After Virtue*, 1984, Notre Dame Press.
102. MacIntyre 205.
103. MacIntyre 223.
104. Martha Nussbaum, "Non-Relative Virtues: An Aristotelian Approach," *Midwest Studies in Philosophy* 13 (1988) 32–39. Reprinted with permission.
105. Nussbaum 34.
106. Martha C. Nussbaum, *Sex and Social Justice* (Oxford University Press, 1999) 41–42.
107. Nussbaum, *Sex and Social Justice* 57.
108. Michael Slote, *From Morality to Virtue* (Oxford: Oxford University Press, 1992).
109. *The Republic of Plato*, trans. F. M. Cornford (Oxford: Oxford University Press, 1941) 45.

Chapter 6
The Problem of Evil and the Existence of God

> *The demand of the human understanding for causation requires but the one old and only answer, God.*
>
> —Henry Martyn Dexter

Where did the universe come from? Why are we here? What is to become of us? Such questions have traditionally been answered by appeal to the supernatural. From time immemorial, the workings of the natural world have been attributed to supernatural beings (gods). The Greeks, for example, believed that thunderstorms were caused by Zeus, earthquakes by Poseidon, and volcanoes by Hephaestus (the Roman Vulcan). Few today would attribute thunderstorms, earthquakes, or volcanoes to the actions of supernatural beings. Some phenomena, however, such as the creation of the universe, the existence of miracles, and the experience of the divine, are still thought to require a supernatural explanation. We will examine these and other phenomena to see if they are best explained by appeal to the supernatural.

The diversity of supernatural beings that have been postulated to explain various phenomena is immense. They range from nature spirits, such as leprechauns, fairies, and gnomes, to supreme beings, such as Jehovah, Allah, and Brahman. Religions that believe in the existence of many supernatural beings or gods are called "polytheistic"; those that believe in one supreme being are called "monotheistic." Even among monotheistic religions, however, there is a wide variation in their conceptions of the supreme being. For example, Jehovah (the supreme being of Christianity), Allah (the supreme being of Islam), and Ahura Mazda (the supreme being of Zoroastrianism) are persons; like us, they have thoughts, feelings, and desires. Unlike us, however, they are all-powerful, all-knowing, and all-good. Brahman (the supreme being of the Hindu religion), however, is not a person but an impersonal substance often described as pure being, pure consciousness, and pure bliss. The supreme being, however, cannot both be and not be a person because that is logically impossible. So if Hinduism is true, Christianity must be false, and vice versa. Those who are interested in understanding the true nature of reality, then, need to determine not only whether there is a supreme being, but if so, what kind of a being it is.

In the space of one chapter, we cannot investigate all the different conceptions of God. So we will focus on the conception of God common to Christianity, Judaism, and Islam—namely, that of an all-powerful (omnipotent), all-knowing (omniscient), and all-good (omnibenevolent) being who created and rules the universe. Our goal will be to determine whether we are justified in believing in the existence of such a being. If not, then killing in the name of God is not only immoral, it's irrational as well.

Religion has been used to justify the massacre of millions of people. Thousands of people in the United States have died at the hands of Islamic fundamentalists. But God-fearing Christians also slaughtered thousands of people in the Crusades and the Inquisition. The rationale was the same in all of these cases: God says that unbelievers should die. As the God of the Bible says, "He that sacrificeth unto any god, save unto the Lord only, he shall be utterly destroyed" (Exod. 22:20). How we should interpret such pronouncements is one of the most important inquiries we can undertake.

- Christians consider the Islamic suicide bombers' belief that each will receive the services of seventy-two virgins in heaven to be absurd. What Christians often fail to realize, however, is that Muslims, Hindus, and Jews consider the Christian claim that only those who believe in Jesus Christ will go to heaven to be equally absurd. The only way to decide which, if either, of these beliefs is true is to examine the reasons behind them.

If you ask someone why he or she believes in God, you are likely to get an answer like, "Because my parents taught me that God exists." But the mere fact that your parents taught you something doesn't make it true. Your parents may have also taught you that Santa Claus, the Easter bunny, and the tooth fairy exist, but that doesn't mean that they do. Your upbringing in a certain religion may have caused you to have certain beliefs, but it doesn't justify those beliefs.

When we ask someone why he or she believes something, we may be looking for two very different sorts of things. On the one hand, we may be looking for the cause of that person's belief. This is the sort of thing that psychologists, sociologists, and anthropologists look for. On the other hand, we may be looking for the reasons that person has for thinking that belief is true. This is the sort of thing that philosophers look for. Philosophers are not particularly interested in how you came by your belief in God; they are interested in determining whether there is any truth to the claim that God exists.

> *Reason unaided by revelation can prove that God exists.*
> —ROMAN CATHOLIC BALTIMORE CATECHISM

Because so many people have been taught from such a young age that a particular God is the one true God, it is often difficult to be objective about the God question. But we must be objective if we hope to get to the truth of the matter. When we reflect on the existence of God, we need to put aside our prejudices and ask ourselves, If I didn't believe, hope, or fear that there was a
- God, how would I assess the arguments for the existence of God?

After assessing the arguments, you may decide that you are justified in believing in God. In that case, you may be a **theist**—that is, one who believes in God. If you find that you are neither justified nor unjustified in believing in God, you may be an **agnostic**—that is, one who neither believes nor disbelieves in God. If you decide that you are justified in believing that God does not exist, you may be an **atheist**—that is, one who does not believe in God.

The traditional God of theism is not only supposed to be the creator of the universe, but he is also supposed to be personally involved with it. God not only watches over us but also helps us in times of need. He listens to our prayers and sometimes grants them. Not everyone who believes in one god, however, shares that conception of god. Many of the founders of our country, including Thomas Jefferson, Benjamin Franklin, and George Washington, were **deists.** They believed that the universe was created by a god, but they didn't believe that he watches over it. The god of the deists is like a watchmaker who is so skillful that the mechanisms he creates never need to be adjusted. Deists do not believe that God intervenes in the world or the affairs of humans. He does not perform miracles or answer prayers.

theist One who believes in a god, especially a personal god who rules the world.

agnostic One who neither believes nor disbelieves in God.

atheist One who disbelieves in God.

deist One who believes that God created the universe and then abandoned it.

> God, I can push the grass apart, And lay my finger on your heart.
>
> —EDNA ST. VINCENT MILLAY

Pantheism is a type of monotheism that is not theist in the traditional sense. **Pantheists** believe that the universe itself is God. This is not to say that the universe is a person, but it is to say that the universe is divine and thus the ultimate object of reverence. Many Hindus are pantheists, as are many Buddhists, Taoists, and Unitarian Universalists. They hold that nature is sacred and that the religious feelings of awe and wonder that we experience need not be attributed to a supernatural agency. Such feelings are merely a recognition of the grandeur of the universe and our intimate connection to it.

In this chapter, we will examine a number of the traditional arguments for the existence of God. There are some arguments that we won't consider, because they are clearly fallacious. These arguments have a certain amount of currency, however, so it's useful to see where they go wrong.

One popular argument for the existence of God appeals to sacred scripture. When asked why they believe in God, many people respond by citing a sacred text. "I believe in God because the Bible says that God exists," a Christian might claim. When asked why they believe the Bible, they might respond, "Because God wrote it." Do you see the problem here? They are trying to prove the existence of God by assuming that He exists. Any argument that assumes what it's trying to prove, however, proves nothing. A good argument should increase the likelihood of its conclusion by citing evidence that is more well established than its conclusion. If the conclusion appears as a premise in an argument, however, it can't increase the likelihood of its conclusion.

> There is no book like the Bible for excellent wisdom and use.
>
> —MATTHEW HALE

The Bible, of course, is not the only book of sacred scripture. Different religions take different texts to be divinely inspired. For Muslims, it is the Koran; for Hindus, it is the Vedas; and for the Zoroastrians (the first monotheistic religion), it is the Avesta. These texts contradict one another in all sorts of ways and so cannot all be true. The Bible, for example, says that God incarnated in the form of Jesus Christ, whereas the other three deny that. So to decide which, if any, of these texts is the true word of God, we must appeal to something other than the texts themselves.

Some defend the Bible on the grounds that it contains historically accurate information. But from the fact that some of what the Bible says about the natural world is true, it doesn't follow that anything it says about the supernatural world is true. Herman Melville's *Moby-Dick* contains many truths about whaling, but from this we can't conclude that there was a great white whale. Moreover, biblical archaeologists have found that there is good reason for believing that a number of the major historical claims of the Bible are false. (See the box "Biblical Archaeology.") To establish the existence of supernatural beings, then, we need something more than a book that claims that they exist.

Another popular argument for the existence of God is based on the claim that every society throughout history has had a belief in God. This is often called the argument from common consent. Even if this claim were true, it wouldn't establish the existence of God, for from the fact that many people believe something, it doesn't follow that it is true. Many people in the world once believed that the earth was flat, but that didn't make it flat. Believing something doesn't make it so. What's more, the claim that every society has a

pantheist One who believes that the universe is God.

> ## Biblical Archaeology
>
> Archaeological investigations have failed to confirm many of the most significant events recorded in the Bible. Many archaeologists believe that this lack of confirming evidence is grounds for thinking that the historical sections of the Bible can't be taken literally, as Haim Watzman reports in *The Chronicle of Higher Education*:
>
> "If Abraham, Isaac, Jacob, Moses, and David aren't proven, how am I supposed to live with that?" This agonized question came from the crowded back row of an auditorium at Ben-Gurion University during a conference titled "Has the Biblical Period Disappeared?" It expressed the shiver that went down Israel's collective spine as puzzled scholars saw Israel's lay population jerked into awareness of the last two decades of biblical archaeological and historical research. . . .
>
> The chill that produced the question at Ben-Gurion University was set off by one of Israeli archaeology's leading biblical minimalists—a label attached by their colleagues to those who think that very little in the Bible's historical sections is true. The Tel Aviv University archaeologist Ze'ev Herzog began the flurry with a cover story in the weekend magazine of the October 29, 1999, issue of *Ha'aretz*, the national daily newspaper.
>
> "This is what archaeologists have learned from their excavations in the Land of Israel: the Israelites were never in Egypt, did not wander in the desert, did not conquer the land in a military campaign and did not pass it on to the 12 tribes of Israel. Perhaps even harder to swallow is the fact that the united monarchy of David and Solomon, which is described by the Bible as a regional power, was at most a small tribal kingdom," he wrote. . . .
>
> None of the scholars speaking at the conference believe that the Bible's historical sections can be accepted as literal, accurate descriptions of historical events. They also agree that the extrabiblical evidence for events described in the Bible dwindles the farther back in time one goes. King Ahab of Israel is well documented in other inscriptions from elsewhere in the Middle East; the united monarchy of David and Solomon is not. Evidence exists of the rise of the new Israelite nation in the Palestinian highlands during the late Bronze Age—the age of the Judges—but it can be interpreted in different ways. There is no external evidence at all for the patriarchs and, in fact, the biblical description contains contradictions and anachronisms that, scholars generally agree, seem to place the patriarchs in the age of the Judges rather than several generations earlier, as the Bible has it.
>
> Mr. Herzog concludes from such findings that the Bible simply should not be used as a historical source. The archaeological practice begun by William Foxwell Albright, who founded the discipline of biblical archaeology in the early part of the twentieth century, was that findings in the field should be interpreted in the light of the biblical text. Mr. Herzog's new paradigm is that the Bible should be set aside and the findings interpreted in their own right.[1]
>
> ### Thought Probe
>
> **Biblical Truths**
>
> Does the failure to find confirming evidence for many of the Bible's historical claims undercut the credibility of its nonhistorical claims? Why or why not?

belief in God is false. The word "god," as we've seen, is extremely ambiguous, and there is no single conception of God that has been held by all societies. Certainly not all societies have believed in the traditional god of theism, nor have they believed in a personal god. Many societies, such as those where Buddhism is the dominant religion, have no belief in God as traditionally conceived. Two of the most fundamental principles of Buddhism are that there are no continuing substances (*anicca*) and thus no continuing selves (*anatta*). If there are no continuing substances, however, there are no eternal beings

and no immortal souls. The argument from common consent, then, is both fallacious and erroneous.

Some defend their belief in God on the grounds that no one can prove that God doesn't exist. This type of argument is known as an appeal to ignorance and is also fallacious. From the fact that one can't prove that something does not exist, it doesn't follow that it does exist. One can't prove that Santa Claus does not exist. But that doesn't mean that he does exist.

Although it's often claimed that one cannot prove a universal negative, (where a universal negative is a statement to the effect that something does not exist), that is not necessarily so. If one can prove that the notion of a thing is self-contradictory, one can prove that it doesn't exist. We know, for example, that there are no round squares, because the notion of a round square is self-contradictory. Similarly, some claim, the theistic notion of God is self-contradictory. To give but one example, the theistic God is often claimed to be perfectly merciful and perfectly just. If He is perfectly just, He makes sure that everyone gets what's coming to them. If He is perfectly merciful, he lets everyone off. But no one, not even God, can do both. So the theistic notion of God may be self-contradictory. If so, such a god can't possibly exist.

The traditional God of theism is supposed to be immaterial. Because God does not have a body, however, it's impossible to sense him. Some atheists use this fact to argue against God. They claim that since no one can prove that God does exist, he must not exist. This, too, is an appeal to ignorance and is just as fallacious as the one made by the theists. A thing may exist even though we can't sense it.

Scientists believe in a lot of things that can't be sensed, like subatomic particles. Their belief in these particles is justified because the assumption that they exist provides the best explanation of a number of phenomena, and it doesn't contradict any known facts. Many of the arguments presented by theists for the existence of God can be viewed as inferences to the best explanation. Theists cite certain phenomena, like the origin and design of the universe, and claim that they are best explained on the assumption that God exists. We will examine such claims to determine whether the God hypothesis does provide the best explanation for them.

If the arguments for the existence of God are as good as the arguments for the existence of subatomic particles, then we should be justified in believing that the existence of God is a fact. And if we're justified in believing that the existence of God is a fact, we should be justified in teaching that fact in public schools. There is no separation between state and science. If religious arguments are as good as scientific ones, maybe there should be no separation between state and church.

On the other hand, if religious arguments are as good as scientific ones, there's no need for religious faith. Our belief in the existence of subatomic particles is not based on faith—it's based on fact. If our belief in the existence of God is similarly based on fact, religious faith would be superfluous. Realizing that strong arguments for the existence of God would undermine faith, many theologians claim that it is wrongheaded to try to justify belief in God through the use of reason. Dutch theologian Herman Bavinck, for example, proclaims,

> I do not feel obliged to believe that the same God who has endowed us with sense, reason, and intellect has intended us to forgo their use.
>
> —GALILEO GALILEI

> ## Religious Adherents
>
> As the ancient Greek historian Herodotus realized over 2500 years ago,
>
> > Everyone without exception believes his own native customs, and the religion he was brought up in, to be the best. . . .[2]
>
> Most people adopt the religion of their parents and will adamantly maintain that they worship the one true god. No one religion, however, commands the allegiance of a majority of the human population. Here's a list of the number of adherents of some of the major religions (and nonreligions):[3]
>
Religion	Adherents
> | Christianity: | 1.9 billion |
> | Islam: | 1.5 billion |
> | Secular/Nonreligious/Atheist: | 1.1 billion |
> | Hinduism: | 900 million |
> | Chinese traditional religion: | 394 million |
> | Buddhism: | 376 million |
> | Primal-indigenous: | 300 million |
> | African traditional & diasporic: | 100 million |
> | Sikhism: | 23 million |
> | Juche: | 19 million |
> | Spiritism: | 15 million |
> | Judaism: | 14 million |
> | Baha'i: | 7 million |
> | Jainism: | 4.2 million |
> | Shinto: | 4 million |
> | Cao Dai: | 4 million |
> | Zoroastrianism: | 2.6 million |
> | Tenrikyo: | 2 million |
> | Neo-Paganism: | 1 million |
>
> These religions have very different beliefs about the nature of god and reality. Because no one religion can claim to be the majority view, most people on the planet must be mistaken about the nature of god and reality. Scott Adams, the creator of the cartoon "Dilbert," explains:
>
> > No major religion holds sway with more than about 25% of the population of earth. And the major religions disagree about very fundamental things. For example, if the Buddhists and Hindus are right about reincarnation, then heaven doesn't exist (much less God or Jesus). If the Muslims or Jews are right, Jesus isn't the Son of God. So we all agree that if any one of the major or minor religions [is] true, then all the others are substantially wrong and the believers of the wrong religions are deluded.
> >
> > Therefore, by any reckoning, in the best-case scenario, 75% of the people on earth are seriously deluded about the nature of God and reality. (In the worst case, 100% are deluded.)[4]
>
> ### Thought Probe
>
> **Deluded Believers**
>
> How do you know you're not part of the 75 percent of the human population who are mistaken about the true nature of god and reality? How do you know that your god is real and those worshipped by adherents of other religions is not? What evidence do you have?

We receive the impression that belief in the existence of God is based entirely upon these proofs. But indeed that would be "a wretched faith, which, before it invokes God, must first prove his existence.". . . The so-called proofs are by no means the final grounds of our most certain conviction that God exists. This certainty is established only by faith. . . .[5]

Evaluating the effectiveness of both reason and faith in establishing the existence of God is one of the goals of this chapter.

Atheists claim not only that the God hypothesis does *not* provide the best explanation of anything but also that it contradicts known facts. One undeniable fact, they claim, is that evil exists. But if the world was created by an all-powerful, all-knowing, and all-good being, there should be no evil in the

Science cannot determine origin, and so cannot determine destiny.

—THEODORE MUNGER

world. If God is all-good, he shouldn't want evil to exist in the world; if he's all-knowing, he should know how to create a world without evil; and if he's all-powerful, he should be able to create a world without evil. So why is there so much evil in the world? This is the famous problem of evil. Theists recognize that this is a serious challenge to the God hypothesis and consequently have devised a number of theories to justify the existence of evil. We will examine some of these theories in the Section 6.2.

Thought Probe

Holy Scripture

Suppose you're a space explorer who lands on a planet where there are a number of different religions. Each religion is based on a holy book supposedly written by a god who is all-powerful, all-knowing, and all-good. To determine whether one of the books is truly the word of god, what would you look for? What characteristics would a book written by such a god possess? Do any of our holy books possess those characteristics?

Objectives

After reading this chapter, you should be able to

- state and evaluate the various arguments for the existence of God.
- state the argument from evil and evaluate the various solutions to it.
- define theism, deism, atheism, agnosticism, pantheism, theodicy, moral evil, and natural evil.
- decide, on the basis of reasons, whether you are a theist, an atheist, or an agnostic.

Section 6.1

The Mysterious Universe
God as Creator

Science is remarkably effective at explaining the workings of the world. It has given us an understanding of everything from galactic clusters to subatomic particles. But many believe that there are some things that science can't explain, like the origin of the universe. To explain that, it is argued, we must appeal to something outside the universe—something supernatural—like God. Arguments that attempt to derive the existence of God from the existence of the universe are known as **cosmological arguments** for the existence of God.

> Let the chain of second causes be ever so long, the first link is always in God's hand.
>
> —GEORGE LAVINGTON

The Traditional Cosmological Argument

The basic cosmological argument is known as the first-cause argument. It rests on the assumption that everything has a cause. Because nothing can cause itself, and the string of causes can't be infinitely long, there must be a first cause—namely, God. This argument received its classic formulation at the hands of the great Roman Catholic philosopher St. Thomas Aquinas. He writes,

> In the world of sensible things, we find there is an order of efficient causes. There is no case known . . . in which a thing is found to be the efficient cause of itself; for so it would be prior to itself, which is impossible. Now in efficient causes it is not possible to go to infinity, because . . . the first is the cause of the intermediate cause, and the intermediate is the cause of the ultimate cause. . . . Now to take away the cause is to take away the effect. Therefore, if there be no first cause among efficient causes, there will be no ultimate, nor any intermediate, cause. . . therefore it is necessary to admit a first efficient cause, to which everyone gives the name God.[6]

cosmological argument An argument that attempts to derive the existence of God from the existence of the universe.

Thomas Aquinas

The greatest thinker of medieval times was the philosopher-theologian Thomas Aquinas (1225–1274). He was born in the castle of Roccasecca in the kingdom of Naples (Italy). At the age of five, he was sent to the Abbey of Monte Cassino to begin his schooling. By his mid-teens, he was ready to continue his education at the University of Naples. There he studied philosophy and liberal arts and, at eighteen, became a Dominican monk. When his aristocratic family learned that he had entered an order of beggars, they locked him in the family castle for about a year. His imprisonment had no effect, for he soon left to study with the Dominicans in Paris and remained devoted to the Dominican ideals of study and preaching for the rest of his life.

In 1256, he lectured as a master of theology at the University of Paris and subsequently taught at Orvieto, Rome, and Naples. For the rest of his days, he continued to teach and to write treatises, scriptural commentaries, and defenses of his philosophical positions. He was involved in all the major philosophical and theological disputations of his day. By the time he had finished, he had created a grand intellectual system that has exerted more influence in the Church than the work of any other theologian.

In December 1273, he had a religious experience during Mass that profoundly affected him. He reportedly said of this incident, "All that I have written seems to me like straw compared to what has now been revealed to me." He stopped writing and died four months later at age fifty.

Aquinas's greatest achievement was a synthesis of the Christianity of his day with the philosophy of Aristotle. Eight hundred years earlier, Augustine brought about a similar marriage between Plato's philosophy and Christianity. But Aquinas thought that the Augustinian synthesis was inadequate. For example, Augustine thought that all true knowledge was to be found in an unearthly, nonmaterial, eternal realm that was far superior to the earthly, material, fleeting world of flesh. But Aquinas, following Aristotle, thought that rational knowledge could be gained through sense experience, as well as through revelation.

St. Thomas Aquinas
1225–1274

St. Thomas's argument goes something like this:

1. Some things are caused.
2. Nothing can cause itself.
3. Therefore, everything that is caused is caused by something other than itself.
4. The chain of causes cannot stretch infinitely backward in time.
5. If the chain of causes cannot stretch infinitely backward in time, there must be a first cause.
6. Therefore, everything that is caused has a first cause—namely, God.

If sound, this argument proves the existence of a first cause. St. Thomas claims that it also proves the existence of God. But this follows only if there is good reason for believing that the first cause is all-powerful, all-knowing, and all-good. The cosmological argument itself, however, gives us no reason for believing that this is the case.

An all-powerful being would be able to create every possible universe. From the fact that a being created this universe, however, we can't conclude that it has that kind of power. For all we know, this is the only universe that being could create. In the absence of any additional evidence, then, we are not justified in believing that the first cause is all-powerful.

- An all-knowing being would know everything there is to know about every possible universe. From the fact that a being created this universe, however, we can't conclude that it has that kind of knowledge. For all we know, this is the only universe the creator knew how to create. So again, in the absence of additional evidence, we are not justified in believing that the first cause is all-knowing.

An all-good being would create only good things. But the universe seems to contain a lot of evil. The simplest explanation of this fact is that the creator of this universe is not all-good. This is the explanation of evil that was favored by the early Christian sect known as the Gnostics. They believed that our world was created by the *demiurge,* a defective, inferior god who is the author of evil. So even if the traditional cosmological argument succeeds in proving the existence of a first cause, it does not succeed in proving the existence of the traditional god of theism.

Some believe that the universe is too flawed to be the creation of a divine being. The Roman poet Lucretius, for example, writing fifty years before the birth of Christ, had this to say about the universe and its creator:

> I dare this to affirm . . .
> That in no wise the nature of all things
> For us was fashioned by a power divine
> So great the faults it stands encumbered with.
> First, mark all regions which are overarched
> By the prodigious reaches of the sky:
> Well-nigh two thirds intolerable heat
> And a perpetual fall of frost doth rob
> From mortal kind. . . .
> Beside these matters, why
- Doth Nature feed and foster on land and sea
> The dreadful breed of savage beasts, the foes
> Of the human clan? Why do the seasons bring
> Distempers with them? Wherefore stalks at large
> Death so untimely?[7]

As an abode for humans, the earth leaves much to be desired. Instead of promoting human flourishing, it seems to be inimical to it. Such would not be the case, Lucretius claims, if the universe was created by a divine being.

Not only might the first cause be something less than perfect, it might be something less than human. Hume provides the following example:

> The Brahmins assert, that the world arose from an infinite spider, who spun this whole complicated mass from his bowels, and annihilates afterwards the whole or any part of it, by absorbing it again, and resolving it into his own essence.[8]

Nothing in the traditional cosmological argument rules out the possibility of a nonhuman first cause. The universe could have been created by an infinite spider or any other sort of sufficiently great creature, like a cosmic chicken. As a result, it can't establish the existence of the traditional God of theism.

When you come to look into this argument from design, it is a most astonishing thing that people can believe that this world, with all the things that are in it, with all its defects, should be the best that omnipotence and omniscience have been able to produce in millions of years.

—BERTRAND RUSSELL

The Mysterious Universe

Notice that St. Thomas's argument doesn't say that everything has a cause. If it did, God would need a cause, and instead of explaining the universe, the argument would generate an infinite regress because for whatever cause was cited, we could always ask, "What caused it?" To avoid such a regress, there must be something eternal and thus uncaused, and that, Aquinas says, is God. Many others, however, claim that it is the universe itself.

Even prior to the advent of modern physics, there were powerful reasons for believing that the universe was eternal. To suppose otherwise, it was argued, was to suppose that you could get something from nothing, and that's impossible. "From nothing, nothing comes," is how Lucretius puts it. Creation always involves taking preexisting stuff and fashioning it in certain ways. It never involves bringing something into existence out of nothing.

This insight is enshrined in one of the fundamental laws of modern physics. Known as the Law of Conservation of Mass-Energy, it says that the total amount of mass-energy in the world can neither be increased nor decreased. In 1785, Antoine Lavoisier proposed the Law of Conservation of Mass, which says that matter can be neither created nor destroyed. In 1842, Julius Robert Mayer proposed the Law of Conservation of Energy, which says that energy can be neither created nor destroyed. In 1907, Albert Einstein, in his famous equation, $E = mc^2$, showed that mass can be converted into energy, and vice versa. Since that time, the two laws have been merged into the Law of Conservation of Mass-Energy. If the total amount of mass-energy can be neither increased nor decreased, then the implication would seem to be that the universe is eternal.

To undercut this notion, St. Thomas tries to argue that an eternal universe is inconsistent with the facts. If there were no first cause, he claims, there would be nothing happening now. But there is something happening now. So there must be a first cause. This argument, however, rests on the mistaken notion that an infinite series of causes is just a very long finite series.

Consider a single-column stack of children's blocks resting on a table. Each block rests on the block below it, except for the block that rests on the table. If the bottom block were taken away, the whole stack would fall down. In a finite stack of blocks, there must be a first block.

There is no more steely barb than that of the infinite.

—CHARLES BAUDELAIRE

In an infinite stack of blocks, however, there is no first block. Similarly, in an infinite causal chain, there is no first cause. Aquinas took this to mean that an infinite causal chain is missing something. But it is a mistake to think that anything is missing from an infinite causal chain. Even though an infinite causal chain has no first cause, there is no event in that chain that doesn't have a cause. Similarly, even though the set of real numbers has no first member, there is no number that doesn't have a predecessor. Logic doesn't demand a first cause any more than it demands a first number. There's no contradiction in assuming that the universe will extend infinitely into the future. Similarly, there's no contradiction in assuming that the universe extends infinitely into the past. An eternal universe is both a physical and a logical possibility.

> ### An Actual Infinite: The Quantum Hilbert Hotel
>
> Aquinas's First Cause or Cosmological argument for the existence of God is based on the belief that it's impossible for there to be an actual infinity of causes. Some have tried to support this belief by claiming that an actual infinity of anything is absurd. To highlight some of the counterintuitive aspects of infinity, David Hilbert, one of the greatest mathematicians of the late nineteenth and early twentieth centuries, proposed a thought experiment that has come to be known as "The Hilbert Hotel." Suppose there is a hotel with an infinite number of rooms, and suppose that every one of those rooms is occupied. Now suppose that a traveler arrives seeking a room for the night. "No problem," says the desk clerk. To free up a room for the traveler, he simply asks each of the guests to add 1 to their room number and move into that room, thus making room number 1 available for occupancy. Now suppose that a bus with an infinite number of passengers pulls up to Hilbert's Hotel looking for lodging. Again, the desk clerk says, "No problem," and asks each of the quests to multiply their room number by two and move into that room, thus making the infinite number of odd rooms available for occupancy. It seems absurd to think that such a hotel could exist.
>
> But seeming absurdity does not necessarily imply physical impossibility as quantum mechanics has taught us time and again. The best way to show that something is physically possible is to show that it's actual, and some quantum physicists have created an actual infinity with all the properties of the Hilbert Hotel. Here's a description of how they did it:
>
> In 1924, David Hilbert conceived a paradoxical tale with an infinite number of rooms to illustrate some aspects of the mathematical notion of infinity. In continuous variable quantum mechanics, we routinely make use of infinite state spaces: here we show that such a theoretical apparatus can accommodate an analog of Hilbert's hotel paradox. We devise a protocol that, mimicking what happens to the guests at the hotel, maps the amplitudes of an infinite eigenbasis to twice their original quantum number in a coherent and deterministic manner, producing infinitely many unoccupied levels in the process. We demonstrate the feasibility of the protocol by experimentally realizing it on the orbital angular momentum of a paraxial field.[9]
>
> To put it in somewhat less technical language, a subatomic particle placed in a box whose walls are impenetrable can occupy an infinite number of energy levels. By manipulating the orbital angular momentum (OAM) of particles of light (photons), the researchers were able to open gaps in the OAM spectrum thus creating an infinity of free states that weren't occupied. Filippo Miatto, one of the researchers who conducted the experiment, summarized the results this way: "Philosophically, after our findings, one could argue that the real world can accommodate for the mathematical notion of infinity in the sense of Hilbert's paradox."[10]

The Kalam Cosmological Argument

Although it may be possible for the universe to be infinitely old, many believe that the universe was created less than fifteen billion years ago in a cataclysmic explosion known as the "big bang." The existence of such a creation event explains a number of phenomena, including the expansion of the universe, the existence of the cosmic background radiation, and the relative proportions of various sorts of matter. As the theory has been refined, more specific predictions have been derived from it. A number of these predictions have recently been confirmed. Although this is a major

In all the vast and the minute, we see the unambiguous footsteps of the God, who gives its luster to the insect's wing and wheels his throne upon the rolling worlds.

—William Cowper

scientific achievement, many believe that it has theological implications as well. Specifically, they believe that it provides scientific evidence for the existence of God. Astronomer George Smoot suggested as much when he exclaimed at a press conference reporting the findings of the Cosmic Background Explorer (COBE) satellite, "If you're religious, it's like looking at the face of God." Why? Because something must have caused the big bang, and who else but God could have done such a thing? Astronomer Hugh Ross, in his book *The Creator and the Cosmos,* puts the argument this way: "If the universe arose out of a big bang, it must have had a beginning. If it had a beginning, it must have a beginner."[11] And that beginner, Ross believes, is God.

The Kalam cosmological argument follows along these lines. It goes like this:

1. Whatever begins to exist has a cause.
2. The universe began to exist.
3. Therefore, the universe had a cause—namely, God.

This argument gets its name from the Arabic word *kalam,* which means "to argue or discuss." It originated with Islamic theologians who sought to challenge the Greek view that the universe was eternal.

The Kalam cosmological argument doesn't require that everything have a cause, only those things that begin to exist. Because God is eternal, he doesn't require a cause. The universe, however, is not eternal. So it does requires a cause.

Like the traditional cosmological argument, however, the Kalam cosmological argument gives us no reason for believing that the first cause is the traditional God of theism. The conclusion of the argument tells us nothing about the nature of the first cause—not even that it's a person. So even if the Kalam cosmological argument did prove the existence of a first cause, it doesn't prove the existence of the theistic God.

There's reason to believe it doesn't even prove the existence of a first cause, however, for modern physics explicitly repudiates premise 1 and provides good reason for rejecting premise 2.

Remarkably enough, modern physics rejects the claim that whatever begins to exist has a cause. On the contrary, it maintains that things like subatomic particles can come into existence without a cause. As physicist Edward Tryon tells us,

> . . . quantum electrodynamics reveals that an electron, positron, and photon occasionally emerge spontaneously in a perfect vacuum. When this happens, the three particles exist for a brief time, and then annihilate each other, leaving no trace behind. . . . The spontaneous, temporary emergence of particles from a vacuum is called a vacuum fluctuation, and is utterly commonplace in quantum field theory.[12]

Vacuum fluctuations are random events, and random events have no cause. So anything produced by a vacuum fluctuation is uncaused.

What's even more remarkable is that, according to modern physics, the universe itself could be the result of a vacuum fluctuation! Tryon explains:

> If it is true that our Universe has a zero net value for all conserved quantities, then it may simply be a fluctuation of a vacuum, the vacuum of some larger space in which our universe is imbedded. In answer to the question of why it happened, I offer the modest proposal that our Universe is simply one of those things which happen from time to time.[13]

According to Tryon, universes happen; they come into existence spontaneously without being caused to exist.

Wouldn't a universe produced by a vacuum fluctuation violate the Law of Conservation of Mass-Energy? Not if the total amount of mass-energy of the universe is zero. How is that possible? Here is physicist Paul Davies:

> There is a . . . remarkable possibility, which is the creation of matter from a state of zero energy. This possibility arises because energy can be both positive and negative. The energy of motion or the energy of mass is always positive, but the energy of attraction, such as that due to certain types of gravitational or electromagnetic field, is negative. Circumstances can arise in which the positive energy that goes to make up the mass of newly created particles of matter is exactly offset by the negative energy of gravity or electromagnetism. . . . Some have suggested that there is a deep cosmic principle at work which requires the universe to have exactly zero energy. If that is so, the cosmos can follow the path of least resistance, coming into existence without requiring any input of matter or energy at all.[14]

If our universe has zero total energy, as measurements seem to indicate, it could be the result of a vacuum fluctuation. But if it was the result of a vacuum fluctuation, it was not caused to exist by anyone or anything. It just happened.

The question of why there is something rather than nothing has vexed philosophers for millennia. In his book *Why Is There Something Rather Than Nothing?* philosopher Bede Rundle calls it "philosophy's central and most perplexing question."[15] The assumption has always been that nothing is somehow more natural than something. A number of physicists now believe that that assumption is mistaken. Vic Stenger, for example, claims that "we can give a plausible scientific reason based on our best current knowledge of physics and cosmology that something is more natural than nothing!"[16] According to Stenger, "the probability for there being something rather than nothing actually can be calculated; it is over 60 percent."[17] The Nobel Prize–winning physicist Frank Wilczek sums up this research this way: "The answer to the ancient question 'Why is there something rather than nothing?' would then be that 'nothing' is unstable."[18]

The late Steven Hawking, the famous physicist who suffered from Lou Gehrig's disease, agrees. In his book *The Grand Design,* he tells us: "Because there is a law such as gravity, the Universe can and will create itself from

> *Eternal nothingness is fine if you happen to be dressed for it.*
>
> —WOODY ALLEN

nothing. Spontaneous creation is the reason there is something rather than nothing, why the Universe exists, why we exist."[19] According to Hawking, God is not needed to create the universe. As he puts it, "It is not necessary to invoke God to light the blue touch paper and set the Universe going."[20] This is not to say that God does not exist. But it is to say that we don't need God to explain the coming into being of the universe.

The second premise of the Kalam cosmological argument says that the universe began to exist at some point in the past. Evidence for the big bang is usually presented as evidence for this claim. But the fact that the big bang occurred doesn't prove that the universe began to exist, for the big bang may itself have been the result of a prior big crunch!

It has long been thought that if the amount of matter in the universe is great enough, then the universe will someday stop expanding and start contracting. Eventually, all the matter in the universe would be drawn back to a single point in what has come to be known as the "big crunch." Because matter supposedly cannot be crushed out of existence, the contraction cannot go on indefinitely. At some point the compressed matter may bounce back in another big bang. If so, the big bang would have been caused by a prior big crunch, rather than by some supernatural being.

> If God did not exist, it would be necessary to invent him.
> —Voltaire

The view that the universe oscillates between periods of expansion and contraction in an endless—and beginningless—cycle of creation and destruction is a very Eastern one. Hindus, for example, believe that everything in the universe—as well as the universe itself—undergoes a continuous process of death and rebirth. For them, time is circular; the beginning and end are one and the same. In this view, the notion of a first cause makes no sense. Only for those who have a linear view of time is the question of the origin of the universe a problem.

Some estimates indicate that there is not enough mass in the universe to stop its expansion. So the big bang may not have been the result of a prior big crunch. But even if the universe as a whole never contracts, we know that certain parts of it do. When a star has used up its fuel, the force of gravity causes it to contract. If the star is massive enough, this contraction results in a black hole. The matter in a black hole is compressed toward a point of infinite density known as a "singularity." Before it reaches the singularity, however, some physicists, most notably Lee Smolin, believe that the matter in the black hole may start expanding again and give rise to another universe. In a sense, then, according to Smolin, our universe may reproduce itself by budding off. He writes,

> A collapsing star forms a black hole, within which it is compressed to a very dense state. The universe began in a similarly very dense state from which it expands. Is it possible that these are one and the same dense state? That is, is it possible that what is beyond the horizon of a black hole is the beginning of another universe? This could happen if the collapsing star exploded once it reached a very dense state, but after the black hole horizon had formed around it....
>
> What we are doing is applying this bounce hypothesis, not to the universe as a whole, but to every black hole in it. If this is true, then we live not in a single

universe, which is eternally passing through the same recurring cycle of collapse and rebirth. We live instead in a continually growing community of "universes," each of which is born from an explosion following the collapse of a star to a black hole.[21]

Smolin's vision of a self-reproducing universe is an appealing one. It suggests that the universe is more like a living thing than an artifact and thus that its coming into being doesn't require an external agent.

Tryon's and Smolin's theories are not the only ones that explain the big bang without appealing to the supernatural. Paul Teinhardt of Princeton University and Neil Turok of Cambridge University have proposed a new oscillating theory of the universe in which the universe is brought into existence as the result of a collision between giant membranes of matter. Andre Linde has proposed a self-reproducing theory of the universe wherein the budding-off process is driven by scalar fields rather than black holes. And Stephen Hawking proposed that although the universe is finitely old, it had no beginning in time because, as St. Augustine suggests, time came into existence with the universe.

These theories are simpler than the God hypothesis because they do not postulate the existence of any supernatural entities. They are also more conservative because they don't contradict any laws of science. In addition, they are potentially more fruitful because they make testable predictions. Other things being equal, the simpler, the more conservative, and the more fruitful a theory, the better. So even if the big bang occurred fifteen billion years ago, we don't have to assume that it was caused by God.

Thought Probe

Why a Universe?

God is supposedly eternal, but our universe is only fifteen billion years old. So if God existed for a long time before creating our universe, what prompted him to create it? Was he bored? Lonely? Underappreciated? Did he finally realize, after thinking about it for an infinite amount of time, that reality was not as good as it could be? What do you think?

The Teleological Argument

For many people, the most convincing evidence for the existence of God is not the existence of the universe but the structure of it. Everything in the universe seems designed for a purpose. But purposeful design can be brought about only by conscious intelligence. And who else but God could have designed the universe?

Telos is Greek for "end" or "result." Arguments such as this are known as **teleological arguments** because they attempt to derive the existence of God from the apparent design or purpose in the universe.

Nature is but a name for an effect whose cause is God.
—William Cowper

teleological argument An argument that attempts to derive the existence of God from the design or purpose of things.

The Mysterious Universe

The Analogical Design Argument

One of the most popular teleological arguments for the existence of God is based on an analogy between the universe and a machine. Cleanthes, in Hume's *Dialogues Concerning Natural Religion,* gives us one version of this argument:

> Look around the world: Contemplate the whole and every part of it: You will find it to be nothing but one great machine, subdivided into an infinite number of lesser machines, which again admit of subdivisions, to a degree beyond what human senses and faculties can trace and explain. All these various machines, and even their most minute parts, are adjusted to each other with an accuracy, which ravishes into admiration all men, who ever contemplated them. The curious adapting of means to ends, throughout all nature, resembles exactly, though it much exceeds, the production of human contrivance; of human design, thought, wisdom, and intelligence. Since therefore the effects resemble each other, we are led to infer, by all the rules of analogy, that the causes also resemble, and that the Author of nature is somewhat similar to the mind of man, though possessed of much larger faculties, proportioned to the grandeur of the work, which He has executed.[22]

Like the parts of a machine, the parts of the universe fit together to perform various functions. For example, subatomic particles fit together to form atoms, atoms fit together to form molecules, and molecules fit together to form everything else. This accurate adjustment of parts and curious adaptation of means to ends is similar to that found in machines. But machines have a designer. So the universe probably has a designer—namely, God.

By showing that two things are similar in some respects, analogical arguments try to establish that they are similar in some further respect. For example, consider this analogical argument for the existence of life on Mars:

1. Earth has air, water, and life.
2. Mars has air and water.
3. Therefore, Mars probably has life.

The fact that Mars resembles Earth in having air and water gives us some reason for believing that it also resembles Earth in having life. But it doesn't prove that Mars has life. There are many dissimilarities between Earth and Mars. The Martian atmosphere is very thin and contains little oxygen, and the water on Mars is trapped in ice caps at the poles. The strength of an analogical argument is determined by the extent of the similarity between the objects being compared. The more dissimilarities, the less likely the conclusion.

The most famous version of the analogical design argument was penned by the English clergyman William Paley. In the following thought experiment, Paley tries to show that there is just as much reason to believe that the universe has a designer as there is to believe that a watch has a designer.

Thought Experiment

Paley's Watch

In crossing a heath, suppose I pitched my foot against a *stone,* and were asked how the stone came to be there, I might possibly answer that, for anything I knew to the contrary, it had lain there for ever; nor would it, perhaps, be very easy to show the absurdity of this answer. But suppose I found a *watch* upon the ground, and it should be inquired how the watch happened to be in that place, I should hardly think of the answer which I had given—that, for anything I knew, the watch might have always been there. Yet why should not this answer serve for the watch as well as for the stone? Why is it not as admissible in the second case as in the first? For this reason, and for no other; viz., that, when we come to inspect the watch, we perceive (what we could not discover in the stone) that its several parts are framed and put together for a purpose. . . .

This mechanism being observed . . . the inference, we think, is inevitable, that the watch must have had a maker; that there must have existed, at some time, and at some place or other, an artificer or artificers who formed it for the purpose which we find it actually to answer; who comprehended its construction, and designed its use. . . .

Every indication of contrivance, every manifestation of design, which existed in the watch exists in the works of nature; with the difference, on the side of nature, of being greater and more, and that in a degree which exceeds all computation.[23]

Paley claims that if he found a watch in a heath (a meadow) and observed that the parts fit together to move the hands, he would have reason to believe that it was designed by somebody. The universe seems to exhibit the same sort of purposeful arrangement of parts that the watch does. So, he concludes, there is reason to believe that it, too, was designed by somebody—namely, God.

Paley's argument is this:

1. The universe resembles a watch.
2. Every watch has a designer.
3. Therefore, the universe probably has a designer—namely, God.

If the analogy between a watch and the universe is a good one, there is reason to believe that the universe has a designer. But from this it doesn't follow that God exists, for, again, the designer need have none of the properties associated with the traditional God of theism.

If the universe was designed for a purpose, there must have been some goal that the designer was trying to accomplish. But if the designer needs a universe to achieve that goal, then the designer can't be all-powerful. Any

evidence for design, then, is evidence against the view that the designer is all-powerful. John Stuart Mill expresses this point as follows:

> It is not too much to say that every indication of design in the Kosmos is so much evidence against the omnipotence of the designer. For what is meant by Design? Contrivance: the adaptation of means to end. But the necessity for contrivance—the need of employing means—is a consequence of the limitation of power. Who would have recourse to means if to attain his end his mere word was sufficient?[24]

An all-powerful being should be able to achieve his goals without using any devices. If God needs a universe to accomplish his goals, there's reason to believe he can't accomplish them by himself. And if he can't accomplish his goals by himself, he's not all-powerful. The existence of the universe, therefore, casts doubt on the existence of an all-powerful designer.

Others claim that the design of the universe casts doubt on the existence of an all-knowing designer. The design of the universe is so flawed, they claim, that even if the universe has a designer, it cannot be all-knowing. Clarence Darrow, famed lawyer of the Scopes Monkey Trial of 1925, had this to say about the design of the universe:

> Even a human being of very limited capacity could think of countless ways in which the earth could be improved as the home of man, and from the earliest time the race has been using all sorts of efforts and resources to make it more suitable for its abode. Admitting that the earth is a fit place for life, and certainly every place in the universe where life exists is fitted for life, then what sort of life was this planet designed to support? There are some millions of different species of animals on this earth, and one-half of these are insects. In numbers, and perhaps in other ways, man is in a great minority. If the land of the earth was made for life, it seems as if it was intended for insect life, which can exist almost anywhere. If no other available place can be found, they can live by the million on man, and inside of him. They generally succeed in destroying his life, and, if they have a chance, wind up by eating his body.[25]

Those who believe in God often assume that he designed the universe for our benefit. If so, Darrow claims, His design is less than perfect. Earth is not particularly hospitable to humans. Every place on earth is subject to natural disasters, and there are many places where humans can't live. Insects, on the other hand, seem to thrive everywhere. When the great biologist G. B. S. Haldane was asked what his study of living things revealed about God, he is reported to have said, "An inordinate fondness for beetles." Because the earth seems more suited to insects than to humans, Darrow concludes, it's doubtful that it was designed by a divine being who had our interests in mind.

Even if the world was designed for us, it need not have been designed by one person. Suppose you were walking along a river and came across a hydroelectric power plant. You would not be justified in believing that it was designed by one person because such large projects usually have many designers. In terms of scale and complexity, the universe resembles a power plant more than it does a watch. Reasoning by analogy, then, it can be claimed that

It is inconceivable that the whole universe was merely created for us who live in this third-rate planet of a third-rate sun.

—ALFRED LORD TENNYSON

the universe had many designers. Maybe the universe was designed by a committee. That would go a long way toward explaining the design flaws noted by Darrow.

An analogical argument is only as strong as the analogy upon which it's based. Although the universe resembles a machine in certain respects, it also resembles a living thing. Living things differ from machines in that they come into being through natural reproduction instead of conscious design. So if the analogy between the universe and a living thing is as good as the analogy between the universe and a machine, we are not justified in believing that the universe was the product of conscious design. Philo makes this point in Hume's *Dialogues Concerning Natural Religion*:

> If we survey the universe, so far as it falls under our knowledge, it bears a great resemblance to an animal or organized body, and seems actuated with a like principle of life and motion. A continual circulation of matter in it produces no disorder: a continual waste in every part is incessantly repaired: The closest sympathy is perceived throughout the whole system. And each part or member, in performing its proper offices, operates both to its own preservation and to that of the whole. The world, therefore, I infer, is an animal, and the Deity is the soul of the world, activating it and activated by it.[26]

Although we don't often think of the universe as a living thing, the analogy is a good one. If you could observe the universe by means of time-lapse photography, taking one picture every million years or so, what would you see? The big bang might seem like the squeezing of a puff-ball, releasing matter (spores?) into the universe. The matter congeals into stars (cells?) that transform (digest?) the matter inside of them and eject (excrete?) it by means of solar winds or stellar explosions. The stars are organized into galaxies (organs?), and these galaxies are organized into galactic clusters (bodies?). The popular version of the Gaia hypothesis proposed by James Lovelock maintains that earth is a living organism. Maybe the universe itself is a living organism. After all, as Smolin claims, the universe may be giving birth to baby universes. The ancient Greek suggestion that the universe was hatched from a cosmic egg seems at least as plausible as Paley's suggestion that it was designed by a cosmic watchmaker.

The Universe should be deemed an immense being: always living.
—ALBERT PIKE

The Best-Explanation Design Argument

In addition to being taken as an analogical argument, the design argument can be taken as an inference to the best explanation. It can be argued that the existence of God provides the best explanation of the apparent design of the universe. The argument would go like this:

1. The universe exhibits apparent design.
2. The best explanation of this apparent design is that it was designed by a supernatural being.
3. Therefore it's probable that the universe was designed by a supernatural being—namely, God.

Just as the success of an analogical argument depends on the closeness of the analogy offered, so the success of an inference to the best explanation depends on the adequacy of the explanation offered. If other explanations are at least as adequate, the argument doesn't go through. Many believe that the apparent design of the universe can be explained without invoking God. It's best explained, they argue, by the theory of evolution.

Although the theory of evolution is usually associated with Charles Darwin, it was first developed in ancient Greece about twenty-five hundred years ago. A study of fossils taught Anaximander (611–547 B.C.) that life on earth was once very different from what it is now. From this, he concluded that the environment of the early earth must also have been very different. As the environment changed, so did the creatures it supported.

> We are the products of editing rather than authorship.
> —George Wald

Anaximander didn't explain how one life-form evolved into another. But another ancient Greek philosopher—Empedocles—did. Empedocles (ca. 495–ca. 435 B.C.) thought that, in the beginning, natural forces randomly created creatures with all sorts of mixed-up features—animals with faces and breasts on both sides, oxen with the heads of men, creatures that were half-male and half-female.[27] Most of these creatures died because their features made it difficult for them to survive and reproduce. Others thrived, however, because their features were well suited to their environment. Those that survived would seem to have been purposefully designed for their habitats even though they were the product of chance combinations and natural selection. As Aristotle recognized, "Wherever, then, everything turned out as it would have if it were happening for a purpose, there the creatures survived, being accidentally compounded in a suitable way; but where this did not happen, the creatures perished and are perishing still, as Empedocles says of his 'man-faced ox-progeny.'"[28] Although scientists today don't accept the details of Empedocles' theory, they do recognize natural selection as one of the driving forces of evolution.

> The universe we observe has precisely the properties we should expect if there is, at bottom, no design, no purpose, no evil, no good, nothing but blind, pitiless indifference.
> —Charles Darwin

Darwin observed that more creatures are born than live long enough to reproduce, that these creatures possess different physical characteristics, and that many of those differences are inherited. He reasoned, like Empedocles, that those characteristics that improve a creature's "inclusive fitness" (ability to live long enough to reproduce) will become more prevalent in future generations. The more such characteristics a creature has, the better suited it will be to its environment. So the accurate adjustment of parts and the curious adaptation of means to ends that so impressed Cleanthes and Paley can be explained in purely natural terms. There is no need to invoke a supernatural designer.

Opponents of evolution often object that various organs or limbs couldn't have evolved gradually because a half-formed organ or limb has no survival value. "What good is half a wing?" they ask. The answer is that half a wing is better than none. Richard Dawkins explains:

> What use is half a wing? How did wings get their start? Many animals leap from bough to bough, and sometimes fall to the ground. Especially in a small animal, the whole body surface catches the air and assists the leap, or breaks the fall,

In the Courts: Is Evolution Just a Theory?

The most recent battle in the war between creation and evolution was fought in Dover, Pennsylvania. The school board there voted to have the following statement read in biology classes:

> Because Darwin's Theory is a theory, it continues to be tested as new evidence is discovered. The theory is not a fact. Gaps in the theory exist for which there is no evidence. A theory is defined as a well-tested explanation that unifies a broad range of observations. Intelligent Design is an explanation of the origin of life that differs from Darwin's view.

Eleven parents of the Dover Area School District sued the school board on the grounds that this statement promoted a particular religious belief under the guise of science education. Judge Jones found in favor of the parents.

What's interesting about this statement, however, is not just its attempt to sneak religion into the science classroom, but also its misunderstanding of the nature of facts and theories. Its definition of a theory is essentially correct. Its claim that evolution is not a fact because it continues to be tested, however, is mistaken. What distinguishes a theory from a fact is not whether it's still being tested or even how certain we are of it, but whether it provides the best explanation of some phenomenon.

A fact is a true statement. A theory is a statement about the way the world is. If the world is the way the theory says it is—if the theory is true—then the theory is a fact. For example, if the Copernican theory of the solar system is true—if planets revolve around the sun—then the Copernican theory is a fact. If Einstein's theory of relativity is true—if $E = mc^2$—then Einstein's theory is a fact. Similarly, if the theory of evolution is true, then it's a fact.

So the question arises: When are we justified in believing something to be true? We have already seen the answer: when it provides the best explanation of some phenomenon. Biologists consider evolution to be a fact because, in the words of Theodosius Dobzhansky, "Nothing in biology makes sense except in the light of evolution."[29] Evolution is a fact because it's the best theory of how biological change occurs over time.

What often goes unnoticed in these discussions is that every fact is a theory. Take the fact that you're reading a book right now, for example. You're justified in believing that to be a fact because it provides the best explanation of your sense experience. But it's not the only theory that explains your sense experience. After all, you could be dreaming, you could be hallucinating, you could be a brain in a vat, you could be plugged into the Matrix, you could be receiving telepathic messages from extraterrestrials, and so on. All of those theories explain your sense experience. You shouldn't accept any of them, however, because none of them is as good an explanation as the ordinary one.

The intelligent design theory is on a par with the theory that extraterrestrials are putting thoughts in your head. It's a possible explanation of the evidence, but not a very good one because, like the extraterrestrial theory, it doesn't identify the designer or doesn't tell us how the designer did it. Consequently, it doesn't meet the criteria of adequacy as well. In a court of law, no one would take seriously an explanation of a crime that didn't identify the criminal or how she or he committed the crime. Similarly, in a science classroom, no one should take seriously an explanation that doesn't identify the cause or how the cause brings about its effect. Evolution does both and does it better than any competing explanation. So we're justified in believing it to be true.

by acting as a crude aerofoil. Any tendency to increase the ratio of surface area to weight would help, for example, flaps of skin growing out in the angles of joints. From here, there is a continuous series of gradations to gliding wings, and hence to flapping wings. Obviously there are distances that could not have been jumped by the earliest animals with proto-wings. Equally obviously, for any degree of smallness or crudeness of ancestral air-catching surfaces, there must be

some distance, however short, which can be jumped with the flap and which cannot be jumped without the flap.[30]

What's more, creatures all along the continuum are alive today. "Contrary to the creationist literature," Dawkins asserts, "not only are animals with 'half a wing' common, so are animals with a quarter of a wing, three quarters of a wing, and so on."[31] So intermediate stages in the development of organs and limbs are not only possible, they are actual.

Intelligent Design If there were structures that were so complex that they could not possibly have evolved through natural selection, there would be reason to believe that evolution was false. Michael Behe, a Lehigh University biochemist, claims to have found such irreducibly complex structures. He describes them this way:

> By irreducibly complex I mean a single system composed of several well-matched, interacting parts that contribute to the basic function, wherein the removal of any one of the parts causes the system to effectively cease functioning. An irreducibly complex system cannot be produced directly (that is, by continuously improving the initial function, which continues to work by the same mechanism) by slight, successive modifications of a precursor system, because any precursor to an irreducibly complex system that is missing a part is by definition nonfunctional.[32]

The operative phrase here is "cannot be produced directly." Behe claims that it's physically impossible for certain biological systems to have been produced naturally. To refute this claim, then, all one has to show is that these systems could be produced without violating any natural laws.

Behe's favorite example of an irreducibly complex mechanism is a mouse trap. A mouse trap consists of five parts: (1) a wooden platform, (2) a metal hammer, (3) a spring, (4) a catch, and (5) a metal bar that holds the hammer down when the trap is set. What makes this mechanism irreducibly complex is that if any one of the parts were removed, it would no longer work. Behe claims that many biological systems (such as cilium, vision, and blood clotting) are also irreducibly complex because each of these systems would cease to function if any of their parts were removed.

Irreducibly complex biochemical systems pose a problem for evolutionary theory because it seems that they could not have arisen through natural selection. A trait, like vision, can improve an organism's ability to survive only if it works. And it works only if all of the parts of the visual system are present. So, Behe concludes, vision couldn't have arisen through slight modifications to a previous system. It must have been created all at once by some intelligent designer.

Intelligent design itself does not have any content.
—GEORGE GILDER

Most biologists are unimpressed with Behe's argument, however, because they reject the notion that the parts of an irreducibly complex system could not have evolved independently of that system. As Nobel Prize–winning biologist H. J. Muller noted in 1939, a genetic sequence that is, at first, inessential to a system may later become essential to it. Biologist H. Allen Orr describes the process as follows: "Some part (A) initially does some job (and

THE MIRACULOUS OCCURRENCE. Does appealing to the supernatural improve our understanding of a situation, or does it simply mask the fact that we do not yet understand?
Source: Sidney Harris

not very well, perhaps). Another part (B) later gets added because it helps A. This new part isn't essential, it merely improves things. But later on A (or something else) may change in such a way that B now becomes indispensable."[33] For example, air bladders—primitive lungs—made it possible for certain fish to acquire new sources of food. But they were not necessary to the survival of the fish. As the fish acquired additional features, however, such as legs and arms, lungs became essential. So, contrary to what Behe would have us believe, the parts of an irreducibly complex system need not have come into existence all at once.

In fact, we know that some of the parts of the systems Behe describes are found in other systems. Thrombin, for example, is essential for blood clotting, but it also aids in cell division and is related to the digestive enzyme trypsin. Because the same protein can play different roles in different systems, the fact that it is part of an irreducibly complex system doesn't indicate that it couldn't have arisen through natural selection. Biologists do not know how all of the parts of every irreducibly complex biochemical system came into being, and they may never know because there is no fossil record indicating how these systems evolved over time. Nevertheless, biologists do know that it is not, in principle, impossible for irreducibly complex systems to arise through natural selection.

To surrender to ignorance and call it God has always been premature, and it remains premature today.

—ISAAC ASIMOV

The Mysterious Universe

Extraterrestrial Design

When Michael Behe gives lectures on intelligent design theory, he often opens the floor to questions. During one of those question-and-answer sessions, he was asked, "Could the designer be an alien from outer space?" to which he answered, "Yes." The intelligent design theory itself tells us nothing about the nature of the designer. So it's entirely possible for the designer to be an extraterrestrial.

Remarkably enough, this is the basic premise on which the religion known as "Raelianism" is founded. Raelianism is the brainchild of the French journalist Claude Vorilhon. He was inspired to create this religion after he was contacted by an extraterrestrial while walking along the rim of the extinct Puy de Lassolas volcano in central France. The extraterrestrial told him that all life on earth was created by aliens from outer space using advanced genetic engineering technology. Here is a summary of the Raelian story from their Web site:

> On the 13th of December 1973, French journalist Rael was contacted by a visitor from another planet, and asked to establish an Embassy to welcome these people back to Earth.
>
> The extra-terrestrial was about four feet in height, had long dark hair, almond shaped eyes, olive skin and exuded harmony and humour. He told Rael that:
>
> "we were the ones who made all life on Earth"
>
> "you mistook us for gods"
>
> "we were at the origin of your main religions"
>
> "Now that you are mature enough to understand this, we would like to enter official contact through an embassy"

The messages dictated to Rael explain how life on Earth is not the result of random evolution, nor the work of a supernatural "God." It is a deliberate creation, using DNA, by a scientifically advanced people who made human beings literally "in their image"—what one can call "scientific creationism." References to these scientists and their work, as well as to their symbol of infinity can be found in the ancient texts of many cultures. For example, in Genesis, the biblical account of creation, the word "Elohim" has been mistranslated as "God" in the singular, but it is a plural, which means *"those who came from the sky."*

Leaving our humanity to progress by itself, the Elohim nevertheless maintained contact with us via prophets including Buddha, Moses, Jesus and Mohammed, all specially chosen and educated by them. The role of the prophets was to progressively educate humanity through the messages they taught, each time adapted to the culture and level of understanding at the time. They were also to leave traces of the Elohim so that we would be able to recognize them as our creators and fellow human beings when we had advanced enough scientifically to understand them.[34]

Thought Probe

Intelligent Design

Suppose that life on earth is the result of intelligent design. Which hypothesis—the God hypothesis or the extraterrestrial hypothesis—is the better explanation? Which hypothesis does better with respect to the criteria of adequacy?

Darwin himself recognized that many systems are composed of parts that originally evolved for other purposes. He writes,

> When this or that part has been spoken of as adapted for some special purpose, it must not be supposed that it was originally always formed for this sole purpose. The regular course of events seems to be, that a part which originally served for one purpose, becomes adapted by slow changes for widely different purposes.[35]

The process by which a structure that originally served one function comes to serve another was dubbed "exaptation" by Stephen J. Gould and Elizabeth

Vrba and appears to be quite common. Darwin recognized this as well: "Thus throughout nature almost every part of each living being has probably served, in a slightly modified condition, for diverse purposes, and has acted in the living machinery of many ancient and distinct specific forms."[36] Because the same structure can perform different functions in different contexts, we do not need to suppose that all of the parts of an irreducibly complex structure came into being at the same time. Thus contrary to what Behe would have us believe, it is physically possible for irreducibly complex structures to arise naturally.

What's more, complexity theory has shown that biochemical systems can be self-organizing; that is, they can acquire their structure without input from outside the system. One such self-organizing system is the Belousov-Zhabotinsky (BZ) reaction, which involves a cyclic sequence of chemical reactions. If any one of the reactions is disrupted, the cycle is broken. Thus the reaction is irreducibly complex in Behe's sense. Nevertheless, it arises naturally, without any outside interference. After explaining the BZ reaction in some detail, Niall Shanks and Karl Joplin conclude that "complexity theory predicts, and experiments confirm, that Behe's irreducibly complex systems can result from the dynamical phenomena of self-organization. Self-organization, resulting in what Kauffman terms 'order for free,' can be exploited with advantage by evolving biological systems."[37] Because there are many ways in which irreducibly complex systems can arise naturally, there is no need to invoke a supernatural designer.

Creationists sometimes cite the absence of certain evidence in an attempt to discredit evolution. But often the evidence they claim is lacking is present in abundance. Consider, for example, the claim that there are no transitional fossils. If one species evolved into another, they argue, there should be fossil remains of intermediate or transitional organisms. But the fossil record contains gaps where the intermediate organisms should be. So, they conclude, evolution did not occur. Given the nature of the fossilization process, however, gaps are to be expected. Very few of the organisms that come into being ever get fossilized. Nevertheless, biologists have discovered thousands of transitional fossils. The transitions from primitive fish to bony fish, from fish to amphibian, from amphibian to reptile, from reptile to bird, from reptile to mammal, from land animal to early whale, and from early ape to human are particularly well documented.[38] In addition, there is a detailed record of the diversification of mammals into rodents, bats, rabbits, carnivores, horses, elephants, manatee, deer, cows, and many others. As the late Harvard biologist Stephen J. Gould reported, "[P]aleontologists have discovered several superb examples of intermediary forms and sequences, more than enough to convince any fair-minded skeptic about the reality of life's physical genealogy."[39]

Creationists also erroneously claim that no one has ever observed evolution. Biological evolution, in its broadest sense, is simply change in the genetic makeup of a group of organisms over time. This sort of change has been observed many times over. Insects that have developed a resistance to pesticides and bacteria that have developed a resistance to antibiotics are

> *Today the theory of evolution is about as much open to doubt as the theory that the earth goes round the sun.*
> —RICHARD DAWKINS

Creationism and Morality

On the wall of the lobby of the Museum of Creation and Earth History run by the Institute for Creation Research hangs two posters: one entitled "Creationist Tree" and the other "Evolutionary Tree." The "Creationist Tree" depicts a lush, verdant tree around whose branches float phrases like "True Christology," "True Gospel," "True Faith," "True Morality," "True Americanism," "True Government," "True Family Life," "True Education," "True History," and "True Science." The "Evolutionary Tree," on the other hand, depicts a withered, barren tree around whose branches float phrases like "Communism," "Nazism," "Atheism," "Amoralism," "Materialism," "Pornography," "Slavery," "Abortion," "Euthanasia," "Homosexuality," "Child Abuse," and "Bestiality." The message here is obvious: Evolution is the root of all evil. Georgia Judge Braswell Dean agrees. As he so alliteratively put it, "This monkey mythology of Darwin is the cause of permissiveness, promiscuity, pills, prophylactics, perversions, pregnancies, abortions, pornotherapy, pollution, poisoning, and the proliferation of crimes of all types."[40] This view lies at the heart of the creation/evolution controversy. It's not so much about the nature of science as it is about the nature of morality.

Creationists believe that evolution undercuts the authority of the Bible by contradicting a literal reading of Genesis. What's more, they believe that if any part of the Bible is untrue, we cannot trust any of it. Without the Bible, however, we have no way of distinguishing right from wrong. So by undercutting the authority of the Bible, evolution undermines the basis of morality.

The theory of morality that lies behind this view is known as the Divine Command Theory. In this view, what makes an action right is that God wills it to be done. As we saw in Chapter 5, however, not only is this theory circular if God is defined as all-good, but it also undercuts any reason we would have for worshipping God. As Leibniz realized,

> In saying, therefore, that things are not good according to any standard of goodness, but simply by the will of God, it seems to me that one destroys, without realizing it, all the love of God and all his glory; for why praise him for what he has done, if he would be equally praiseworthy in doing the contrary? Where will be his justice and his wisdom if he has only a certain despotic power, if arbitrary will takes the place of his reasonableness, and if in according with the definition of tyrants, justice consists in that which is pleasing to the most powerful? Besides it seems that every act of willing supposes some reason for the willing and this reason, of course, must precede the act.[41]

Leibniz's point is that if actions are neither right nor wrong prior to God's willing them, then God cannot choose one set over another because one is morally better than another. Thus if God does choose one over another, his choice must be arbitrary. But a being whose actions are arbitrary is not a being worthy of worship.

According to Leibniz, God's choosing an action to be done is not what makes it right. Instead God chooses an action to be done because it is right. Its rightness is independent of His will and thus can guide His choices. Morality doesn't depend on God any more than mathematics does. God can't make the number 3 an even number because by its very nature, 3 is odd. Similarly God can't make justice or mercy bad things because by their very nature, they are good. So even if evolution did undercut the authority of the Bible—which most denominations say it doesn't—it wouldn't thereby undermine the basis of morality.

just two examples of biological evolution familiar to us all. These instances of biological evolution do not impress creationists because they are examples of what they call "micro-evolution"—genetic changes within a particular species. What creationists say has never been observed is "macro-evolution"—genetic changes from one species to another. But, in fact, this too has been observed. Eight new species of fruit flies have been observed in the laboratory, as have six new species of other insects. A new species of mouse

arose on the Faeroe Islands in the last two hundred fifty years, and scientists have recently recorded a new species of marine worm. The origin of over a dozen new species of plants has been observed in the last fifty years.[42] So it is simply inaccurate to claim that either micro- or macro-evolution has never been observed.

Fine-Tuning Another aspect of the universe that many people believe lends credibility to the notion that the universe was designed is the remarkable "fine-tuning" of many of its physical properties. If forces, like gravity and electromagnetism, were stronger or weaker than they are, or if the properties of subatomic particles, like mass and charge, were larger or smaller than they are, atoms and molecules wouldn't be able to form, and life as we know it wouldn't exist. The laws that govern the universe seem tailor-made for us. As physicist Paul Davies says, "It seems as though someone has fine-tuned nature's numbers to make a universe. . . . The impression of design is overwhelming."[43] But appearances can be deceiving.

The fine-tuning of the universe is something that needs to be explained only if it's possible for the universe to be tuned differently than it is. A number of physicists, however, believe that the laws of physics could not be any different than they are. Einstein used to wonder how much choice God had in constructing the universe. Physicist Stephen Hawking believed that God had very little choice. In his best-seller *A Brief History of Time,* Hawking wrote, "There may well be only one, or a small number, of complete unified theories . . . that are self-consistent and allow the existence of structures as complicated as human beings who can investigate the laws of the universe and ask about the nature of God."[44] Philosopher Baruch Spinoza held a similar view. He thought that there was only one possible universe. If so, the fact that the universe is so well suited to us needs no explanation. It couldn't be any other way.

Alternatively, it's possible that the laws of nature are the result of natural selection. We have seen that black holes may give birth to other universes. Any universe that can form black holes, then, can reproduce. In biology, if we ask why a particular species has a certain trait, the answer we get is that having that trait makes it more likely for members of the species to live long enough to reproduce. Why do humans have an opposable thumb? Because having one makes it possible to make tools, and creatures who make tools are more likely to live long enough to reproduce. Lee Smolin suggests that this sort of reasoning can be applied to universes. Why does the universe have the specific natural laws that it does? Because having them makes the formation of black holes possible, and universes that exist long enough to make black holes are more likely to reproduce.

Here's how Smolin puts it:

> Any universe in the collection, no matter what its own parameters are, is likely to spawn in time a vast family of descendants that after a while are dominated by those whose parameters are the most fit for producing black holes. . . . After a sufficient time, it is probable that a universe chosen at random from the collection has parameters that are near a peak of the production of black holes.

It is exactly because of this that this theory, based on a collection of unobservable universes, can have explanatory power. We need only make one additional hypothesis, which is that *our universe is a typical member of the collection.* Then we can conclude that the parameters that govern our universe must also have parameters that are close to one of the peaks of the production of black holes.[45]

Just as the features of an organism can be explained by appeal to natural selection, so can the features of the universe. As a result, there is no need to invoke God to explain the fine-tuning of the universe.

What's more, recent research suggests that intelligent life could exist in universes with very different physical properties than ours. In "A Universe without Weak Interactions," physicists Roni Harnik, Graham D. Kribs, and Gilad Perez describe a universe that lacks the weak force but can still support life.[46] In "An Observational Test for the Anthropic Origin of the Cosmological Constant," Harvard astronomer Abraham Loeb argues that even if the cosmological constant were a thousand times larger, life could still exist on planets in dwarf galaxies.[47] In "What's the Trouble with Anthropic Reasoning?" Oxford physicists Roberto Trotta and Glenn D. Starkman also claim that sentient beings could evolve in universes whose physical constants are very different from ours.[48] The notion that intelligent life could exist only in a universe like ours doesn't seem to fit the facts. Consequently, the universe may not be as "fine-tuned" as it first appears.

Naturalistic theories are simpler than supernatural theories (theories that claim that the universe was designed and created by a supernatural being) because they can account for the apparent design of living things without postulating a supernatural being. They are also more conservative than creationist theories because they fit better with the findings of various sciences. As Isaac Asimov puts it, "Creationism cannot be adopted without discarding all of modern biology, biochemistry, geology, astronomy—in short without discarding all of science."[49]

Evolutionary theories also have greater scope than creationist theories because they can explain how different species arose. Creationists, such as Duane Gish of the Institute for Creation Research, admit that they cannot do this:

> We do not know how the Creator created, what processes He used, for He used processes which are not now operating anywhere in the natural universe. This is why we refer to creation as special creation. We cannot discover by scientific investigation anything about the creative processes used by the Creator.[50]

The will of God is the refuge of ignorance.

—Baruch Spinoza

But if creationists can't tell us how the creator created, they can't explain creation. It's impossible to explain the unknown in terms of the incomprehensible. As Plato realized, to say that "God did it" is not to give a reason but to give an excuse for not having a reason.[51]

Evolutionary theories are also more fruitful than creationist theories because they have successfully predicted a number of new facts; creationist theories have predicted none. Evolutionary theories, for example, predicted that the chromosomes and proteins of related species would be similar, that

mutations would occur, and that organisms would adapt to changing environments. All of these predictions have been verified. Creationist theories have no predictive successes. Because evolutionary theories meet the criteria of adequacy better than creationist theories, they are better theories.

Given the manifest inadequacy of the theory of creationism, why does it persist? The answer is not hard to find. Many believe that evolution is incompatible with religion, for not only does it contradict the Biblical story of creation, but it suggests that our lives are purposeless and devoid of meaning. This is not a view shared by most mainline churches, however. For example, the Roman Catholic Church, the Lutheran World Federation, the American Jewish Congress, the General Convention of the Episcopal Church, the United Presbyterian Church, the Iowa Congress of the United Methodist Church, and the Unitarian-Universalist Association all disavow scientific creationism of the sort espoused by the Institution for Creation Research and endorse evolution as a more plausible account of the origin of species.

What's more, there is reason to believe that evolution is the only view that makes a meaningful relationship with God—and thus a meaningful life—possible. Biologist Kenneth R. Miller explains:

> It is often said that a Darwinian universe is one whose randomness cannot be reconciled with meaning. I disagree. A world truly without meaning would be one in which a deity pulled the string of every human puppet, indeed of every material particle. In such a world, physical and biological events would be carefully controlled, evil and suffering could be minimized, and the outcome of historical processes strictly regulated. All things would move toward the Creator's clear, distinct, established goals. Such control and predictability, however, come at the price of independence. Always in control, such a Creator would deny his creatures any real opportunity to know and worship him—authentic love requires freedom, not manipulation. Such freedom is best supplied by the open contingency of evolution.[52]

A life where all of our actions were determined by God would not be a meaningful one. If what we did were not up to us, we would be little better than robots. Our actions are our own only if they are free. And truly free actions, says Miller, are possible only in a world that is not manipulated by an outside force. So evolution, far from diminishing our relationship with God, actually strengthens it.

Thought Probe

Human Design Flaws

Bertrand Russell once said, "If I were granted omnipotence, and millions of years to experiment in, I should not think man much to boast of as the final result of all my efforts."[53] Biologists S. Jay Olshansky, Bruce A. Carnes, and Robert N. Butler agree with Russell that our design leaves much to be desired.

The best explanation of our design flaws, they claim, is that human beings were the product of natural selection.

> Bulging disks, fragile bones, fractured hips, torn ligaments, varicose veins, cataracts, hearing loss, hernias and hemorrhoids: the list of bodily malfunctions that plague us as we age is long and all too familiar. Why do we fall apart just as we reach what should be the prime of life? . . .
>
> In evolutionary terms, we harbor flaws because natural selection, the force that molds our genetically controlled traits, does not aim for perfection or endless good health. If a body plan allows individuals to survive long enough to reproduce (and, in humans and various other organisms, to raise their young), then that plan will be selected. . . . More important, anatomical and physiological quirks that become disabling only after someone has reproduced will spread. For example, if a body plan leads to total collapse at age 50 but does not interfere with earlier reproduction, the arrangement will get passed along despite the harmful consequences late in life.[54]

The foregoing figure shows one way of improving our design. Do our design flaws provide evidence against intelligent design?

The Argument from Miracles

The existence of miracles is thought by many to be a compelling reason for believing in God. The sacred texts of many religions are filled with accounts of wondrous events. The Bible, for example, tells us of a stick turning into a snake, of the Red Sea being parted, and of the sun standing still. These events

seem to have no natural explanation. This has led many to accept a supernatural explanation of them.

A miracle is something more than an unusual or a surprising event. An eclipse of the sun is unusual, but it is not miraculous. Winning a lottery is surprising, but it does not call for a supernatural explanation. Only a violation of natural law would do that. Thus a **miracle** can be defined as a violation of natural law by a supernatural being.

The argument from miracles can be formulated this way:

1. There are events that seem to be miracles.
2. The best explanation of these events is that they were performed by a miracle worker.
3. Therefore, there probably is a miracle worker—namely, God.

Although the existence of miracles does imply a miracle worker, it doesn't imply the existence of God. For a miracle worker, like a cosmic creator or designer, need not be all-powerful, all-knowing, or all-good. Many theists, for example, believe that the Devil can perform miracles because he, too, can violate natural law. But the Devil is not all-powerful, all-knowing, or all-good. So even if there is a miracle worker, the miracle worker need not be God.

Some argue that, far from proving God's existence, miracles disprove it. Miracles are violations of natural law. Why, they ask, would God break his own laws? To rectify a mistake he had made? To deal with a situation he hadn't foreseen? Accepting either alternative requires rejecting God's omnipotence or omniscience. A perfect being wouldn't have to tinker with his creation. He would get it right the first time. This is the insight that lies behind deism. Any evidence for miracles, on this view, is evidence against the existence of God.

A reported event counts as a miracle only if (1) the reported event actually occurred and (2) the event violates a law of nature. Hume argues that we can never be justified in believing either of these things. Consequently, we can never legitimately claim that a miracle occurred.

Many reports of miracles date from ancient times and come from sources of dubious credibility. Such anecdotal evidence is not sufficient to establish the existence of miracles. "There is not to be found in all history," Hume says, "any miracle attested by a sufficient number of men, of such unquestioned good sense, education, and learning as to secure us against all delusion in themselves; of such undoubted integrity, as to place them beyond all suspicion of any design to deceive others."[55] Those who report miracles typically are not trained observers. Often they have a great desire to believe in miracles or something to gain by getting others to believe in them. In either case, their testimony is not to be trusted.

But suppose that a number of people of unquestioned good sense, education, and learning did report a miraculous event. Even then, we would not be justified in believing that a miracle had occurred, because the evidence for a miracle can never outweigh the evidence for the natural law it supposedly violates. Hume puts it this way:

> Nothing is esteemed a miracle if it ever happens in the common course of nature. There must, therefore, be a uniform experience against every miraculous event,

The Christian religion not only was at first attended with miracles, but even at this day cannot be believed by any reasonable person without one.
—DAVID HUME

Nature never breaks her own laws.
—LEONARDO DA VINCI

A Miracle: An event described by those to whom it was told by men who did not see it.
—ELBERT HUBBARD

miracle A violation of natural law by a supernatural being.

otherwise that event would not merit the appellation. And as a uniform experience amounts to a proof, there is here a direct and full proof; from the nature of the fact, against the existence of miracles.[57]

Deciding between competing claims requires weighing the evidence in favor of each. But the evidence in favor of a miracle can never outweigh the evidence in favor of a natural law. All past experience will be on the side of the natural law. So the scale can never tip in favor of the miracle.

Weighing evidence, for Hume, is a matter of counting experiments. In his *Enquiries Concerning the Human Understanding,* he tells us that to decide between competing claims, "we must balance the opposite experiments, where they are opposite, and deduct the smaller number from the greater, in order to know the exact force of the superior evidence."[58] This approach to evaluating claims assumes that every experiment carries the same weight. But that is not the case. Some are more carefully controlled than others and thus deserve to be weighted more heavily. Any evaluation of competing claims must take into account both the quality and the quantity of the evidence available.

Contrary to what Hume would have us believe, the results of one experiment, done under properly controlled conditions, can outweigh the results of any number of other experiments. For example, it was long believed that the principle of the conservation of matter was a law of nature. Einstein suggested that this principle was mistaken. His famous equation—$E = mc^2$—predicts that matter can be converted into energy, and thus that the total amount of matter in the universe can be altered. The explosion of the first atomic bomb provided ample proof of Einstein's theory. So one event can provide sufficient grounds for rejecting what has long been considered to be a law of nature.

No event, however, can provide sufficient grounds for believing that a miracle has occurred, because its seeming impossibility may simply be due to our ignorance of the operative laws. St. Augustine concurs: "A miracle is not contrary to nature but contrary to our knowledge of nature."[60] Something may seem impossible to us because we are unaware of the laws governing it. For example, in the eighteenth century, the scientific community dismissed reports of meteorites on the grounds that they violated natural law. The great chemist Lavoisier, for example, argued that stones couldn't fall from the sky because there were none up there. Even Thomas Jefferson, after reading a report by two Harvard professors claiming to have observed meteorites, remarked, "I could more easily believe that two Yankee professors would lie than that stones would fall down from heaven."[61] Meteorites seemed impossible to Lavoisier and Jefferson because they were unaware of the laws governing heavenly bodies. Now that we know those laws, we no longer consider meteorites to be impossible.

We would be justified in believing that an apparent violation of a natural law was a miracle only if we were justified in believing that no natural law would ever be discovered to explain the occurrence. But we can never be justified in believing that, because no one can be sure what the future will bring. We can't rule out the possibility that a natural explanation will be found for an event, no matter how incredible. The recent discovery of a natural explanation

> *If God did a miracle, He would deny His own nature and the universe would simply blow up, vanish, become nothing.*
> —Joyce Cary

> *All the Biblical miracles will at last disappear with the progress of science.*
> —Matthew Arnold

Was Jesus a Magician?

Psychologist Nicholas Humphrey reports that Jesus's "miracles" were similar to tricks being performed by the magicians of his time:

> Many scholars have noted (to their dismay or glee, depending on which side they were taking) that Jesus' miracles were in fact entirely typical of the tradition of performance magic that flourished around the Mediterranean at that time. Lucian, a Roman born in Syria, writing in the second century A.D., catalogued the range of phenomena that the "charlatans" and "tricksters" could lay on. They included walking on water, materialisation and dematerialisation, clairvoyance, expulsion of demons, and prophecy. And he went on to explain how many of these feats were achieved by normal means. Hippolytus, too, exposed several pseudo miracle workers who had powers uncannily similar to those of Jesus, including a certain Marcus who had mastered the art of turning the water in a cup red by mixing liquid from another cup while the onlookers' attention was distracted.
>
> So close were the similarities between Jesus' works and those of common, lower-class magicians, that several Jewish and pagan commentators at the time simply took it for granted that there was little except style and zeal to distinguish Jesus from the others. In their view, while Jesus might have been an especially classy conjuror, he was certainly not in an altogether separate class.
>
> Celsus claimed that Jesus had picked up the art during his youth in Egypt, where the Samarian magicians were the acknowledged masters. Having listed the tricks of the Samarians, such as expelling diseases, calling up spirits of the dead, producing banquets out of thin air, and making inanimate objects come to life, Celsus (according to the Christian writer Origen) went on to say: "Then, since these fellows do these things, will you ask us to think them sons of God? Should it not rather be said that these are the doings of scoundrels?"
>
> Christian apologists were, early on, only too well aware of how their Messiah's demonstrations must have looked to outsiders. They tried to play down the alarming parallels. There is even some reason to think that the Gospels themselves were subjected to editing and censure so as to exclude some of Jesus' more obvious feats of conjuration and to delete references to the possible Egyptian connection. . . .
>
> The somewhat lame solution, adopted by Origen and others, was to admit that the miracles would indeed have been fraudulent if done by anybody else, simply to make money, but not when done by Jesus to inspire religious awe. "The things told of Jesus would be similar if Celsus had shown that Jesus did them as the magicians do, merely for the sake of showing off. But as things are, none of the magicians, by the things he does, calls the spectators to moral reformation, or teaches the fear of God to those astounded by the show."[59]

Thought Probe

Jesus's Miracles

Is Origen's solution a good one? Is it plausible to say that if Jesus's feats were performed by anyone else, they would just be tricks but that, because they were performed by Jesus, they were miracles? Why or why not?

for the "miracle" of the parting of the Red Sea illustrates this point nicely. (See the box "Parting the Red Sea.") When we are faced with an inexplicable event, it is always more rational to look for a natural cause than to attribute the event to something supernatural. Appealing to the supernatural does not increase our understanding. It simply masks the fact that we do not yet understand.

What's more, any supposed miracle could be the result of a superadvanced technology rather than a supernatural being. Arthur C. Clarke once said that

> ## Parting the Red Sea
>
> An oceanographer and a meteorologist—Doron Nof and Nathan Paldor—published a paper in the *Bulletin of the American Meteorological Society* explaining how a strong wind, of the sort described in the Bible, could cause the Red Sea to part in such a way as to allow the Israelites to cross but then drown the pursuing Egyptians. Here is a selection from the abstract of their paper:
>
> > [Suppose that a] uniform wind is allowed to blow over the entire gulf for a period of about a day. . . . [Then] in a similar fashion to the familiar wind setup in a long and narrow lake, the water at the edge of the gulf slowly recedes away from its original prewind position. . . . Even for moderate storms . . . a receding distance of more than 1 km and a sea level drop of more than 2.5 m are obtained. These relatively high values are a result of the unique geometry of the gulf (i.e., its rather small width-to-length and depth-to-length ratios) and the nonlinearity of the governing equation. Upon an abrupt relaxation of the wind, the water returns to its prewind position as a fast (nonlinear) gravity wave that floods the entire receding zone within minutes. It is suggested that the crossing occurred while the water receded and that the drowning of the Egyptians was a result of the rapidly returning wave.[56]
>
> ### Thought Probe
>
> Parting the Red Sea
>
> Does the fact that the Red Sea can be parted by natural forces undercut the notion that it was parted by God as described in the Bible? Why or why not?

any sufficiently advanced technology is indistinguishable from magic. So the seemingly inexplicable events that many attribute to God could simply be the work of advanced aliens. Erich von Däniken argues as much in his book *Chariots of the Gods,* where he claims that the wheel that Ezekiel saw in the sky was really an unidentified flying object (UFO). Explanations that appeal to advanced aliens are actually superior to explanations that appeal to supernatural beings because they are simpler and more conservative: They do not postulate any nonphysical substances, and they do not violate any natural laws. (Of course, they are not as good as explanations that *don't* appeal to aliens.) Nevertheless, apparent miracles don't provide evidence for the existence of God because they can be better explained on other hypotheses.

Thought Probe

> #### The Fivefold Challenge
>
> According to Robby Berry, "there are five major miraculous events in the Bible which are completely unconfirmed by modern archaeology. These miracles are (1) the parting of the sea by Moses (Exodus 14: 21–31); (2) the stopping of the sun by Joshua (Joshua 10: 12–14); (3) the reversal of the sun's course by Isaiah (Isaiah 38: 7–8); (4) the feeding of thousands of people by Jesus using only five loaves of bread and two fishes (Mark 6: 34–44); and (5) the resurrection of the saints, and their subsequent appearance to many (Matthew 27: 52–53)."[62] These miracles were supposedly witnessed by thousands of people, but there is no

archaeological evidence to back them up. Berry believes that this is good reason to believe that these miracles never occurred. Do you agree? Why or why not? (Berry is offering a reward to anyone who can provide reliable non-biblical evidence that any of these events occurred: He will read three books of that person's choice or attend a church of the denomination of that person's choice for three months.)

The Argument from Religious Experience

Much of our knowledge of the world comes from sense experience. But sense experience is not the only kind of experience we can have. Some people also have religious experience. Just as sense experience can give us knowledge of natural things, some people claim that religious experience can give us knowledge of supernatural things.

Religious experience comes in many varieties, from a feeling of peace and well-being to a direct personal experience of God. Because our concern here is whether God exists, we will focus on those experiences that people take to be experiences of God.

St. John describes such an experience:

> The end I have in view is the divine Embracing, the union of the soul with the divine Substance. In this loving, obscure knowledge God unites Himself with the soul eminently and divinely. This knowledge consists in a certain contact of the soul with the Divinity, and it is God Himself Who is then felt and tasted, though not manifestly and distinctly, as it will be in glory. But this touch of knowledge and of sweetness is so deep and so profound that it penetrates into the inmost substance of the soul.[63]

The most beautiful thing we can experience is the mysterious.
—ALBERT EINSTEIN

There is no doubt that St. John took his experience to be an experience of God. But the fact that he took it to be an experience of God doesn't mean that it was an experience of God. For we can be mistaken about what we experience, as Descartes illustrated. What seems to be a cat lying in the yard can turn out to be an old shoe. We are justified in believing that what we seem to experience actually exists only if the hypothesis that it exists provides the best explanation of our experience. So we are justified in believing that we have experienced God only if the hypothesis that God exists provides the best explanation of our experience.

If you talk to God, you are praying; if God talks to you, you have schizophrenia.
—THOMAS SZASZ

The argument from religious experience, then, can be put this way:

1. People have experiences that seem to be of God.
2. The best explanation of these experiences is that they are of God.
3. Therefore, it is probable that God exists.

The crucial claim here is premise 2. To determine whether the God hypothesis is best, we have to compare it with competing hypotheses.

The main competitor to the God hypothesis is the hallucination hypothesis, which says that religious experiences are caused by abnormal conditions of the body. Bertrand Russell was a proponent of the hallucination hypothesis. He writes,

> From a scientific point of view, we can make no distinction between the man who eats little and sees heaven and the man who drinks much and sees snakes. Each is in an abnormal physical condition, and therefore has abnormal perception.[64]

Russell claims that the cause of religious experiences is internal rather than external. As a result, such experiences provide no evidence for the existence of God.

The happy do not believe in miracles.
—GOETHE

Although religious experiences can happen spontaneously, those who claim to have seen God have often led lives of extreme self-denial and self-discipline. They have renounced worldly goods, repressed their physical desires, and rejected normal human companionship. They have filled their lives with prayers, devotions, and rituals. Psychologists now know that this sort of ascetic life-style can have the same effect on the brain as hallucinogenic drugs.[65]

What's more, studies have shown that descriptions of religious experiences are indistinguishable from descriptions of drug experiences. On Good Friday, 1962, Walter Pahnke, a Harvard Divinity School student, gave psilocybin (a drug whose effects are similar to those of LSD) to half of a group of thirty students at Boston College's Marsh Chapel. (The other half were given a placebo.) After listening to the Good Friday sermon, the group listened to organ music and recorded their experiences. Nine members of the group reported having a genuine religious experience. To evaluate their claims, Pahnke had three women, trained to identify descriptions of religious experiences, read their reports. The women found that the subjects' reports had all the earmarks of a genuine religious experience. Pahnke concluded, "Those subjects who received psilocybin experienced phenomena which were indistinguishable from if not identical with . . . the categories defined by our typology of mysticism."[66]

The fact that religious experiences are often produced by abnormal physiological conditions does not, by itself, show that they are untrue. Every experience we have is affected by the condition of our body. Maybe certain physiological conditions are conducive to discovering certain types of truths. C. D. Broad explains:

> Suppose, for the sake of argument, that there is an aspect of the world which remains altogether outside the ken of ordinary persons in their daily life. Then it seems very likely that some degree of mental and physical abnormality would be a necessary condition for getting loosened from the objects of ordinary sense perception to come into contact with this aspect of reality. One might have to be slightly "cracked" in order to have some peep-holes into the supersensible world.[67]

Theology is but the ignorance of natural causes reduced to a system.
—BARON PAUL HENRI T. D'HOLBACH

What we experience is determined by the state of our body at the time of the experience. To experience God, maybe we have to be in an abnormal state. As Broad suggests, maybe we have to be "cracked" to see through the cracks of our ordinary experience.

We can't discount religious experiences simply because they occur under abnormal conditions. Neither can we accept them at face value simply because

This Is Your Brain on God

Michael Persinger, a neurophysiologist at Laurentian University in Sudbury, Ontario, believes that religious experience is the result of a particular type of electrical activity in the brain. To test his hypothesis, he has developed a helmet lined with magnets that uses electromagnetic radiation to create various brain wave patterns. Journalist Jack Hitt reports on his experiences in Persinger's lab:

> [Persinger's] theory is that the sensation described as "having a religious experience" is merely a side effect of our bicameral brain's feverish activities. Simplified considerably, the idea goes like so: when the right hemisphere of the brain, the seat of emotion, is stimulated in the cerebral region presumed to control notions of self, and then the left hemisphere, the seat of language, is called upon to make sense of this nonexistent entity, the mind generates a "sensed presence." . . .
>
> It may seem sacrilegious and presumptuous to reduce God to a few ornery synapses, but modern neuroscience isn't shy about defining our most sacred notions—love, joy, altruism, pity—as nothing more than static from our impressively large cerebrums. Persinger goes one step further. His work practically constitutes a Grand Unified Theory of the Otherworldly: He believes cerebral fritzing is responsible for almost anything one might describe as paranormal—aliens, heavenly apparitions, past-life sensations, near-death experiences, awareness of the soul, you name it. . . .
>
> Using his fixed wavelength patterns of electromagnetic fields, Persinger aims to inspire a feeling of a sensed presence—he claims he can also zap you with euphoria, anxiety, fear, even sexual stirring. Each of these electromagnetic patterns is represented by columns of numbers—thousands of them, ranging from 0 to 255—that denote the increments of output for the computer generating the EM [electromagnetic] bursts. . . .
>
> Persinger envisions a series of EM patterns that work the way drugs do. Just as you take an antibiotic and it has a predictable result, you might be exposed to precise EM patterns that would signal the brain to carry out comparable effects.
>
> Another possible application: Hollywood. Persinger has talked to Douglas Trumbull, the special-effects wizard responsible for the look of everything from 2001: *A Space Odyssey* to *Brainstorm*. They discussed the technological possibility of marrying Persinger's helmet with virtual reality. "If you've done virtual reality," Persinger says, "then you know that once you put on the helmet, you always know you are inside the helmet. The idea is to create a form of entertainment that is more real." But he adds, sounding like so many people who've gotten a call from the coast, "we haven't cut a deal yet."[68]

Thought Probe

Religious Experience

Does the fact that religious experiences can be produced electronically undercut the claim that they are produced by a supernatural being? Why or why not?

they seem so real. To be considered true, they must pass the same sorts of tests that ordinary experiences do.

One test of the truth of an experience is agreement among those who've had the experience. If there is widespread agreement, there is reason to believe that those who had the experience actually experienced what they thought they did. In the case of religious experience, however, there is very little agreement about what is experienced. According to theologian John Hick, "As we listen to the world-wide company of those who have spoken about the divine reality out of direct personal experience, we find that they have conceptualized their experiences in many different and often incompatible

ways, each in accordance with his own environing traditions and culture."[69] For example, Christian mystics tend to experience a personal God (Jehovah), whereas Hindu mystics tend to experience a nonpersonal god (Brahman). But the supreme being cannot be both personal and nonpersonal. So both of these experiences cannot be true. Unless some way of resolving this disagreement is found, there is little reason to believe that either of these experiences is true.

Disagreements about what has been experienced are usually resolved by gathering more information. Suppose someone claims that the fruit in a bowl is real, but someone else claims that it is plastic. To determine who is right, we would touch, smell, and perhaps taste the objects in the bowl. If they felt, smelled, and tasted like real fruit, we would be justified in believing that they are real. Disagreements about religious experience cannot be resolved in this way, however, because God cannot be sensed. There is no way to tell whether a religious experience was caused by God. But without a method for distinguishing real religious experiences from fake ones, they can't be used to justify belief in God.

Thought Probe

St. Paul on the Road to Damascus

Perhaps the world's most consequential mystical experience happened to Paul the Apostle on the road to Damascus around 33–36 C.E. Known as Saul of Tarsus prior to his experience, he was in the business of persecuting Christians. On orders from the High Priest of Judaism, he would round up Christians and bring them back to Jerusalem to be tortured or killed. One day, while traveling on the road to Damascus, Saul had a mystical experience in which he claims God spoke to him. He described it from a third-person point of view in chapter 9 of the book of Acts.

After this experience, Saul converted to Christianity, changed his name to Paul, founded several churches in Asia Minor, and wrote fourteen of the twenty-seven books of the New Testament. Few question that Paul had a life-changing experience on the road to Damascus. Some question, however, whether that experience was caused by God because it has many of the hallmarks of an epileptic fit. Writing in the journal of *Neurology, Neurosurgery, and Psychiatry*, D. Landsborough provides evidence that suggests that Paul's mystical experience had a neurological origin. He writes, "The account bears a close resemblance to the psychotic and perceptual experience of a temporal lobe seizure."[70]

Neuroscientist Vilayanur Ramachandran agrees. He has studied many epileptic patients who have had experiences like St. Paul's, but he acknowledges that this doesn't mean God wasn't involved. "If God exists and he is interacting with us humans, he could have put an antenna in your brain to be sensitive to him or her."[71]

What do you think is the most reasonable explanation of Paul's experience on the road to Damascus? Why?

The Ontological Argument

The arguments we have canvassed so far attempt to prove the existence of God by appealing to some fact about the world. The **ontological argument,** however, attempts to prove the existence of God by appealing to nothing more than the concept of God itself. A proper understanding of the concept of God, it is claimed, will reveal that there must be something that falls under that concept.

Everything actual must have first been possible, before having actual existence.

—Albert Pike

Anselm's Ontological Argument

The first to propose such an argument was St. Anselm (A.D. 1033?–1109), who conceived of God as the greatest possible being (a being "than which none greater can be conceived"). Such a being must exist, Anselm claims, because if he didn't, it would be possible for there to be a greater being. He writes,

> And whatever is understood exists in the understanding. And assuredly that than which nothing greater can be conceived cannot exist in the understanding alone. For, suppose it exists in the understanding alone: then it can be conceived to exist in reality; which is greater.
>
> Therefore; if that than which nothing greater can be conceived exists in the understanding alone, the very being, than which none greater can be conceived is one, than which a greater can be conceived. But, obviously, this is impossible. Hence, there is no doubt that there exists a being than which nothing greater can be conceived.[72]

A being that exists "in the understanding alone" is a being that exists only in our minds. But a being that exists in reality is greater than a being that exists only in our minds. So if God existed only in our minds, it would be possible for there to be a being greater than God—namely, a being like God that exists in reality. But it's not possible for there to be a being greater than God. So God must exist in reality.

More formally, the argument looks like this:

1. God, by definition, is the greatest being possible.
2. If God exists only in our minds, then it is possible for there to be a being greater than God—namely, a being like God that exists in reality.
3. But it is not possible for there to be a being greater than God.
4. Therefore, God must exist in reality.

Although this argument is valid, most people find it unconvincing, for they don't believe that you can define something into existence.

A contemporary of Anselm, Gaunilo, shared that belief. He used a thought experiment to show that if Anselm's style of reasoning were correct, you could prove that the greatest island possible exists.

ontological argument An argument from the nature of God to the existence of God.

Thought Experiment

Gaunilo's Lost Island

Consider this example: Certain people say that somewhere in the ocean there is an island, which they call the "Lost Island" because of the difficulty or, rather, the impossibility of finding what does not exist. They say that it is more abundantly filled with inestimable riches and delights than the Isles of the Blessed, and that although it has no owner or inhabitant, it excels all the lands that men inhabit taken together in the unceasing abundance of its fertility.

When someone tells me that there is such an island, I easily understand what is being said, for there is nothing difficult here. Suppose, however, as a consequence of this, that he then goes on to say: You cannot doubt that this island, more excellent than all lands, actually exists somewhere in reality, because it undoubtedly stands in relation to your understanding. Since it is more excellent not simply to stand in relation to the understanding, but to be in reality as well, therefore this island must necessarily be in reality. Otherwise, any other land that exists in reality would be more excellent than this island, and this island which you understand to be the most excellent of all lands would then not be the most excellent.[73]

The greatest island possible would have the ideal climate, the broadest array of natural resources, the greatest number of trees per acre, and the like. Gaunilo points out that by Anselm's lights, if it didn't exist, then it wouldn't be the greatest island possible. So, by parity of reasoning, it would seem that the greatest island possible must exist.

Anselm was aware of Gaunilo's objection and tried to counter it by claiming that his argument applied only to the greatest being possible, not to particular kinds of beings. But if existence is intrinsic to God because it makes him better, it's hard to see why it couldn't be intrinsic to other things as well. It could be argued, for example, that the most evil being possible must exist because if it didn't, it wouldn't be the most evil being possible. This is obviously absurd. What has gone wrong?

The problem lies with Anselm's understanding of the phrase "exists only in the understanding." Apparently Anselm believed that to say that God exists only in the understanding is to say that there is something in our minds that is like God in all respects except that it doesn't exist in reality. That is indeed impossible. But that is not a plausible interpretation of the phrase "exists only in the understanding." To say that something, x, exists only in the understanding (mind) is to say that the concept of x doesn't apply to anything in reality. For example, to say that centaurs exist only in the mind is to say that the concept of centaurs doesn't apply to anything in reality. Similarly, to say that God exists only in the mind is to say the concept of God doesn't apply to anything in reality, and that is not self-contradictory. There is no contradiction involved in saying that the concept of the greatest being possible is not exemplified. So the ontological argument does not succeed in showing that God must exist by definition.

Descartes' Ontological Argument

Descartes also offered an ontological argument. He defined God as the most perfect being possible instead of the greatest being possible. The most perfect being possible possesses all possible perfections. Because existence is a perfection (it's better to exist than not to exist), God exists. Here's how Descartes puts it:

> Whenever I choose to think of the First and Supreme Being and as it were bring out the idea of him from the treasury of my mind, I must necessarily ascribe to him all perfections, even if I do not at the moment enumerate them all, or attend to each. This necessity clearly ensures that when later on I observe that existence is a perfection, I am justified in concluding that the First and Supreme Being exists.[74]

Descartes' argument can be put this way:

1. God, by definition, possesses all possible perfections.
2. Existence is a perfection.
3. Therefore, God exists.

This argument assumes that there can be a supremely perfect being and that existence can be a defining property. Both assumptions have been questioned.

Kant argues that existence can't be a defining property because it adds nothing to our concept of a thing. We don't know anything more about the nature of a thing when we are told that it exists. Paul Edwards elucidates Kant's point by means of the following thought experiment.

Thought Experiment

Edwards's Gangle

Suppose I am an explorer and claim to have discovered a new species of animal which I call "gangle." I have been asked to explain what I mean by calling an animal a "gangle" and I have given this answer:

© Marcus C. Krause

The Mysterious Universe 477

"By a gangle I mean a mammal with eleven noses, seven blue eyes, bristly hair, sharp teeth and wheels in the place of feet." Let us now contrast two supplementary remarks I might make. The first time I add "furthermore a gangle has three long tails." The second time I add "furthermore, let me insist that gangles exist." It is evident that these are two radically different additions. In the first case I was adding to the definition of "gangle"; I was enlarging the concept; I was mentioning a further property which a thing must possess before I would call it a "gangle." The second time I was doing something quite different. I was not enlarging the concept of gangle, I was saying that there is something to which the concept applies, that the combination of characteristics or qualities *previously* mentioned belong to something.[75]

To be told that a thing exists is not to be given any information about the type of thing it is. It's merely to be apprised of the fact that there are things of that type. Consequently, existence can't be a defining property.

Even if existence could be a defining property, there would be some question as to whether it's a perfection. A perfection always makes something better. But it's doubtful that it's always better to exist than not to exist. Consider someone who is terminally ill and suffering intense, untreatable pain. In such a situation, nonexistence might be a blessing.

And, further still, whether or not existence is a perfection, there is reason to doubt that something could possess all possible perfections. Consider the perfections of justice and mercy, for example. God is often considered to be perfectly just and perfectly merciful. But, as we've seen, He can't give everyone exactly what's coming to them *and* let them all off. So it seems that he can't be perfectly just *and* perfectly merciful.

Similar problems arise with respect to many other perfections. Take omniscience and goodness, for example. To say that God is all-knowing is to say that there is nothing that he doesn't know. To say that he is all-good is to say that he never does anything wrong. The question arises, then, Can God know what it is to be greedy? To be envious? To be gluttonous? To know what it is to be greedy, envious, or gluttonous, one has to have been greedy, envious, or gluttonous. But a totally good person would never have committed these sins. So it seems that we can know things that God can't. If this is the case, however, it is doubtful he is all-knowing.

Perhaps the most telling criticism of Descartes' ontological argument, however, is that it is uninformative. The first premise of Descartes' argument cannot be taken to assert the existence of God, for if it did, the argument would be circular: It would assume what it is trying to prove. The first premise, then, is best taken to be a hypothetical,

1'. If God exists, then he possesses all possible perfections.

But, when the first premise is taken this way, the conclusion becomes

3'. If God exists, then he exists.

This is undoubtedly true, but it's uninformative: It doesn't tell us anything that we don't already know. And it certainly doesn't establish the existence of God. So Descartes' ontological argument is no more successful than Anselm's.

Thought Probe

One More God

By some estimates, humans have worshipped more than three thousand different gods throughout history. So monotheists (those who believe in only one god) don't believe in thousands of other gods. The difference between atheists and monotheists, then, is that atheists believe in one less god than monotheists. If monotheists are rationally justified in not believing in thousands of other gods, are atheists equally justified in not believing in the god of the monotheists? Why or why not?

Pascal's Wager

Blaise Pascal, one of the seventeenth century's greatest mathematicians, was well aware that a belief in God could not be rationally justified by the traditional arguments for God's existence. Nevertheless, he thought that it could be pragmatically justified. A belief is *rationally justified* when there is sufficient reason for believing it to be true. A belief is *pragmatically justified* when there is sufficient reason for believing that having it will benefit you. Pascal thought that because there is a chance that believing in God will get us into heaven, we should believe in God, even though the evidence doesn't warrant it.

To get a better sense of the difference between rational and pragmatic justification, consider the following case. Suppose you are a homeless person, living hand to mouth, with no prospect of a steady income or regular meals. You know, however, that if you were committed to an insane asylum, you'd have a warm bed to sleep in and three square meals a day, which is all you have ever hoped for. You also know that if you could convince mental health workers that you believe you are Jesus Christ, you would be committed. In this case, you would be pragmatically justified in believing that you are Jesus Christ, because having that belief would be a great benefit to you. To realize that benefit, you ought to do everything you can to acquire that belief. Similarly, Pascal thought that we ought to do everything we can to acquire a sincere, passionate belief in God. The question is, Would such a belief be pragmatically justified?

Pascal admits that it is impossible to know either what God is or whether he exists. Nevertheless, he believes that it's in our own best interest to believe in the God of Jansenism (a heretical Roman Catholic sect to which Pascal converted after having a mystical experience), because if you do, and he exists, you go to heaven. If you believe in Pascal's God, and he doesn't exist, you lose nothing. Here's Pascal's analysis of the situation:

> *The dice of God are always loaded.*
> —RALPH WALDO EMERSON

Thought Experiment

Pascal's Wager

Let us weigh up the gain and the loss involved in calling heads that God exists. Let us assess the two cases: if you win, you win everything, if you lose, you lose nothing. Do not hesitate then; wager that he does exist.[76]

It would be irrational not to bet on the flip of a coin if you had everything to win and nothing to lose. Similarly, Pascal claims, it would be irrational not to bet that God exists.

Pascal here assumes that there is a 50 percent chance that there is a God that grants eternal salvation to those who believe in him. But Pascal also assumes that we know nothing about God's nature. So it's hard to see how he could assign a probability to any particular view of the nature of God.

Maybe God rewards those who don't believe in him. Philosopher and literary critic Galen Strawson makes an interesting case for this possibility:

> It is an insult to God to believe in God. For on the one hand, it is to suppose that he perpetrated acts of incalculable cruelty. On the other hand, it is to suppose that he has perversely given his human creatures an instrument—their intellect—which must inevitably lead them if they are dispassionate and honest, to deny his existence. It is tempting to conclude that if He exists, it is the atheists and agnostics that He loves best, among those with any pretensions to education. For they are the ones who have taken Him most seriously.[77]

I have always considered "Pascal's Wager" as a questionable bet to place, since any God worth believing in would prefer an honest agnostic to a calculating hypocrite.
—ALAN DERSHOWITZ

Reason is considered by many to be God's greatest gift to humanity. But as we have seen (and Pascal agrees), the existence of God apparently cannot be established through reason alone. If we are to respect God's gift, we should follow it where it leads—which may not be to theism.

There are many other possibilities. Maybe God doesn't care whether people believe in him or not. Maybe he randomly chooses who gets eternal life. Maybe he punishes those who believe in him for purely selfish reasons. Maybe he punishes anyone who gambles. Given that the chances that Pascal's God exists are something less than 50 percent, Pascal's wager may not be such a good bet.

The stakes in the bet may also be different from what Pascal would have us believe. For one thing, heaven may not be such a great prize. If it involves sitting on a cloud playing a harp all day, few would find it enjoyable. (Milton's Satan, who thought it was better to rule in hell than serve in heaven, certainly wouldn't want to go there.) For another, it's not true that you lose nothing by believing in God. Performing the rituals and living according to the dictates of a religion (as Pascal advocates) take time, energy, and money. If there is no God, that time, energy, and money may have been wasted.

Nothing is sacred to a gamester.
—BERNARD JOSEPH SAURIN

In any event, you should think twice before accepting Pascal's wager, because the risk and rewards may be very different from the way they're represented.

Silverman's Wager

Herb Silverman, professor of mathematics at Charleston College and founding chair of the Coalition for the Community of Reason, proposes his own wager to counter Pascal's:

> Blaise Pascal (1623–1662) and Herb Silverman (1942–) have had two common interests: mathematics, which led to our mutual profession, and theology, which led to our respective wagers. Though a Christian, Pascal was also a doubter. In Number 233 of his Pensées he says, "If there is a God, He is infinitely incomprehensible, since, having neither parts nor limits, He has no affinity to us. We are then incapable of knowing either what He is or if He is." Pascal later went on to say, "Reason can decide nothing here." He then concluded, in his now famous wager, that belief in God was the only rational choice to make: "If God does not exist, one will lose nothing by believing in him; while if he does exist, one will lose everything by not believing."
>
> Before stating my own wager, let me make a couple of comments about Pascal's. His first conditional statement could just as well refer to the Tooth Fairy or the pot of gold at the end of the rainbow. Were we to devote our entire life to such fruitless searches, we would be left with an unproductive and wasted life—certainly a loss.
>
> The second conditional statement is even more problematic. Pascal assumes the only existing god would be his Christian version—one who rewards believers with eternal bliss and punishes nonbelievers with eternal damnation. Moreover, it would be a god who either could not distinguish genuine from feigned belief or who would simply reward hypocrites for pretending a faith that they lack.
>
> I agree with Pascal that no god is comprehensible to us. But suppose, for the sake of argument, I posit the existence of a creator who actually cares about human beings and elects to spend an eternity with a chosen few. What selection criteria would such a Supreme Being adopt? I expect this divine scientist would pre-fer having a "personal relationship" with the same kind of folks I would—intelligent, honest, rational people who require some evidence before holding a belief. Pascal would undoubtedly agree with me that our most promising students ask provocative questions until convinced by rational arguments, while our dullest students mindlessly accept what they think we want them to believe. Wouldn't a supreme teacher concur? My kind of Supreme Being would favor eternal discourse with a Carl Sagan over a Pat Robertson.
>
> Such a superior intellect would presumably be bored by and want little contact with humans who so confidently draw unwarranted conclusions about his unprovable existence. This brilliant designer would be as appalled as I am by those who profess and glorify blind faith. With that kind of deity in mind, I modestly make my own wager. It is almost a plagiarism. I change none of Pascal's words, except that his last *not* now appears earlier in the wager. But what a difference a *not* makes!
>
> I hereby propose "Silverman's Wager": If God does not exist, one will lose nothing by not believing in him; while if he does exist, one will lose everything by believing.[78]

Thought Probe

The Best Bet

Which wager, Pascal's or Silverman's, do you think is better? Why?

Thought Probe

Alien Religion

Suppose that we are visited by aliens from outer space and find that they have no religion and have never heard of any of the gods worshipped by humans. Would this undermine the credibility of our religions? Would it be appropriate to try to evangelize the aliens and convert them to one of our religions? Why or why not?

God and Science

If there is a God, atheism must strike Him as less of an insult than religion.

—EDMOND AND
JULES DE GONCOURT

Robert Coburn reports that although there is no unanimous agreement that the arguments for the existence of God fail, "there is certainly near-unanimous agreement on this matter, at least among professional philosophers."[79] Most (but not all) of those who have studied these arguments have found them wanting. They provide neither rational nor pragmatic justification for a belief in God.

Some have argued that even if the arguments, taken individually, are not convincing, taken collectively, they make a strong case. But that would be true only if all of the arguments were about the same thing, and that doesn't seem to be the case. The cosmological argument is about a creator, the design argument is about a designer, the argument from miracles is about a miracle worker, and so on. The arguments themselves give us no reason to believe that they are all talking about the same thing. A separate argument would be needed to prove that, and no such argument has been forthcoming.

The major problem with all of the arguments from experience is that even if they were cogent, they wouldn't prove the existence of the traditional God of theism. Even if the universe does have a creator, a designer, a miracle worker, or a source of religious experience, there is no reason to believe that any of them is all-powerful, all-knowing, or all-good. The arguments aren't cogent, however, because everything they attempt to explain by invoking God can be better explained without invoking him. So they don't justify believing in the existence of God.

Religion, which should most distinguish us from the beasts, and ought most particularly to elevate us, as rational creatures, above brutes, is that wherein men often appear most irrational, and more senseless than beasts themselves.

—JOHN LOCKE

The goodness of an explanation is determined by how much understanding it produces, and the amount of understanding produced by an explanation is determined by how well it systematizes and unifies our knowledge. The extent to which an explanation systematizes and unifies our knowledge can be measured by various criteria of adequacy, such as simplicity (the number of assumptions made), scope (the types of phenomena explained), conservatism (fit with existing theory), and fruitfulness (ability to make successful novel predictions).

Supernatural explanations are inherently inferior to natural ones because they do not meet the criteria of adequacy as well. For example, they are usually less simple because they assume the existence of at least one additional type of entity. They usually have less scope because they don't explain how or why the phenomena in question are produced, and thus they raise more questions than they answer. They are usually less conservative because they imply that certain natural laws have been violated. And they are usually less fruitful because they don't make any novel predictions. That is why scientists avoid them.

Given the inherent inferiority of supernatural explanations, we would be justified in accepting a supernatural explanation only if we were sure that a natural explanation would never be found. But we can never be sure of that, because we can never know what the future will bring.

Theologians realized a long time ago that religion should not be in the business of trying to explain physical reality. Writing in the early fifth century, St. Augustine, for example, tells us,

> It not infrequently happens that something about the earth, about the sky, about other elements of this world, about the motion and rotation or even the magnitude and distances of the stars, about definite eclipses of the sun and moon, about the passage of years and seasons, about the nature of animals, of fruits, of stones, and of other such things, may be known with the greatest certainty by reasoning or by experience, even by one who is not a Christian. It is too disgraceful and ruinous, though, and greatly to be avoided, that he [the non-Christian] should hear a Christian speaking so idiotically on these matters, and as if in accord with Christian writings, that he might say that he could scarcely keep from laughing when he saw how totally in error they are. In view of this and in keeping it in mind constantly while dealing with the book of Genesis, I have, insofar as I was able, explained in detail and set forth for consideration the meanings of obscure passages, taking care not to affirm rashly some one meaning to the prejudice of another and perhaps better explanation.[80]

Augustine did not believe that the Bible was a science text, and he did not believe that everything in the Bible was meant to be taken literally. For him, it is a guide for our salvation, and for that, it is not necessary for us to know any specific facts about the physical world. All that is necessary is to have faith.

Writing in the late twentieth century, Harvard biologist Stephen J. Gould echoed St. Augustine's view, claiming that science and religion should not be seen as being in the same business. In fact, their purposes are very different:

> Science tries to document the factual character of the natural world, and to develop theories that coordinate and explain these facts. Religion, on the other hand, operates in the equally important, but utterly different realm of human purposes, meanings and values—subjects that the factual domain of science might illuminate, but can never resolve.[81]

For Gould, science and religion are "non-overlapping magisteria." Each has its own domain of authority which is totally distinct from the other. Science is concerned with physical facts, while religion is concerned with values. The failure of religion to provide any convincing explanations of physical reality, then, does not undermine the value of religion.

Thought Probe

Goulder versus Augustine

Michael Donald Goulder, former Anglican priest and professor of biblical studies at the University of Birmingham in the United Kingdom, resigned from the priesthood in 1981 and became a "non-aggressive atheist" because, he said, "God no longer has any real work to do," meaning that He is no longer needed to explain anything. Is this a good reason for becoming an atheist? Or do you agree with Augustine and Goulder that religion should not be in the business of explaining the world? Which view do you think is the most plausible? Why?

Summary

Arguments that try to derive the existence of God from the existence of the universe are known as cosmological arguments. One of them is the so-called first-cause argument: Some things are caused, and because nothing can cause itself, and the chain of causes can't be infinitely long, there must be a first cause, which we call God. But this argument, if sound, proves only the existence of a first cause, not of God, for the first cause need not be all-powerful, all-knowing, or all-good. It is also not necessarily true that the universe has a cause, or that an infinite regress of causes is logically possible.

The Kalam cosmological argument maintains that whatever begins to exist has a cause. Because the universe began to exist with the big bang, it must have a cause, namely God. But whatever caused the big bang need not be God—it may not be all-powerful, all-knowing, or all-good. Furthermore, the big bang doesn't necessarily have to have a cause. It could have been the result of what scientists call a vacuum fluctuation, an uncaused event. Or the big bang could have been just another cycle in an infinitely "oscillating" universe—a universe without a first cause.

Teleological arguments try to derive the existence of God from the apparent design or purpose in the universe. One popular teleological argument is based on an analogy between the universe and a machine: The universe resembles a watch; every watch has a designer; therefore the universe probably has a designer—God. But even if this is a good analogical argument, it doesn't show that such a designer must be God. In addition, the very existence of a universe designed for a purpose casts doubt on the notion of an all-powerful designer, who should need no universe to achieve goals. The design argument can also be construed this way: The existence of God provides the best explanation of the design of the universe. But another explanation of this design is better. That explanation is evolution.

Some argue that the existence of miracles shows that God must exist. But the existence of miracles implies only a miracle worker, not God. In fact, some have argued that the existence of miracles disproves the existence of an all-powerful or all-knowing God. Furthermore, no event can provide us with sufficient grounds for believing that a miracle has occurred.

Religious experience is also alleged to provide us with proof of God's existence. But there is no way to tell whether a religious experience was caused by God. Without a method for distinguishing real religious experiences from fake ones, we are not justified in believing any to be real.

It seems that belief in God (as traditionally conceived) cannot be rationally justified. Blaise Pascal, however, thought that it could be pragmatically justified. He asserted that it's in your best interests to believe in God because if you do and God exists, you go to heaven; if you believe and God doesn't exist, you lose nothing. But this simple bet ignores many other possibilities. Maybe God rewards those who don't believe; maybe God doesn't care who believes; maybe heaven is no real prize. Moreover, it's not true that you lose nothing by believing in God. Living a religious life costs time, energy, and money. And following religious dictates may lead to unnecessary suffering.

Study Questions

1. According to the traditional theism, what sort of being is God?
2. What is the traditional cosmological argument?
3. What is the Kalam cosmological argument?
4. What is the analogical design argument?
5. What is the best-explanation design argument?
6. What is the argument from miracles?
7. What is the argument from religious experience?
8. What is Anselm's ontological argument?
9. What is Descartes' ontological argument?
10. What is Pascal's wager?
11. What is the argument from meaning?

Discussion Questions

1. There are many books that claim to contain the revealed word of God, such as the Bible, the Koran, and the Vedas. How can we tell which, if any, actually does contain the revealed word of God?
2. Is the existence of one God (monotheism) inherently more plausible than the existence of many gods (polytheism)?
3. Can God make a rock so heavy that he can't lift it? If not, does this impugn his omnipotence?
4. If God knows everything you will ever do in your life, do you have free will?
5. Is there any situation in which a supernatural explanation would be superior to a natural one? If so, describe it.
6. Recently, a trailer park was destroyed by a tornado. Many people were killed, but one child was found alive in the rubble. Many consider it a miracle that the child was saved. Was it?
7. Some say that the purpose of miracles is to make God's presence known to us. Is this a good justification for miracles?
8. Is there anything God could do that would give us unequivocal proof of his existence?
9. Suppose you were raised in a different culture in a family that worshipped a different god than you do now. Would you still have the religion that you have now? If not, can you be sure that your current religion is the true one? If so, what would have convinced you to change religions?
10. Suppose you're trying to make a rational choice among religions. What criteria would you use to determine which religion is the best? Would those be the same criteria you would use to determine which religion is true? If not, how would they differ?

Internet Inquiries

1. Whatever your beliefs about God, are they logically consistent—or do they conflict with one another? To test the coherence of your theistic beliefs, *The Philosophers' Magazine* invites you to play its online brain-teaser called "Battleground God" at **http://www.philosophyexperiments.com/** You have to make it across an intellectual battlefield without taking a direct hit by being guilty of inconsistency. Good luck!

2. The traditional God of theism is not for deists; they posit a creator God that is not intimately involved in the world or in the lives of men and women. Is deism a more plausible notion of God than the traditional conception? Is it a simpler explanation of the workings of the world? Enter "deism" and "theism" into an Internet search engine to explore this issue.

3. Some claim that it's possible to know that Christianity is true through a self-authenticating encounter with the Holy Spirit. Is this view plausible? Can anyone come to know something this way? To research the issue, enter "holy spirit," "craig," and "martin" into an Internet search engine.

Section 6.2

When Bad Things Happen to Good People
God as Troublemaker

None of the arguments we've canvassed justifies believing in the existence of God because none of them establishes God's existence beyond a reasonable doubt. That doesn't mean that God doesn't exist, however. There may be good arguments that we've overlooked. But there is an argument that many believe proves that God *doesn't* exist—namely, the argument from evil.

The world contains a great deal of evil. Think of all the babies born with serious defects, of all the people killed in natural disasters, of all the victims of war and crime. An all-knowing being would know that there is a great deal of evil in this world. An all-good being would want to prevent this evil. And an all-powerful being would be able to prevent it. So if God is all-knowing, all-powerful, and all-good, why is there so much evil in the world? The early Christian writer Lactantius put the problem this way:

> God either wishes to take away evils and is unable; or he is able and is unwilling; or he is neither willing nor able; or he is both willing and able. If he is willing but unable he is feeble, which is not in accordance with the character of God. If he is able and unwilling, he is envious, which is equally at variance with God. If he is neither willing nor able, he is both envious and feeble, and therefore not God. If he is both willing and able, which alone is suitable for God, from what source then are evils? Or why does he not remove them?[82]

The existence of evil, then, seems to be incompatible with the existence of God. If there is a being that meets the description traditionally associated with God, there shouldn't be any evil in the world.

Evil is something that is the source or cause of suffering, injury, or destruction.[83] Humans are obviously responsible for a good deal of evil in the world. Almost every crime is evil insofar as it causes suffering, injury, or destruction. The evil that humans suffer at the hands of their fellow human beings is known as **moral evil**. But moral evil is only a small part of all the evil in the

If God lived on earth, people would break his windows.
—JEWISH PROVERB

evil Something that is the source or cause of suffering, injury, or destruction.

moral evil The evil that humans suffer at the hands of other humans.

world. The evil that humans suffer at the hands of nature, known as **natural evil**, is far more significant. John Stuart Mill explains:

> In sober truth, nearly all the things which men are hanged or imprisoned for doing to one another, are nature's every-day performances. Killing, the most criminal act recognized by human laws, Nature does once to every being that lives; and in a large proportion of cases, after protracted tortures such as only the greatest monsters whom we read of ever purposely inflicted on their living fellow-creatures. . . . Nature impales men, breaks them as if on the wheel, casts them to be devoured by wild beasts, burns them to death, crushes them with stones like the first Christian martyr, starves them with hunger, freezes them with cold, poisons them by the quick or slow venom of her exhalations, and has hundreds of other hideous deaths in reserve, such as the ingenious cruelty of a Nabis or a Domitian never surpassed. All this, Nature does with the most supercilious disregard both of mercy and of justice, emptying her shafts upon the best and noblest indifferently with the meanest and worst; upon those who are engaged in the highest and worthiest enterprises, as often as the direct consequences of the noblest acts; and it might almost be imagined as a punishment for them. She mows down those on whose existence hangs the well-being of a whole people, perhaps the prospects of the human race for generations to come, with as little compunction as those whose death is a relief to themselves, or a blessing to those under their noxious influence.[84]

> *As flies are to wanton boys, are we to the gods: they kill us for their sport.*
>
> —SHAKESPEARE

Millions suffer and die in natural disasters every year. According to traditional theism, this is God's handiwork. Because he created the natural world, he is directly responsible for all of this evil. But an all-knowing, all-powerful, all-good being would not subject his children to such horrendous suffering. So the evidence seems to suggest that the world is not the product of an all-powerful, all-knowing, all-good being.

Not all evil is immoral, however, because sometimes evil is necessary to prevent a greater evil or to promote a greater good. Chemotherapy, for example, is a necessary evil; it's evil because it's the cause of suffering, but it's necessary because it's required to prevent death and promote health.

Unnecessary evil, on the other hand, is immoral because it's not required to prevent a greater evil or promote a greater good. Torturing innocent children, for example, is not only evil, it's immoral as well. It runs afoul of the great principle of mercy: Unnecessary suffering is wrong. Any evil that is not required to prevent a greater evil or promote a greater good is immoral as well.

If there is any unnecessary evil in the world, then God, as traditionally conceived, can't exist. According to the traditional conception, God is all-knowing, all-powerful, and all-good. If he's all-good, he doesn't want there to be any unnecessary evil in the world; if he's all-knowing, he knows whether there's unnecessary evil in the world; and if he's all-powerful, he can prevent there being any unnecessary evil. To prove that God, as traditionally conceived, doesn't exist, all one has to show is that there is one instance of unnecessary evil in the world.

William Rowe provides one such instance.

natural evil The evil that humans suffer at the hands of nature.

Thought Experiment

Rowe's Fawn

Suppose in some distant forest lightning strikes a dead tree, resulting in a forest fire. In the fire a fawn is trapped, horribly burned, and lies in terrible agony for several days before death relieves its suffering. So far as we can see, the fawn's intense suffering is pointless. For there does not appear to be any greater good such that the prevention of the fawn's suffering would require either the loss of that good or the occurrence of an evil equally bad or worse. Nor does there seem to be any equally bad or worse evil so connected to the fawn's suffering that it would have had to occur had the fawn's suffering been prevented. Could an omnipotent, omniscient being have prevented the fawn's apparently pointless suffering? The answer is obvious, as even the theist will insist. An omnipotent, omniscient being could have easily prevented the fawn from being horribly burned, or, given the burning, could have spared the fawn the intense suffering by quickly ending its life, rather than allowing the fawn to lie in terrible agony for several days.[85]

Humans are not the only creatures capable of intense suffering. Certainly all mammals can suffer, and probably, most other vertebrates can as well. Much of the suffering that sentient creatures experience at the hands of nature seems unnecessary, and all of it is preventable by an omniscient, omnipotent being. Because an all-good being would want to prevent unnecessary suffering, there seems to be good reason for believing that God, as traditionally understood, does not exist.

The argument from evil, then, can be stated like this:

1. There is unnecessary evil in the world.
2. If there were an all-powerful, all-knowing, all-good being, there would be no unnecessary evil in the world.
3. Therefore, there is no all-powerful, all-knowing, all-good being.

The second premise of this argument is uncontroversial because theists and atheists alike believe that it's good to prevent unnecessary evil. The success or failure of this argument, then, hinges on the truth or falsity of the first premise.

Necessary evils are morally justified because they either prevent a greater evil or promote a greater good. Unnecessary evils, however, are not. To defeat the argument from evil, then, theists need to show that there is reason to believe that all the evil in the world is necessary. To defend it, nontheists must show that there is reason to believe that at least some evil is unnecessary.

A theory that seeks to justify belief in God in the face of all the evil in the world is known as a **theodicy** (which comes from the Greek words *theos* meaning "god" and *dike* meaning "judgment"). Many different theodicies have been proposed over the years, and all seek to defend the claim that the evil in the world is necessary.

> *As surely as God is good, so surely there is no such thing as necessary evil.*
> —Robert Southey

theodicy An attempt to justify belief in God given the existence of evil.

St. Augustine and the Free-Will Defense

If there were no bad people there would be no good lawyers.
—CHARLES DICKENS

St. Augustine was the Roman Catholic bishop of Hippo Regius (the ancient name of the modern city Annaba, Algeria) from A.D. 396 to 430. For nine years prior to his conversion to Christianity, however, Augustine was a Manichean. Although few have heard of the religion of Manichaeism, many have seen it portrayed on the big screen—the religion of the Star Wars saga is Manichean. Mani (the founder of Manichaeism, who lived from A.D. 210 to 276) taught that good and evil are two separate forces or substances locked in an unending struggle for supremacy. Like the battle between the dark side of the force and the light side in Star Wars, one side will get the upper hand from time to time, but neither is capable of completely defeating the other. In such a world, evil is easy to explain—it's simply the work of the evil force. Such an explanation is not available to one who believes in the traditional god of theism, however. For the god of theism is supposedly all-powerful, all-knowing, and all-good, and an all-powerful being can vanquish any enemy. Because the good force of Manichaeism can't defeat the evil force, it can't be all-powerful. So the god of traditional theism can't be identified with the good force of Manichaeism.

Some Christians try to explain evil in much the same way as Mani did. Evil, they claim, is the work of the devil (also known as Satan or Lucifer). But just as traditional theists can't accept the notion that evil is the product of an evil force, so they can't accept the notion that it's the result of an evil person, because an all-powerful being like God would be able to prevent such a person from doing evil. If God can prevent the devil from doing evil but doesn't, then he is no better than the devil.

To see this, suppose you were walking down a street and came upon a five-year-old boy who was lighting cigarettes and putting them out on his two-year-old baby sister. If you didn't stop the boy, you would be as bad as the boy himself. The devil is like the boy in this story; he inflicts pain and suffering on the human race. If God can stop him but doesn't, then he is as guilty as the devil.

When Augustine converted to Christianity, he came to believe that there is only one god, who is all-powerful, all-knowing, all-good, and the creator of all things. But an all-good being can't create evil. So evil, he concluded, must not be a thing: "Evil has no positive nature, but the loss of good has received the name evil."[86] Contrary to what the Manicheans would have us believe, then, evil is not a thing in its own right but merely the absence of good. Just as darkness is the absence of light and cold is the absence of heat, so evil is the absence of good. This is not to deny that evil exists, but it is to deny that God created it. Where did evil come from then? According to Augustine, Adam and Eve brought evil into the world by disobeying God and eating the fruit of the tree of knowledge.

According to the Book of Genesis in the Bible, God created Adam and Eve, gave them free will, and told them not to eat the fruit of the tree of knowledge. At the prompting of Satan, an angel who had previously rebelled against God, Adam and Eve ate the fruit. In so doing, they introduced evil into the world. Augustine explains: "For when the will abandons what is above itself, and

turns to what is lower, it becomes evil—not because that is evil to which it turns, but because the turning itself is wicked."[87] The fruit itself is not evil, but the choice to eat it is because it involves a turning away from God. By choosing to eat the fruit, Adam and Eve put themselves before God and thus committed the original sin. This sin not only brought death into the world, but it so corrupted human nature that it became almost impossible for humans to do good. Only through the grace of God, thought Augustine, can humans do good.

The question arises: Why should all of humanity have to suffer for what Adam and Eve did? Augustine's answer is that all of humanity was there when it happened! As he puts it, "In the misdirected choice of that one man all sinned in him since all were that one man, from whom on that account they all severally derive original sin."[88] How exactly it's possible for all of us to be present with Adam when he ate the fruit, Augustine doesn't say.

> *I cannot imagine a God who rewards and punishes the objects of his own creation.*
> —ALBERT EINSTEIN

The view that all of humanity was somehow present in Adam when he ate the fruit is not universally shared among Christians. And Jews, for whom the book of Genesis is also a sacred text, don't even believe in original sin. But both Christians and Jews appeal to free will to explain the existence of evil. So let's examine this explanation in more detail.

The most serious problem facing the free-will defense is a logical one: If God's creation was perfectly good, how could evil enter into it? As the German theologian Friedrich Schleiermacher realized, if Adam and Eve were tempted by Satan to sin, "the inclination towards sin must have been present in the first pair before the first sin, else they would be not liable to temptation."[89] Because God made Adam and Eve, their inability to resist Satan was not their fault; it was God's. If he had given them more strength of will, they would not have succumbed to temptation.

A being who has free will and yet always chooses the good does not seem to be a contradiction in terms. God is supposed to be such a being. He supposedly has free will and always chooses the good. Couldn't God have made us the same way? If not, why not? Alvin Plantinga claims that humans, by their very nature, might be so depraved that it's impossible for God to create a world containing humans in which they do not do evil. He calls this the doctrine of "transworld depravity."[90] This doctrine, however, flies in the face of church teaching. Most Christian churches teach that Jesus was a sinless human being, and the Catholic Church teaches that his mother, Mary, was also born without sin. Accepting Plantinga's doctrine, then, requires rejecting basic doctrines of the Christian church.

Even if God could not have made us so that we never do evil, it certainly seems that he could have made us so that we do evil less often than we do. Having a stronger desire to do good would not make us any less free. We do not diminish our children's freedom by teaching them to do good. A world filled with people of high moral character, then, would not be a world with less free will. But it would be a world with less evil. So the free-will defense fails, for there seems to be more evil in the world than is necessary for the existence of free will.

What's more, it seems that we can't blame Adam and Eve for what they did because they couldn't have known it was wrong. Prior to eating the fruit

of the tree of knowledge of good and evil, Adam and Eve didn't know the difference between right and wrong. According to our legal system, then, Adam and Eve were "criminally insane." But criminally insane people don't deserve to be punished for any crimes they commit because they're incapable of doing wrong intentionally. Adam and Eve couldn't have intended to do evil because they didn't know what evil was. So they shouldn't have been punished for what they did.

And even if Adam and Eve deserved to be punished, it's not fair to punish us for what they did. It wouldn't be fair to throw you in jail for something your father did, even if you were "seminally present" in his loins when he did the deed. Similarly it's not fair to punish us for Adam and Eve's actions. To do so is to violate the fundamental principle of retributive justice: Only the person who commits a crime deserves to be punished for it.

One might try to get around this objection by claiming that God's justice is not our justice, but to do so would make the claim that God is all-good meaningless. To say that God is all-good is to say he is good according to our understanding of goodness. If his actions don't fit our concept of goodness, he is not all good. Voltaire makes this point in his *Philosophical Dictionary* under the heading "The Impious."

> The silly fanatic repeats to me, after others, that it is not for us to judge what is reasonable and just in the great Being, that His reason is not like our reason, that His justice is not like our justice. Eh! how, you mad demoniac, do you want me to judge justice and reason otherwise than by the notions I have of them? Do you want me to walk otherwise than with my feet, and to speak otherwise than with my mouth?[91]

If something doesn't fit our definition of good, then it is not good. To claim otherwise is to make a meaningless claim, for in that case, we have no idea what is meant by the word "good."

John Stuart Mill was adamant on this point. He claims that he would rather go to hell than to call a being good whose actions are not good by our lights.

> I know that infinite goodness must be goodness, and that what is not consistent with goodness, is not consistent with infinite goodness.
>
> If in ascribing goodness to God I do not mean what I mean by goodness; if I do not mean the goodness of which I have some knowledge, but an incomprehensible attribute of an incomprehensible substance, which for aught I know may be a totally different quality from that which I love and venerate . . . what do I mean by calling it goodness? and what reason have I for venerating it? If I know nothing about what the attribute is, I cannot tell that it is a proper object of veneration. To say that God's goodness may be different in kind from man's goodness, what is it but saying, with a slight change of phraseology, that God may possibly not be good? . . .
>
> If, instead of the "glad tidings" that there exists a Being in whom all the excellences which the highest human mind can conceive, exist in a degree inconceivable to us, I am informed that the world is ruled by a being whose attributes are infinite, but what they are we cannot learn, not what are the principles of his government, except that "the highest human morality which we are capable of

conceiving" does not sanction them; convince me of it, and I will bear my fate as I may. But when I am told that I must believe this, and at the same time call this being by the names which express and affirm the highest human morality, I say in plain terms that I will not. Whatever power such a being may have over me, there is one thing which he shall not do: he shall not compel me to worship him. I will call no being good, who is not what I mean when I apply that epithet to my fellow-creatures; and if such a being can sentence me to hell for not so calling him, to hell I will go.[92]

Mill's point is that it would be "glad tidings" to learn that there is a being who is all-good in our sense of good. But to be told that there is a being who is all-good in some other sense would not be anything to celebrate. To call such a being good would not only be dishonest, it would be false.

Even if free will could account for all the moral evil in the world—the evil that humans suffer at the hands of their fellow human beings—it can't account for all the natural evil—the evil that humans suffer at the hands of nature. Floods, earthquakes, hurricanes, volcanoes, disease, and famine are not the result of human actions. According to traditional theism, they are God's doing. A follower of Augustine might try to get God off the hook by claiming that we have it coming because we were present in Adam when he ate the fruit. But as we've seen, the notion that we should be punished for what Adam and Eve did is suspect. And even if, somehow, we deserved to be punished for the actions of the first pair, we don't deserve it in such disproportionate amounts. Some people suffer horribly at the hands of nature. Others never experience a natural disaster in their lives. If we all sinned equally, we deserve equal punishment, not the disproportionate amounts we actually experience.

Finally, even if Augustine's theodicy were totally successful in explaining human suffering, it does not explain the sort of animal suffering portrayed in Rowe's fawn thought experiment. Animals don't deserve any of the suffering they experience at the hands of nature. So the free-will defense can't explain all the evil in the world.

Thought Probe

Is There Free Will in Heaven?

Heaven is popularly considered to be a place where there is no sin and thus no evil. But according to the free-will defense, there can be no free will without evil. So how can there be free will in heaven? If there is no free will in heaven, is it a desirable place to go?

The Knowledge Defense

After describing many horrendous acts of evil, Ivan, in Fyodor Dostoyevsky's *The Brothers Karamazov,* asks, "Do you understand why this infamy must be and is permitted? Without it, I am told, man could not have existed on Earth,

for he could not have known good and evil."⁹³ This argument assumes that a knowledge of evil is a good thing and that such a knowledge cannot be acquired unless evil exists. Both of these assumptions are questionable.

When Adam and Eve were first created, they supposedly had no knowledge of good or evil. But this wasn't such a bad thing because before the fall, they are said to have lived in paradise. What's more, to acquire their knowledge, they didn't have to experience evil. All they had to do was eat the apple. So the story of Adam and Eve suggests that both of the assumptions underlying this argument are false.

Even if they were true—even if a knowledge of evil was a good thing and such a knowledge could be acquired only by experiencing evil—there seems to be far more evil in the world than is necessary to give us a knowledge of it. To know what blue is, we have to see only a few blue things. Similarly, to know what evil is, we have to experience only a few examples of it. If the evil in the world is necessary, it must be necessary for something other than our education.

> *With God, what is terrible is that one never knows whether it's just a trick of the Devil.*
> —JEAN ANOUILH

The Ideal-Humanity Defense

Natural evil has been defended on the grounds that it's necessary to improve the human race. By pushing some of us to our limits, it's claimed, the struggle against nature helps us to achieve our potential as a species. Natural evil is helping us evolve toward an ideal humanity.⁹⁴

There are a number of problems with this proposal. For one thing, there is little evidence that the struggle for survival has improved the human race. As a species, we seem no better than our ancestors. Another problem is that the advances we have made in science and the arts are not the result of natural evil. Great scientists and artists are not, by and large, motivated by a desire to overcome natural evil. They are usually motivated by the values of truth and beauty. Even in the case of those who are engaged in the battle against natural evil, such as doctors and rescue workers, there seems to be much more natural evil than is needed to motivate them.

The biggest problem facing the ideal-humanity defense, however, is that it seems to contradict the fundamental principle of Christian morality: that each human being is of infinite value. John Hick explains:

> Although it took Christianity a long time to clarify and is taking even longer for it to implement its valuation of individual personality, perhaps its chief contribution to the life of the world has been its insistence that each human being is equally a child of God, made for eternal fellowship with his Maker and endowed with unlimited value by the divine love which has created him, which sustains him in being, and which purposes his eternal blessedness. Thus, in spite of so many failures in Christian practice, Christianity teaches that the human individual is never a mere means, expendable in the interests of some further goal, but is always an end in himself as the object of God's love.⁹⁷

As Kant taught us, because we are rational beings capable of shaping our own destiny, it's wrong for anyone to use us against our will. When we force others

> *The first lesson of history, is, that evil is good.*
> —RALPH WALDO EMERSON

> ### In the News: Natural Evil
>
> One of the most poignant examples of natural evil is the tsunami (tidal wave) that occurred in the Indian Ocean on December 26, 2004, killing more than 200,000 people, many of whom were infants and children. Instead of viewing the tsunami as evidence of the nonexistence of God, however, some see it as evidence of God's wrath, as James A. Haught reports.
>
> > Immediately after the Indian Ocean tragedy, Israel's chief Sephardic rabbi, Shlomo Amar, told Reuters: "This is an expression of God's great ire with the world. The world is being punished for wrongdoing." The international news syndicate also quoted a Hindu high priest as stating the tsunami was caused by "a huge amount of pent-up manmade evil on Earth" combined with the positions of the planets. And it quoted a Jehovah's Witness as saying the tragedy is "a sign of the last days," fulfilling Christ's promise that devastation will precede the time when believers will "see the Son of Man coming in a cloud with power and great glory." Catholic Bishop Alex Dias of Port Blair, India, said the tsunami was "a warning from God to reflect deeply on the way we lead our lives." On MSNBC's *Scarborough Country*, Jennifer Giroux, director of Women Influencing the Nation (WIN), said the tsunami was divine punishment for America's "cloning, homosexuality, trying to make homosexual marriages, abortion, lack of God in the schools, taking Jesus out of Christmas."[95]
>
> Arkansas governor and Baptist minister Michael Huckabee disagrees with those who see natural disasters as the work of God. He claims that God does not do evil. In 1997 he refused to sign a bill granting relief to tornado victims because the bill referred to the tornado as an "act of God." Huckabee explains, "It's a matter of conscience. I refuse to walk through tornado damage and to say that what destroyed it was God and what built it back was only human beings. I saw God protect a lot of people, save a lot of people. That's an act of God, too."[96]
>
> #### Thought Probe
> Wrath of God
>
> Would an all-good, all-knowing, all-powerful being allow 200,000 of his children to die in such a horrible manner just to express his anger or teach people a lesson? Would he kill Asians to punish Americans? Or is Huckabee right that God is not responsible for natural disasters?

to do our bidding—when we use others as means to an end rather than as ends in themselves—we treat them as slaves and fail to respect their inherent dignity and worth. But if it's wrong for humans to treat each other as slaves, it's also wrong for God to treat us as slaves. Thus the suffering we undergo cannot be justified on the grounds that it's necessary to bring about a greater good for others.

Dostoyevsky eloquently expresses this point when one of his characters says,

> Surely I haven't suffered simply that I, my crimes and my sufferings may manure the soil of the future harmony for somebody else. I want to see with my own eyes the hind lie down with the lion and the victim rise up and embrace his murderer. I want to be there when every one suddenly understands what it has all been for.[98]

It's not right, Dostoyevsky implies, to make someone suffer for the benefit of someone else. Because the ideal-humanity defense suggests otherwise, it's unsuccessful.

The Soul-Building Defense

What does not destroy me makes me stronger.
—NIETZSCHE

John Hick claims that although it's wrong to make us suffer for the sake of someone else, it's not wrong to make us suffer for our own sake. He writes, "The only morally acceptable justification of the agonies and heartaches of human life must be of a . . . kind in which the individuals who have suffered themselves participate in the justifying good and are themselves able to see their own past sufferings as having been worthwhile."[99] According to Hick, evil is necessary, not to improve the human race, but to improve each individual human being.

The assumption behind this view is that suffering can build character. By overcoming adversity, Hick believes, we can acquire virtues such as courage, endurance, and sympathy. But trials and tribulations do not always make us better people. Instead of ennobling us, intense suffering often makes us bitter, resentful, and cynical. It can destroy our faith in humankind, as well as our will to live. English novelist W. Somerset Maugham concurs:

> I have never found that suffering improves the character. Its influence to refine and ennoble is a myth. . . . I have suffered from poverty and the anguish of unrequited love, disappointment, disillusion, lack of opportunity and recognition, want of freedom; and I know that they made me envious and uncharitable, irritable, selfish, unjust; prosperity, success, happiness, have made me a better man.[100]

Maugham rejects the assumption that suffering can build character. Instead of ennobling us, he claims, suffering debases us. Only prosperity, success, and happiness can make us better people.

Hick recognizes that suffering often has negative consequences. Most people don't realize their full potential in this life. Many, in fact, become less virtuous over time. That's why he believes that there must be life beyond the grave. "If the human potential is to be fulfilled in the lives of individual men and women," he says, "those lives must be prolonged far beyond the limits of our present bodily existence."[101] The purpose of life, according to Hick, is to become the best that we can be. But most of us don't achieve a state of moral or spiritual perfection in this life. So we must lead additional lives either in this world or in other worlds.

Hick does not believe that it's permissible to use people against their will to benefit others. But he does believe that it's permissible to use people against their will to benefit themselves. Practices or laws that limit people's freedom for their own good are called *paternalistic*. Motorcycle helmet laws, for example, are paternalistic because they limit motorcyclists' freedom in an attempt to protect them from injury. Hick's theodicy is paternalistic because it attempts to justify suffering on the grounds that it's good for the soul. But not only is it doubtful that suffering has such a salutary effect, it's also doubtful that, even if it did, it would be morally justified. The same sort of considerations that make it wrong to use people to benefit others make it wrong to use people to benefit themselves. In both cases, people are being treated merely as means to an end and not as ends in themselves, and that fails to respect the dignity that resides in each person. As Charles Fried said of paternalistic

medical experiments, "... even if the ends are the patient's own ends, to treat him as a means to them is to undermine his humanity insofar as humanity consists in choosing and being able to judge one's own ends, rather than being a machine which is used to serve ends, even one's own ends."[102] From a moral point of view, then, the soul-building defense doesn't seem to be any better than the ideal-humanity defense.

What's more, Hick's theodicy leads to some unsavory consequences. If evil is necessary to build character, then eliminating evil is wrong. You shouldn't alleviate another person's suffering because, in so doing, you could be stunting his or her spiritual growth. It was this sort of reasoning that led to the untouchable class in India.

Untouchables occupy the lowest rung of Indian society. In the not-so-distant past, it was forbidden to aid these people because it was thought that their misery was punishment for the wickedness of their past lives. Hindus believe that reincarnation is governed by the law of Karma, which says, in effect, "As ye sow, so shall ye reap." In other words, what you do will come back to you, if not in this life, then in a future life. So if you do evil in this life, then an equivalent amount of evil will be done to you in some future life. Your future suffering will atone for your past crimes and prepare you for a better life to come. Alleviating your misery would interfere with your spiritual evolution. By this logic, then, the more misery you endure, the better off you are. Because Hick's soul-building defense implies that it's wrong to alleviate another's suffering, it cannot be correct.

> The doing of evil to avoid an evil cannot be good.
> —SAMUEL COLERIDGE

In addition, there seems to be much more evil in the world than is necessary to build character. Hick admits that most people make little or no spiritual progress during their lives. Why is that? Couldn't God have arranged things so that more spiritual growth took place during our stay on earth? What reason do we have for believing that more growth occurs in other lives on other planets? And why does God need a universe to make us virtuous anyway? Couldn't he just have created us with virtue? If not, can he really be all-powerful? In light of these difficulties, Hick's soul-building theodicy is no more successful than any of the others we've examined.

The Finite-God Defense

In a world created by an all-powerful, all-knowing, and all-good being, there should be no unnecessary evil. Although each defense we've examined might be able to show that some of the evil in the world is necessary, none of them can show that all of it is necessary. One way to explain all the unnecessary evil in the world is to admit that God does not have all of the properties traditionally attributed to him. The Gnostics, as we have seen, thought that the creator of our universe was not all-good. On that assumption, the existence of unnecessary evil is not hard to explain.

> The world is not growing worse and it is not growing better—it is just turning around as usual.
> —FINLEY PETER DUNNE

Rabbi Harold Kushner believes that unnecessary evil exists because God is not all-powerful. In his best-selling book *When Bad Things Happen to Good People,* he claims that evil exists because God is powerless to prevent it. He tells us,

Karma and the Problem of Inequality

One aspect of the problem of evil that is easy to overlook is the problem of inequality. According to the Judeo-Christian tradition, none of us has lived before, so none of us deserves the particular situation we find ourselves in. But some people are born with crippling defects to parents who abuse them, whereas others are born in perfect health to billionaires who adore them. How is that fair? John Hick describes the problem:

> We have not created by our own free actions either the favourable or the unfavourable make-up of our genetic code; and we have not earned the fortunate or the unfortunate conditions in which our lives are set. Neither our inner constitution nor our outer circumstances are in any way appropriate to what we have hitherto been or done—for we did not exist at all prior to our birth as the particular individuals that we are, living in the particular place and in the particular historical period in which we have been born.
>
> On a purely naturalistic view these inequalities would simply have to be accepted as details of the natural order, neither fair nor unfair, just nor unjust. . . . But if, on the other hand, the religious claim is well founded that man's life is established by a higher spiritual power or process, then these disparities of human life take on an inescapable moral significance. It becomes appropriate to ask why they occur and to consider whether they are just or unjust. And on the western assumption that we have had no previous existence and have been brought into being *ab initio* in our present state of inequality, the human scene seems cruelly unfair.[103]

The doctrine of Karma, many believe, can solve both the problem of inequality and the problem of evil. Hick explains:

The alternative assumption of the religions of Indian origin is that we have all lived before and that the conditions of our present life are a direct consequence of our previous lives. There is no arbitrariness, no randomness, no injustice in the inequalities of our human lot, but only cause and effect, the reaping now of what we have ourselves sown in the past. Our essential self continues from life to life, being repeatedly reborn or reincarnated, the state of its karma, or the qualitative sum of its volitional activity, determining the nature of its next earthly life. As R. K. Tripathi of Banaras Hindu University says, "The law of karma along with the doctrine of rebirth has the merit of solving one great problem of philosophy and religion, a problem which is a headache to the western religions and which finds no satisfactory solution in them. The problem is: How is it that different persons are born with an infinite diversity regarding their fortunes in spite of the fact that God is equally good to all? It would be nothing short of denying God to say that He is whimsical. If God is all-Goodness and also All-Powerful, how is it that there is so much evil and inequality in the world? Indian religions relieve God of this responsibility and make our *karmas* responsible.[104]

Thought Probe

Karma

Does the law of Karma along with the doctrine of rebirth provide a better solution to the problem of evil and inequality than those offered by Christians? Why or why not?

> God does not want you to be sick or crippled. He didn't make you have this problem, and He doesn't want you to go on having it, but He can't make it go away. That is something which is too hard even for God.[105]

Kushner's God is a limited God. Specifically, he is not capable of performing miracles because he cannot violate natural law. Nevertheless, Kushner believes that such a God is worthy of worship. At least he's more worthy of worship than a God that could do something about evil and doesn't.[106]

Many theists don't share Kushner's view of God, however. John Baillie, former co-president of the World Council of Churches, for example, says,

> ... I should say that the only grounds I know for believing in God would show Him omnipotent or not at all; and I should feel also that if some ground did appear for believing in the existence somewhere *within* reality of a being of loving purpose but finite power, I should not be moved to worship but only to admiration—I should applaud but I should not kneel. Nothing less than the Infinite can really slake the soul's thirst.[107]

My faith hath no bed to sleep upon but omnipotency.
—SAMUEL RUTHERFORD

Baillie would admire a finite, loving being, but he would not worship him. He might tip his hat to him if he passed him on the street, but he would not get down on his knees and worship him. In Baillie's estimation one can derive little comfort from the belief in a being that can prevent evil but doesn't. But one can derive little more comfort from the belief in a being that is powerless to prevent evil. If God is just as limited as we are, why worship him?

The existence of evil could be squared with the existence of God if we were willing to give up either of his other two attributes: omniscience and omnibenevolence. We could say that although God is all-powerful and all-good, he

The Argument from Nonbelief

The argument from evil tries to prove the nonexistence of the traditional God of theism by showing that a certain fact about the world, namely, that it contains so much evil, is incompatible with a belief in that God. Theodore Drange has recently argued that there is another fact about the world that is incompatible with belief in the God of the New Testament, namely, that so few people believe that Jesus Christ is Lord. According to the New Testament, only those who accept Jesus Christ as their savior will receive eternal salvation. In John 14:6, for example, Jesus declares, "I am the way and the truth and the life. No-one comes to the Father except through me." Drange argues that if there were an all-powerful, all-knowing, and all-good God that only grants salvation to those who believe in him, there wouldn't be so much nonbelief in the world because such a being wouldn't want to deny his children the opportunity for eternal happiness. Drange spells out this argument along these lines:

1. If the God of the New Testament were to exist, (i) he would be able to bring it about that people believe in him, (ii) he would want people to believe in him, (iii) he would have no other wants that would conflict with his desire for people to believe in him, and (iv) he would never refrain from trying to get people to believe in him.

2. If God were to have all four of those properties, the vast majority of people who have lived since the time of Jesus would have believed in him.

3. But the vast majority of people who have lived since that time have not believed in him.

4. So the God of the New Testament does not exist.[108]

The idea is that if the God of the New Testament exists, he loves us and wants us to spend eternity with him. And if the only way for us to do so is to believe in him, then he should do all that he can to bring it about that we do believe in him. But since he can do anything (within reason), and since the vast majority of people do not believe in him, he must not exist.

Thought Probe

The Argument from Nonbelief

Is this a sound argument? Why or why not? If not, which premise(s) are false? What evidence do you have for your view?

is not all-knowing and doesn't realize how bad we have it down here. Or we could say that although God is all-powerful and all-knowing, he is not all-good and likes to see us suffer. Both of these alternatives, however, seem even less plausible than Kushner's.

Many believe that the hypothesis that God exists cannot be tested because God is an immaterial being, and immaterial beings can't be sensed. But even if God can't be sensed, his effects can. The God hypothesis makes at least one testable prediction: If the world was created and is ruled by an all-powerful, all-knowing, and all-good being, it should contain no unnecessary evil. All the evidence, however, seems to indicate that this prediction is false, for the world seems to contain a great deal of unnecessary evil. The various theodicies we've examined are "ad hoc" hypotheses designed to explain away the seeming failure of the prediction. (*Ad hoc* is a Latin phrase meaning "toward this.") None of them seems to be successful, however. That is not to say that there is no way to justify all of the evil in the world. Maybe there is and we haven't found it yet. If we could see things from God's point of view, maybe we'd realize that everything is for the best. But from the fact that there might be a justification for evil, it doesn't follow that there is one; nor does it follow that we're justified in believing that there is one. If you believe in God, then, your belief must be a matter of faith.

Thought Probe

What If God Died?

If God is finite, it's possible for God to die. In the trilogy *Towing Jehovah, Blameless in Abaddon,* and *The Eternal Footman,* science-fiction writer James Morrow explores this possibility. Suppose God died. How would the universe be different? How would we tell that God no longer existed?

Alternatives to Theism

We have been considering arguments for and against the traditional God of theism: an all-powerful, all-knowing, all-good personal being who created the universe and looks after it by listening to prayers and performing miracles. This conception of God is not universally shared, however, even among those who call themselves Christian. Other conceptions of God have been developed, often to avoid some of the objections brought against the theistic God. Let's take a look at a few of them.

Gnosticism

One alternative to traditional theism—Gnosticism—was such a threat to the orthodox understanding of Jesus and the Bible that Irenaeus—the first Christian theologian—devoted five volumes of his *Refutation and Overthrow of the Knowledge Falsely So Called* to combatting it. Irenaeus branded the Gnostics

as heretics, and consequently they were expelled from the church and their sacred texts were destroyed. Most of what we knew about them came from Irenaeus' account, but in 1945, an Arab peasant discovered a collection of ancient scrolls inside a clay jar in a cave near the town of Nag Hammadi in upper Egypt. These scrolls turned out to be some of the texts attacked by Irenaeus, and, as a result, they have come to be known as the Gnostic Gospels.

"Gnosis" means knowledge, and one of the central teachings of the Gnostics is that the way to achieve salvation is not through faith in God or good works, but by knowing yourself. Each of us contains a spark of the divine, and by coming to know our true selves, we come to know God. In the Gospel of Thomas, Jesus puts it this way: "The Kingdom's inside you, and it is outside of you. When you come to know yourselves, then you will become known, and you will realize it is you who are the sons of the living father."[109]

According to Gnosticism, Jesus came to Earth not to die for our sins, but to reveal the true nature of ourselves and our world. Like most Christians, Gnostics believe that our world is in a deplorable state, full of suffering, pain, and misery. But unlike them, the Gnostics do not believe we brought about this condition by disobeying God (as the Adam and Eve story in the book of Genesis suggests). Rather, they believe that the world is in the state that it's in because it was created by a half-wit who didn't know what he was doing! The creator of the material world, known as the "Demiurge" (half maker), is a flawed, ignorant being who created the world in the image of his own flaw—a far cry from the traditional God of theism.

The Gnostics do believe in a supreme being, but that being did not create the material world and is so far removed from our experience that none of our concepts apply to it. It is totally incomprehensible and thus totally ineffable or indescribable.

One advantage of adopting the Gnostic worldview is that it seemingly evades the problem of evil because the creator of the material world is an imperfect flawed being who is neither all-knowing, all-powerful, nor all-good. One would not expect his creation to be perfect. There is no need to try to square all the gratuitous evil and unnecessary suffering in the world with the existence of a supremely perfect being because the creator of the universe is not supremely perfect. The natural evil we see in the world is indeed God's handiwork, not that of angels, demons or humans.

Deism

Christianity, Judaism, and Islam are commonly considered "revealed religions," because they are allegedly based on a revelation from God that is contained in their sacred texts. Deism, on the other hand, is a "natural religion" because it is allegedly based on the observation of nature and the use of reason; not on any supernatural source. Deism became popular in the seventeenth and eighteenth centuries, during the period of time known as the Enlightenment, when science began to flourish. Some of America's most influential founding fathers such as George Washington, Thomas Jefferson, and Benjamin Franklin are generally considered to be Deists, as is the pamphleteer Thomas Paine, who said of Deism:

> There is a happiness in Deism, when rightly understood, that is not to be found in any other system of religion. All other systems have something in them that either shock our reason, or are repugnant to it, and man, if he thinks at all, must stifle his reason in order to force himself to believe them.[110]

During the enlightenment, more and more people began to think for themselves regarding questions concerning the nature of reality, and they became less and less willing to accept the word of an authority simply because they were an authority—they wanted to see the evidence for themselves.

Scientific investigations revealed that there is an underlying pattern to the universe that could be expressed in the form of mathematical laws. Deists took this as evidence of design, and design, they thought, required a designer. Some were even willing to grant that the designer is all-knowing, all-powerful, and all-good. But if so, they argued, much of what traditional theism tells us about God's relationship to the world cannot be true.

For example, a supremely perfect being would create a supremely perfect world. There would be no need to tinker with it or change the underlying pattern because no change could improve it. If changing it could make it better, it wouldn't have been perfect in the first place. So the God of Deism does not intervene in the world, perform miracles, or answer prayers. He is not concerned with the plight of humans at all and, like an absentee landlord, leaves the tenants of the universe to fend for themselves.

A perfect being does not want for anything. He has no defects, and no deficits; he does not desire or respond to adulation or praise. Thus, building places of worship—churches, synagogues, mosques—is pointless. Going to them will not change anything.

Deists do not have an answer to the question of why there is so much evil in the world. But they do have a method for alleviating it: the use of science and reason. Thoughts and prayers are a waste of time because God does not respond to them. Our only hope for improving the human condition is to use our God-given reason.

Pantheism

Whereas Deism takes God to be totally separate from and independent of the world, pantheism takes God to be the world. "Pantheism" comes from the Greek word *pan* meaning "all or everything" and *theos* meaning "God." According to pantheism, God is the world and the world is God.

Modern pantheism received its most cogent formulation in the writings of the Dutch philosopher Benedict de Spinoza. Spinoza's pantheism stems from his conception of substance. "By substance," Spinoza writes, "I understand what is in itself and is conceived through itself, i.e., that whose concept does not require the concept of another thing, from which it must be formed."[111] When we think of particular objects, we think of them having various properties such as that of being a cat, or a dog, or a desk. But when we think of the thing that has those properties—the bearer of the properties—we realize that there can be only one such thing because if there were two, there would be no way to tell them apart. Stripped of all their properties, they would be

indistinguishable from one another, and so we would have no reason to consider them two instead of one.

Spinoza, then, rejects Descartes' view that the world contains two kinds of substances: mental and physical. For Spinoza, there is only one substance that has an infinite number of properties, only some of which we are aware of, and that substance Spinoza refers to as "God or Nature."

Pantheism's God is not a person separate from nature or the universe; it is the universe itself. Because it is not a person, it does not have the sorts of thoughts, feelings, or desires that we ordinarily associate with persons. Like the God of deism, the God of pantheism does not answer prayers or perform miracles. But unlike the God of deism, it did not design or create the universe, for nothing can create itself. The God of pantheism—the universe—is eternal. It had no beginning and it will have no end.

By not considering God to be a person, pantheism solves—or dissolves—the problem of evil. Evil is a problem for those who take the universe to be the creation of a supremely good and powerful being because such a being would not want evil to exist and would be capable of preventing it. But since pantheists do not see the world as the creation of a supernatural agent, the existence of evil is not inconsistent with the existence of God. It simply is.

If God is Nature, how is that different from there being no God at all? How does pantheism differ from atheism? Pantheists would say, by their attitude toward nature. Pantheists view nature as sacred—as having value in and of itself—independent of the value it has for us. As such, it deserves to be treated with respect—not for ourselves—but for its own sake. Many in the environmental movement are drawn to pantheism for this reason.

Summary

The argument from evil says that if there were an all-powerful, all-good being, there would be no unnecessary evil in the world; but there is a great deal of unnecessary evil in the world, so there is no all-powerful, all-good being. To counter this argument, one must reject the premise that there is unnecessary evil in the world. One way to do this is to say that evil is necessary if humans are to have free will. Free will is a good thing, and exercising it will sometimes lead to evil. But a being with free will who always chooses good is not logically impossible. God is such a being; so, presumably, are angels. Why couldn't God have made us the same way?

Another approach to justifying evil is to assert that a knowledge of evil is a good thing and that we can't acquire this knowledge unless evil exists. But neither of these assertions is plausible.

The theist must also justify natural evil—the evil that humans suffer at the hands of nature. And indeed many theists have asserted that natural evil is necessary to bring about a greater good. One proposal is that natural evil improves the human race, helping the species achieve its full potential. But this implies that because evil is necessary to bring about good, any attempt to eliminate evil would be wrong. In addition, this greater-good defense

contradicts the fundamental Christian principle that each individual is of infinite value and shouldn't be used as a means to some greater end.

John Hick claims that evil is necessary to improve not the human race but each individual human being. But this approach rests on the paternalistic notion that it's permissible to force people to do things against their will for their own good. Hick's view also has the same flaw as the traditional greater-good defense: If evil is necessary to build character, then eliminating it is wrong.

One way to escape the argument from evil is to embrace the notion of a finite God. One could claim, for example, that there is so much evil in the world because God is powerless to prevent it. But is such a God worthy of worship?

Various nontheistic conceptions of God have been developed in the West, some of which avoid the problem of evil. Gnosticism claims that the world was created by a flawed being. Deism claims that God created the world but no longer has anything to do with it. Pantheism claims that God is the world.

Study Questions

1. What is the argument from evil?
2. What is the ontological defense?
3. What is the knowledge defense?
4. What is the free-will defense?
5. What is the ideal-humanity defense?
6. What is the soul-building defense?
7. What is the finite-God defense?
8. What is the difference between natural and moral evil?

Discussion Questions

1. Would the world be a worse place without free will?
2. Do the doctrines of Karma and reincarnation solve the problem of evil?
3. Some claim that if we could see the world from God's point of view, what looks evil to us would no longer look evil. Is this a satisfactory justification of evil?
4. If we get a reward in heaven commensurate with the amount of pain we experienced on earth, does that solve the problem of inequality?
5. Consider this thought experiment presented by British philosopher Antony Flew.

Thought Experiment

The Invisible Gardener

Let us begin with a parable. It is a parable developed from a tale told by John Wisdom in his haunting and revelatory article "Gods." Once upon a time two explorers came upon a clearing in the jungle. In the clearing were growing many flowers

and many weeds. One explorer says: "Some gardener must tend this plot." The other disagrees: "There is no gardener." So they pitch their tents and set a watch. No gardener is ever seen. "But perhaps he is an invisible gardener." So they set up a barbed-wire fence. They electrify it. They patrol with bloodhounds. (For they remember how H. G. Wells's The Invisible Man could be both smelt and touched though he could not be seen.) But no shrieks ever suggest that some intruder has received a shock. No movements of the wire ever betray an invisible climber. The bloodhounds never give cry. Yet still the Believer is not convinced: "But there is a gardener, invisible, intangible, insensible to electric shocks, a gardener who has no scent and makes no sound, a gardener who comes secretly to look after the garden which he loves." At last the Skeptic despairs: "But what remains of your original assertion? Just how does what you call an invisible, intangible, eternally elusive gardener differ from an imaginary gardener or even from no gardener at all?"[112]

Is the claim that God exists like the claim that a gardener exists? Why or why not?

Internet Inquiries

1. Is eternal damnation consistent with the notion of an all-good God? Can infinite torment in hell be just punishment for wrongs committed in a finite lifetime? To examine these questions, enter "problem of evil," "God," and "hell" into an Internet search engine.

2. Many people have been troubled by the depiction of God in the Bible. What conclusion can you draw from this biblical picture? That God is evil? That such a God cannot exist? That the Bible is mistaken? Enter "divine evil," "moral," and "bible" into an Internet search engine to explore this issue.

3. Some philosophers have argued against the existence of God based on the fact of widespread unbelief. The argument can found at: **http://www.infidels.org/library/modern/theodore_drange/anbvslea.html.** Is this argument sound? Why or why not?

Section 6.3

Faith and Meaning
Believing the Unbelievable

Faith, according to the *American Heritage Dictionary*, is "belief that does not rest on logical proof or material evidence."[113] Many have argued that belief in the existence of the Christian God must be a matter of faith because, from a logical point of view, the Christian story is illogical.

The Leap of Faith

The way to see by faith is to shut the eye of reason.
—Benjamin Franklin

Danish philosopher Søren Kierkegaard (1813–1855) was particularly troubled by the Christian belief that an immortal being (God) became mortal (Jesus Christ). He writes, "That that which in accordance with its nature is eternal comes into existence in time, is born, grows up, and dies—this is a breach with all thinking."[114] So difficult is this notion to comprehend that Kierkegaard labeled it "absurd."

It has long been known that many of the Christian dogmas are paradoxical. Ordinarily, that would be grounds for rejecting them, for the more unreasonable a claim, the less reason there is for believing it. In the case of religious claims, however, some apologists argue the opposite. Carthaginian theologian Tertullian (c. 155–c. 240 CE), for example, says of the incarnation, "It is to be believed because it is absurd."[115] Here absurdity becomes a reason for belief. Kierkegaard agrees, "The absurd is the object of faith and the only object that can be believed."[116] Kierkegaard takes this attitude toward the absurd because faith requires passion and only that which is contrary to reason can be believed passionately.

Kierkegaard realized that, at best, a rational "proof" for the existence of God would only make God's existence probable. He writes, "Even if all the brains of all the critics were concentrated in one, it would still be impossible to obtain anything more than an approximation." But an approximation is

"incommensurable with an infinite personal interest in eternal happiness."[117] Only certainty can ensure Kierkegaard's salvation. And certainty can be achieved only through faith. So those who are serious about their salvation must make a "leap of faith" and embrace the absurd. But because the absurd flies in the face of reason, faith in it requires an extremely passionate act of will.

Bertrand Russell concurs:

> When there are rational grounds for an opinion, people are content to set them forth and wait for them to operate. In such cases, people do not hold their opinions with passion; they hold them calmly, and set forth their reasons quietly. The opinions that are held with passion are always those for which no good ground exists; indeed the passion is the measure of the holder's lack of rational conviction.[118]

The more absurd the proposition, the more passionate the belief in it must be. Because the proposition that God became mortal is about as absurd as they come, Kierkegaard thinks that belief in it requires the maximum amount of passion. Russell views passionate belief unfavorably because he believes that the more passionately a belief is held, the more likely it is to be false. Kierkegaard, on the other hand, views passionate belief favorably because he believes that the more passionately a belief is held, the more likely it is to be true.

Kierkegaard recognizes two kinds of truth: objective and subjective. Objective truth is concerned with "what" is believed; subjective truth is concerned with "how" it is believed. Something is objectively true if it corresponds to reality. Something is subjectively true if it is believed passionately. Because only the absurd can be believed passionately, Kierkegaard defines subjective truth this way:

> *An objective uncertainty held fast in an appropriation-process of the most passionate inwardness is the truth,* the highest truth attainable for an existing individual.[119]

The idea is that what makes someone a truly religious person is not *what* but *how* that person believes. If you believe in God passionately enough, it changes your whole being. In that case, Kierkegaard says, you are subjectively "in the truth."

But Kierkegaard goes on to say that if you are subjectively in the truth, you are objectively in the truth as well. He writes, "There is a 'how' which has this quality, that if it is truly given, the 'what' is also given; and that is the 'how of faith'. . . inwardness at its maximum proves to be objectivity."[120] In other words, if you believe something passionately enough, it becomes objectively true. Only maximum passion will do. But if you've got it, you've got the truth:

> At its maximum this inward "how" is the passion of the infinite, and the passion of the infinite is the truth. But the passion of the infinite is precisely subjectivity, and thus subjectivity becomes the truth.[121]

According to Kierkegaard, believing something to be true can make it true. But is that really the case? Let's put it to the test.

Christians are not the only ones who can hold maximally passionate beliefs. Although atheists are not known for their passion, it certainly seems

> *What is wanted is not the will to believe, but the will to find out, which is the exact opposite.*
>
> —BERTRAND RUSSELL

that there could be maximally passionate atheists. Consider someone brought up in a very religious home who wants desperately to believe only what he is justified in believing. It takes a supreme act of will for him to accept reason—as opposed to revelation—as a source of knowledge. But suppose he succeeds in passionately believing in the nonexistence of God. Then, according to Kierkegaard, it would be objectively true that there is no God. Now suppose that his twin brother believes just as passionately in the existence of God. Then it would be objectively true that there is a God. But it's logically impossible for it to be objectively true that God exists and that He doesn't exist. So Kierkegaard's theory of truth cannot possibly be correct.

Maybe Kierkegaard's theory doesn't apply to atheists. In that case, consider one of the many cult leaders who believe themselves to be the one true God. Suppose one of these leaders believes it with a maximum amount of inwardness. Then he would be the one true God. Now suppose that another cult leader believes just as passionately that he is the one true God. Then he would be the one true God. But they both can't be the one true God. So again Kierkegaard's theory must be mistaken. The moral of the story is that even in religious matters, you can't make something true simply by believing it to be true.

Kierkegaard not only considers passionate belief to be the road to truth, he also considers it to be the road to virtue. People who believe in God passionately are better than people who don't. As he puts it, "Whoever is neither cold nor hot is nauseating."[122] But is passionate belief in God something to be admired? Bertrand Russell doesn't think so:

> There is something feeble, and a little contemptible, about a man who cannot face the perils of life without the help of comfortable myths. Almost inevitably some part of him is aware that they are myths and that he believes them only because they are comforting. But he dare not face this thought, and he therefore cannot carry his own reflections to any logical conclusion. Moreover, since he is aware, however dimly, that his opinions are not rational, he becomes furious when they are disputed. He therefore adopts persecution, censorship, and a narrowly cramping education as essentials of statecraft. In so far as he is successful, he produces a population which is timid and unadventurous and incapable of progress.[123]

Rather than admiring those who believe something when there is no good evidence for it, Russell despises them. Because they can't support their view by reason, they have to resort to force and violence. Such people, Russell says, do not make the world a better place.

A casual stroll through the lunatic asylum shows that faith does not prove anything.
—FRIEDRICH NIETZSCHE

Thought Probe

Kierkegaard and Russell

Kierkegaard claims that people who are coolly rational are "nauseating." Russell claims that people who can't get through life without comfortable myths are "feeble and contemptible." Whom, if either, do you agree with? Why?

Evidentialism

In courts of law, you can't convict someone unless you have adequate evidence of his or her guilt, because without adequate evidence, a guilty verdict would not be justified. Many claim that what goes in courts of law should go in everyday life: You are justified in believing something only if you have adequate evidence for it. This view, known as **evidentialism,** holds that only beliefs based on evidence can be justified. Some go further and claim that you have a moral obligation to proportion your belief to the evidence. In their view, if you believe something for which you do not have adequate evidence, you have done something wrong.

No one has expressed this point of view more forcefully than the distinguished mathematician W. K. Clifford: "It is wrong always, everywhere, and for anyone to believe anything on insufficient evidence."[124] Others of similar stature have echoed this sentiment. Biologist Thomas Henry Huxley, for example, declared, "It is wrong for a man to say that he is certain of the objective truth of any proposition unless he can produce evidence which logically justifies that certainty."[125] The reason these men think that it is wrong for belief to outstrip the evidence is that our actions are guided by our beliefs, and if our beliefs are mistaken, our actions may be misguided.

To demonstrate the importance of basing belief on the evidence, Clifford provides the following example:

> A shipowner was about to send to sea an emigrant-ship. He knew that she was old, and not overwell built at the first; that she had seen many seas and climes, and often had needed repairs. Doubts had been suggested to him that possibly she was not seaworthy. These doubts preyed upon his mind, and made him unhappy; he thought that perhaps he ought to have her thoroughly overhauled and refitted, even though this should put him at great expense. Before the ship sailed, however, he succeeded in overcoming these melancholy reflections. He said to himself that she had gone safely through so many voyages and weathered so many storms that it was idle to suppose she would not come safely home from this trip also. He would put his trust in Providence, which could hardly fail to protect all these unhappy families that were leaving their fatherland to seek for better times elsewhere. He would dismiss from his mind all ungenerous suspicions about the honesty of builders and contractors. In such ways he acquired a sincere and comfortable conviction that his vessel was thoroughly safe and seaworthy; he watched her departure with a light heart, and benevolent wishes for the success of the exiles in their strange new home that was to be; and he got his insurance-money when she went down in mid-ocean and told no tales.[126]

The shipowner did not base his belief on the evidence. Instead he engaged in wishful thinking and self-deception. Consequently, Clifford claims, he is morally responsible for the death of the emigrants. Even if the ship had not sunk, the shipowner would still be in the wrong because "he had no right to believe on such evidence as was before him."[127]

When lives hang in the balance, it certainly seems that we have a duty to proportion our belief to the evidence, that is, to believe no more—and no

> *I respect faith, but doubt is what gets you an education.*
> —WILSON MIZNER

evidentialism The doctrine that you are justified in believing something if and only if your evidence supports it.

less—than what the evidence warrants. But according to Clifford, we have a duty to proportion our belief to the evidence in all cases.

> Every time we let ourselves believe for unworthy reasons, we weaken our powers of self-control, of doubting, of judicially and fairly weighing evidence. We all suffer severely enough from the maintenance and support of false beliefs and the fatally wrong actions which they lead to. . . . But a greater and wider evil arises when the credulous character is maintained and supported, when a habit of believing for unworthy reasons is fostered and made permanent.[128]

According to Clifford, responsible believing is a skill that can be maintained only through constant practice. And because responsible believing is a prerequisite for responsible acting, we have a duty to foster that skill. If we don't, we diminish our powers of judgment and thereby weaken the social fabric.

Brand Blanshard agrees, arguing that the duty to proportion our belief to the evidence is absolute:

> To think is to seek to know. In seeking knowledge, we assume that it is something worth having, something intrinsically good, that to miss it through ignorance or error is an evil, and that the more of it we have, the better. To court falsity is wrong, and that is what we do when we allow belief to outrun the evidence. To forgo truth needlessly is also wrong, and that is what we do when, with sufficient evidence before us, we decline to believe. Strangely enough, the rule that we should equate our belief with the evidence seems to have no exceptions. Most maxims of conduct, of course, do have exceptions. The rule that we should keep a promise must at times be broken for the sake of the overriding good of saving a life. The rule that life should be saved must at times be broken in the interest of the overriding good of a nation. But it is hard to imagine any circumstances in which it would be right, if we could avoid it, to believe either more or less than the evidence before us warrants.[129]

Blanshard here attempts to justify evidentialism not by appeal to its social consequences, but by appeal to the intrinsic value of knowledge. Knowledge, he claims, is a good thing, whereas error is an evil. The surest way to maximize our knowledge and minimize our error is to proportion our belief to the evidence.

We certainly have a duty to act responsibly. Do we also have a duty to believe responsibly? Is it as immoral to believe something we have no right to believe as it is to take something we have no right to take? Clifford and Blanshard believe so. As evidence for this belief, Blanshard offers the case of Torquemada, the head of the Spanish Inquisition.

Torquemada burned more than two thousand people at the stake for what he considered to be their heretical beliefs. We consider what he did to be terribly wrong. But why? Blanshard offers the following analysis:

> When an act is set down as wrong, it is usually because of bad consequences or a bad motive. Suppose that in this case you fix upon the consequences, which included the excruciating suffering in mind and body of many good men and women. Torquemada would have admitted the suffering. But he would have

They who imagine truth in untruth and see untruth in truth, never arrive at truth, but follow vain desires.
—THE DHAMMAPADA

The notion that faith in Christ is to be rewarded by an eternity of bliss, while a dependence upon reason, observation, and experience merits everlasting pain, is too absurd for refutation, and can be believed only by that unhappy mixture of insanity and ignorance called "faith."
—ROBERT G. INGERSOLL

pointed out that in his view, the consequences included very much more; they included the cleansing from Spain of human plague-spots from which a pestilence was spreading, a pestilence that threatened to carry large numbers of persons to perdition and was averted cheaply by this relatively small number of deaths. So far as consequences were concerned, the balance was therefore good. As for motive, the highest of all motives is the sense of duty, and this Torquemada felt strongly. One may say that a human being should have some humanity as well as a sense of duty. He would probably reply, following Augustine, that he was doing a genuine kindness to the people he sent to the stake. If they continued heretics, they would suffer agonizingly and eternally in hell; so far they had resisted everything that might, by inducing them to recant, have prevented their going there; there was some chance that, if put on the pyre and burnt by a slow fire, as they not infrequently were to give more time to repent, they would renounce their error; and was not an hour or so of fire in this life a low price at which to purchase exemption from an eternity of fire hereafter?[130]

Torquemada believed that he was doing his duty, and he also may have believed that he was doing what was best for both society and his victims. Why, then, are his actions wrong? Blanshard claims that they are wrong because "he had no right to believe what he did."[131]

To students of World War II, Torquemada's reasoning should sound familiar, for it is the same sort of reasoning Hitler gave for exterminating the Jews. Hitler claimed that the Jews were a plague on humankind and that he was doing the human race a favor by eradicating them. Torquemada's reasoning should also sound familiar to students of the war against terrorism, for it is the same sort of reasoning that Islamic terrorists give for killing Americans. Islamic terrorists believe that America is an agent of the devil (the Great Satan) and a source of great evil. They believe that their suicide bombings are sanctioned by God and that their sacrifice will be rewarded in heaven with seventy-two virgins. We think that what Hitler did and what the Islamic terrorists are doing are wrong. But what makes their actions wrong? Is it, as Blanshard claims, that they have no right to believe what they do?

No, because even if they had a right to believe what they did, their actions would still be wrong. Two thousand years ago, people had a right to believe that the earth was flat. All the evidence available pointed to that conclusion. But that didn't make the earth flat. Believing something to be so doesn't make it so, even if the belief is justified. Similarly, suppose that Torquemada had what seemed to be a reliable test for being a Devil-loving witch. Perhaps his research had revealed that all, and only, those who passed the test had admitted to being a witch in their diaries. In any event, even if he was justified in believing that he could accurately identify witches, what he did was still wrong because there are no such witches. The rightness or wrongness of an action depends on the way the world is, not on the way that people think the world is.

As we saw in Chapter 5, a moral judgment follows from a moral principle and a factual claim. If the factual claim is false, then any moral judgment based solely on that claim is mistaken. Torquemada's, Hitler's, and the Islamic terrorists' actions are wrong because the facts on which they are based are false:

A faith that cannot survive collision with the truth is not worth many regrets.

—Arthur C. Clarke

There are no Devil-loving witches, Jews are not a plague on humankind, and Americans are not agents of the Devil.

Actions are not the only things we make moral judgments about, however. In addition to judging actions to be right or wrong, we also judge people to be good or bad. Perhaps Clifford's and Blanshard's arguments can be better understood as arguments about what makes persons good or bad.

A good (virtuous) person is one who has a tendency to do the right thing. But doing the right thing requires believing what is true. And the best way to ensure that you believe what is true is to proportion your belief to the evidence. So it could be argued that anyone who does not practice responsible believing is not a good person. In other words, being morally virtuous requires being intellectually virtuous.

A virtue, you will recall, is an admirable quality that is either good for you or good for other people. Proportioning your belief to the evidence is good for you because it makes it less likely that you'll be taken in by con artists, swindlers, and charlatans. It is good for other people because it makes it less likely that you will do something immoral. So proportioning your belief to the evidence can be considered to be a virtue.

Thought Probe

Blanshard's Beliefs

Are Blanshard and Clifford correct in claiming that our duty to proportion our beliefs to the evidence is absolute? Can you think of a counterexample, a case where it would not be right to proportion your belief to the evidence? Should people who don't proportion their belief to the evidence be ashamed of themselves? Why or why not?

The Will to Believe

Believe that life is worth living, and your belief will help create that fact.
—WILLIAM JAMES

American philosopher and psychologist William James argues that our duty to proportion our belief to the evidence is not absolute. There are times, he says, when we are justified in believing something on faith. He agrees with Clifford and Blanshard that it's wrong not to base our belief on the evidence when the matter can be decided on purely intellectual grounds. But in those cases where we're faced with a genuine option, and when believing something to be true can help make it true, we are justified in believing more than what the evidence warrants.

A genuine option, for James, is one that is forced, live, and momentous. A forced option is one where there are two mutually exclusive alternatives and you must choose one or the other. A live option is one that is believable because it is possible for it to be true. And a momentous option is one whose consequences are significant. James gives the following example of a genuine option where it is permissible not to proportion our belief to the evidence.

Do you like me or not?—for example. Whether you do or not depends, in countless instances, on whether I meet you half-way, am willing to assume that you must like me, and show you trust and expectation. The previous faith on my part in your liking's existence is in such cases what makes your liking come. But if I stand aloof, and refuse to budge an inch until I have objective evidence . . . ten to one your liking never comes.[132]

Although I have no evidence that you like me, if I have faith that you do, then you may come to like me. Because unfounded beliefs can bring about desirable consequences, James believes that only a fool would not have unfounded beliefs. As he puts it, *"where faith in a fact can help create the fact,* that would be an insane logic which would say that faith running ahead of scientific evidence is the 'lowest kind of immorality' into which a thinking being can fall."[133]

But are such beliefs really unfounded? It wouldn't seem so, for they are based on well-known facts about human behavior. We know, for example, that if we treat people with kindness and respect, they will usually return the favor. This knowledge has been gained through experience and serves as the evidence on which our faith rests. Far from being groundless, then, our faith is actually well rooted in our knowledge of human nature. James is right in claiming that the decision to show kindness to strangers can be rational. He is wrong, however, in claiming that there is no evidence to support such a decision.

What's more, James's claim that our faith can transform others is misleading. It is not our faith that brings about the change; it is our behavior. By acting *as if* we like someone, we may get her to like us. For such a strategy to work, however, it is not necessary that we actually like the person. All that is required is that we get her to believe that we like her. So it's our actions rather than our beliefs that produce the desired results.

A better example would be that of believing in yourself. If you believe that you can accomplish something—if you are self-confident—you may be more likely to accomplish it. But again it's unclear that such self-confidence is unfounded. Folk wisdom tells us that believing in yourself is an important ingredient of success. (That's the moral of the story "The Little Engine That Could," for example.) So the belief that you can accomplish something, even if you've never accomplished it before, can be justified on the basis of well-established psychological principles.

But let's grant that there are cases where faith in a fact can bring about a fact. Is belief in the existence of God one of them? It wouldn't seem so. We can no more bring God into existence by believing in him than we can bring the tooth fairy into existence by believing in her. God's existence doesn't depend on our belief. If it did, he wouldn't be all-powerful.

Faith in the existence of a particular god is not the sort of faith James is trying to justify, however. He is trying to justify faith in the affirmations common to all religions, which he identifies as follows:

> First, she says that the best things are the eternal things . . . the things in the universe that throw the last stone . . . and say the final word. "Perfection is eternal. . . ."

We owe it to ourselves as respectable human beings, as thinking human beings, to do what we can to make humanity more rational. . . . Humanists recognize that it is only when people feel free to think for themselves, using reason as their guide, that they are best capable of developing values that succeed in satisfying human needs and serving human interests.

—Isaac Asimov

The second affirmation of religion is that we are better off even now if we believe her first affirmation to be true.[134]

What can faith in these affirmations accomplish? According to James, it can give us a sense of being personally related to the universe.

> The more perfect and more eternal aspect of the universe is represented in our religions as having personal form. The universe is no longer a mere *It* to us, but a *Thou,* if we are religious; and any relation that might be possible from person to person might be possible here.[135]

Your believing that the universe has person-like aspects can help you develop a personal relationship to it, and such a relationship can help give meaning, point, and purpose to your life.[136] But your believing that the universe has person-like aspects can't turn it into a person or the creation of one. The fact that your faith can create is a fact about you—the fact that you have a certain attitude toward the universe.

Thought Probe

James and Pandeism

The view that the universe is not only God but also a person is known as "pandeism." Do you agree with James that viewing the universe as a person would help give meaning to your life? Why or why not?

The Meaning of Life

> *Without a god there is for man neither purpose, nor goal nor hope, only a wavering future, and an eternal dread of every darkness.*
>
> —Jean Paul Richter

Many theists believe that God is needed to give their lives meaning. If there was no intelligence behind the creation of the universe—if the universe came into existence as the result of a random vacuum fluctuation, for example—there is no reason for its existing. But if there is no reason for its existing, they feel, there is no reason for their existing either.

The assumption here is that fulfilling God's plan would make our lives meaningful. Robert Nozick puts that assumption to the test in the following thought experiment.

Thought Experiment

God's Plan

Suppose God decides to reveal to us why He created us. Everywhere on the planet, everyone hears a deep, beautiful voice resonating in their heads: "Now, my children, the time has come for me to reveal why I created you. In a week, a band of intergalactic travelers will be passing through your solar

system. I arranged their trip, and it just so happens that the only thing they can eat [is] human beings. (I designed them that way.) So I created you as a source of food for them. When they land, I want you to walk into their food processing chambers and turn yourself into people burgers."[137]

It's possible that God created us to serve as food for another species. After all, many people believe that God put animals and plants here for us to eat. Who knows what super-advanced aliens eat?

If our sole purpose for being were to serve as food for someone else, would being eaten by that group make our lives meaningful? Nozick thinks not. He writes, "If the cosmic role of human beings was to provide a negative lesson to some others ('don't act like them') or to provide needed food for passing intergalactic travelers who were important, this would not suit our aspirations—not even if afterwards the intergalactic travelers smacked their lips and said that we tasted good."[138] Doing our creator's bidding does not necessarily make our lives meaningful.

This can be demonstrated by a much more mundane example. Suppose your parents had always planned on your being a doctor, but you had always wanted to be an artist. In that case, would being a doctor make your life meaningful? Probably not. Even though your parents created you, doing what they want you to do would not necessarily endow your life with meaning. Similarly, even if God created you, doing what he wants you to do would not necessarily make your life meaningful.

What's more, if all meaning comes from without, then God's existence must be meaningless because he is not part of anybody's plan. But if God's existence is meaningless, then our existence is meaningless, for as Irish philosopher George Berkeley realized, "Nothing can give to another that which it hath not itself."[139] On the other hand, if God's existence is not meaningless, he must be able to create his own meaning. But if God can create his own

The world rolls round forever like a mill: It grinds out deaths and life and good and ill: It has no purpose, heart or mind or will.

—James B. V. Thomson

First say to yourself what you would be; and then do what you have to do.

—Epictetus

Faith and Meaning 515

meaning, why can't we? We're rational, self-conscious beings with free will. We know what gives us satisfaction, and we can formulate plans to achieve it. It seems that we have all we need to generate our own meaning.

Thought Probe

Meaning and Morality

It's wrong to use people merely as a means because that violates their fundamental right to self-determination. If God created us for a specific purpose, it would seem that he wants to use us as a means to an end. Would it be wrong for God to use us in this way? Why or why not?

Existentialism

The notion that we are part of a divine plan is one of the oldest and most influential ideas in Western intellectual history. It holds that everything was created for a purpose, and that the value of a thing is determined by how well it accomplishes its purpose. Because it also maintains that the different types of things can be arranged in a hierarchy from lowest to highest—minerals, vegetables, animals, humans, angels, God—this idea has come to be known as the "Great Chain of Being."

Existentialists explicitly repudiate this idea. They do not believe that our lives were planned out by God before we came into existence. Instead, they believe that we come into existence and then decide for ourselves how we are going to live our lives. This view is summed up in their central principle: Existence precedes essence. Philosopher and Nobel Prize–winning author Jean-Paul Sartre explains:

> Atheistic existentialism, of which I am a representative, declares with greater consistency that if God does not exist there is at least one being whose existence comes before its essence, a being which exists before it can be defined by any conception of it. That being is man or, as Heidegger has it, the human reality. What do we mean by saying that existence precedes essence? We mean that man first of all exists, encounters himself, surges up in the world and defines himself afterwards. If man as the existentialist sees him is not definable, it is because to begin with he is nothing. He will not be anything until later, and then he will be what he makes of himself. Thus, there is no human nature, because there is no God to have a conception of it. Man simply is.... Man is nothing else but that which he makes of himself. That is the first principle of existentialism.[140]

In Sartre's view, then, we have not been put here to do anyone's bidding; there is no purpose that we are designed to serve. Consequently, the meaning of our lives can't consist in following some prearranged plan because there is no such plan. Whatever meaning we find in life we must create for ourselves.

In claiming that we have no essence, Sartre isn't denying that we possess certain physical and social properties. We all have a certain height, weight,

There is not one big cosmic meaning for all, there is only the meaning we each give to our life, an individual meaning, an individual plot, like an individual novel, a book for each person.

—Anaïs Nin

skin color, class, nationality, and so on. But these properties (which Sartre refers to as our "facticity") don't make us who we are because that depends on what we *make* of those properties. Unlike other creatures that exist only "in themselves" ("*en soi*"), we exist "for ourselves" ("*pour soi*"). Who we are is an issue for us, an issue that we can decide for ourselves.

According to the existentialists, we create ourselves in the act of making choices. We exist in a world that demands that we do things, that we undertake certain projects. We interpret the things we encounter in the world in terms of those projects. But as these projects unfold, our selves come into being. In the act of deciding what to do, we determine who we will become.

Only authentic choices are self-determining, however. An authentic choice is one with which you identify. If you do something simply because it's the normal or expected thing to do, your decision is not authentic. But if you do it because it reflects the kind of person you want to become, then it's authentic.

There is no one you can turn to for guidance in making authentic choices, however, because if your choice is based on the views of an external authority, it's not authentic. So Sartre characterizes the human condition as one of abandonment, anguish, and despair: Abandonment because we're on our own, no one can make our choices for us. Anguish because we have to choose. We can't simply do nothing because, as theologian Harvey Cox realized, "Not to choose is to choose." And despair because we have to live with the consequences of our choices.

This is a bleak view of the human condition. Existential art and literature promote this view by exploring such themes as alienation, absurdity, and angst. But are such negative responses the only plausible ones to the realization that we are ultimately responsible for our lives? Classicist Hazel Barnes thinks not. She writes,

> No humanistic existentialist will allow that the only alternative is despair and irresponsibility. Camus has pointed out the fallacy involved in leaping from the premise "The universe has no higher meaning" to the conclusion "Therefore my life is not worth living." The individual life may have an intrinsic value, both to the one who lives it and to those in the sphere of his influence, whether the universe knows what it's doing or not.[141]

In other words, just because there's no meaning *of* life, it doesn't follow that there can be no meaning *in* life.[142] As long as you're doing your own thing, your life can be meaningful, even if it's not part of anyone else's plan.

Thought Probe

Meaning and Purpose

Do you believe that the universe must have been designed for a purpose for life to be meaningful or do you believe that you can create your own meaning by exercising your freedom to choose? Why?

Faith and Meaning 517

Religion without God

Going to church doesn't make you a Christian any more than going to the garage makes you a car.

—Laurence J. Peter

Many think that being a religious person requires holding certain beliefs about God. But as we've seen, the belief that there is a God who is all-powerful, all-knowing, and all-good is suspect. A growing number of theologians, after realizing that traditional theistic beliefs cannot be rationally maintained, have concluded that we should reject those beliefs. Foremost among them are theologian Paul Tillich and his student John Shelby Spong, former Episcopal bishop of Newark, New Jersey. According to Tillich, God is not a person but the ground of the personal. As he puts it, "God is the ground of everything personal and . . . he carries within himself the ontological power of personality."[143] In other words, God is not *a* being but the ground of being—the power that exists in all of us to lead meaningful, fulfilling, religious lives.

To lead a religious life, one doesn't have to believe in a personal God, as witness the Buddhists. Buddhists don't believe in a personal God, and yet many consider them to be among the most religious people on the planet. What makes them so religious is not their particular beliefs, but the kinds of persons they are and the kinds of lives they lead.

Robert Coburn argues that those who have a religious attitude toward life share four important characteristics:

> First, they have a sense of the numinous. That is, they are struck or moved, at least from time to time, by awareness of the sacred, by an apprehension of something in (or about) life or the world that is deeply mysterious, something both attractive and fearful that evokes such responses as awe and reverence. . . .
>
> Second, they find themselves, at least from time to time, possessed of those "fruits of the spirit" that St. Paul called "love, joy [and] peace." That is, they frequently, or at least occasionally, know a deep serenity, poise, tranquility, or quietness within, a peace that is rooted in a profound sense of security despite the contingencies of life. . . .
>
> Third, more or less devoutly religious people within the Christian tradition often have certain characteristic attitudes toward life and toward some of the more fundamental events and situations in life. Thus they often regard seeking after fame, fortune, and power as wrong insofar at least as one is motivated by vanity or a desire for self-glorification. . . .
>
> Fourth, the behavior of those who live the life of faith has a characteristic shape. At least the following three behavioral features tend to be present among the devout in the Christian tradition. Such people participate in public and private "acts of worship." . . . Such people also regularly act in ways that involve putting on "the form of the servant." . . . Last, such people act in ways designed to "share the blessing" they feel they have received through participation in the life of their religious community and tradition with those who are outside "the circle of the faithful."[144]

I have ever judged of the religion of others by their lives. . . . But this does not satisfy the priesthood. They must have a positive, a declared assent to all their interested absurdities. My opinion is that there would never have been an infidel, if there had never been a priest.

—Thomas Jefferson

To have these characteristics—to have a religious orientation toward life—it is neither necessary nor sufficient to have a belief in God. It's not necessary because, like the Buddhists, one can have these characteristics and not believe in God. It's not sufficient because one can believe in God and not have these characteristics.

We all know people who believe in God but have little respect for nature, are always on the go, only look out for number one, and never do volunteer work. Even though these people have religious beliefs, they are not religious people.

Being a good person and leading a good life do not require having a belief in God. Theists and atheists alike can possess high moral character and be socially responsible. Similarly, being a religious person doesn't require having any particular religious beliefs. Atheists can have a religious orientation toward life, and theists can lack one. The fruits of religion, then, are not limited to only the faithful.

Summary

Kierkegaard realizes that accepting the Christian story requires making a leap of faith because certain aspects of that story are absurd. But he advocates making the leap because by doing so you can attain the highest truth possible. Russell finds those who believe on faith feeble and contemptible because they are not willing to face reality. Because they can't back up their views with logic or reason, they often resort to violence.

Clifford argues that we have a moral duty to proportion our belief to the evidence on the grounds that it will strengthen society. Blanshard argues for that duty on the grounds that it will help us attain knowledge and avoid error.

James argues that we need not always proportion our belief to the evidence. When we are faced with a genuine choice that can't be decided on intellectual grounds, and where faith in a fact can help create that fact, we may justifiably believe on faith.

The existentialists believe that we define ourselves through our choices. If those choices are authentic, our lives can be meaningful, even if they're not part of a divine plan.

Study Questions

1. Why does Kierkegaard believe that being a Christian requires a leap of faith?
2. According to Kierkegaard, what is the difference between objective and subjective truth?
3. Why does Russell think that faith is not something to be admired?
4. What is evidentialism?
5. Why does Clifford believe we should proportion our beliefs to the evidence?
6. Why does Blanshard believe we should proportion our beliefs to the evidence?
7. According to James, when is an option genuine?
8. According to James, when is faith justified?
9. What do the existentialists mean by "existence precedes essence"?
10. According to the existentialists, when is a choice authentic?

Discussion Questions

1. Are there any cases where simply believing something to be true makes it true? If so, what are they?
2. Is faith a virtue? Why or why not?
3. What if children were taught from an early age to be ashamed of themselves if they didn't believe responsibly, in the same way they are now taught to be ashamed of themselves if they don't behave responsibly? Would society be better or worse for it?
4. Do you agree with the existentialists that your life can be meaningful even if it isn't part of a divine plan? Why or why not?
5. Consider this quote from Edmund Way Teale: "It is morally as bad not to care whether a thing is true or not, so long as it makes you feel good, as it is not to care how you got your money as long as you have got it."[145] Is this true? Is it immoral not to question your religious beliefs?

Internet Inquiries

1. Some allege that religious faith is fertile ground for fanaticism because religious views are often exempted from the usual standards of reason and evidence and from normal ethical restraints. Is this claim justified? Enter "religious fanaticism," "faith," and "rational" into an Internet search engine to study this question.
2. For many believers, the essence of their faith is obedience to God's will or submission to his divine plan. Is such obedience or submission consistent with personal autonomy, our capacity for self-determination? To explore this question, enter "God's will," "autonomy," and "Rachels" into an Internet search engine.
3. Is religious belief beneficial to a society? A recent study published in *Evolutionary Psychology* suggests not. The study can be found at **http://www.epjournal.net/wp-content/uploads/EP07398441_c.pdf.** Does this study change your opinion about the benefits of faith and religious practice? Why or why not?

St. Thomas Aquinas

The Five Ways

A biography of St. Thomas Aquinas can be found on page 264. In the following selection, Aquinas responds to objections that God doesn't exist by providing his own arguments for the existence of God.

Objection 1. It seems that God does not exist; because if one of two contraries be infinite, the other would be altogether destroyed. But the word 'God' means that He is infinite goodness. If, therefore, God existed, there would be no evil discoverable; but there is evil in the world. Therefore God does not exist.

Obj. 2. Further, it is superfluous to suppose that what can be accounted for by a few principles has been produced by many. But it seems that everything we see in the world can be accounted for by other principles, supposing God did not exist. For all natural things can be reduced to one principle, which is nature; and all voluntary things can be reduced to one principle, which is human reason, or will. Therefore there is no need to suppose God's existence.

On the contrary, It is said in the person of God: *I am Who I am* (Exod. iii. 14).

I answer that, The existence of God can be proved in five ways.

The first and more manifest way is the argument from motion. It is certain, and evident to our senses, that in the world some things are in motion. Now whatever is in motion is put in motion by another, for nothing can be in motion except it is in potentiality to that towards which it is in motion; whereas a thing moves inasmuch as it is in act. For motion is nothing else than the reduction of something from potentiality to actuality. But nothing can be reduced from potentiality to actuality, except by something in a state of actuality. Thus that which is actually hot, as fire, makes wood, which is potentially hot, to be actually hot, and thereby moves and changes it. Now it is not possible that the same thing should be at once in actuality and potentiality in the same respect, but only in different respects. For what is actually hot cannot simultaneously be potentially hot; but it is simultaneously potentially cold. It is therefore impossible that in the same respect and in the same way a thing should be both mover and moved, *i.e.,* that it should move itself. Therefore, whatever is in motion must be put in motion by another. If that by which it is put in motion be itself put in motion, then this also must needs be put in motion by another, and that by another again. But this cannot go on to infinity, because then there would be no first mover, and, consequently, no other mover; seeing that subsequent movers move only inasmuch as they are put in motion by the first mover; as the staff moves only because it is put in motion by the hand. Therefore it is necessary to arrive at a first mover, put in motion by no other; and this everyone understands to be God.

The second way is from the nature of the efficient cause. In the world of sense we find there is an order of efficient causes. There is no case known (neither is it, indeed, possible) in which a thing is found to be the efficient cause of itself; for so it would be prior to itself, which is impossible. Now in efficient causes it is not possible to go on to infinity, because in all efficient causes following in order, the first is the cause of the intermediate cause, and the intermediate is the cause of the ultimate cause, whether the intermediate cause be several, or one only. Now to take away the cause is to take away the effect. Therefore, if there be no first cause among efficient causes, there will be no ultimate, nor any intermediate cause. But if in efficient causes it

Source: St. Thomas Aquinas, *Summa Theologica* (London: Burns, Oates, and Washbourne, 1920) 24–27.

is possible to go on to infinity, there will be no first efficient cause, neither will there be an ultimate effect, nor any intermediate efficient causes; all of which is plainly false. Therefore it is necessary to admit a first efficient cause, to which everyone gives the name of God.

The third way is taken from possibility and necessity, and runs thus. We find in nature things that are possible to be and not to be, since they are found to be generated, and to corrupt, and consequently, they are possible to be and not to be. But it is impossible for these always to exist, for that which is possible not to be at some time is not. Therefore, if everything is possible not to be, then at one time there could have been nothing in existence. Now if this were true, even now there would be nothing in existence, because that which does not exist only begins to exist by something already existing. Therefore, if at one time nothing was in existence, it would have been impossible for anything to have begun to exist; and thus even now nothing would be in existence—which is absurd. Therefore, not all beings are merely possible, but there must exist something the existence of which is necessary. But every necessary thing either has its necessity caused by another, or not. Now it is impossible to go on to infinity in necessary things which have their necessity caused by another, as has been already proved in regard to efficient causes. Therefore we cannot but postulate the existence of some being having of itself its own necessity, and not receiving it from another, but rather causing in others their necessity. This all men speak of as God.

The fourth way is taken from the gradation to be found in things. Among beings there are some more and some less good, true, noble, and the like. But 'more' and 'less' are predicated of different things, according as they resemble in their different ways something which is the maximum, as a thing is said to be hotter according as it more nearly resembles that which is hottest; so that there is something which is truest, something best, something noblest, and, consequently, something which is uttermost being; for those things that are greatest in truth are greatest in being, as it is written in *Metaph.* ii. Now the maximum in any genus is the cause of all in that genus; as fire, which is the maximum of heat, is the cause of all hot things. Therefore there must also be something which is to all beings the cause of their being, goodness, and every other perfection; and this we call God.

The fifth way is taken from the governance of the world. We see that things which lack intelligence, such as natural bodies, act for an end, and this is evident from their acting always, or nearly always, in the same way, so as to obtain the best result. Hence it is plain that not fortuitously, but designedly, do they achieve their end. Now whatever lacks intelligence cannot move towards an end, unless it be directed by some being endowed with knowledge and intelligence; as the arrow is shot to its mark by the archer. Therefore some intelligent being exists by whom all natural things are directed to their end; and this being we call God.

Reply Obj. 1. As Augustine says (*Enchir.* xi.): *Since God is the highest good, He would not allow any evil to exist in His works, unless His omnipotence and goodness were such as to bring good even out of evil.* This is part of the infinite goodness of God, that He should allow evil to exist, and out of it produce good.

Reply Obj. 2. Since nature works for a determinate end under the direction of a higher agent, whatever is done by nature must needs be traced back to God, as to its first cause. So also whatever is done voluntarily must also be traced back to some higher cause other than human reason or will, since these can change and fail; for all things that are changeable and capable of defect must be traced back to an immovable and self-necessary first principle, as was shown in the body of the *Article*.

READING QUESTIONS

1. What two objections does Aquinas give to the claim that God exists?

2. What are Aquinas's replies to those objections?

3. What are the five arguments that Aquinas uses to prove God's existence?

4. Which argument do you find most convincing? Why?

David Hume

Dialogues Concerning Natural Religion

David Hume (1711–1776) wrote his *Treatise of Human Nature* in his early twenties. Although it is one of the finest pieces of empiricist philosophy ever written, its importance was not recognized at the time, and none of the philosophy departments Hume applied to would hire him. Hume became Keeper of the Advocates' Library in Edinburgh and there wrote his *History of England,* which established him as one of the greatest literary figures of his time. The following selections are taken from his *Dialogues Concerning Natural Religion,* in which Philo argues from the lack of empirical evidence to the conclusion that God does not exist.

Not to lose any time in circumlocutions, said CLEANTHES, addressing himself to DEMEA, much less in replying to the pious declamations of PHILO; I shall briefly explain how I conceive this matter. Look round the world: Contemplate the whole and every part if it: You will find it to be nothing but one great machine, subdivided into an infinite number of lesser machines, which again admit of subdivisions, to a degree beyond what human senses and faculties can trace and explain. All these various machines, and even their most minute parts, are adjusted to each other with an accuracy, which ravishes into admiration all men, who have ever contemplated them. The curious adapting of means to ends, throughout all nature, resembles exactly, though it much exceeds, the productions of human contrivance; of human design, thought, wisdom, and intelligence. Since therefore the effects resemble each other, we are led to infer, by all the rules of analogy, that the causes also resemble; and that the Author of nature is somewhat similar to the mind of man; though possessed of much larger faculties, proportioned to the grandeur of the work, which he has executed. By this argument *a posteriori,* and by this argument alone, we do prove at once the existence of a Deity, and his similarity to human mind and intelligence. . . .

If we see a house, CLEANTHES, we conclude, with the greatest certainty, that it had an architect or builder; because this is precisely that species of effect, which we have experienced to proceed from that species of cause. But surely you will not affirm, that the universe bears such a resemblance to a house, that we can with the same certainty infer a similar cause, or that the analogy is here entire and perfect. The dissimilitude is so striking, that the utmost you can here pretend to is a guess, a conjecture, a presumption concerning a similar cause; and how that pretension will be received in the world, I leave you to consider.

It would surely be very ill received, replied CLEANTHES; and I should be deservedly blamed and detested, did I allow that the proofs of a Deity amounted to no more than a guess or conjecture. But is the whole adjustment of means to ends in a house and in the universe so slight a resemblance? The economy of final causes? The order, proportion, and arrangement of every part? Steps of a stair are plainly contrived, that human legs may use them in mounting; and this inference is certain and infallible. Human legs are also contrived for walking and mounting; and this inference, I allow, is not altogether so certain, because of the dissimilarity which you remark; but does it, therefore, deserve the name only of presumption or conjecture? . . .

Now according to this method of reasoning, DEMEA, it follows (and is, indeed, tacitly allowed by CLEANTHES himself) that order, arrangement, or the adjustment of final causes is not, of itself, any proof of design; but only so far as it has been experienced to proceed from that principle. For aught we can know *a priori,* matter may contain the source or spring of order originally, within itself, as well as mind does; and there is no more difficulty in conceiving, that the several elements, from an internal unknown cause, may fall into the most exquisite arrangement, than to conceive that their ideas, in the great, universal mind, from a like internal, unknown cause, fall into that arrangement. The equal

Source: David Hume, *Dialogues Concerning Natural Religion,* 1779.

possibility of both these suppositions is allowed. By experience we find (according to Cleanthes), that there is a difference between them. Throw several pieces of steel together, without shape or form; they will never arrange themselves so as to compose a watch: Stone, and mortar, and wood, without an architect, never erect a house. But the ideas in a human mind, we see, by an unknown, inexplicable economy, arrange themselves so as to form that plan of a watch or house. Experience, therefore, proves, that there is an original principle of order in mind, not in matter. From similar effects we infer similar causes. The adjustment of means to ends is alike in the universe, as in a machine of human contrivance. The causes, therefore, must be resembling.

I was from the beginning scandalised, I must own, with this resemblance, which is asserted, between the Deity and human creatures; and must conceive it to imply such a degradation of the supreme Being as no sound theist could endure. With your assistance, therefore, Demea, I shall endeavour to defend what you justly call the adorable mysteriousness of the divine nature, and shall refute this reasoning of Cleanthes; provided he allows, that I have made a fair representation of it.

When Cleanthes had assented, Philo, after a short pause, proceeded in the following manner.

That all inferences, Cleanthes, concerning fact, are founded on experience, and that all experimental reasonings are founded on the supposition, that similar causes prove similar effects, and similar effects similar causes; I shall not, at present, much dispute with you. But observe, I entreat you, with what extreme caution all just reasoners proceed in the transferring of experiments to similar cases. Unless the cases be exactly similar, they repose no perfect confidence in applying their past observation to any particular phenomenon. Every alteration of circumstances occasions a doubt concerning the event; and it requires new experiments to prove certainly, that the new circumstances are of no moment or importance. A change in bulk, situation, arrangement, age, disposition of the air, or surrounding bodies; any of these particulars may be attended with the most unexpected consequences: And unless the objects be quite familiar to us, it is the highest temerity to expect with assurance, after any of these changes, an event similar to that which before fell under our observation. The slow and deliberate steps of philosophers, here, if any where, are distinguished from the precipitate march of the vulgar, who, hurried on by the smallest similitude, are incapable of all discernment or consideration.

But can you think, Cleanthes, that your usual phlegm and philosophy have been preserved in so wide a step as you have taken, when you compared to the universe houses, ships, furniture, machines; and from their similarity in some circumstances inferred a similarity in their causes? Thought, design, intelligence, such as we discover in men and other animals, is no more than one of the springs and principles of the universe, as well as heat or cold, attraction or repulsion, and a hundred others, which fall under daily observation. It is an active cause, by which some particular parts of nature, we find, produce alterations on other parts. But can a conclusion, with any propriety, be transferred from parts to the whole? Does not the great disproportion bar all comparison and inference? From observing the growth of a hair, can we learn any thing concerning the generation of a man? Would the manner of a leaf's blowing, even though perfectly known, afford us any instruction concerning the vegetation of a tree?

But to show you still more inconveniences, continued Philo, in your anthropomorphism; please to take a new survey of your principles. *Like effects prove like causes.* This is the experimental argument; and this, you say too, is the sole theological argument. Now it is certain, that the liker the effects are, which are seen, and the liker the causes, which are inferred, the stronger is the argument. Every departure on either side diminishes the probability, and renders the experiment less conclusive. You cannot doubt of this principle: Neither ought you to reject its consequences. . . .

Now, Cleanthes, said Philo, with an air of alacrity and triumph, mark the consequences. *First,* By this method of reasoning, you renounce all claim to infinity in any of the attributes of the Deity. For as the cause ought only to be proportioned to the effect, and the effect, so far as it falls under our cognisance, is not infinite; what pretensions have we, upon your suppositions, to ascribe that attribute to the divine Being? You will still insist, that, by removing him so much from all similarity to human creatures, we give into the most arbitrary hypothesis, and at the same time weaken all proofs of his existence.

Secondly, You have no reason, on your theory, for ascribing perfection to the Deity, even in his finite capacity; or for supposing him free from every error, mistake, or incoherence in his undertakings. There are many inexplicable difficulties in the works of nature, which, if we allow a perfect Author to be proved *a priori,* are easily solved, and become only seeming difficulties, from the narrow capacity of man, who cannot trace infinite relations. But according to your method of reasoning, these difficulties become all real; and perhaps will be insisted on, as new instances of likeness to human art and contrivance. At least, you must acknowledge, that it is impossible for us to tell, from our limited

views, whether this system contains any great faults, or deserves any considerable praise, if compared to other possible, and even real systems. Could a peasant, if the Æneid were read to him, pronounce that poem to be absolutely faultless, or even assign to it its proper rank among the productions of human wit; he, who had never seen any other production?

But were this world ever so perfect a production, it must still remain uncertain, whether all the excellencies of the work can justly be ascribed to the workman. If we survey a ship, what an exalted idea must we form of the ingenuity of the carpenter, who framed so complicated, useful, and beautiful a machine? And what surprise must we entertain, when we find him a stupid mechanic, who imitated others, and copied an art, which, through a long succession of ages, after multiplied trials, mistakes, corrections, deliberations, and controversies, had been gradually improving? Many worlds might have been botched and bungled, throughout an eternity, ere this system was struck out: Much labour lost: Many fruitless trials made: And a slow, but continued improvement carried on during infinite ages in the art of world-making. In such subjects, who can determine, where the truth; nay, who can conjecture where the probability, lies; amidst a great number of hypotheses which may be proposed, and a still greater number which may be imagined?

And what shadow of an argument, continued Philo, can you produce, from your hypothesis, to prove the unity of the Deity? A great number of men join in building a house or ship, in rearing a city, in framing a commonwealth: Why may not several Deities combine in contriving and framing a world? This is only so much greater similarity to human affairs. By sharing the work among several, we may so much farther limit the attributes of each, and get rid of that extensive power and knowledge, which must be supposed in one Deity, and which, according to you, can only serve to weaken the proof of his existence. And if such foolish, such vicious creatures as man can yet often unite in framing and executing one plan; how much more those Deities or Dæmons, whom, we may suppose several degrees more perfect? . . .

But farther, Cleanthes; men are mortal, and renew their species by generation; and this is common to all living creatures. The two great sexes of male and female, says Milton, animate the world. Why must this circumstance, so universal, so essential, be excluded from those numerous and limited Deities? Behold then the theogony of ancient times brought back upon us.

And why not become a perfect anthropomorphite? Why not assert the Deity or Deities to be corporeal, and to have eyes, a nose, mouth, ears, &c.? Epicurus maintained, that no man had ever seen reason but in a human figure: therefore the gods must have a human figure. And this argument, which is deservedly so much ridiculed by Cicero, becomes, according to you, solid and philosophical.

In a word, Cleanthes, a man, who follows your hypothesis, is able, perhaps, to assert, or conjecture, that the universe, sometime, arose from something like design: But beyond that position he cannot ascertain one single circumstance, and is left afterwards to fix every point of his theology, by the utmost licence of fancy and hypothesis. This world, for aught he knows, is very faulty and imperfect, compared to a superior standard; and was only the first rude essay of some infant Deity, who afterwards abandoned it, ashamed of his lame performance; it is the work only of some dependent, inferior Deity; and is the object of derision to his superiors: it is the production of old age and dotage in some superannuated Deity; and ever since his death, has run on at adventures, from the first impulse and active force, which it received from him. . . . You justly give signs of horror, Demea, at these strange suppositions: But these, and a thousand more of the same kind, are Cleanthes's suppositions, not mine. From the moment the attributes of the Deity are supposed finite, all these have place. And I cannot, for my part, think, that so wild and unsettled a system of theology is, in any respect, preferable to none at all. . . .

It must be a slight fabric, indeed, said Demea, which can be erected on so tottering a foundation. While we are uncertain, whether there is one Deity or many; whether the Deity or Deities, to whom we owe our existence, be perfect or imperfect, subordinate or supreme, dead or alive; what trust or confidence can we repose in them? What devotion or worship address to them? What veneration or obedience pay them? To all the purposes of life, the theory of religion becomes altogether useless: And even with regard to speculative consequences, its uncertainty, according to you, must render it totally precarious and unsatisfactory.

To render it still more unsatisfactory, said Philo, there occurs to me another hypothesis, which must acquire an air of probability from the method of reasoning so much insisted on by Cleanthes. That like effects arise from like causes: This principle he supposes the foundation of all religion. But there is another principle of the same kind, no less certain, and derived from the same source of experience; that where several known circumstances are *observed* to be similar, the unknown will also be *found* similar. Thus, if we see the limbs of a

human body, we conclude, that it is also attended with a human head, though hid from us. Thus, if we see, through a chink in a wall, a small part of the sun, we conclude, that, were the wall removed, we should see the whole body. In short, this method of reasoning is so obvious and familiar, that no scruple can ever be made with regard to its solidity.

Now if we survey the universe, so far as it falls under our knowledge, it bears a great resemblance to an animal or organized body, and seems actuated with a like principle of life and motion. A continual circulation of matter in it produces no disorder: A continual waste in every part is incessantly repaired: The closest sympathy is perceived throughout the entire system: And each part or member, in performing its proper offices, operates both to its own preservation and to that of the whole. The world, therefore, I infer, is an animal, and the Deity is the SOUL of the world, actuating it, and actuated by it.

You have too much learning, CLEANTHES, to be at all surprised at this opinion, which, you know, was maintained by almost all the theists of antiquity, and chiefly prevails in their discourses and reasonings. For though sometimes the ancient philosophers reason from final causes, as if they thought the world the workmanship of God; yet it appears rather their favourite notion to consider it as his body, whose organization renders it subservient to him. And it must be confessed, that as the universe resembles more a human body than it does the works of human art and contrivance; if our limited analogy could ever, with any propriety, be extended to the whole of nature, the inference seems juster in favour of the ancient than the modern theory.

There are many other advantages too, in the former theory, which recommended it to the ancient theologians. Nothing more repugnant to all their notions, because nothing more repugnant to common experience, than mind without body; a mere spiritual substance, which fell not under their senses nor comprehension, and of which they had not observed one single instance throughout all nature. Mind and body they knew, because they felt both: An order, arrangement, organization, or internal machinery in both they likewise knew, after the same manner: And it could not but seem reasonable to transfer this experience to the universe, and to suppose the divine mind and body to be also coeval, and to have, both of them, and arrangement naturally inherent in them, and inseparable from them. . . .

. . . The world plainly resembles more an animal or a vegetable, than it does a watch or a knitting-loom. Its cause, therefore, it is more probable, resembles the cause of the former. The cause of the former is generation or vegetation. The cause, therefore, of the world, we may infer to be some thing similar or analogous to generation or vegetation.

But how is it conceivable, said DEMEA, that the world can arise from any thing similar to vegetation or generation?

Very easily, replied PHILO. In like manner as a tree sheds its seed into the neighbouring fields, and produces other trees; so the great vegetable, the world, or this planetary system, produces within itself certain seeds, which, being scattered into the surrounding chaos, vegetate into new worlds. A comet, for instance, is the seed of a world; and after it has been fully ripened, by passing from sun to sun, and star to star, it is at last tossed into the unformed elements, which everywhere surround this universe, and immediately sprouts up into a new system.

Or if, for the sake of variety (for I see no other advantage), we should suppose this world to be an animal; a comet is the egg of this animal; and in like manner as an ostrich lays its egg in the sand, which, without any farther care, hatches the egg, and produces a new animal; so. . . .

I understand you, says DEMEA: But what wild, arbitrary suppositions are these? What *data* have you for such extraordinary conclusions? And is the slight, imaginary resemblance of the world to a vegetable or an animal sufficient to establish the same inference with regard to both? Objects, which are in general so widely different; ought they to be a standard for each other?

Right, cries PHILO: This is the topic on which I have all along insisted. I have still asserted, that we have no *data* to establish any system of cosmogony. Our experience, so imperfect in itself, and so limited both in extent and duration, can afford us no probable conjecture concerning the whole of things. But if we must needs fix on some hypothesis; by what rule, pray, ought we to determine our choice? Is there any other rule than the greater similarity of the objects compared? And does not a plant or an animal, which springs from vegetation or generation, bear a stronger resemblance to the world, than does any artificial machine, which arises from reason and design? . . .

Compare, I beseech you, the consequences on both sides. The world, say I, resembles an animal, therefore it is an animal, therefore it arose from generation. The steps, I confess, are wide; yet there is some small appearance of analogy in each step. The world, says CLEANTHES, resembles a machine, therefore it is a machine, therefore it arose from design. The steps are here equally wide, and the analogy less striking. And if he pretends to carry on *my* hypothesis a step farther, and to infer design or reason from the great principle

of generation, on which I insist; I may, with better authority, use the same freedom to push farther *his* hypothesis, and infer a divine generation or theogony from his principle of reason. I have at least some faint shadow of experience, which is the utmost that can ever be attained in the present subject. Reason, in innumerable instances, is observed to arise from the principle of generation, and never to arise from any other principle.

Hesiod, and all the ancient mythologists, were so struck with this analogy, that they universally explained the origin of nature from an animal birth, and copulation. Plato too, so far as he is intelligible, seems to have adopted some such notion in his Timæus.

The Brahmins assert, that the world arose from an infinite spider, who spun this whole complicated mass from his bowels, and annihilates afterwards the whole or any part of it, by absorbing it again and resolving it into his own essence. Here is a species of cosmogony, which appears to us ridiculous, because a spider is a little contemptible animal, whose operations we are never likely to take for a model of the whole universe. But still here is a new species of analogy, even in our globe. And were there a planet wholly inhabited by spiders (which is very possible), this inference would there appear as natural and irrefragable as that which in our planet ascribes the origin of all things to design and intelligence, as explained by Cleanthes. Why an orderly system may not be spun from the belly as well as from the brain, it will be difficult for him to give a satisfactory reason.

Reading Questions

1. What is Cleanthes' argument by analogy for the existence of God? How strong is the argument? What is Philo's initial reaction to the analogy? Do you agree with his criticism?

2. What is Philo's point about arguing from parts to wholes? Do you think his reasoning is sound? Why or why not?

3. What are Philo's main objections to the design argument? What is the strength of these objections? Taken together, do they refute the design argument? Explain.

4. Philo contends that the world is more like an animal than a machine. How does this claim undermine the argument from design?

John Stuart Mill

A Finite God

John Stuart Mill (1806–1873) was one of the most influential philosophers, social reformers, and political theorists of the nineteenth century. A staunch defender of the utilitarian ethical theory, he also championed free speech. In this selection from his essay, "Theism," he considers what "natural theology" can tell us about the nature of God. Natural theology is the attempt to acquire knowledge of God through the study of nature. Mill's question is: What can we infer about the nature of God from a study of the world around us?

The question of the existence of a Deity, in its purely scientific aspect . . . is next to be considered. Given the indications of a Deity, what *sort* of a Deity do they point to? What attributes are we warranted, by the evidence which Nature affords of a creative mind, in assigning to that mind?

It needs no showing that the power if not the intelligence, must be so far superior to that of Man, as to surpass all human estimate. But from this to Omnipotence and Omniscience there is a wide interval, And the distinction is of immense practical importance.

It is not too much to say that every indication of Design in the Kosmos is so much evidence against the Omnipotence of the Designer. For what is meant by Design? Contrivance: the adaptation of means to an end, But the necessity for contrivance the need of employing means is a consequence of the limitation of power. Who would have recourse to means if to attain his end his mere word was sufficient? The very idea of means implies that the means have an efficacy which the direct action of the being who employs them has not. Otherwise they are not means, but an incumbrance. A man does riot use machinery to move his arms. If he did, it could only be when paralysis had deprived him of the power of moving them by volition. But if the employment of contrivance is in itself a sign of limited power, how much more so is the careful and skilful choice of contrivances? Can any wisdom be shown in the selection of means, when the means have no efficacy but what is given them by the will of him who employs them, and when his will could have bestowed the same efficacy on any other means? Wisdom and contrivance are shown in overcoming difficulties, and there is no room for them in a Being for whom no difficulties exist.

The evidences, therefore, of Natural Theology distinctly imply that the author of the Kosmos worked under limitations; that he was obliged to adapt himself to conditions independent of his will, and to attain his ends by such arrangements as those conditions admitted of.

And this hypothesis agrees with what we have seen to be the tendency of the evidences in another respect. We found that the appearances in Nature point indeed to an origin of the Kosmos, or order in Nature, and indicate that origin to be Design but do not point to any commencement, still less creation, of the two great elements of the Universe, the passive element and the active element, Matter and Force. There is in Nature no reason whatever to suppose that either Matter or Force, or any of their properties, were made by the Being who was the author of the collocations by which the world is adapted to what we consider as its purposes; or that he has power to alter any of those properties. It is only when we consent to entertain this negative supposition that there arises a need for wisdom and contrivance in the order of the universe, The Deity had on this hypothesis to work out his ends by combining materials of a given nature and properties. Out of these materials he had to construct a world in which his designs should be carried into effect through given properties of Matter and Force, working together and fitting into one another. This did require skill and contrivance, and the means by which it is effected are often such as justly excite our wonder and admiration: but exactly because it requires wisdom, it implies limitation of power, or

Source: John Stuart Mill, "Theism," in *Three Essays on Religion* (London: Longmans, Greene, 1875) 176–190.

rather the two phrases express different sides of the same fact.

● If it be said, that an Omnipotent Creator, though under no necessity of employing contrivances such as man must use, thought fit to do so in order to leave traces by which man might recognize his creative hand, the answer is that this equally supposes a limit to his omnipotence. For if it was his will that men should know that they themselves and the world are his work, he, being omnipotent, had only to will that they should be aware of it. Ingenious men have sought for reasons why God might choose to leave his existence so far a matter of doubt that men should not be under an absolute necessity of knowing it, as they are of knowing that three and two make five. These imagined reasons are very unfortunate specimens of casuistry; but even did we admit their validity, they are of no avail on the supposition of omnipotence, since if it did not please God to implant in man a complete conviction of his existence, nothing hindered him from making the conviction fall short of completeness by any margin he chose to leave. It is usual to dispose of arguments of this description by the easy answer, that we do not know what wise reasons the Omniscient may have had for leaving undone things which he had the power to do. It is not perceived that this plea itself implies a limit to Omnipotence. When a thing is obviously good and obviously in accordance with what all the evidences of creation imply to have been the Creator's design, and we say we do not know what good reason he may have had for not doing it, we mean that we do not know to what other, still
● better object—to what object still more completely in the line of his purposes, he may have seen fit to postpone it. But the necessity of postponing one thing to another belongs only to limited power. Omnipotence could have made the objects compatible. Omnipotence does not need to weigh one consideration against another. If the Creator, like a human ruler, had to adapt himself to a set of conditions which he did not make, it is as unphilosophical as presumptuous in us to call him to account for any imperfections in his work; to complain that he left anything in it contrary to what, if the indications of design prove anything, he must have intended. He must at least know more than we know, and we cannot judge what greater good would have had to be sacrificed, or what greater evil incurred, if he had decided to remove this particular blot. Not so if he be omnipotent. If he be that, he must himself have willed that the two desirable objects should be incompatible; he must himself have willed that the obstacle to his supposed design should be insuperable. It cannot therefore be his design. It will not do to say that it was, but that he had other designs which interfered with it; for no one purpose imposes necessary limitations on another in the case of a Being not restricted by conditions of possibility.

Omnipotence, therefore, cannot be predicated of the Creator on grounds of natural theology. The fundamental principles of natural religion as deduced from, the facts of the universe, negate his omnipotence. They do not, in the same manner, exclude omniscience: if we suppose limitation of power, there is nothing to contradict the supposition of perfect knowledge and absolute wisdom. But neither is there anything to prove it. The knowledge of the powers and properties of things necessary for planning and executing the arrangements of the Kosmos, is no doubt as much in excess of human knowledge as the power implied in creation is in excess of human power. And the skill, the subtlety of contrivance, the ingenuity as it would be called in the ease of a human work, is often marvellous. But nothing obliges us to suppose that either the knowledge or the skill is infinite. We are not even compelled to suppose that the contrivances were always the best possible. If we venture to judge them as we judge the works of human artificers, we find abundant defects. The human body, for example, is one of the most striking instances of artful and ingenious contrivance which nature offers, but we may well ask whether so complicated a machine could not have been made to last longer, and not to get so easily and frequently out of order. We may ask why the human race should have been so constituted as to grovel in wretchedness and degradation for countless ages before a small portion of it was enabled to lift itself into the very imperfect state of intelligence, goodness and happiness which we enjoy. The divine power may not have been qual to doing more; the obstacles to a better arrangement of things may have been insuperable. But it is also possible that they were not. The skill of the Demiourgos was sufficient to produce what we see; but we cannot tell that this skill reached the extreme limit of perfection compatible with the material it employed and the forces it had to work with. I know not how we can even satisfy ourselves on grounds of natural theology, that the Creator foresees all the future; that he foreknows, all the effects that will issue from his own contrivances. There may be great wisdom without the power of foreseeing and calculating everything: and human workmanship teaches us the possibility that the workman's knowledge of the properties of the things he works on may enable him to make arrangements admirably fitted to produce a given result, while he may have very little power of foreseeing the agencies of another kind which may modify or counteract the operation of the machinery he has made . . .

We now pass to the moral attributes of the Deity, so far as indicated in the Creation; or (stating the problem in the broadest manner) to the question, what indications Nature gives of the purposes of its author. This question bears a very different aspect to us from what it bears to those teachers of Natural Theology who are incumbered with the necessity of admitting the omnipotence of the Creator. We have not to attempt the impossible problem of reconciling infinite benevolence and justice with infinite power in the Creator of such a world as this. The attempt to do so not only involves absolute contradiction in an intellectual point of view but exhibits to excess the revolting spectacle of a Jesuitical defence of moral enormities.

On this topic I need not add to the illustrations given of this portion of the subject in my Essay on Nature. At the stage which our argument has reached there is none of this moral perplexity. Grant that creative power was limited by conditions the nature and extent of which are wholly unknown to us, and the goodness and justice of the Creator may be all that the most pious believe; and all in the work that conflicts with those moral attributes may be the fault of the conditions which left to the Creator only a choice of evils.

It is, however, one question whether any given conclusion is consistent with known facts, and another whether there is evidence to prove it: and if we have no means for judging of the design but from the work actually produced, it is a somewhat hazardous speculation to suppose that the work designed was of a different quality from the result realized. Still, though the ground is unsafe we may, with due caution, journey a certain distance on it. Some parts of the order of nature give much more indication of contrivance than others; many, it is not too much to say, give no sign of it at all. The signs of contrivance are most conspicuous in the structure and processes of vegetable and animal life. But for these, it is probable that the appearances in nature would never have seemed to the thinking part of mankind to afford any proofs of a God. But when a God had been inferred from the organization of living beings, other parts of Nature, such as the structure of the solar system, seemed to afford evidences, more or less strong, in confirmation of the belief: granting, then, a design in Nature, we can best hope to be enlightened as to what that design was, by examining it in the parts of Nature in which its traces are the most conspicuous.

To what purpose, then, do the expedients in the construction of animals and vegetables, which excite the admiration of naturalists, appear to tend? There is no blinking the fact that they tend principally to no more exalted object than to make the structure remain in life and in working order for a certain time: the individual for a few years, the species or race for a longer but still a limited period. And the similar though less conspicuous marks of creation which are recognized in inorganic Nature, are generally of the same character. The adaptations, for instance, which appear in the solar system consist in placing it under conditions which enable the mutual action of its parts to maintain instead of destroying its stability, and even that only for a time, vast indeed if measured against our short span of animated existence, but which can be perceived even by us to be limited : for even the feeble means which we possess of exploring the past, are believed by those who have examined the subject by the most recent lights, to yield evidence that the solar system was once a vast sphere of nebula or vapour, and is going through a process which in the course of ages will reduce it to a single and not very large mass of solid matter frozen up with more than arctic cold. If the machinery of the system is adapted to keep itself at work only for a time, still less perfect is the adaptation of it for the abode of living beings since it is only adapted to them during the relatively short portion of its total duration which intervenes between the time when each planet was too hot and the time when it became or will become too cold to admit of life under the only conditions in which we have experience of its possibility. Or we should perhaps reverse the statement, and say that organization and life are only adapted to the conditions of the solar system during a relatively short portion of the system's existence.

The greater part, therefore, of the design of which there is indication in Nature, however wonderful its mechanism, is no evidence of any moral attributes., because the end to which it is directed, and its adaptation to which end is the evidence of its being directed to an end at all, is not a moral end: it is not the good of any sentient creature, it is but the qualified permanence, for a limited period, of the work itself, whether animate or inanimate. The only inference that can be drawn from most of it, respecting the character of the Creator, is that he does not wish his works to perish as soon as created; he wills them to have a certain duration. From this alone nothing can be justly inferred as to the manner in which he is affected towards his animate or rational creatures.

After deduction of the great number of adaptations which have no apparent object but to keep the machine going, there remain a certain number of provisions, for giving pleasure to living beings, and a certain number of provisions for giving them pain. There is no positive certainty that the whole of these ought not to take their place among the contrivances for keeping the creature

or its species in existence; for both the pleasures and the pains have a conservative tendency; the pleasures being generally so disposed as to attract to the things which maintain individual or collective existence, the pains so as to deter from such as would destroy it.

When all these things are considered it is evident that a vast deduction must be made from the evidences of a Creator before they can be counted as evidences of a benevolent purpose: so vast indeed that some may doubt whether after such a deduction there remains any balance. Yet endeavouring to look at the question without partiality or prejudice and without allowing wishes to have any influence over judgment, it does appear that granting the existence of design, there is a preponderance of evidence that the Creator desired the pleasure of his creatures. This is indicated by the fact that pleasure of one description or another is afforded by almost everything, the mere play of the faculties, physical and mental, being a never-ending source of pleasure, and even painful things giving pleasure by the satisfaction of curiosity and the agreeable sense of acquiring knowledge; and also that pleasure, when experienced, seems to result from the normal working of the machinery, while pain usually arises from some external interference with it, and resembles in each particular case the result of an accident. Even in cases when pain results, like pleasure, from the machinery itself, the appearances do not indicate that contrivance was brought into play purposely to produce pain: what is indicated is rather a clumsiness in the contrivance employed for some other purpose. The author of the machinery is no doubt accountable for having made it susceptible of pain but this may have been a necessary condition of its susceptibility to pleasure; a supposition which avails nothing on the theory of an Omnipotent Creator but is an extremely probable one in the case of a contriver working under the limitation of inexorable laws and indestructible properties of matter. The susceptibility being conceded as a thing which did enter into, design, the pain itself usually seems like a thing undesigned; a casual result of the collision of the organism with some outward force to which it was not intended to be exposed, and which, in many cases, provision is even made to hinder it from being exposed to. There is, therefore, much appearance that pleasure is agreeable to the Creator, while there is very little if any appearance that pain is so: and there is a certain amount of justification for inferring, on grounds of Natural Theology alone, that benevolence is one of the attributes of the Creator. But to jump from this to the inference that his sole or chief purposes are those of benevolence, and that the single end and aim of Creation was the happiness of his creatures, is not only not justified by any evidence but is a conclusion in opposition to such evidence as we have. If the motive of the Deity for creating sentient beings was the happiness of the beings he created, his purpose, in our corner of the universe at least, must be pronounced, taking past ages and all countries and races into account, to have been thus far an ignominious failure; and if God had no purpose but our happiness and that of other living creatures it is not credible that he would have called them into existence with the prospect of being so completely baffled. If man had not the power by the exercise of his own energies for the improvement both of himself and of his outward circumstances, to do for himself and other creatures vastly more than God had in the first instance done, the Being who called him into existence would deserve something very different from thanks at his hands. Of course it may be said that this very capacity of improving himself and the world was given to him by God, and that the change which he will be thereby enabled ultimately to effect in human existence will be worth purchasing by the sufferings and wasted lives of entire geological periods. This may be so; but to suppose that God could not have given him these blessings at a less frightful cost, is to make a very strange supposition concerning the Deity. It is to suppose that God could not, in the first instance, create anything better than a Bosjesman or an Andaman islander, or something still lower; and yet was able to endow the Bosjesman or the Andaman islander with the power of raising himself into a Newton or a Fenelon. We certainly do not know the nature of the barriers which limit the divine omnipotence; but it is a very odd notion of them that they enable the Deity to confer on an almost bestial creature the power of producing by a succession of efforts what God himself had no other means of creating.

Such are the indications of Natural Religion in respect to the divine benevolence. If we look for any other of the moral attributes which a certain class of philosophers are accustomed to distinguish from benevolence, as for example Justice, we find a total blank. There is no evidence whatever in Nature for divine justice, whatever standard of justice our ethical opinions may lead us to recognize. There is no shadow of justice in the general arrangements of Nature; and what imperfect realization it obtains in any human society (a most imperfect realization as yet) is the work of man himself, struggling upwards against immense natural difficulties, into civilization, and making to himself a second nature, far better and more unselfish than he was created with. But on this point enough has been said in another Essay, already referred to, on Nature.

These, then, are the net results of Natural Theology on the question of the divine attributes. A Being of great but limited power, how or by what limited we cannot even conjecture; of great, and perhaps unlimited intelligence, but perhaps, also, more narrowly limited than his power: who desires, and pays some regard to, the happiness of his creatures, but who seems to have other motives of action which he cares more for, and who can hardly be supposed to have created the universe for that purpose alone. Such is the Deity whom Natural Religion points to; and any idea of God more captivating than this comes only from human wishes, or from the teaching of either real or imaginary Revelation.

We shall next examine whether the light of nature gives any indications concerning the immortality of the soul, and a future life.

READING QUESTIONS

1. What are Mill's reasons for denying that God is omnipotent (all-powerful)?

2. What does Mill believe that nature reveals about the intelligence of the creator?

3. What is it about life on this planet that leads Mill to question God's omnibenevolence (all-goodness)?

4. Do you believe that Mill's conception of God solves the problem of evil? Why or why not?

Notes

1. Haim Watzman, excerpts from "Archaeology vs. the Bible" from *Chronicle of Higher Education* (January 21, 2000).
2. Herodotus, *The Histories*, Book III, chapter 38.
3. http://adherents.com/Religions_By_Adherents.html, accessed 9/1/2008.
4. Scott Adams, quote from Dan Wooding, "God's Debris: A Thought Experiment," Assist News Service, www.assistnews.net/strategic/s0110093.htm.
5. Herman Bavinck, *The Doctrine of God,* trans. William Hendricksen (Grand Rapids, MI: Eerdmans, 1951) 78–79.
6. St. Thomas Aquinas, *Summa Theologica* (London: Burns, Oates, and Washbourne, 1920) 25.
7. Lucretius, excerpt from *On the Nature of Things*, translated by William Ellery Leonard.
8. David Hume, *Dialogues Concerning Natural Religion*, 1779.
9. Václav Potoček et al., "Quantum Hilbert Hotel," *Physical Review Letters* 115 (2015).
10. Institute for Quantum Computing, "Infinity Is a Bit Closer," October 21, 2015, https://uwaterloo.ca/institute-for-quantum-computing/news/infinity-bit-closer, accessed 4/28/18.
11. Hugh Ross, *The Creator and the Cosmos* (Colorado Springs: Navpress, 1995) 14.
12. Edward Tryon, "Is the Universe a Vacuum Fluctuation?" *Nature* 246 (1973) 396–397.
13. Tryon 397.
14. Paul Davies, *God and the New Physics* (New York: Simon & Schuster, 1983) 31–32.
15. Bede Rundle, *Why Is There Something Rather Than Nothing?* (Oxford: Clarendon Press, 2004) vii.
16. Victor J. Stenger, *God: The Failed Hypothesis* (Amherst, MA: Prometheus Books, 2007) 132.
17. Stenger 133.
18. Frank Wilczek, "The Cosmic Asymmetry between Matter and Antimatter," *Scientific American* 243 (1980) 82–90.
19. Steven Hawking and Leonard Mlodinow, *The Grand Design* (New York: Bantam, 2010) 180.
20. Hawking and Mlodinow 180.
21. Lee Smolin, excerpts from *The Life of the Cosmos*, 1997, Oxford University Press, Ltd.
22. Hume, *Dialogues* 143.
23. William Paley, *Natural Theology* (Whitefish, MT: Kessinger Publishing, 2003).
24. John Stuart Mill, "Three Essays on Religion," *Essays on Ethics, Religion and Society,* ed. J. M. Robson (Toronto: University of Toronto Press, 1969) 451.
25. Clarence Darrow, *The Story of My Life* (New York: Charles Scribner's Sons, 1932).
26. Hume, *Dialogues* 170–171.
27. G. S. Kirk, J. E. Raven, and M. Schofield, *The Presocratic Philosophers* (Cambridge: Cambridge University Press, 1983) 304.
28. Aristotle, *The Presocratic Philosophers* 304.
29. Theodosius Dobzhansky, "Nothing in Biology Makes Sense Except in the Light of Evolution," *The American Biology Teacher*, March 1973 (35) 125–129.
30. Richard Dawkins, *The Blind Watchmaker* (New York: Norton, 1987) 89.
31. Dawkins 90.
32. Michael J. Behe, *Darwin's Black Box: The Biochemical Challenge to Evolution* (New York: The Free Press, 1996) 39.
33. H. Allen Orr, "Darwin vs. Intelligent Design (Again)," *Boston Review* (Dec.–Jan. 1996–1997) online, Internet.
34. Raelian Movement, excerpt from www.rael.org/english/index.html.
35. Charles Darwin, *The Various Contrivances by Which Orchids Are Fertilised by Insects* (New York: D. Appleton & Co., 1877) 282.
36. Darwin 284.
37. Niall Shanks and Karl H. Joplin, "Redundant Complexity: A Critical Analysis of Intelligent Design in Biochemistry," *Philosophy of Science* 66 (June 1999) 275.
38. Kathleen Hunt, "Transitional Vertebrate Fossils FAQ," *The Talk. Origins Archive*, online, Internet, 24 April 2002.
39. Stephen J. Gould, "Hooking Leviathan by Its Past," *Natural History (*May 1994) 8–15.
40. Judge Braswell Dean, quoted in *Time* (March 16, 1981) 82.
41. Gottfried Wilhelm von Leibniz, "Discourse on Metaphysics," *Leibniz Selections,* ed. Philip P. Wiener (New York: Charles Scribner's Sons, 1951) 292.
42. Joseph Boxhorn, "Observed Instances of Speciation," *The Talk. Origins Archive*, online, Internet, 24 April 2002.
43. Paul Davies, "The Anthropic Principle," *Science Digest* 191.10 (1983) 24.
44. Stephen Hawking, *A Brief History of Time* (New York: Bantam, 1988) 174.
45. Smolin 101–102.
46. Roni Harnik et al., "A Universe without Weak Interactions," *Physical Review D* 74 (2006).
47. Abraham Loeb, "An Observational Test for the Anthropic Origin of the Cosmological Constant," *Journal of Cosmology and Astroparticle Physics* 5 (2006).
48. Roberto Trotta and Glenn D. Starkman, "What's the Trouble with Anthropic Reasoning?" *AIP Conference Proceedings,* Vol 878, 323–329. 2nd International Conference on the Dark Side of the Universe DSU 2006, Madrid (Spain), 20–24 June 2006, ed. C. Munoz and G. Yepes.
49. Isaac Asimov and Duane Gish, "The Genesis War," *Science Digest* (October 1981) 87.
50. Duane Gish, *Evolution–The Fossils Say No!* 40, quoted in Jeffrie G. Murphy, *Evolution, Morality and the Meaning of Life* (Totowa, NJ: Rowman and Littlefield, 1987) 136.
51. Plato, "Cratylus," trans. Benjamin Jowett, *Plato: The Collected Dialogues*, ed. Edith Hamilton and Huntington Cairns (Princeton, NJ: Princeton University Press, 1961) 426a (p. 460).
52. Kenneth R. Miller, "Finding Darwin's God," *Brown Alumni Magazine* (November/December 1999) 42.
53. Bertrand Russell, "Cosmic Purpose," *Religion and Science* (New York: Henry Holt and Company, 1935) 233.
54. S. Jay Olshansky, Bruce Carnes, and Robert N. Butler, excerpt from "If Humans Were Built to Last" from *Scientific American* 284 (March 2001).
55. Hume, *Dialogues* 116.
56. Doron Nof and Nathan Paldor, excerpt from "Are There Oceanographic Explanations for the Israelites' Crossing of the Red Sea?" from *The Bulletin of the American Meteorological Society* 73 (March 1992).
57. Hume, *Dialogues* 114–115.
58. David Hume, *Enquiries Concerning the Human Understanding,* ed. L. A. Selby-Bigge (Oxford: Clarendon Press, 1902) *Christian Classics Ethereal Library*, online, Internet, 24 April 2002.
59. Nicholas Humphrey, excerpt from *Leaps of Faith* (New York: Copernicus, 1996).
60. St. Augustine, *City of God,* trans. Phillip Schaff (New York: Christian Literature Publishing Co., 1890) Book XXI, Chapter 8 (p. 655).
61. Thomas Jefferson, quoted in Saul-Paul Sirag, "The Skeptics," *Future Science,* ed. John White and Stanley Krippner (Garden City, NJ: Doubleday, 1977) 535.
62. Robby Berry, "The Fivefold Challenge," *Skeptical Review* 6.4 (1995) online, Internet, 24 April 2002.
63. Cited in Paul Kurtz, *The Transcendental Temptation* (Buffalo, NY: Prometheus Books, 1991) 96.

64. Bertrand Russell, *Mysticism.* Quoted in Walter Kaufmann, *Critique of Philosophy and Religion* (Garden City, NY: Doubleday, 1961) 315.
65. A. Mandell, "Toward a Psychobiology of Transcendence: God in the Brain," *Psychobiology of Consciousness,* ed. J. Davidson and R. Davidson (New York: Plenum Press, 1980) 379–464.
66. R. E. L. Masters and Jean Houston, *The Varieties of Psychedelic Experience* (New York: Holt, Rinehart & Winston) 254.
67. C. D. Broad, *Religion, Philosophy, and Psychical Research* (New York: Harcourt, Brace, 1953) 198.
68. Jack Hitt, excerpt from "This Is Your Brain on God" from *Wired* 7.11 (November 1999).
69. John Hick, *Death and Eternal Life* (San Francisco: Harper & Row, 1976) 324.
70. D. Landsborough, "St. Paul and Temporal Lobe Epilepsy," *Journal of Neurology, Neurosurgery, and Psychiatry* 50 (1987) 659–664.
71. Vilayanur Ramachandran quoted in Jonathan Wynne-Jones, "St. Paul Converted by Epileptic Fit, Suggests BBC," *The Telegraph* April 19, 2003.
72. St. Anselm, "Prologium," *St. Anselm* (La Salle, IL: Open Court, 1958) 8.
73. Gaunilo, *The Many-Faced Argument,* ed. John Hick and Arthur Gill (New York: Macmillan, 1968).
74. René Descartes, excerpts from "Meditations on First Philosophy," Meditation V from *The Method, Meditations, and Philosophy of Descartes,* translated by John Veitch, London: M. Walter Dunne, 1901.
75. Paul Edwards, "The Existence of God," *A Modern Introduction to Philosophy* (New York: Free Press, 1973) 375.
76. Blaise Pascal, *Pensées* (1670) *Classical Library,* online, Internet, 24 April 2002.
77. Galen Strawson, quoted in the *Independent* (London: 24 June 1990).
78. Herb Silverman, excerpt from "Silverman's Wager" from *Free Inquiry* (Spring 2001).
79. Robert C. Coburn, *The Strangeness of the Ordinary* (Savage, MD: Rowman and Littlefield, 1990) 137.
80. St. Augustine, *The Literal Interpretation of Genesis 1:19–20,* Chapter 19.
81. Stephen J. Gould, *Rocks of Ages: Science and Religion in the Fullness of Life* (New York: Ballantine, 1999) 4.
82. Lactantius, *De Ira Dei,* Chapter 13.
83. *American Heritage Dictionary of the English Language* (Boston: Houghton Mifflin, 1970) 471.
84. John Stuart Mill, "Three Essays on Religion," *Essays on Ethics, Religion and Society,* ed. J. M. Robson (Toronto: Routledge and Kegan Paul, 1969) 385.
85. William Rowe, "The Problem of Evil and Some Varieties of Atheism," *American Philosophical Quarterly* 16 (October 1979) 337.
86. Augustine, *City of God,* Book XI, Chapter 9.
87. Augustine, *City of God,* Book XII, Chapter 6.
88. Augustine, *On Marriage and Concupiscence,* Book II, Chapter 15.
89. Friedrich Schleiermacher, *The Christian Faith,* trans. ed. H. R. Mackintosh and J. S. Stewart (Edinburgh: T & T Clark, 1928) par. 72.2.
90. Alvin Plantinga, *The Nature of Necessity* (Oxford: Clarendon Press, 1974) 186.
91. Voltaire, "The Impious," *The Philosophical Dictionary,* trans. H. I. Woolf (New York: Knopf, 1924).
92. John Stuart Mill, *An Examination of Sir William Hamilton's Philosophy* (London: Longmans Green, 1865) 101.
93. Fyodor Dostoyevsky, *The Brothers Karamazov,* trans. Constance Garnett (New York: Random House, 1950) 287.
94. Hick 158.
95. James A. Haught, "Why Would God Drown Children?" *Free Inquiry* 25 (April/May 2005) 14.
96. David A. Lieb, "Arkansas Governor Wants God Held Harmless," Associated Press, *The Morning Call,* 22 (March 1997) A13.
97. Hick 158–159.
98. Dostoyevsky 289.
99. Hick 159.
100. Somerset Maugham, *A Writer's Notebook* (New York: Penguin, 1967) 147.
101. Hick 156.
102. Charles Fried, *Medical Experimentation: Personal Integrity and Social Policy* (New York: American Elsevier Publishing Co., 1974) 101.
103. Hick 300–301.
104. R. K. Tripathi, quoted in Hick 301.
105. Harold S. Kushner, *When Bad Things Happen to Good People* (New York: Avon, 1981) 129.
106. Kushner 134.
107. John Baillie, *And the Life Everlasting,* quoted in Castell and Borchert, *An Introduction to Modern Philosophy* (New York: Macmillan, 1983) 164.
108. Theodore M. Drange, *Nonbelief and Evil* (Amherst: Prometheus Books, 1998) 60.
109. Quoted in F. F. Bruce, *Jesus and Christian Origins Outside the New Testament* (Grand Rapids, MI: Eerdmans, 1974), 112–113.
110. Thomas Paine, "Of the Religion of Deism Compared with the Christian Religion," http://www.thomaspainesociety.org/paineondeism, accessed 4/28/18.
111. Benedict de Spinoza, *The Ethics,* Part 1, Paragraph 3, trans. R.H.M. Elwes, http://www.sacred-texts.com/phi/spinoza/ethics/eth01.htm, accessed 4/28/18.
112. Antony Flew, "Theology and Falsification," *Philosophical Essays,* ed. John Shosky (Lanham, MD: Rowman and Littlefield, 1998).
113. *American Heritage Dictionary of the English Language* (Boston: Houghton Mifflin, 1970) 471.
114. Søren Kierkegaard, *Concluding Unscientific Postscript,* trans. David F. Swenson (Princeton, NJ: Princeton University Press, 1941) 513.
115. Tertullian, *De Carne Christi,* trans. Peter Holmes, *Ante-Nicene Christian Library,* Vol. XV (Edinburgh: T&T Clark, 1870) Chapter 5 Verse 4.
116. Kierkegaard 189.
117. *Ibid.*
118. Bertrand Russell, *Let the People Think* (London: William Clowes and Sons, 1941) 2.
119. Kierkegaard 182.
120. Søren Kierkegaard, *The Journals of Søren Kierkegaard,* trans. Alexander Dru (London: Oxford University Press, 1938) 355, entry 1021.
121. Kierkegaard, *Concluding* 181.
122. *Ibid.*
123. Bertrand Russell, "Will Religious Faith Cure Our Troubles?" *Human Society in Ethics and Politics* (New York: Simon & Schuster, 1955) 207.
124. W. K. Clifford, "The Ethics of Belief," *Philosophy and Contemporary Issues,* ed. J. Burr and M. Goldinger (New York: Macmillan, 1984) 142.
125. T. H. Huxley, *Science and Christian Tradition* (London: Macmillan, 1894) 310.
126. W. K. Clifford, *Lectures and Essays: Volume II, Essays and Reviews* (London: Macmillan, 1879) 163.
127. Clifford, *Lectures and Essays,* 163.
128. Clifford, "The Ethics of Belief" 142.
129. Brand Blanshard, excerpts from *Reason and Belief,* 1975, Yale University Press.
130. Blanshard 408–409.
131. Blanshard 409.
132. William James, "The Will to Believe," *Philosophy and Contemporary Issues,* ed. J. Burr and M. Goldinger (New York: Macmillan, 1984) 146–147.
133. James 20.
134. James 29–30.
135. James 31.

136. Ludwig F. Schlecht, "Re-Reading 'The Will to Believe,'" *Religious Studies* 33 (1997) 217–225.
137. Robert Nozick, excerpt from *Philosophical Explanations*, 1981, Harvard University Press. Robert Nozick, excerpts from *Anarchy, State, and Utopia*, 1974, Basic Books.
138. Nozick 586.
139. George Berkeley, *Three Dialogues Between Hylas and Philonous, Harvard Classics,* Vol. 37 (New York: P. F. Collier and Son, 1909–1914), Part III.
140. Jean-Paul Sartre, "Existentialism and Humanism," *The Humanities in Contemporary Life* (New York: Holt, Rinehart, and Winston, 1960) 425.
141. Hazel Barnes, "The Far Side of Despair," from *The Meaning of Life*, ed. Steven Sanders and David R. Cheney (Englewood Cliffs, NJ: Prentice-Hall, 1980) 107.
142. Kurt Baier, "The Meaning of Life," from *The Meaning of Life*, ed. Steven Sanders and David R. Cheney (Englewood Cliffs, NJ: Prentice-Hall, 1980) 52.
143. Paul Tillich, *Systematic Theology, I* (Chicago: University of Chicago Press, 1951) 245.
144. Coburn 128–130.
145. Teale, quoted in Carl Sagan, *The Demon Haunted World* (New York: Random House, 1995) 12.

Chapter 7
The Problem of Skepticism and Knowledge

All men by nature desire knowledge.
—Aristotle

What is knowledge? How does knowledge differ from belief? Does knowledge require certainty? How do we acquire knowledge? Are reason and sense experience both sources of knowledge? What is the extent of our knowledge? Do we have knowledge of the external world? These are the sorts of questions that epistemology—the branch of philosophy that studies knowledge—tries to answer.

We ordinarily claim to know many different types of things. Most of us, for example, would claim to know what pain feels like, how to ride a bicycle, and that snow is white. In each case the object of our knowledge (what our knowledge is about) is different. In the first case, it is about an experience; in the second, a skill; and in the third, a fact. Our focus here will be on the third type of knowledge because we're interested in how we come to know facts.

The sort of knowledge we have when we know what it's like to be in pain is called **knowledge by acquaintance,** or "knowing what." Bertrand Russell claimed that "we have acquaintance with anything of which we are directly aware without the intermediary of any process of inference or any knowledge of truth."[1] For Russell, the only things we are directly aware of are our sensations. Russell thought that our sensations were caused by material objects, but he didn't think that we were directly aware of them. When we hold an apple in our hand and look at it, for example, we're directly aware of a certain color, shape, smell, feel, and so on, but we're not directly aware of the apple itself. We infer the existence of the apple on the basis of our sensations. The distinction between direct and indirect awareness, however, raises one of the most difficult problems in epistemology: How do we know that our sensations are caused by physical objects? After all, we could be dreaming, hallucinating, or hooked up to a sophisticated virtual reality machine. If we can't be certain that such possibilities are not actual, can we acquire knowledge by means of our senses? Those who think not are known as **philosophical skeptics.** According to them, the extent of our knowledge is much more limited than we ordinarily assume.

Nothing in this life, after health and virtue, is more estimable than knowledge.
—Lawrence Sterne

The sort of knowledge we have when we know how to ride a bicycle is known as **performative knowledge,** or "knowing how." Anyone who has a skill has this sort of knowledge. Ordinarily, anyone who knows how to do something also knows what it is to do it. For example, those who know how to ride a bicycle usually know what it is to ride a bicycle because they learned how to ride a bicycle by actually riding one. But one can learn how to do something without actually doing it. One can learn how to fly an airplane, for example, by training in a flight simulator, and in the future we might be able to upload performative knowledge directly into our brains as is done in the movie *The Matrix.* So, although knowing how and knowing what are often correlated, they are not necessarily connected with each other.

knowledge by acquaintance Knowledge of what it is to have a certain experience.

philosophical skepticism The doctrine that we have no knowledge of some realms, such as the external world.

performative knowledge Knowledge of how to perform a certain activity.

propositional knowledge Knowledge of whether a proposition is true or false.

The type of knowledge we have when we know that snow is white is known as **propositional knowledge,** or "knowing that." A proposition is a statement that affirms or denies something and thus is either true or false. One of the first and foremost attempts to characterize propositional knowledge can be

found in the works of Plato. In his dialogue "Meno," Socrates remarks, "it is not, I am sure, a mere guess to say that right opinion and knowledge are different. There are few things that I should claim to know, but that at least is among them, whatever else is."[2] The point that Plato is trying to make here is that while having right opinions (true beliefs) may be a necessary condition for knowledge, it is not sufficient—there must be something more to having knowledge than just having true beliefs.

True belief is necessary for knowledge because we can't know something that's false, and if we know something, we can't believe that it's false. For example, we can't know that 2 + 2 equals 5 because 2 + 2 doesn't equal 5. In other words, we can't know what isn't so. Similarly, if we know that 2 + 2 equals 4, we can't believe that it doesn't. To know that something is true is to believe that it's true.

True belief is not sufficient for knowledge, however, because we can have true belief without having knowledge. Consider, for example, the following situation. Suppose you believe that it's raining in Hong Kong right now, and suppose that it is. Does this mean that you know that it's raining in Hong Kong right now? Not if you have no good reason for believing so, for in that case, your belief is nothing more than a lucky guess. Having knowledge, then, would seem to require having good reasons for what you believe. Plato agrees. "True opinions," Socrates tells Meno, "are a fine thing and do all sorts of good so long as they stay in their place, but they will not stay long. They run away from a man's mind; so they are not worth much until you tether them by working out the reason. . . . Once they are tied down, they become knowledge."[3] For Plato, then, knowledge is true belief that is based on reason. Determining when a belief is adequately based on reason or justified is one of the major tasks of epistemology.

Traditionally, philosophers have recognized two sources of knowledge: reason and sense experience. Those who believe that knowledge of the external world can be gained through the use of reason are known as **rationalists.** Those who believe that sense experience is our only source of knowledge of the external world are known as **empiricists.** Empiricists recognize that reason can give us knowledge of logical truths like "Either it's raining or it's not raining." But they deny that reason alone can tell us anything about the external world. Knowing that either it's raining or it's not raining, for example, tells us nothing about the weather.

Propositions can be known in different ways. Some propositions are knowable **a priori**—that is, prior to or independently of sense experience. For example, the proposition that either it's raining or it's not raining is knowable a priori because you don't have to look outside to determine its truth. Whether it's raining or not raining, the proposition that *either* it's raining *or* it's not raining is true. Other propositions are knowable only **a posteriori**—that is, on the basis of sense experience. For example, the proposition that water boils at 212 degrees Fahrenheit is knowable only a posteriori because it can be known only after observing boiling water.

rationalism The doctrine that reason is a source of knowledge of the external world.

empiricism The doctrine that sense experience is the only source of knowledge of the external world.

a priori knowledge Knowledge that can be acquired prior to or independently of sense experience.

a posteriori knowledge Knowledge based on sense experience.

> *The pleasure and delight of knowledge far surpasseth all other in nature.*
> —Francis Bacon

Logical truths or propositions that can be turned into logical truths by substituting synonyms for synonyms are called **analytic propositions.** The truth that either it's raining or it's not raining is analytic because it is a logical truth. It has the form "either A or not A" and that is true no matter what proposition we substitute for A. The proposition "either there's liquid precipitation or it's not raining" is also an analytic truth because it can be turned into an analytic truth by substituting synonyms for synonyms. Propositions that are not analytic are called **synthetic propositions.** These would include most of the facts discovered by science.

Both rationalists and empiricists agree that analytic propositions are knowable a priori. They disagree, however, about whether synthetic propositions are also knowable in that way. Rationalists tend to believe that at least some synthetic propositions—such as "From nothing, nothing comes"—are knowable a priori. Empiricists, on the other hand, believe that no synthetic propositions are knowable a priori. On this issue hangs the status of reason as a source of knowledge.

In addition to understanding how we come to know things, epistemologists are also interested in understanding what it is for a proposition to be true. Ordinarily, we would say that a proposition is true when it tells it like it is. In other words, a proposition is true when things in the world are as it says they are. Aristotle expresses that insight this way: "To say of what is that it is not, or of what is not that it is, is false; while to say of what is that it is and of what is not that it is not, is true."[4] This view of truth assumes that there is a way the world is and that a proposition is true when it corresponds to the way the world is. Thus it has come to be known as the **correspondence theory of truth.**

Explicating the notion of correspondence has been notoriously difficult, however. One suggestion, made by Ludwig Wittgenstein, is that true propositions are pictures of reality. Just as the arrangement of the elements in a picture represents the arrangement of objects in reality, Wittgenstein thought that the arrangement of the elements in a proposition represented the arrangement of objects in reality. The problem is that not every proposition can be considered a picture of reality. Consider, for example, the proposition that unicorns are not centaurs. Although this proposition is true, neither unicorns nor centaurs exist. So it's difficult to see how the elements of the proposition could picture them. Other attempts to explicate the correspondence relation have proved equally problematic. Consequently, a number of other accounts of truth have been proposed.

Some believe that truth can be defined as coherence with our beliefs. Brand Blanshard explicates the coherence theory of truth as follows:

> . . . reality is a system, completely ordered and fully intelligible with which thought in its advance of more and more identifying itself. . . . And if we take this view, our notion of truth is marked out for us. Truth is the approximation of thought to reality. It is thought on its way home. . . . Hence at any given time the degree of truth in our experience as a whole is the degree of system it has

analytic proposition A proposition that is a logical truth or can be turned into a logical truth by substituting synonyms for synonyms.

synthetic proposition A proposition that is not analytic.

correspondence theory of truth The doctrine that a proposition is made true by its correspondence with reality.

achieved. The degree of truth of a particular proposition is to be judged in the first instance by its coherence with experience as a whole, ultimately by its coherence with that further whole, all-comprehensive and fully articulated, in which thought can come to rest.[5]

According to the **coherence theory of truth,** a proposition is true if and only if it coheres with our belief system. Our belief system is not yet complete because there are aspects of reality we do not yet fully understand. So any proposition that coheres with our current belief system is at best only partially true. Only a proposition that coheres with a complete belief system—one that accounts for all aspects of reality—can be considered fully true.

Coherence with our belief system is certainly a test of truth. Fit with existing theory—conservatism—is a criterion of adequacy for hypotheses because the better a hypothesis fits with what we've already learned, the more likely it is to be true. But those who accept the coherence theory of truth maintain that coherence is more than just a test of truth: It's the nature of truth. For them, there is nothing more to a proposition's being true than its cohering with our beliefs.

There must be more to truth than coherence, however, because a proposition can cohere with one's belief system and be false. Consider the case of David Koresh, the former leader of the Branch Davidians, who died when the cult's headquarters near Waco, Texas, burned down in 1993. Koresh believed that he was Jesus Christ. He maintained that this belief was based on a coherent interpretation of the Scriptures. Suppose it was. And suppose that everything else that he believed cohered with that belief. Does that mean that it was true that he was Jesus Christ? No. Just because someone consistently believes something doesn't mean that it's true.

To avoid the problem of coherent but false belief systems, some have tried to specify which belief system a proposition must cohere with to be true. Charles Sanders Peirce claims that a belief is true if it coheres with the belief system fated to be agreed on by all who investigate.[6] But there is no guarantee that all investigators will eventually agree on one belief system. For any set of data, an infinite number of theories can be constructed to account for those data. We can't rule out the possibility that, at the end of inquiry, there will be two or more incompatible belief systems that account for the data equally well. But two incompatible belief systems cannot both be true. Because it's possible for two incompatible belief systems to be equally coherent, there must be more to truth than coherence.

William James proposed that we define truth in terms of usefulness. He writes, "The true is only the expedient in the way of our behaving, expedient in almost any fashion, and expedient in the long run and on the whole course."[7] For James, a true proposition is one that works. According to the **pragmatic theory of truth,** then, a proposition is made true by its practical consequences. One of the reasons why truth is so valuable is that actions based on true propositions are much more likely to succeed than those based

coherence theory of truth The doctrine that a proposition is made true by its coherence with a system of beliefs.

pragmatic theory of truth The doctrine that a proposition is made true by its practical consequences.

Knowledge is the food of the soul.

—PLATO

on false ones. James suggests that this insight can be used to define truth. For him, a true proposition is one that is such that if we acted on it, it would bring about the desired result.

The problem, of course, is that false beliefs can lead to desired results. The Nazis desired to win World War II. If they had, would that mean that the proposition that Jews are subhuman is true? Suppose that Muslim extremists succeed in taking over the world. Would that mean that Allah is the one true God? Or take David Koresh's belief that he was Jesus Christ. That belief seemed to work for him. He got a lot of followers and a lot of wives out of it. Does that mean he really was Jesus Christ? The answer to all of these questions seems to be "No." The fact that a proposition works may provide some reason for believing that it's true, but that doesn't make it true.

Some believe that truth is simply a matter of belief. We've all heard statements like "What's true for you is not true for me" or "You have your truth, I have mine." The implication here is that truth is relative to individuals. Consequently, this view is known as **cognitive subjectivism.**

The view that you can make something true by simply believing it to be true is not unique to the twentieth century. It flourished in ancient Greece over twenty-five hundred years ago. The ancient champions of cognitive subjectivism are known as Sophists. They were professors of rhetoric who earned their living by teaching wealthy Athenians how to win friends and influence people. Because they believed that truth was relative, however, they taught their pupils to argue both sides of any case, which created quite a scandal at the time. (The words "sophistic" and "sophistical" are used to describe arguments that appear sound but are actually fallacious.) The greatest of the Sophists—Protagoras—famously expressed his subjectivism thus: "Man is the measure of all things, of existing things that they exist, and of nonexisting things that they do not exist."[8] Truth does not exist independently of human minds but is created by our thoughts. Consequently, whatever anyone believes is true.

Plato saw clearly the implications of such a view. If whatever anyone believes is true, then everyone's belief is as true as everyone else's. And if everyone's belief is as true as everyone else's, then the belief that subjectivism is false is as true as the belief that subjectivism is true. Plato put it this way: "Protagoras, for his part, admitting as he does that everybody's opinion is true, must acknowledge the truth of his opponents' belief about his own belief, where they think he is wrong."[9] Cognitive subjectivism, then, is self-refuting. If it's true, it's false. Any claim whose truth implies its falsehood cannot possibly be true.

It's ironic that Protagoras taught argumentation because in a Protagoran world, there shouldn't be any arguments. Arguments arise when there is some reason to believe that someone is mistaken. If believing something to be true made it true, however, no one could ever be mistaken; everyone would be infallible. It would be impossible for anyone to have a false belief because the mere fact that one believed something would make it true. So if Protagoras's customers took his philosophy seriously, he would be out of a job. If no one can lose an argument, there's no need to learn how to argue.

cognitive subjectivism The doctrine that a proposition is made true by one's believing it to be true.

● Some believe that truth is relative to societies or cultures. There's no doubt that different cultures have different beliefs about what is true. But according to **cognitive cultural relativism,** each culture manufactures its own truth. This view is as problematic as cognitive subjectivism, however. For if a society believed that truth was *not* socially constructed (as ours may well believe), then that view would be as true as the claim that truth is socially constructed, which is absurd.

The problem with the relativist is that he wants to have his cake and eat it too. On the one hand, he wants to say that he or his society is the supreme authority on matters of truth. But on the other hand, he wants to say that other individuals, societies, or conceptual schemes are equally authoritative. He can't have it both ways. As philosopher W. V. O. Quine explains,

> Truth, says the cultural relativist, is culture-bound. But if it were, then he, within his own culture, ought to see his own culture-bound truth as absolute. He cannot proclaim cultural relativism without rising above it, and he cannot rise above it without giving it up.[10]

If relativism were true, there would be no standpoint outside of yourself or your society from which to make valid judgments. But if there were no such standpoint, you would have no grounds for thinking that relativism is true. In proclaiming that truth is relative, then, the relativist hoists himself on his own petard; he blows himself up, so to speak.

● Much as we might like all of our beliefs to be true, we know that they aren't. Even the most fervent relativist must confess that he or she dials a wrong number, bets on a losing racehorse, or forgets a friend's birthday. These admissions reveal that truth is not simply a matter of belief. If believing something to be so made it so, the world would contain a lot fewer unfulfilled desires, unrealized ambitions, and unsuccessful projects than it does.

So what is the truth about truth? The British philosopher J. L. Austin once said, "If a proposition is true, there is, of course, a state of affairs that makes it true."[11] And of course there is. We can't make a proposition true by simply believing it to be true, and a proposition can't make itself true. Thus truth must consist in some sort of relationship between a proposition and reality, as the correspondence theory suggests. No one has yet specified exactly what that relationship is, but that shouldn't prevent us from accepting the correspondence theory any more than the fact that no one has been able to specify exactly what gravity is should prevent us from accepting the theory of gravity. We can provisionally adopt what might be called a **minimal correspondence theory,** which says that a proposition is true if and only if things are as it says they are. This preserves the insight that true propositions accurately represent reality without falling prey to the criticisms that were fatal to the other theories of truth.

To say that truth consists in a correspondence between a proposition and reality is not to say that there is only one way to represent reality accurately. Reality can be represented in many different ways, just as a territory can be mapped in many different ways. Consider, for example, road maps,

cognitive cultural relativism The doctrine that a proposition is made true by a society's believing it to be true.

minimal correspondence theory The doctrine that a proposition is true if and only if things are as it says they are.

topographical maps, and relief maps. These maps use different symbols to represent different aspects of the terrain, and the symbols that appear on one map may not appear on another. Nevertheless, it makes no sense to say that one of these maps is the correct map. Each can provide an accurate representation of the territory, and thus each can be considered to be true. The view that there is only one correct way of representing the world may be called "absolutism." Accepting the correspondence theory of truth does not commit one to absolutism.

In this chapter, we'll touch on just a few of the problems of epistemology. The first section deals with the problem of skepticism, the second with the problem of perception, and the third with the problem of defining knowledge.

Objectives

After reading this chapter, you should be able to

- state Descartes' dream argument and his evil genius argument.
- evaluate the claim that knowledge requires certainty.
- state the different theories of perception.
- evaluate the different theories of perception.
- state the various theories of knowledge.
- evaluate the arguments for each theory of knowledge.
- define knowledge by acquaintance, philosophical skepticism, performative knowledge, propositional knowledge, rationalism, empiricism, a priori proposition, a posteriori proposition, analytic proposition, synthetic proposition, correspondence theory of truth, coherence theory of truth, pragmatic theory of truth, sense data, primary qualities, and secondary qualities.

Section 7.1

● # Things Aren't Always What They Seem
Skepticism about Skepticism

Much of what we claim to know about the world is based on sense experience. The way things look, feel, taste, sound, and smell is generally believed to be an accurate indication of the way they are. But is this belief justified? Is sense experience a source of knowledge? Or is it only a source of opinion?

All wish to possess knowledge, but few, comparatively speaking, are willing to pay the price.

—Juvenal

Greek Rationalism

● The world that presents itself to our senses is constantly changing. Winds blow, rains fall, mountains crumble to the sea, and living things come into being, grow old, and pass away. But change is a mystery. How can something change and yet remain the same thing? If something changes, it's different, and if it's different, it's no longer the same. So it seems that nothing can remain the same through change.

The problem greatly perplexed the ancient Greeks. Heraclitus, unwilling to deny the evidence of his senses, maintained that identity over time is an illusion. The same thing cannot exist over time because "Change alone is unchanging."[12] The world, he thought, was being created anew each instant. "You cannot step into the same river twice," he proclaimed, "for the water into which you first stepped has flowed on."[13] Heraclitus viewed the world not as a static collection of discrete objects, but as a dynamic web of interconnected processes.

Change alone is eternal, perpetual, immortal.

—Arthur Schopenhauer

This view was shared by the Buddha (ca. 563–ca. 483 B.C.), who walked the earth at the same time as Heraclitus. The Buddha also used the analogy of a river to illustrate the dynamic nature of our existence. "O Brahmana," he says, "it is just like a mountain river, flowing far and swift, taking everything along with it; there is no moment, no instant, no second when it stops flowing, but it

goes on flowing and continuing. So Brahmana, is human life, like a mountain river."[14] Both Heraclitus and the Buddha deny the existence of any continuing substance. Nothing remains the same over time. Everything is in a constant state of flux.

Parmenides

No one can destroy this unchanging reality.
—Bhagavad Gita

Heraclitus's contemporary Parmenides (born ca. 515 B.C.) found this view of the world incomprehensible. Reality must contain a continuing substance, he thought, because only that which is unchanging is real. Although Parmenides expressed his philosophy in a poem, he based it on a logical argument. Thus he is often considered to be the father of rationalism—the view that the only source of knowledge is reason. Parmenides realized that whatever involves a logical contradiction cannot exist. So, he reasoned, nonexistence (nothingness) cannot exist. But from nothing, nothing comes. So everything that exists must have always existed. And everything that exists must continue to exist because it's just as impossible for something to become nothing as it is for nothing to become something. So according to Parmenides, nothing ever comes into being or passes away. Whatever exists has always existed and will continue to exist forever.

Furthermore, if nonexistence cannot exist, then there is no place where there is nothing. But if every place is occupied, there is no place for anything to move to. So the world must be a single, solid, eternal, and unchanging sphere in which no motion—and thus no change—is possible. Of course, the world doesn't seem that way. The world revealed by our senses seems to be full of movement and change. All that shows, says Parmenides, is that our senses don't put us in touch with reality. So our senses can't be a source of knowledge.

Just as Heraclitus's philosophy is echoed in the teachings of Buddhism, so Parmenides' philosophy is echoed in the teachings of Hinduism. In Chapter 2, verse 16 of the epic Hindu poem *Bhagavad Gita* (Sanskrit for "song of the Lord"), we read, "That which is not shall never be; That which is, shall never cease to be. To the wise, these truths are self-evident." The notions that change is an illusion and that everything is one are two of the central teachings of Hinduism. Instead of viewing the world as essentially material in nature, however, the Hindus view it as essentially spiritual. The only thing that truly exists (because it is unchanging) is Brahman, which is pure being, pure consciousness, and pure bliss.

According to Parmenides, what we take to be real is nothing but an illusion. The world seems to be composed of numerous objects that move and change. But logic, he claims, proves otherwise. Motion and therefore change is logically impossible, and anything that's logically impossible can't exist. So we can't use our senses to discover the true nature of reality. Only through the use of reason, he thought, can we come to know the way the world really is. Because Parmenides argued that the way the world appears is very different from the way it must be, he is also often considered to be the father of the distinction between appearance and reality.

Thought Probe

Thinking about Nothing

Parmenides believed that because nonexistence cannot exist, it cannot be thought about. Do you agree? Can you think about nothing? That is, can nothingness be the object of your thought? If so, can you describe what you're thinking about when you're thinking about nothing?

Zeno

Parmenides attracted some very able followers, most notably Zeno of Elea (C. 485 BCE). Zeno reportedly concocted dozens of additional arguments in support of his mentor's view, only a handful of which have come down to us. To get a sense of these arguments, consider his paradox of bisection.

Thought Experiment

Zeno's Paradox of Bisection

Suppose you are in a stadium at a given distance from the exit door. Then you can never get out of the stadium because before you reach the door you must

Things Aren't Always What They Seem

reach the point halfway there. But before you can reach the halfway point, you must reach a point halfway to that. And since it takes some finite interval of time to move from one point to another, and there are an infinite number of halfway points, it would take you an infinite time to pass through them all and get out.[15]

If we would guide by the light of reason, we must let our minds be bold.

—Louis Brandeis

If Zeno's analysis of motion is correct, not only can we never get out of the stadium, but we can never take the first step toward the door. Before we reach the halfway point, we would first have to reach a point halfway to that. And before we reach that point, we would have to reach a point halfway to that, and so on. So just as it would take an infinite amount of time to get out of the stadium, it would take an infinite amount of time to take the first step. And because finite beings like ourselves do not have an infinite amount of time on our hands, motion is impossible.

Zeno did not deny that people seem to move from place to place. What he denied was that the way the world seems is an accurate reflection of the way it really is. Like his teacher, Parmenides, he claimed that whatever involves a logical contradiction can't exist. And because motion involves a logical contradiction, it can't exist.

Although Zeno's thought experiments did not convince many people of their own immobility, they had an enormous influence on subsequent philosophizing. Zeno was the first philosopher to present logical arguments in prose, a form of exposition used by philosophers ever since. In recognition of this accomplishment, Aristotle refers to Zeno as "the inventor of dialectic." Aristotle also notes that Zeno's thought experiments led to the development of the atomic theory of matter.[16] Of Zeno's thought experiments, Gregory Vlastos writes, "In the whole history of philosophy no better device has ever been found for sensitizing us to the possibility that commonplaces may conceal absurdities and hence to the need of reexamining even the best entrenched and most plausible assumptions."[17] We may disagree with Zeno's conclusions, but we cannot but admire his method.

The notion that the world may be very different from the way it appears has been explored in a number of movies, most notably *The Matrix*. The movie takes place sometime in the future when computers have taken over the world and use humans as a source of energy. The humans are kept alive in fluid-filled pods, their brains being stimulated by electrodes connected directly to their nervous systems. Those plugged into the matrix think they're leading normal lives in the late twentieth century, whereas in reality they're floating in a pod. What they take to be real is nothing more than a computer-generated fantasy.

Plato

Although the image presented in *The Matrix* is striking, it strongly resembles one presented by Plato about twenty-five hundred years ago. Plato, following Parmenides, held that only that which is unchanging is real, and, following Heraclitus, that what is presented to our senses is constantly changing. So he concluded that what we sense isn't fully real. To convey this view, Plato

> ## Solving Parmenides' and Zeno's Paradoxes
>
> Parmenides' and Zeno's paradoxes have engaged some of the world's greatest minds for more than two thousand years, and many solutions have been offered. The best way to solve a paradox, however, is to "dissolve" it: to show that it rests on contradictory assumptions and thus cannot get off the ground. Some think that a contradiction lies at the heart of Zeno's paradoxes. In the paradox of bisection, for example, Zeno assumes that space can be infinitely divided. This means that the smallest amount of space—a point—has no dimensions. On the other hand, Zeno also assumes that it takes a finite amount of time to traverse any amount of space. But it takes no time at all to traverse a point, for a point has no dimensions. So Zeno seems to be trying to have his cake and eat it too. Both assumptions can't be true, and once we reject either one of them, there is no longer a paradox.
>
> What about Parmenides' claim that nonexistence cannot exist? Hasn't modern science proved that the world is mostly empty space? Indeed it has. But it has also proved that space is a thing. Einstein's theory of general relativity predicts that space will be curved around massive objects, and this prediction has been confirmed many times over in many different experiments. But you can't curve something that doesn't exist. So space is not mere nothingness. Russell Ruthen, staff writer for *Scientific American,* explains:
>
>> Space is not just the nothing between the earth and the stars. Nor is it simply the void between the electron and the atomic nucleus. It is a ubiquitous medium more resilient than rubber, more rigid than steel.[18]
>
> So Parmenides was right. There is no place where there is nothing. There are places where there is nothing but empty space, but space itself is a thing. Where Parmenides went wrong was in assuming that if a place is occupied, nothing else can move into it. Empedocles realized the error in this reasoning more than two thousand years ago and suggested that we move through space like fish move through water. His view appears to be pretty accurate.

fashioned one of the most vivid and significant images in the history of philosophy: the allegory of the cave. The allegory appears in Book VII of his *Republic,* where Socrates is talking to Glaucon:

SOCRATES: And now, I said, let me show in a figure how far our nature is enlightened or unenlightened: —Behold! human beings living in a underground cave, which has a mouth open towards the light and reaching all along the cave; here they have been from their childhood, and have their legs and necks chained so that they cannot move, and can only see before them, being prevented by the chains from turning round their heads. Above and behind them a fire is blazing at a distance, and between the fire and the prisoners there is a raised way; and you will see, if you look, a low wall built along the way, like the screen which marionette players have in front of them, over which they show the puppets.

GLAUCON: I see.

SOCRATES: And do you see, I said, men passing along the wall carrying all sorts of vessels, and statues and figures of animals made of wood and stone and various materials, which appear over the wall? Some of them are talking, others silent.

GLAUCON: You have shown me a strange image, and they are strange prisoners.

Socrates: Like ourselves, I replied; and they see only their own shadows, or the shadows of one another, which the fire throws on the opposite wall of the cave? . . .

Socrates: And suppose further that the prison had an echo which came from the other side, would they not be sure to fancy when one of the passers-by spoke that the voice which they heard came from the passing shadow?

Glaucon: No question, he replied.

Socrates: To them, I said, the truth would be literally nothing but the shadows of the images.

Glaucon: That is certain.

Socrates: And now look again, and see what will naturally follow if the prisoners are released and disabused of their error. At first, when any of them is liberated and compelled suddenly to stand up and turn his neck round and walk and look towards the light, he will suffer sharp pains; the glare will distress him, and he will be unable to see the realities of which in his former state he had seen the shadows; . . .

Socrates: And suppose once more, that he is reluctantly dragged up a steep and rugged ascent, and held fast until he's forced into the presence of the sun himself, is he not likely to be pained and irritated? When he approaches the light his eyes will be dazzled, and he will not be able to see anything at all of what are now called realities.

Glaucon: Not all in a moment, he said.

Socrates: He will require to grow accustomed to the sight of the upper world. And first he will see the shadows best, next the reflections of men and other objects in the water, and then the objects themselves; then he will gaze upon the light of the moon and the stars and the spangled heaven; and he will see the sky and the stars by night better than the sun or the light of the sun by day?

Glaucon: Certainly.

Socrates: Last of all he will be able to see the sun, and not mere reflections of him in the water, but he will see him in his own proper place, and not in another; and he will contemplate him as he is. . . .

Socrates: Imagine once more, I said, such a one coming suddenly out of the sun to be replaced in his old situation; would he not be certain to have his eyes full of darkness?

Glaucon: To be sure, he said.

Socrates: And if there were a contest, and he had to compete in measuring the shadows with the prisoners who had never moved out of the cave, while his sight was still weak, and before his eyes had become steady (and the time which would be needed to acquire this new habit of sight might be very considerable) would he not be ridiculous? Men would say of him that up he went and down he came without his eyes; and that it

PLATO'S ALLEGORY OF THE CAVE. The model of a horse being held up in front of the fire represents the truly real objects—the forms. The shadow it casts on the wall of the cave represents what the prisoners of the cave take to be real. For them, the truth is literally nothing but shadows.

was better not even to think of ascending; and if any one tried to loose another and lead him up to the light, let them only catch the offender, and they would put him to death.

GLAUCON: No question, he said.

SOCRATES: This entire allegory, I said, you may now append, dear Glaucon, to the previous argument; the prison-house is the world of sight, the light of the fire is the sun, and you will not misapprehend me if you interpret the journey upwards to be the ascent of the soul into the intellectual world according to my poor belief, which, at your desire, I have expressed whether rightly or wrongly God knows. But, whether true or false, my opinion is that in the world of knowledge the idea of good appears last of all, and is seen only with an effort; and, when seen, is also inferred to be the universal author of all things beautiful and right, parent of light and of the lord of light in this visible world, and the immediate source of reason and truth in the intellectual; and that this is the power upon which he who would act rationally, either in public or private life must have his eye fixed.[19]

The allegory of the cave is meant to represent not only the human situation in general but Socrates' life in particular. Socrates, like the prisoner loosed from the cave, had glimpsed the true nature of reality and tried to convince the inhabitants of Athens that they didn't know what they thought they knew. Some didn't welcome this news, however, and conspired to put him to death.

The objects that cast shadows on the wall represent what Plato considers to be the truly real objects: the forms. A form is a universal; it is a property that can be possessed by many different things. Various works of art, for example, can be beautiful. What makes them beautiful, Plato claims, is that they participate in the form of beauty. As he puts it, "By beauty all beautiful things become beautiful."[20] So, for Plato, forms are causes: They make the world what it is. To understand the world, then, we must understand the forms that give rise to it.

We can't acquire knowledge of the forms by means of the senses, however, because the forms aren't physical objects. How, then, do we acquire knowledge of them? Plato suggests that we come to know them through an act of recollection.

The first step to knowledge is to know that we are ignorant.
—RICHARD CECIL

We often judge things to fall short of an ideal. An action may be just but not perfectly just; two objects may be equal but not perfectly equal; a painting may be beautiful but not perfectly beautiful. To make such judgments, Plato claimed, we must have knowledge of the ideal (the form) involved. But we can't acquire that knowledge through our senses because nothing that we sense is perfectly just, equal, or beautiful. So we must have been born with a knowledge of these forms, and sense experience helps us recall that knowledge.

Knowledge we are born with is known as "innate knowledge." Rationalists characteristically attribute innate knowledge to us, thus explaining how it's possible to have knowledge that does not depend on sense experience. Some rationalists claim that we have an innate knowledge of concepts; others claim that we have an innate knowledge of statements. But in either case, it's knowledge possessed by all normal human beings.

Thought Probe

Innate Knowledge

Do you think that there are any concepts or truths that all normal humans have or know? If so, what are they?

Cartesian Skepticism

The most influential modern rationalist is Descartes. He doubted that sense experience can give us knowledge because knowledge requires certainty and nothing we learn through our senses is certain. Descartes holds that you are justified in believing something to be true only if you are certain of it. "I ought no less carefully to withhold my assent from matters which are not entirely

certain and indubitable," he informs us, "than from those which appear to me manifestly to be false."²¹ You are no more justified in believing something that is uncertain than you are in believing something that is obviously false. So if something can be doubted—if there is a possibility that it's false—you can't know that it's true.

Although this conception of knowledge may seem unduly strict, it does seem to accord with our use of the term. We often discount others' testimony if there is a possibility that they're mistaken. Suppose, for example, that a witness in a murder trial claims to have seen the defendant at the scene of the crime. If the defense attorney can show that there is reason to doubt the witness's testimony (because it was dark, because he was too far away, because his glasses were broken), she undercuts his claim to know that he saw the defendant. When there's reason to doubt a witness, you can't know that the person is telling the truth.

One of Descartes' goals in his *Meditations on First Philosophy* was to determine the extent of our knowledge. To accomplish this goal, he did not try to inspect every one of his beliefs. Instead, he examined the principles upon which they are based. He realized that if the principles are dubious, then so are the beliefs that are based on them. One principle that underlies many of our beliefs is that sense experience is a source of knowledge. But our senses can deceive us. What appears to be round, for example, can turn out to be square. Because we can't be certain that what we've learned through our senses is true, sense experience cannot be a source of knowledge.

> Doubt is the vestibule which all must pass before they can enter the temple of wisdom.
> —CALEB C. COLTON

Cartesian Doubt

To show that we can't trust our senses, Descartes presents two of the most famous thought experiments in the history of philosophy: the dream argument and the evil genius argument. We examined them briefly in Chapter 2. Now let's examine them more closely.

Here's Descartes' dream argument:

> Where doubt is, there truth is—it is her shadow.
> —G. BAILEY

Thought Experiment

Descartes' Dream Argument

How often have I dreamt that I was in these familiar circumstances, that I was dressed, and occupied this place by the fire, when I was lying undressed in bed? At the present moment, however, I certainly look upon this paper with eyes wide awake; the head which I now move is not asleep; I extend this hand consciously and with express purpose, and I perceive it; the occurrences in sleep are not so distinct as all this. But I cannot forget that, at other times I have been deceived in sleep by similar illusions; and, attentively considering those cases, I perceive so clearly that there exist no certain marks by which the state of waking can ever be distinguished from sleep, that I feel greatly astonished; and in amazement I almost persuade myself that I am now dreaming.²²

Dreams can often seem quite real. Even when we do things that we can't do when we're awake (like flying), it seems as if we're really doing them. Because there is no way to tell for certain while we're dreaming that we're dreaming, we can't be certain that we're not dreaming right now. And if we can't be certain that we're not dreaming right now, we can't acquire knowledge through the use of our senses.

Thought Probe

Dreams and Reality

Is Descartes right that there are no certain indications by which we can distinguish wakefulness from sleep? Suppose that every dream you had ended by your getting into bed and going to sleep. Would you be able to tell what was a dream and what was reality? How?

Descartes' dream argument can be spelled out this way:

1. We can't be certain that we're not dreaming.
2. If we can't be certain that we're not dreaming, we can't be certain that what we sense is real.
3. If we can't be certain that what we sense is real, we can't acquire knowledge through sense experience.
4. Therefore, we can't acquire knowledge through sense experience.

In contemplation, if a man begins with certainties he shall end in doubts; but if he be content to begin with doubts, he shall end in certainties.

—Francis Bacon

Although Descartes was not certain that he was not dreaming, you may feel that you are certain that you're not dreaming. But feeling certain and being certain are two different things. In Descartes' view, you can be certain of something only if it's impossible for you to be mistaken. But it's not impossible for you to be mistaken that you're awake. On the contrary, you could wake up at any moment and discover that your whole life has been a dream. Because you can't rule out the possibility that you're dreaming, Descartes claims that your senses can't give you knowledge of the external world.

Even if you can't be certain that you're not dreaming, it would seem that you can still know some things. You can know, for example, that some things are colored, for if you hadn't experienced colored things, how could you know what color is? None of the things that you take to be colored may actually be colored, but there must be some colored things in the world, for otherwise you wouldn't know what color is.

But even this can be doubted. You could have learned what color is by having that knowledge directly implanted in your mind. Descartes explores this possibility in his evil genius argument.

Thought Experiment

Descartes' Evil Genius Argument

How, then, do I know that he has not arranged that there should be neither earth, nor sky, nor any extended thing, nor figure, nor magnitude, nor place, providing at the same time, however, for [the rise in me of the perceptions of all these objects, and] the persuasion that these do not exist otherwise than as I perceive them?[23]

An all-powerful being could put thoughts in your mind, and he could arrange it so that everything you believe about the external world is false. Because we can't be certain that we're not in the grip of such a demon, we can't acquire knowledge through the senses.

To prove that we could be systematically deluded, we don't have to appeal to the supernatural. The evil genius could just as well be a mad scientist. Peter Unger presents a modern-day version of Descartes' evil genius argument.

Thought Experiment

Unger's Mad Scientist

This scientist uses electrodes to induce experiences and thus carries out his deceptions, concerning the existence of rocks or anything else. He first drills holes painlessly in the variously colored skulls, or shells, of his subjects and

then implants his electrodes into the appropriate parts of their brains, or protoplasm, or systems. He sends patterns of electrical impulses into them through the electrodes, which are themselves connected by wires to a laboratory console on which he plays, punching various keys and buttons in accordance with his ideas of how the whole thing works and with his deceptive designs. The scientist's delight is intense, and it is caused not so much by his exercising his scientific and intellectual gifts as by the thought that he is deceiving various subjects about all sorts of things. Part of that delight is caused, on this supposition, by his thought that he is deceiving a certain person, perhaps yourself, into falsely believing that there are rocks. He is, then, an evil scientist, and he lives in a world which is entirely bereft of rocks.[24]

> *There are only two kinds of people who are really fascinating-people who know absolutely everything and people who know absolutely nothing.*
> —OSCAR WILDE

Because Unger's mad scientist directly controls the firing patterns of the neurons in your brain, he can give you any experience he wants. As a result, he can implant in you any number of false beliefs. Because you can't be sure that you're not at the mercy of such a scientist right now, sense experience can't be a source of knowledge.

The argument suggested by Descartes' and Unger's evil geniuses is this:

1. We can't be certain that our sense experience is not caused by an evil genius.
2. If we can't be certain that our sense experience is not caused by an evil genius, we can't be certain that what we sense is real.
3. If we can't be certain that what we sense is real, we can't acquire knowledge through sense experience.
4. Therefore, we can't acquire knowledge through sense experience.

An evil genius of the sort described by Descartes or Unger could exist. There is no contradiction involved in assuming that there is such a being. As a result, premise 1 seems to be true. And given Descartes' assumption that knowledge requires certainty, premise 2 also seems to be true. If we can't be certain that we are not deluded, we can't acquire knowledge through the use of our senses.

Cartesian Certainty

> *I am certain that there is too much certainty in the world.*
> —MICHAEL CRICHTON

Even if there is an evil genius, Descartes believes that there is at least one thing that he knows—namely, that he exists. He writes,

> But I had the persuasion that there was absolutely nothing in the world, that there was no sky and no earth, neither minds nor bodies; was I not, therefore, at the same time, persuaded that I did not exist? Far from it; I assuredly existed, since I was persuaded. But there is I know not what being, who is possessed at once of the highest power and the deepest cunning, who is constantly employing all his ingenuity in deceiving me. Doubtless, then, I exist, since I am deceived; and, let him deceive me as he may, he can never bring it about that I am nothing, so long as I shall be conscious that I am something. So that it must, in fine, be maintained, all things being maturely and carefully considered, that this proposition *I am, I exist*, is necessarily true each time it is expressed by me, or conceived in my mind.[25]

Descartes can't doubt that he thinks because doubting is a species of thinking. Any attempt to doubt that he's thinking proves that he's thinking because to doubt is to think. But he can't think unless he exists. So he's also certain that he exists. With this truth—I think, therefore I am—as a first principle, Descartes hoped to set our knowledge of the external world on as firm a foundation as our knowledge of mathematics.

The facts that he thinks and that he exists are not the only facts he knows, however. He also knows the contents of his own mind. For example, if Descartes is hungry, he knows that he is hungry. If Descartes is in pain, he knows that he is in pain. And if Descartes seems to see a tree, then he knows that he seems to see a tree.

This last bit of knowledge is important because it can serve as a basis for our knowledge of the external world. From the fact that you seem to see a tree, it doesn't follow that there is a tree. You might be dreaming, or you might be under the influence of an evil genius. But if there were a way to rule out these counterpossibilities, then you would know that there is a tree. What's needed, then, is a principle that will bridge the gap between appearance and reality.

Descartes claims to have such a principle—the principle of clarity and distinctness—which says that whatever is clearly and distinctly perceived is true. As he puts it,

> as often as I so restrain my will within the limits of my knowledge, that it forms no judgment except regarding objects which are clearly and distinctly represented to it by the understanding, I can never be deceived; because every clear and distinct conception is doubtless something, and as such cannot owe its origin to nothing, but must of necessity have God for its author—God, I say, who, as supremely perfect, cannot, without a contradiction, be the cause of any error; and consequently it is necessary to conclude that every such conception [or judgment] is true.[26]

This principle allows Descartes to deduce truths about the external world from truths about his mental states. The deductions go like this:

1. I clearly and distinctly seem to see a tree in front of me.
2. Whatever I clearly and distinctly perceive is true.
3. Therefore, there is a tree in front of me.

The principle of clarity and distinctness closes the gap between the way the world appears and the way it really is. If Descartes can prove that the principle is true, he can defeat the skeptics.

Descartes attempts to establish this principle by establishing the existence of God. He is fully aware that God did not give him an infallible mind. But he is sure that God, being all-good, would not give him a mind that could not know the truth. So if he falls into error, it must be his fault, not God's.

> Whence, then, spring my errors? They arise from this cause alone, that I do not restrain the will, which is of much wider range than the understanding, within the same limits, but extend it even to things I do not understand, and as the will is of itself indifferent to such, it readily falls into error and sin by choosing the false in room of the true, and evil instead of good.[27]

What we know here is very little, but what we are ignorant of is immense.
—PIERRE-SIMON LAPLACE

Descartes believes that God gave humans free will. Unfortunately our will sometimes usurps our understanding and jumps to unwarranted conclusions. When it does, we deceive ourselves. But if our will followed our understanding—if we believed only what was sanctioned by the principle of clarity and distinctness—we would never believe anything that was false.

Descartes' argument for the principle of clarity and distinctness, then, goes as follows:

1. God exists and is no deceiver.
2. If God exists and is no deceiver, then whatever I clearly and distinctly perceive is true.
3. Therefore, whatever I clearly and distinctly perceive is true.

The first premise of this argument is problematic, for as we have seen, Descartes' ontological argument for the existence of God is not convincing. (He offers other arguments, but they are even less convincing than his ontological argument.) But whether or not these arguments succeed, many commentators believe that Descartes' defense of the principle of clarity and distinctness suffers from a more serious defect: circularity.

A circular argument assumes what it is trying to prove. Descartes is trying to prove the principle of clarity and distinctness. He claims that the truth of this principle follows from the existence of God. But he uses this principle to prove the existence of God. So Descartes seems to be caught in a circle: He can't know that God exists and is no deceiver unless he knows that what he clearly and distinctly perceives is true. But he can't know that what he clearly and distinctly perceives is true unless he knows that God exists and is no deceiver. This problem is known as the "problem of the Cartesian circle."

> *Doubt is not a very agreeable state, but certainty is a ridiculous one.*
>
> —VOLTAIRE

This problem is not unique to Descartes. It faces anyone who takes a foundationalist approach to knowledge. **Foundationalism** maintains (1) that there are basic beliefs—that is, beliefs whose justification does not depend on other beliefs, and (2) that the justification of all other beliefs depends, at least in part, on the basic beliefs. Foundationalists use what are known as "epistemic principles," like the principle of clarity and distinctness, to bridge the gap between basic beliefs and all other beliefs. Critics of foundationalism claim that these principles cannot be justified in a foundationalist framework. So foundationalism is a flawed approach to knowledge.

The problem with this criticism is that epistemic principles don't have to be known to be used. (If they did, only epistemologists or those who had studied epistemology could know anything.) The principle of clarity and distinctness says that whatever is clearly and distinctly perceived is true. Descartes need not know this principle to use it. If the principle is true, then whatever Descartes clearly and distinctly perceives is true, whether or not he consciously accepts the principle. The beliefs generated by the principle can then be used to justify the principle.[28]

foundationalism The theory of knowledge that maintains (1) that there are basic beliefs and (2) that the justification of all other beliefs depends on the basic beliefs.

The problem with Descartes' attempt to justify the principle of clarity and distinctness is not that it is circular but that it is inadequate. The conclusion of a deductive argument can be only as certain as its premises. If the premises are doubtful, then so is the conclusion. But it is doubtful that God exists. So we can't be certain that the principle of clarity and distinctness is true. And because we can't be certain that it's true, then, according to Descartes, we can't know that it's true.

Reasonable Doubt

The assumption that lies behind the first premise of both the dream argument and the evil genius argument is that knowledge requires certainty. But is that true? Does Descartes know that knowledge requires certainty? He does only if he's certain that knowledge requires certainty. But can he be certain of that? Consider these propositions: that the earth is inhabited, that cows produce milk, that water freezes at 32 degrees Fahrenheit, and so on. These are all propositions we would ordinarily claim to know, yet none of them is absolutely certain. In light of these counterexamples, can Descartes legitimately claim to know that knowledge requires certainty? It wouldn't seem so. For unless he is certain that knowledge requires certainty, he can't know that it does. And he can't be certain that knowledge requires certainty because the counterexamples cited above provide good reason for doubting that it does.

So if knowledge doesn't require certainty, what does it require? It does not require enough evidence to put the claim beyond any possibility of doubt but, rather, enough to put it beyond any reasonable doubt. There comes a point beyond which doubt, although possible, is no longer reasonable. It's possible, for example, that our minds are being controlled by aliens from outer space, but to reject the evidence of our senses on that basis would not be reasonable. To know a proposition, then, we don't have to establish it beyond a shadow of a doubt. We only have to establish it beyond a reasonable doubt. This is the standard of evidence used in courts of law to adjudicate matters of life and death. If we can stake our lives on it, we should be able to stake our knowledge on it.

> *Doubt is an incentive to truth, and patient inquiry leadeth the way.*
> —Hosea Ballou

The Empiricist Alternative

As we saw in Chapter 2, empiricists such as David Hume believe that only terms that stand for ideas derived from sense experience can refer to real objects. The mind at birth, they claim, is a tabula rasa—a blank slate—that contains only what has been inscribed on it by the senses. Concepts that represent sensations, such as hot/cold, light/dark, sweet/sour, smooth/rough, and the like, are the intellectual atoms or "simple ideas" out of which all "complex ideas" are composed. The complex idea of a tomato, for example, is composed of the simple ideas of a particular shape, size, color, texture, and so on. If a term does not stand for a simple or complex idea, it is meaningless. As Hume puts it, "When we entertain any suspicion that a philosophical term is employed without any meaning or idea (as is but too frequent) we need but enquire, from what impression is that supposed idea derived? And if it be impossible to assign any, this will serve to confirm our suspicion."[29] So empiricists reject the two characteristic theses of rationalism: (1) that reason is a source of knowledge of the external world, and (2) that we have some sort of innate knowledge.

Using his theory of concept acquisition, Hume tries to show that many philosophical terms—terms that purportedly refer to something that cannot

> *All our knowledge has its origins in our perceptions.*
> —Leonardo da Vinci

be sensed, like causation, liberty, and the self—are meaningless. He sums up his program this way:

> When we run over libraries, persuaded of these principles, what havoc must we make? If we take in our hand any volume; of divinity or school metaphysics, for instance; let us ask, *Does it contain any abstract reasoning concerning quantity or number?* No. *Does it contain any experimental reasoning concerning matter of fact and existence?* No. Commit it then to the flames: for it can contain nothing but sophistry and illusion.[30]

Empiricism, then, leads to skepticism about the existence of anything that cannot be sensed.

Although empiricists deny that reason is a source of knowledge of the external world, they admit that it can be used to discover logical truths. For example, if we have the concept of identity, reason can tell us that A is identical to A. Such truths are knowable a priori because they can be known prior to or independently of sense experience. We don't need to gather any data or conduct any experiments to confirm them. Reason alone is sufficient to establish their truth.

Statements that are logical truths, or can be turned into logical truths by substituting synonyms for synonyms, are known as "analytic" statements. Thus the statement that all males are males is analytic because it's a logical truth. The statement that all bachelors are males is analytic because it can be turned into a logical truth by substituting "unmarried male" for "bachelor."

Nonanalytic statements are known as "synthetic" statements. The statement that all crows are black, for example, is synthetic because it is not a logical truth nor can it be turned into a logical truth by substituting synonyms for synonyms. The truth of such statements can be known only a posteriori, by means of sense experience.

For the empiricists, then, there are two types of statements—analytic and synthetic—and all analytic statements are knowable a priori whereas all synthetic statements are knowable a posteriori. As Hume puts it,

> All objects of human reason or enquiry may naturally be divided into two kinds, to wit, Relations of Ideas, and Matters of Fact. Of the first kind are the sciences of Geometry, Algebra, and Arithmetic; and in short, every affirmation which is either intuitively or demonstratively certain. . . . Matters of fact, which are the second objects of human reason, are not ascertained in the same manner; nor is our evidence of their truth, however great, of a like nature with the foregoing. The contrary of every matter of fact is still possible; because it can never imply a contradiction, and is conceived by the mind with the same facility and distinctness, as if ever so conformable to reality.[31]

Synthetic truths differ from analytic ones in that they give us knowledge of the external world. Analytic truths, because they are equivalent to logical truths, don't tell us anything about the world. To be told that all bachelors are males is not to be told whether the world contains any males or any bachelors. So even if reason is the source of our knowledge of analytic truths, it isn't a source of knowledge of the external world.

> *General observations drawn from particulars are the jewels of knowledge, comprehending great store in a little room.*
>
> —JOHN LOCKE

The Problem of Induction

Our senses can give us knowledge about objects we can observe, and our memory can give us knowledge about objects we have observed, but we often claim to know things about objects we can't observe. For example, we often claim to know what's going on in distant parts of the world as well as what will go on in the future. How can we know these things? Hume claims that our knowledge of them is based on the relation of cause and effect:

> All reasonings concerning matter of fact seem to be founded on the relation of Cause and Effect. By means of that relation alone we can go beyond the evidence of our memory and senses. If you were to ask a man, why he believes any matter of fact, which is absent; for instance, that his friend is in the country, or in France; he would give you a reason; and this reason would be some other fact; as a letter received from him, or the knowledge of his former resolutions and promises. A man finding a watch or any other machine in a desert island, would conclude that there had once been men in that island. All our reasonings concerning fact are of the same nature. And here it is constantly supposed that there is a connection between the present fact and that which is inferred from it. Were there nothing to bind them together, the inference would be entirely precarious.[32]

The empiricist thinks he believes only what he sees, but he is much better at believing than at seeing.
—GEORGE SANTAYANA

We can have knowledge about things that are not present to our senses because objects and events in the world are bound together by the relation of cause and effect. As a result, if we know a cause, we can often predict its effect, and if we know an effect, we can often retrodict its cause.

The question, then, arises, How do we know that the same cause will always produce the same effect? We can't know it by means of reason or logic because the notion that the same effect will *not* produce the same cause is not self-contradictory. Hume explains:

> *That the sun will not rise tomorrow* is no less intelligible a proposition, and implies no more contradiction than the affirmation, *that it will rise*. We should in vain, therefore, attempt to demonstrate its falsehood. Were it demonstratively false, it would imply a contradiction, and could never be distinctly conceived by the mind.[33]

The claim that the same cause always produces the same effect, then, cannot be known a priori by the light of pure reason because it's not a logical truth. Its denial doesn't entail a contradiction, and so it must be a synthetic statement.

But it can't be known a posteriori by means of sense experience either, because any attempt to prove it in that way would assume its truth. Here's Hume again:

> To say [the same cause will always produce the same effect] is experimental [based on sense experience], is begging the question. For all inferences from experience suppose, as their foundation, that the future will resemble the past, and that similar powers will be conjoined with similar sensible qualities. If there be any suspicion that the course of nature may change, and that the past may be no rule for the future, all experience becomes useless, and can give rise to no inference or conclusion. It is impossible, therefore, that any arguments from

experience can prove this resemblance of the past to the future; since all these arguments are founded on the supposition of that resemblance.[34]

All inductive arguments assume that like causes produce like effects (that the future will resemble the past). As a result, we can't use induction to prove that claim because in that case, we would be arguing in a circle—we would be assuming what we are trying to prove—and such an argument proves nothing.

The problem, then, is this: Much of what we claim to know about the external world is based on inductive arguments from experience—inferences like: Every day in the past, the sun has risen. Therefore, the sun will rise tomorrow. But those arguments are based on the claim that the future will resemble the past, and that claim can be justified neither a priori by the light of pure reason nor a posteriori by sense experience. So it looks as if we can't know as much as we thought we did.

Science is often considered to be our best source of knowledge about the external world. Knowledge, however, requires justification. We can legitimately claim to know something only if we're justified in believing it to be true. But it looks as if we're not justified in believing what science tells us about the world because scientific inquiry is based on induction, and induction, as we've seen, is not rationally justified. There's no way to prove the assumption that underlies all inductive inferences—namely, that the future will resemble the past. So contrary to popular opinion, it seems that science can't be a source of knowledge. If you're looking for knowledge, then, you'll just have to look somewhere else.

Ironically, the view that our knowledge of the external world is based on sense experience seems to imply that we can know very little about the external world. Instead of suggesting that we give up the principle that the future will resemble the past, however, Hume suggests that we recognize it for what it is: a custom or habit that is so ingrained into us that we can't think without it.

> [W]hen we assert that, after the constant conjunction of two objects—heat and flame, for instance, weight and solidity—we are determined by custom alone to expect the one from the appearance of the other. This hypothesis seems even the only one which explains the difficulty, why we draw, from a thousand instances, an inference which we are not able to draw from one instance that is, in no respect, different from them.[35]

Recognizing that we habitually make certain inferences doesn't justify them, but it does help to explain why we make them.

Thought Probe

Science and Faith

There seems to be no way to prove the claim that like causes produce like effects (that the future will resemble the past). Yet all scientific inferences are based on that belief. Does that mean that science is based on faith? Faith, you will recall, is belief that does not rest on logical proof or material evidence. If science is based on faith, is it a type of religion? Why or why not?

The Kantian Synthesis

Immanuel Kant was scandalized by the view that we can't justify the claim that like causes produce like effects because it implies that we can't know whether one thing causes another. Remember that knowledge requires justification. We know something only if we're justified in believing it to be true. But if Hume is right, we're never justified in believing that one thing causes another because all such claims rest on the unprovable assumption that like causes produce like effects. According to Hume, then, not only can't we know whether one thing causes another, we can't even know whether there are any causes. Kant's reading of Hume woke him from his "dogmatic slumbers" and inspired him to write some of the most influential works in the history of philosophy, including *Prolegomena to Any Future Metaphysics* and *The Critique of Pure Reason*. He agrees with Hume that the claim that like causes produce like effects is synthetic, for it's not a logical truth and its denial doesn't lead to a contradiction. But he disagrees with Hume that synthetic truths are only knowable a posteriori. On the contrary, Kant claims that we can know a priori that like causes produce like effects. He writes,

> . . . the very concept of a cause so manifestly contains the concept of a necessity of connection with an effect and of the strict universality of the rule, that the concept would be altogether lost if we attempted to derive it, as Hume has done, from a repeated association of that which happens with that which precedes, and from a custom of connecting representations, a custom originating in this repeated association, and constituting therefore a merely subjective necessity.[36]

> *But although all our knowledge begins with experience, it does not follow that it arises from experience.*
>
> —IMMANUEL KANT

Kant believes that we know a priori that there is a necessary connection between cause and effect—something we couldn't know if the causal relation were simply the product of custom or habit as Hume thought. So Kant rejects the empiricist claim that all synthetic statements are only knowable a posteriori. Some, he claims, are knowable a priori. So the question Kant needs to answer, then, is, How are synthetic a priori truths possible?

To answer this question, Kant examines the method of inquiry used by mathematicians because, he thinks, they, too, traffic in synthetic a priori truths. He found that what makes it possible for them to discover such truths is that they study the principles the mind uses to construct mathematical objects. Kant realized that mathematicians don't acquire knowledge the way that scientists do, by investigating the properties of physical objects. Instead, he claims, they acquire knowledge by investigating the properties of the mathematical concepts they have constructed in their minds.

> The true method . . . was not to inspect what he discerned either in the figure, or in the bare concept of it, and from this, as it were, to read off its properties; but to bring out what was necessarily implied in the concepts that he had him-self formed a priori, and had put into the figure in the construction by which he presented it to himself.[37]

Mathematicians don't study physical circles or triangles because no physical objects have the properties they're interested in. No physical circle, for example, has all of its points exactly equidistant from the center, and no physical

triangle has the sum of all of its interior angles exactly equal to two right angles. Instead, Kant claims, mathematicians study the principles governing concepts that they themselves have constructed.

Just as mathematical concepts are not read off from experience but read into it, so Kant thinks that certain metaphysical concepts like space, time, and causality are read into experience to make sense of it. What the senses present to the mind, in the words of William James, is a "blooming, buzzing, confusion." To make sense of this material, the mind gives it a structure by bringing it under certain concepts and placing it in certain categories. Without these concepts, intelligible experience would not be possible. Kant explains:

> The objective validity of the categories as a priori concepts rests, therefore, on the fact that, so far as the form of thought is concerned, through them alone does experience become possible. They relate of necessity and a priori to objects of experience, for the reason that only by means of them can any object whatsoever of experience be thought.[38]

The faculty of the mind that gives us knowledge of these concepts Kant calls the "understanding." Truths discovered by the understanding are synthetic because they are not logical truths and a priori because they apply to all possible experience. Synthetic a priori truths, then, describe those features of the world that are necessitated by our construction of it.

Some things have to be believed to be seen.

—RALPH HODGSON

Kant describes his view that the mind constructs the objects of experience as a "Copernican Revolution" in philosophy. It was previously assumed that concepts are derived from experience. But instead, Kant insists that experience is derived from concepts. So just as Copernicus was able to explain the movements of the planets by rejecting the hypothesis that the sun moved around the earth and replacing it with the hypothesis that the earth moved around the sun, so Kant thinks he is able to explain the possibility of synthetic a priori truths by rejecting the hypothesis that concepts are derived from experience and replacing it with the hypothesis that experience is derived from concepts.

Kant's theory of knowledge saves empiricism from skepticism by wedding it to rationalism. Empiricism holds that only concepts derived from experience have objective reality. But if this were the case, then concepts like space, time, and causality would not have objective reality because they are not derived from experience. Kant maintains, on the contrary, that these concepts, which are innate, do have objective reality because they make the experience of objects possible. We know that all objects we will experience will have a location in space and time as well as a cause, because if they didn't, we wouldn't recognize them as objects. Falling under the concepts of space, time, and causality, then, is a necessary condition of objective experience.

Kant is a precursor of present-day cognitive psychologists because he understands the mind on the model of an information-processing mechanism. Empiricists conceive of the mind as a passive receiver of information. Kant conceives of the mind as an active processor of it. According to Kant, all perception involves conceptualization. We can't perceive something until we've brought it under the concepts of space, time, causality, and so on. But this view, too, seems to lead to a sort of skepticism. According to Kant, we

The mind's eye — Conceptual scheme — Raw sense experience

CONCEPTUALIZATION. According to Kant, all perception involves conceptualization.

are not directly aware of anything in the world. Everything we experience has been filtered through our conceptual scheme, which functions like a prism, taking the undifferentiated white light of experience and organizing it into identifiable objects (colors). So we know the world not as it is in itself, but only as our conceptual scheme presents it to us.

Kant dubs the world as it is in itself the "noumena," and our experience of it, the "phenomena." We can never tell whether the phenomena accurately reflects the noumena because we can't get outside of our conceptual scheme and compare it with reality. We can never take off the conceptual spectacles through which we view the world. Consequently, we can never know the world as it is in itself.

Some object to Kant's view on the grounds that it leads to a sort of relativism. Kant thought that every human being had to employ the categories he identified to have objective experience. But research by linguists, anthropologists, and social psychologists suggests that people in non-Western cultures categorize their experience differently than we do. It is still a matter of debate whether the differences are significant enough to justify the claim that they have different conceptual schemes, but in any event, it seems that Kant's goal of trying to prove that all human beings must use one particular conceptual scheme is doomed to failure. We can't establish the unique applicability of a conceptual scheme by comparing it to other conceptual schemes because any comparison requires standards, and any such standards would themselves be a part of a conceptual scheme. So there seems to be no non-question-begging way of establishing one conceptual scheme as the "correct" one.

Some conclude from this that truth is relative—that there is no one way the world is because people with different conceptual schemes live in different worlds. But such a conclusion is unwarranted because, from the fact that people represent the world to themselves in different ways, it doesn't follow that they live in different worlds.

Conceptual schemes can be viewed as maps. A territory can be mapped in many different ways, and each map, provided that it is an accurate one, can be considered true. Each science, for example, can be considered as a different map of reality. The map provided by biology may contain few of the concepts contained in the map provided by physics, just as a topographical map may contain very few of the symbols contained in a road map. But biology and physics can be maps of the same reality, just as a topographical map and a road map can be maps of the same territory, and both can be considered true. Whether you consult a biologist or a physicist will depend on what you want to do, just as whether you consult a topographical map or a road map

Facts are stubborn things; and whatever may be our wishes, our inclinations, or the dictates of our passions, they cannot alter the state of facts and evidence.

—JOHN QUINCY ADAMS

will depend on where you want to go. Different conceptual schemes, like different maps, are good for different things. So saying there is no one correct conceptual scheme no more relativizes truth than saying there is no one correct map. What we must not forget is that, as mathematician Alfred Korzybski famously noted, "the map is not the territory."[39] People using different maps are not necessarily traversing different territories. Similarly, people using different conceptual schemes are not necessarily living in different worlds. The world is what it is and is not affected by our representations of it.

Thought Probe

Constructing Reality

Are scientific laws invented or discovered? The traditional view is that scientific laws exist "out there" in the world and that the job of the scientist is to discover them. Kant, however, claims that "the order and regularity of the appearance we entitle nature, we ourselves introduce."[40] For him, reality is a human construct. Which view do you think is correct? Why?

Mystical Experience

Mysticism is just tomorrow's science dreamed today.
—Marshall McLuhan

Recognizing that we ordinarily experience reality not directly but only as it is filtered through our conceptual scheme, some have sought a direct experience of reality by transcending our conceptual scheme. They believe that our conceptual scheme functions like a veil, hiding from us the true nature of reality. By lifting the veil we can experience reality as it is in itself and thus come to know its true nature. Such direct experiences of reality are known as mystical experiences, and many who've had them claim that they are truer than any other experiences they've had.

Are the mystics correct? Is mystical experience the royal road to the truth? The only way to tell is by putting their claims to the test. One way to test the truth of someone's claim is to see how well it agrees with the claims of others. Unfortunately mystics don't agree about the true nature of reality. Christian mystics, for example, describe their experience as an intimate relationship with a personal god, whereas Buddhist mystics describe their experience as an awareness of emptiness. According to theologian Steven Katz, "There is no intelligible way that anyone can legitimately argue that a 'no self' experience of empty calm is the same experience as the experience of [an] intense, loving, intimate relationship between two substantial selves, one of whom is conceived of as the personal God of Western religion and all that this entails."[41] Given the diversity of their descriptions of their experiences, it's doubtful that mystics are having the same experience or experiencing the same thing.

But even if all mystics did have the same experience, that wouldn't prove that their experiences are a source of knowledge. For we've all shared with others what seems to be the same perceptual experience, then discovered that the experience "wasn't real." Lots of people, for example, have reported

identical perceptual illusions, like mirages in the desert. But this agreement among the experiences doesn't prove that the oasis in the distance is real. Experiences can be common, but false.

To preserve the view that all mystical experience yields knowledge, it has been claimed that although there are many different descriptions of mystical experience, the experience itself is nevertheless the same for everyone. The different descriptions arise from the fact that mystical experience transcends our ordinary linguistic categories. It is so unlike any other experience we've had that we lack the words to describe it. Thus mystical experience is said to be ineffable.

According to philosopher Walter Stace, to say that something is ineffable is to say that nothing can truthfully be predicated on it. Thus, for example, to say that God is ineffable is to say that "any statement of the form 'God is x' [where 'x' is a predicate] is false."[42] If mystical experience is ineffable in this sense, however, nothing can truthfully be said about it. In particular, it can't truthfully be said that mystical experience is a source of knowledge because to say that is to predicate something of it and any such predication is false. Someone convinced of the ineffability of mystical experience, then, would do well to follow the advice of philosopher Ludwig Wittgenstein: "Whereof one cannot speak, thereof one must be silent."[43] Second, if no description of mystical experience is true, there can be no grounds for believing that it's the same for everyone. Our only access to others' experience is through their descriptions of it. If these descriptions can't be trusted, we have no way of knowing whether their experiences are similar, for totally indescribable experiences can't be compared.

Many Eastern mystical traditions teach that the way to achieve a mystical experience is to silence our minds. Only by emptying our minds of all thoughts can we open the door to true perception. In the words of mystic Sri Aurobindo, "The cup [has to be] left clean and empty for the divine liquor to be poured into it."[44] In a mystical state of consciousness, then, the mind is not directed upon anything. With no objects to limit awareness, it may seem as if consciousness has expanded to infinity; as if all there is is consciousness; as if everything is one. But if that is what is going on in mystical experience—if mystical experience is simply consciousness without an object—then it can't give us knowledge of reality because in that case, it would not put us in contact with it. As philosopher Robert Nozick notes, "It would be a mistake to think there is an unusual reality being encountered, when that merely is what it feels like when the experience-mechanism is turned on yet nothing is present to be experienced."[45] An empty mind may not be the best tool for acquiring knowledge.

A mystical experience can transform your life. It can infuse it with meaning, significance, and value. Where once you only saw pointless posturing you may now see profound purpose. Some take the profound effect that mystical experiences have on people as evidence for the reality of what's experienced. But as Bertrand Russell replied to Father Copleston when he made such a claim, "The fact that a belief has a good moral effect upon a man is no evidence whatsoever in favor of its truth."[46] Russell explains: "Obviously the character of a young man may be—and often is—immensely affected for

> *Mystical explanations are thought to be deep: the truth is that they are not even shallow.*
> —FRIEDRICH NIETZSCHE

good by reading about some great man in history, and it may happen that the great man is a myth and doesn't exist, but the boy is just as much affected for good as if he did."[47] Similarly, dreams may profoundly affect one's life for the better. (Scrooge comes to mind here.) Because changes in character can be brought about by false beliefs as well as true, such changes provide no evidence for the truth of their incipient beliefs.

Even though an experience's being mystical doesn't guarantee its truth, it doesn't guarantee its falsity either. It's entirely possible that mystical experiences do reveal aspects of reality that are normally hidden to us. But the only way we can tell is by putting them to the test. If they are revelatory of reality, we should be able to corroborate them. The Dalai Lama, spiritual leader of Tibetan Buddhism, agrees. At a conference on neuroscience held at Newport Beach, California, he remarked, "If there's good, strong evidence from science that such and such is the case and this is contrary to Buddhism, then we will change."[48] Truth, as the Dalai Lama realizes, should be able to withstand the closest scrutiny, for only that which can withstand such scrutiny deserves to be called true.

Summary

Parmenides and Zeno argue that we cannot acquire knowledge by means of our senses because we know the world is different from the way it appears. Everything seems to be constantly changing, but change is impossible. So our senses must not put us in touch with reality. Plato, too, thinks that what we sense is not fully real. The only real objects are ideas or forms, because they are unchanging and the ultimate cause of everything.

Descartes held that knowledge requires certainty. But if this is so, we know very little that is derived from our senses. Descartes presents two powerful arguments that purport to show that our senses cannot give us knowledge of the external world. His dream argument asserts that we cannot have knowledge because, for all we know, we may be dreaming right now. His evil genius argument says that we cannot have knowledge because, for all we know, our experiences may be caused by an evil genius.

Descartes believes, however, that he can know at least two things: that he thinks and that he exists. He can't doubt that he thinks because the very act of doubting is thinking. He can't doubt that he exists because existence is a necessary condition of thinking. Beyond these two propositions, Descartes believes that we can also know (be certain of) propositions about the way things seem. We can know that we seem to have certain sensations, though we could be mistaken about their cause. What's more, Descartes thinks that we have a principle that guarantees that many of our sensations accurately reflect reality. It's the principle of clarity and distinctness: Whatever is clearly and distinctly perceived is true. If this principle is true, Descartes can defeat the skeptic.

Descartes tries to establish the principle's truth by bringing in God. God exists and is no deceiver, Descartes says, and if this is so, then whatever we clearly and distinctly perceive is true. But Descartes' attempt to establish the principle is inadequate. It is not certain that God exists. So it is not certain

that the principle of clarity and distinctness is true. Consequently, Descartes' bid to defeat the skeptic fails.

Skeptical doubts arise from the notion that knowledge requires certainty, as Descartes insists. But does it? We seem to know many things that aren't certain. This casts considerable doubt on Descartes' claim. We do seem to know things—but without certainty. But if knowledge doesn't require certainty, what does it require? It requires not that a proposition be beyond any possible doubt but that it be beyond any reasonable doubt.

Because empiricists believe that sense experience is our only source of knowledge of the external world, they believe that no synthetic propositions are knowable a priori. But the principle that underlies inductive reasoning—that like causes produce like effects—is synthetic and seemingly can't be known either a priori or a posteriori. If so, many of our beliefs about the external world are unjustified.

Kant claims that the principle that like causes produce like effects can be known a priori because it is a principle we read into experience to make sense of it. Our experience of objects must conform to that principle because it makes objective experience possible.

According to Kant, we don't experience objects directly, but only indirectly by means of our conceptual scheme. Some mystics argue that we can get a clearer view of reality if we transcend our conceptual scheme and experience the world directly. Such experience can yield knowledge, however, only if it can be corroborated.

Study Questions

1. What are the requirements for knowledge?
2. What are Parmenides' arguments for the impossibility of change?
3. What is Zeno's paradox of bisection?
4. What is Plato's allegory of the cave supposed to demonstrate?
5. What is Descartes' dream argument?
6. What is Descartes' evil genius argument?
7. How does Descartes close the gap between appearance and reality?
8. Why do empiricists believe that there are no synthetic a priori truths?
9. How does Kant explain the possibility of synthetic a priori truths?

Discussion Questions

1. The ultimate virtual reality machine would present a world so real that we couldn't tell that it was fake. Can you know that you're not plugged into an ultimate virtual reality machine right now? If not, what difference does it make?
2. Descartes assumes that we can be certain about our mental states. Is that true? Could you be mistaken about your mental states? Could you be mistaken about the fact that you're in pain, for example? If so, what does that imply for Descartes' program?

3. Can the epistemic principles that Descartes uses to prove the existence of the external also be used to prove the existence of other minds? Why or why not?
4. Can you think of something that people take for granted that they should be more skeptical of?
5. Can Descartes know that knowledge requires certainty? If not, does his program go through?
6. Can we know beyond a reasonable doubt that the external world exists? Why or why not?
7. Mystics have long maintained that ordinary perception is distorted by our conceptual scheme. To get a pure, undistorted view of reality, they try to perceive the world directly, without the use of any concepts. Is such pure perception possible? Can it serve as a source of knowledge? Kant claimed that thought without concepts is blind. Do you agree?

Internet Inquiries

1. Are you now living in the Matrix (a computer-generated virtual reality)? If you are, is there any way you could know that? To explore the implications of such questions, play the philosophy game called *Strange New World* at **http://www.philosophyexperiments.com/**
2. If you feel certain of a proposition, is that an indication that it's true? What is the distinction that philosophers draw between psychological certainty and epistemic certainty? To find out more about this issue, go to **http://plato.stanford.edu/entries/certainty/#KinCer.**
3. Do people who speak different languages have different conceptual schemes and experience the world differently? This was the view of anthropologist Edward Sapir and linguist Benjamin Lee Whorf. To explore this issue, enter "linguistic relativity" into an Internet search engine.
4. Nick Bostrom, director of the Future of Humanity Institute at Oxford University, thinks that there's a good chance that we are currently living in a computer simulation. Do you agree? To examine his arguments, type "simulation argument" into an Internet search engine.

Section 7.2

● Facing Reality
Perception and the External World

Scientists and laypersons alike assume that sense experience gives us knowledge of the external world. Descartes called this assumption into question by showing that we couldn't always trust our senses. But contrary to what Descartes would have us believe, knowledge doesn't require certainty. So from the fact that our senses might not be trustworthy, it doesn't follow that they aren't trustworthy. Nevertheless, we are justified in believing what our senses tell us about the external world only if we have a good reason for believing that they put us in touch with it.

● Direct Realism

Common sense tells us that our senses put us in direct contact with reality. When we see a book, for example, it seems that we are directly aware of the book itself. This view is known as **direct realism:** "direct" because it assumes that nothing comes between our perception of the world and the world itself, "realism" because it assumes that there is an external world that is not affected by what we think about it. Philosophers have challenged both of these assumptions.

The most telling argument against direct realism is the argument from illusion. If we are directly aware of physical objects in perception, then they should appear to us as they really are. But the way things seem is often very different from the way they are. This has led many to conclude that we're not directly aware of the external world. British philosopher A. J. Ayer explains,

> Why may we not say that we are directly aware of material things? The answer is provided by what is known as the argument from illusion. This argument, as it is ordinarily stated, is based on the fact that material things may present different appearances to different observers, or to the same observer in different

We need realism to deal with reality.
—SLICK RICK

direct realism The doctrine that perception puts us in direct contact with reality.

Facing Reality **571**

THE BENT PENCIL. Illusions like the bent pencil suggest that we don't perceive the world directly.

conditions, and that the character of these appearances is to some extent causally determined by the state of the conditions and the observer. For instance, it is remarked that a coin which looks circular from one point of view may look elliptical from another; or that a stick which normally appears straight looks bent when it is seen in water; or that to people who take drugs such as Mescal, things appear to change their colors.[49]

Physical objects cannot possess incompatible properties. Nothing can be both circular and elliptical, bent and straight, or red and green at the same time. But one and the same object can appear to have such incompatible properties. So what appears to us—what we're directly aware of in perception—must not be physical objects themselves.

Consider Ayer's example of the stick placed in a glass of water. The problem that it poses for direct realism can be put in the form of an argument.

1. What we see is bent.
2. The stick is not bent.
3. So what we see is not the stick.

But if we don't see the stick, what do we see? Empiricists have traditionally claimed that what we see is a representation or an appearance or an idea of a stick. The technical term that is often used to refer to what we're directly aware of in perception is **sense data.** Bertrand Russell introduces that term this way:

sense data The objects that are immediately known in sensation.

Let us give the name of "sense data" to the things that are immediately known in sensation; such things as colours, sounds, smells, hardnesses, roughnesses, and so

572 Chapter 7 • The Problem of Skepticism and Knowledge

on. We shall give the name "sensation" to the experience of being immediately aware of these things. Thus whenever we see a colour, we have a sensation of the colour, but the colour itself is a sense datum, not a sensation. The colour is that of which we are immediately aware and the awareness itself is the sensation.[50]

Sense data, then, are the content of our sensations. They are what is given to us in sense experience. We take sensory experience to be about physical objects, but that is not what is given to us. What is given is sense data.

According to those who believe in sense data, then, the process of perception has two parts. The first part—sensation—involves receiving data from the senses. The second part—perception—involves interpreting those data and bringing them under a concept. Some believe that these two parts are temporally distinct—that one actually happens before the other—whereas others believe that they are only logically distinct—that although the process happens all at once, these are two discriminable aspects of the process. In either case, however, we're not directly aware of physical objects.

Perception supposedly gives us knowledge of the external world. But if all we are directly aware of in perception is sense data, there's a problem: How do we know whether our sense data accurately represent the external world? We can't get outside of our sense data and compare them with the external world. All we can do is get more sense data. So how can we know what the external world is like in itself? Locke put the problem this way:

> 'Tis evident that the mind knows not things immediately, but only by the intervention of the ideas [sense data] it has of them. Our knowledge, therefore, is real only so far as there is conformity between our ideas and the reality of things. But what shall be here the criterion? How shall the mind when it perceives but its own ideas, know that they agree with things themselves?[51]

On the sense data theory, it seems that we're trapped behind a "veil of ideas." How, Locke asks, can we lift the veil and come to know things as they are in themselves? This is the problem of the external world.

Representative Realism

Locke believes that we can lift the veil of ideas by recognizing (1) that our sensations are caused by external objects and (2) that at least some of our ideas (sense data) resemble the qualities of those objects. This view is often referred to as **representative realism.** Like direct realism, it maintains that there is a world that exists independently of our minds, but unlike direct realism, it maintains that our knowledge of that world is indirect; it is mediated by our sense data.

In support of the first claim, Locke offers a number of considerations:

- "Those that want the organs of any sense never can have the ideas belonging to that sense."[52] For example, those who are blind from birth can never acquire the idea of color. Similarly, those who have never had certain sensations can never have the sense data associated with them.

representative realism The doctrine that sensations are caused by external objects and that our sensations represent those objects.

Facing Reality 573

For example, those who have never tasted a pineapple can never know what a pineapple tastes like.

- "Sometimes I find that I cannot avoid having those ideas produced in my mind."[53] The sense data that we receive does not seem to be up to us. If we look at the sun, for example, we cannot help but see bright light.
- "Many of those ideas are produced in us with pain, which afterwards we remember without the least offense."[54] There seems to be a real difference between the ideas that come from outside and those that come from inside. The ones that seem to be generated by external objects have much more force and vivacity than those generated by internal objects such as memories.
- "Our senses in many cases bear witness to the truth of each other's report concerning the existence of sensible things without us."[55] The information that we receive from various senses is usually complementary. The thing that looks like a fire feels hot, for example.

The best explanation of these facts, says Locke, is that our sensations are produced by external objects. "Thus the certainty of things existing *in rerum natura*, when we have the testimony of our senses for it, is not only as great as our frame can attain to, but as our condition needs."[56] It's not absolutely certain that sense data are caused by external objects because it's logically possible that we're dreaming. But even if it's not true beyond a shadow of a doubt, it's true beyond a reasonable doubt because the hypothesis that sense data are caused by external objects provides a better explanation of the data than the hypothesis that we're dreaming.

Thought Probe

Hypothesizing the External World

Do you agree with Locke that the hypothesis of an external world provides the best explanation of our sense data? Compare that hypothesis and the dream hypothesis in terms of the criteria of adequacy. Which does better with regard to simplicity, scope, conservatism, and fruitfulness?

If successful, however, all Locke's argument shows is that our sensations are caused by external objects. By itself, it tells us nothing about the nature of those objects. Locke maintains, however, that further reflection on the nature of our sense data reveals that some actually resemble the qualities of external objects. Thus we can have knowledge of the external world because some of our sense data conform to the qualities of external objects.

External objects have the power of producing sense data. They have this power in virtue of possessing certain qualities. But not every sense datum resembles a quality in an external object. For example, if we dip one of our hands in a cold bucket of water and the other in a warm bucket of water,

and then dip both of them into a lukewarm bucket of water, the lukewarm bucket of water will feel cold to one hand (the one that had been dipped in the warm water) and warm to the other (the one that had been dipped in the cold water). But the water in the bucket cannot be both warm and cold. So the sense data of warmth and coldness cannot resemble qualities possessed by the water. These sense data exist only in the mind, not in the water itself. Locke calls these qualities **secondary qualities.**

Even though the water does not possess the qualities of being warm or cold, it must possess qualities with the power to produce the sense data of warmth and coldness. Locke calls these qualities **primary qualities.** For Locke, they are the essential qualities of material objects, the qualities that material objects could not possibly do without. As he puts it, "Qualities thus considered in bodies are, first such as are utterly inseparable from the Body, in what estate whatsoever it be; and such as Sense constantly finds in every particle of Matter."[57] They include solidity, extension, figure, and mobility. Locke thought that these qualities really exist in objects because they can be sensed by more than one sense, and, unlike secondary qualities, they do not vary as the conditions of perception are varied.

To get a better idea of what Locke is getting at with this distinction, consider the qualities that physicists attribute to the basic building blocks of matter: subatomic particles. They are solid (insofar as they do not contain gaps like a sponge), they have extension (insofar as they occupy space), they have figure (insofar as they have a shape), and they have mobility (insofar as they are in motion). Modern physics also attributes a number of other qualities to them, such as mass, charge, and spin. But notice that nowhere in this list are qualities such as color, taste, and sound. Modern physicists agree with Locke that these qualities are not possessed by the subatomic particles themselves. Individual electrons, for example, do not have a particular color, taste, or sound. These secondary qualities come into existence only when groups of particles interact with our sense organs.

Locke's representative realism solves the problem of the external world by claiming that some of our sense data—namely, those corresponding to primary qualities—actually resemble qualities of material objects. So at least part of our sense experience gives us an accurate picture of how material objects are in themselves.

Knowledge is what we get when an observer, preferably a scientifically trained observer, provides us with a copy of reality that we can all recognize.

—CHRISTOPHER LASCH

Phenomenalism

Bishop George Berkeley (1685–1753) agrees with Locke that we directly perceive sense data. But he disagrees that the best explanation of our sense data is that they are caused by material objects. In his view, sense data are caused by God! To see how Berkeley arrived at this view, we can begin with his criticism of Locke.

Berkeley rejected Locke's distinction between primary and secondary qualities because he believed that primary qualities are just as variable as secondary qualities.

secondary qualities
Qualities that exist in the mind but not in material objects themselves.

primary qualities
Qualities possessed by material objects.

Facing Reality 575

. . . [A]fter the same manner as modern philosophers prove certain sensible qualities to have no existence in matter, or without the mind, the same thing may be likewise proved of all other sensible qualities whatsoever. Thus, for instance, it is said that heat and cold are affectations only of the mind, and not at all patterns of real beings existing in the corporeal substances which excite them, for that the same body which appears cold to one hand seems warm to another. Now, why may we not as well argue that figure and extension are not patterns or resemblances of qualities existing in matter, because to the same eye at different stations, or eyes of a different texture at the same station, they appear various and cannot, therefore, be the images of anything settled and determinate without the mind?[58]

> *The idealist deals with facts as much as with reality. He merely sees them differently.*
> —Margaret Halsey

Just as what feels warm to one hand can feel cold to another, Berkeley claims that what looks round from one angle can look elliptical from another. Primary qualities can differ depending on the conditions of perception just as much as secondary qualities do. So there is no reason to think that they are not in the mind, too.

But more important than his rejection of the distinction between primary and secondary qualities is Berkeley's rejection of the existence of material objects. Berkeley thought that our sensations could not be caused by material objects because material objects could not exist. The notion of a material object, he thought, was a contradiction in terms. We know that there are no married bachelors or round squares because such notions are self-contradictory—they violate the law of noncontradiction and thus cannot possibly exist. Berkeley thought that the notion of a material object was similarly self-contradictory. Here's the thought experiment that he used to prove his point.

Thought Experiment

The Inconceivability of the Unconceived

But, say you, surely there is nothing easier than for me to imagine trees, for instance, in a park, or books existing in a closet, and nobody by to perceive them. I answer, you may so, there is no difficulty in it; but what is all this, I beseech you, more than framing in your mind certain ideas which you call books and trees, and at the same time omitting to frame the idea of any one that may perceive them? But do not you yourselves perceive or think of them all the while? This therefore is nothing to the purpose: it only shows you have the power of imagining or forming ideas in your mind; but it does not show that you can conceive it possible the objects of your thought may exist without the mind. To make out this, it is necessary that you conceive them existing unconceived or unthought of, which is a manifest repugnancy. When we do our utmost to conceive the existence of external bodies, we are all the while only contemplating our own ideas. But the mind taking no notice of itself, is deluded to think it can and does conceive bodies existing unthought of or without the mind, though at the same time they are apprehended by or exist in itself. A little attention will discover to any one the truth and evidence of what is here said, and make it unnecessary to insist on any other proof against the existence of material substance.[59]

We ordinarily suppose not only that material objects cause our sensations but also that they continue to exist when no one is thinking about them. But Berkeley claims that this cannot be the case because it's impossible to conceive of something's existing unconceived.

Try it yourself. Try thinking about an object that is not being thought about. Berkeley says you can't do it because the minute you think about it, it's no longer not being thought about. But material objects are supposed to be able to exist without anyone's thinking about them. So if we cannot conceive an object's existing unconceived, Berkeley claims, material objects cannot exist.

Even though Berkeley doesn't believe that there are any material objects, he doesn't recommend that we stop talking about them. Instead, he proposes that we understand our talk about them in a new way. When we claim that a material object is present, what we mean is that we have experienced a certain pattern of sensations. For Berkeley, then, material objects are nothing but recurring patterns of sensations.

Berkeley uses the example of a cherry to make his point:

> I see this cherry, I feel it, I taste it, and I am sure *nothing* cannot be seen or felt or tasted; it is therefore *real.* Take away the sensation of softness, moisture, redness, tartness, and you take away the cherry. Since it is not a being distinct from sensations, a cherry, I say, is nothing but a congeries of sensible impressions, or ideas perceived by the various senses, which ideas are united into one thing (or have one name given them) by the mind because they are observed to attend each other. Thus, when the palate is affected with such a particular taste, the sight is affected with a red color, the touch with roundness, softness, etc. Hence, when I see and feel and taste in sundry certain manners, I am sure the cherry exists or is real, its reality being in my opinion nothing abstracted from those sensations. But if by the word "cherry" you mean an unknown nature distinct from all those sensible qualities, and by its "existence" something distinct from its being perceived, then, indeed, I own neither you nor I, nor anyone else, can be sure it exists.[60]

Whenever we have certain sensations, we believe that a cherry is present. We can be mistaken, however. If we have the sensation of reaching for the cherry and our hand passes right through it, we know it's not a real cherry. What determines whether a perceived object is real, then, is not whether it corresponds to a material object but whether the sensations associated with it fit a particular pattern.

The view that statements about physical objects are reducible to statements about sensations is known as **phenomenalism.** In this view, to say "There is a tree in front of me" is equivalent to saying "If I were to have reaching-out sensations, I would have hardness sensations; if I were to have kicking sensations, I would have pain-in-the-toe sensations; . . ." and so on for every possible action. Phenomenalism, then, is the reverse of behaviorism. Whereas behaviorism tries to reduce talk about mental states to talk about material objects, phenomenalism tries to reduce talk about material objects to talk about mental states. Twentieth-century empiricists, particularly logical positivists, found this view appealing because it provided an elegant solution to the problem of the external world. If material objects were nothing but

phenomenalism The view that all talk of things is reducible to talk of sensations.

George Berkeley: The Ultimate Empiricist

Some philosophers produce interesting theories but they themselves are fairly dull. George Berkeley (1685–1753) was not one of those. He produced an entirely original and exasperating (to some) view of the world known as "idealism"—but he also was a fascinating character in his own right.

He was born in Kilkenny, Ireland, and educated at Trinity College in Dublin. He graduated at age nineteen, was given a fellowship there in 1707, and proceeded to produce his greatest works—all during his twenties. He wrote *A Treatise Concerning the Principles of Human Knowledge* in 1710 and *Three Dialogues between Hylas and Philonous* in 1713. In 1709 he published a work, not of philosophy, but of psychology—"An Essay Towards a New Theory of Vision." His theory of vision became the definitive view of the subject and remained so for almost two hundred years.

His passion was the promotion of education in the New World. He wanted to establish a college in Bermuda for the Christian education of the people of America, and the Crown had promised him the funds to do just that. But the money never came, and he spent three years in Rhode Island waiting for it. He bequeathed his library and estate in Rhode Island to Yale University, where one of the colleges is named after him. Berkeley, California, also got its name from this Irish philosopher who lived most of his life half a world away.

Berkeley returned to London in 1732, and in 1734 he was made Bishop of Cloyne. For most of the rest of his life he tended to his duties as a cleric, publishing mostly works benefiting his flock.

Berkeley's reputation as a philosophical idealist followed him through the years and caused controversy and consternation everywhere. Samuel Johnson, the most famous man of letters in the eighteenth century, ridiculed his theory. The story is told of a philosopher who argued so strenuously with Berkeley that he suffered a fit of apoplexy and died. The tale is probably false, but it is easy to imagine some learned folks becoming incensed with Berkeley's counterintuitive idealism—especially because he claimed that his view was just common sense.

Bishop Berkeley
(1685–1753)

patterns of sensations, then the problem of how we can know whether our sensations accurately represent the world could no longer arise. Phenomenalism closes the gap between appearance and reality by denying that the gap exists.

Sensations cannot exist without a mind to have them. Because Berkeley's objects are patterns of sensations, it follows that they cease to exist when no one is thinking about them. This view strikes many people as extremely odd because they believe that objects continue to exist whether or not they are in anyone's thoughts.

Suppose you leave a fire in a fireplace and come back a few hours later to find a heap of smoldering embers. Doesn't that prove that objects can exist without being observed? Not according to Berkeley. What you've experienced is just a typical pattern of fire sensations. There is no reason to suppose that in addition to the fire sensations there is also a material fire.

The classic philosophical conundrum—If a tree falls in the forest and no one is around to hear it, does it make a sound?—is often associated with Berkeley. It is commonly believed that Berkeley would answer no to this question. But Berkeley would not respond to this question because it is based on an assumption that he rejects—namely, that objects can exist unperceived. If there were no one around to hear a tree fall, there would be no tree in the first place. So the question makes no sense.

Legend has it that when Samuel Johnson first heard Berkeley's theory he exclaimed, "I refute it thus!" and kicked a rock. But of course this doesn't refute Berkeley at all. Berkeley doesn't deny that usually when we have the sensation of kicking something that looks like a rock, we have the sensation of stubbing our toe. What he denies is that this recurrent pattern of sensation is best explained on the hypothesis that material objects exist. In his view, it is best explained on the assumption that God creates these sensations.

We do not produce our own sensations. What we sense is not up to us. So our sensations must be caused by something outside of us. According to Berkeley, that something is God. In his view, we are all telepathically linked to God, and God puts all of our sensations directly into our minds. Berkeley's God, then, functions just like Descartes' evil genius. But Berkeley does not consider his God to be evil, for he is not deluding us about the nature of reality; he is creating it.

Berkeley's view that God is the source of all of our sensations inspired Monsignor Ronald Knox to pen the following limerick:

> There was a young man who said "God
> Must think it exceedingly odd
> If he finds that this tree
> Continues to be
> When there's no one about in the quad."
>
> Reply:
> Dear Sir: Your astonishment's odd
> I am always about in the quad
> And that's why the tree
> Will continue to be
> Since observed by
> Yours faithfully,
> God.[61]

According to Berkeley, things exist only as long as they are being thought about. That would seem to imply that things cease to exist when we stop thinking about them. But we are not the only beings that think about things. God does too. So things may continue to exist when we're not thinking about them as long as God is thinking about them.

Berkeley thought that his view refuted skepticism and proved the existence of God. It refuted skepticism by closing the gap between appearance and reality. In Berkeley's system, the question of whether our sensations accurately represent external objects does not arise because there are no external objects—objects are just collections of ideas. It proves the existence of God by showing that God is the best explanation of our sense experience.

Although Berkeley thought that his system proved the existence of the Christian God, it does no such thing. In the first place, it gives us no reason for believing that the cause of our sensations is all-powerful, all-knowing, or all-good. Second, it gives us no reason for believing that our sensations are caused by one being. Maybe different kinds of sensations are caused by

Reality is that which refuses to go away when I stop believing in it.

—PHILLIP K. DICK

different kinds of spirits. So even if we accept a supernatural cause of our sensations, there is no need to identify it with the Christian God.

But must our sensations have a supernatural cause? If they can't be caused by material objects (because material objects cannot exist), it might seem that there is no other alternative. But Berkeley's rejection of material objects is questionable.

Berkeley claims that it's impossible for something to exist unconceived. This could mean one of two things: (a) that it's not possible to conceive *of* something that is unconceived or (b) that it's not possible to conceive *that* something exists unconceived. In the first case, our thought is directed on an object; in the second, on a proposition. (a) is undoubtedly true. If something is being conceived (thought about) by someone, it cannot also be unconceived (not thought about). But (b) is false. You can believe the proposition that something exists unconceived without thereby thinking about any particular object. When you believe that something exists unconceived, the object of your belief—what your belief is about—is the *proposition* that something exists unconceived, not some individual thing. So believing that something exists unconceived is logically possible because it doesn't involve attributing both a property and its negation to anything. Consequently, the notion of a material object is not self-contradictory.

The question now becomes, Which is the better explanation of our sensations? That they are produced by God or by material objects? We have seen that, in general, natural explanations are preferable to supernatural ones because supernatural explanations usually raise more questions than they answer. Berkeley's theory raises a number of them. How is the mind link established? What sort of energy carries thoughts from God's mind to ours? Why does God choose the particular sensations he does? Why do some people get good sensations and others get bad ones? A theory that raises more questions than it answers, however, does not increase our understanding. Alan Goldman puts the point this way:

> ... [S]everal other standard criteria for evaluating explanations disqualify appeals to the supernatural despite their seeming theoretical depth.
>
> First, such appeal does not really deepen our understanding ... since we have no conception of the mechanism or the precise link between the supposed divine intentions and their effects. This, coupled with the lack of predictive power, renders the appeal epistemically sterile. Not only would our understanding not be deepened by such an explanation, not only would no natural questions be answered, but many more would arise without possibility of answer.[62]

Berkeley's appeal to God as the cause of our sensations would be justified if it provided the best explanation of our sense experience. But it doesn't. It is inconsistent with established views about the cause of our sensations, and it is more complex than the materialist hypothesis in that it postulates supernatural beings. So Berkeley's theory lacks the virtues of conservatism and simplicity. It also lacks the virtue of fruitfulness. It has not successfully predicted any new phenomena or solved any problems it was not intended to solve. The materialist theory, on the other hand, has innumerable successful predictions

to its credit. Because Berkeley's theory does not provide the best explanation of perception, we're not justified in believing it.

But what if we remove God from Berkeley's theory? What if we simply say that objects are patterns of sensation and leave it at that? Explanation has to stop somewhere. If we took patterns of sensations as brute facts without trying to explain where they come from, we could at least defeat the skeptic and simplify our theory of what exists. Unfortunately, phenomenalism can't even claim these benefits, because material objects can't be reduced to patterns of sensations.

Consider the phenomenalist claim that to say that there is a tree in front of you is to say that "if you were to have reaching-out sensations, you would have hardness sensations; if you were to have kicking sensations, you would have pain-in-the-toe sensations; . . ." and so on for every possible action. From the fact that there is a tree in front of you, does it follow that if you had reaching-out sensations, you would have hardness sensations? No, because you might be on drugs, your nervous system might be wired wrong, you might be having a seizure, or the like. What you sense is determined by the state of your body at the time. If your body is in an abnormal state, your sensory patterns may also be abnormal. To make the sentence about sensations equivalent to the sentence about mental states, we would have to preface it with the statement, "If your body were in a normal state. . . ." But now we no longer have a reduction because the statement about sensations contains a reference to bodies. Statements about material objects are not reducible to statements about sensations, because we cannot translate all statements that refer to material objects into statements that refer only to sensations. So even a godless phenomenalism won't do.

It looks like the best explanation of perception is the one provided by science. There are material objects in the world. These material objects have certain intrinsic qualities identified by the physical sciences. When these objects interact with our sense organs, they produce certain sensations. To have knowledge of the external world, our sensations don't have to resemble the qualities of the objects that produce them. All we need to know is what properties produce what sensations in what circumstances. And science gives us that knowledge.

Summary

Direct realism claims that we perceive objects directly, without the intermediary of any ideas. The argument from illusion, however, suggests that we're not directly aware of the external world. Our perception of the external world seems to be mediated by our sensations.

Representative realism holds that our sensations are caused by material objects and that some of our sensations resemble the qualities of those material objects. The sensations that resemble the qualities of objects are known as primary qualities, whereas those that exist only in the mind are known as secondary qualities. All of our sensations can vary depending on the

conditions under which they're produced, so it doesn't seem that the distinction between primary and secondary qualities is a viable one.

Berkeley not only rejects the distinction between primary and secondary qualities, he also rejects the notion that our sensations are caused by material objects. According to him, minds and their contents are all that really exist. Objects are just patterns of sensations. For them to exist, they must be perceived. To be is to be perceived. Berkeley tries to show that the whole idea of our sensations representing material objects is incoherent. The notion that material objects continue to exist when we're not thinking of them is incoherent, Berkeley says, because it's impossible to conceive of something's existing unconceived. He says that the best explanation of our recurrent patterns of sensations is not that material objects exist, but that God puts those sensations in our minds.

But there is nothing incoherent about the proposition that something exists unconceived. It is logically possible for matter to exist. Furthermore, the better (simpler, more conservative, more fruitful) explanation of our sensations is not that God produced them, but that material objects produced them.

Study Questions

1. What is direct realism?
2. What is the argument from illusion?
3. What is representative realism?
4. What is the distinction between primary and secondary qualities?
5. What is phenomenalism?
6. Why does Berkeley believe that sensations can't represent material objects?
7. Why does Berkeley believe that it's impossible for material objects to exist?

Discussion Questions

1. Do you think that the argument from illusion requires the postulation of sense data? Are there other ways of accounting for illusions?
2. Is there any difference between a perfect illusion and the real thing? If so, what is that difference?
3. Must a representative realist believe that some sense data actually resemble the qualities of material objects? Is it enough if the sense data just represent the qualities of material objects? Why or why not?
4. Can Berkeley's phenomenalism account for hallucinations? If ideas are all that exist, how could a hallucination be distinguished from an ordinary perception?

Internet Inquiries

1. Solipsism is the view that one's own mind is all that can be known to exist. Can you know otherwise? To explore the issue, go to **http://www.iep.utm.edu/s/solipsis.htm**.

2. Are we justified in believing that there is such a thing as extrasensory perception (ESP)? To explore this issue, enter "esp," "evidence," and "knowledge" into an Internet search engine.

3. Some who deny that there is a world existing independently of our minds are scientists who work in the branch of physics known as quantum mechanics, which studies subatomic particles. On the subatomic level (the quantum realm), particles behave strangely. For example, they don't acquire some of their characteristics until they are observed. Such odd facts have prompted some quantum physicists to reject the notion that the world is made up of objects that exist independently of human consciousness. These antirealists ask, in effect, "Does the moon exist when someone isn't looking at it?" Other scientists and philosophers, the realists, think this antirealist view is profoundly mistaken. For a brief review of the controversy and of some of the arguments on both sides, see **http://www.sfu.ca/content/dam/sfu/philosophy/docs/bradley/moon.pdf**. Which arguments do you find most plausible? Are you a realist or an antirealist? Why?

Section 7.3

What Do You Know?
Knowing What Knowledge Is

Ignorance is the curse of God; knowledge is the wing wherewith we fly to heaven.

—WILLIAM SHAKESPEARE

So, it seems, we can acquire knowledge of the external world by means of the senses. But what is knowledge? As we saw at the beginning of the chapter, knowledge has traditionally been taken to be true belief that is based on reason. True belief, by itself, doesn't count as knowledge because a true belief could be a lucky guess. What grounds our beliefs in reality and promotes them to the status of knowledge is the reasons we have for them. If the reasons are good ones, the beliefs they support are justified. Thus knowledge has traditionally been defined as justified true belief.

This account of knowledge was accepted for millennia. But in 1963, a surprising thing happened. Edmund Gettier, an unpublished philosophy professor, developed some thought experiments that seemed to undermine the traditional account. Gettier's thought experiments suggest that although justified true belief is necessary for knowledge, it's not sufficient; you can have justified true belief without having knowledge. This was a startling discovery, and epistemologists have spent the last forty-five years trying to come up with a theory of knowledge that captures its essence without falling prey to Gettier-type thought experiments.

Here's Gettier's most famous thought experiment. It's a little contrived, but just as a technically sophisticated physical experiment can reveal flaws in a well-established scientific theory, Gettier's thought experiment reveals flaws in the traditional theory of knowledge.

Thought Experiment

Gettier's Guy in Barcelona

Let us suppose that Smith has strong evidence for the following proposition:

(f) Jones owns a Ford.

Smith's evidence might be that Jones has at all times in the past within Smith's memory owned a car, and always a Ford, and that Jones has just offered Smith a ride while driving a Ford. Let us imagine, now, that Smith has another friend, Brown, of whose whereabouts he is totally ignorant. Smith selects three place-names quite at random, and constructs the following three propositions:

(g) Either Jones owns a Ford, or Brown is in Boston;

(h) Either Jones owns a Ford, or Brown is in Barcelona;

(i) Either Jones owns a Ford, or Brown is in Brest-Litovsk.

Each of these propositions is entailed by (f). Imagine that Smith realizes the entailment of each of these propositions he has constructed by (f), and proceeds to accept (g), (h), and (i) on the basis of (f). Smith has correctly inferred (g), (h), and (i) from a proposition for which he has strong evidence. Smith is therefore completely justified in believing each of these three propositions. Smith, of course, has no idea where Brown is.

But imagine now that two further conditions hold. First, Jones does *not* own a Ford, but is at present driving a rented car. And secondly, by the sheerest coincidence, and entirely unknown to Smith, the place mentioned in proposition (h) happens really to be the place where Brown is. If these two conditions hold, then Smith does *not* know that (h) is true, even though (*i*) (h) *is* true, (*ii*) Smith does believe that (h) is true, and (*iii*) Smith is justified in believing that (h) is true.[63]

Do you see why Smith has knowledge according to the traditional account? Smith believes the proposition (h)—Either Jones owns a Ford, or Brown is in Barcelona—and that proposition is true because Brown is, in fact, in Barcelona. Furthermore, Smith is justified in believing (h) because as far back as he can remember, Jones has always owned a Ford and he recently offered Smith a ride in one. But even though Smith is justified in believing that (h) is true, he doesn't know that (h) is true because his justification is not related to what makes it true. Smith is justified in believing that Jones owns a Ford. But what makes (h) true is that Brown is in Barcelona. Reasons, remember, are supposed to ground our beliefs in reality, and in this case, they don't do so. So Smith, we might say, believes the right thing for the wrong reason. As a result, he doesn't have knowledge.

The Defeasibility Theory

What has gone wrong? How can we alter the traditional account to accurately reflect the fact that Smith doesn't have knowledge? Some claim that the reason that Smith doesn't have knowledge is that there are facts, unknown to him, that defeat his claim to know. If Smith were to realize that (f)—Jones owns a Ford—is false, he would no longer be justified in believing (h). So the fact that Jones doesn't own a Ford defeats Smith's claim to know. If there were no such defeaters—if there were no further facts which are

> *To kill an error is as good a service as, and sometimes even better than, the establishing of a new truth or fact.*
>
> —Charles Darwin

such that if he came to believe them, he would lose his justification—then he would have knowledge. A proposition that can't be defeated by the addition of any new facts is said to be indefeasible. Thus we have what has come to be known as the **defeasibility theory:** Knowledge is indefeasible justified true belief.

This theory does an admirable job of handling Gettier's Guy in Barcelona. Unfortunately it has the effect of shrinking our knowledge almost to the vanishing point because many things we can legitimately claim to know can be defeated. For most propositions we are justified in believing, there are facts which are such that if we came to believe them, we would lose our justification. Consider Lehrer and Paxson's Case of the Demented Mrs. Grabit.

Thought Experiment

Lehrer and Paxson's Demented Mrs. Grabit

Suppose I see a man walk into the library and remove a book from the library by concealing it beneath his coat. Since I am sure the man is Tom Grabit, whom I have often seen before when he attended my classes, I report that I know that Tom Grabit has removed the book. However, suppose further that Mrs. Grabit, the mother of Tom, has averred that on the day in question Tom was not in the library, indeed, was thousands of miles away, and that Tom's identical twin brother, John Grabit, was in the library. Imagine, moreover, that I am entirely ignorant of the fact that Mrs. Grabit has said these things. The statement that she has said these things would defeat any justification I have for believing that Tom Grabit removed the book. Thus, I could not be said to [know] that Tom Grabit removed the book.

The preceding might be acceptable until we finish the story by adding that Mrs. Grabit is a compulsive and pathological liar, that John Grabit is a fiction of her demented mind, and that Tom Grabit took the book as I believed. Once this is added, it should be apparent that I did know that Tom Grabit removed the book.[64]

Knowledge is knowing that we cannot know.
—RALPH WALDO EMERSON

defeasibility theory
The doctrine that knowledge is undefeated justified true belief.

In this case, Lehrer is justified in believing that Tom Grabit stole a book from the library because he saw him do it. But the fact that Mrs. Grabit said that it was not Tom but Tom's identical twin, John, who was in the library defeats Lehrer's justification. So, according to the defeasibility theory, Lehrer's belief that Tom stole a book does not count as knowledge because that belief is defeasible; there is a fact which is such that if Lehrer came to believe it, he would no longer be justified in his belief. But wait—that conclusion can't be correct because there is another fact that defeats the defeater, namely, the fact that Mrs. Grabit is a pathological liar! It seems, then, that what knowledge requires is not simply a justification that has no defeaters, but a justification all of whose defeaters can themselves be defeated. Spelling out exactly what that involves has not proved to be an easy task.

The Causal Theory

Recall that in the case of Gettier's Guy in Barcelona, the problem seemed to be that what Smith believed was not appropriately related to what made it true. So some have sought to solve the Gettier problem by requiring a closer link between one's belief and its truth-makers. Specifically, it has been claimed that knowledge requires a causal relation between the two. First proposed by Alvin Goldman, the **causal theory** says that knowledge is suitably caused true belief. Here "suitably caused" means produced by the state of affairs that makes the belief true.

The causal theory accords with our judgments in both the Gettier case and the Lehrer and Paxson case. In the Gettier case, Smith doesn't know that either Jones owns a Ford or Brown is in Barcelona because he is not causally related to the fact that makes it true, namely, that Brown is in Barcelona. In the Lehrer and Paxson case, Lehrer does know that Tom Grabit stole a book from the library because he is causally related to the fact that makes it true; he saw it with his own eyes.

The causal theory is a dramatic departure from the standard account, for the causation requirement would replace the justification condition found in the traditional account. Knowing something, according to the causal theory, does not require being able to state your justification for your belief. Rather, it requires being suitably causally connected to the object of your belief. This is not to deny that knowledge is sometimes based on inference, but when it is, the inference is part of the causal chain that produced that knowledge. In this way, the conversion of your true belief into knowledge can depend entirely on facts or items of which you are not even aware. This dependence on external factors is why the causal theory is sometimes called an "externalist theory." A theory like the standard account is called "internalist" because what changes true belief into knowledge depends on something—justification, in this case—that is part of the knower's mental life.

But is suitably caused true belief really sufficient for knowledge? Consider the following scenario. Suppose someone, let's call him Henry, is leisurely driving through an area of the country known for its historic barns. It's a clear day, Henry's eyesight is good, and his view is unobstructed by any natural or artificial objects, like trees or traffic signs. If Henry looks closely at one of the barns as he drives by, we would ordinarily claim that Henry knows that he is looking at a barn. But if we were given certain sorts of information about the countryside, we might rescind our claim, as Alvin Goldman explains:

> *An explanation of cause is not a justification by reason.*
> —C. S. LEWIS

Thought Experiment

Goldman's Fake Barns

Suppose that, unknown to Henry, the district he has just entered is full of papier-mâché facsimiles of barns. These facsimiles look from the road exactly like barns, but are really just facades, without back walls or interiors, quite

causal theory The doctrine that knowledge is suitably caused true belief.

incapable of being used as barns. Having just entered the district, Henry has not encountered any facsimiles; the object he sees is a genuine barn. But if the object on that site were a facsimile, Henry would mistake it for a barn. Given this new information, we would be strongly inclined to withdraw the claim that Henry knows the object is a barn.[65]

Henry's belief that he is looking at a barn seems to be caused in an appropriate way by the barn he is looking at—but he doesn't know that he's looking at a barn because the presence of the fake barns undermines his ability to know. The right kind of causal connection seems to be there, but that's not enough to ensure knowledge given the sort of environment he finds himself in.

The Reliability Theory

Knowledge is the small part of ignorance that we arrange and classify.

—AMBROSE BIERCE

In Goldman's fake barns thought experiment, why doesn't Henry know that the object is a barn? Some have thought that the problem in such cases is that the belief was acquired in an unreliable way. Henry doesn't know that the object is a barn because, under the circumstances of facsimile barns dotting the landscape, just looking while driving along is not a reliable way to acquire the belief that a certain object is a barn. In this situation, Henry would frequently believe that there was a barn when there wasn't one. His belief would be produced in an unreliable fashion. This suggests an account of knowledge that's an improvement over the causal theory. It is the **reliability theory:** the doctrine that knowledge is reliably produced true belief. You know p if p is true, you believe that p is true, and your belief is produced in a reliable way.

Like the causal theory, the reliability theory is externalist. What turns true belief into knowledge is the reliability of the process of producing belief. Some internal factor like the justification condition referred to in the standard account does not play a role. According to the causal theory, the knower may not even be aware of the belief-producing process. So here, too, knowing is a matter of registering truth, like a thermometer registering the temperature of a room. The important thing is that this registering be reliable.

But is such registering—such reliably produced true belief—knowledge? Let's pursue the thermometer analogy a little further in a thought experiment and see what it tells us.

Thought Experiment

Lehrer's Human Thermometer

Suppose a person, whom we shall name Mr. Truetemp, undergoes brain surgery by an experimental surgeon who invents a small device which is both a very accurate thermometer and a computational device capable of generating thoughts. The device, call it a tempucomp, is implanted in Truetemp's head so that the very tip of the device, no larger than the head of a pin, sits unnoticed

reliability theory
The doctrine that knowledge is reliably produced true belief.

on his scalp and acts as a sensor to transmit information about the temperature to the computational system in his brain. This device, in turn, sends a message to his brain causing him to think of the temperature recorded by the external sensor. Assume that the tempucomp is very reliable, and so his thoughts are correct temperature thoughts. All told, this is a reliable belief-forming process. Now imagine, finally, that he has no idea that the tempucomp has been inserted in his brain, is only slightly puzzled about why he thinks so obsessively about temperature, but never checks a thermometer to determine whether these thoughts about the temperature are correct. He accepts them unreflectively, another effect of the tempucomp. Thus, he thinks and accepts that the temperature is 104 degrees. It is. Does he know that it is? Surely not. He has no idea whether he or his thoughts about the temperature are reliable. What he accepts, that the temperature is 104 degrees, is correct, but he does not know that his thought is correct.[66]

How can Truetemp be said to know that the temperature is 104 degrees if he has no idea that his reliable belief-forming process even exists? He is in possession of correct information, but he has no idea if that information is correct. On the reliability account, having evidence regarding whether the information is correct is irrelevant. But this is implausible. In at least some cases, knowing seems to require more than just having correct information; it seems to require that we have some adequate indication that the information is correct. Without such indication, our having some true belief would be merely coincidental. Relative to whatever evidence we had, the belief would be no better than a lucky guess. But, as we have already observed, a lucky guess cannot be knowledge. The reliability theory may be able to account for many cases of knowledge, but it doesn't seem to account for them all.

Ignorance cannot be learned.
—GERARD DE NERVAL

Virtue Perspectivism

Ernest Sosa has developed an approach to knowledge that incorporates aspects of both externalism and internalism. Known as **virtue perspectivism**, it is based on the view that knowledge is a cognitive achievement attained through the use of intellectual virtue. A virtue, in general, is a skill or ability that reliably produces some good. A moral virtue is a skill or ability that reliably produces right actions, whereas an intellectual virtue is a skill or ability that reliably produces true beliefs. Intellectual virtues would include such things as perception, memory, and reason, as well as the acceptance of testimony.

Sosa believes acquiring knowledge is a kind of performance because, like a performance, it has a goal—true belief—and it can be evaluated along the same lines as any other performance: accuracy, adroitness, and aptness.[67]

A performance is accurate if it achieves its goal. Consider the case of an archer shooting at a target. If the archer hits the bull's-eye, his performance is accurate.

A performance is adroit if it manifests the skill of the performer. If the archer, in taking his shot, does everything that a skilled archer should do,

Theories that are capable of giving more detailed explanations are automatically preferred.
—DAVID DEUTSCH

virtue perspectivism The doctrine that knowledge is apt belief, that is, belief that is taken to be true because of one's intellectual virtue.

his performance is adroit. An adroit performance, however, need not be accurate. Even if the archer does everything right—and thus gives an adroit performance—he may fail to hit the bull's-eye because of some unforeseen circumstance, like a gust of wind.

A performance is apt if it's accurate because it's adroit. If the archer hits the bull's-eye because of his skill—and not because of some lucky coincidence—then his performance is apt.

In the case of knowledge acquisition, the goal is true belief. So a belief is accurate if it's true, adroit if it manifests the intellectual virtue of the believer, and apt if it's believed to be true because of that virtue. To solve the Gettier problem, however, Sosa needs to draw one more distinction: that between animal knowledge and reflective knowledge.

Animal knowledge is apt belief, that is, true belief that one has acquired because of one's intellectual virtue. It's called "animal knowledge" because, as you might suspect, animals can have this kind of knowledge. When an animal forms true beliefs about its environment by means of its senses, for example, it has animal knowledge. Most perceptual knowledge—including ours—is animal knowledge. Animal knowledge is an externalist form of knowledge because to have it, we don't have to be aware of the principles or processes that underlie it.

Reflective knowledge is apt belief that we know to be apt. In other words, it is animal knowledge that we know to be knowledge. Reflective knowledge, then, is a second-order or meta-level kind of knowledge that is acquired by reflecting on the principles or processes that underlie animal knowledge. It's an internalist form of knowledge because those who have it are consciously aware of the conditions that produced it.

With these intellectual resources, Sosa believes that he can solve—or dissolve—the Gettier problem. Take the case of Gettier's Guy in Barcelona. Sosa would say that Smith has neither animal nor reflective knowledge because his belief is not apt—he doesn't believe that (h) is true because of his intellectual competence. His intellectual competence may explain why he believes (h), but it doesn't explain why (h) is true. So he doesn't know that (h) is true.[68]

In the case of Goldman's fake barns, Henry has animal knowledge but not reflective knowledge. He has animal knowledge because his true belief that he sees a barn is caused by him looking at a barn. But he doesn't have reflective knowledge because he doesn't know that he knows that he sees a barn. He doesn't have this second-order type of knowledge because he is unaware that he is in a situation that makes his seeing a barn a lucky coincidence. Because he is not aware of the fact that the conditions under which he is viewing a barn are abnormal, he doesn't have reflective knowledge.[69]

Sosa would give the same verdict in the case of Lehrer's Human Thermometer: Truetemp has animal knowledge but not reflective knowledge. He has animal knowledge because the tempucomp device implanted in his head reliably produces true beliefs about the temperature. But he doesn't have reflective knowledge because he is totally unaware of the principles or processes that underlie those true beliefs.

What about the case of the Demented Mrs. Grabit? Sosa could say that, in this case, Lehrer has both animal and reflective knowledge. He has animal

knowledge that Tom stole the book because he saw him do it, and he has reflective knowledge because he knows that the conditions under which he saw him steal it are conducive to knowledge. There are no undefeated defeaters to undermine his reflective knowledge. If there were, then, as in the case of Goldman's fake barns, he would no longer have reflective knowledge.

Sosa's theory is certainly not the last word on the Gettier problem, but it marks an important advance in our thinking about the nature of knowledge. A number of criticisms have been raised against it, and it has inspired others to develop alternative virtue epistemologies in an attempt to address them. Sosa himself has continued to refine his theory. How successful it is will be determined by its explanatory power and how well it holds up to future thought experiments.

Summary

The traditional account of propositional knowledge says that there are three necessary and sufficient conditions for knowledge—a proposition must be true, one must believe that it is true, and one must be justified in believing that it is true. Philosopher Edmund Gettier and others, however, have produced thought experiments showing that one can have a justified true belief and still not know. So the traditional theory of knowledge is inadequate, and the challenge is to craft a better account.

One of the first attempts at another theory of knowledge was the defeasibility theory—the doctrine that knowledge is undefeated justified true belief. It requires that our justification for a true belief not be defeated by additional evidence were we to acquire that evidence. But thought experiments reveal that undefeated justified true belief is not sufficient for knowledge.

The causal theory avoids the defeasibility problems. It's the theory that knowledge is suitably caused true belief. If what makes a belief true is also what causes the belief in us, we have knowledge, whether or not we have justification (in the usual sense) for that belief. The causal analysis fails, however, because it is possible to have suitably caused true belief and still not have knowledge. Also, it is possible to have knowledge without the proposed causal connection.

The reliability theory is an improvement over the causal theory. It's the theory that knowledge is reliably produced true belief. If your true belief arises from a reliable process, you have knowledge, even if you have no idea whether the belief is well founded. But this is implausible because knowing seems to require more than just having correct information—it requires that we have some adequate indication that the information is correct.

Virtue perspectivism is the theory that knowledge is apt belief, that is, belief taken to be true because of one's intellectual virtue. This type of knowledge is externalist because to have it, you don't have to be aware of the principles or processes that produced it. Reflective knowledge is apt belief that one knows to be knowledge. This type of belief is internalist because having it requires being aware of the conditions under which it was produced. In Gettier-type cases, one can have neither, one or the other, or both.

Study Questions

1. What is the standard account of knowledge?
2. What is Gettier's Guy in Barcelona thought experiment? What does it reveal about the standard account of knowledge?
3. What is the defeasibility theory?
4. What is Lehrer and Paxson's demented Mrs. Grabit thought experiment? How does it attempt to undermine a version of the defeasibility theory?
5. What is the causal theory? Why is it called an externalist theory?
6. What is Goldman's fake barns thought experiment? How does it attempt to undermine the causal theory?
7. What is the reliability theory? Is it an externalist view?
8. How is the reliability theory an improvement over the causal theory?
9. What is Lehrer's human thermometer thought experiment? How does it attempt to undermine the reliability theory?
10. What is the difference between animal and reflective knowledge? How can these types of knowledge be used to evaluate Gettier cases?

Discussion Questions

1. If the defeasibility theory is correct, is the scope of our knowledge (the extent of what we could rightfully claim to know) likely to be greater or less than what we normally assume?
2. If the causal theory is correct, how would this change the scope of our knowledge?
3. Suppose some weird surgeon secretly implants a device in your head that consistently gives you accurate beliefs regarding the terrain on Mars. You are not aware of this belief-forming process, but it is highly reliable. You thus have plenty of true beliefs about the Martian landscape—but do you know these propositions?
4. Suppose that every week, you suddenly believe that a certain five-digit number will be the big winner in the state lottery. You have no idea where these beliefs come from, but the numbers invariably win the weekly lottery. You never even check to see whether the number does win; you just come to believe that it will. You regularly believe truly—but do you know?
5. How would virtue perspectivism explain the lack of knowledge in Gettier's Guy in Barcelona thought experiment?

Internet Inquiries

1. Suppose that God (or a demon or a space alien) secretly beams into your brain accurate forecasts of the next day's weather. You don't know why or how, but every day you find yourself predicting tomorrow's weather,

for no reason, and you are always right. Is it correct to say, then, that you know what tomorrow's weather will be? To explore this question, enter "knowledge," "reliabilism," and "philosophy" into an Internet search engine.

2. Do you have a choice about what you believe, or are all of your beliefs programmed into you? Can you make yourself believe something you know to be false? To examine this issue, enter "volitionalism" and "belief" into an Internet search engine.

3. Why is knowledge so important? Is it as important as understanding? Or is understanding more important? What should be the goal of inquiry? To explore these issues, enter "knowledge," "understanding," and "epistemic value" into an Internet search engine.

RENÉ DESCARTES

Meditations on First Philosophy: Meditation 1

See Chapter 2 readings and the box "René Descartes: Father of Modern Philosophy" for biographical information. In this selection, Descartes argues for the principle of clarity and distinctness, which says that whatever one clearly and distinctly perceives is true.

OF THE THINGS OF WHICH WE MAY DOUBT.

SEVERAL years have now elapsed since I first became aware that I had accepted, even from my youth, many false opinions for true, and that consequently what I afterward based on such principles was highly doubtful; and from that time I was convinced of the necessity of undertaking once in my life to rid myself of all the opinions I had adopted, and of commencing anew the work of building from the foundation, if I desired to establish a firm and abiding superstructure in the sciences. But as this enterprise appeared to me to be one of great magnitude, I waited until I had attained an age so mature as to leave me no hope that at any stage of life more advanced I should be better able to execute my design. On this account, I have delayed so long that I should henceforth consider I was doing wrong were I still to consume in deliberation any of the time that now remains for action. Today, then, since I have opportunely freed my mind from all cares [and am happily disturbed by no passions], and since I am in the secure possession of leisure in a peaceable retirement, I will at length apply myself earnestly and freely to the general overthrow of all my former opinions.

But, to this end, it will not be necessary for me to show that the whole of these are false—a point, perhaps, which I shall never reach; but as even now my reason convinces me that I ought not the less carefully to withhold belief from what is not entirely certain and indubitable, than from what is manifestly false, it will be sufficient to justify the rejection of the whole if I shall find in each some ground for doubt. Nor for this purpose will it be necessary even to deal with each belief individually, which would be truly an endless labor; but, as the removal from below of the foundation necessarily involves the downfall of the whole edifice, I will at once approach the criticism of the principles on which all my former beliefs rested.

All that I have, up to this moment, accepted as possessed of the highest truth and certainty, I received either from or through the senses. I observed, however, that these sometimes misled us; and it is the part of prudence not to place absolute confidence in that by which we have even once been deceived.

But it may be said, perhaps, that, although the senses occasionally mislead us respecting minute objects, and such as are so far removed from us as to be beyond the reach of close observation, there are yet many other of their informations (presentations), of the truth of which it is manifestly impossible to doubt; as for example, that I am in this place, seated by the fire, clothed in a winter dressing gown, that I hold in my hands this piece of paper, with other intimations of the same nature. But how could I deny that I possess these hands and this body, and withal escape being classed with persons in a state of insanity, whose brains are so disordered and clouded by dark bilious vapors as to cause them pertinaciously to assert that they are monarchs when they are in the greatest poverty; or clothed [in gold] and purple when destitute of any covering; or that their head is made of clay, their body of glass, or that they are

Source: René Descartes, excerpts from "Meditations on First Philosophy," Meditation I, Meditation II, and Meditation IV from *The Method, Meditations, and Philosophy of Descartes*, translated by John Veitch, London: M. Walter Dunne, 1901.

gourds? I should certainly be not less insane than they, were I to regulate my procedure according to examples so extravagant.

● Though this be true, I must nevertheless here consider that I am a man, and that, consequently, I am in the habit of sleeping, and representing to myself in dreams those same things, or even sometimes others less probable, which the insane think are presented to them in their waking moments. How often have I dreamt that I was in these familiar circumstances, that I was dressed, and occupied this place by the fire, when I was lying undressed in bed? At the present moment, however, I certainly look upon this paper with eyes wide awake; the head which I now move is not asleep; I extend this hand consciously and with express purpose, and I perceive it; the occurrences in sleep are not so distinct as all this. But I cannot forget that, at other times I have been deceived in sleep by similar illusions; and, attentively considering those cases, I perceive so clearly that there exist no certain marks by which the state of waking can ever be distinguished from sleep, that I feel greatly astonished; and in amazement I almost persuade myself that I am now dreaming.

Let us suppose, then, that we are dreaming, and that all these particulars—namely, the opening of the eyes, the motion of the head, the forth-putting of the hands—are merely illusions; and even that we really possess neither an entire body nor hands such as we see. Nevertheless it must be admitted at least that the objects which appear to us in sleep are, as it were, painted representations which could not have been formed

● unless in the likeness of realities; and, therefore, that those general objects, at all events, namely, eyes, a head, hands, and an entire body, are not simply imaginary, but really existent. For, in truth, painters themselves, even when they study to represent sirens and satyrs by forms the most fantastic and extraordinary, cannot bestow upon them natures absolutely new, but can only make a certain medley of the members of different animals; or if they chance to imagine something so novel that nothing at all similar has ever been seen before, and such as is, therefore, purely fictitious and absolutely false, it is at least certain that the colors of which this is composed are real. And on the same principle, although these general objects, viz. [a body], eyes, a head, hands, and the like, be imaginary, we are nevertheless absolutely necessitated to admit the reality at least of some other objects still more simple and universal than these, of which, just as of certain real colors, all those images of things, whether true and real, or false and fantastic, that are found in our consciousness (cogitatio), are formed.

To this class of objects seem to belong corporeal nature in general and its extension; the figure of extended things, their quantity or magnitude, and their number, as also the place in, and the time during, which they exist, and other things of the same sort.

We will not, therefore, perhaps reason illegitimately if we conclude from this that Physics, Astronomy, Medicine, and all the other sciences that have for their end the consideration of composite objects, are indeed of a doubtful character; but that Arithmetic, Geometry, and the other sciences of the same class, which regard merely the simplest and most general objects, and scarcely inquire whether or not these are really existent, contain somewhat that is certain and indubitable: for whether I am awake or dreaming, it remains true that two and three make five, and that a square has but four sides; nor does it seem possible that truths so apparent can ever fall under a suspicion of falsity [or incertitude].

Nevertheless, the belief that there is a God who is all powerful, and who created me, such as I am, has, for a long time, obtained steady possession of my mind. How, then, do I know that he has not arranged that there should be neither earth, nor sky, nor any extended thing, nor figure, nor magnitude, nor place, providing at the same time, however, for [the rise in me of the perceptions of all these objects, and] the persuasion that these do not exist otherwise than as I perceive them? And further, as I sometimes think that others are in error respecting matters of which they believe themselves to possess a perfect knowledge, how do I know that I am not also deceived each time I add together two and three, or number the sides of a square, or form some judgment still more simple, if more simple indeed can be imagined? But perhaps Deity has not been willing that I should be thus deceived, for he is said to be supremely good. If, however, it were repugnant to the goodness of Deity to have created me subject to constant deception, it would seem likewise to be contrary to his goodness to allow me to be occasionally deceived; and yet it is clear that this is permitted.

Some, indeed, might perhaps be found who would be disposed rather to deny the existence of a Being so powerful than to believe that there is nothing certain. But let us for the present refrain from opposing this opinion, and grant that all which is here said of a Deity is fabulous: nevertheless, in whatever way it be supposed that I reach the state in which I exist, whether by fate, or chance, or by an endless series of antecedents and consequents, or by any other means, it is clear (since to be deceived and to err is a certain defect) that the probability of my being so imperfect as to be the constant victim

of deception, will be increased exactly in proportion as the power possessed by the cause, to which they assign my origin, is lessened. To these reasonings I have assuredly nothing to reply, but am constrained at last to avow that there is nothing of all that I formerly believed to be true of which it is impossible to doubt, and that not through thoughtlessness or levity, but from cogent and maturely considered reasons; so that henceforward, if I desire to discover anything certain, I ought not the less carefully to refrain from assenting to those same opinions than to what might be shown to be manifestly false.

But it is not sufficient to have made these observations; care must be taken likewise to keep them in remembrance. For those old and customary opinions perpetually recur—long and familiar usage giving them the right of occupying my mind, even almost against my will, and subduing my belief; nor will I lose the habit of deferring to them and confiding in them so long as I shall consider them to be what in truth they are, viz, opinions to some extent doubtful, as I have already shown, but still highly probable, and such as it is much more reasonable to believe than deny. It is for this reason I am persuaded that I shall not be doing wrong, if, taking an opposite judgment of deliberate design, I become my own deceiver, by supposing, for a time, that all those opinions are entirely false and imaginary, until at length, having thus balanced my old by my new prejudices, my judgment shall no longer be turned aside by perverted usage from the path that may conduct to the perception of truth. For I am assured that, meanwhile, there will arise neither peril nor error from this course, and that I cannot for the present yield too much to distrust, since the end I now seek is not action but knowledge.

I will suppose, then, not that Deity, who is sovereignly good and the fountain of truth, but that some malignant demon, who is at once exceedingly potent and deceitful, has employed all his artifice to deceive me; I will suppose that the sky, the air, the earth, colors, figures, sounds, and all external things, are nothing better than the illusions of dreams, by means of which this being has laid snares for my credulity; I will consider myself as without hands, eyes, flesh, blood, or any of the senses, and as falsely believing that I am possessed of these; I will continue resolutely fixed in this belief, and if indeed by this means it be not in my power to arrive at the knowledge of truth, I shall at least do what is in my power, viz, [suspend my judgment], and guard with settled purpose against giving my assent to what is false, and being imposed upon by this deceiver, whatever be his power and artifice. But this undertaking is arduous, and a certain indolence insensibly leads me back to my ordinary course of life; and just as the captive, who, perchance, was enjoying in his dreams an imaginary liberty, when he begins to suspect that it is but a vision, dreads awakening, and conspires with the agreeable illusions that the deception may be prolonged; so I, of my own accord, fall back into the train of my former beliefs, and fear to arouse myself from my slumber, lest the time of laborious wakefulness that would succeed this quiet rest, in place of bringing any light of day, should prove inadequate to dispel the darkness that will arise from the difficulties that have now been raised.

READING QUESTIONS

1. What is Descartes trying to accomplish in this first meditation?

2. How are the dream argument and the evil demon argument supposed to help Descartes accomplish his goal?

3. What is Descartes' dream argument and evil demon argument? Are they sound? Why or why not?

4. Does knowledge require certainty? If so, how much do we know about the world? If not, what does knowledge require?

BERTRAND RUSSELL

On Induction

A biographical sketch of Bertrand Russell appears on page 59. In this selection, he provides an overview of the problem of induction.

In almost all our previous discussions we have been concerned in the attempt to get clear as to our data in the way of knowledge of existence. What things are there in the universe whose existence is known to us owing to our being acquainted with them? So far, our answer has been that we are acquainted with our sense-data, and, probably, with ourselves. These we know to exist. And past sense-data which are remembered are known to have existed in the past. This knowledge supplies our data.

But if we are to be able to draw inferences from these data—if we are to know of the existence of matter, of other people, of the past before our individual memory begins, or of the future, we must know general principles of some kind by means of which such inferences can be drawn. It must be known to us that the existence of some one sort of thing, A, is a sign of the existence of some other sort of thing, B, either at the same time as A or at some earlier or later time, as, for example, thunder is a sign of the earlier existence of lightning. If this were not known to us, we could never extend our knowledge beyond the sphere of our private experience; and this sphere, as we have seen, is exceedingly limited. The question we have now to consider is whether such an extension is possible, and if so, how it is effected.

Let us take as an illustration a matter about which of us, in fact, feel the slightest doubt. We are all convinced that the sun will rise tomorrow. Why? Is this belief a mere blind outcome of past experience, or can it be justified as a reasonable belief? It is not easy to find a test by which to judge whether a belief of this kind is reasonable or not, but we can at least ascertain what sort of general beliefs would suffice, if true, to justify the judgement that the sun will rise tomorrow, and the many other similar judgements upon which our actions are based.

It is obvious that if we are asked why we believe that the sun will rise tomorrow, we shall naturally answer, 'Because it always has risen every day'. We have a firm belief that it will rise in the future, because it has risen in the past. If we are challenged as to why we believe that it will continue to rise as heretofore, we may appeal to the laws of motion: the earth, we shall say, is a freely rotating body, and such bodies do not cease to rotate unless something interferes from outside, and there is nothing outside to interfere with the earth between now and tomorrow. Of course it might be doubted whether we are quite certain that there is nothing outside to interfere, but this is not the interesting doubt. The interesting doubt is as to whether the laws of motion will remain in operation until tomorrow. If this doubt is raised, we find ourselves in the same position as when the doubt about the sunrise was first raised.

The only reason for believing that the laws of motion remain in operation is that they have operated hitherto, so far as our knowledge of the past enables us to judge. It is true that we have a greater body of evidence from the past in favour of the laws of motion than we have in favour of the sunrise, because the sunrise is merely a particular case of fulfillment of the laws of motion, and there are countless other particular cases. But the real question is: Do any number of cases of a law being fulfilled in the past afford evidence that it will be fulfilled in the future? If not, it becomes plain that we have no ground whatever for expecting the sun to rise tomorrow, or for expecting the bread we shall eat at our next

Source: Bertrand Russell, *The Problems of Philosophy* (New York: Henry Holt and Company, 1912) 60–69.

meal not to poison us, or for any of the other scarcely conscious expectations that control our daily lives. It is to be observed that all such expectations are only probable; thus we have not to seek for a proof that they must be fulfilled, but only for some reason in favour of the view that they are likely to be fulfilled.

Now in dealing with this question we must, to begin with, make an important distinction, without which we should soon become involved in hopeless confusions. Experience has shown us that, hitherto, the frequent repetition of some uniform succession or coexistence has been a cause of our expecting the same succession or coexistence on the next occasion. Food that has a certain appearance generally has a certain taste, and it is a severe shock to our expectations when the familiar appearance is found to be associated with an unusual taste. Things which we see become associated, by habit, with certain tactile sensations which we expect if we touch them; one of the horrors of a ghost (in many ghost-stories) is that it fails to give us any sensations of touch. Uneducated people who go abroad for the first time are so surprised as to be incredulous when they find their native language not understood.

And this kind of association is not confined to men; in animals also it is very strong. A horse which has been often driven along a certain road resists the attempt to drive him in a different direction. Domestic animals expect food when they see the person who feeds them. We know that all these rather crude expectations of uniformity are liable to be misleading. The man who has fed the chicken every day throughout its life at last wrings its neck instead, showing that more refined views as to the uniformity of nature would have been useful to the chicken.

But in spite of the misleadingness of such expectations, . . . they nevertheless exist. The mere fact that something has happened a certain number of times causes animals and men to expect that it will happen again. Thus our instincts certainly cause us to believe the sun will rise tomorrow, but we may be in no better a position than the chicken which unexpectedly has its neck wrung. We have therefore to distinguish the fact that past uniformities cause expectations as to the future, from the question whether there is any reasonable ground for giving weight to such expectations after the question of their validity has been raised.

The problem we have to discuss is whether there is any reason for believing in what is called 'the uniformity of nature'. The belief in the uniformity of nature is the belief that everything that has happened or will happen is an instance of some general law to which there are no exceptions. The crude expectations which we have been considering are all subject to exceptions, and therefore liable to disappoint those who entertain them. But science habitually assumes, at least as a working hypothesis, that general rules which have exceptions can be replaced by general rules which have no exceptions. 'Unsupported bodies in air fall' is a general rule to which balloons and aeroplanes are exceptions. But the laws of motion and the law of gravitation, which account for the fact that most bodies fall, also account for the fact that balloons and aeroplanes can rise; thus the laws of motion and the law of gravitation are not subject to these exceptions.

The belief that the sun will rise tomorrow might be falsified if the earth came suddenly into contact with a large body which destroyed its rotation; but the laws of motion and the law of gravitation would not be infringed by such an event. The business of science is to find uniformities, such as the laws of motion and the law of gravitation, to which, so far as our experience extends, there are no exceptions. In this search science has been remarkably successful, and it may be conceded that such uniformities have held hitherto. This brings us back to the question: Have we any reason, assuming that they have always held in the past, to suppose that they will hold in the future?

It has been argued that we have reason to know that the future will resemble the past, because what was the future has constantly become the past, and has always been found to resemble the past, so that we really have experience of the future, namely of times which were formerly future, which we may call past futures. But such an argument really begs the very question at issue. We have experience of past futures, but not of future futures, and the question is: Will future futures resemble past futures? This question is not to be answered by an argument which starts from past futures alone. We have therefore still to seek for some principle which shall enable us to know that the future will follow the same laws as the past.

The reference to the future in this question is not essential. The same question arises when we apply the laws that work in our experience to past things of which we have no experience—as, for example, in geology, or in theories as to the origin of the Solar system. The question we really have to ask is: "When two things have been found to be often associated, and no instance is known of the one occurring without the other, does the occurrence of one of the two, in a fresh instance, give any good ground for expecting the other?" On our answer to this question must depend the validity of the whole of our expectations as to the future, the whole of the results obtained by induction, and in fact practically all the beliefs upon which our daily life is based.

It must be conceded, to begin with, that the fact that two things have been found often together and never apart does not, by itself, suffice to prove demonstratively that they will be found together in the next case we examine. The most we can hope is that the oftener things are found together, the more probable it becomes that they will be found together another time, and that, if they have been found together often enough, the probability will amount almost to certainty. It can never quite reach certainty, because we know that in spite of frequent repetitions there sometimes is a failure at the last, as in the case of the chicken whose neck is wrung. Thus probability is all we ought to seek.

It might be urged, as against the view we are advocating, that we know all natural phenomena to be subject to the reign of law, and that sometimes, on the basis of observation, we can see that only one law can possibly fit the facts of the case. Now to this view there are two answers. The first is that, even if some law which has no exceptions applies to our case, we can never, in practice, be sure that we have discovered that law and not one to which there are exceptions. The second is that the reign of law would seem to be itself only probable, and that our belief that it will hold in the future, or in unexamined cases in the past, is itself based upon the very principle we are examining.

The principle we are examining may be called the principle of induction, and its two parts may be stated as follows:

(a) When a thing of a certain sort A has been found to be associated with a thing of a certain other sort B, and has never been found dissociated from a thing of the sort B, the greater the number of cases in which A and B have been associated, the greater is the probability that they will be associated in a fresh case in which one of them is known to be present;

(b) Under the same circumstances, a sufficient number of cases of association will make the probability of a fresh association nearly a certainty, and will make it approach certainty without limit.

As just stated, the principle applies only to the verification of our expectation in a single fresh instance. But we want also to know that there is a probability in favour of the general law that things of the sort A are always associated with things of the sort B, provided a sufficient number of cases of association are known, and no cases of failure of association are known. The probability of the general law is obviously less than the probability of the particular case, since if the general law is true, the particular case must also be true, whereas the particular case may be true without the general law being true. Nevertheless the probability of the general law is increased by repetitions, just as the probability of the particular case is. We may therefore repeat the two parts of our principle as regards the general law, thus:

(a) The greater the number of cases in which a thing the sort A has been found associated with a thing the sort B, the more probable it is (if no cases of failure of association are known) that A is always associated with B;

(b) Under the same circumstances, a sufficient number of cases of the association of A with B will make it nearly certain that A is always associated with B, and will make this general law approach certainty without limit.

It should be noted that probability is always relative to certain data. In our case, the data are merely the known cases of coexistence of A and B. There may be other data, which might be taken into account, which would gravely alter the probability. For example, a man who had seen a great many white swans might argue by our principle, that on the data it was probable that all swans were white, and this might be a perfectly sound argument. The argument is not disproved by the fact that some swans are black, because a thing may very well happen in spite of the fact that some data render it improbable. In the case of the swans, a man might know that colour is a very variable characteristic in many species of animals, and that, therefore, an induction as to colour is peculiarly liable to error. But this knowledge would be a fresh datum, by no means proving that the probability relatively to our previous data had been wrongly estimated. The fact, therefore, that things often fail to fulfil our expectations is no evidence that our expectations will not probably be fulfilled in a given case or a given class of cases. Thus our inductive principle is at any rate not capable of being disproved by an appeal to experience.

The inductive principle, however, is equally incapable of being proved by an appeal to experience. Experience might conceivably confirm the inductive principle as regards the cases that have been already examined; but as regards unexamined cases, it is the inductive principle alone that can justify any inference from what has been examined to what has not been examined. All arguments which, on the basis of experience, argue as to the future or the unexperienced parts of the past or present, assume the inductive principle; hence we can never use experience to prove the inductive principle without begging the question. Thus we must either accept the inductive principle on the

ground of its intrinsic evidence, or forgo all justification of our expectations about the future. If the principle is unsound, we have no reason to expect the sun to rise tomorrow, to expect bread to be more nourishing than a stone, or to expect that if we throw ourselves off the roof we shall fall. When we see what looks like our best friend approaching us, we shall have no reason to suppose that his body is not inhabited by the mind of our worst enemy or of some total stranger. All our conduct is based upon associations which have worked in the past, and which we therefore regard as likely to work in the future; and this likelihood is dependent for its validity upon the inductive principle.

The general principles of science, such as the belief in the reign of law, and the belief that every event must have a cause, are as completely dependent upon the inductive principle as are the beliefs of daily life. All such general principles are believed because mankind have found innumerable instances of their truth and no instances of their falsehood. But this affords no evidence for their truth in the future, unless the inductive principle is assumed.

Thus all knowledge which, on a basis of experience tells us something about what is not experienced, is based upon a belief which experience can neither confirm nor confute, yet which, at least in its more concrete applications, appears to be as firmly rooted in us as many of the facts of experience. The existence and justification of such beliefs—for the inductive principle, as we shall see, is not the only example—raises some of the most difficult and most debated problems of philosophy. We will, in the next chapter, consider briefly what may be said to account for such knowledge, and what is its scope and its degree of certainty.

READING QUESTIONS

1. What is the problem of induction? Can the problem be solved by empirical investigation? Why or why not?
2. Russell asks whether any number of cases of a law of nature being fulfilled in the past can provide us with evidence that it will be fulfilled in the future, and his answer is no. Why does he say this?
3. Is the inductive principle capable of being disproved by an appeal to experience? Why or why not?
4. According to Russell, are the general principles of science dependent on the inductive principle (which cannot be proved)? Is belief in these principles, then, a matter of religious faith? How do you think Russell would answer this?

ERNEST SOSA

Getting It Right

Ernest Sosa is Board of Governors Professor of Philosophy at Rutgers University and editor of *Nous* and *Philosophy* and *Phenomenological Research*. He has served as President of the American Philosophical Association and is a Fellow of the Academy of Arts and Sciences. In this selection, he outlines the principles underlying the approach to epistemology that he pioneered—virtue epistemology—and explains how it helps solve the Gettier problem.

What is it to *truly know* something? In our daily lives, we might not give this much thought—most of us rely on what we consider to be fair judgment and common sense in establishing knowledge. But the task of clearly defining true knowledge is trickier than it may first seem, and it is a problem philosophers have been wrestling with since Socrates.

In the complacent 1950s, it was received wisdom that we know a given proposition to be true if, and only if, it *is* true, we believe it to be true, and we are justified in so believing. This consensus was exploded in a brief 1963 note by Edmund Gettier in the journal Analysis.

Here is an example of the sort used by Gettier to refute that theory. Suppose you have every reason to believe that you own a Bentley, since you have had it in your possession for many years, and you parked it that morning at its usual spot. However, it has just been destroyed by a bomb, so that you own no Bentley, despite your well justified belief that you do. As you sit in a cafe having your morning latte, you muse that someone in that cafe owns a Bentley (since after all *you* do). And it turns out you are right, but only because the other person in the cafe, the barista, owns a Bentley, which you have no reason to suspect. So you here have a well justified true belief that is not knowledge.

After many failed attempts to fix the justified-true-belief account with minor modifications, philosophers tried more radical departures. One promising approach suggests that knowledge is a form of action, comparable to an archer's success when he consciously aims to hit a target.

An archer's shot can be assessed in several ways. It can be *accurate* (successful in hitting the target). It can also be *adroit* (skillful or competent). An archery shot is adroit only if, as the arrow leaves the bow, it is oriented well and powerfully enough. But a shot that is both accurate and adroit can still fall short. Consider an adroitly shot arrow leaving the bow with an orientation and speed that would normally take it straight to the bull's-eye. A gust of wind then diverts it, but a second gust puts it back on track. This shot is both accurate and adroit, but it fails to be *apt*. A shot's aptness requires that its success be attained not just by luck (such as the luck of that second gust). The success must rather be a result of competence.

This suggests the *AAA account* of a good archery shot. But we can generalize from this example, to give an account of a fully successful attempt of any sort. Any attempt will have a distinctive aim and will thus be fully successful only if it succeeds not only adroitly but also aptly.

Of course, a fully successful attempt is good overall only if the agent's goal is good enough. An attempt to murder an innocent person is not good even if it fully succeeds. Aristotle in his "Nicomachean Ethics" developed an AAA account of attempts to lead a flourishing life in accord with fundamental human virtues (for example, justice or courage). Such an approach is called virtue ethics. Since there is much truth that must be grasped if one is to flourish, some philosophers have begun to treat truth's apt attainment as virtuous in the Aristotelian sense, and have developed a *virtue*

Ernest Sosa, "Getting It Right," *The New York Times*, May 25, 2015. Copyright © 2015 by The New York Times Company. All rights reserved. Used by permission and protected by the Copyright Laws of the United States. The printing, copying, redistribution, or retransmission of the Material without express written permission is prohibited.

epistemology, which also turns out to solve problems like that posed by Gettier. (Aristotle himself in VI.2 of the "Nicomachean Ethics" upholds attaining truth as the proper work of the intellect.)

Virtue epistemology begins by recognizing assertions or *affirmations*. These can be either public, out loud, or to oneself in the privacy of one's own mind. An affirmation could have any of many and various aims, and it could even have several at once. It could aim at misleading someone, as when it is a lie. Or it could be aimed at showing off, or at propping someone up, or at instilling confidence in oneself as one enters athletic competition.

A particularly important sort of affirmation is one aimed at attaining truth, at getting it right. Such an affirmation is called alethic (from the Greek term for truth). All it takes for an affirmation to be alethic is that one of its aims be: getting it right.

Humans perform acts of public affirmation in the endeavor to speak the truth, acts with crucial importance to a linguistic species. We need such affirmations for activities of the greatest import for life in society: for collective deliberation and coordination, and for the sharing of information. We need people to be willing to affirm things publicly. And we need them to be sincere (by and large) in doing so, by aligning public affirmation with private judgment. Finally, we need people whose assertions express what they actually know.

Virtue epistemology gives an AAA account of knowledge: to know affirmatively is to make an affirmation that is accurate (true) and adroit (which requires taking proper account of the evidence). But in addition, the affirmation must be apt; that is, its accuracy must be attributable to competence rather than luck.

Requiring knowledge to be apt (in addition to accurate and adroit) reconfigures epistemology as the ethics of belief. And, as a bonus, it allows contemporary virtue epistemology to solve our Gettier problem. We now have an explanation for why you fail to know that someone in the cafe owns a Bentley, when your own Bentley has been destroyed by a bomb, but the barista happens to own one. Your belief in that case falls short of knowledge for the reason that it fails to be apt. You are *right* that someone in the cafe owns a Bentley, but the correctness of your belief does *not* manifest your cognitive or epistemic competence. You are right only because by epistemic luck the barista happens to own one. When in your musings you affirm to yourself that someone in the cafe owns a Bentley, therefore, your affirmation is not an apt alethic affirmation, and hence falls short of knowledge.

Reading Questions

1. According to Sosa, what makes a performance accurate? adroit? apt?
2. What distinguishes Gettier-style cases of true belief from cases of knowledge?
3. How is virtue epistemology similar to virtue ethics?
4. According to Sosa, why do Gettier-style cases fail to count as knowledge?

THOMAS D. DAVIS

Why Don't You Just Wake Up?

Thomas D. Davis has taught philosophy at Michigan, Grinnell College, the University of Redlands, and De Anza College. He is the author of numerous short stories, as well as two mystery novels with philosophical themes: *Suffer Little Children,* which received a Shamus Award from the Private Eye Writers of America for best first mystery of 1991, and *Murdered Sleep.* In this short story, Davis explores the implications of Descartes' dream argument.

I'm in the living room at home, and Dad's there, all serious, saying, "John, where's your mind these days—you've got to wake up," and I think I wake up, and I'm at my desk at home. I straighten up and yawn and pick up my history book, and just then Mom comes in, saying, "Johnny, you're just not concentrating—you've got to wake up," and I think I wake up, and I'm sitting in class. I look around, and Teresa's sitting next to me looking all upset, saying, "John, what's with you these days—why don't you just wake up," and I think I wake up, and I'm lying in bed in my dorm room.

It was all dreams within dreams within dreams, and what I thought was waking was just more dreaming. I am in my dorm bed and wonder who is going to come in next and wake me from this, only no one comes in, and the digital clock blinks slowly toward seven-thirty, and I guess this must be real.

It doesn't seem real, though. Nothing does these days. Everything that happens seems sort of vague somehow and out of focus and not all that important. I have trouble concentrating—taking things seriously—and everybody's on my case. That's the reason, I think, for all those dreams about dreaming and waking.

One reason, anyway. The other is that philosophy class and all that talk about Descartes and whether all reality could be a dream. That's not helping much either.

I'm late picking up Teresa again, and she's had to wait, and there won't be time for us to get coffee together. She gives me that exasperated look I see a lot these days, and we walk across campus without talking. Finally, she says:

"I don't know why I took that stupid philosophy class. I can't wait 'til it's over."

I know it's not really the class she's annoyed at. It's me and the way I've been lately. I know I should say something nice. But I'm feeling pushed and kind of cranky.

"I like the class," I say, to be contrary. "You do not."

"I do. It's kind of interesting."

"Interesting. Right. Like I really want to sit around all day wondering whether I'm dreaming everything in the world."

"Maybe you are."

"Sure." She shakes her head. "That's so stupid."

"Just because you say 'stupid' doesn't make it wrong. How do you know you aren't just dreaming this all up?"

She glares at me, but her eyes begin to dart the way they always do when she's thinking hard. She's not in the mood for this, but I've gotten her mad.

"Because . . . I know what dreams look like. They're all hazy. Not like the world looks now."

"You mean what you can see of it through the smog."

"Funny."

I know what she means, though. A few weeks back I would have said that being awake looked a lot different from dreaming. But the guy in class is right. That's just a matter of how things look. It doesn't prove how things are.

"Look," I say, "nobody's denying that what we call 'dreaming' looks different from what we call 'being awake.' But is it really different? Maybe 'being awake' is just a different kind of dream."

"Yeah, well, if I'm making all this up, how come we're talking about something I don't want to talk about?"

Source: Thomas D. Davis, "Why Don't You Just Wake Up?" *Philosophy* (New York: McGraw-Hill, 1993) 163–166.

"Because you're not in control of this dream any more than you are your dreams at night. It's your unconscious doing it."

"This is so much bullsh. . . ."

"Why?"

"It's crazy. You're standing here trying to convince me that everything is my dream while you know you're real. That doesn't make any sense."

"Yeah, it does. I'm saying you can't know that I really exist, I can't know that you. . . ."

I stop suddenly, because something scary is happening. It's like a ripple moving through the whole world, coming from the horizon to my left, but moving fast as if the world is really much smaller than it appears. And where the ripple is, everything becomes elongated and out of focus. The ripple passes over Teresa, distorting her for a moment, like a fun house mirror. Then it's gone, and everything's back to normal.

"John, are you okay?" says Teresa, giving me a worried look. "You look white as a sheet."

"I don't know. I just got the weirdest feeling. I guess I'm okay."

"John, are you on something?"

"No. I told you. Really."

She looks at me for a moment and decides I'm telling the truth.

"Come on," she says, taking my hand. "The last thing you need right now is philosophy class. Let's go get something to eat and then sit in the sun for awhile. I bet you'll feel better."

"Hey, Ter, I'm sorry I'm being such a jerk. I . . ."

"Don't worry about it, John. It's okay. Come on."

Later I do feel better. I feel like things are almost back to normal. But my night is full of dreams within dreams, and the next day the world seems full of unreality once again. And then, at midday, the world ripples again.

I go to the university health service, and of course the doctor thinks it's drugs, and we go round and round on that until I insist that he test me and then he begins to believe I'm not lying. He becomes nicer then, and more concerned, and schedules some tests and an appointment with a specialist he'd like me to see, though he's "sure its nothing, just exhaustion."

Walking across campus, I see the world ripples again and suddenly I realize what it all looks like. It's like when you are watching a movie in class, and the movie screen ripples, distorting the image, and suddenly you're aware that it wasn't a world in front of you at all, but just an illusion on a not-very-large piece of material. I put my arm out to feel the ripple, only my arm ripples too because it's part of the movie.

I don't know what's happening, and I'm afraid. At night I keep myself from sleeping because the idea of dreaming is something I suddenly find disturbing. In the morning I'm exhausted, but I stumble off to class because I want something to divert my attention, but once there I have trouble paying attention. I guess the professor must have asked me something I didn't hear because I feel Teresa nudging me in the ribs, and hear her say, "Come on, John, wake up."

I look up then at the professor standing behind his lectern, and just above and in back of him a dark line seems to appear in the wall. It looks like the slow fissure of an earthquake, except that the edges fold back against the surface of the wall like the edges of torn paper, and I see that behind the tearing there is nothing at all, just darkness. Then I see that the tear isn't in the wall at all but in my field of vision because as it reaches the professor he begins to split apart and then the lectern and then the head of the student in the front row. On both sides of the tear the world distorts and folds and collapses. The fissure moves downward through the students and then, as I glance down, through my own body. No one is moving or screaming—they take no more notice than movie characters on a torn movie screen would. In a panic I reach out and touch Teresa, then watch as she and my hand distort, as everything, absolutely everything, falls away.

* * * * *

It is night. It's always night. A night without stars, without anything—just an infinite emptiness falling away on every side. And so I float, an invisible being in a nonexistent world.

How long have I been like this? I don't know. It feels like years, but that's just a feeling because there is nothing here by which to mark the time.

I try to remember how it was, but my memories are such pale things, and they grow more pale as time drags on.

I would pray, but there is nothing to pray to. And so I hope, for hope is all I have: that one day, as inexplicably as once I did, I will begin to dream the world again.

Reading Questions

1. Teresa insists that she can tell the difference between dreams and reality, but John thinks not. What reason does he give for thinking she's wrong?
2. John at first finds the idea of dreaming disturbing, but in the end he seems eager to dream again. Why the change?
3. Does this story illustrate or undermine Descartes' point about dreaming and waking?
4. This story is fiction, but it makes a serious point. What point?

Notes

1. Bertrand Russell, *The Problems of Philosophy* (New York: Henry Holt & Co., 1912) 73.
2. Plato, "Meno," 98b, trans. W. K. C. Guthrie, *The Collected Works of Plato,* ed. Edith Hailton and Huntington Cairns (Princeton, NJ: Princeton University Press, 1961) 382.
3. Plato, "Meno," 98a 381.
4. Aristotle, "Metaphysics," 1011b 25–28, trans. Richard McKeon, *The Basic Works of Aristotle* (New York: Random House, 1941) 749.
5. Brand Blanshard, *The Nature of Thought,* vol. 2 (New York: Allen and Unwin, 1955) 264.
6. Charles Sanders Peirce, "How to Make Our Ideas Clear," *Popular Science Monthly* 12 (January 1878) 286–302.
7. William James, *Essays in Pragmatism* (New York: Hafner, 1948) 170.
8. Plato, "Theatetus," in *Plato: The Collected Dialogues,* ed. Edith Hamilton and Huntington Cairns, trans. F. M. Cornford (Princeton, NJ: Princeton University Press, 1961) 152a (p. 856).
9. Plato, "Theatetus," 171a, trans. F. M. Conford, *The Collected Works of Plato* (Princeton, NJ: Princeton University Press, 1973) 876.
10. W. V. O. Quine, "On Empirically Equivalent Systems of the World," *Erkenntnis* 9 (1975) 327–328.
11. J. L. Austin, "Unfair to Facts," *Philosophical Papers,* ed. J. O. Urmson and W. O. Warnock (Oxford: Oxford University Press, 1979) 165.
12. Heraclitus, *Herekleitos and Diogenes,* trans. Guy Davenport (San Francisco: Grey Fox Press, 1979) 15.
13. Heraclitus 14.
14. The Buddha, quoted in Walpola Rahula, *What the Buddha Taught* (New York: Grove Press, 1974) 25–26.
15. *The Philosophers of Ancient Greece* (Albany: State University of New York Press, 1981) 60–61.
16. Aristotle, *Physics* 187a 2–3.
17. Gregory Vlastos, "Zeno of Elea," *The Encyclopedia of Philosophy,* vol. 8 (New York: Macmillan, 1967) 378.
18. Russell Ruthen, "Catching the Wave," *Scientific American* 266 (March 1992) 90.
19. Plato, *Republic,* 514a–520a, trans. Benjamin Jowett (New York: Colonial Press, 1901).
20. Plato, "Phaedo," *The Dialogues of Plato,* trans. Benjamin Jowett (New York: Random House, 1937) 100e (p. 484).
21. René Descartes, *Meditations on First Philosophy,* Meditation I, *The Philosophical Works of Descartes,* ed. E. S. Haldane and G. R. T. Ross (Cambridge: Cambridge University Press, 1973) 145.
22. René Descartes, *Meditations on First Philosophy,* Meditation I, *The Method, Meditations, and Philosophy of Descartes,* trans. by John Veitch (London: M. Walter Dunne, 1901), 221.
23. *Ibid.* 222.
24. Peter Unger, *Ignorance* (Oxford: Oxford University Press, 1975) 7–8.
25. René Descartes, *Meditations on First Philosophy,* Meditation II, *The Method, Meditations, and Philosophy of Descartes,* trans. by John Vietch (London: M. Walter Dunne, 1901) 225–226.
26. René Descartes, *Meditations on First Philosophy,* Meditation IV, *The Method, Meditations, and Philosophy of Descartes,* trans. by John Veitch (London: M. Walter Dunne, 1901) 257.
27. *Ibid.* 254.
28. James Van Cleve, "Foundationalism, Epistemic Principles, and the Cartesian Circle," *The Philosophical Review* 88 (1979) 55–91.
29. David Hume, *Enquiries Concerning the Human Understanding and Concerning the Principles of Morals,* sec. II, para. 20, ed. L. A. Selby-Bigge (Oxford: Clarendon Press, 1972) 22.
30. Hume, *Enquiries,* sec. XII, pt. III, para. 132, p. 165.
31. Hume, *Enquiries,* sec. IV, pt. I, para. 20, p. 25.
32. Hume, *Enquiries,* sec. IV, pt. I, para. 22, p. 26.
33. Hume, *Enquiries,* sec. IV, pt. I, para. 21, pp. 25–26.
34. Hume, *Enquiries,* sec. IV, pt. I, para. 32, pp. 37–38.
35. Hume, *Enquiries,* sec. V, pt. I, para. 36, p. 43.
36. Immanuel Kant, *Critique of Pure Reason,* trans. Norman Kemp Smith (New York: St. Martin's Press, 1929) B5.
37. Immanuel Kant, *Critique of Pure Reason,* Bxii–Bxv.
38. Kant, *Critique of Pure Reason,* A93–B126.
39. Alfred Korzybski, *Science and Sanity,* 4th ed. (Lakeville, CT: International Non-Artistotelian Library, 1933) 58.
40. Kant, *Critique of Pure Reason,* A125.
41. Steven T. Katz, "Language, Epistemology, and Mysticism," in *Mysticism and Philosophical Analysis,* ed. Steven T. Katz (New York: Oxford University Press, 1978) 39–40.
42. Walter T. Stace, *Time and Eternity* (Princeton, NJ: Princeton University Press, 1952) 33.
43. Ludwig Wittgenstein, *Tractatus Logico-Philosophicus,* proposition 7.
44. Satprem, *Sri Aurobindo, or the Adventure of Consciousness* (New York: Harper & Row, 1968) 37.
45. Robert Nozick, *Philosophical Explanations* (Cambridge, MA: Harvard University Press, 1981) 158.
46. Bertrand Russell "A Debate on the Existence of God," in *Bertrand Russell on God and Religion,* ed. Al Seckel (Buffalo, NY: Prometheus Books, 1986) 136.
47. Russell 136.
48. Pamela Weintraub in "Masters of the Universe," *Omni,* March (1990) 89.
49. A. J. Ayer, "The Argument from Illusion," *Perception and the External World,* ed. R. J. Hirst (New York: Macmillan, 1965) 128.
50. Bertrand Russell, *The Problems of Philosophy* 17.
51. John Locke, *An Essay Concerning Human Understanding,* book 4, chap. 4, sec. 3, ed. Peter Nidditch (Oxford: Clarendon Press, 1975) 563.
52. Locke, book 4, chap. 11, sec. 4, 632.
53. Locke, sec. 5, 632.
54. Locke, sec. 6, 633.
55. Locke, sec. 7, 633.
56. Locke, sec. 8, 634.
57. Locke, book 2, chap. 8, sec. 9, 134.
58. George Berkeley, "A Treatise Concerning the Principles of Human Knowledge," para. 14 in *Principles, Dialogues, and Philosophical Correspondence,* ed. Colin Murray Turbayne (New York: Bobbs-Merrill, 1965) 28.
59. Berkeley (23) 32.
60. George Berkeley, "Three Dialogues between Hylas and Philonous" in *George Berkeley: Principles, Dialogues, and Philosophical Correspondence,* ed. Colin Murray Turbayne (New York: Bobbs-Merrill Company, 1965) 196.
61. Cited in Martin Gardner, "Quantum Weirdness," *Discover* (October 1982) 69.
62. Alan Goldman, *Empirical Knowledge* (Berkeley: University of California Press, 1988) 233–234.
63. Edmund L. Gettier, "Is Justified True Belief Knowledge?" from *Analysis* 23 (1963).
64. Keith Lehrer and Thomas D. Paxson, Jr., excerpt from "Knowledge: Undefeated Justified True Belief " from *Journal of Philosophy* 66.8 (1969).
65. Alvin I. Goldman, "Discrimination and Perceptual Knowledge," *Journal of Philosophy* 73 (1976) 771–791.
66. Keith Lehrer, *Theory of Knowledge* (Boulder, CO: Westview Press, 1990) 163–164.
67. Ernest Sosa, *A Virtue Epistemology* (Oxford: Clarendon Press, 2007) 22ff.
68. Sosa 95.
69. Sosa 96.

Index

A posteriori knowledge, 539, 560, 563
A priori knowledge, 539, 540, 560, 563
Abduction, 36
Abelard, Pierre, 96
Abolitionist project, 366–367
Abortion
 Bible on, 57
 cultural relativism and, 336
 moral arguments on, 46–49, 52, 56
Absent qualia objection, 125, 127–128
Absolutism
 defined, 544
 political, Hobbes on, 390
 subjective, 332–340
Absurdity, and faith, 506, 507
Accidental property, 252
Acquaintance, knowledge by, 538
Acton, Lord (John Dalberg-Acton), 341
Actual duty, 381
Act-utilitarianism, 355–363, 367
 Bentham and, 356, 357, 420
 on caring relationships, 394
 defined, 356
 duties and, 360–361
 happiness calculations in, 356–358, 359
 happiness in, 355–358, 359, 365–366, 379, 402–403
 justice and, 361–363, 374
 Kant's categorical imperative *vs.*, 371, 374, 377, 378–389
 Mill and, 357–358
 "Of the Principle of Utility" (Bentham), 420–422
 punishment and, 362, 374
 rights and, 359–360
 thought experiments, 359–360, 361–363
 virtuous person in, 402–403
Ad hoc hypotheses, 500
Ad hominem (against the person), 40
Adam and Eve story, 490–492, 493, 494, 501
Adams, John, 387
Adams, John Quincy, 565
Adams, Scott, 441
Adequacy, criteria of, 37–38
Adler, Alfred, 14
Affirming a disjunct, 34
Affirming the antecedent, 31
Affirming the consequent, 33
Afterlife
 hell, 344, 345
 in new body, Christianity on, 251
 in reanimated body, 259–261
Agar, W. E., 156
Agent causation, 227–232
Agnosticism, 437
Ahura Mazda, 436
AI (movie), 114
Albus, James S., 71–72
Alexander, Samuel, 155
Alexander the Great, 17, 407
Alien hand syndrome, 297
Aliens
 creating humans, 260, 460
 miracles and, 470
 religion and, 481
 speciesism and, 112
Allah, 436
Allegory of the cave, 549–552
Allen, Woody, 11, 70, 78, 252, 449
Alternative possibilities, principle of, 205, 206, 207, 215–216, 221
Amar, Shlomo, 495
Ambrose, St., 10
American Jewish Congress, 465
American Society for the Prevention of Cruelty to Robots, 50
Analogical design argument, 452–455
Analogical induction, 35–36
Analogy, faulty, 41
Analytic propositions, 540, 541, 560
Anarchists, 392
Anatta, 439
Anaxagoras, 15–16
Anaximander, 18, 456

Anaximines, 18–19
Ancient Greeks. *See* Greeks, ancient
Androids, and free will, 178, 232
Anicca, 439
Animal(s)
 ability to feel pain, 84
 Descartes and, 84
 free will and, 215
 knowledge of, 590–591
 suffering of, Bentham on, 358, 378–379
 unnecessary suffering of, as evil, 489, 493
Animal experimentation, 84
Animal knowledge, 590–591
Animal Liberation Front (ALF), 84
Animal rights, 50, 379
Animalism, 258–267, 272–273
 body switches and, 263–264
 brain transplants and, 264–265
 defined, 259
 multiple persons in one body and, 265–267
 reanimation of body and, 259–261
 vegetative states and, 258–259, 261–262
Animatrix, The (movie), 114
Anouilh, Jean, 494
Anselm, Saint, ontological argument for God's existence, 475–476
Anthony, Susan B., 336
Anthropology
 cultural relativism and, 336, 337–338, 339
 moral relativism and, 331
Antirealism, 583
Antrim, Minna, 103
Apeiron, 18
Apparent memory, 280, 281
Appeal
 to fear, 41
 to ignorance, 40–41
 to the masses, 40
 to tradition, 40
 to unqualified authority, 40
Aquinas, Saint Thomas
 beliefs of, 444
 biography, 444
 "The Five Ways," 521–522
 on God's abilities, 342
 on God's existence, 443–447, 484, 521–522
 on God's will as morality, 342–343
 resurrection of body and, 260–261
 traditional cosmological (first-cause) argument of, 443–447, 484, 521–522
Argument(s), 28–42
 cogent, 34, 35
 cognitive subjectivism and, 542
 deductive, 30, 31–34, 328
 defined, 28, 29
 dialectic, 548
 fallacious, 38–42
 good, conditions for, 28–29
 identifying, 29–31
 inductive, 30–31, 34–38
 invalid forms of, 33–34
 overview, 28–29, 42
 against the person, 40
 sound, 32–33
 strong, 31, 34, 35
 valid, 30, 31
 valid forms of, 31–34
Argument from common consent, 438–440
Argument from evil, 487–489, 503
Argument from miracles, 466–471, 482, 484
Argument from nonbelief, 449
Argument from religious experience, 471–474, 484
Aristotle
 on agent causation, 227
 Aquinas and, 444
 biography, 407
 on desire for knowledge, 538
 evolutionary theory and, 456
 on happiness, 407–408
 on justice, 361
 laws of logic and, 24
 Plato and, 407
 on "spheres of life," 415
 Stoics *vs.*, 410, 413
 theory of human beings, tested, 44–45
 theory of motion, tested, 54
 on virtue, 406–409, 415, 418
 on Zeno, 548
Armstrong, David M., 162
 "The Mind-Brain Identity Theory," 162–167
Arnold, Matthew, 468
Artificial beings with real general intelligence (AGI), 75

Artificial intelligence, 25. *See also* Robots
 absent qualia objection to, 125
 coming age of, questions raised by, 71–72
 as end of human era, 74, 138
 intentionality and, 134–136
 language ability and, 71, 128
 meaning of symbols and, 131–134
 nonhuman, rights to, 50
 overview, 121–123
 problem-solving ability and, 71
 strong, 121
 as superhuman intelligence, 8, 74
 thought experiments, 128–129, 131–134, 135–136
Asceticism, 472
Asimov, Isaac, 459, 464, 513
Aspect, 149
Astonishing Hypothesis, The (Crick), 8
Atheism
 defined, 437
 in existentialism, 516
 monotheism *vs.*, 479
 number of adherents, 441
 passionate belief in, 507–508
 religious life in, 518–519
Atlas Shrugged (Rand), 353
Atomic physics
 Dalton and, 99
 Greek atomists, 8, 19, 99
Atoms, unobservability of, 141, 271
Attachment disorder, 405
Augustine, Saint
 Aquinas and, 444
 biography, 267, 490
 on evil as absence of good, 490–491
 free-will defense for evil, 491–493
 on miracles, 468
 on religion and physical reality, 482–483
 teachings of, 267
 on time and universe, 451
Aurelius, Marcus, 410, 412–413
Aurobindo, Sri, 567
Austin, J. L., 543
Authentic choices, 517
Automatism, 277
Autonomy, in Kant's categorical imperative, 378
Avengers, The (movie), 231

Avesta, 438
Axiology, 5–6
Ayer, A. J.
 on direct realism, 571–572
 on emotivism, 334
 on free will and moral responsibility, 204–205

Bacon, Francis, 540, 554
Baier, Kurt, 406
Baillie, John, 499
Balaguer, Mark
 on agent causation, 231
 biography, 240
 on free will, 231
 "Torn Decisions," 240–242
Balance of power, Locke on, 391
Baldwin, Christina, 279
Baldwin, James, 305
Ballou, Hosea, 559
Barrett, William, 71
Basketball Player (thought experiment), 386–387
Bats, 111
Baudelaire, Charles, 446
Bavinck, Herman, 440–441
Beauty, Plato on, 552
Beck, Lewis White, 45
Beecher, Henry Ward, 15, 283, 327, 329
Begging the question, 39
Behavior modification, 194
Behavioral conditioning/reconditioning, 9, 105
Behavioral dispositions, mental states as, 100–106, 115–116
Behavioral therapy, 105
Behaviorism, 191–194
 beliefs of, 8–9
 functionalism *vs.*, 120
 phenomenalism *vs.*, 577
Behe, Michael, 458, 459, 460, 461
Belief
 basing on evidence, as moral duty, 509–512
 in causal theory of knowledge, 587–588
 as causing truth, 507–508
 in eliminative materialism, 141–142
 in evidentialism, 509–512
 factual, and moral judgments, 339, 511

Belief (*continued*)
 in foundationalism, 558
 James on, 512–514
 Kierkegaard on, 512–514
 in miracles, 467–470
 as nonexistent, 141–142
 in oneself, 513
 passionate, 506–508
 pragmatically justified, 479
 in propositional knowledge, 539–544
 rationally justified, 479
 in reliability theory of knowledge, 588–589
 in virtue perspectivism, 589–591
 will to believe, 512–514
Belousov-Zhabotinsky (BZ) reaction, 461
Benchley, Robert, 278
Benedict, Ruth, 336
Benjamin, Martin, 261–262
Bennett, Charles H., 289
Bent pencil illusion, 572
Bentham, Jeremy
 act-utilitarianism and, 356
 on animals, 358, 378–379
 beliefs of, 357
 biography, 357
 on human motivation, 356
 "Of the Principle of Utility," 420–422
 quantification of happiness by, 356
Berger, Ted, 117
Bergson, Henri, 408
Berkeley, George
 biography, 578
 on God's existence, 579–581
 phenomenalism of, 575–581, 582
Berry, Robby, 470–471
Best explanation, inference to the, 440, 455–456
Best-explanation design argument, 455–466
Beyerstein, Barry, 108
Bhagavad Gita, 4, 546
Bible
 on abortion, 57
 Adam and Eve story, 490–492, 493, 494, 501
 in creationism, 462
 God of, 436
 God's existence as proven by, 438
 historical accuracy of, 438, 439
 on killing of unbelievers, 436
 miracles in, 466–471
 as moral code, 327, 444
 on person, 82
 on rebirth in new body, 251
 on value of life, 351
Biblical archaeology, 438, 439
Biblical minimalists, 439
Bickford, Maria, 277
Bierce, Ambrose, 588
"Big bang," 447, 448, 450, 451, 455
"Big crunch," 450
Billiard ball analogy (of soul switch), 270–271
Biochips (neural chips), 116, 117, 250
Biological systems, irreducibly complex, 458–461
Biran, I., 297
Bisection, paradox of, 547–548, 549
Bishop, Jim, 53
"Black Box, The" (Klempner), 243–244
Black holes, 450–451, 463–464
Blade Runner (movie), 281
Blake, William, 47
Blanshard, Brand
 biography, 63
 on coherence theory of truth, 540–541
 on emotivism, 334–335
 on evidentialism, 510–511, 512
 "The Philosophic Enterprise," 63–66
Blanshard's Rabbit (thought experiment), 334–335
Block, Ned, 124
 Chinese Nation (thought experiment), 124–125
 Conversational Jukebox (thought experiment), 135–136
Body
 cryonic suspension of, 259
 Descartes on, 70, 83, 86
 existence without, conceivability argument for, 81–85
 identity retained in, 256
 as machine, 70
 multiple persons occupying, 265–267
 in psychological continuity theory, 285, 292
 reanimation of, 259–261
 rebirth in celestial, 251, 267, 290
 resurrection of, 82, 259–261
 surviving death of, 259, 303

Body organs, selling, 388
Body switches, 263–264, 267, 283
Boethius, 187
Born-again Christians, 251–252, 284
Bostrom, Nick, 570
Bottom-up causation, 151
Bouchard, Thomas J., 193
Boufflers, Stanislas, 8
Boutros-Ghali, Boutros, 337
Brahman, 436, 546
Brain
 artificial devices replacing, 115–116, 117
 in Cartesian dualism, 88–89, 92
 composition and function, 108
 downward causation in, 151–154
 in functionalism, 120, 121
 mental states in beings without, 112–116, 119
 mind as machine and, 72–73
 myth of 10% use of, 110
 separated from body, 262
 split, 86–87, 295–298, 313, 316–317
 transfer of contents to computer, 121–122, 250–251, 283
Brain death, 262
Brain Replacement (thought experiment), 115–116
Brain theory of personal identity, 293–298
 defined, 294
 split brain and, 295–298
 thought experiments, 293–294, 297
Brain transplant, 264–265, 293–294
Brain Transplant (thought experiment), 293–294
Brainstorm (movie), 281, 473
Brandeis, Justice Louis, 382
Brandes, Bernd-Jurgen, 388
Brandt, Richard, 359, 360, 364
 Utilitarian Heir (thought experiment), 360
Brave Officer and Senile General, tale of (thought experiment), 279
Brentano, Franz, 134, 150
Brief History of Time, A (Hawking), 463
British Telecom, 282
Broad, C. D.
 on disembodied existence, 84–85
 on religious experiences, 472
 Typhoid Man (thought experiment), 379

Brontë, Charlotte, 336
Brothers Karamazov, The (Dostoyevsky), 493–494
Broughton, James, 257
Bruno, Giordano, 97
Bryan, William Jennings, 205
Brydges, Samuel, 413
Buchner, Ludwig, 188
Buddha
 on belief, 30
 on change, 545–546
 on virtue, 409
Buddhism
 on change, 299, 545–546
 on evil, 299
 mystical experience in, 566
 on nirvana, 299, 409
 number of adherents, 441
 on self, 10, 271, 299, 303, 439
 supreme being/God in, 438, 439, 518
Bundle theory, 314–317
Buñuel, Luis, 275
Burgess, Anthony, 192
Burke, Edmund, 402
Burt, Sir Cyril, 150
Bush, Jeb, 57
Butler, Bishop Joseph, 280, 355
Butler, Robert N., 465
Butler, Samuel, 145, 180
BZ reaction, 461

Cabanis, Pierre-Jean Georges, 109
Caldwell, Taylor, 194
Callahan, Daniel, 52
Campbell, Donald, 151
Camus, Albert, 277, 517
Candide (Voltaire), 342
Cannibalism
 consensual, 388
 resurrection of the body and, 260–261
Capital punishment, categorical imperative on, 374
Carbon chauvinists, 114
Care
 duty and, 405–406
 ethics of, 394–396
Carnap, Rudolf, 15, 100
Carnegie, Dale, 38

Carnes, Bruce A., 465
Carroll, Lewis, 8
Cartesian certainty, 78, 80, 556–558, 559
Cartesian circle, problem of, 558
Cartesian dualism, 77–93. *See also* Descartes, René
 agent causation and, 228–229
 artificial intelligence and, 71
 causal closure of the physical and, 90–92
 conceivability argument in, 81–85, 259
 defined, 77, 78
 divisibility argument in, 86–87
 empiricist attack on, 99
 identity theory *vs.*, 108–105
 logical behaviorism *vs.*, 101–103
 Meditations on First Philosophy: Meditation II (Descartes), 159–161
 mind in, 70–71, 77, 81
 problem of other minds and, 92–93
 science-religion conflict and, 97
 thought experiments, 70, 119
Cartesian skepticism, 552–558
 certainty in, 78, 80, 556–558, 559
 doubt in, 78–79, 80, 552–556
 thought experiments, 553–554, 555–556
Cary, Joyce, 468
Categorical imperative
 concern for person and, 394, 403–404
 defined, 372
 first formulation, 372–377
 objections to, 375–376
 second formulation, 377–380
 utilitarianism *vs.*, 371, 374, 377, 378–379
 virtue in, 402, 403–405
Category mistake, 102
Causal closure of the physical, 90–92, 101, 154
Causal determinism
 common sense and, 198–199
 compatible with free will. *See* Compatibilism
 defined, 186
 explained, 179, 186, 201
 fatalism *vs.*, 189
 in hard determinism, 184, 186, 188–190
 incompatible with free will, 188, 190
 James on, 179
 moral responsibility ruled out by, 190
 refuted, 195
 science and, 191–198

Causal indeterminism, 198, 199–200, 204
Causal theory of knowledge, 587–588, 591
Causally impossible, 25
Causation
 agent, 227–232
 bottom-up, 151
 in causal determinism, 186, 197–198
 in causal theory of knowledge, 587–588
 in determinism, 179
 downward, 149–154
 event, 227–228
 in first-cause (traditional cosmological) argument, 443, 446
 free will and, 178–179
 in indeterminism, 199
 in induction, 561–562
 in Kalam cosmological argument, 447–448
 Kant on, 563
 lack of need for, 448–449
 by mental states, advantage of viewing, 155
 in traditional compatibilism, 206
Cave, allegory of the, 549–552
Cecil, Richard, 552
Celsus, 469
Central Intelligence Agency (CIA), 212
Cerebral commissurotomy, 86
Certainty
 Cartesian, 77, 80, 556–558, 559
 reasonable doubt *vs.*, 559
Chalmers, David, 168
 "The Puzzle of Conscious Experience," 152, 168–172
 Zombies (thought experiment), 143, 144–146
Chamberlain, Wilt, 386–387
Change
 Anaximander on, 18
 constant, in Buddhism, 299, 545–546
 in Greek rationalism, 545–546
 in Hinduism, 546
 personal identity and, 9–10, 250, 251–252, 253, 268–269, 299, 303
 self as process and, 303
 in soul theory, 268, 269
 through mystical experience, 567

Character, evil as improving, 497
Character change, 9–10
 personal identity and, 9–10, 251–252, 253
 responsibility and, 9–10, 251–252, 253, 302–303
Chariots of the Gods? (von Däniken), 470
Charity, principle of, 30
Chatbots, 138
Chess, human *vs.* computer, 130
Chesterton, G. K., 41, 337
Children
 morality in, 346, 404, 405
 as psychopaths, 405
 without a conscience, 405
Chisholm, Roderick, 106, 150
Choice, in agent causation, 229–232
Christianity
 Aquinas and, 444
 Augustine and, 267, 490
 dualism in, 82, 97
 on evil, 490–493
 free will and determinism in, 187
 God of, 436
 historic conflict with science, 96–97
 ideal-humanity defense for evil and, 494–495
 "immortal soul" in, 267
 incarnation in, 506
 leap of faith in, 506–508
 mystical experience in, 566
 number of adherents, 441
 person in, 82
 rebirth in new body in, 251
 resurrection of body in, 82, 259–261
 transubstantiation in, 269
 on unbelievers, 436, 437
Christians, born-again, 251–252, 284
Christman, John, 305
Churchland, Patricia Smith, 195
Cicero, 208, 404, 412
City of God, The (Augustine), 267
Clarity and distinctness, principle of, 557–558, 594–596
Clarke, Arthur C., 25, 341, 469–470, 511
Clifford, W. K., 509–510, 512
Clockwork Orange, A (Burgess), 192
Clockwork Orange, A (movie), 105, 192

Clonaid, 260
Cloning, 260
Closest continuer theory, 298–300
COBE satellite, 448
Coburn, Robert, 482, 518
Cogent argument, 34, 35
Cognitive cultural relativism, 543
Cognitive psychology, 564
Cognitive subjectivism, 542, 543
Cohen, G. A., 389
Coherence theory of truth, 540–541
"Coherent, Naturalistic, and Plausible Formulation of Libertarian Free Will, A" (Balaguer), 231
Coherently imaginable, 52–53
Colton, Caleb C., 553
Common consent, argument from, 438–440
Common sense
 causal determinism and, 198–199
 hard determinism, 198–199
 reflective, 191, 198
Communion, Roman Catholic, 270
Compatibilism. *See also* Traditional compatibilism
 defined, 204
 libertarianism *vs.,* 229, 230, 231
 soft determinism, 204
Complexity theory, 461
Composition, fallacy of, 39
Computers
 conscious, 113–114
 simulations, 79, 80
 and speciesism, 114
 with superhuman intelligence, 74
 transfer of mind/brain contents to, 250–251, 283, 318–323
Conceivability, 52–53
Conceivability argument (Descartes), 81–85, 259
Concept acquisition, theory of, 559–560
Concepts, in thought experiments, 50–51
Conceptual ability, 53
Conceptual analysis, Socratic Method of, 15, 20–22
Conceptual schemes
 Kant on, 563–565
 mysticism and, 566
Conceptualization, Kant on, 564–565

Conclusion (of argument)
 defined, 28
 good argument, 28–29
 identifying, 29
 inductive argument, 30–31
 sound argument, 32–33
 valid argument, 30
Confucius, 417
Conjoined twins, 266–267
Conscious Computer (thought experiment), 113, 114
Consciousness
 in beings without brain, 112–116, 119
 in computers, 113–114
 Hinduism on, 74–75
 of inanimate objects, in panpsychism, 156
 Leibniz on, 73
 in mysticism, 567
 in nonhumans, 110–116
 soul and, 270–271
 subjective character of, 111
 understanding, 75
Consequentialist (teleological) ethical theories, 350
Conservation of mass-energy, law of, 90, 446, 449
Conservatism (of hypothesis), 37–38, 541
Conservatives, on positive rights, 416
Consistency (of hypothesis), 37
Contact (Sagan), 37
Contractarianism
 defined, 384
 Rawls, 382–385
Copernican hypothesis, 96–97
Copernicus, 96–97, 564
Corinthians, St. Paul's first letter to the, 251
Corpus callosum, 295, 296
Correspondence theory of truth, 540
 minimal, 543–544
Cosmological arguments (for God's existence)
 defined, 443
 Kalam, 447–451, 484
 traditional (first-cause), 443–447, 484
Counterexample, 44–45
Cowper, William, 447, 451
Creationism
 evolutionary theory *vs.*, 457, 464
 flaws of, 457, 464–465
 meaningful life and, 465
 and morality, 462
 naturalistic theories *vs.*, 464
 objections to evolutionary theory, 456–470
 Raelian, 460
Creator and the Cosmos, The (Ross), 448
Cremation, 259–260
Crichton, Michael, 556
Crick, Francis, 8
Criminal behavior, in test of theory of personal identity, 250–252
Criteria of adequacy, 37–38
Critique of Pure Reason (Kant), 423
Cryonic suspension, 259, 261
Cult leaders, 448
Cultural relativism, 335–339
 anthropology and, 336, 337–338, 339
 cognitive, 543
 defined, 336
 moral judgment. *See* Moral judgments

Da Vinci, Leonardo, 467, 559
Dalai Lama, 568
Dali, Salvador, 280
Däniken, Erich von, 470
Darrow, Clarence, 185, 454–455
Darth Vader (character), 285
Darwin, Charles, 456–457, 460–461, 462, 585
"Date-rape drugs," 278
David, King, 439
Davies, Paul
 on design in universe, 463
 on energy in universe, 449
Davis, Thomas D., 603
 "Why Don't You Just Wake Up?", 603–605
Dawkins, Richard
 on evolution, 456–457, 461
 on free will and determinism, 9
De Silva, Lynn, 82
Dean, Braswell, 462
Death, definitions of, 262
Debbs, Eugene V., 359
Decision making
 agent causation and, 229–232
 ethical, 396–398

Deductive argument, 30, 31–34
 valid, 30, 31
 valid forms of, 31–33
Defeasibility theory of knowledge, 585–586, 587, 591
Defenders, The (movie), 231
"Defense of Hard Determinism, A" (Holbach), 234–235
Deism, 437, 467, 501–502
Demented Mrs. Grabit (thought experiment), 586, 587, 590–591
Demiurge, 445, 501
Democritus, 8, 19
Dennett, Daniel
 on agent causation, 227
 on self, 304
Denying the antecedent, 33–34
Denying the consequent, 31
Deontological ethical theories. *See* Formalist (deontological) ethical theories
Dershowitz, Alan, 480
Descartes, René
 on animals, 84
 biography, 80
 on doubt of sense experience, 78–79, 552–556
 on doubtlessness of thinking, 80, 556–558
 dream argument of, 553–554
 evil genius argument of, 554–556
 "I think, therefore I am," 80–81, 557
 Mechanical Moron (thought experiment), 70
 Meditations on First Philosophy, 77, 78, 80, 88, 159–161, 553, 594–596
 on mind, 70–71, 81, 83, 86, 259
 ontological argument for God's existence, 477–479, 557–558
 rationalism of, 552–558, 568
 science-religion conflict and, 97
 on soul, Locke's criticism of, 255
Desires
 first-order, 213, 214, 218
 in hierarchical compatibilism, 213–218
 impersonal *vs.* personal, 284
 as not under our control, 217–218
 and personal identity, 284
 quasi-, 284
 second-order, 213, 214, 215, 216, 218
 traditional compatibilism and, 210–212

Determinism. *See also* Causal determinism; Hard determinism
 causation in, 179
 as defense for criminal behavior, 178, 180–182, 190
 foreknowledge and, 187
 meaningful life and, 465
 problem of, explained, 178–182
 as self-refuting, 195
 soft, 204
"Determinism defense," 180–182
Deutsch, David, 75, 589
Devil
 in Adam and Eve story, 490–491
 evil as work of, 490
 miracles and, 467
Dewey, John, 50
Dexter, Henry Martyn, 436
Dhammapada, The, 510
"Diachronic style of being," 305
Dialectic, origins of, 548
Dialogues Concerning Natural Religion (Hume), 452, 455, 523–527
Dialogues Concerning the Two Chief World Systems (Galileo), 97
Dias, Alex, 495
Dick, Phillip K., 579
Dickens, Charles, 490
Diderot, Denis, 88
Dinesen, Isak, 304
Direct memory, 279
Direct realism, 571–573, 582
Discourse on Method (Descartes), 70, 80, 84, 159
Disjunctive syllogism, 32
Distinctness, principle of clarity and, 594–596
"Divided Minds and the Nature of Persons" (Parfit), 313–317
Divine command theory, 340–345
 creationism and, 462
 morality as equal to God's will in, 462
Divine intervention, 89, 437
Divine plan, 514–516
Divisibility argument (Descartes), 86–87
Division, fallacy of, 39–40
Dobzhansky, Theodosius, 457
Dolphins, 49
Dostoyevsky, Fyodor, 493, 495

Index 615

Doubt
 Descartes on, 78–79, 80, 552–556
 reasonable, 559
Dover Area School District (Pennsylvania), 457
Doyle, Arthur Conan, 48, 99
Drange, Theodore, 499
Dreams, Descartes on, 553–554
Drug addiction
 hierarchical compatibilism on, 214–215
 traditional compatibilism on, 211
Drug Addiction (thought experiment), 211, 212
Drug intoxication, and religious experiences, 472
Drugs, memory-erasing, 278, 291
Drunkenness, 278
Dualism
 of Augustine, 267
 defined, 75
"Dualism from Reductionism" (Moravec), 318–323
Dualistic interactionism, 88–89
Dunne, Finely Peter, 497
Dupré, John, 198
Duty(ies)
 actual, 381
 to base belief on evidence, 509–512
 imperfect, 373
 perfect, 373
 prima facie, 380–382
 problems with, 360–361

E. T.-The Extra-terrestrial (movie), 112
Eastern mysticism, 567
Eastern philosophy, 4, 11
Eddington, Sir Arthur, 197, 303
Edison, Thomas A., 85
Edwards, Paul, Gangle (thought experiment), 477–478
Ego theory, 313–317
Egoism, ethical, 349–355
Einstein, Albert, 5
 $E = mc^2$, 188, 446, 468
 general relativity theory, 549
 on God, 463, 491
 on the mysterious, 471
 on science and epistemology, 5
 on scientific method, 22

 on surviving death of body, 259
 on truth, 54
Electroconvulsive therapy (ECT), 292
"Elimination of Metaphysics through the Logical Analysis of Language, The" (Carnap), 100
Elizabeth, Princess of Bohemia, 88
Emergency Economic Stabilization Act of 2008, 389
Emerson, Ralph Waldo, 479, 494, 586
Emmons, Nathaniel, 353
Emotivism, 333–335
Empedocles, 456, 549
Empiricism, 97–99
 on analytic and synthetic propositions, 540, 560
 beliefs of, 97–99, 539
 defined, 97, 539
 Descartes refuting, 78–79
 induction in, 561–562
 Kant's synthesis of rationalism and, 562–565
 knowledge by acquaintance in, 538
 Locke and, 276, 309
 phenomenalism and, 577–578
 on rationalism, 539, 559–560
En soi, 517
Enquiries Concerning the Human Understanding (Hume), 98–99, 468
Enumerative induction, 34–35
Epictetus, 410, 411
Epiphenomenalism, 90–92, 140, 155
Episcopal Church, General Convention of, 465
"Episodic style of being," 305
Epistemic principles, 558
Epistemology
 causal theory in, 587–588, 591
 defeasibility theory in, 585–586, 587, 591
 defined, 5, 538
 questions explored by, 5, 538, 539, 540
 reliability theory of, 588–589
 thought experiments, 584–591
 virtue perspectivism in, 589–591
Equivocation, 39
Erikson, Erik, 9
Essay Concerning Human Understanding, An (Locke), 255, 276, 309
Essence, as following existence, 516
Essential property, 252

Eternal Sunshine of the Spotless Mind, The
 (movie), 278
Ethical egoism, 351–355
Ethical narrativity thesis, 305
Ethical theories
 consequentialist, 350
 formalist, 350
"Ethics and Personhood" (Perry), 58
Ethics of care, 394–396
Euthyphro (Plato), 20–22
Event causation, 227–228
Evil
 as absence of good, 490–491
 argument from (against God's existence), 487–489
 defined, 487–488
 as devil's work, 490
 finite-God defense for, 497–500
 as force *vs.* good, 490
 free-will defense for, 491–493
 Gnostics on, 445
 ideal-humanity defense for, 494–495
 Indian Ocean tsunami as punishment for, 495
 inequality and, 498
 justifications for existence of, 490–505
 knowledge defense for, 493–494
 knowledge of, 494
 moral, 487–488
 natural, 488, 493, 494–495, 503
 necessary, 488, 489
 overview, 487–489
 problem of, 7, 11, 488, 489
 soul-building defense for, 496–497
 unnecessary, 488–489
Evil genius argument, 554–556
Evil genius argument (thought experiment), 555–556
Evolution, theory of
 creationist theories *vs.*, 457, 464
 half-formed structures and, 456–458
 history of, 456
 human design flaws and, 464–465
 intelligent design *vs.*, 458–466
 irreducibly complex systems and, 458–461
 meaningful life and, 464
 observation of speciation and, 461–463
 as theory *vs.* fact, 457
 transitional fossils and, 461
Ewing, A. C., 380
 Innocent Criminal (thought experiment), 362–363
 Prudent Diplomat (thought experiment), 380
 Utilitarian Torture (thought experiment), 362
Examined Life, The (Nozick), 393
"Exaptation," 460–461
Excluded middle, law of the, 24
"Existence precedes essence" principle, 516
Existentialism, 516–517
Existenz (movie), 79
Experience Machine (thought experiment), 365–366
Explanation, scientific *vs.* religious, 482–483
Explanation, goodness of, 37
Explication, 15
Externalist theories of knowledge, 587, 588, 589, 590
Extrinsically valuable. *See* Instrumentally valuable

Fact
 faith as causing, 507–508, 512–514
 and theory, 457
"Facticity," 517
Factual beliefs, and moral judgments, 511–512
Faith
 as causing fact, 507–508, 512–514
 defined, 506
 in establishing God's existence, 441–442, 506–507, 508, 513
 James on, 512–514
 Kierkegaard on, 506–508
 leap of, 506–508
 in science, 483, 562
 will to believe and, 512–514
Fake Barns (thought experiment), 587–588, 590
Fallacious arguments, 38–42
False cause, fallacy of, 41–42
False dilemma, 39
Fantastic Voyage (movie), 73
Fatalism *vs.* causal determinism, 189
Faulty analogy, 41
Fawkes, Guy, 286–287, 298

Fear, appeal to, 41
Feinberg, Joel, 354
Fetus
 in memory theory, 280
 status of, 48–49, 52, 280
Final Cut, The (movie), 282
"Finite God, A" (Mill), 528–532
Finite-God defense (for evil), 497–500
Fire Rescue (thought experiment), 361
First-cause arguments
 of Aquinas (traditional cosmological), 443–447, 484
 Kalam cosmological, 447–451, 484
First-order desire, 213, 214, 218
"Five Ways, The" (Aquinas), 521–522
Flanagan, Owen, 304
Flew, Anthony, 504
"Fly, The" (Langelaan), 263
Fodor, Jerry, 23, 155
"Forced option," 512
Foreknowledge, freedom and, 187
Formalist (deontological) ethical theories, 350
Formalist ethical theory, decision making using, 396–398
Form(s), Plato on, 552
Fossils, transitional, 461
Foundationalism, defined, 558
Fountainhead, The (Rand), 353
Fragility of Goodness, The (Nussbaum), 427
Frankfurt, Harry, 213–216, 218
 Decision Inducer (thought experiment), 216
 on free actions, 213–215
 Happy Addict (thought experiment), 215
 Unwilling and Wanton Addicts (thought experiment), 214–215
Franklin, Benjamin, 437, 506
Free actions
 agent causation, 227–232
 alternative possibilities, 204–205
 in hierarchical compatibilism, 213–218
 in indeterminism, 199–200
 as nonexistent, 179
 in traditional compatibilism, 206–207, 209–212
 as uncaused, 199–200

Free will
 agent causation, 227–232
 androids and, 178, 232
 animals and, 215
 belief in, dilemma of, 204
 causal determinism incompatible with, 188–190
 Descartes on, 557–558
 in determinism, 179, 185–186, 188–190
 foreknowledge and, 187
 hierarchical compatibilism and, 215
 Holbach on, 185–186
 as illusion, 186
 in indeterminism, 199–200
 lack of, 179, 185–186, 188–190
 materialism and, 8
 original sin and, 491–493
 problem of, explained, 7, 8–9, 178–182
 in soft determinism, 204
 in traditional compatibilism, 207
Free-will defense (for evil), 491–493
Frege, Gottlob, 25
Fried, Charles, 496–497
Fromm, Erich, 32, 250
Froude, James, 8
Fruitfulness (of hypothesis), 37, 38
Fuller, Thomas, 31
Functional organization of living things, 256, 258
Functional states
 defined, 120
 mental states as, 120, 123–124, 127, 136
Functionalism, 120–136
 absent qualia objection, 125, 127–128
 artificial intelligence and, 121–123
 behaviorism *vs.*, 120
 defined, 120
 identity theory *vs.*, 120, 121
Fundamental Principles of the Metaphysics of Morals (Kant), 423

Gage, Phineas, 107–108
Gaia hypothesis, 455
Galileo Galilei, 206
 on Aristotle's theory of motion, 54
 Copernican hypothesis and, 97
 on discovery of truths, 34

Galle, Johann, 23
Games, concept of, 14–15
Gangle (thought experiment), 477–478
Gardner, Martin, 53
 Random Bombardier (thought experiment), 197
 on souls in heaven, 272
Garrison, William Lloyd, 336
Gaunilo, 475–476
Geiger counter, 197–198
Gell-Mann, Murray, 197
General relativity theory, 549
Generalization, hasty, 41
Genetic engineering, 196
Genetic fallacy, 40
Genetics
 behavior and, 192, 193, 194–196
 body switches and, 263
 eugenics laws, 195
 free will and, 9
 mental characteristics and, 193
Gentler, Troy Matthew, 181
"Genuine option," 512
Gettier, Edmund, 584, 591
 Guy in Barcelona (thought experiment), 584–585, 586, 587, 590
"Getting It Right" (Sosa), 601–602
Gibson, Althea, 394
Gilder, George, 458
Gilligan, Carol, 394, 395
Giroux, Jennifer, 495
Gish, Duane, 464
Gnosticism, 445, 497, 500–501
Gnostics, 445, 497, 500–501
God
 all actions determined by, 187, 465
 belief in evolution and, 465
 as creator of universe, 436, 443–451, 484
 cult leaders claiming to be, 508
 in deism, 437
 in Descartes' evil genius argument, 555
 as designer of mind-body interaction, 89
 as designer of universe, 436, 447, 451–471
 devil and, 490
 as first cause, Aquinas on, 443–444, 446
 goodness of, as different from ours, 492–493
 as ground of being, 517
 incarnated as Jesus, 506
 Indian Ocean tsunami and, 491
 intervention by, 89, 437
 as just and merciful, self-contradiction of, 440
 kingdom of, Augustine on, 267
 Leibniz on, 89
 as limited, 498–499
 morality as independent of, 462
 of New Testament, 499
 in occasionalism, 89
 in pandeism, 514
 in pantheism, 438
 in parallelism, 89
 as person, 48, 436, 513–514, 518
 in phenomenalism, 575–581
 plan of, 514–515
 religion without, 518–519
 of traditional theism, 437, 440
 as universe, 438, 514
 as watchmaker, 437, 452–453, 455
Gods, 436, 479
"Gods" (Wisdom), 504
God's existence
 meaning in life and, 514–515
 proving or not proving, implications of, 440–442
 question of, 437
 thought experiments, 476, 477–478, 480, 489, 504–505
God's existence, arguments against
 existence of evil as, 486–489
 of Hume, 523–527
 inability to prove God's existence as, 440
 inability to sense God as, 440
God's existence, arguments for
 analogical design, 452–455
 of Anselm, 475–476
 of Aquinas, 443–447, 484, 521–522
 of Augustine, 443–447, 484
 of Berkeley, 515, 579–581
 best-explanation design, 455–466
 clearly fallacious, 438–440
 from common consent, 438–440
 cosmological, 443–451
 of Descartes, 477–479, 557–558
 failure of, 482
 faith *vs.* reason in, 441–442, 506–507

God's existence (*continued*)
 first-cause (traditional cosmological), 443–447, 484
 "Five Ways, The" (Aquinas), 521–522
 impossibility of disproving God as, 440
 inferences to the best explanation as, 440
 intelligent design, 458–466
 Kalam cosmological, 447–451, 484
 from miracles, 466–471
 ontological, 475–479
 Pascal's wager, 479–480
 from religious experience, 471–474, 484
 sacred scripture/Bible as, 438
 teleological, 451–471
 universal belief in God as, 438–440
God's existence, belief in
 as causing God, 507, 513
 faith-based, 441–442, 506–507, 508, 513
 meaning and sources of, 437
 passionate, 507–508
 pragmatically justified, 479
 as universal, 438–440
 unnecessary for religious life, 518
God's plan, 514–516
God's Plan (thought experiment), 514–515
Godwin, William, 361
Goethe, Johann Wolfgang von, 182, 472
Goldman, Alan, 580
Goldman, Alvin
 causal theory and, 587–588
 Fake Barns (thought experiment), 587–588, 590
Goncourt, Edmond de, 482
Goncourt, Jules de, 482
Good life, belief in God and, 518
Good Samaritan (thought experiment), 376
"Good Will, Duty, and the Categorical Imperative" (Kant), 423–426
Goodness
 evil as absence of, 490–491
 as force *vs.* evil, 490
 of God, as different from ours, 492–493
 God's will as equal to, 462
Gould, Stephen J., 460–461, 483
Goulder, Michael Donald, 483
Gourmont, Remy de, 110

Grand Design, The (Hawking), 449–450
Grapes of Wrath, The (Steinbeck), 182
Grasshopper: Games, Life and Utopia, The (Suits), 15
"Great Chain of Being," 516
Great Pain (thought experiment), 264–265
Greeks, ancient
 on "atoms," 8, 19, 99
 on cognitive subjectivism, 542
 evolutionary theory in, 456
 gods of, 436
 materialism in, 8
 on origin of universe, 455
 pre-Socratic philosophers, 15, 18–19
 rationalism of, 545–552
 science of, 18–19
Greville, Lord, 381
Guilty minds, pre-crime and, 211
Guy in Barcelona (thought experiment), 584–585, 586, 587, 590

Hal (character), 113–114
Haldane, G.B.S., 454
Hale, Matthew, 438
Hallucination hypothesis, 471–472
Hallucinations
 religious experiences as, 471–472
Halsey, Margaret, 576
Hanlon, Stuart, 253
Hanoukai, Moosa, 181
Hanson Robotics, 50
Happiness, Aristotle on, 407–408
Happy Addict (thought experiment), 215
Hard determinism, 184–199
 behaviorism, 191–194
 common sense, 198–199
 consequence argument, 188–191
 defined, 184
 science and nature/nurture debate, 191–198
 as self-refuting, 195
 sociobiology, 194–198
 thought experiments, 185, 197
Hare, R. M., 375
 Nazi fanatic (thought experiment), 375–376
Harkins, Arthur, 71, 74
Harlow, John, 107

Harnik, Roni, 464
Hastings Center, 52
Hasty generalization, 41
Haught, James A., 495
Hauser, Larry, 119
Hawking, Stephen
 brain transplant and, 295
 on God, 450, 463
 logical behaviorism and, 116
 on origin of universe, 449–450, 451
Hawley, Robert, 266
Head transplant, 295, 308
Heaven
 free will in, 493
 rebirth in new body in, 251, 267
 souls in, 269, 272
Hedonism, psychological, 352–355
Hegel, G.W.F, 74–75, 283
Heidegger, Martin, 100
Heine, Heinrich, 15
Heinz dilemma, 395
Heisenberg, Werner, 2
Heisenberg uncertainty principle, 289
Hensel, Abigail, 266–267
Hensel, Brittany, 266–267
Heraclitus, 19, 545, 546, 549
Herodotus, 441
Herzog, Ze'ev, 439
Hick, John
 on ideal-humanity defense for evil, 494–495
 on inequality as evil, 498
 on karma, 498
 on religious experience, 473–474
 on soul theory, 272
 soul-building defense for evil, 496–497
Hierarchical compatibilism, 213–218
 defined, 214
 explained, 214
 hierarchy of desires and volitions, 213–214
 principle of alternative possibilities and, 215–216
 thought experiments, 214–218
Hinduism
 on consciousness and reality, 74–75
 and Greek rationalism, 546
 karma in, 497, 498
 on mind, 283
 number of adherents, 441
 on origin of universe, 445
 pantheism in, 438
 rebirth/reincarnation in, 498
 religious experiences in, 474
 sacred scripture of, 438
 supreme being in, 436
 time and universe in, 450
Hitchens, Christopher, 389, 391
Hitler, Adolf, 511
Hitt, Jack, 473
Hobbes, Thomas
 biography, 206
 on compatibilism, 206–207
 political philosophy of, 206
 Ship of Theseus (thought experiment), 256
Hock, Dee, 256
Hodgson, Ralph, 564
Holbach, Paul Henri d'
 biography, 234
 "Defense of Hard Determinism, A," 234–235
 on determinism, 185–186
 on theology, 472
Holmes, Oliver Wendell, 78
Holmes, Robert L., 45
Homer, 17, 206
Hospitalized patient (thought experiment), 404
Hubbard, Elbert, 9, 467
Huckabee, Michael, 495
Hugo, Victor, 44
Human beings
 Aristotle on discovering the function of, 407
 Aristotle's theory of, tested, 44–45
 artificial intelligence as threat to, 74
 design flaws in, 465–466
 evil as improving, 496–497
 in existentialism, 516, 517
 as intrinsically valuable, 494–496, 518
 as naturally depraved, 490–491
 as nothing to begin with, 516
 Plato on, 46, 57
Human condition, in existentialism, 516–517
Human rights, universal, 337
Human species
 artificial intelligence as threat to, 74
 evil as improving, 494–495

Human Thermometer (thought experiment), 588–589, 590
Hume, David
　on analytic and synthetic propositions, 560, 563
　biography, 98, 523
　on Christianity, 467
　concept acquisition theory of, 559–560
　Dialogues Concerning Natural Religion, 452, 455, 523–527
　on first cause, 445
　on God's nonexistence, 523–527
　on induction, 561
　Kant on, 563
　on mind, 97–99
　on miracles, 467–468
　on rationalism, 559–560
　on reason, 53
　universe compared to living thing by, 455
Humphrey, Nicholas, 469
Hunt, Morton, 105
Husserl, Edmund, 45
Huxley, Aldous, 180
Huxley, Thomas Henry, 51, 90–91, 509
Hypnosis, 281
Hypothesis
　conservatism, 37–38, 541
　criteria of adequacy of, 37–38
　in scientific method, 23
　in Socratic Method, 22
Hypothetical approach, 15
Hypothetical induction, 36–38
Hypothetical syllogism, 32

I CARE procedure, 397–399
"I think, therefore I am," 80–81, 557
IBM, 289
Ideal society (Skinner), 192
Ideal-humanity defense (for evil), 494–495
Idealism
　of Berkeley, 578
　defined, 75
Ideas, simple and complex, 98
Identity
　numerical, 252, 253, 256, 300–301
　qualitative, 252, 253
　transitivity of, 265
Identity conditions, 252

Identity theory, 107–116, 118
　Cartesian dualism *vs.,* 108–109
　consciousness in nonhumans and, 110–116
　defined, 108, 109
　functionalism *vs.,* 120, 121
　indiscernibility of identicals and, 109–110
　logical behaviorism *vs.,* 109
　overview, 108–109
　as speciesist, 114
　test of, 109–116
　thought experiments, 111–116, 119
"If and only if," 14
Ignorance, appeal to, 40–41, 440
Iliad (Homer), 206
Illusions, and direct realism, 571–572
"Immortal soul," 267
Immortality
　of soul, 82, 267
　through cloning, 260
　through memory recording, 282
　through reanimation of body, 259–261
　through rebirth in new body, 251, 267, 289
　through resurrection of body, 259–261
　through transfer of mind/brain contents to computer, 318–323
Imperfect duty, 373
Impersonal desire, 284
Impossibility of Aristotle's Theory of Motion (thought experiment), 54
Impossible/impossibility
　causally, 25
　logically, 25, 30
In a Different Voice (Gilligan), 395
In Defense of Dolphins: The New Moral Frontier (White), 49
Incarnation, the, 506
Incompatibilism, 188
Indeterminism, 199–201
　causal, 199
　defined, 200
India, 497
Indian Ocean tsunami, 495
Indirect memory, 284
Indiscernibility of identicals, 86, 109
Induction, 561–562
　analogical, 35–36
　enumerative, 34–35

hypothetical, 36–38
"On Induction" (Russell), 597–600
Inductive arguments, 561–562
 cogent, 34, 35
 common forms of, 34–38
 lack of certainty in, 30–31
 strong, 31, 34, 35
Inequality, as evil, 498
Inference, in causal theory of knowledge, 587
Inference to the best explanation, 36–38, 440, 456–458
Infinite causal chain, 446
Ingenious Physiologist (thought experiment), 209–211
Ingersoll, Robert G., 510
Innate knowledge, 552
Innocent Criminal (thought experiment), 362–363
Inquisition, 510
Institute for Creation Research, 462, 464
Instrumentally valuable, 350
Insufficient premises, 41–42
Intellectual virtue, 512, 589, 590
Intelligence
 artificial. *See* Artificial intelligence
 as linguistic and problem-solving ability, 71
 superhuman, robots/computers with, 8, 74
"Intelligence explosion," 74
Intelligent design theory, 457, 458–466
 fine-tuning of universe and, 463–465
 human design flaws and, 465–466
 as theory *vs.* fact, 457
Internalist theories of knowledge, 587, 589, 590
Intrinsically valuable, 350
Introduction to the Principles of Morals and Legislation (Bentham), 420
Invisible Gardener (thought experiment), 504–505
Irrelevant premises, 39–41
"Is Neuroscience the Death of Free Will?" (Nahmias), 236–238
Islam, 436, 438, 441
Islamic suicide bombers, 437, 511
Israel, 439

James, William
 on belief through faith, 512–514
 biography, 200
 on indeterminism, 199–200
 on pragmatic theory of truth, 541–542
 on sense experience, 563
 on soft determinism, 204
Jansenism, 479
Jefferson, Thomas
 as deist, 437, 501
 on immaterialism, 94, 99
 on meteorites, 468
 on religion, 518
Jehovah, 436
Jennings, Ken, 130
Jesus
 as God's incarnation, 506
 mind-body unity in, 82
 "miracles" of, 469, 470
 resurrection of, 82, 259
 as sinless, 491
 transubstantiation and, 269
Jews, extermination of, 511
Jillian's Choice, 394
John, Saint, 471
Johnson, Samuel, 358, 578, 579
Joplin, Karl, 461
Judaism
 on free will and evil, 491
 God of, 436
 number of adherents, 441
Justice, 389–393
 Adam and Eve story and, 493, 494
 and mercy, contradiction of, 440
 principle of, 347
 problems with, 361–363
Justification, pragmatic *vs.* rational, 479
Juvenal, 545

Kafka, Franz, 263
Kalam cosmological argument, 447–451, 484
Kane, Robert, 216, 217–218, 230, 231
Kant, Immanuel
 on causation, 563
 on conceptual schemes, 563–565
 "Good Will, Duty, and the Categorical Imperative," 423–426
 on knowledge, synthesis of theories of, 563–566, 569
 ontological argument and, 477
Karma, 498
Katz, Steven, 566

Kennedy, John F., 406
Keogh, Tom, 405
Kierkegaard, Søren, 506–508
Kindness to strangers, 513
King of China (thought experiment), 268
Kingdom of God, 267
Klempner, Geoffrey, 243–244
Knowledge
 a posteriori, 539, 560, 563
 a priori, 539, 540, 560, 563
 by acquaintance, 538
 animal *vs.* reflective, 590–591
 definitions of, 584
 Descartes on, 78–79, 80, 552–559, 569
 of evil, 493–494
 foundationalist approach to, 558
 induction and, 561–562
 innate, 552
 intrinsic value of, in evidentialism, 510
 Locke on, 276, 560
 mystical experience as source of, 11, 566–568
 performative, 538
 Plato on, 548–552
 propositional, 538–544, 591
 reasonable doubt in, 559
 science as source of, 564
 skepticism toward. *See* Skepticism
 study of. *See* Epistemology
 theories. *See* Knowledge, theories of
 thought experiments, 584–591
 types of, 538
 in virtue perspectivism, 589–591
Knowledge, theories of
 causal, 587–588, 591
 defeasibility, 585–586, 587, 591
 empiricist. *See* Empiricism
 Kant's synthesis of, 563–566, 569
 rationalist. *See* Rationalism
 reliability, 588–589, 591
Knowledge defense (for evil), 493–494
Knox, Ronald, 579
Kohlberg, Lawrence, 346, 394–395
Koran, 438
Koresh, David, 541, 542
Korzybski, Alfred, 565
Kribs, Graham D., 464

Krutch, Joseph Wood, 91
Kurzweil, Ray, 264
Kushner, Harold, 497–500

La Bruyère, Jean de, 29
La Mettrie, Julien Offray de, 271
Lactantius, 487
Laertius, Diogenes, 19, 27
Lamont, Corliss, 229
Langelaan, George, 263
Language
 artificial intelligence and, 71
 logical positivism on, 100, 102
 meaning and, 98–99, 100
 verifiability theory of meaning and, 100, 101, 106–107
Laplace, Pierre-Simon, 11, 557
Lasch, Christopher, 575
Lavington, George, 443
Lavoisier, Antoine, 446, 468
Law of conservation of energy, 446
Law of conservation of mass, 446
Law of conservation of mass-energy, 90, 446, 449
Law of excluded middle, 24
Law of identity, 24
Law of noncontradiction, 24, 25
Laws
 paternalistic, 496–497
 scientific, construction *vs.* discovery of, 566
Laws of logic (laws of thought), 24
Laws of nature, natural selection of, 463–464
Le Verrier, Urbain, 22–23
Legal system
 character change and responsibility, 9–10 251–252, 253, 303
 memory of crime and, 276–277
 multiple-personality disorder and, 265–266, 305
Lehrer, Keith
 Demented Mrs. Grabit (thought experiment), 586, 587, 590–591
 Human Thermometer (thought experiment), 588–589, 590
Leibniz, Wilhelm Gottfried von
 on divine command theory, 462
 King of China (thought experiment), 268

on memory as identity, 275
Mental Mill (thought experiment), 72
on mind, 72–73
on preestablished harmony, 89
on soul, 268
Letter Concerning Toleration, A (Locke), 276
Leucippus, 8
Leviathan (Hobbes), 206
Lewis, C. S., 587
Lewis, David, Pained Martian (thought experiment), 112, 114
Liberals, on positive rights, 416
Libertarianism, 220–232, 386–393
 agent causation and, 227–232
 argument from deliberation in, 222
 argument from experience in, 221–222
 defined, 220
 neurophysiological challenge to, 222–226
 Nozick and, 386–389, 391–393
 on social contract, 391–393
 thought experiment, 392–393
Linde, Andre, 451
Living things
 functional organization of, 256, 258
 identity in, Locke on, 255–256
 memory-sharing among, 283
 universe as, 455
Locke, John, 48
 Berkeley's criticism of, 575–576
 biography, 276
 on change and identity, 255–256
 on knowledge, 276, 560
 on memory as personal identity. *See* Memory theory
 on mind, 97–98
 Nestor and Thersites (thought experiment), 270
 "Of Identity and Diversity," 309–311
 on person, 257
 on personal identity, 255–256, 263, 275–284, 302, 309–311
 on religion, 482
 on responsibility, 276–278, 302
 on sense experience, 573–576
 on soul and consciousness, 270–271
 Tale of the Prince and the Cobbler (thought experiment), 263

Loeb, Abraham, 464
Logic. *See also* Argument(s)
 defined, 5
 function of, 28
 laws of, 24
 questions explored by, 6
Logical behaviorism, 100–107, 117–118
 Cartesian dualism *vs.*, 101–103
 defined, 101
 functionalism *vs.*, 120–121
 identity theory *vs.*, 109
 overview, 100–103
 test of, 103–106, 115–116
 thought experiments, 102–106, 115–116
Logical positivism
 overview, 99–100, 101
 phenomenalism and, 577–578
Logical structure of moral judgments, 338–339
Logically impossible, 25, 30
Lorber, John, 110
Lost Island (thought experiment), 476
Lovelock, James, 455
Lowe, Jules, 277
Lowell, James Russell, 178
Lucian, 469
Lucretius, 445, 446
Luther, Martin, 217, 260
Lutheran World Federation, 465
Lyceum, 407

Machine(s)
 mind as, 70–71, 72–73
 with minds, 71–72
 universe as, 452
MacIntyre, Alasdair, on virtue, 413–414
"Macro-evolution," observation of, 462–463
Mad Scientist (thought experiment), 555–556
Malebranch, Nicholas, 84
Manchurian Candidate, The (movie), 212
Mani (the founder of Manichaeism), 490
Manichaeism, 490
Mao Tse-tung, 414
Maps
 Kant's conceptual schemes compared to, 565
 truth of, 543–544
Mars, life on, 452
Martineau, James, 251

Mary (mother of Jesus), 491
Masses, appeal to, 40
Material objects
 Berkeley's rejection of existence of, 576–578
 mind-body problem and, 6–7
Materialism
 causal closure of the physical, 90–92
 defined, 75
 free will and, 8
 mind-body problem and, 8
Mathematics
 certainty in, Descartes on, 78–79
 Kant on concepts of, 563–564
 Pythagoras and, 19
Matrix, The (movie), 17, 79, 538, 548
Maugham, W. Somerset, 179, 496
Mayer, Julius Robert, 446
Mayo Clinic, 295
McCloskey, H. J., 359
McConnell, James, 9
McCormick, Richard, 351
McDougall, Duncan, 94
McDougall, W., 101
McLuhan, Marshall, 566
Meaning, verifiability theory of, 100, 101, 106–107
Meaningful life
 evolutionary theory and, 465
 in existentialism, 516, 517
 God's plan and, 514–515
Mechanical Moron (thought experiment), 70
Medical research, analogical induction in, 36–37
Meditations on First Philosophy (Descartes), 553
 "Meditation I," 594–596
Melville, Herman, 251
Memories
 apparent, 280, 281
 direct, 279
 drugs erasing, 278, 291
 having someone else's, 282
 indirect, 279
 loss of, 268, 269, 276–279
 merging of, 283
 in personal identity, 10, 269. *See also* Memory theory
 personal identity and, 10
 quasi-, 281–283

 real, 280–283
 recording of lifetime's, 282
 responsibility for actions and, 276–278
 soul's loss of, 268–269
 transfer to computers, 10, 283
Memory theory, 275–284
 circularity objection to, 280–283
 inconsistency objection to, 278–280
 insufficiency objection to, 283–284
 psychological continuity theory *vs.*, 285
 responsibility for actions and, 276–278
 sleepwalking and, 277
Men, and ethics of care, 395
Mencken, H. L., 79
"Meno" (Plato), 539
Mental illness, and behavioral therapy, 105
Mental Mill (thought experiment), 72
Mental states
 in beings without brain, 112–116, 119
 qualitative content of, 103–104
Mercy
 and justice, as contradictory, 440
 principle of, 347, 488
Meta-conscious awareness, 224
"Metamorphosis, The" (Kafka), 263
Metaphysics, 100
 defined, 5
 questions explored by, 5
Meteorites, 468
Methodist Church, 465
Micro-evolution, 462
Miletus, 16
Mill, John Stuart, 420
 on analogical design argument, 454
 "Finite God, A," 528–532
 on goodness and God, 492–493
 on natural evil, 488
 on natural theology, 528–532
Millay, Edna St. Vincent, 438
Miller, Kenneth R., 465
Mind(s)
 artificial intelligence and, 71, 121
 Berkeley on God's link to, 579–581
 as blank slate, 98, 276
 as by-product of body, 90–92
 as capacity of body, 87
 as essential for existence, 81, 83

as greater than sum of its parts, 73, 150–151
guilty, pre-crime and, 211
as immaterial, 77, 81, 92
as indivisible, 86–87
Kant on, 563–565
Leibniz on, 72–73
as machine, 70–71, 72–73
machines/robots with, 71–72, 103
merging, 283
in mysticism, 567
of others, problem of, 92–93, 101–102
as program, 121–122
self as property of, 303
as sole reality, 75
as soul, 77
splitting of brain and, 86–87
transfer/uploading to computer, 250–251, 283, 318–323
understanding nature of, 75
Mind, theories of
dualism, 75
Eastern, 74–75
eliminative materialism, 139–145
empiricism as, 75, 97–99
epiphenomenalism, 90–92, 93, 140, 155
idealism, 75
materialism as, 75
mechanical, 70–71, 72–73
overview, 75
Mind transferal
to computer, 10, 250–251, 283, 318–323
to other living being, 283
Mind-body interaction
in Cartesian dualism, 88–92
causal closure of the physical and, 90–92
epiphenomenalism, 90–92, 93
in parallelism, 89
Mind-body problem
explained, 6–7, 8, 70
necessary and sufficient conditions in, 13
"Mind-Brain Identity Theory, The" (Armstrong), 162–167
Minimal correspondence theory of truth, 543–544
Ministry of Environment and Forests of India, 50
Minsky, Marvin, 8, 120, 121

Miracles
argument from (for God's existence), 466–471
belief in, 467–470
defined, 467
Mizner, Wilson, 96, 509
MKULTRA, 212
Modus ponens, 31
Modus tollens, 31
Molyneaux, William, 255
Momentous option, 512
"Monads," 73
Monotheism, 436, 438, 479
Moral agents, 304–306
Moral children, 346
Moral evil, 487–488
Moral judgments
about people, 511–512
factual beliefs and, 511
logical structure of, 338–339
Moral principles, 345–347
Moral relativism, problem of, 7, 10
Moral responsibility, for beliefs, 510
Moral theory(ies)
divine command theory, 462
evidentialism as, 508–512
Moral virtue, 512, 589
Morality
of abortion, 46–49, 52
creationism and, 462
evil and, 487–488
God's will as equal to, 462
purpose of, 406
Moravec, Hans, 283
biography, 318
"Dualism from Reductionism," 318–323
Morrow, James, 500
Motion
Aristotle's theory of, 54
Newton's laws of, 22, 23
in paradox of bisection, 547–548
random, in quantum mechanics, 448
Moyes, Jojo, 144
Muller, H. J., 458
Multiple realizability, 114, 115
Multiple-personality disorder, 265–266, 305
Multiplicity (movie), 301
Munger, Theodore, 442

Murder/killing
 abortion as not, 46–49
 by sleepwalkers, 277
 of unbelievers, 436
Murphy, Arthur, 405
Musk, Elon, 79, 80
Mystical experience, as source of knowledge, 11, 566–568

Nagel, Thomas, 110–111, 150
Nagel's Bat (thought experiment), 111
Nahmias, Eddy, 236–238
Napoleon, 5, 52
Narrative, and personal identity, 304–306
Narrativity theory, 305
National Institute of Neurological Disorders and Stroke, 58
Natural disasters, 454, 487, 488
 Indian Ocean tsunami, 495
Natural evil
 explained, 488
 free-will defense and, 493
 ideal-humanity defense and, 494–495
 thought experiment, 489
Natural laws
 miracles and, 467, 469–470
 natural selection of, 463–464
Natural selection, 456
 half-formed structures and, 456–458
 and human design flaws, 465–466
 irreducibly complex systems and, 458–461
 of laws of nature, 463–464
Natural theology (Mill), 528–532
Naturalistic theories, supernatural theories *vs.*, 464, 482
Nature spirits, 436
Nature/nurture debate, 191–198
Nazi fanatic (thought experiment), 375–376
Necessary condition, 12–15, 44
Necessary evil, 488, 489
Negative, universal, 440
Negative rights, 416
Neptune, discovery of, 23
Nero, 410
Nerval, Gerard de, 589
Nestor and Thersites (thought experiment), 270
Neural chips (biochips), 116, 117, 250

Neurophysiology
 downward causation and, 151, 152
 religious experiences and, 473
New Testament, God of, 499
Newcomb's Paradox (thought experiment), 203
Newman, John Henry, 301
Newton's laws of gravity and motion, 22, 23, 150
Nietzsche, Friedrich, 104, 231, 496, 508, 567
Nin, Anaïs, 516
Nirvana, 283, 299
Nof, Doron, 470
Nonbelief, argument from, 449
Nonbranching theory, 298, 299
Noncontradiction, law of, 24, 25
Nonexistence, Parmenides on, 19, 546–547, 549
Nonhuman persons, 49–50
Non-Relative Virtues (Nussbaum), 427–431
Noumena, 565
Nozick, Robert
 Basketball Player (thought experiment), 386–387
 closest continuer theory, 298–300
 Experience Machine (thought experiment), 365–366
 God's Plan (thought experiment), 514–515
 libertarian theories, 386–389
 on mystical experience, 567
 on social contract, 389, 391–393
Numerical identity
 change of character and, 302–303
 defined, 252
 functional organization and, 256
 importance of personal continuity *vs.*, 300–301
Nussbaum, Martha
 biography, 427
 "Non-Relative Virtues," 427–431
 on virtue, 414–416

Objective truth, 507
"Observational Test for the Anthropic Origin of the Cosmological Constant, An" (Loeb), 464
Occam's razor, 37, 101
Occasionalism, 89
Odyssey (Homer), 206
Oedipus Rex (Sophocles), 109–110

"Of Identity and Diversity" (Locke), 309–311
"Of the Principle of Utility" (Bentham), 420–422
Olshansky, S. Jay, 465
Olson, Eric
 Transplant Case, The (thought experiment), 264
 Vegetable Case, The (thought experiment), 258–259
Olson, Frank, 212
Olson, Sara Jane, 253
"On Induction" (Russell), 597–600
"On the Moral and Legal Status of Abortion" (Warren), 46-49
On the Revolution of the Heavenly Spheres (Copernicus), 97
Only x and y principle, 298–300
Ontological argument (for God's existence), 475–479
 of Anselm, 475–476
 defined, 475
 of Descartes, 477–479, 557–558
 thought experiments, 476, 477–478
Oracle at Delphi, 16, 17
Origen, 469
Original sin, 491
Orr, H. Allen, 458–459
Other minds, problem of
 in Cartesian dualism, 92–93
 in logical behaviorism, 101–102

Pahnke, Walter, 472
Pain
 in animals, Descartes on, 84
 eliminative materialism and, 140
 as folk theory, 140
 functionalism and, 122–123
 identity theory and, 112–113
 inability to feel, 103
 logical behaviorism and, 103–105
 pain behavior as equal to feeling, 103–105
 physicalism and, 143
 without brain, 112
Pain avoidance, in test of identity, 250, 264–265
Pained Madman (thought experiment), 122–123
Pained Martian (thought experiment), 112, 114
Paldor, Nathan, 470

Paley, William, 452–453, 455, 456
Paley's Watch (thought experiment), 453
Pandeism, 514
Panpsychism, 155–156
Pantheism, 438, 439, 502–503
Paradise engineering, 366–367
Paradox(es), 549
 of bisection, 547–548, 549
 of nonexistence, 546–547, 549
Parallelism, 89
Parfit, Derek
 biography, 313
 on brain theory, 296–298
 on character change and responsibility, 302–303
 "Divided Minds and the Nature of Persons," 313–317
 on numerical identity *vs.* psychological continuity, 300–301
 on quasi-memory, 281
 on reduplication, 297–298, 299
 Reformed Nobelist (thought experiment), 302
 Transporter Tale (thought experiment), 287–288
Parfit's Division (thought experiment), 297, 298–299, 300, 301, 302
Parker, Theodore, 403
Parmenides, 19, 83, 546–547, 549
Parrot and prince story, 257
Parsimony, principle of, 37
Particle physics
 cause as unnecessary in, 447–448
 existence of external world and, 583
 in panpsychism, 156
 random movement in, 448
 sense data lacking in, 440
 senses affecting particles in, 575, 583
 teleportation and, 289
Pascal, Blaise
 on God's existence, 479–480, 484
 on mind-body relationship, 83
 on philosophy, 2
Pascal's wager, 479–480, 484
Passions of the Soul, The (Descartes), 80, 88–89
Paternalism, 496–497
Paternalistic laws, 496–497
Paul, Saint, first letter to the Corinthians, 251
Paxson, Thomas, 586

Peace Corps, 229
Pearson, Ian, 282
Peirce, Charles Sanders, 36, 541
People's Capitalism: The Economics of the Robot Revolution (Albus), 71–72
Perception
 defined, 573
 in direct realism, 571–573
 Kant on, 564–565
 in phenomenalism, 575–581
 primary *vs.* secondary qualities in, 575–576
 in representative realism, 573–575
 scientific explanation of, 581
 steps in process of, 573
Perceptual ability, 53
Perez, Gilad, 464
Perfect duty, 373
Perfect Pretender (thought experiment), 103, 104
 empiricism refuted by, 99–100
 sense data lacking in, 99–100
Perfections, 477, 478
Performance, acquisition of knowledge as type of, 589–590
Performative knowledge, 538
Periodic table of elements, 14
Perry, David, 58
Persinger, Michael, 473
Persistent vegetative state (PVS), 58, 258, 262
Person. *See also* Human beings
 argument against the, 40
 biblical conception of, 82
 defined, 257
 in ethics, 46
 fetus as, 48–49, 52
 God as, 48, 436, 513–514, 518
 Locke on, 257
 narrative and, 304
 nonhuman, 49–50, 257
 unity of self and, 304, 305
 universe as, 513–514
 vegetative states and, 58, 259
Personal desire, 284
Personal identity
 character change and, 9–10, 251–252, 253, 302–303
 epistemological question of, 253
 as illusion, in Hinduism, 283
 Locke on, 255–256, 257, 263, 275–283, 302, 309–313
 metaphysical question of, 253
 moral agents and, 304
 narrative and, 304–306
 numerical identity and, 252, 253, 256, 300–301
 only x and y principle and, 298–300
 overview, 250–253
 Parfit on, 281, 287–289, 296–303, 313–317
 person and, 257
 problem of, 7, 9–10
 as process, 303
 psychological continuity and, 301
 responsibility and, 9–10, 251–252, 255, 302–303
 self as process and, 303–304
Personal identity, theories of
 animalism, 258–267, 273
 brain theory, 293–298
 closest continuer theory, 298–300
 defined, 250
 memory theory, 275–284
 narrativity theory, 304–306
 nonbranching theory, 298, 299
 process-based, 293–306
 psychological, 275–290
 psychological continuity theory, 285–290
 questions answered by, 250, 251–253
 soul theory, 267–273
 substance-based, 255–273, 290, 303
 testing, 250–251
Personal relationships, ethics of care, 394–395
Personhood, 49
Perspectivism, virtue, 589–591
Peter, Laurence J., 518
Phenomena, 564
Phenomenalism, 575–581, 582
"Philosophic Enterprise, The" (Blanshard), 63–66
Philosophical beliefs
 categories of, 5–6
 constructing, 2, 4
 dying for, 4–5
 importance of, 59–61
 inquiry influenced by, 6
 scientific inquiry influenced by, 5, 6, 63–66
 survey of your, 12

Philosophical inquiry
 goal of, 12
 importance of, 4, 5, 59–61
 necessary and sufficient conditions in, 12–13, 15, 44
 scientific inquiry *vs.*, 22, 23–26
 Socratic Method in, 15, 20–22
 stakes in, 7–12
 "The Philosophic Enterprise" (Blanshard), 63–66
 thought experiments in, 25–26, 44–55
Philosophical problems, 3, 5–7, 26
 listed and explained, 6–7, 8–12
Philosophical theories
 conceivability of, 52–53
 criteria of adequacy for, 37–38
 possibility of, 50–51, 53–54
 testing, 25–26, 44–45, 55
Philosophy
 branches of, major, 5
 defined, 2, 3
 meaning of word, 2
 overview, 2–3, 6
 questions explored by, 2, 5–6
 science and, 5, 6, 23–25, 26, 63–66
 subfields of, 6
 "Value of Philosophy, The" (Russell), 59–61
Philosophy for Business, 243
Photorealistic 3d simulations, 80
Physicalism, 142–146
Physics
 in ancient Greece, 18
 "fine-tuning" of universe and, 463–464
 law of conservation of mass-energy, 90, 154, 446, 449
 modern, rise of, 99–100
 on origin of universe, 446, 447–449
Piaget, Jean, 280
Pike, Albert, 220
 on the possible and the actual, 475
 on universe, 455
Pike, Kenneth L., 285
Pineal gland, 88–89, 90
Plantinga, Alvin, 491
Plato
 allegory of the cave, 549–552
 Aquinas and, 444
 Aristotle and, 407
 on cognitive subjectivism, 542
 on divine causation, 464
 dualism of, 267
 Euthyphro, 20–22
 human being defined by, 46, 57
 "Meno," 539
 on philosophy, 2
 on propositional knowledge, 539
 rationalism of, 548–552
 Republic, 418, 549–552
 The Ring of Gyges, 418
 Socrates and, 16–17
 on soul, 77
Pletcher, Galen, 358
Plotinus, 267
Pluralistic formalism, 381, 382, 399
Poe, Edgar Allan, 12
Political philosophy, of Locke, 276
Polytheism, 436
Positive rights, 416
Positivism, logical, 99–100, 101
Post hoc, ergo propter hoc, 42
Pour soi, 517
Pragmatic theory of truth, 541–542
Pragmatically justified belief, 479
Precedent
 defined, 36
 legal, 36
Pre-crime, guilty minds and, 211
Preestablished harmony, 89
Preimplantation genetic diagnosis (PGD), 195
Premises (of argument)
 cogent argument, 34
 defined, 28
 fallacious argument, 38–39
 good argument, 28–29
 identifying, 29–30
 insufficient, 39, 41–42
 irrelevant, 39–41
 sound argument, 32
 strong argument, 34
 unacceptable, 38, 39
Prepunishment, 209–213
Pre-Socratic philosophers, 15, 18–19, 156
Prigogine, Ilya, 303
Prima facie duty, 380–382

Primary qualities, 575–576
Primitive property, 148, 150
Prince and the Cobbler, Tale of the (thought experiment), 263
Principia Mathematica (Russell and Whitehead), 59
Principle
 in Cartesian skepticism, 553
 epistemic, 558
 moral, 345–347
 reversible, 372, 373, 376, 378, 385
 universalizable, 372, 373, 376, 378, 385
Principle of alternative possibilities, 205
Principle of charity, 30
Principle of clarity and distinctness, 557–558, 594–596
Principle of justice, 347
Principle of mercy, 347, 488
Principle of parsimony, 37
Principle of the transitivity of identity, 265
Principles of Philosophy (Descartes), 80
Problem of Cartesian circle, 558
Problem of evil
 defined, 7
 explained, 11, 488, 489
Problem of free will, 7, 8–9
 defined, 7
 importance of, 8–9
Problem of inequality, 498
Problem of moral relativism, 7, 10
Problem of other minds, 92–93, 101–102
Problem of personal identity. *See* Personal identity, problem of
Problem of skepticism. *See* Skepticism, problem of
Problems of Philosophy, The (Russell), 59
Problem-solving ability, and artificial intelligence, 71
Programming, mind as, 121–122
Property
 accidental, 252
 emergent, 150–151
 essential, 252, 253
 primitive, 148, 150
Property dualism, 148–157
 double aspect theory, 149
 emergentism, 150–155

explained, 148
 panpsychism, 155–156
 primitive intentionality, 148–150
 thought experiment, 149
Proposition(s). *See also* Statements
 a posteriori, 539, 560, 563
 a priori, 539, 540, 560, 563
 analytic, 540, 541, 560
 defined, 538
 determining truth of, 538–544
 reasonable doubt about, 559
 synthetic, 540, 541, 560, 563
Propositional knowledge, 538–544, 591
Protagoras, 542
Protoconsciousness, 156
Prudent Diplomat (thought experiment), 380
Pseudonormal vision, 127
Psilocybin, 472
Psychological connectedness, 285
Psychological continuity
 defined, 285
 importance of, 301
 nonbranching, 298, 299
 numerical identity *vs.*, 300–301
Psychological continuity theory, 285–290
 brain theory and, 293
 explained, 285
 reincarnation and, 285–286
 teletransportation, 287–290, 298
 thought experiments, 285–286, 287–288, 291
Psychological hedonism, 352–355
Psychological narrativity thesis, 305
Psychology
 cognitive, 564
 folk, 141–142
Psychopaths, children as, 405
Punishment
 act-utilitarianism, 362, 374
 Locke on, 276–278
 traditional compatibilism, 208
Pusey, E. B., 409
Putnam, Frank W., Jr., 266
Putnam, Hilary, 398
 Conscious Computer (thought experiment), 113, 114

Inverted Spectrum (thought experiment), 125–126
Super-Spartans (thought experiment), 104–105, 123
"Puzzle of Conscious Experience, The" (Chalmers), 168–172
Pythagoras, 19

Qualia inversion, 127
Qualitative content (of mental states), 103
 in eliminative materialism, 142–146
 in functionalism, 123–128
 in logical behaviorism, 103–104
 in physicalism, 142–143
 in property dualism, 148
Qualitative identity, 252, 253
Quantum mechanics, 447, 448, 583
Quasi-desires, 284
Quasi-memories, 281–283
Questionable Cure (thought experiment), 261
Quine, W. V. O., 543

Raelianism, 260, 460
Rahula, Walpola, 299
Ramachandran, Vilayanur, 87, 295
Rand, Ayn, 353
Random Bombardier (thought experiment), 197
Rationalism
 on analytic and synthetic propositions, 540
 defined, 539
 Descartes on, 552–558, 568
 empiricism on, 539, 559–560
 Greek, 545–552
 Kant's synthesis of empiricism and, 563–565
 reasonable doubt and, 559
Rationally justified belief, 479
Rawls, John, on contractarianism, 382–385
Real memories, 280–283
Realism
 direct, 571–573, 582
 representative, 573–575, 582–583
Reality
 in coherence theory of truth, 540–541
 in correspondence theory of truth, 540
 in minimal correspondence theory of truth, 543–544

mystical experience and, 566–567
 Parmenides on, 546
 Plato on, 549–552
Reason
 doubt and, Descartes on, 78, 79, 552–556, 554–558
 in empiricism, 539, 559–560
 in establishing God's existence, 441–442, 506–507
Reasonable doubt, 559
Reasons and Persons (Parfit), 313
Recidivism, 194
Red Sea, parting of, 466, 470
Reductive theories, 101
Reductive theories of mind
 eliminative materialism *vs.*, 139, 140
 failure of, 115–116, 139, 168–172
 identity theory as, 109
 logical behaviorism as, 101
Reduplication
 brain theory and, 295, 297–298
 closest continuer theory and, 298, 299–300
 nonbranching theory and, 298, 299
 numerical identity *vs.* psychological continuity and, 300–301
 Parfit's Division (thought experiment), 297, 298–299, 300, 301, 302
 reincarnation and, 285–286
 responsibility and, 302
Reduplication Argument (thought experiment), 286
Reflection, and personal identity, 305
Reflective common sense, 191, 198
Reflective knowledge, 590–591
Rehabilitation, 208
Reid, Thomas
 Tale of the Brave Officer and Senile General (thought experiment), 279
Reincarnation
 in Hinduism, 498
 memory theory and, 276
 problem of inequality and, 498
 reduplication problem in, 285–286
 soul and, 267
Reincarnation of Guy Fawkes (thought experiment), 285–286, 298
Reitz, Stephen, 277

Relativism
 cultural. *See* Cultural relativism
 Kant's conceptual schemes and, 565
 moral. *See* Moral relativism
 subjective, 332–333
 of truth, 542–543
Reliability theory of knowledge, 588–589, 591
Religion(s)
 affirmations common to, 513
 different beliefs of, implications of, 436, 441
 domain of, *vs.* science, 482–483
 God/gods in, 436
 number of adherents, 441
 without God, 518–519
Religious cults, 213
Religious experience, 471, 518–519
 argument from (for God's existence), 471–474, 484
Religious orientation, characteristics of, 518
Representative realism, 573–575, 582–583
Republic (Plato), 418
 allegory of the cave in, 549–552
Responsibility
 alternative possibilities and, 205
 belief in, and behavior, 193
 for beliefs, in evidentialism, 510
 character change and, 9–10, 251–252, 253, 302–303
 in determinism, 178, 180–182, 188–190
 in indeterminism, 200
 memory of actions and, 276–278
 personal identity and, 9–10, 250–251, 255, 302–303
 in traditional compatibilism, 207, 208, 209
 unity of self and, 305–306
Resurrection of the body, 82, 259–261
Retributive punishment, 208
 Adam and Eve story and, 492
Reversible principle, 372, 373, 376, 378, 385
Revolutions, 4–5
Richter, Jean Paul, 514
Rights
 animal, 50
 negative, 416
 positive, 416
 problems with, 359–360

 robots, 50, 71, 72
 universal human, 337
Ring of Gyges, 418
Robots. *See also* Artificial intelligence
 marriage with human beings, 71
 with minds, 71–72, 103
 persons, 50
 rights for, 50, 71, 72
 as slaves, 71–72
 Sophia, 50
 speciesism and, 114
 with superhuman intelligence, 8
Roman Catholic Church
 Baltimore Catechism, 437
 on evolution, 465
 historic conflict with science, 96–97
 Inquisition, 510–511
 on Mary, 491
 transubstantiation in, 269
Rorty, Richard, 139–140, 141
Rorty's Demons (thought experiment), 139–140, 141
Rosen, Richard, 192
Roskies, Adina, 224–225
Ross, Hugh, 448
Ross, W. D.
 Good Samaritan (thought experiment), 376
 prima facie duties, 380–382
 Unhappy Promise (thought experiment), 360
Rowe, William, 488–489
Rowe's Fawn (thought experiment), 488–489
Rule-utilitarianism, 363–367
 defined, 363
Rundle, Bede, 449
Russell, Bertrand, 445
 biography, 59
 on faith, 507, 508
 hallucination hypothesis, 471–472
 on human design flaws, 465
 on knowledge by acquaintance, 538
 on mystical experience, 567
 "On Induction," 597–600
 on religious experience, 471–472
 on sense data, 572–573
 "Value of Philosophy, The" (Russell), 59–61

Ruthen, Russell, 549
Rutherford, Samuel, 499
Rutter, Brad, 130
Ryle, Gilbert, 102

Sacred scriptures, 438
Sagan, Carl, 37
Saks, Elyn, 304
Sameness, types of, 252
Sand, George, 303
Santayana, George, 86, 269, 561
Sapir, Edward, 570
Sartre, Jean-Paul, 516–517
Saurin, Bernard Joseph, 480
Schechtman, Marya, 304
Schiavo, Michael, 58
Schiavo, Terri, 57–58, 262
Schiller, F. C. S., 156
Schleiermacher, Friedrich, 491
Schopenhauer, Arthur, 261, 545
Science
 causal determinism and, 191–198
 creationism and, 464
 Descartes on, 78
 domain of, *vs.* religion, 482–483
 faith in, 483, 562
 historic conflict with religion, 96–97
 induction in, 562
 and logical behaviorism, 101
 and nature/nurture debate, 191–198
 necessary and sufficient conditions in, 14, 22
 on perception, 581
 philosophical inquiry *vs.*, 22, 23–26
 philosophy and, 5, 6, 23–25, 26, 63–66
 Pythagoras' insight, 19
 reductive theories in, 101
 thought experiments in, 54
"Scientific creationism," 460, 465
Scientific laws, construction *vs.* discovery of, 566
Scientific method, steps in, 23
Scope (of hypothesis), 37
Searle, John
 Brain Replacement (thought experiment), 115–116
 Chinese Room (thought experiment), 131–132, 134–135
 on intentionality, 134–135
 on Turing test, 131–132
Secondary qualities, 575–576
Second-order desires, 213, 214, 215, 216, 218
 agent causation, 230, 232
Second-order knowledge, 590
Second-order volitions, 213–215, 217, 218, 232
Selective breeding, human, 195
Selective reinforcement, 192
Self, the
 as narrative, 304–305
 as process, 303–304
 Buddhism on, 10, 272, 299, 303, 440
 created through choices, in existentialism, 516
 unity of, 303, 304–306
Self-confidence, 513
Self-consciousness, 257, 259, 303, 305, 306
Selfishness, as virtue, 353
"Self-forming actions," 230
Self-reflection, 305
Sellars, Wilfred, 51
Semantics, 132–134
Seneca, 6, 178, 410
Sense experience
 in direct realism, 571–573
 of lifetime, recording, 282
 Locke on, 573–576
 in phenomenalism, 575–581
 primary *vs.* secondary qualities in, 575–576
 religious experience as, 473
 in representative realism, 573–575
 scientific explanation of, 581
 sense data in, 572–575
 as theoretical, 141
Sex and Social Justice (Nussbaum), 427
Shakespeare, William, 52, 250, 488, 584
Shankara, 74–75, 283
Shanks, Niall, 461
Shaw, George Bernard, 258
Ship of Theseus (thought experiment), 256
Shoemaker, Sydney
 Brain Transplant (thought experiment), 293–294
 nonbranching theory, 298, 299
 on quasi-memory, 281

Silicon chips, neurons replaced with, 115–116, 117
Silverman, Herb, 481
Silverman's wager, 481
Simplicity (of hypothesis), 37
Simulations, 79, 80
 photorealistic 3d, 80
Singer, Peter, 403
Single-Minded Hedonist (thought experiment), 354
Singularity (black holes), 450
Singularity (computer science), 74
Skepticism
 Cartesian. *See* Cartesian skepticism
 defined, 538
 empiricism and, 559–560
 explained, 540
 Greek rationalism and, 545–552
 induction and, 561–562
 phenomenalism and, 579
 problem of, 7, 11–12
 reasonable doubt and, 559
Skills, knowledge of, 538
Skinner, B. F.
 beliefs of, 191–192, 196
 on free will, 8–9
 ideal society of, 192
 on predictability of human, 191
 Walden II, 9, 192
Slavery
 by God, 495
 Kant's categorical imperative on, 495
 of robots, 71–72
Sleepwalking, murder while, 277
Slick Rick, 571
Slote, Michael, 217
Smilansky, Saul, 193, 209
Smith, Adam, 98
Smith, Eric, 181
Smolin, Lee, 450–451, 455, 463
Smoot, George, 448
Social contract, 389–393
Sociobiology, 194–198
Socrates, 98
 in allegory of the cave, 549–552
 Euthyphro (Plato), 20–22
 on importance of philosophical inquiry, 4
 life and death of, 15–19
 in "Meno" (Plato), 539
Socratic Method, 15, 20–22
 applied to Aristotle's theory of human being, 44–45
 steps in, 22
Soft determinism, 204
Soliah, Kathleen, 253
Solipsism, 92–93, 583
Solomon, King, 439
Sophia (robot), 50
Sophie's Choice (Styron), 394
Sophists, cognitive subjectivism of, 542
Sophocles, 109–110
Sosa, Ernest
 biography, 601
 "Getting It Right," 601–602
 on virtue epistemology, 601–602
 on virtue perspectivism, 589–591
Soul
 Augustine on, 267
 Buddhism on, 299
 and consciousness, 270–271
 Hume on, 99
 mind as, 77
"Soul Catcher," 282
Soul Switch (thought experiment), 271
Soul switches, 269–272
Soul theory, 267–272
 consciousness and, 270–271
 defined, 267
 memory loss and, 268–269
 soul switches and, 269–272
 thoughts and, 268–270
Soul-building defense (for evil), 496–497
Souls
 in heaven, 269, 272
 problem of defining, 268
 thoughts distinct from, 268–270
Sound argument, 32–33
South American Showdown (thought experiment), 368–369
Southey, Robert, 489
Space, nonexistence and, 549
Species, observation of new, 461–463
Speciesism, 114
Sperm banks, 195

Sperry, Roger
　on downward causation, 152, 154
　on split-brain patients as two persons, 86–87, 296, 297
Spinoza, Baruch
　double aspect theory of, 149
　pantheism, 502–503
　on universe, 463
　on will of God, 341, 464
Split brain, 86–87, 295–298, 316–317
Spong, John Shelby, 518
Stace, Walter Terence
　on free *vs.* unfree acts, 207
　and mystical experience, 567
Staight, Kevin, 144
Star Trek (TV series), 104, 128, 138, 283, 287
Star Wars (movies), 285, 490
Starkman, Glenn D., 464
Statements (sentences)
　meaning of, logical positivism on, 100
　verifiability theory of meaning and, 100, 101, 106–107
Stenger, Vic, 449
Sterilization, involuntary, 195
Stern, Robert A. M., 305
Sterne, Lawrence, on knowledge, 538
Sting, 81
Stocker, Michael, 403, 404, 405
　hospitalized patient (thought experiment), 404
Stoicism, 410, 419
Stoics
　Aristotle *vs.*, 410, 413
　on virtue, 410–413
Stoll, Clifford, 213
Strange Days (movie), 281
Strawson, Galen, 229
　on belief in God, 480
　on self as narrative, 305
String theory, 18
Strong AI, 121
Strong argument, 31, 34, 35
Study in Scarlet, A (Doyle), 36
Styron, William, 394
Subjective absolutism, 332–340
Subjective knowledge, 142–146
Subjective relativism, 332–333

Subjective truth
　in cognitive subjectivism, 542, 543
　Kierkegaard on, 507
Subjectivism, cognitive, 542, 543
Suffering
　effect on character, 488
　unnecessary, 487, 488
Sufficient condition, 12–15
Suits, Bernard, 15
Superbeing (thought experiment), 185
Supererogatory actions, 403
Supermind, 283
Supernatural theories
　alien theories *vs.*, 470
　naturalistic theories *vs.*, 464, 482
　of sense experience, 579–581
Super-Spartans (thought experiment), 104–105, 123
Supreme beings, 436
Sussman, Jay, 121–122
Swinburne, Richard, 48
Syllogism
　disjunctive, 32
　hypothetical, 32
Symbionese Liberation Army (SLA), 253
Symbols, understanding meaning of, 131–134
Syntax, 132–133
Synthetic propositions, 540, 560, 563, 569
System of Nature (Holbach), 234
Szasz, Thomas, 471
Szentágothai, János, 151

Tabula rasa (blank slate), 98, 276, 559
Tale of the Brave Officer and Senile General (thought experiment), 279
Tale of the Prince and the Cobbler (thought experiment), 263
Tanguay, Armand R., 117
Taoism, 438
Taylor, Richard, 200
　Drug Addiction (thought experiment), 211, 212
　Ingenious Physiologist (thought experiment), 209–211
　Unpredictable Arm (thought experiment), 201
Teale, Edmund Way, 520
Teilhard de Chardin, Pierre, and panpsychism, 156

Teleological arguments (for God's existence), 451–471, 484
 analogical design, 452–455
 best-explanation design, 455–466
 defined, 451
 explained, 451
Teleological ethical theories. *See* Consequentialist (teleological) ethical theories
Teletransportation, 287–290, 298
Temple, William, 48
"Terri's law," 57–58
Tertullian, 506
Test implication, 44, 45
Thales, 18
Thatcher, Adrian, 82
Theism
 defined, 437
 traditional God of, 437, 440
Theodicies, 489
 defined, 489
 evil as force *vs.* good, 490
 evil as work of devil, 490
 finite-God defense, 497–500
 free-will defense, 491–493
 ideal-humanity defense, 494–495
 knowledge defense, 493–494
 soul-building defense, 496–497
Theory, and fact, 457
Theory of mind, 75
Thersites, 270–271
Thirteenth Floor (movie), 79
Thomson, James B. V., 2, 515
Thomson, Judith Jarvis, 56
 Diseased Musician (thought experiment), 56
 Transplant Problem (thought experiment), 369
 Trolley Problem (thought experiment), 369
Thought
 distinct from soul, 268–270
 empiricism on, 98
 intentionality in, 134
 by machines, Turing on, 71, 128–129
 mechanical explanations of, 72–73
 as proof of existence, Descartes on, 556–558
Thought, laws of, 24
Thought experiments, 25–26, 44–54
 on abortion, 46–49, 52, 56
 on alternative possibilities and, 205, 215–216
 on analogical design argument, 453
 on Aristotle's theory of human beings, 44–45
 on Aristotle's theory of motion, 54
 on artificial intelligence, 128–129, 131–133, 135–136
 on belief in demons, 139–140, 141
 on body switches, 263
 on brain transplants, 264–265
 on Cartesian dualism, 70, 119
 on Cartesian skepticism, 553–554, 555–556
 on causal theory of knowledge, 587–588
 conceivability of, 52–53
 concept use in, 50–51
 critiquing, 51–52
 on defeasibility theory of knowledge, 586
 defined, 44
 on Descartes' dream argument, 553–554
 on Descartes' evil genius argument, 555–556
 on desires and actions of drug addicts, 214–215
 on eliminative materialism, 139–140, 141, 142–146
 on evidentialism, 509
 on foreknowledge, 203
 on functionalism, 123–126, 128–129, 131–136
 functions of, 45, 53–54
 on God's existence, 476, 477–478, 480, 489, 504–505
 on God's plan, 514–515
 from Greek rationalism, 547–548
 on hard determinism, 185, 197, 203
 on hierarchical compatibilism, 214–218
 on identity theory, 111–116, 119
 on inability to feel pain, 103
 on indeterminism, 197, 200
 on knowledge, theories of, 584–591
 on logical behaviorism, 102–106, 115–116
 on mad scientist, 555–556
 on memory theory, 279
 on mind as machine, 70, 72
 on ontological argument for God's existence, 476, 477–478
 overview, 25–26, 44–46
 on pain behavior, 103–105
 on perception, 576
 performing, 44–45
 on person, 46–49

possibility of, 50–51, 53–54
on potentiality principle, 55–56
on property dualism, 149
on psychological continuity theory, 285–288, 291
on reincarnation, 285–286
on reliability theory of knowledge, 588–589, 590
scientific, 54
on soul, 269
on soul switching, 270–271
on split brain, 297
on Turing test, 128–129, 131–133, 134–135
on unnecessary evil, 489
on vegetative states, 258, 261–262
on zombies, 116, 119
Thrombin, 459
Thucydides, 206
Tillich, Paul, 518
Time
as circular *vs.* linear, 450
and origin of universe, 450, 451
Time travel, 52–53
Tirrell, Albert, 277
Tolerance
Locke on, 276
Tolstoy, Leo, 51
Tooley, Michael, 55–56
"Torn Decisions" (Balaguer), 240–242
Torquemada, 510–511
Total Recall (movie), 281
Total Turing Test, 134
Tradition, appeal to, 40
Traditional compatibilism, 206–213
critiqued, 209–212
defined, 207
explained, 206–207
hierarchical compatibilism *vs.*, 215
prepunishment, 209–213
punishment, 208
thought experiments on, 209–213
"Transcendental ego," 303
Transitivity of identity, principle of, 265
Transplant Case, The (thought experiment), 264
Transplant Problem (thought experiment), 369
Transporter Tale (thought experiment), 287–288
Transporters, 287–289, 298

Transubstantiation, 269
"Transworld depravity" doctrine of, 491
Trapped Conversationalist (thought experiment), 205
Treatise of Human Nature, A (Hume), 99, 523
Treatise of Man (Descartes), 91
Tripathi, R. K., 498
Trolley Problem (thought experiment), 369
Trotta, Roberto, 464
Trumbull, Douglas, 473
Truth
belief as causing, 507–508, 512–514
coherence theory of, 540–541
correspondence theory of, 540
in empiricism, 560
Kierkegaard on, 507–508
and knowledge, circularity of, 280
minimal correspondence theory of, 543–544
mystical experience and, 566–567
passion and, 507
pragmatic theory of, 541–542
in propositional knowledge, 539–544
relativism of, 542–543
subjective *vs.* objective, 507
Tryon, Edward, 448–449, 451
Tsunami of 2004, 495
Turing, Alan
biography, 130
description of Turing test, 128–129
The Imitation Game (thought experiment), 128–129
on thinking by machines, 71, 128–129
Turing machine, 130
Turing test, 71, 128–136
critiques of, 131–136
intentionality, 134–136
overview, 128–131
thought experiments on, 128–129, 131–133, 134–135
Total, 134
Turing's description of, 128–129
understanding meaning of symbols and, 131–134
Turner, Stansfield, 212
Turok, Neil, 451
Twain, Mark, 46, 77
Twin studies, on biology and behavior, 193

Index 639

2001: A Space Odyssey (Clarke), 129
2001: A Space Odyssey (movie), 113–114, 473
Two Treatises of Government (Locke), 276
Typhoid Man (thought experiment), 379

Unacceptable premises, 38, 39
Unbelievers, killing of, 436
Uncertainty. *See also* Doubt
 in quantum mechanics, 197
Understanding, Kant on, 564
Unger, Peter
 Great Pain (thought experiment), 264–265
 Mad Scientist (thought experiment), 555–556
Unhappy Promise (thought experiment), 360
UNICEF, 402
Unitarian Universalism, 438, 465
Universal human rights, 337
Universal negative, proving, 440
Universalizable principle, 372, 373, 376, 378, 385
Universe
 as contracting and expanding, 450
 Copernican hypothesis on, 96–97
 as eternal, 446
 "fine-tuning" of, 463–465
 as God, 438, 514
 God as creator of, 436, 443–451, 484
 God as designer of, 436, 447, 451–471
 God as intervening in, 89, 437
 in hard determinism, 184–185, 186
 intelligent life elsewhere in, 464
 as living thing, 455
 as machine, 185, 452
 in materialism, 185
 particle physics models of, 184–185
 as self-reproducing, 450–451
 supernatural *vs.* naturalistic theories of, 464
 as uncaused, 446, 448
Universe, origin of
 "big bang," 447, 448, 450, 451, 455
 in first-cause argument, 443–447
 Gnostic explanation of, 445
 in Kalam cosmological argument, 447–451
 modern physics on, 447–451
 as spontaneous, 448–450
"Universe without Weak Interactions, A" (Harnik, Kribs, and Perez), 464

University of Southern California, 117
University Seeker (thought experiment), 102
Unnecessary evil, 488–489
Unnecessary suffering, 484, 488, 489, 501
Unpredictable Arm (thought experiment), 201
Unqualified authority, appeal to, 40
Untouchables, 497
Unwilling and Wanton Addicts (thought experiment), 214–215
Upheavals of Thought: The Intelligence of Emotions (Nussbaum), 427
Uranus, 22–23
Utilitarian Heir (thought experiment), 360
Utilitarian Informant (thought experiment), 359
Utilitarian Torture (thought experiment), 362
Utilitarianism
 act-utilitarianism. *See* Act-utilitarianism
 rule, 363–367
 thought experiment on, 365–367
 virtuous person, 402–403
Utility machine, 363

Vacuum fluctuations, 448–449
Valid argument, 30–33
Value
 instrumental, 350, 351
 intrinsic, 350, 351
"Value of Philosophy, The" (Russell), 59–61
Vanbrugh, Sir John, 336
Vedas, 438
Vegetative states, 258–259, 261–262
"Veil of ignorance," 383, 385, 399
Verifiability theory of meaning, 100, 101, 106–107, 334
Vices, Aristotle on, 408
Victimless crimes, 487
Vienna circle, 99–100
Vinge, Verner, 74
Virtue
 Aristotle on, 406–409, 415, 418
 basing belief on evidence as, 512
 Buddha on, 409
 defined, 406, 589
 in evidentialism, 512
 intellectual, 512, 589
 in knowledge, theories of, 589–591

 MacIntyre on, 413–414
 moral, 512, 589
 "Non-Relative Virtues," 427–431
 Nussbaum on, 414–416, 427–431
 passionate belief and, Kierkegaard on, 508
 Stoics on, 410–413
Virtue epistemology, 601–602
Virtue ethics, 417
Virtue perspectivism, 589–591
Virtuous person
 belief in God and, 518
 evidentialist, 512
 explained, 402, 417
 Kantian, 403–405
 right action *vs.*, 402, 417
 thought experiment on, 403
 utilitarianism, 402–403
Vision
 as irreducibly complex system, 458
 pseudonormal, 127
Vitalism, 195
Vivisection, 84
Vlastos, Gregory, 548
Vogt, Carl, 123
Vohs, Kathleen, 193
Voices, 87
Voltaire
 on causation, 207
 on certainty, 558
 on God, 450, 492
 on morality, 345
 on objects of philosophy, 3
 Philosophical Dictionary, 492
 on religion, 345
 on soul, 268
 on virtue, 414
Vorilhon, Claude, 260, 460
Vrba, Elizabeth, 460–461
Vulcan mind-meld, 283
Vulcans, 104

Wald, George, 456
Walden II (Skinner), 9, 192
Wallace, David Foster, 92
Walters, Richard (Slick Rick), 571
Warren, Mary Anne, "On the Moral and Legal Status of Abortion," 46–49
Warren's Moral Space Traveler (thought experiment), 46–47, 52
Washington, George, 364, 437, 501
Watson (supercomputer), 130
Watson, John B., 192
Watson, Thomas J., 130
Watts, Alan, 300
Watts, Isaac, 28
Watzman, Haim, 439
Weak AI, 133
Wearing, Clive, 306
Weinfurtner, Eva, 277
Western philosophy, 11, 75
"What Is It Like to Be a Bat?" (Nagel), 110–111
What Is Metaphysics? (Heidegger), 100
"What's the Trouble with Anthropic Reasoning?" (Trotta and Starkman), 464
When Bad Things Happen to Good People (Kushner), 497
White, Robert J., 295, 308
White, Thomas, 49
Whitehead, Alfred North, 6
 on method of discovery, 45
 and panpsychism, 156
 Principia Mathematica, 59
 on science and philosophy, 6, 75
Whole greater than sum of its parts, mind as, 73, 150–151
Whorf, Benjamin Lee, 570
"Why Don't You Just Wake Up?" (Davis), 603–605
Why Is There Something Rather Than Nothing? (Rundle), 449
Widerquist, Karl, Libertarian Monarchy (thought experiment), 392–393
Wiezenbaum, Joseph, 124
Wikler, Dan, 262
Wilczek, Frank, 449
Wilde, Oscar, 556
Will. *See also* Free will
 brain activity preceding, 222–226
 good, Kant on, 371
 neurophysiological evidence for, 226
 in traditional compatibilism, 206–207
Will to believe, 512–514
William of Occam, 37

Williams, Bernard, 285–286
 Reduplication Argument, 286
 Reincarnation of Guy Fawkes (thought experiment), 285–286, 298
 South American Showdown (thought experiment), 368–369
Williams, Ted, 259
Wilson, E. O.
 on moral theory, 327–328
 and sociobiology, 194, 196
Winter, Chris, 282
Witches, 139, 326, 511, 512
Witmer, Enos, 156
Wittgenstein, Ludwig, 14–15, 92, 540, 567
Wolpe, Joseph, 105
Women, and ethics of care, 395
Women's equality, moral judgments on, 339
Words, meaning of, 98–99

World, The (Descartes), 159
Wundt, Wilhelm, 156

Xenophon, 16, 415

Your Mother, the Zombie (thought experiment), 119

Zeno of Citium, 410
Zeno of Elea, 19, 547–548, 549
 Paradox of Bisection (thought experiment), 547–548, 549
Zimmerman, Johann, 338
Zombies, 116, 119, 143, 144–146, 147
Zombies (thought experiment), 144–146
Zoroastrianism, 436, 438, 441
Zwolinski, Matt, 389
Zygmanik, George, 326, 350, 399
Zygmanik, Lester, 326, 332, 350, 351, 399, 417